Christmas, 2006 Dear Bob,

Thanks to our painting buddy for driving & guiding us through the autumn workshop

Sarah & Brenda

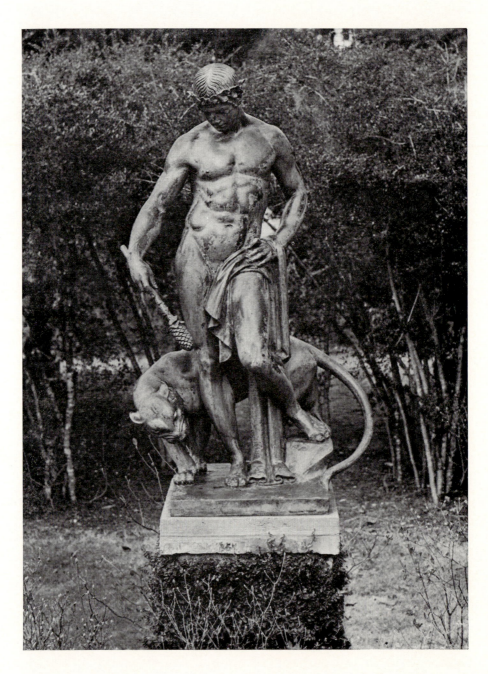

Edward McCartan DIONYSUS

Brookgreen Gardens Sculpture

BY BEATRICE GILMAN PROSKE

New edition,
revised and enlarged

Printed by order of the Trustees

BROOKGREEN GARDENS

1968

Contents

v

Contents

Acknowledgments

UNFAILING CO-OPERATION from the sculptors represented has greatly facilitated the writing of this catalogue. They have generously supplied photographs and information about themselves and their work. Theodora Morgan and the staff of the National Sculpture Society have been most helpful. For identifying the kinds of stone used in the sculpture I am indebted to Robert A. Baillie and for measurements to Mr. Baillie, F. G. Tarbox, Jr., and Gurdon L. Tarbox, Jr., who took many of the photographs in this volume. Frances Spalding made other fine photographs. Museums throughout the country have responded in detail to inquiries about their collections of American sculpture.

Foreword

BROOKGREEN GARDENS is a quiet joining of hands between science and art. The original plan involved a tract of land from the Waccamaw River to the sea in Georgetown County, South Carolina, for the preservation of the flora and fauna of the southeast. At first the garden was intended to contain the sculpture of Anna Hyatt Huntington. This has gradually found extension in an outline collection representative of the history of American sculpture, from the nineteenth century, which finds its natural setting out of doors. Its object is the presentation of the natural life of a given district as a museum, and as it is a garden, and gardens have from early times been rightly embellished by the art of the sculptor, that principle has found expression in American creative art.

A.M.H.

Introduction

THE BRIEF HISTORY of sculpture in America has seen the rapid rise of an art where none existed. Into the span of a few decades has been crowded a development which, in other countries, has taken centuries. America, after a complete dependence on foreign models, has acquired its own masters and its own schools and even when closely associated with the art of another country has left its own impress on the work produced here. Although little sculpture was brought overseas in the early years, it must be remembered that contact with Europe was never broken. The art of sculpture began, not as a true primitive art springing only from the instincts of the people, but as a provincial art, an offshoot of the older civilization of the mother continent. Throughout the nineteenth century our sculpture echoed the successive phases of European style, selecting for greater emphasis those which best suited its natural bent.

During the period of colonization the settlers had been too busy making a livelihood to have much time or inclination for the arts. Nor, unlike the Spaniards in South America, did they find an established civilization on which to build. The church discouraged religious image-making, and the feeling grew that artistic pursuits and works of art were frivolous and unprofitable. On the eastern seaboard in the course of the eighteenth century a cultured aristocracy tended to revise this attitude and began to cultivate some arts and crafts, but sculpture was not prominent among them.

In 1770 England sent to her colonies the first public statues erected in this country. Joseph Wilton was the sculptor of one of William Pitt which was placed at New York City and Charleston, South Carolina, and of a lead equestrian statue of George the Third erected also at New York. Only six years later that of the King was torn down by the disaffected colonists and the one of Pitt at New York by the British troops in reprisal.[1] A marble statue of Norborne Berkeley, royal governor of Virginia, carved in London in 1773 by Richard Hayward, was set up at Williamsburg. It was over twenty years before another statue, Houdon's marble *Washington*, was placed at Richmond, Virginia. A few of his fine busts were destined for overseas, but the only American sculptor who might have come in contact with him, William

1 Henderson, H. W. *A loiterer in New York*. p. 81–85.

Rush, had not the technical ability to profit from the meeting to any great extent. Rush's *Winter*, with the tightly wrapped cloak held by crossed arms, is a conception similar to Houdon's *La Frileuse*, but the manner of treatment is hardly comparable. The bust of Elizabeth Rush may owe something not only as to subject but also as to style to Houdon's delightful portraits of girls. In the interim a few other sculptors, the Englishman John Dixey and the Italian Ceracchi, had visited the country and left behind them portrait busts of notables feebly affecting a Roman grandeur. The first native-born modeler, Patience Lovell Wright, when her portraits in wax had gained her some fame, removed to the more artistic surroundings of London.

Despite this lack of example, there began to be sculptors. A knife and a piece of wood are enough to rouse the urge to whittle, and the feel of clay in the hand stirs a desire to shape it. The marble yard and the clay pit are the natural schools for carving and modeling. Before the days of the photograph a sculptured bust was the best possible likeness, while weather vanes, duck decoys, and figureheads gave scope to the carpenter-carver, trained in the shops of furniture and carriage makers and shipwrights. In the last decade of the eighteenth century Rush at Philadelphia turned from carving figureheads to other decorative figures and to portrait busts. Although his mythological ladies in stiffly swirling draperies now arouse little interest, in portrait sculpture he achieved a rude power of characterization. Much of his technique he learned from *The Artist's Repository*, published at London in 1808; a very little, perhaps, from Houdon; while reference to a living model gave the *Water Nymph and Bittern* greater naturalness.[2]

With the opening of the nineteenth century more carvers began to try their hands at works of art. Trained in marble-cutters' shops at tombstones and mantelpieces, their creative instincts urged them to more original efforts. They made portraits and occasionally a figure drawn from their imaginations. John Frazee, at New York in 1824, was the first native American to carve a portrait bust in marble, a bust of John Wells in Saint Paul's Church, New York. His study of a child eating pie heralded the Rogers groups. At about the same time Hezekiah Augur at New Haven progressed from carving furniture to working in marble, a pair of small-sized figures, *Jephthah and His Daughter*, being his most ambitious creation.

It is hard to imagine the tremendous difficulties under which these forerunners worked. There was no sculpture which they could see, except perhaps an occasional copy of a Greek or Roman statue in the possession of the wealthy, such as that of Phocion which Greenough's father had in his garden.[3] In default of major works English ceramic figurines and busts served as models,

2 Marceau. p. 20.
3 Dunlap. v. 3, p. 216.

but their chief inspiration came from rare casts from the antique and from engravings in books which were themselves rarities. The Pennsylvania Academy had a collection of casts from statues in the Musée Napoléon which Houdon selected [4] and there were others at the American Academy of Fine Arts in New York and the Boston Athenæum. To these men, then, sculpture must have meant classic sculpture, as they could have had little knowledge of the rich centuries in between. After an abortive preliminary attempt by Charles Willson Peale, Ceracchi, and Rush about 1791, the first art school, that of The Pennsylvania Academy of the Fine Arts, was established in 1805, but there were not many others until after mid-century. Of as late a period as the 1840's Ball could write, "It must be remembered that at that time there were no schools or academies where the student could learn the technique of his art; but each was obliged to dig one out for himself, taking the works of those more fortunate artists who had studied abroad, for his models." [5] In the cities a few ornament carvers, some foreign-trained, could teach the rudiments of technique. It is extraordinary that under such adverse circumstances the impulse to create could still work so strongly. There was no public sentiment to encourage the artist, since the early scorn for cultural values had been perpetuated on successive frontiers and in the East by the rush to get rich.

The social atmosphere began to be less severe towards art as the century advanced, for rapidly increasing fortunes allowed a margin to buy things for decoration as well as for use. Cities grew, and in rich homes there was place for more than the family portraits of earlier times. Europe became the goal for the intellectual traveler, who began to bring back some works of art. Would-be sculptors emigrated in increasing numbers to Italy for instruction. Horatio Greenough went from Boston to Rome in 1825 to study with Thorvaldsen, Thomas Crawford followed from New York, and Hiram Powers went from Cincinnati to Florence. This first group of professionally trained sculptors, modest in their consciousness of a lack of background, followed to the letter the neoclassic tenets of Canova and Thorvaldsen, with their strict dependence on fixed canons and rigid suppression of a personal attitude. They established their studios in Italy and came home only for brief visits, collecting commissions for portrait busts, memorials, and ornamental statues which they executed, chiefly in marble, in their Italian studios. A few neoclassic models entered the country. Canova's statue of Washington as a Roman general for Raleigh, North Carolina, done in 1816, was destroyed by fire fifteen years later. Copies of works by Canova were exhibited at the Pennsylvania Academy and the Boston Athenæum. When the National Gallery of

4 Marceau. p. 16.
5 Ball. p. 93.

Art was first founded at Washington in 1840, Thorvaldsen's *Saint Cecilia* was in the collection; his *Venus* and John Gibson's *Venus and Cupid* were among the sculpture owned by the National Academy of Design, New York, when it was opened. A pupil of Thorvaldsen, Launitz, was Crawford's first teacher, and another pupil, the German Ferdinand Pettrich, visited the country in 1835 and modeled a series of Indians. Chantrey's *Washington*, erected at Boston in 1828, impressed young Thomas Ball before he thought of becoming a sculptor. Of the men who were preparing the way for new theories David d'Angers alone was represented by a statue of Jefferson and two colossal busts in the Capitol.

The classic style seemed to have a suitably noble character for presenting the heroes of our rampant nationalism and our nascent ideals. The government, interested in beautifying the newly built Capitol, was a powerful stimulus to native sculptors. From Greenough were ordered a statue of Washington and a group called *The Rescue*, which were the first colossal marbles in the United States. The *Washington* he treated as a Roman emperor, half-draped in a cloak; *The Rescue* has an indigenous subject, a settler saving his family from an Indian attack, but the whole theme is conceived in a grandiose manner—even the Indian is an academic figure. To Thomas Crawford was entrusted the design of the pediment of the Capitol, another new undertaking for this country, in which he, too, tried to embody native elements to show the past and present of America. To the row of figures aligned on the cornice he has given a more local character than Greenough attempted and has certainly not referred to any classic model for his scheme. In the subject matter is the germ of a future crop of monumental sculpture on patriotic ideas.

The third of this early group, Hiram Powers, had a slightly different bent. More than the others he was attracted by the sweetness rather than the monumentality of Canova and is perhaps the first to show that gentle idealism which persisted as an underlying current into the next century. His *Greek Slave*, at the time a bold innovation in presenting the nude figure, through its notoriety stands as a symbol of the taste of the period. After it had been exhibited in London it was commended in an English magazine for its faithfulness to Greek models "in the simple severity of its outline, and in the intellectual expression . . . Appealing to the sympathies and sensibilities of our nature, rather than to those feelings which call forth words of delight, we are yet won to admiration by its touching beauty and its unexaggerated ideality." [6]

Rome and Florence continued to be the Mecca for a group of slightly

6 *The Art-journal.* February 1st, 1850. v. 12, p. 56.

younger sculptors, Thomas Ball, William Wetmore Story, Randolph Rogers, and William Henry Rinehart. They, too, sent home portrait busts, memorials of allegorical intent, and figures with titles chosen from Greek mythology, the Bible, and other literary sources. Still faithful to the spirit of the neoclassicists, they allowed themselves greater variety of movement and a more lifelike treatment of the figure. Story, declaiming in verse,

> Where is the voice that in the stone can speak
> In any other language than the Greek?

could still in prose complain, "Modern sculpture is so subservient to Grecian, that the human face is generally treated as if it were of no moment in the expression of passion and character, because the Greeks so treated it. We have a thousand Venuses, but no women." [7] Many replicas of Randolph Rogers's pathetic *Nydia*, with its familiar story, decorated American parlors. Erastus D. Palmer of Albany, self-trained, began to achieve a certain naturalness and ease by a closer study of the living model, and by his softer modeling and pensive mood created a distinct atmosphere.

While the expatriate group was trying to catch up with the Old World, other men were struggling at home with the handicaps of inadequate materials. In the hardy tradition of Rush, Frazee, and Augur, they were rising by their own efforts to the status of independent artists. It was through them that American sculpture received another strong bias, that towards accurate observation and recording of things seen. John Rogers, the household favorite of the post-Civil War period, seldom attempted anything more ambitious than his anecdotal groups of everyday life, illustrations in clay. Henry Kirke Brown begins the long line of sculptors of public monuments. Although he studied for a while in Italy, his portrait statues pretend to little more than a lifelike presentation of the subject. As the teacher of J. Q. A. Ward, who in turn taught Daniel Chester French, he was the founder of a continuous native tradition. A contemporary, Clark Mills, entirely self-taught, preceded Brown in the modeling of an equestrian statue, the first by an American and cast in his own foundry. Erected to General Jackson at Washington in 1853, it introduced the novelty of a boldly rearing horse, the hind legs exactly under the center of the body to give it perfect balance. Six years before, the Englishman Ball Hughes had been the first to cast a bronze statue in America, and following these pioneers some sculptors employed local foundries, but the majority of the work was put in bronze at Munich or Paris until about 1900. Hughes is also given the distinction of being the first to carve a statue in marble in the United States, that of Alexander Hamilton erected in the New York Merchants' Exchange in 1835 but destroyed by fire the same year.

7 Phillips. p. 129.

Peter Stephenson claimed that his *Wounded Indian* cut in 1850 was the first statue ever carved in Vermont marble.[8]

With the second half of the nineteenth century sculpture became an established though still not a popular art. Tuckerman bewailed our apathy towards things artistic, characterizing the American temperament as more inventive and mechanical than creative, but noticed a rapid awakening. The homes of the wealthy might now contain a bust by Crawford, Powers, or Palmer, or a group by John Rogers. From the centers of culture on the Atlantic seaboard—Philadelphia, New York, Boston, and Washington— sculpture spread inland and to smaller cities. A few sculptors had early been attracted to the capitals of the eastern states: Albany, where H. K. Brown, E. D. Palmer, and Launt Thompson were all active at about the same time; Baltimore, the scene of Rinehart's endeavors; and Hartford, where the state capitol was being built. Cincinnati as early as 1830 to 1835 had a nucleus of four sculptors, Powers, H. K. Brown, Clevenger, and John King, and later established one of the earliest art schools. Randolph Rogers settled at Ann Arbor, Michigan, by 1848, and Leonard Volk, best known for his portrait of Lincoln, opened a studio at Saint Louis in the same year, later transferring it to Chicago. In the seventies the Austrian Elisabeth Ney settled in Texas and, a phenomenon in what was still frontier country, became the official commemorator of the state's heroes.

After the Civil War there was hardly a town without its bronze or granite soldier to commemorate the conflict. Randolph Rogers carved a number at Rome, Martin Milmore designed several for the vicinity of Boston, and Leonard Volk others for New York State and Illinois. They all used a standard pattern which Rogers probably originated, a statue on a central shaft and military figures grouped around the base, which was commercialized by the granite companies. Public buildings began to be decorated with sculptured groups and pediments, and more and more statues of local heroes were placed in city squares.

Chief among the men who produced these statues, Ward was the first to give them personalities. Caring little for heroics, but never lapsing from dignity, he abandoned the dramatic pose in favor of characteristic attitudes. Looking to no other artists for inspiration, he tried in an honest and downright fashion to make his subjects live again. Even though his work is scrupulously exact in re-creating the subject and though the literalness of his mind is often betrayed in harshness of touch, his sense of order and proportion led him to subordinate detail and achieve a simple monumentality. Had he been able to follow up *The Indian Hunter* with other things of the same kind,

8 Lee. v. 2, p. 193.

he might by his truthful, direct attack have raised the level of the quantity of trivial themes which now came forth and saved them from an overdose of sentiment, prettiness, and anecdote.

The nude or artfully draped figures in studied poses which were among the chief concerns of the younger sculptors were baptized as before with names from Greek mythology and the Bible. Since greater importance was attached to the meaning of the sculpture and its symbolic content, personifications of abstract qualities and pseudo-philosophical ideas such as Rinehart's *Love Reconciled with Death* were popular conceptions. In this contemplative spirit was begun the band of angels which for many decades was to hover over memorials. A lighter mood and gently poetical thoughts gave rise to nymphs and fauns, figures of the seasons and the stars, and from the hands of women sculptors, Harriet Hosmer and Emma Stebbins, came the earliest fountain designs. This group of sculptors was as concerned about the expressions of the faces as with the harmonious placing of the limbs on their figures.

A unique figure, William Rimmer, the Boston anatomist-sculptor, went his own way, rapt in lofty visions and preoccupied with problems of the body in motion and the relations of its forms. He embodied his tragic sense of life, "the powers and principles which lead to great action," [9] in boldly imagined figures like the *Dying Centaur* and *Fallen Gladiator*. His *Fighting Lions*, with their heavy musculation, fierce mood, and intricately woven composition, make one think of Barye, though lacking his convincing force, and it is probable that he had seen the French sculptor's work, already in the collection of his friend William Morris Hunt. A granite statue of Alexander Hamilton was a premature attempt at solidity of mass and simplification of contour which looked to a critic of the nineties "like a snow image which is partially melted." [10] He carved directly in the stone, and working from memory without the living model tried to achieve an imaginative synthesis of form.

During this time American sculpture had lagged far behind France, where new theories and practices were rapidly developing. Rude had lived and died without any American's becoming aware of him, and Carpeaux made little more impression. It was not until Saint-Gaudens went to Paris to study in 1867 that new impulses awoke American sculpture from its long classic sleep. With him and his contemporaries began a new era in which American sculpture was drawn more closely into the ebb and flow of French styles, for France now took undisputed lead in Europe in artistic matters.

In France the neoclassic mania, sponsored by sculptors of minor caliber, had caused no permanent break in the fine traditions carried down from the eighteenth century. The romanticism which agitated the painters of the early

9 Bartlett, T. H. *Dr. William Rimmer.* p. 468.
10 Downes. p. 370.

nineteenth century gained little hold on sculpture, so ill-suited to impalpable notions, but the return to the study of nature captured it completely. Rude with his powerful movement and sustained emotion brought a new sense of life and vigor, Barye was a pioneer in considering the animal world worth attention, and Carpeaux recaptured the vivacity of the eighteenth century by his rare ability to bring his figures to pulsating life.

When Saint-Gaudens reached Paris, Carpeaux's *La Danse* had been in place only two years, but the American, attracted neither by this wanton gaiety nor by the cold correction of his teacher, Jouffroy, developed a quietly colorful manner, informed with a thoroughly American earnestness. The first of our sculptors to become technically proficient, he inaugurated that heyday of the modeler which was the end of the nineteenth century. When he accompanied Mercié to Rome, he took from the sculptors of the Renaissance, newly rediscovered by his French associates, his skill in delicate modulations of surface, his delight in exquisite detail and airiness of fluttering drapery. The disparate strains in his background can be picked out with difficulty from the fusion of his personality. The serene idealism and other-worldliness which breathe through his sculpture had already touched his neoclassic forerunners, and a minute study of tangible things had been evident in the style of some Americans even before it captivated French sculptors in the seventies. His work as a whole is definitely his own and leaves him with the distinction of being the first American sculptor to evolve a personal style. He begins the era of intense individuality which demanded that each artist have an independent expression rather than be an exponent of fixed canons.

Where Story abroad and Palmer at home had been the favorite sculptors of the seventies, the next decade saw the height of Ward's activity and the rise of Saint-Gaudens, Olin Warner, and Daniel Chester French. The first two belonged to the group of brilliant young men just returned from Europe who broke with the Academy to found the Society of American Artists. Richard Watson Gilder in the pages of the *Century Magazine* helped to make them known. French, slightly younger and home trained but already engaged on important commissions, had to wait longer for critical acclaim. A fellow student with Saint-Gaudens in Jouffroy's *atelier*, Olin Levi Warner also studied with Falguière and Mercié and was an assistant in Carpeaux's studio. Like Saint-Gaudens he learned in France a sound technique, the ability to weld his statues into an artistic whole, and flexible modeling. More in harmony with the classic ideal and less original than Saint-Gaudens, he shared with him that quiet sense of beauty which prevailed in the last few decades of the nineteenth century. He too drew something from the Italian Renaissance in the delicate treatment of low relief and the crisp handling of formal ornament. His personal contribution seems to have been a feeling for space

and monumentality in composition, as witness his use of large single figures for the bronze doors of the Library of Congress—an idea copied by many successors—and a restrained, coherent style. The realistic current missed him entirely, and in spirit he is closer to Palmer than to the schools of Paris.

Daniel Chester French, Saint-Gaudens's successor as dean of American sculptors, was a more robust personality, whose development was consistent with that of his American forerunners. Like those immediately preceding him, he was responsible for his own early art education, except for Rimmer's lectures, which bore no visible fruit, and a little study with Ward. Two years in Ball's studio at Florence did nothing to disturb this traditional background, but a stay at Paris in 1888 gave him a new outlook and saw the crystallizing of his ideas. After one essay in pictorial realism, the Gallaudet Memorial, he settled on an ample, monumental style. This new grasp of sculptural values is evident in breadth of treatment, for the basic point of view, compounded of moderation and idealism, was still classic, though its type of physical beauty was closer to life. No one French sculptor seems to have made an impression on him, though points of comparison might be found with Chapu, another man of the golden mean. From Saint-Gaudens he may have taken a hint as to the way of handling drapery. His compositions are always thoroughly integrated and rhythmically satisfying, and his modeling of the nude showed rare freedom and power. Although his symbolic figures swathed in soft, heavy folds, fell out of favor after his death, they are the archetype of American sculptural expression at the end of the nineteenth and beginning of the twentieth century, their dignity and graciousness an emanation of its spirit.

Both the American artist and his patron were striving to emerge from provincialism and widen their outlooks. Education and scholarship were improving in quality, and under the stimulus of LaFarge the decorative arts were being revived. Cultured people, revolting from the ugliness of man-made things about them but lacking the background to create their own standards, turned to familiar periods in European art for a guide. So dawned the Era of Good Taste. Sculptors still leaned heavily upon the established excellence of the Renaissance and the eminence of French contemporaries, but after Saint-Gaudens's break with neoclassicism, a spirit of confidence somewhat overcame the hesitancy of the preceding era. American sculpture had now come of age, for its exponents began to be received as equals in the Paris *salons*, where they exhibited in increasing numbers and often won recognition. Frank Edwin Elwell claimed to be the author of the first statue by an American sculptor erected in Europe, while French's equestrian *Washington* and Bartlett's *Lafayette* were accepted with honor by Paris. The founding of the National Sculpture Society in 1893 gave recognition to sculptors as a body and raised their standards.

French sculptors were still the mentors of most Americans. Chapu, Falguière, Mercié, and later Puech and Injalbert were the men with whom the majority studied, while Paul Dubois was one whom they especially admired. Specimens of the work of these men could be seen in America: Mercié and Falguière collaborated on the Lafayette Monument at Washington, Mercié's equestrian statue of General Lee was erected at Richmond, and Frémiet's to John Eager Howard at Baltimore. In the same square were placed Dubois's *Military Courage* and four splendid groups by Barye, a favorite among American collectors as were also lesser animal sculptors such as Cain and Mène. The dominant note among French sculptors continued to be realism, but even in the eighties certain of them were departing from too literal a copying of nature and trying to launch a style more suggestive than specific. Forms and faces were veiled in a soft modeling which smoothed over hard outlines and invoked a contemplative atmosphere of half statement, a kind of impressionism. Men trained in this school, such as Taft, deplored the use of strong shadows breaking the unity of the composition with "black holes."

Another group stressed pictorial values, varying the height of the relief to suggest the planes of a picture, spreading drapery in broad irregular sweeps comparable to brush strokes, and introducing delicate, sketchily modeled flowers and trees to give an effect of color and background. Paul Wayland Bartlett, who spent the greater part of his life in France, is the most representative of this trend. His pediment for the East Wing of the United States Capitol, in progress from 1909 to 1916, was hailed as "thoroughly modern"; the informal groupings, choice of characters from everyday life, and play of light on varied surfaces could have been produced at no other moment. Within the same broad group, Herbert Adams retained a classic serenity and repose but enriched the forms with a refined beauty of modeling which is his own contribution. From the Florentine sculptors of the Renaissance he learned the subtle blending of surfaces and the delicacy of thin stuffs lightly drawn across the figure. The polychrome busts of women which he made his special field were a form already popular with some French sculptors but ultimately derived from the same source.

In common with his French compeers George Grey Barnard made a close study of the living model, but, working quite by himself, he had a clear and definite sense of form, shorn of the grace of ornament. Like many painters of a slightly earlier period and like Rodin, he was preoccupied with the effects of light, and in his modeling brought out powerful harmonies of light and shade. The form was always subservient to the thought which inspired it, and his thoughts were on such universal themes as the dignity of labor, the brotherhood of man, and the futility of war. It is only in his compositions and poses, which affect the unstudied arrangements of nature, that he is in accord with

his period. Single-minded and dwelling apart in grandiose visions, he had little share in the ephemeral splendors of expositions and in public monuments.

The periodic world fairs have served a special purpose in the art of this country. Although they seem to have had slight influence in shaping the character of its development, except perhaps in architecture, they have been moments of self-appraisal and orientation and have made American artists conscious of their work as a whole. The first, at Philadelphia in 1876, is often chosen as the starting point in the rise of a national sculpture, though it seems rather to have been coincident with it than formative. While it enlightened those who had not been abroad about the sculpture then being produced in Europe, that from Italy bulked largest, with its anecdotal subjects and virtuosity in the treatment of stuffs and textures. Many of these works must have stayed in the country through purchase, just as they did later from the Columbian Exposition, but American sculptors were as yet unqualified to copy their technique.

On the buildings for the Columbian Exposition at Chicago in 1892 American sculptors made their first concerted effort. Saint-Gaudens and French were the leading spirits, followed by the rank and file, but younger men, fresh from the Paris studios, introduced the next phase. The one who, to the minds of the visitors, ushered in a new era was Frederick MacMonnies. His joyous *Columbian Fountain* with its lavish ornament and banks of oarsman nymphs initiated the American public into a new way of using sculpture—for entertainment. America's first idea of the purpose of statuary was to edify as much as beautify. Public virtues were extolled by raising statues to citizens who exemplified them; civic pride found expression in the rhetorical decoration on the façades of buildings; shapes of ideal purity brought a lifting of the spirit; but the merely ornamental was eschewed, and for many years neither gay figures, sculptured urns, nor fountains enlivened our parks and gardens.

MacMonnies's extraordinary facility and light-hearted spirit were continued in a series of works which amazed and often shocked. Many figures in vivid action were skillfully combined in large reliefs, from which his admirers could learn what he had absorbed from the French masters to whom he was devoted. The spirit of Rude's winged *Victory* hovers over his soldiers and sailors as over many later groups of heroes. The pulse of life beats as strongly in his work as in that of any of his Parisian fellows, controlled by a like sense of style. He is of his period in the way in which the detail is blended with the whole, only emerging at irregular intervals to break the surface and lighten it with softer touches.

With him garden sculpture as a fine art had its beginnings. Up to this time it had existed as a commercial enterprise with a stock of copies from the

antique, neoclassic spelter figures after Canova, Thorvaldsen, Rauch and his pupils, and *genre* groups. Before the Columbian Exposition MacMonnies's *Pan of Rohallion* and *Faun with Heron* had started the series of blithe outdoor pieces which, in the hands of Janet Scudder and many later sculptors, were to form so considerable a part of American sculpture for the next half century. The country estates of the wealthy, just being formed, created a demand and provided fine settings.

Although from the beginning of the nation foreign artists had been transient visitors, there had been no great enterprises and no patrons to attract them to settle here before the end of the nineteenth century. By that time public buildings and monuments were rapidly rising, and the men who had recently amassed huge fortunes were developing a scale of living consistent with their wealth. This mode demanded impressive residences richly decorated. Avid for the splendors of the past, they built Renaissance châteaux and eighteenth-century *salons*. Native sculptors had not been trained to produce the sculpture which such styles demanded, but sensing new opportunities, European craftsmen with the right equipment began to arrive. Their output, designed solely to please the eye and add elegance to architecture, was something entirely new. Coming from countries where sculpture was abundant, a part of everyday scenes, they had none of the American's awe of the art and its innate magic nor his feeling that only noble subjects should be chosen and those approached with reverence. They modeled frankly ornamental figures, as pretty and graceful as they could be made. The development of terra cotta as a material for molded ornament gave scope to their facile invention. American terra cotta was first used on the old Museum of Fine Arts, Boston, in 1876.

The first of these immigrant sculptors, Philip Martiny, had received some training in his native Alsace before arriving in the United States in the 1870's. Work as an assistant to Saint-Gaudens hardly sobered his native exuberance, for when he was given a free hand on the Agricultural Building for the Columbian Exposition, he lightened the façade with many jaunty figures in fluttering draperies, hung with garlands. Two other European-trained sculptors who worked for the Chicago World's Fair were Karl Bitter and Isidore Konti from Vienna. They shared gaiety of spirit, restless movement, and lightness of touch, but of them all Bitter alone matured into a sculptor of serious creative ability. About the same time the Piccirilli family came from Italy and joined in the decoration of buildings with pleasant groups and figures, while with the increase in the amount of sculpture demanded and the use of the pointing instrument to aid in accurately reproducing the model, they were profitably employed in carrying out in marble the work of other men. The Scotsman John Massey Rhind produced a tremendous

amount of architectural and monumental sculpture in a conventional, realistic vein which harmonized with what many Americans were doing. The baroque style revived by the Germans was introduced in the 1890's with Rudolph Siemering's Washington Monument at Philadelphia and Bruno Schmitz's Soldiers' and Sailors' Monument at Indianapolis, but neither one seems to have impressed native sculptors.

Just before 1900 a great national undertaking brought together most of the well-known artists of the day. The Library of Congress at Washington had lavished on it all the artistic effort that could be commanded. Reliefs and statues in marble, statues and doors in bronze offer a complete picture of the state of American sculpture with its classic echoes, its admiration of nature, and its yearning for grandeur.

As the number of artists increased, New York became the acknowledged center to which they came to study and where they settled at the end of their student days. In the East, Philadelphia, which had kept a continuous tradition of sound craftsmanship centering about the Academy of Fine Arts, developed the principal local school. Charles Grafly's teaching and after him Laessle's had undisputed ascendancy. Among their pupils may be noted a special firmness in modeling and precision in detail. In Boston, no longer a leader in the creative arts, Henry Hudson Kitson had a number of pupils who like him worked in a downright realistic manner, and Bela Pratt, a pupil of Chapu, developed a more generalized style. From the time of Rinehart a small group continued to work at Baltimore. The World's Fair had brought sculptors to Chicago, where Lorado Taft already had a flourishing studio and fame as a teacher and lecturer. Cincinnati and Saint Louis, with schools and a few resident sculptors, were the main centers where aspiring artists of the Middle West got their preliminary training before emigrating eastward to New York and Europe. On the West Coast, Douglas Tilden, Paris-trained, practiced a hardy realistic style. His pupil Robert Aitken began his career there, and Haig Patigian employed a measured combination of classicism and realism not unlike that of D. C. French's school. Stirling Calder, in a few years' stay, developed his special style of architectural sculpture. More and more small cities started their own art schools and museums, and in attractive places the summer artists' colony, such as that gathered around Saint-Gaudens at Cornish, New Hampshire, began to flourish.

The opening of the twentieth century saw little change in the prevailing mode. Saint-Gaudens, though approaching the end of his powers, was still working and employing in his studio many younger men; French was at the height of his career; Adams, Bartlett, and Barnard all engaged on important commissions. MacMonnies alone of the men who were prominent in the nineties had turned from his furious burst of activity in sculpture to painting.

One quantity held fairly constant, the impressionistic pictorial realism most in favor. The use of bronze in preference to marble as a material may have contributed to the vogue for realistic detail and vivid action. Sculptors became aware of themselves as a national school and were anxious to emphasize their nationality. They opened their eyes to the characters and scenes around them and began to present them frankly, with verve and spontaneity. Unaffected interest in their fellow humans led such artists as Mahonri Young and Abastenia Eberle to portray people in the lower walks of life, laborers and slum dwellers.

Seeking to introduce fresh, untouched themes with a distinctly American flavor, one group, several of them familiar from boyhood with life in the West, turned to Indian and frontier subjects. The Indian was no new theme, since as nature's nobleman he had already appeared in neoclassic guise, splendid in feathered headdress had ornamented the prows of ships, and at the hands of Ward had received again his true character. Now his physique and customs were studied and made the theme of many works in varying moods and manners. Dallin, the first to make the subject his own, worked in a straightforward style, with carefully finished detail, controlled by a calm, restrained spirit; MacNeil and Proctor were more animated and impressionistic, choosing striking poses and moments of action, MacNeil especially liking to dwell on picturesque details. Remington with his illustrations in bronze preserved the life of the cowboy and Indian fighter, while Solon Borglum tried to read deeper meanings into the lives of horses and their riders and in sweeping lines convey the inevitability of the forces of nature.

A study of the animal world has always been a part of the return to nature and was one of the interests of the group connected with the Western scene, most of them realists, viewing their subjects objectively though sympathetically. Edward Kemeys, largely self-trained, was the first to make animals an exclusive study. Since his aim was to give as lifelike as possible a rendition of his subjects, he limited himself to broadly sketched forms and characteristic action. Proctor first won attention by vivid animal studies, and Bartlett began his career in Paris as an *animalier* after the manner of Frémiet. As interest increased, animal sculpture often became a life study. The point of view and manner of treatment varied as widely as for other forms of sculpture. Anna Hyatt Huntington is a spiritual descendant of Barye in her ability to convey the living essence of her subject. Laessle and his many pupils interpreted their models with attention to peculiar traits and telling detail, and the sculptors who learned to model while mounting specimens for natural history museums brought special knowledge and integrity in recording. Arthur Putnam had an emotional, impressionistic approach, and numerous sculptors after Roth increasingly simplified for decorative effect.

The most influence was that of Rodin. The *Man with the Broken Nose* was modeled as early as 1864 and much of his most significant work done in the 1880's, but even French sculpture did not show the results of his revolutionary vision until the last decade of the nineteenth century. In the United States, where his work was early publicized by the critic William C. Brownell, his influence was strongest from 1900 until the World War. Rodin's practice was not entirely in disaccord with established usage. The antithesis of classicism, it shared with objective realism emphasis on the living quality of its subjects, but it discarded all the trappings of everyday life to try to capture emotional states. The nude form as an expression of the life within was Rodin's theme. The arrangement of the forms and the composition as a whole were of less interest to him than impulsive movements revealing the forces which inspire action. The play of light over minute variations of surface, giving the warmth of the flesh, which had been typical of Carpeaux, he purposely exaggerated to produce more intense vibrations.

The Americans, still timidly feeling their way in artistic matters, approached the great master gingerly, but his example made a lasting impression. Wherever there occurs the breaking of the surface into shallow heights and hollows which flow gradually into one another and give a luminous fluid quality, there is a return to Rodin's innovations, and where instinct and feeling are the springs of creation, there his spirit moves. In the work of any number of sculptors of very divergent personalities, especially in their formative periods, a touch of Rodin may be seen. Gutzon Borglum, who had at first numbered among the men developing Western themes, after a stay at Paris carved some marbles with a strong flavor of Rodin and kept in the majority of his works an informality of pose, exaggerated gesture, and flickering surface derived from the same source. Early works of Fraser, McCartan, and Evans, who studied with him, also show the Rodin impress, and it is doubtful if without his example the palpitating surfaces of MacMonnies's later phase would have existed. A number of American sculptors had criticisms or worked under his guidance, Malvina Hoffman perhaps for the longest period, though she never lost an even balance and close touch with actuality. The pulsing vitality of Harriet Frishmuth's lithe figures and the suave modulations of Korbel's exquisite nudes owe something to his precepts.

His trick of leaving the form half-submerged in the marble to concentrate attention on what was to him significant, giving an enigmatic tone, was easily grasped and untiringly copied. Barnard's *Brotherly Love*, done in 1886 to 1887, has this peculiarity, but since Rodin first used this device only the year before, it seems more likely that both drew from a common inspiration, Michelangelo. The things which these two sculptors had in common were a mystic attitude towards life and their art as an interpretation of life and a deep

concern with the effects of light on sculptured forms, though the one pre-
ferred the clarity of reflected light while the other let broken surfaces absorb
and diffuse it. Lorado Taft's *Solitude of the Soul*, modeled about 1900, has a
mystic idea and the unfinished marble block as a background, but the figures
themselves are in an entirely different style. Critical though he was of Rodin
in his writings, the grandiose theme of the *Fountain of Creation*, imagined by
1914, and the groups of emergent figures owe something to the influence
which the author deplored. It remained for a later generation to exalt dis-
torted positions, irregular surfaces, and exaggerations of contour and propor-
tion, all in the interest of heightened emotion—devices for which Rodin is
directly responsible.

An exactly opposite trend, a reaction both from pictorial realism and from
impressionism, was a new emphasis on formal structure, on the reduction of
natural shapes to a clear design of plane and silhouette. One of the leaders was
Stirling Calder, who added to sound knowledge of the human form a special
interest in its decorative values. With this aim, instead of smoothing the
transition of planes he sharpened them to bring out the contours, and flattened
masses in order to make a more definite scheme. From his romantically
minded forerunners he kept a certain sketchiness of detail which gave an
informal freshness to his treatment, and in his way of adapting natural forms
he had an affinity with *art nouveau* designers. The singing line of his figures
and the strong patterns of light and shade created by his treatment of surfaces
were something quite new in American sculpture. They were first widely
appreciated at the Panama-Pacific Exposition of 1915, where Calder was in
charge of the decorative sculpture. His fertile imagination and sense of
design, with the help of a number of able sculptors, made its sculpture the
richest and most unified of any of the expositions.

The stylizing tendency was most apparent in the sculpture which was
allied with architecture. Hitherto there had been little opportunity for sculp-
tors to collaborate with architects. Colonial buildings had called forth fine
carvers of ornament in wood but no figure sculptors. Among the classic
buildings of the early nineteenth century the Capitol at Washington had
received sculptured pediments and groups at the entrance by Greenough,
Crawford, and Persico, while Italian sculptors had been called in for the
interior decoration. The Englishman John Dixey made symbolic statues for
the New York City Hall and the Albany State House in addition to many
floral compositions for other buildings. The Gothic revival was unfavorable to
sculpture. Richardson employed the French sculptor Bartholdi, who later
designed the Statue of Liberty, to model a frieze for one of his Romanesque
churches in Boston and for Trinity he planned his own sculpture. The
elaborate Renaissance adaptations which followed could accommodate more

and freer ornamentation. Saint-Gaudens and French had begun a closer association between sculptor and architect in their relations with Stanford White, McKim, and Henry Bacon, but the architect was more often called into consultation for the settings of their sculpture than they for assistance on his buildings. The Italian Renaissance was frankly imitated in Adams's tympanum for Saint Bartholomew's Church and Weinman's pediment for the Madison Square Presbyterian Church, both in New York, but the prevailing fashion, developed by MacNeil, Weinman, and Aitken building on the example of Saint-Gaudens and French, was a modified classicism with softened surfaces and the added piquancy of occasional realistic touches.

There was in process of formulation a creed which demanded for architectural sculpture a design to accord with that of the building for which it was destined. The first deliberately, even though moderately stylized figure was French's *Republic* for the Columbian Exposition, which was then designated as "modern-archaic." *Wisdom* for the Minnesota Capitol in 1901 had an even more pronounced archaistic quality, which critics found repellent. Furthering the new trend Karl Bitter abandoned the baroque exuberance of his decorations for private houses and public buildings of the nineties and began to seek broader planes, clearer lines, and a balanced alternation of light and shade. He experimented with the short-lived decorative naturalism of *art nouveau* and anticipated other Americans in seeing the possibilities of archaic Greek reliefs with their flat planes and sharp outlines when adapted to modern themes, such as he used on the base of the Schurz Memorial, erected at New York in 1913. The classic-inspired buildings of the early twentieth century with their rectilinear shapes and expanses of unbroken wall demanded a similar starkness in sculptural treatment, while on purely functional buildings only geometric surface patterning and a few strictly conventionalized reliefs or figures could find a place. Ecclesiastical Gothic was too often a *pastiche* from medieval sources, but with genuinely original creations in the Gothic spirit went a sculpture which was as finely expressive as it was decorative. Lee Lawrie, working with Bertram Goodhue, evolved an imaginative yet concise manner which later adapted itself perfectly to the buildings on which it was placed.

Adolph Alexander Weinman from the very beginning of his work showed a keen sense of style. At the outset of his career he brought to a high degree of perfection the medallic art which Warner and Saint-Gaudens had begun in this country. It may be that both Saint-Gaudens and Weinman owed something of this special skill to their apprentice periods with cameo and ivory carvers. Weinman's method differed from that of Calder in that, stemming from the classic-Renaissance rather than the French school, it was rich in precise detail and fully expressed forms, from which all possible decorative

values were extracted. His statue of General Macomb at Detroit, modeled by 1906, has already a consistent style in which the appearance of the figure—its purely artistic qualities—counts for more than the impression of character. His *Sphinxes of Power* for the Scottish Rite Temple at Washington, erected in 1916, are among the first strictly conventionalized figures in this country. Although the concept and some of the detail are Egyptian in source, the sculptural intention and treatment are original. Other works of this time show familiarity with the archaic Greek manner just beginning to prevail, but it was discarded as too vertical and supplanted by reference to Chinese systems of patterning, by which curving and twisting lines, intricately involved, could be brought into play.

Eclecticism was the keynote of the first quarter of the twentieth century. Among the influx of immigrants were men familiar with the art of many other countries, who carried with them their own heritage. Travel and study abroad had already in the nineteenth century extended American artistic horizons to Europe, but the European horizon had spread much further both in time and space. Within the range of Greek art, the bringing of the Elgin marbles to London had moved attention backward from the Hellenistic period and Praxitelean types of beauty to Phidias and the fifth century. Egypt, following Napoleon's expedition, had continued, if in a superficial way, to attract attention. Mesopotamia, Syria, and Palestine were being explored before the middle of the nineteenth century, and the art of Assyria and Babylon discovered, but it was only towards the end of the century that the civilizations of archaic Greece and Minoan Crete became known. Japanese prints had a share in revolutionizing French painting, and Japanese decoration helped to formulate *art nouveau*. Much later, sculpture awoke to the aesthetic values of Chinese, Japanese, Indian, South Sea, and lastly Negro art.

America was slower to notice these distant regions, though the China trade had early taken her ships to the Far East. James Jackson Jarves wrote on Japanese art in the 1850's, and in the seventies three Bostonians had made Japanese art a life study, the results of which were ultimately housed in the museum. Whistler and some other painters came under the spell of Japanese prints, and Japanese styles strongly affected the decorative arts. At a later period, the minuteness of Albert Laessle's study of small animal forms was due to Japanese bronzes. By the eighties the museum movement was well under way, and the collections began to increase in variety; an American archaeological expedition to Mesopotamia was organized in the same decade. Considering these things at first only of historical interest, sculptors came to see in them certain principles and procedures which could be applied to their own work.

Architecture, earlier than sculpture, broke in a wave of eclecticism. The

Tombs prison at New York had been built in an Egyptian style as early as mid-century, and later, Temple Emanu-El in an Oriental manner, while in the last twenty years of the century, many other exotic forms were attempted. Elwell, among the sculptors, claimed to be "the first to revive Egyptian sculpture in modern times," [11] though, like some French contemporaries who resorted to the same source, he copied the superficial appearance without grasping the fundamental qualities of his models. Bitter had been the first American sculptor to see the beauties in archaic Greek art, but it remained for Paul Manship and his followers to shape elements from it into a distinctive style which was dominant for almost two decades. Manship's artistic character was formed at the American Academy in Rome, an outcome of the Rinehart Scholarship founded in 1895 to provide broader training for American artists by giving them a period of study abroad and helping them to form "a correct taste." Of the first holders, Proctor and MacNeil, the one studied at Paris and the other remained true to the Parisian tradition even while working at Rome. The early fellows developed nothing new in their way of working, but Manship, when he exhibited at New York in 1913, the same year that Bitter's Schurz Memorial was erected, opened people's eyes to new shapes of beauty. Vague or irregularly broken outlines were abandoned for precise, clear silhouettes; the modeling, though rich, was firm and smooth-surfaced, and details were subjected to a schematic treatment which brought out all their decorative possibilities. From the archaic Greeks were borrowed scallops and fishhook curls for the hair; flat, parallel folds for drapery. The playful spirit, the bold compositions, and the free use of detail counteracted any danger of meagerness and made the whole full of vitality. Almost baroque in its lavishness was an orientalizing period which lasted for a few years until the sculptor assimilated these disparate influences and settled on a soberer, more completely realized art. Succeeding and even earlier students at the American Academy in Rome fell in line with Manship, so that the archaizing style came to be associated with that institution. Other sculptors, trained in the studios of Saint-Gaudens and French, especially those working with architects, found that simplification and conventionalization fitted in with the times and followed Manship's lead to some extent. On another tack, Allan Clark went directly to the Far East and studied the technique of Japanese sculptors.

The first three decades of the twentieth century saw the emergence of an unmistakably American sculpture which, dependent though it was on foreign sources for its origins, had a different stamp from that of any other country. Since there were now a number of able sculptors and adequate schools, it was not necessary to go abroad for training, while the prestige of

11 *American art annual.* 1898. v. 1, p. 503.

well-known sculptors made their work a canon for younger men. In this way there grew up a body of tradition which within wide limits and varying guises shaped the main trend of the art.

The concept of "ideal" beauty, abstract and generalized rather than specific and based on an individual model, had never quite died out. This classic strain had been kept alive chiefly by the pupils of Saint-Gaudens and French. On the other hand the sentiment of humanity, the love of the immediate world strongly inculcated by French schools and reoriented by the influence of Rodin, had a powerful hold. The search for more concise compositions and clearer patterns led to an amalgamation of the opposing strains into a coherent style. The fusing agent seems to have been a rediscovery of the properties of disencumbered line, smoothly flowing and uniting, bringing an even rhythm. Calder and Weinman had been the pioneers. Classicists like Evelyn Longman, versed in the methods of D. C. French, or like Jennewein and John Gregory, schooled at Rome, stressed this quality in their work. For those enthralled by the Italian Renaissance it was a logical consequence. It tempered the impressionism of Chester Beach and became a distinctive characteristic of men who started out from the camp of the realists. McCartan, although his eighteenth-century leanings are peculiar to him, perhaps best synthesizes the style, with its emphasis on pure harmonious contours. Symmetry and studied grace were vital elements. The mood was buoyant, calm confidence in a world of physical well-being; at its lowest key only subdued to pensiveness, at its highest pitch exultant with good spirits. At the ebb, shorn of the remnants of realism which gave it warmth, the style hardened and tightened into a narrow, stiff mold. The victory of form over content in a struggle which had begun before the opening of the century was for the moment almost complete. This dominance of style was something which the neoclassics had sensed in the Greek, Saint-Gaudens in the Italian Renaissance, Manship in archaic art and the Orient, McCartan in eighteenth-century France; each by his own processes of selecting and discarding tried to create a similar unity.

Well before the meteoric appearance of Manship, sculptors were looking for more fundamental solutions to problems of form. The cradle of ideas was still France, and among the immediate pupils of Rodin were men forging new principles. Bourdelle, the first to find inspiration in archaic sculpture, returned to an ordered structure while keeping a rough, impressionistic surface. Within the architecture of his designs he introduced swiftly moving shapes and decorative schemes of strong lines and sharp contrasts of light and dark. Powerful emotions, fiercer and more impersonal than those of his predecessor, inspirited his work, conceived in a romantic vein. Maillol made a

more definite break with the Rodin tradition and evolved a new kind of naturalistic classicism. The classicism comes out in the calm, untroubled spirit, the quiet, self-contained postures, and the compact arrangement of full volumes. The naturalism is evident in unidealized individuals as subjects and a modeling which is often a direct transcript from life.

Bourdelle's effective patterns changed architectural sculpture, but Maillol's influence was more widespread and longer felt, giving to almost the whole range of French sculpture a simpler and solider structure. Several Americans who were at Paris before the War sensed the new developments. As early as 1909 Edith Woodman Burroughs appreciated the frank simplicity of Maillol's figures and adopted some of his principles. Charles Cary Rumsey's work shows that he saw and admired that of Bourdelle, but it was not until after the War that their styles had any vogue. A number of American young women studied with Bourdelle in the 1920's, listening to the exposition of his ideas but often not grasping his aims or methods. Maillol, without pupils, gained steadily in popularity and was one of the prime sources for the monumental figures of the 1930's. Even before Bourdelle and Maillol reached their ultimate expression, Lucien Schnegg was teaching the virtues of simplification, and the work of one of his pupils, Jane Poupelet, was known in America through an exhibition in 1911.

Experimental sculptors were trying to find the basic qualities of the art by more drastic methods. The increasing devotion to science fostered an analytical frame of mind, and the freeing of sculpture from its old allegiances to religion and to the state made men look more sharply for some justification for its existence within itself. Cubism, a breaking up into component geometrical shapes, was one result. The Age of Machines exalted the utilitarian and the functional at the expense of sheer beauty, substituting for spiritual idealism the doctrine of practical service to mankind. Artists either responded to the flawless precision of the machine or revolted from it to deliberately anarchistic methods. In protest against the system of commercial stonecutting with mechanical aids, many sculptors returned to doing their own carving in stone without carefully finished preliminary models. Consideration for volume at the expense of contour and line was the result. Difficulty in mastering technique after a lapse in tradition contributed to the reduction into large masses and to coarseness of modeling. The accompanying romantic concept, reverting to Michelangelo, was that the form existed intact in the block waiting for the sculptor's hand to free it. With direct carving went a doctrine of respect for the material which demanded an appropriate treatment for each to bring out its inherent aesthetic values of mass, grain, and tone.

The vogue for Negro art led certain artists to try arbitrary proportions and

dispositions of masses. Hitherto, sculptors had viewed their figures as figures and had them criticized from their relation to the human form; now they were conceived as arrangements of volumes.

Paris in the years just before World War I seethed with artistic theorizing and experimentation. Bourdelle and Maillol were already accepted masters, but other men were trying radical procedures, simplifications, exaggerations, and distortions of all kinds in an effort to arrive at "significant form." Rebelling against realism, against the romantic attitude and sentimental tone, they sought the basic elements of structure in order to erect a new set of canons on logical foundations. But even within the ranks of the vanguard the old dualism persisted, for where one group was concerned with form alone, the other dwelt on intuitive emotional values. Brancusi from Roumania brought his natural shapes down to cylinders and ovoids; a Russian, Archipenko, dissolved human forms into abstruse combinations of swelling, hollow, and open shapes, with an ingratiating flow of line, in an attempt to approximate musical melodies and harmonies; Elie Nadelman, a Pole, was smoothing surfaces to fluent contours and adjusting forms to delicate proportions; the German, Lehmbruck, was elongating his classic figures to pathetic expressiveness. In London at the same time, Gaudier-Brzeska, emigrated from France, was furthering the creed of vorticism, and American-born Epstein was stressing emotional intensity by aggressively discordant forms and roughness of surface. The Germans, largely trained at Paris, had their own group of stylizers, chiefly concerned with massive and powerful monumental and architectural sculpture.

The Americans, on the fringes of these movements, were first attracted to the decorative possibilities of stylization, which they often employed as little more than a surface treatment of natural forms. Hunt Diederich, working mostly in Europe, used rectangular planes meeting at abrupt angles for his highly ornamental, nervously elegant groups of animals. Eugenie Shonnard, at Paris, simplified animal and bird shapes to smooth contours.

The notorious Armory Show at New York in 1913 brought the new movements to the startled attention of the American public, but few artists joined them, and some of these only used certain elements as a veneer on familiar styles. After the War two of the leaders, Nadelman and Archipenko, settled in New York, the latter founding a school which became a formative influence on a number of young sculptors. The furor over the admission of Brancusi's *Bird in Space* through the customs as a work of art gained him notoriety. Gaston Lachaise left France before the new movements were well launched and developed in America his private aesthetic of bulky yet buoyant forms which came to have a certain following and reinforced the Maillol influence in substituting full, robust shapes for slender and graceful propor-

tions. The German expressionists found disciples among those who were still trying to make sculpture a vehicle for emotions by the use of distortions and crude simplifications. The emotional force of Meštrović and the linear beauty of his Byzantine conventions commanded attention and won for him a commission for two equestrian Indians in Grant Park, Chicago. The sculptors of fountain and garden figures increasingly echoed the witty, effective stylizations of the Swedish sculptor Milles, resident at the Cranbrook Foundation in Michigan after 1931.

After World War I, in which the United States first played a decisive part in European affairs, came another period of national self-esteem. Respect for European culture had, with increased familiarity, become a little tempered. A clamor for an exclusively American art arose, which should find both its inspiration and its form within the country. Allegories of Liberty and Justice, sentimental re-creations of family and village life, depictions of the red man and the cowboy, had had their day. With a sense of social responsibility and a return to didacticism, that moral seriousness which has been an enduring quality, sculpture took up the cause of the oppressed, glorified the worker, extolled civic virtues, or underscored the defects of modern civilization. With the new collectivist theories of the importance of the group, sculpture was required to reflect mass rather than individual emotions and problems. The American scene as a subject was given still further importance when the government became a patron of the arts by establishing the Section of Fine Arts of the Federal Works Agency and subsidized artists in the Public Works of Art projects. These commissions revived interest in American history and legend, institutions, characteristics, and ideals.

American sculpture is still in a state of ferment, with many influences striving to change its direction. From them it is in process of assimilating what suits its needs and rejecting the rest. In little more than a lifetime all these developments have taken place.

SCULPTORS

and their works

John Quincy Adams Ward

It is John Quincy Adams Ward, born so short a time ago as June 29th, 1830, who marks a turning point in the history of American sculpture. Those who went before were either given over to the neoclassic school or provincial men, whose limited skill and training warrant them only historical interest. Of English stock, his ancestors had landed in Virginia, moved to Kentucky, and pushed on to what is now Ohio, founding Urbana, where the sculptor was born to John Anderson and Eleanor (Macbeth) Ward. Stories of his youth tell of his experiments in modeling the clay on his father's farm and in the shop of a potter. After half-hearted attempts at farming and the study of medicine, he left when he was nineteen for a visit to Brooklyn, New York. There he gained admission to the studio of Henry Kirke Brown first as a pupil and then as an assistant, staying for seven years. It is extraordinary that in an atmosphere so barren of art as was that of the United States when he began to work he could have reached such a high level of artistic and technical excellence. Believing far ahead of his time that the American artist should embody American ideas and that craftsmanship should be developed in this country, he never studied abroad but acquired his professional skill by hard work and experimentation. The pioneer era in which his work began is emphasized by the fact that he was engaged on the second equestrian statue to be cast in this country, that of Washington at Union Square, New York, in 1854, in which he had so important a share that his signature was added to Brown's.

Ward spent two winters at Washington, D.C., and Columbus, Ohio, modeling portrait busts. Returning to New York in 1861, the sculptor was employed by a foundry to design decorative objects suitable for precious metal, in particular the gold mountings of swords which it was the fashion to present to noted officers. A sketch for one of these is in the collection of The American Academy of Arts and Letters, New York. A statuette which reflected the preoccupations of the Civil War era was *The Freedman*, a Negro with broken chains.[1] The large model of *The Indian Hunter* led to his first important commission, since August Belmont was so favorably impressed by

1 The Boston Athenæum, The Cincinnati Art Museum, and The American Academy of Arts and Letters own examples.

it that he ordered a statue of Commodore Perry for Newport, Rhode Island, prelude to an increasing number of commissions for statues and monuments. In *The Pilgrim* for Central Park his imagination worked in literal fashion to summon up a concrete image of a serious young pioneer. Among portrait and commemorative statues the *Shakespeare*, also for Central Park, was admired for the simplicity and dignity of the conception and the effect of naturalness. These qualities, united to a classic breadth and an impression of nobility and power, are those of the statue of Washington for the steps of the Sub-Treasury Building, New York. Ward's popularity extended as far as South Carolina, where for Charleston he modeled a statue of William Gilmore Simms and for Spartanburg one of General Daniel Morgan. Even more suited to the artist's temperament were statues of contemporary men in which he could lay aside all pretext of grandeur and concentrate on character. The *Garfield* at Washington represented as delivering an oration, three symbolic statues around the base, had a more dramatic quality than Ward usually permitted himself, but the *Horace Greeley* at New York and the *Henry Ward Beecher* at Brooklyn deal with men of more rugged stamp. Although the sculptor has not dwelt unnecessarily on homely details, he has shown these men in their everyday appearance, letting the distinction of their personalities redeem their undistinguished figures. With keen powers of observation, he relied on truth of gesture and attitude to give significance to his work. Even in tempting subjects he never became anecdotal but preserved a monumental style.

In 1878 he had an opportunity to model an equestrian statue of his own, the *General Thomas* for Washington, D.C., in which he could show his knowledge of horses and riding. Eschewing violent action, he has given the group life by the alert pose of the horse, with lifted head and wind-blown mane and tail, and reality in the characteristic seat of the rider. Again towards the end of his life he received commissions for two equestrian statues. That of Sheridan brought him only unpleasantness, as the model was never approved by the General's widow nor the society which gave the order. That of General Hancock for Philadelphia, the horse finished by another sculptor during Ward's last illness, is solid and imposing in its quiet force.

The pediment for the New York Stock Exchange was one of the most ambitious plans for permanent sculptural ornament which had been undertaken in this country up to that time, 1903. There is a central figure of Integrity and a variety of bending and standing figures almost in the round, stepping out of their frame in an excess of vigor but united in a logical composition. Poetic and graceful touches can be attributed to the collaboration

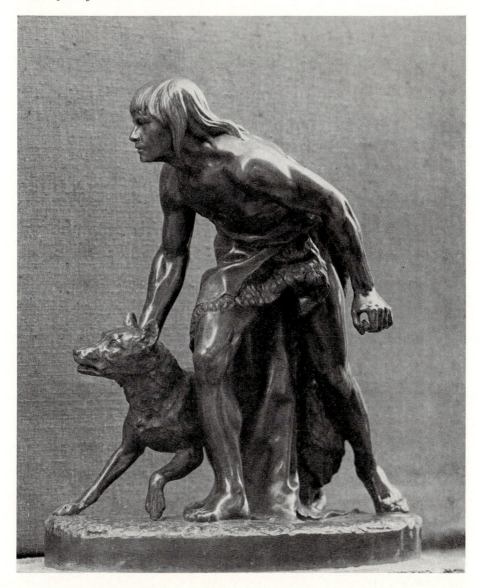

THE INDIAN HUNTER

Bronze group. Cast from an example in the collection of The American Academy of Arts and Letters. Height 1 ft. 3¾ in. Base: Length 1 ft. 2¼ in.—Width 8¼ in. Signed on base: J. Q. A. WARD 1860 Founder's mark: GARGANY FDRY. N.Y. Placed in Brookgreen Gardens in 1936. Other example: The New-York Historical Society.

of Paul W. Bartlett.[2] Active almost to the end, Ward died in New York on
May 1st, 1910.

"Dean of American sculptors" was no empty title in Ward's case in that he
was a born leader and throughout his life interested himself in the advance-
ment of American sculpture. He was president of the National Sculpture
Society from its foundation in 1893 to 1904 and president of the National
Academy of Design in 1874. He had much to do in planning the sculptural
ornament of the Library of Congress as well as contributing a statue of his
own, and when in 1899 there was erected the triumphal arch for Admiral
Dewey upon which the talents of all the leading New York sculptors were
expended, his was the *Naval Victory* drawn by sea horses which crowned the
monument. Biographers speak of his kindness to younger sculptors and his
interest in if not his acceptance of new ideas. It was through his courtesy in
stepping aside that Saint-Gaudens was given the commission for the Farragut
Memorial. Ward's uncompromising artistry did not go without reward by his
fellows. At the Saint Louis Exposition he received a gold medal and diploma of
honor for distinguished service in art. The Architectural League of New York
gave him its first medal of honor for sculpture, and the National Institute of
Arts and Letters elected him a member. Alone among sculptors of the nine-
teenth century, his reputation has suffered no eclipse; he is still revered for his
honest and able contribution to the development of American sculpture.

The Indian Hunter

An Indian leans intently forward, a restraining hand on the neck of an
eager dog at his side. A skin knotted about the waist falls to the ground
between his feet. First in Ward's list of works, this statuette was originally
modeled in 1857 in the Brooklyn studio which he had taken over from H. K.
Brown. During a winter in Washington, 1859–60, six copies were cast in
bronze "which were flatteringly received and well paid for."[3] After further
study of the Dakota Indians on a trip to the Northwest, the sculptor revised
and enlarged it in 1864. When it was exhibited in plaster at a gallery on
Broadway, it aroused so much enthusiasm that it was bought by a group of
citizens for Central Park. In bronze it was shown at the Paris Exposition three
years later and the following year was placed in the Park, one of the first
statues to be erected there. A replica marks the sculptor's grave at Urbana,

2 In 1936, when the stone of the pediment was crumbling dangerously, the sculp-
ture was replaced by lead-coated copper reproductions and the original figures were
destroyed.
3 Townley. p. 406–407.

Ohio. The statuette at Brookgreen is one of the early sketches differing considerably from the final version, in which the hair is shaggier, the face more racially characterized, and the dragging hide eliminated. It received wide acclaim for its vitality and the unacademic, lifelike handling, unusual at the period.[4]

Augustus Saint-Gaudens

AUGUSTUS SAINT-GAUDENS was the great figure of the sudden rise of American sculpture in the latter part of the nineteenth century. His singleness of purpose, the originality of his vision, and a thorough grounding in technique qualified him to be a leader, while in the great series of monuments to heroes of the Civil War he first adequately translated into bronze a national epic. Born of a French father, Bernard Paul Ernest Saint-Gaudens, and an Irish mother, Mary (McGuiness) Saint-Gaudens, at Dublin on March 1st, 1848, he was taken by his parents to America when he was only a few months old. After a childhood spent in New York, determined to be an artist, he became apprentice to a stone-cameo cutter. This craft supported him during his student days and the lean years of struggle. Evenings at Cooper Union and the National Academy of Design provided his formal teaching until in 1867 he sailed for Paris, where he studied with Jouffroy and laid a sound foundation for his later achievements. His admiration for Paul Dubois, whose *Florentine Singer* had recently been exhibited, and association with Falguière and Mercié brought him into the neo-Florentine group and inspired a love of the Renaissance which was confirmed by a stay at Rome during the Franco-Prussian War. Rome was also the scene of his first professional work.

In 1875 he returned to the United States and established a studio in New York, where he entered upon a fruitful period of collaboration with the painter John LaFarge and the architect Stanford White. The work which was the culmination of these years and which launched him on the full tide of his career was the monument to Admiral Farragut erected at Madison Square, New York, in 1881. He made a great innovation in established custom by placing the vivid figure of the sturdy seaman above an exedra decorated in low relief. From this time until 1897 his life was a steady progress from one success to another, although his painstaking methods limited his output. Each

4 The group is discussed by Adeline Adams (p. 42–43), Taft (*The history of American sculpture*. p. 219–220), W. J. Clark, Jr. (p. 114–115), LaFollette (p. 152), and Tuckerman (v. 2, p. 581).

work shows some new instance of the artist's lively imagination and the dramatic instinct which made him say that he was born to be an actor. *The Puritan* of 1887, in the romantic spirit, excelled in impression of character and telling use of costume; the *Lincoln* of the same year for Chicago in nobility of conception is often considered his masterpiece. One of his most far-famed works is the figure wrapped in a cloak which is placed as a memorial to Mrs. Henry Adams in Rock Creek Cemetery, Washington, D.C. He departed entirely from his usual manner in the utter repose of the figure, the simplicity and breadth of the enveloping folds, and infused with deep feeling the enigmatic, heavily shadowed face and veiled form. The *Diana* made for the top of the former Madison Square Garden is a rare instance of his treatment of the nude.[1] The Shaw Memorial, inaugurated at Boston in 1897, is original in the combination of an equestrian figure with ranks of soldiers in high relief, the recurrent guns, blanket rolls, and canteens accenting the rhythm of the march. A figure floating above them adds the spiritual note so characteristic of the sculptor.

After his position in the front rank of American art was definitely established, he wished to test his standing among French sculptors and returned to Paris for a stay of several years, working chiefly on the Sherman Monument for Central Park, New York. An airy figure of Victory precedes the mounted general; wind-lifted draperies, the billowing cloak, and the swift-stepping horse create a rushing movement. The detail, carefully worked out for repetition and variety, is yet subordinate to the main theme. When the monument was shown at the Paris Exposition of 1900 with a group of his works, he was awarded a grand prize and elected an officer of the Legion of Honor. At the Buffalo Exposition in the following year a special medal of honor was designed for him. The last years of his life, showered with honors, were spent at his studio at Cornish, New Hampshire, where in spite of frequent interruptions by illness he continued to work until his death on August 3rd, 1907. His home and studio were maintained as a memorial to him and in 1964 made a National Historic Site. A bust of him by James Earle Fraser has been placed in the Hall of Fame at New York University.

Saint-Gaudens began a new era in American sculpture by breaking completely with the neoclassic tradition which had prevailed until his coming. There is still a flavor of classicism in the reticence of his work, in the regular features and finely pleated garments of some of his angel figures, such as the one with a tablet called *Amor Caritas*, but it is the classicism of the Italian Renaissance, its harmony full of warmth and movement. Saint-Gaudens achieved the same springtime freshness of form and attitude which distin-

1 It is now in the Philadelphia Museum of Art.

guished the sculptors of the fifteenth century, the same airy buoyancy of drapery. He used the shadowy *schiacciato* of the Italians in reliefs which show the sculptor's qualities to their best advantage. The mastery of technique gained from his early experience in cameo cutting is evident in the delicate outlines and the ease with which he handled the subtle relations of planes, as in the Robert Louis Stevenson plaque. Paralleling this affinity for the Renaissance is a realistic strain, a fondness for color in composition and modeling, but this realism is keyed to a romantic pitch, the evocative quality of charm on which he laid so much stress. With a peculiarly light and graceful touch he extracted pictorial qualities from intractable detail of feature and costume. Both in portraits and commemorative statues a serious aim was to convey character, while informality of pose and asymmetry of design added to the natural effect.

Saint-Gaudens was in a very real sense the father of American sculpture, for his influence and example were dominant through the fertile years of his own generation and the next, which saw the rise of a national school. The art of the medal and the artistic designing of coinage owe their beginnings in this country to him. The welfare of his fellow sculptors was a constant preoccupation which led to the founding of the Society of American Artists and gave support to the American Academy in Rome.

The Puritan

A stern-visaged man strides determinedly forward, holding a Bible under his left arm and striking the ground with a stick grasped in his right hand. He is dressed in the costume of the seventeenth century, with a long cape sweeping back from his shoulders in deep folds. On the ground at his feet lies a pine branch.

The history of this figure is a good illustration of the untiring care which Saint-Gaudens expended on his sculpture and his constant desire to alter and improve even after a work was completed. The first version of this subject was made in 1887 as a monument to Deacon Samuel Chapin, one of the founders of Springfield, Massachusetts, who lived from 1595 to 1675. Saint-Gaudens gives the following account of the production of it in his Thirty-sixth Street studio at New York:

"After the 'Lincoln,' on the scaffolding behind the 'Shaw,' came the statue of Deacon Samuel Chapin, for Mr. Chester W. Chapin, at that time President of the Boston and Albany Railroad . . . It formed part of a scheme some gentlemen of Springfield, Massachusetts, had in mind for erecting three statues of the three founders of that city: Pynchon, which was made by Mr.

THE PURITAN

Bronze statuette. Height 2 ft. 6½ in. Signed on base at right: AVGVSTVS ·
SAINT GAUDENS On front: · THE PVRITAN · Founder's mark: QAWW GORHAM
CO. CIRE PERDUE Placed in Brookgreen Gardens in 1934. Other examples:
Cornish, N.H. The Augustus Saint-Gaudens Memorial; Lincoln. The University of
Nebraska; New York. The Metropolitan Museum of Art, Whitney Museum of
American Art; Pittsburgh. Carnegie Institute.

Jonathan Hartley, Chapin which I modeled, and a third which has not yet
been carried out." [2]

The sculptor's chief assistant on this statue was Philip Martiny. Prelimi-
nary sketches show the many arrangements of the figure which Saint-
Gaudens tried before he hit upon the idea of the billowing cloak. Among these
sketches is a seated figure, one standing without a cloak, and another, more
carefully worked out, with the cloak gathered in the right arm and the cane
held in the left hand. His son cites the folds of the cloak, as it finally appeared,
to exemplify his father's fondness for the repetition of a successful accent. In
1897 the sculptor was preparing reductions in his New York studio which
were cast in 1899 during his stay at Paris.[3] Of a later reworking, called *The
Pilgrim*, erected at Philadelphia in 1905, Saint-Gaudens writes as follows:

"The statue, as I have said, was to represent Deacon Samuel Chapin, but I
developed it into an embodiment, such as it is, of the 'Puritan.' And so it came
about that, in 1903, the New England Society of Pennsylvania commissioned
me to make a replica of it. This I did as far as the general figure and
arrangement went, though I made several changes in details. For the head in
the original statue, I used as a model the head of Mr. Chapin himself,
assuming that there would be some family resemblance with the Deacon, who
was his direct ancestor. But Mr. Chapin's face is round and Gaelic in charac-
ter, so in the Philadelphia work I changed the features completely, giving
them the long, New England type, beside altering the folds of the cloak in
many respects, the legs, the left hand, and the Bible." [4]

2 Saint-Gaudens, Augustus. *The reminiscences*. v. 1, p. 353.
3 Idem. *Familiar letters*. v. 31, p. 608; v. 32, p. 2.
4 Idem. *The reminiscences*. v. 1, p. 354. *The Puritan* is discussed by Caffin (*The
World's work*. 1904. v. 7, p. 4410), Cortissoz (*The North American review*. 1903.
v. 177, p. 732), Cox (*The Atlantic monthly*. 1908. v. 101, p. 307), Hind (p. xxviii),
and Taft (*The history of American sculpture*. p. 294).

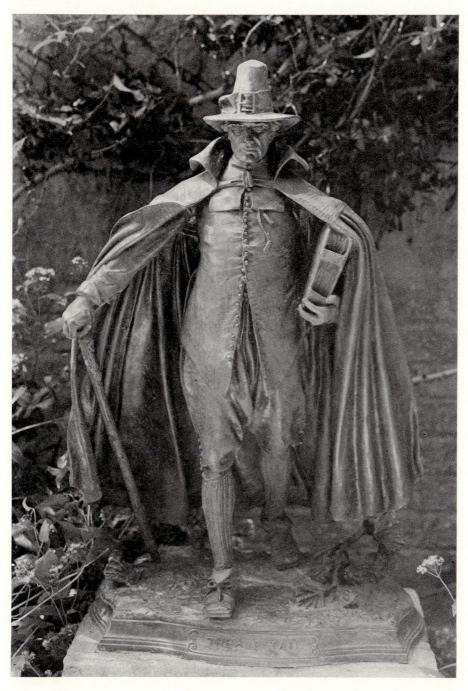

Louis St.-Gaudens

THE CAREER OF Louis St.-Gaudens [1] was so fostered and directed by his older brother Augustus that it was for many years almost completely absorbed in helping to carry out the famous sculptor's many commissions. "The brothers were extremely close all their lives. The dynamic, ambitious, red-headed Augustus led the way and the dark, quiet, introspective Louis followed." [2] Louis was born in New York City to Bernard Paul Ernest and Mary (McGuiness) Saint-Gaudens on January first, 1853, six years after his brother. During the time he was a schoolboy the family was living on Twenty-first Street near the shop on Fourth Avenue where his father made shoes. When in 1872 Augustus returned from his years of study in Europe, Louis was nineteen, old enough to be taught to cut cameos and encouraged to follow in his brother's footsteps. A year later Augustus was going back to his studio in Rome to execute various commissions and sent Louis on ahead to get the studio ready for his arrival and to ply his trade as a cameo cutter.

When in 1878 Augustus transferred his activities to Paris, Louis joined him there and lived with the family, helping in the studio, studying at the École des Beaux-Arts, and modeling his first portrait bust. The principal work then in Augustus' studio upon which Louis would have been occupied was the monument to Admiral Farragut. After that had been cast, Augustus came back to New York, bringing Louis with him. Louis shared in all the work that came into the studio, in particular the decorative carving in the residence of Cornelius Vanderbilt. Louis is mentioned particularly as having been associated with LaFarge in composing the models designed by the painter for the ceiling of the main dining-room. At Augustus' special request Louis modeled the finish of the *Diana* for Madison Square Garden.

As Louis matured and gained wider experience he began to take on commissions independently, though still with the advice and often collaboration of his brother, for his diffidence and lack of worldly ambition kept him from seeking out work. Augustus was no doubt instrumental in having his brother included among the artists chosen to decorate the Boston Public Library. Louis's part was the recumbent lions of Siena marble placed on newels of the stairway as memorials to two Massachusetts regiments.

1 Louis preferred the abbreviated spelling of the surname.
2 St.-Gaudens, Paul. *Letter*. October 8th, 1952.

12

Louis also modeled plaques and medallions with portraits in relief not quite so low and shadowy as the style cultivated by his brother. When in 1882 Stanford White remodeled a house for Richard Watson Gilder on East Fifteenth Street, two plaster reliefs with portraits of his children were placed on the façade, one by Augustus and the other, later destroyed in a storm, by Louis. A marble bas-relief with a portrait of the physicist Joseph Henry was part of a memorial tablet placed in Marquand Chapel, Princeton University, in 1885. This work, too, was destroyed when the chapel burned. A later relief, executed in bronze in 1906, is a commemorative plaque with a portrait of Samuel Brearley in the auditorium of the school that he founded in New York.

About 1898 Louis married a former pupil of Augustus who was a fellow assistant in the studio, Annetta Johnson of Flint, Ohio. Their son Paul writes of their early married years, "My father said that his worldly goods when he married my mother were a borrowed valise, an extra collar, three socks and a banjo. They went to my mother's people in Ohio for the first two years, building a small studio and doing small work. I was born in 1900, and a year later my parents moved permanently to Cornish [New Hampshire]."

In this age of expositions, when those at Chicago, Buffalo, and Saint Louis followed each other in quick succession, almost every sculptor of note was drawn into the ambitious schemes of decoration. Augustus Saint-Gaudens was general adviser for sculpture at the World's Columbian Exposition, but from his studio came only the statue of Columbus in front of the Administration Building, the joint work of his pupil, Mary Lawrence, and of his brother. At the Pan-American Exposition at Buffalo in 1901, Louis exhibited a *Faun* which was given a silver medal. For the Louisiana Purchase Exposition at Saint Louis in 1904, Louis was assigned a marble statue, *Painting*, to be placed, forming a pair with Daniel Chester French's *Sculpture*, at the entrance to the Palace of Fine Arts, later given over to the City Art Museum. It was not completed in permanent form until after Louis's death, when his widow had it cut in marble, doing the final carving herself. A seated classic figure, modeled with vigor and assurance, it has the ample draperies in fine, soft folds developed by Augustus Saint-Gaudens. In Louis's next major work he was even more on his own, for though he consulted his brother, even then seriously ill, he drew preliminary sketches and carried out the work by himself. This commission was for six huge monolithic statues to decorate the façade of the Union Station, Washington, D.C., a task that lasted for six years, until its completion in 1908. In addition the sculptor made three nine-foot models for Roman soldiers for the interior of the station to symbolize the states. Also for Washington he modeled a statue of Homer to be placed in the Library of Congress. Another architectural commission was for two of

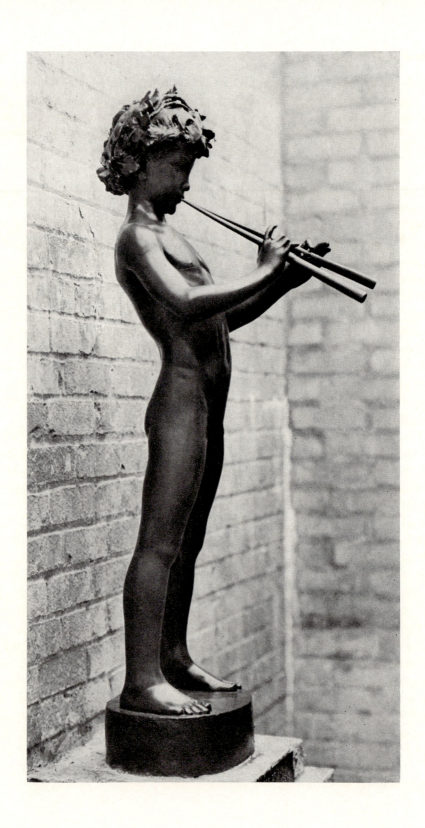

PIPES OF PAN

Bronze statuette. Height 3 ft. 7½ in. Base: Width 11⅝ in.—Depth 9 in. Signed on base at back, in monogram: LSG Founder's mark: Cast by Griffoul. Newark, N.J. Placed in Brookgreen Gardens in 1950. Other example: New York. The Metropolitan Museum of Art.

the twelve heroic statues personifying seafaring nations, along the attic of the Custom House, New York.

Smaller works gave the sculptor more freedom in design and the chance to use a lighter touch. A baptismal font with a bronze statuette of Saint John the Baptist as a boy, in front of a plaster tablet with an inscription upheld by two angels, was modeled for the Church of the Incarnation, New York. Both the bronze statue and the reliefs of youthful angels with candid faces, spread wings, and softly draped forms are in a style strongly affected by the Italian Renaissance. In a similar manner was a relief of flying angels holding a chalice above the altar of the Church of the Ascension, New York. Because of his training as a cameo cutter and his experience with portrait plaques, he was well fitted to do medallic work. A fine example is the gold medal commemorating the two hundredth anniversary of the birth of Benjamin Franklin, designed in 1906 with the collaboration of Augustus.

Louis survived his brother only six years, dying on March 8th, 1913. He had gone to Washington to see his statues in place on the Union Station, and on his return caught pneumonia from driving home through a blizzard in an open carriage. His widow and his son Paul stayed in Cornish, eventually establishing a pottery there.

Overshadowed by his brother's eminence, Louis was not widely known. The long years spent in Augustus' studio are reflected in the soundness of his technique. Personal contributions were in smaller things special qualities of grace and candor, and in architectural sculpture breadth of form and an impressive dignity. Completely in harmony with the ideals of his brother and the group gathered around him, he deviated little from their accepted modes of expression. In contrast, glimpsed through letters and reminiscences, a distinct personality emerges. "Louis Saint Gaudens was a strange fellow," writes Maitland Armstrong, "none of your Greenwich Village bohemians, but a true example of the artistic temperament, and with very nearly as much genius as his famous brother. He was never bound by any convention as such." [3] Other quirks besides his dislike of written contracts were his refusal to admit any assistants except his wife and a reluctance to employ living models, since he suffered acutely from what he knew to be their pain and

3 Armstrong, D. M. *Day before yesterday.* p. 308.

fatigue in posing. "He was a handsome man, with a fine head, and there was something subtly attractive about him," says Cortissoz, "But it must have taken a long intimacy to penetrate his shy reserve." [4]

Pipes of Pan

A boy stands firmly on both feet, braced by legs spread a little apart; the supple contours of his boyish form are delicately modeled. His raised hands lightly hold double pipes to his lips. His chin is drawn back and his cheeks puffed out as he blows. Beneath eyebrows slanting to a short nose, dark spots of shadow where pupil and iris are deeply hollowed out give the eyes, widely spaced, an open, innocent look. An intent, dreamy expression shows his delight in the music that he makes. A wreath of ivy crowns thick, unruly locks of hair.

The work was done in New York at the order of Charles T. Barney for the garden of his Southampton estate. "The model was a young Italian boy he [the sculptor] found on the street and had to scrub off under the courtyard pump before it was possible to see the lad's anatomy clearly." [5] After St.-Gaudens's death his wife obtained permission to have two more examples cast from the original model. A few reductions were made at the same time.

Cortissoz wrote of this work: "Now and then an artist does something the peculiar charm of which he never surpasses, even if he manages to equal it in a long and busy life. . . . So it was with Louis Saint-Gaudens when he made his 'Pan.' That was many years ago, so many that I wonder if he was not still in his twenties, or at any rate in his early thirties, at the time. The little statue started a kind of legend. It was heard of here and there before it was at all widely known, and then it created a stir which only became the more interesting in retrospect as nothing of consequence followed it and people talked of Louis Saint-Gaudens only as a more or less mysterious man of talent in the background of his brother's life. . . . The beauty of his 'Pan' lies partly in its sweetness and grace as an interpretation of the spirit of blithe childhood, and it lies even more in the profound sculptural feeling which went to the making of the statue, in the modelling which is so full of knowledge and strength and is at the same time so subtle, so fine, so instinct with style. It is a little piece, yet the man who made it unmistakably approached sculpture with a certain largeness of view. He ennobled the slender, fragile form. Portraying it, it was as though he had arrived at an almost Greek synthesis of his subject.

4 Cortissoz. *American artists.* p. 276.
5 St.-Gaudens, Paul.

One would, indeed, call this a work of Greek beauty if it were not even richer in the more sensuously human quality which we associate with the Italian Renaissance. On this occasion, if ever in his life, the sculptor was both a master and a poet. Here he had his one unmistakable gust of creative genius;" [6]

Daniel Chester French

A MAN two years younger than Saint-Gaudens carried on the classical tradition in American sculpture. Daniel Chester French, born at Exeter, New Hampshire, on April 20th, 1850, to Henry Flagg and Anne (Richardson) French, was brought up at the shrine of New England culture, Concord, Massachusetts. May Alcott lent him modeling tools, and Emerson posed for a bust. French studied the casts of Greek and Roman sculpture in The Boston Athenæum, took lessons in art anatomy from Boston's sculptor-physician, Dr. William Rimmer, and had a month in J. Q. A. Ward's studio. With this much professional training, at the age of twenty-three, he received a commission to model a statue of the Minute Man for Concord and carried it to a satisfactory conclusion. After two years at Florence working in Thomas Ball's studio and another two winters at Washington, he established studios in Concord and Boston. From this early period date some decorations for public buildings and the monument to John Harvard at Cambridge. Although *The Minute Man* had a classic pose, the sculptor obviously tried for naturalness in feature and dress, and the *John Harvard* sprang even more from an honest desire to recall the man and his period. In the Gallaudet Memorial he repeated the *genre* style of some youthful compositions and gave way to anecdotal, sentimental tendencies.

A visit to Paris in 1888 gave him a new insight into the art of sculpture, so that with the moving of his studio to New York he began to produce work of greater maturity, handled with more freedom and grace. In the memorial to Martin Milmore, *The Angel of Death Staying the Hand of the Young Sculptor*, there first appeared one of the majestic angels with great soft wings and many-folded draperies which were often to reappear, while the sculptor's figure, in close-fitting garments, already shows that mastery of the human form which was to be so distinctive of French's later work. The idea is the important thing, and the conception is pictorial, but the subordination of the background to the broadly treated figures gives monumentality and power.

6 Cortissoz. *American artists.* p. 277–278.

His life in New York was connected with the artistic and literary circle of which Richard Watson Gilder was the center and in which Saint-Gaudens also moved.

The statue of the Republic for the Chicago World's Fair was an early instance in this country of the stylization of a figure for architectural purposes, the lines of the raised arms and the long straight folds of the tunic all contributing to the verticality of the composition. It was while French was working for this exposition, which did so much to bring American artists together, that he came into close contact with fellow sculptors and architects such as McKim and Henry Bacon. Here began the collaboration with Edward Clark Potter, who was especially interested in modeling horses, which resulted in the Grant, Washington, and Hooker equestrian statues, done between 1899 and 1903. In the O'Reilly and the Hunt memorials, the one at Boston, the other at New York, the sculptor evolved a new treatment of the monument in which a portrait bust was placed in an architectural setting embellished with symbolic figures. The doors for the Boston Public Library, unveiled in 1904, gave him a chance to employ a very delicate low relief with flowing lines which well suited the ethereal single figures with which he ornamented each valve, following a precedent set by Olin Warner at the Library of Congress. The flying looped fold which he used so often to break the long lines of his angel figures is to be seen here.

The groups representing the continents for the Custom House at New York, which were dedicated in 1907, are the finest of his many sculptural compositions destined to ornament buildings. In them he could pile up all the appropriate accessories to lend atmosphere with which he delighted in surrounding his statues and weld them into a coherent design. Most impressive of all is *Africa*, the first of the magnificent nudes which were to crown his achievement. The most famous of his statues of great men are the two noble figures of Lincoln at Lincoln, Nebraska, and in the Lincoln Memorial at Washington. They illustrate his ability to suggest abstract qualities and get sculptural effects without sacrificing individuality.

Still more variations of angel figures came from French's chisel. On the *Mourning Victory* of the Melvin Memorial, the form half sunk in the marble block, there are heavy soft draperies and a fold shadowing the face as on the Milmore Memorial. For others, such as the angel at Forest Hills Cemetery, he has made use of a finely pleated Greek tunic. *The Spirit of Life* for the Trask Memorial at Saratoga Springs, with lifted arms and wings, has more movement and an airy grace. A war memorial at Milton, Massachusetts, called *In Flanders Fields*, the sculptor considered one of his best works. The figure of a young man, his strength failing as he holds a torch aloft, is a rare instance of his treatment of the male figure.

Some of the finest of his imaginative compositions came towards the end of his life. A group in the Corcoran Gallery, Washington, D.C., an angel with curving wings who tenderly draws a girl to his embrace dates from 1924, *Death and the Young Warrior* from 1929, while the *Memory* of 1921, in The Metropolitan Museum of Art, New York, is the culmination of the artist's study of the nude, a female figure in repose, done with a fine full modeling devoid of literalism. In all his tremendous output the high serious-

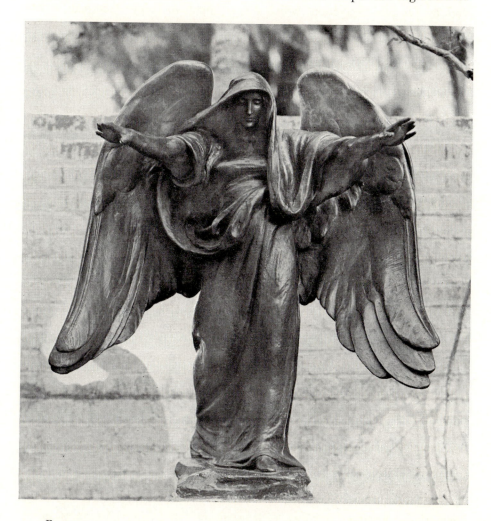

BENEDICTION

Bronze statuette. Height 3 ft. 1½ in. Signed on base at right: D. C. FRENCH SC. © Placed in Brookgreen Gardens in 1934. Other examples: Oaks, Pa. Saint Paul's Memorial Church. Memorial to Elizabeth Vaux Cresson; Cambridge, Mass. William Hayes Fogg Art Museum.

ness of the sculptor's purpose is evident. Throughout the latter part of his life, until his death on October 7th, 1931, French took an active part in various artistic organizations. He was a member of the National Arts Commission inaugurated by President Theodore Roosevelt. The National Sculpture Society awarded him a medal of honor in 1929. "Chesterwood," French's home and studio at Stockbridge, Massachusetts, is maintained as a museum and a memorial to him.

Benediction

With both arms raised in blessing, an angel is stepping forward. An ample cloak is thrown over the slightly bowed head and wrapped around the form, falling in a loose fold over one shoulder and standing out in a wide curve behind the other arm. Great soft-feathered wings spread in a tender sweep behind the outstretched arms. The original statue was designed as a war memorial.

"Midway between the towns of Verdun and St. Mihiel, on the military road bordering the River Meuse, are six rocky bluffs, at the foot of one of which the Commonwealth of Massachusetts is to erect a memorial to its men who died in the World War. The sculptural elements of this shrine, designed by Henry Bacon, have been modelled by Daniel Chester French. The Memorial is to consist of a terrace, with a flight of steps flanked by two bases bearing American eagles, a pedestal to occupy the rear of this opening, ornamented with rams' heads, symbolizing Sacrifice. On this will be placed a heroic winged figure of Benediction, below and in front of which will lie the form of a soldier covered by the American flag." [1] The project was abandoned and the large statue never made.

This figure repeats familiar themes in French's work; the heavily shadowed face is his way of giving a sense of mystery and otherworldliness; the wings and the pose of head and arms are very like the *Genius of Creation* for the Panama-Pacific Exposition, and the compassionate spirit pervades many of his angel forms.

Disarmament

A warrior in a helmet, a mantle held about his waist by a broad belt, stands holding a long-handled sword in his left hand, its point resting on the ground. On his right forearm is a round shield. He looks down at a baby boy standing

1 *International studio.* April 1922. v. 75, p. 171.

on tiptoes with both arms held up to him. A tender expression softens the soldier's rugged face, with its heavy jaw, low forehead, and broken nose.

Representing physical force, this statuette was the model for a temporary statue created for the Victory Arch erected in New York as part of the celebration of the armistice at the end of the First World War.

Bronze group. Height 3 ft. 6 in. Base: Width 1 ft. ½ in.—Depth 1 ft. ¾ in. Signed on top of base: D C FRENCH March 1919 Founder's mark: ROMAN BRONZE WORKS Placed in Brookgreen Gardens in 1950.

Charles Henry Niehaus

ANOTHER MAN in whose work the classical and the realistic have a strange alternation is Charles Henry Niehaus, although he seems to have absorbed more of the form of classical sculpture than of the spirit. He was born at Cincinnati, Ohio, on January 24th, 1855. His parents, John Conrad and Sophia (Block) Niehaus, were of German stock. As a prelude to his life work he practiced wood engraving, stonecutting, and carving in marble. After winning a prize at the McMicken School of Design, Cincinnati, at the age of twenty-two he continued his studies at the Royal Academy, Munich, receiving a medal for a baroque allegorical group entitled *Fleeting Time*. Upon his return to America in 1881, by virtue of being an Ohioan, he received a commission to model for Cincinnati a statue of President Garfield, who had just been assassinated. This work, showing the President as an orator, in a natural but effective pose, ably modeled, was immediately acclaimed. The State of Ohio also gave Niehaus the contract for a statue of William Allen for the rotunda of the Capitol at Washington. To carry out these commissions Niehaus removed to Rome, and in that propitious atmosphere he developed the classical vein which was his happiest and the one to which, much later, he returned. Only three of these studies, *The Scraper, Caestus,* and *Silenus,* have survived. They won him recognition among Italian artists, who made him a fellow of L'Associazione della Artistica Internazionale di Roma.

With the establishing of a studio in New York came more work of an official character, including statues and decorations for the Library of Congress, statues for the State House at Hartford, Connecticut, and a pediment for the Appellate Court building at New York. One of the groups on the arch erected for Dewey's triumphal entry into New York in 1899 was by him, and he had a share in the sculptural decorations for several expositions, although

he seems little at home in the bravura demanded for these ephemeral displays of magnificence.

The Hahnemann Monument commissioned in 1895 for Washington, D.C., is one of the most successful of his many statues of noted men, which are habitually conceived and executed in a simple and natural, if dry, manner. It is a seated figure wrapped in the broad folds of an academic gown, the lean face thoughtful and expressive. A departure from the use of the portrait statue as a memorial is *The Driller* for the Drake Monument at Titusville, Pennsylvania, a nude male figure in somewhat the same pose as Barnard's *The Hewer* of a year later, although it is less forcefully and feelingly expressed. Niehaus is the author of an equestrian statue of General Forrest at Memphis, Tennessee, and of soldiers' and sailors' memorials for several New Jersey towns, unveiled in 1922 and 1924. One of the most pleasing of his numerous portrait busts is the bluff countenance of the sculptor J. Q. A. Ward. The pediment which Niehaus made for the Kentucky State Capitol at Frankfort, built in 1907, is composed of classical figures, while there is a definite return to the style of his Roman works in the Francis Scott Key Memorial at Baltimore, unveiled in 1922. It is a statue of Orpheus striking the lute, a spirited and poetic figure. Niehaus died on June 19th, 1935.

In the eclectic character of this sculptor's work, certain debts are owed to his great contemporaries, Saint-Gaudens and French, while his personal taste was for literal realism, even in classic subjects. He was elected to the National Academy of Design, the National Sculpture Society, and the National Institute of Arts and Letters. His bust has been placed in the Hall of American Artists at New York University.

The Scraper

A bearded, muscular athlete stands firmly poised, his hand lifted to balance the turn of the figure and the bent knee as he looks down while scraping his leg with a strigil. This statuette, originally called *Greek Athlete Using a Strigil*, was modeled in 1883 during the sculptor's stay at Rome and was exhibited at the World's Columbian Exposition in 1893. At the time when it appeared it was an innovation in this country in the representation of the male form and aroused admiration by its truthful modeling.[1] A companion piece is *Caestus*, the boxer binding leather coverings about his hands, in The Metropolitan Museum of Art, New York.

1 Taft. *The history of American sculpture.* p. 400–401.

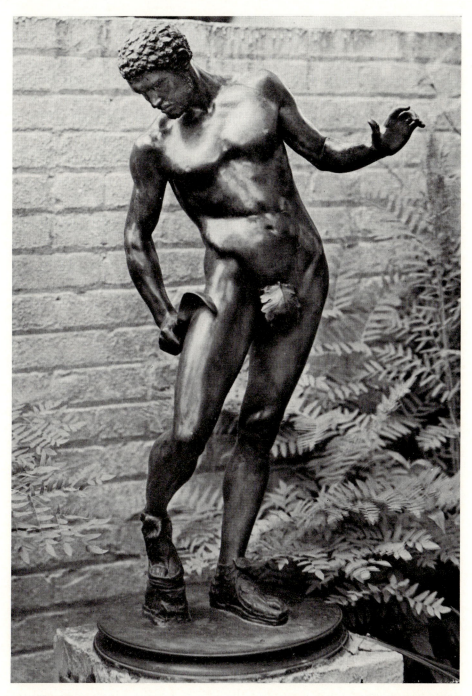

The Scraper

Bronze statuette. Height 2 ft. 11½ in. Signed on base at back: *C. H. Niehaus Sc.*
Founder's mark: CELLINI BRONZE WORKS N-Y- Placed in Brookgreen Gardens in
1935.

Cyrus Edwin Dallin

ALTHOUGH American Indians as subjects had long attracted sculptors, it was Cyrus Edwin Dallin who first made them a life study. He was born at Springville, Utah, on November 22nd, 1861, to English parents, Thomas and Jane (Hamer) Dallin, who had emigrated some years earlier and built a log cabin in which to raise their family of eight children. When Cyrus was eighteen years old, working in his father's mines, his choice of a profession was determined by the discovery of some clay with which he experimented in modeling. He began his art education at Boston in 1880 with Truman Bartlett and opened his own studio two years later, making portrait busts and statuettes. Here in 1884 he began his interpretations of Indians with an equestrian statuette called *An Indian Chief*. His studies were continued at Paris in 1888 at the Académie Julian with Chapu. He returned to Boston in 1890 and varied his work with a nude figure study, *The Awakening of Spring*. During several years at Salt Lake City he made an angel for the Mormon Temple, some busts, and part of a monument to the pioneers of Utah. For a short time he became an instructor at Drexel Institute, Philadelphia, and then returned to Paris for three years to study with Jean Dampt. Another figure composition, *Apollo and Hyacinthus*, and an equestrian statuette of Don Quixote date from this time.

Like MacNeil at Chicago a few years later, Dallin had received a further impulse to revive his boyhood memories and to model Indian subjects from Buffalo Bill's Wild West Show, which visited Paris in 1889. The four equestrian figures which compose a series of episodes in the losing struggle of the Indian with the white man began in 1890 with *The Signal of Peace*, now placed in Lincoln Park, Chicago. This was followed by *The Medicine Man* in Fairmount Park, Philadelphia; *The Protest*, which is the most dramatic; and *The Appeal to the Great Spirit* of 1909, which stands in front of the Boston Museum of Fine Arts. The last of the series were done after his terms of study abroad had ended and he had settled in Boston, where he became an instructor at the Massachusetts State Normal Art School. Other statues, such as *The Scout* in Penn Valley Park at Kansas City, Missouri, and the standing figure of Massasoit erected on Cole's Hill, Plymouth, in 1921, as well as many statuettes, recorded other aspects of the Indian, usually represented with a splendid physique and crowned with the war bonnet of feathers, details of dress and ornament meticulously exact.

Dallin departed from his chosen field in various monuments. An equestrian

statue, *The Cavalryman*, was unveiled at Hanover, Pennsylvania, in 1905; an *Alma Mater* for Mary Institute, Saint Louis, dates from 1916. The figure of Anne Hutchinson, moderately realistic in treatment, was placed in the Boston State House. She is in simple Puritan costume, her face turned upward, a little girl standing by her side. In 1931 a memorial to the pioneer woman of Utah, for which Dallin's mother was the model, was erected at his birthplace. An equestrian statue of Paul Revere which won a competition in 1885 was finally placed at Boston.

For his Indian subjects, which remain his most distinctive contribution, Dallin has chosen moments of suspended action which are impressive from their very gravity. With a real knowledge of his subject and an undeviating

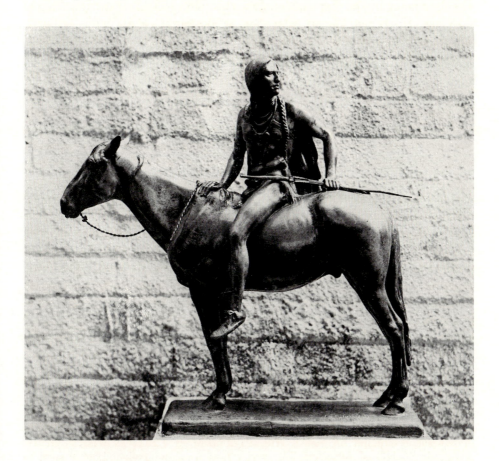

ON THE WARPATH

Bronze equestrian statuette. Height 1 ft. 11 in. Base: Length 1 ft. 3¼ in.—Width 3¼ in. Signed on base at right: © C. E. Dallin Founder's mark: GORHAM CO. FOUNDERS Placed in Brookgreen Gardens in 1936.

faithfulness to fact he combines a depth of sympathy and largeness of conception which lend authority to his interpretations. He was a member of the National Sculpture Society, the National Institute of Arts and Letters, the National Academy of Design, and the Royal Society of Arts, London. He died on November 14th, 1944, at Arlington Heights, Massachusetts.

On the Warpath

An Indian turns on his pony's back to look behind him. The horse is standing still, its ears laid back. The Indian wears a feather in his braided hair and holds a bow and arrows, while at his back hang the quiver and a round shield edged with feathers on which in low relief is a figure of a mounted Indian in a feather headdress.[1] The statuette was exhibited at The Pennsylvania Academy of the Fine Arts in 1915.

Herbert Adams

HERBERT ADAMS united with the reserve of his New England background a rare sense of beauty. He was born at West Concord, Vermont, on January 28th, 1858, the son of Samuel M. and Nancy (Powers) Adams, and was given his early education at Fitchburg, Massachusetts. After his graduation from the Massachusetts Normal Art School he went to Paris and studied with Mercié, staying from 1885 to 1890. Like Saint-Gaudens he acquired the technique of his French contemporaries and joined them in admiration for the Florentine masters of the fifteenth century, although he did not visit Italy until 1898. Lightly sketched detail, delicate modeling of flesh and drapery he learned from the pictorial impressionists. His own personality and conscientious craftsmanship at once fused these influences into a consistent style which kept the same even tenor throughout his career. While he was at Paris he made for Fitchburg a fountain of two boys playing with turtles and began the lovely heads of women which form a characteristic group, one of the finest being that of Adeline Pond, who became his wife, now in the collection of The Hispanic Society of America. The series was continued when he returned to the United States and took the position of instructor at Pratt Institute, Brooklyn, for eight years. In these busts Adams, like some of his French contempo-

1 This work is discussed by Kineton Parkes (*Sculpture of to-day*. v. 1, p. 182).

raries, experimented with polychromy, tinting plaster in soft tones and using wood, marble, ivory, and metals in simple combinations.

The influence of Saint-Gaudens is visible in several angels done before 1900 which have much of the quiet grace of the *Amor Caritas*. The *Pratt Memorial Angel* for Emmanuel Baptist Church, Brooklyn, is clad in finely pleated draperies; the angel of the Welch Memorial for Auburn Theological Seminary is in relief, framed by spread wings and a rayed halo.

His refinement of modeling and skillful use of ornament are particularly suited to work in low relief, a method which Saint-Gaudens had initiated. In portrait reliefs there are subtle impressions of personality, while in larger works medieval and classic associations add overtones to the balanced compositions. The bronze doors for the Library of Congress, which he undertook to finish after the death of Olin Warner in 1896, he carried out in the single-figure design and classic style begun by the original author. His doors for Saint Bartholomew's Church, New York, and the lunette above are in the Italian Renaissance manner with naturalistic touches in the sensitively rendered flowers and leaves of the borders. In the 1930's two important commissions added to his reputation. For the doors of The American Academy of Arts and Letters the formal style is appropriate, with symbolic figures of modified Renaissance design, but for The Mariners' Museum at Newport News the history of shipping and the mythology of the sea allowed freedom of fancy and freshness and variety of ornament.

Although the demands of the public monument hardly called forth his best qualities, he was the author of such notable statues as the standing figure of William Ellery Channing for Boston, the seated *William Cullen Bryant* in Bryant Park, New York, and *John Marshall*, one of four for the Cleveland Court House. Dignity of bearing is accentuated by enveloping robes and mellowed by fine modeling of the heads. For two war memorials, that at Fitchburg done in 1917 and one for Winchester, Massachusetts, ten years later, he preferred the symbolic figure which he could endow with the beauty of feature and softly clinging and sweeping draperies in which he excelled. The one at Fitchburg is a single figure holding a flag, the draperies swirling and lifting into butterfly wings, while at Winchester, Humanity and Justice hold a wreath, grouped beneath a half-furled flag. Even more congenial are the serene and poetic fountain and garden figures, like the three girls holding sprays of flowers and fruit of the MacMillan Fountain, Washington, D.C., the *Nymph of Fynmere*, and the *Girl with Water Lilies*.

During his busy professional life Adams found time for many activities in behalf of the advancement of American sculpture. He held office in art organizations and was the sculptor member of the National Arts Commission. In 1915 his work was recognized by the award of a medal of honor by The

Architectural League of New York and another at the Panama-Pacific Exposition. He was presented with a gold medal by the National Institute of Arts and Letters in 1926, in 1938 with the president's medal of honor of the National Academy of Design, and in 1940 with the medal of honor of the National Sculpture Society. Both Yale University and Tufts College conferred on him the honorary degree of master of arts. He died at New York on May 21st, 1945.

"The wisdom, restraint, and true sense of the just and fitting, which for years have rendered all relation with his calm and balanced intellect the delight of friends and the aid of fellow workers, are mirrored in an art which so easily reflects these qualities." [1]

Sea Scape

A girl adventurously rides a galloping sea horse, one arm around its neck and the other grasping a rein, while both knees are drawn up and pressed against its ribs and the long tail curves behind her. She looks down at an inquisitive fish which leaps from the waves rising under the horse's webbed forefeet. The fluent handling of details—the surges of water and the wind-blown hair—harmonizes with the subtle modeling of the forms.

Eagle

On a globe supported by four dolphins, the arms of the United States of America at the front, stands an eagle in defiant attitude with wings lifted, tail spread, the claws of one foot and the beak open. The original surmounts the monument erected at New Haven, Connecticut, in 1906 to Cornelius Scranton Bushnell, who made possible the building of the *Monitor*, and to John Ericsson, who made the plans.

Study in bronze. Height 2 ft. 1½ in. Founder's mark: QGWR GORHAM CO. FOUNDERS Presented to Brookgreen Gardens by the sculptor in 1934.

Coiled Snake

A small snake is coiled on an oval leaf in double convolutions, the head lifted from among the coils. This small bronze was done when the sculptor was studying at Paris, as an experiment in casting by the lost-wax process.

Bronze statuette. Length 2¾ in.—Width 1½ in. Signed underneath: HERBERT ADAMS First Casting Experiment CIRE PERDUE, PARIS 1889. Presented to Brookgreen Gardens by the sculptor in 1942.

1 Prefatory note to Adams, Adeline. p. XIII.

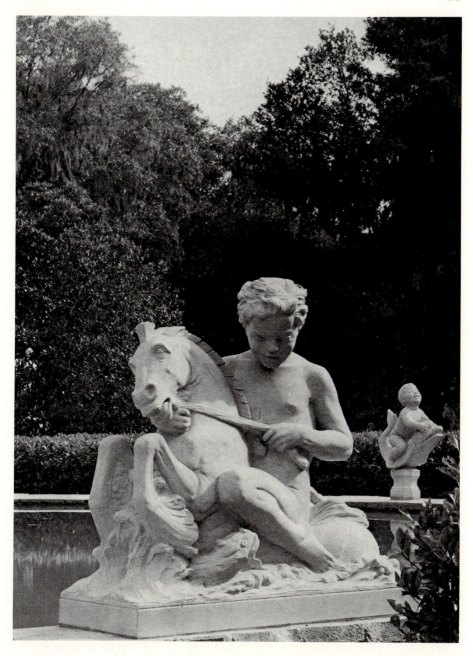

SEA SCAPE

Limestone group. Height 2 ft. 11½ in. Base: Length 3 ft.—Width 1 ft. 2½ in. Signed on base at right: HERBERT ADAMS SC 1935 Placed in Brookgreen Gardens in 1935.

Paul Wayland Bartlett

PAUL WAYLAND BARTLETT, born at New Haven, Connecticut, on January 24th, 1865, was the son of Truman Howe Bartlett, sculptor and critic, and his wife Mary Ann (White) Bartlett. Like MacMonnies, Paul Bartlett made France his real home, but he never broke his connections with the country of his birth. Since he was early destined to be an artist, and the father thought that no good foundation could be laid in this country, the boy was sent to live in Paris with his mother when he was nine years old. In their garden at Marly his attempts at modeling came to the attention of Frémiet, who gave him criticisms and whose classes in animal sculpture at the Jardin des Plantes he later joined. A bust of his grandmother, modeled when he was twelve, was accepted by the *Salon* in 1880, the year he entered the École des Beaux-Arts, where Cavelier taught. There is also recorded some instruction from Rodin. During the early part of Bartlett's career his entire attention was given to animal sculpture, he and his friend Gardet hawking their services about the studios of other sculptors and so leaving pledges of their talent among the public monuments of Paris.

A major success was *The Bohemian Bear Tamer* in The Metropolitan Museum of Art, New York, a lively group which was exhibited at the 1887 *Salon*. The *Indian Ghost Dancer* in a grotesque pose and the dramatic *Dying Lion* added to his reputation, until at the age of twenty-four he was placed *hors concours* and invited to become a member of the *Salon* jury. Through association with the sculptor-ceramist Jean Carriès, he experimented with patination to produce brilliant color effects and tried out his theories on small bronzes of animals which he cast himself in cire perdue. Shown at the 1895 *Salon* and also at the Saint Louis Exposition, they aroused great interest, and a group found a permanent home in the Musée du Luxembourg.[1] In that year the French Government recognized his eminence in his profession by electing him a *chevalier* of the Legion of Honor; his rank was later raised to that of officer, and, a year before his death, to commander. With no other artistic background than the schools of Paris, it was inevitable that he should share their theories and preferences. A romantic spirit, a realistic idiom, and an impressionistic technique are combined in his spontaneous, picturesque creations.

1 Some of these were lost during World War II.

30

The first public monument entirely his own was the equestrian statue of Lafayette, a gift of the school children of America, in the Place du Carrousel, Paris, which remains one of his finest productions. It owes something to Frémiet, and has, too, an eighteenth-century elegance. Commissioned in 1898, the plaster was inaugurated two years later, but the final version, incorporating many changes by the fastidious author, was not completed until 1908.

After this came an increasing number of demands for his work on public buildings, as well as for the inevitable exposition sculpture. Several fountains were his contribution to the Pan-American Exposition, Buffalo, in 1901, and the work which he exhibited received a gold medal, while at the Saint Louis Exposition three years later it took the grand prize. The *Michelangelo* and the *Columbus* for the rotunda of the Library of Congress were both original conceptions, vividly imagined, giving a strong impression of character. A statue of General Joseph Warren was erected at Roxbury, Massachusetts, and an equestrian statue of General McClellan at Philadelphia. Bartlett assisted J. Q. A. Ward on the pediment for the New York Stock Exchange and soon afterward received the contract for the pediment of the House Wing of the Capitol, Washington. Drawing his themes from American life, he composed it in a romantic, colorful strain, far removed from what are considered the requirements of architectural sculpture at the present day but consonant with the ideals of the time and full of delightful decorative passages. Broad, flat surfaces flood the space with areas of light, and the figures projecting against the cornice introduce strong accents. The next large architectural contract was for six statues for the attic of the New York Public Library façade. Here again Bartlett's conception of an appropriate style to decorate a Renaissance building was a graceful, impressionistic one, the dreamy figures draped in broad, crosswise folds with softly ruffled edges. His equestrian statue of Washington for Philadelphia is as distinguished as the *Lafayette*, though less dramatic. The *Benjamin Franklin* at Waterbury, Connecticut, is a seated figure in an unconventional pose, well characterized.

In his later work there is a distinct effort for monumentality at the expense of picturesqueness, and less bravura in treatment. Two statues of Puritans for the Hartford State Capitol, the *Robert Morris* at Philadelphia, and *The Pilgrim Mother* for Provincetown, Massachusetts, make skillful use of the broad folds of colonial garments. Still more restrained are the red granite figure of *Patriotism Guarding the Flag* at Duluth, Minnesota, and the *Blackstone* presented by the American Bar Association to the London Law Courts.

Chief among the many honors accorded him, in addition to the Legion of Honor, were associate membership in the Académie des Beaux-Arts, France,

and in the Académie Royale des Sciences, des Lettres et des Beaux-Arts de Belgique, and membership in The American Academy of Arts and Letters. He died at Paris on September 20th, 1925.

Study in Bronze

A man is seated, his head bowed on his knees. One arm clasps the knees, and the other falls limply at the side. It was done before 1905, since it is among some of his bronzes illustrated in that year.[2]

2 *The New England magazine.* 1905. v. 33, p. [374].

STUDY IN BRONZE

Bronze statuette. Height 9 in. Signed on base at back. Presented to Brookgreen Gardens by Bessie Potter Vonnoh in 1941. Other example: Paris. Musée National d'Art Moderne.

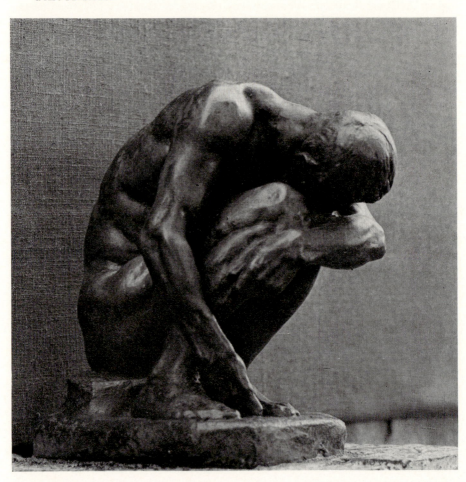

Fledgling

A young bird huddles with feathers fluffed, the head and beak tilted upward. Mr. and Mrs. Charles Downer Hazen saw the plaster of this study in Bartlett's studio at Paris. They admired it and obtained a cast.

Bronze statuette. Height 3¾ in. Signed on base: P w B 95 Presented to Brookgreen Gardens by Mr. and Mrs. Charles Downer Hazen in 1937. Other example: Concord, Mass. Art Association (entitled *Blackbird*).

Frederick William MacMonnies

FREDERICK WILLIAM MACMONNIES stands very much by himself in the development of American sculpture, completely individual and more akin in spirit and in perfection of technique to his French contemporaries of the period just before Rodin than any of his countrymen. Born at Brooklyn on September 28th, 1863, the son of William and Juliana Eudora (West) MacMonnies, he gained admittance to Saint-Gaudens's studio as a chore boy in 1880, beginning to model there and studying at the National Academy of Design and the Art Students' League in the evenings. Once Saint-Gaudens became aware of MacMonnies's talent he was unstinting in his encouragement and in 1884 helped him to go to Paris. MacMonnies's first year at the École des Beaux-Arts under the instruction of Falguière was broken by a stay at Munich studying painting and by a brief recall to New York. He returned to Paris, studying with both Falguière and Mercié, and again came back to New York in 1887 to help Saint-Gaudens. This time when he left for Paris it was to establish a residence which lasted until the World War.

The years between 1889 and 1900 saw the greater part of his life work in sculpture poured out on a stream of furious and joyous energy. The *Diana* of 1889, his first success in the *Salon*, is very much in the manner of Falguière, and it was at this point that Saint-Gaudens lamented the conversion of his disciple to French ways. In the *Nathan Hale* for City Hall Park, New York, and the portrait statue of James Stranahan for Prospect Park, Brooklyn, both exhibited at the *Salon* in 1891, MacMonnies's personal style appeared fully matured. He was awarded a second-class medal, the first American to be so honored. The *Nathan Hale* is highly poetic, arresting in the simple pose and the way in which it is charged with emotion, made graceful by the casual

treatment of the garments lightened with delicate touches. The *Stranahan* charms by the straightforward approach and the concentration of character in the face. At one phase of his career, MacMonnies's sympathies again coincided with those of Saint-Gaudens. He too felt a kinship with the Italian Renaissance, but the phase which took his fancy was the representation of the mischievous joy of childhood. *Pan of Rohallion*, the *Boy and Duck* fountain, and the *Running Cupid* all show this affinity, which was later to inspire his pupil, Janet Scudder, and through her a long line of American sculptors.

Virtuosity came to the front in the Columbian Fountain of the Chicago Exposition of 1893, an exuberant array of lovely figures manning a colossal galley. With this triumph MacMonnies's reputation was established in his own country, and many commissions were given to him. The *Sir Harry Vane* in the Boston Public Library, the personification of elegance, was well received, but about another work for the library arose the first of those incidents which have made MacMonnies the stormy petrel among American sculptors. The gay and vital *Bacchante and Infant Faun* was banned by the city fathers, though it was soon on exhibition at the Metropolitan Museum, New York, and the Luxembourg, Paris. The *Shakespeare* of 1898 is a sincere endeavor to interpret the man of genius beneath the richly embroidered coat. More work for Brooklyn was of a character which allowed the sculptor full scope for ingenuity and brilliance. The Soldiers' and Sailors' Arch had piers faced with two large groups and a quadriga at the top. In the group representing the army the composition, conceived as an explosion, carries much of the excitement of Rude's *Le Départ*. There are also in Prospect Park a lively equestrian statue of General Slocum and the two magnificent gatepost groups, *The Horse Tamers*.

After this astounding burst of creative energy, rewarded by a grand prize at the Paris Exposition of 1900, MacMonnies stopped modeling for a time and turned to painting portraits in which he reveled in bright colors. He produced an equestrian statue of McClellan for Washington in 1906, and, after his definite return to the United States, the Princeton Battle Monument, erected in 1919. Washington on horseback, grimly refusing to accept defeat, rises above a seething mass of soldiers. The strange dripping lines of the composition and the violently gesticulating female figure in the foreground are unlike anything else in the range of American sculpture. There were fountain figures, *Truth* and *Inspiration*, for the New York Public Library, the Pioneer Monument to Kit Carson at Denver, and *Civic Virtue* for City Hall Park, New York, a male figure of heroic mold standing with a welter of siren forms around his feet, which became another center of controversy.[1] The

1 *Civic Virtue* was moved to Kew Gardens in 1941 and placed in front of Queens Borough Hall.

monument to the Battle of the Marne was commissioned in 1916 for a site near Meaux, France. In contrast to his earlier rapidity of execution, the sculptor spent ten years on it and concentrated all his devotion to his second homeland in the stirring figure, *France Defiant*, shouting above the dead at her feet. During the last decade of his life, refusing larger contracts, MacMonnies produced many portrait busts suavely modeled and strong in characterization. He died in New York on March 22nd, 1937.

In the work done after his return to the United States there was a certain reorientation. Vivacity deepened to intensity; compositions became more compact even while keeping an elaborate contrapuntal flow of line and piquant variations of texture. More than in his earlier works—for the great vogue of Rodin had intervened—he broke up the surface to catch a minute play of light and shade. His pagan spirit and impish sense of humor in conjunction with the sensual quality of his modeling and his challengingly baroque compositions alienated his American audience at the same time that his mastery of vibrating surfaces and easy handling of intricate design gave him a special place among his fellow artists. His eminence in both the United States and France was acknowledged when he was made a member of The American Academy of Arts and Letters and a commander of the Legion of Honor.

Rearing Horses

One of a pair of rearing horses is ridden by a nude youth who leans far back holding by a rope the other horse, which rises high on its hind legs. He has a lash in his lowered right hand.

The original groups, conceived as *The Triumph of Mind over Brute Force* and also known as *The Horse Tamers*, are dated 1898 and placed at the Ocean Avenue entrance to Prospect Park, Brooklyn. "To produce them, Mr. MacMonnies bought two wild horses in Andalusia and had them brought to his studio in Paris. There, by means of ropes and stretchers, the horses were posed more than three hundred times in the positions in which they appear in the groups." [2] The fluent modeling of taut muscles and wind-tossed manes gives these brilliant studies of action spontaneous freedom and vigor within a well-ordered design.

Reduction of a bronze group. Height 3 ft. 2½ in. Base: Length 2 ft. 4 in.—Width 1 ft. 6½ in. Signed on base at right: MAC.MONNIES Sculp�~ Founder's mark: H. ROUARD. Fondeur. PARIS Placed in Brookgreen Gardens in 1934. Other examples: New York. The Metropolitan Museum of Art (first proof); Paris. Musée National d'Art Moderne.

2 Strother. p. 6972. The groups are also discussed by Lorado Taft (*The history of American sculpture*. p. 354–355).

Rearing Horses

On the back of the near horse rides a youth who holds by a rope the second horse, rearing still higher. A whip is raised in his left hand.

Venus and Adonis

Venus, a full-blown beauty, leans provocatively on the shoulder of young Adonis, who turns to her, his hand resting on the head of a mastiff standing behind him, as if he were reluctantly distracted from thoughts of the hunt. With the dog and a tree trunk for support at the base, the group builds up to a firm pyramid. MacMonnies's works were seldom translated into marble, since bronze preserved better the impetuous virtuosity of the clay model. In this instance the carver has retained the palpable softness of flesh and the free handling of loose masses of hair. Not a hard surface nor a sharp edge has intruded.

This work was done at Paris in 1895 and shown there in the Universal Exposition of 1900. There were also smaller versions cast in bronze. New Yorkers had a chance to see the marble group in the 1923 exhibition sponsored by the National Sculpture Society, where the flippant treatment of classical mythology was not well received. When it was sent to an exhibition at New Rochelle, it was covered with a cloth for fear its unabashed nudity might shock visitors. Thereafter it remained in storage for many years until it was placed at Brookgreen. It is a splendid example of MacMonnies's rich development of forms, to which he brought a special feeling of buoyancy and an instinct for balanced masses.

Numidian marble group. Height 6 ft. 7 in.—Width 5 ft. 7¼ in.—Depth 2 ft. 2½ in. Signed on base at right: F · MAC.M°NNIES · Broken and repaired. Presented to Brookgreen Gardens by Mrs. MacMonnies in 1959.

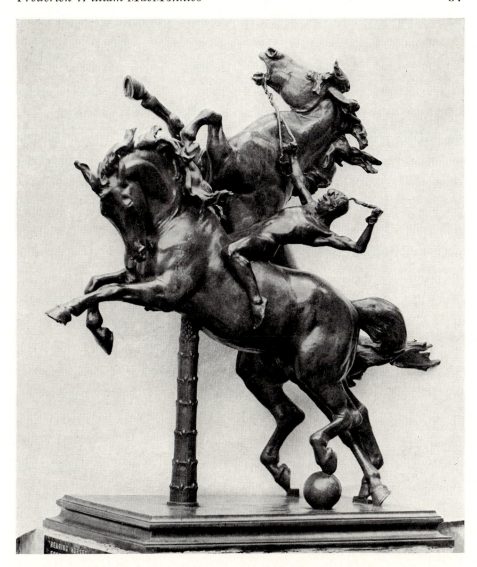

REARING HORSES

Reduction of a bronze group. Height 3 ft. 3 in. Base: Length 2 ft. 4 in.—Width 1 ft. 6 in. Signed on base at right: MAC-MONNIES Sculpt Founder's mark: H. ROUARD. Fondeur. Paris. Placed in Brookgreen Gardens in 1934. Other examples: New York. The Metropolitan Museum of Art (first proof); Paris. Musée National d'Art Moderne.

George Grey Barnard

GEORGE GREY BARNARD represents a titanic struggle to embody universal ideas in sculptural forms. His inspiration, like Rodin's, reverts to the work of Michelangelo, casts of which he first saw as a student at Chicago. Barnard was born at Bellefonte, Pennsylvania, on May 24th, 1863, the son of a Presbyterian clergyman, Joseph H. Barnard, and his wife Martha Grey (Grubb) Barnard. During his boyhood spent partly at Chicago and in Iowa, conchology, geology, and taxidermy were his hobbies. As apprentice to a jeweler he became an expert engraver. He went to Chicago to carry on his trade but abandoned it to attend classes at the Art Institute for a year. A commission for the portrait bust of a child in 1883 provided the means to go to Paris, where he remained for twelve years, living to himself, completely absorbed in his work. During the first four he studied at the Atelier Cavelier of the École des Beaux-Arts. *The Boy*, completed at this time, was masterly in modeling. The cost of the marble carving was borne by Alfred Corning Clark, who became interested in the sculptor in 1886. Clark asked him to carve a monument for a friend, the Norwegian singer Lorentz Severin Skougaard, to be erected at Langesund, not far from Oslo. Called *Brotherly Love*, this monument took the form of two figures groping through an unfinished block of marble, as if the two friends were trying to reach each other through the barrier of death. In it the sculptor's qualities appear fully developed; recondite thought, the powerful expression of lean muscular forms, and firm surfaces broken by strong shadows over which the light plays in bold patterns. Subsequent visits to Norway excited his interest in the country and in Norse mythology. He first interpreted those legends on a Norse stove and a little later carved them on an oak clock case on which the swirling shapes of *art nouveau* develop into leaves and meanders and into human groups.

Even more cosmic ideas began to take shape about this time, when Barnard opened his own studio. The group of one man rising above another prone at his feet was given the title, *"I Feel Two Natures within Me."* The strong ungainly forms, the broken silhouette, re-enforce the impression of blind struggle. It scored a tremendous success at the Paris *Salon* of 1894, where Barnard first exhibited his work publicly, and is now in the Metropolitan Museum, New York, as *Struggle of the Two Natures in Man*. *The Hewer*, another powerful nude with clearly articulated muscles, crouching with arm uplifted, was to form part of a group relating the progress of human labor, called *Primitive Man*.

The sculptor then returned to the United States, showed his work, and took a studio in New York. His first commission in this country, the *God Pan* on Columbia University campus, is like a lull in the storm of his surging thoughts. The old god stretched out, his strong muscles relaxed, playing on his reed pipe, expresses lazy enjoyment. This is the only really merry note among all Barnard's organ tones. From 1900 through 1903 Barnard taught at the Art Students' League.

In the latter year came a commission after his heart, that for two huge groups for the Capitol at Harrisburg, Pennsylvania. He took a studio at Moret-sur-Loing and worked for eight years. These two groups composed of many loosely connected life-sized figures starting from niches beside the entrance, which were faced with the naturalistic flowers and birds then in vogue, had for subjects *The Burden Bearers* and *Work and Brotherhood*. The statue of Lincoln for Cincinnati, a sincere attempt to portray him as the man of the people, aroused much adverse criticism because of the uncouthness of the posture and dress. Barnard's reverence for Lincoln inspired several other arresting studies of his head. A calm and rhythmic *Rising Woman*, an *Adam* and an *Eve* on the Rockefeller Estate, Pocantico Hills, New York, powerfully imagined and clearly stated in pure forms, mark an interval of serenity and controlled force.

The last twenty years of his life Barnard dedicated almost entirely to a tremendous undertaking, *The Rainbow Arch*, a sermon against war. More than fifty heroic statues were included among the youths rising as immortals at the left and tragic refugees climbing the mountain of despair at the right. The upward-straining forms have the intensity of the vision which inspired them, and the figures of war-sufferers are charged with emotion. The sculptor's mastery of form led to a richer diffusion of light by fine gradations of modeling, further varied by the addition of drapery, clinging material lightly veiling the shape beneath. The scheme, as in earlier work which tried to get the unstudied effects of nature, lacked a definite architectural framework. A few other figures, such as a colossal statue of Christ called *The Carpenter at the Door*, have the mystic significance and virtuosity of technique of the Arch. *Mother Earth and Child*, a columnar figure, black and gold, is an essay in primitive simplifications, savage-faced.

During his residence in France, Barnard made it his avocation to collect French Romanesque and Gothic sculpture. These pieces of architectural ornament and figures he brought to the United States and built into an appropriate setting on Washington Heights, New York, called The Cloisters.[1] His death occurred in New York on April 24th, 1938. He was a member of The

1 The collection was acquired by The Metropolitan Museum of Art in 1925.

American Academy of Arts and Letters and a corresponding member of the
Académie des Beaux-Arts, France. A memorial collection of his work has
been assembled at Swarthmore, Pennsylvania.

Maidenhood

A girl is seated sidewise, supported by her hands, her pensive face, with
closed eyes, turned in profile over her shoulder. The smooth curves of the

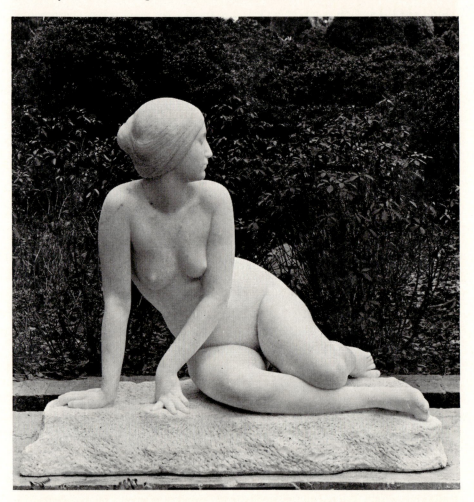

MAIDENHOOD

White marble statue. Height 3 ft. Base: Length 3 ft. 6 in.—Width 2 ft. 1½ in.
Placed in Brookgreen Gardens in 1935. Formerly in the collection of Alexander
Blair Thaw.

forms are broadly handled; the straight hair is wound softly around the head and gathered in a knot. The sculptor said of this figure, which he made at New York in 1896, "I finished that marble in a way I finished no other flesh." [2]

2 Letter to Archer Milton Huntington. March 29th, 1938. This work is discussed by Laurvik (p. XLVI) and McSpadden (p. 194).

Lorado Taft

SOMEWHAT APART from the sculptors who worked in the East, Lorado Taft, by precept and example, made Chicago a focus for sculpture. He was among the first in this country to evolve a monumental style for his sculpture, which meant a departure from the detailed treatment of form in the direction of broader masses and indefinite outlines. Born at Elmwood, Illinois, on April 29th, 1860, he was the son of Mary Lucy (Foster) and Don Carlos Taft, a pastor and educator who later became professor of geology at the University of Illinois. There Lorado Taft took his bachelor's degree in 1879 and his master's degree a year later after a preparatory education given him entirely by his parents. The acquisition by the University of one of the earliest collections of casts of sculpture in the West may have inspired his choice of a profession, since in 1880 he left for Paris to become a sculptor. He stayed until 1883, studying at the École des Beaux-Arts with the neoclassicists Augustin Dumont, Bonnassieux, and Jules Thomas, made a visit home, and returned for two more years. He had a bust accepted at the *Salon*, worked briefly in Injalbert's studio, and had criticisms from Mercié. When in 1886 he received a commission for a statue of Schuyler Colfax, Indiana statesman, he settled in Chicago and became instructor in modeling at the Art Institute, a post which he held for twenty years. His career as a lecturer on the history of art, which also began there, was later extended to the universities of Chicago and Illinois. Even at this early period his double mission as creative artist and as apostle of the art of sculpture was defined.

Taft's initial efforts in sculpture were devoted to busts, war memorials, and a few imaginative compositions. In these his fine sentiments and abstract ideas, often dependent on literary inspiration, found expression by means of a technique which slurred detail in favor of broad surfaces. "To be suggestive rather than direct is what I aim at," he has said.[1] In common with several

1 Information from the artist on the photograph of *Black Hawk* in the Frick Art Reference Library, New York.

other sculptors, he received his first recognition at the World's Columbian Exposition in 1893, with two subjects for the horticultural building, *The Sleep of the Flowers* and *The Awakening of the Flowers*. From that time on he could indulge his preference for groups of ideal figures and place increasing emphasis on the symbolic content. *The Solitude of the Soul*, four pensive nudes with clasped hands half emerging from the rough marble block, received a gold medal at the Saint Louis Exposition. Maeterlinck's *Les Aveugles* inspired the emotional group, *The Blind*. The *Washington* for the Seattle Exposition of 1909 was the first of several statues imagined as generalizations rather than personifications, with the enveloping cloak used to convert the figure into a massive column. In the colossal statue of Black Hawk for Oregon, Illinois, a noble head crowns a monolithic blanketed form. To the main element of the Columbus Memorial Fountain of 1912 at Washington, D.C., a statue against a shaft, the sculptor wished to give "something of the simplicity of Egyptian sculptures with their suggestion of calm and permanency," [2] although he could have taken no more than a very general idea from such a source.

A series of monumental fountains began with the completion in 1913 of the *Fountain of the Great Lakes*, a group of five draped female figures pouring water from shell to shell. In 1922 was erected at Chicago *The Fountain of Time*, intended to form part of an elaborate scheme for sculptural decoration of the Midway, Washington and Jackson Parks, which was to include a *Fountain of Creation*, bridges, and statues. A compact procession of human forms is arranged in wave-like rhythms before the draped figure of Time, inspired by Austin Dobson's lines,

> Time goes, you say? Ah no!
> Alas, Time stays, *we* go.

Taft used the symbolism in favor among Eastern sculptors of the period in certain other works. The Thatcher Memorial Fountain at Denver, Colorado, has a classically draped figure surrounded by symbolic groups dressed in medieval fashion, while the *Alma Mater* of 1929 for the University of Illinois, standing in front of a chair like the Saint-Gaudens *Lincoln*, is in the semi-classic manner of D. C. French. In *The Pioneers* for Elmwood, Illinois, the sculptor has made a half-hearted venture into the field of realism, which never attracted him, as his vision was that of the inward rather than the outward eye. He made two pylons, *The Patriots* and *The Pioneers* for the State Capitol at Baton Rouge, and in the last year of his life was engaged on a frieze

2 Information from the artist on the photograph of the Columbus Memorial Fountain in the Frick Art Reference Library, New York.

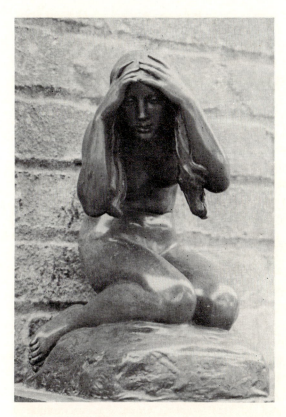

DAUGHTER OF PYRRHA

Sketch model in bronze. Height
1 ft. Signed on base at right:
Lorado Taft. Sc.
Placed in Brookgreen Gardens
in 1937.

representing the Lincoln-Douglas Debate to be placed at Quincy, Illinois. The
sculptor has defined his own art in these terms, " 'I would say that my
distinctive characteristic is a feeling for the mass and a preference for a
sculptural interpretation, rather than a literal or realistic one.' " [3]

In the midst of his creative work he was gathering about him pupils and
associates to whom he gave generous help and encouragement and was
extending his program of art education to free public lectures and demonstra-
tions of the methods of sculpture. His pioneer experiments in concrete as a
material for sculpture, used for both *Black Hawk* and *The Fountain of Time*,
were recorded in a cinema film by the United States Bureau of Mines. His
interest in the history of art bore fruit in two books: the first comprehensive
survey of American sculpture, published in 1903 and revised and enlarged in
1930, and *Modern Tendencies in Sculpture*, from lectures delivered at The
Art Institute of Chicago in 1917. At the end of World War I he went to France
for a few months to give lectures on artistic subjects to soldiers. He died at
Chicago on October 30th, 1936. His Midway Studios, restored and used by
students in the Department of Art of the University of Chicago, have been
designated a National Historic Landmark.

3 Rolfe. p. 44.

Daughter of Pyrrha

A kneeling woman is about to rise. Both hands are placed on her head, her parted hair flowing loosely against her arms. On her face is an expression of awakening consciousness. The idea of using the myth of Deucalion and Pyrrha, the evolution of man from matter in stones taking human shape, in a composition for a monumental fountain came to the sculptor in 1909. He made a small sketch of a ring of figures almost prostrate where they begin to emerge from the stone, rising higher as they awake to life, meet, and struggle, until at the top they stand united and exultant. The water was to flow between the various groups. This girl, completely formed, is just becoming aware of her existence; the figure was at the right, in the curve where the nascent beings assumed full human stature. The working model was made and exhibited in 1910 but not cast in bronze until 1934. The sculptor's intention was to have the fountain erected at the east end of the Midway, Chicago, as a pendant to his *Fountain of Time*. At his death almost all the small working models were finished, fourteen were enlarged in plaster to ten-foot size, and four, including this one, were carved in limestone. These four were bequeathed with the other contents of his studio to the University of Illinois; the two male figures flank the entrance to the Auditorium and the two female figures are at the east entrance to the Library.

Edith Howland

EDITH HOWLAND was born near Auburn, New York, on March 29th, 1863, the daughter of Benjamin and Louise (Powell) Howland. She was of Quaker ancestry, her father descended from New England and her mother from Welsh and Dutch settlers. After attending Vassar College she went to Paris and studied drawing at the Académie Julian, modeling with Gustave Michel. In the *Salon* of 1893 she exhibited a bust of Maud Muller which was shown in marble the following year. During a stay at New York she continued to study at the Art Students' League, her teachers being George deForest Brush for drawing and Saint-Gaudens and Daniel Chester French for sculpture. The winter of 1911 was spent in Florence and the following year traveling in India, China, and Japan. Upon her return she took a studio at Neuilly near Paris for a few years. By 1917 she was again in New York City. Later she

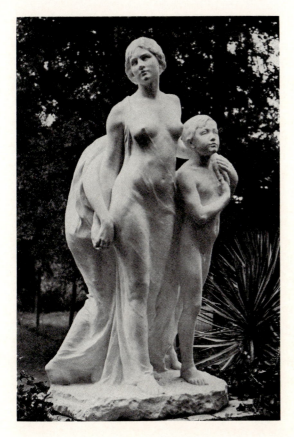

BETWEEN YESTERDAY AND
TOMORROW

White marble group. Height 6 ft.
4 in. Signed on base at back: *E.
Howland*
Presented to Brookgreen Gardens
by the sculptor in 1940.

I move like a prisoner caught,
For behind me comes my shadow,
And before me goes my thought.

retired to Catskill, New York, where she died on September 8th, 1949. Her work comprised small figures and heads in bronze, including two heads of Indian squaws shown at the Philadelphia Sesqui-Centennial Exposition, and garden pieces cut directly in stone. One of her garden subjects was a *Boy and Swan* fountain. She was a member of the National Association of Women Painters and Sculptors and an associate of the National Sculpture Society.

Between Yesterday and Tomorrow

Three periods of life are represented by a woman in her prime, one hand leading the bent form of an old woman behind her, and the other on the shoulder of a boy who walks beside her. A light drapery thinly veils the form of the young woman, and a soft mantle clings to the bowed back and head of the old woman, the edges blown before her. The group is closely held together by the drapery filling the spaces between the figures and the rhythm of their intertwined arms. The subject was suggested by a Spanish gypsy

song. Modeled at Neuilly in 1913, the plaster model won honorable mention at the Paris *Salon*, the marble being shown the following year. It has been on exhibition at The Metropolitan Museum of Art, New York, and the Brooklyn Museum.

Charles Grafly

CHARLES GRAFLY was born at Philadelphia on December 3rd, 1862. Of German and Dutch ancestry, his parents were Charles and Elizabeth (Simmons) Grafly. At the age of seventeen he apprenticed himself as a carver in Struthers' Stoneyard, some of his work being destined for the Philadelphia City Hall. After studying at the Spring Garden Institute, he entered the Pennsylvania Academy, receiving instruction from the painters Thomas Eakins and Thomas Anshutz. In 1888 he went to Paris for four years and studied drawing with Bouguereau and Fleury at the École des Beaux-Arts, modeling with Chapu at the Académie Julian. The *Salon* in 1890 accepted his heads *Saint John* and *Daedalus*, the latter being cast in bronze for the Pennsylvania Academy's collection. *Mauvais Présage* won honorable mention at the *Salon* in the next year.

In 1892 he returned to Philadelphia and became instructor in modeling at the Drexel Institute and the Pennsylvania Academy, where he taught until his death. With his wife he returned to Paris for the winter of 1895. He had criticisms from Jean Dampt and worked on the figure, *Vulture of War*, a fragment of a contemplated group called *War*, never finished. His sculpture in the next few years took the form of allegorical groups such as *Symbol of Life*, two figures standing side by side, and *From Generation to Generation*, a youth and an old man advancing under a winged clock. Esoteric thoughts were expressed in realistic nude figures, precisely modeled. For the Buffalo Exposition of 1901 his share was a symbolic *Fountain of Man*, for Saint Louis, *Truth*, and for the Panama-Pacific at San Francisco in 1915, a *Pioneer Mother Monument* which was erected in permanent form. Two of the statues on the New York Custom House, *France* and *Great Britain*, and a portrait of General Reynolds for the Smith Memorial, Fairmount Park, Philadelphia, are by him. His greatest achievement in monumental sculpture is the memorial to General George Gordon Meade unveiled at Washington in 1927. In a compact group resembling a cortege, led by a winged male figure representing War, seven symbolic figures escort General Meade. For many years Grafly's summer home and studio were at Lanesville, near Gloucester, Massachusetts, and from 1917 he also taught at the Boston Museum of Fine Arts.

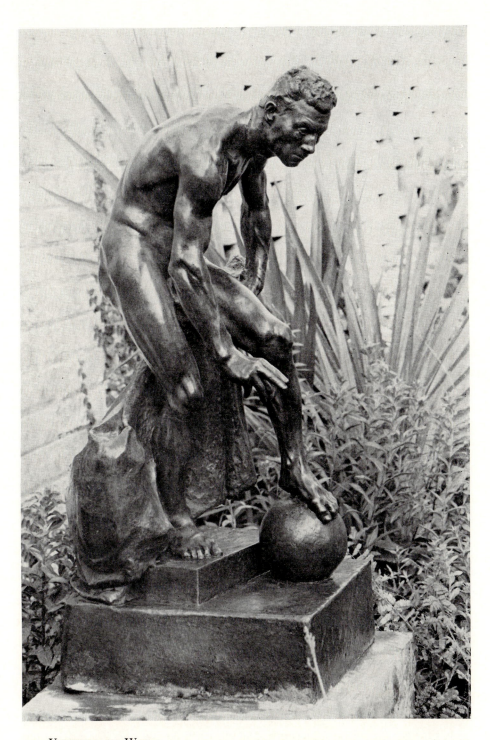

VULTURE OF WAR

Bronze statuette. Height 2 ft. 8¼ in. Founder's mark: THE GORHAM CO FOUNDERS QIZQ Presented to Brookgreen Gardens by the Grafly Estate in 1937.

Among the early works exhibited were busts of his mother and his wife, but it was his portrait busts of men, many artists among them, which brought him most fame. Each one is an individual, the physical appearance modeled with absolute assurance to convey a strong impression of personality. A bust of his teacher, Thomas Anshutz, won the Widener Medal of the Pennsylvania Academy in 1913 and was acquired for its permanent collection, that of Childe Hassam now in the Philadelphia Museum of Art, the Watrous Gold Medal of the National Academy of Design in 1918, and one of Frank Duveneck the Potter Palmer Gold Medal of The Art Institute of Chicago in 1921.[1] There are several others among his works in the permanent collection of the Pennsylvania Academy. At the Hall of Fame, New York University, he is the author of the portraits of James Buchanan Eads, Jonathan Edwards, and Admiral Farragut. That of President Buchanan was made for Lancaster, Pennsylvania. His work was rewarded with many honors, gold medals at the Pennsylvania Academy in 1899 and at the Paris, Buffalo, and Charleston expositions, and a grand prize at the Buenos Aires Exposition of 1910. Among the societies to which he belonged were the Fellowship of the Pennsylvania Academy, the National Sculpture Society, of which he was one of the charter members, the National Academy of Design, The Architectural League of New York, and the National Institute of Arts and Letters. He died at Philadelphia on May 5th, 1929.

Vulture of War

A sinewy, brutal-faced man crouches menacingly, one foot advanced, his right hand stealing forward ready to seize a victim, a cloak dragging from his left hand. This figure was modeled in Grafly's studio at Paris in the winter of 1895 to 1896 and exhibited at The Pennsylvania Academy of the Fine Arts in 1898. It was to have formed part of a large group on the subject of war. "In it man is being pitted against man. The central figure, 'War,' swings a man in the form of a scythe, his outstretched arm and hand holding a flaming torch forming the blade; across the 'scythe' rests the dead form of a woman, representing death and destruction. Upon 'War's' back is a vulture following after to reap from the carnage his impious harvest." [2] There exists a small sketch for two figures, one prone and one standing. A helmeted head in heroic size for the other figure was completed in plaster. Only two bronzes of the *Vulture of War* were cast, the other being the property of the sculptor's daughter, Dorothy Grafly. A plaster statue, exhibited at the Louisiana Purchase Exposition, is in the City Art Museum, Saint Louis.

1 The Carnegie Institute, Pittsburgh; The Cincinnati Art Museum; The Art Institute of Chicago; and the Hall of American Artists in New York University own examples.
2 Dallin. p. 229.

Harriet Hyatt Mayor

HARRIET RANDOLPH HYATT was born on April 25th, 1868, at Salem, Massachusetts, where her father Alpheus Hyatt, the paleontologist, was curator of Essex Institute. Her mother's maiden name was Audella Beebe. Harriet studied at the Cowles Art School, Boston, with the painter Dennis Bunker and the sculptor Henry Hudson Kitson and also had instruction from the painter Ernest L. Major and the water-colorist Ross Turner. She exhibited a *Head of a Laughing Girl* at the World's Columbian Exposition in 1893, and her work received a silver medal at the Atlanta Exposition in 1895. On August 27th, 1900, she married Alfred Goldsborough Mayor, a zoologist and at one time lecturer in biology at Princeton University. Realistic figure studies include *Shouting Boy* in Mariners' Museum Park, Newport News. Her specialty was portraits, among them a bust of Admiral Goldsborough at Annapolis and a marble bust of Anna Hyatt Huntington as a girl, in the collection of The American Academy of Arts and Letters, New York. Later works were memorial tablets to Alpheus Hyatt at the Marine Biological Laboratory, Woods Hole, Massachusetts, and to Alfred Mayor at Carnegie Institution, Washington, D.C. Other memorial tablets are those at Meeting House Plain and Stage Fort Park, Gloucester, Massachusetts, and that to the Reverend Benjamin Bulkeley at Concord, Massachusetts. In addition to the plaque to Howard Crosby Warren at Princeton University, there was completed in 1935 the medal bearing his name. The last years of Mrs. Mayor's life were spent with her sister, Anna Hyatt Huntington, at Bethel, Connecticut, where she died on December 8th, 1960. She had been a New Jersey regent of the Daughters of the American Revolution and a member of the Colonial Dames of America.

Boy and Chickens

A boy crouches on his knee, his hand extended with grain in the palm. Two chickens run towards it, and a rooster hurries forward with lifted wings. Under the title *My Little Model* it was exhibited at the Boston Art Club in 1898.

Bronze group. Height 1 ft. 6¼ in. Base: Length 1 ft. 7½ in.—Width 1 ft. 2½ in. Signed on base at left: *Copyrighted. Aug. 26–1896 Harriet R. Hyatt Sculptor* Founder's mark: CAST BY THE HENRY-BONNARD BRONZE CO N-Y. 1896. Placed in Brookgreen Gardens in 1935.

Girl with Fish

A laughing girl sits on a rock, teasing a squirming fish raised in her right hand. Kipling's story of Mowgli and his impish pranks was the inspiration for the figure.

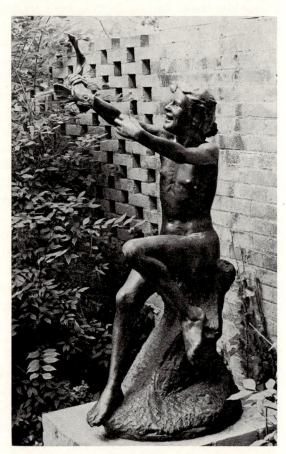

GIRL WITH FISH

Bronze statue. Height 4 ft. 11½ in. Signed on base at front: *H R Hyatt* Founder's mark: KUNST FDRY N-Y
Placed in Brookgreen Gardens in 1941.

Clio Hinton Bracken

CLIO HINTON BRACKEN was born at Rhinebeck, New York, on July 25th, 1870, the daughter of Howard and Lucy (Brownson) Hinton. Arts and letters were natural interests in the family, since her father, an editor of the *Home Journal*, was also a teacher and scholar; her mother, one of the early suffragists, a painter and sculptor, pupil of Carpeaux and Chapu. While in her teens Clio Hinton attended the Art Students' League; she also studied with Saint-Gaudens. A model for a statue of Frémont, planned for erection in California at his death in 1890, won her a prize of ten thousand dollars. As with many young sculptors, portraiture was one of her first interests, a bas-relief of Paderewski and a bust of Emma Eames being among her youthful works. In 1895 she went to Paris, where Louis Oury and MacMonnies were her teachers and where she also came under the influence of Rodin. Her mother and she both exhibited in the *Salon* in 1898, a bust of a child being Clio's entry. While at Paris she became interested in the *art nouveau* style of decoration then in vogue and adapted its principles to her own small decorative objects and statuettes. Stressing nature as the source of all design, the followers of this system tried to give their works the untutored grace and restless sweep of wind and wave, the soft, irregular curves and candid charm of growing things.

In 1899 the sculptor returned to New York and shared a studio on Tenth Street with her cousin, Roland Hinton Perry. Here she modeled a bust of Sarah Bernhardt. A brief marriage to James Gibbons Huneker, music critic and essayist, had ended in divorce, and in 1900 she married William Barrie Bracken, an attorney. There were periods of residence at Greenwich, Connecticut, and Boston before her definite return to New York in 1917. In her work done in the United States she carried on the themes begun in Paris, a poetic imagination creating delicate miniature figures palpitating with fervent emotions, to be cast in gold, bronze, and silver. One of her greatest successes was a punch bowl inspired by the Rubáiyat of Omar Khayyam, with nude forms massed around the rim and drooping towards the base. A *Spanish Dancer*, *The Roman Youth*, *The Kiss*, a nymph on the crest of a wave, and a girl devotee kneeling before a bust of Pan were other subjects. In harmony with the theories to which she subscribed, she chose an impressionistic technique with varied, melting surfaces, lightly indicated detail, and insistent suggestion of mood.

Like a number of other sculptors—George Grey Barnard and her cousin R. Hinton Perry among them—she was given a commission for sculpture to ornament the state capitol at Harrisburg, Pennsylvania. Her share was to be large groups. Due to a political scandal involving the money appropriated, the working models were never carried to completion. Mrs. Bracken continued to model portraits, among them busts of General Pershing, Clarence Whitehill of the Metropolitan Opera Company, and the American composer Henry Hadley. Since her small works readily lent themselves to garden settings, some were enlarged for this purpose, one group being placed in the garden of Mrs. Oakleigh Thorne at Santa Barbara, California. The sculptor died at New York on February 12th, 1925.

Chloe

A girl stands easily, one foot forward, left hand raised to her head. A grapevine spray dangles from the other hand, held at her shoulder. She looks downward, musing. A thin skirt clings to torso and thighs and hangs unevenly below the knees. Loose hair and slim body are lightly modeled to suggest natural grace. The figure has been given the name of the patroness of verdure. The small model was done early in the twentieth century, enlarged and cut in marble about twenty years later.

Chassignelles marble statue. Height 6 ft. 2 in. Base: Width 1 ft. 10 in.—Depth 1 ft. 10 in. Placed in Brookgreen Gardens in 1953.

R. Hinton Perry

MASTER of two arts, both painting and sculpture, Roland Hinton Perry began as a painter. He was born in New York City on January 15th, 1870, the son of George and Ione (Hinton) Perry. His father was an editor of the *Home Journal*, his mother a talented amateur painter and miniaturist. He received his early education in private schools and, since his boyish drawing showed talent, began to study drawing and painting at the Art Students' League when he was sixteen. After three years there he went to Paris and studied with Paul Delance at the Académie Delécluse. He then entered the

École des Beaux-Arts, the only American admitted that year, and had Gérôme as his teacher. He had already made rapid progress as a painter and had exhibited at the *Salon* when, in an effort to better his rendering of anatomy, he became interested in sculpture and enrolled in Chapu's classes at the Académie Julian, continuing with Denys Puech after Chapu's death. Perry remained in Paris for six years, producing both paintings and sculpture. In 1894 he traveled through Germany and Norway, painting as he went, and then returned to New York.

Since an elaborate scheme for the decoration of the new Library of Congress was under way, Perry went to Washington hoping to be chosen as one of the mural painters. He found that there were already enough of them but that a man who could do bas-reliefs was needed. He undertook four octagonal medallions representing sibyls for the ceiling of the entrance pavilion and returned to Paris to execute the commission. This work was such a success that Perry was given the commission for the monumental fountain in front of the building. He ambitiously chose as a subject the court of Neptune, feeling that powerful muscular figures amidst rushing water well expressed the youthful vigor of a growing nation. The design follows a tradition long established in Italy, with an architectural background of a wall cut by three niches and rocky bases for the statues giving the effect of grottoes. Neptune is seated in the middle niche, flanked by Tritons blowing conches. Nymphs gaily ride curveting seahorses, their hair blown backward by the wind, and water creatures spout water or play in the basin. These important works won him membership in the National Sculpture Society. After their completion he again went to Europe, traveling through France and Italy.

The exuberance of the Library of Congress fountain was appropriate to exposition sculpture, and for the Pan-American Exposition at Buffalo in 1901 Perry modeled a Fountain of Hercules and a Fountain of Prometheus, typifying man's physical and intellectual powers. By an accident both these groups were so badly damaged that they could not be placed, but *Atlas with the Globe*, a colossal group, was erected on the façade of the Palace of Machinery at the Louisiana Purchase Exposition.

His interest in spirited movement and heroic figures in action, as well as his enthusiasm for Wagner's music, led Perry to Wagnerian themes such as the Valkyrie, inspired by romantic fervor and developed in both painting and sculpture. The Neptune Fountain had included some water creatures, and animals continued to be an occasional interest. A realistic *Elk* of giant size was among the first sculptured monuments erected at Portland, Oregon.

Perry had a chance to explore the pictorial, dramatic vein still further when he shared in the elaborate decorations of the New Amsterdam Theater, carried

out in an *art nouveau* setting in 1903. His part was twelve panels for the lobby, with Wagnerian scenes again the subject of five of them and moments from Shakespearean dramas of another five. The fact that his first wife, his cousin Irma (Hinton) Perry, was connected with the theater as a member of Mrs. Carter's company brought him in close contact with the stage, and many of his portraits are of theatrical people.

A more classical manner seemed appropriate for the bronze doors of the Buffalo Historical Society, each valve with a draped female figure, one representing History, the other Ethnology. The personification of Pennsylvania to top the dome of the state capitol at Harrisburg, inaugurated in 1905, was also conceived as a figure in classical draperies holding a standard, but the draperies cling and accent the figure in the taste of Paris.

Events and heroes of the Civil War were still being immortalized in sculpture. As the New York Peace Memorial on Lookout Mountain at Chattanooga, Perry modeled *Reconciliation*, a group of a Confederate and a Federal soldier clasping hands. The New York memorial at Andersonville, Georgia, took the form of a relief with a draped figure holding a wreath above a tablet. Most recent of these war memorials was one erected at Syracuse after the First World War as a tribute to the Thirty-eighth Infantry, called *The Rock of the Marne*, exemplified by a realistic doughboy.

Although he abandoned the imaginative themes with which he had begun his career, Perry continued to model a few garden figures such as *Bird Maiden*, a *Daughter of Pan* seated on a rock playing pipes, and a *Boy with Fish*. In spite of an imposing array of commissions, Perry became discouraged with the lack of opportunities for sculpture or possibly with changes in taste not to his liking and again turned to painting. His brilliant, flattering portraits of notables and society women became fashionable and completely absorbed his attention after 1916. Among those whom he portrayed was his second wife, May (Hanbury) Fisher. In his studio on West Tenth Street, New York, and his summer home at Richmond, Massachusetts, he continued to work prolifically until shortly before his death on October 27th, 1941.

Perry's impetuous temperament led him instinctively to restless, involved compositions, and his schooling in the precepts of French sculptors of the 1890's, bent on unrestrained naturalness and liveliness of expression, strengthened his inclinations. An inborn facility in modeling encouraged him to dwell in detail on the robust muscularity of men's bodies or the daintiness and grace of women. Sweetness and florid prettiness were emphasized by clinging, fluttering draperies with frothy edges. His predominantly realistic conceptions were modified by dashing freedom of handling and soft blending of planes.

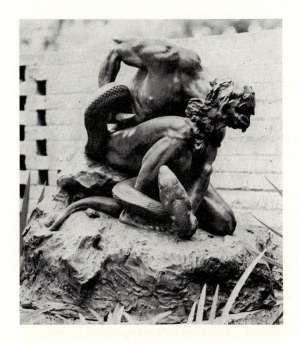

PRIMITIVE MAN AND SERPENT

Bronze group. Height 3 ft.—
Length 3 ft. 1 in.—Width 2 ft. 8
in. Signed on base at left: R.
 Hinton Perry 1899
Placed in Brookgreen Gardens in
 1950.

Primitive Man and Serpent

A powerful man is crouched on one knee, struggling with a huge serpent
coiled in tortured convolutions around his body and under his legs. Strong
muscles tense with effort are modeled in detail to show the elemental force of
the rugged physique, and his primitive nature is emphasized by shaggy hair
and a long, unkempt beard. Bowed shoulders, sharply doubled up legs, and
bent arms combine with the serpent's sinuous bends into an intricate counter-
play of angles and curves within a contained silhouette. Contemporary critics
noted how skillfully the composition was directed inward to a central point.[1]

Originally entitled *Thor and the Midgard Serpent*, this group was modeled
in 1899 and shown the following year in the exhibition of The Architectural
League of New York. With *Siegfried and the Dragon* it carries on in sculp-
ture an interest in Norse mythology that the artist also expressed in paintings.
Thor, strongest among gods and men, had the thunder at his command. He
was constantly battling the serpent who dwelt in the sea around Midgard,
center of the world. In their final struggle during the Twilight of the Gods,
both perished. Thor is here represented without his special attributes, gener-
alized to stand as an expression of male strength pitted against the malevolent
powers of nature.

1 Hughes. p. 29, and Robard, V. *A new group by Perry.* In *The Criterion.* December
16th, 1899. v. 21, no. 517, p. 14.

Amory C. Simons

ONE OF THE few sculptors from South Carolina in his generation, Amory Coffin Simons was born at Aiken on April 5th, 1866, to John Hume and Mary Hume (Lucas) Simons. In order to study sculpture he went to Philadelphia and attended John J. Boyle's classes at The Pennsylvania Academy of the Fine Arts. He also had Charles Grafly as a teacher. With this basis he decided to further his education by going to Paris. Enrolling in the Académie Julian, he studied first with Denys Puech and later with Jean Dampt and Emmanuel Frémiet. He had the advantage of criticisms from Auguste Rodin and worked with his own compatriot, Paul Bartlett, who was busy with many commissions for monuments and architectural sculpture. By 1897 Simons was exhibiting portrait busts in the *Salon* of the Société des Artistes Français. Soon after, he began to show animal subjects—cats, dogs, goats, and the studies of horses for which he was to be most widely known. As a further step in his fastidious attention to technique, he learned the cire-perdue or lost-wax method of bronze casting and cast some of his own statuettes. He was given honorable mention in 1900 at the *Salon* for three reliefs and again in 1906 for a group of statuettes of horses and dogs. *Surprise*, a horse looking down curiously at a turtle near its feet, was awarded honorable mention at the International Exposition of 1900. This work also won a similar award at the Pan-American Exposition in Buffalo, and a group including studies of horses and of cats gained a silver medal for the artist at the Louisiana Purchase Exposition.

In 1905 Simons met "Buffalo Bill" Cody when he brought his Wild West show to Paris and modeled a statuette of him on his favorite mount, noting the characteristically close seat and the natural ease with which he rode. This statuette is now in the Buffalo Bill Museum at Cody, Wyoming. *Haute École*, a trained horse with foreleg raised high, done at Paris in 1910, is in The Metropolitan Museum of Art, New York, and *French Mounted Guard*, dated 1914, in the Musée de l'Armée, Paris. Visits to Rome in 1904 and 1912 are recorded by small bronzes of an Italian mounted guard, now in the High Museum of Art, Atlanta, Georgia, and a pair of oxen observed as they were drawing a road roller, among the group of his works in the Gibbes Art Gallery, Charleston, South Carolina.

At the beginning of the First World War, Simons ended his long stay in Paris and returned to the United States, opening a studio in New York. Here he continued to develop his favorite themes, choosing as models police horses

with their riders and the last of the fire-engine horses. One version of this theme was awarded the Speyer Memorial Prize at the National Academy of Design in 1922. The Sculptors' Gallery gave an exhibition of his works, and a large group filled one room in the Baltimore Museum of Art's 1924 exhibition of American art, his *Rearing Colt* eventually finding a place in the museum's permanent collection. Some of the works exhibited in the 1920's were equestrian portraits of men and women mounted on the steeds of their choice. In 1923 the sculptor was elected a member of the National Sculpture Society. His knowledge of the structure of horses was such that from 1922 to 1926 he was engaged by The American Museum of Natural History to prepare three models in a series showing the development of the horse, from fossil specimens, *Neohipparion* and *Pliohippus*, to modern types. As a fine example, Lee Axworthy, famous trotting horse, was modeled in action, with the skeleton in the museum collection as a guide, cast in bronze, and placed in the Hall of Horses.

Simons went to California towards the end of the 1920's, living first at Hollywood and later at Santa Barbara, where he settled after he had retired from active work and where he died on July 24th, 1959. His *Circus Horse* and *Horse Being Shod* are in the Public Library there, and a group of animal statuettes, including studies of hares, cats, and a dog, is in the Santa Barbara Museum of Art. From 1935 to 1945 he made for Mrs. Irénée Du Pont a long series of statuettes showing various breeds of dogs, each modeled from a thoroughbred; this collection was shown at the Natural History Museum, New York, in 1947. A departure from his normal subjects is *Handstand*, a study of a muscular athlete, while *Blizzard*, a marble carving of two horses huddled together with manes and tails blown forward, has a note of impressionism in its muted suggestion of snow, wind, and cold.

Brought up in the atmosphere of Paris art schools that demanded realistic exactitude and a high degree of technical competence, Simons's work embodies these qualities. It was probably Frémiet, noted both for animal sculpture and equestrian monuments of historical accuracy, who most strongly inspired the American sculptor. His own work, small in scale, is executed with great finesse, a quick grasp of characteristic movement, and fidelity to anatomical detail. Real enthusiasm for his subjects and a direct approach give his creations the stamp of authority.

Horse Scratching

A horse stands with head bent downward, hoof raised to scratch its jaw, tail blown forward completing the curve of the back and neck. The play of muscles is convincingly depicted; mane and forelock are unevenly tossed.

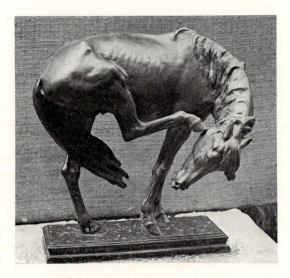

HORSE SCRATCHING

Bronze statuette. Height 8⅞ in.
Base: Length 7⅜ in.—Width 3⅛
in. Signed on base at left: By
 A C Simons Paris
Presented to Brookgreen Gardens
by the sculptor in 1951. Other
example: New York. The Metro-
 politan Museum of Art.

Modeled in 1910 during the sculptor's stay at Paris, this work has often been
exhibited, having been included in the National Sculpture Society's exhibition
at New York in 1923. It is among those cast in cire perdue by the sculptor
himself.

The Kicker

A horse stands resting with right hind leg flexed, head lowered and turned
slightly to the left, the eyes with a wary expression. An uncertain temper is
suggested by ears laid back and open mouth ready to nip. The forelock is
blown forward, the mane laid in irregular masses, and the long tail spread
between the legs. The compact body is modeled in accurate detail, ribs
showing through the skin, tendons stretched along the slim legs. The work
was first exhibited at the National Academy of Design, New York, in
1923.

Bronze statuette. Height 8⅞ in. Base: Length 8⅜ in.—Width 3⅛ in. Signed on base
at left: A. C. SI[MONS] Presented to Brookgreen Gardens by the sculptor in 1951.

Gutzon Borglum

MOST SPECTACULAR among the sculptors of the early twentieth century was a man of dynamic personality whose tremendous energies eventually found an outlet in sculpture on a colossal scale. Gutzon Borglum was born on March 25th, 1867, near Bear Lake in Idaho to Danish pioneers, James de la Mothe and Ida (Michelson) Borglum. Recently emigrated to the United States, they had been traveling on the Oregon Trail when they stopped at this spot and built a primitive house. Christened John Gutzon de la Mothe, Gutzon later dropped the other two given names. The father eventually settled at Fremont and later at Omaha, Nebraska, to practice medicine. In public schools in that state the son received his early education. When he was sent to a Jesuit boarding school, Saint Mary's College near Topeka, Kansas, he made the acquaintance of Italian art, being urged to copy religious pictures, while of his own choice he drew Indians and horses from memory. When his father moved to Los Angeles for a brief period early in the 1880's, Gutzon was apprenticed to a lithographer. After he had learned that trade he worked for a fresco painter and in a small studio of his own began to paint in oils. For instruction he went to San Francisco and studied painting with Virgil Williams and William Keith at the Art Association, returning to Los Angeles to continue painting. Borglum was also preparing himself for his future vocation by experimenting with small sculpture. After his marriage to Mrs. Elizabeth Putnam, a move to Sierra Madre brought him near a ranch where he could draw and model horses at will. Setting out in 1890 for the East with a lot of paintings, he sold them at Omaha for enough to finance a trip to Paris. He got a more thorough foundation for his career by study at the Académie Julian and the École des Beaux-Arts and had some instruction from Stephan Sinding, the Norwegian sculptor. Paintings were exhibited at the *Salon* in 1891 and 1892, and in the former year, a small bronze of a horse standing over his fallen master, *The Death of the Chief*, which won for the artist membership in the Société Nationale des Beaux-Arts. From Paris he traveled to Holland and Belgium and went to Spain for a year, the result in sculpture being a small bronze of a horse dying in the bullring.

After three years in Europe Borglum was ready to come home. With subjects done on camping trips in the mountains he painted enough canvases in two years, together with a few small pieces of sculpture, to venture on an exhibition. Since Western scenes were reputedly popular in England, he chose London for the scene of his first important public showing. His work,

generally admired, brought in many orders for portraits and a commission of a different kind, a series of mural decorations for the Queen's Hotel, Leeds, depicting the activities of Pan and a group of nymphs. When he received a second commission for mural decorations, this time for the Midland Railway Concert Hall, Manchester, he returned to America to carry out this important order, an unusual honor in that it was a work of art done in America for England.

In a studio remodeled from a stable on East Thirty-eighth Street, New York, he devoted himself more and more to sculpture. A sketch drawn from the life in England was the basis for a statuette of John Ruskin, seated in a chair, made monumental in spite of its small scale.[1] Borglum's first great triumph in sculpture was an ambitious group called the *Mares of Diomedes*, a turbulent mass of rearing, plunging horses skillfully organized into a coherent composition. This success was immediately followed by the first of many commissions for statues, that of John W. Mackay eventually placed in front of the School of Mines at Reno, Nevada.

During this time Borglum was formulating his own artistic creed and publishing articles in which he vigorously urged American artists to stop depending on European example and develop an independent, original art inspired by national ideals. Like most young sculptors working at Paris, he had frequented Rodin's studio and felt the fascination of that master's powerful personality and his vibrant interpretations of the human form. When, abandoning the factual, often anecdotal themes of his bronze sculpture, Borglum turned to marble carving, his thoughts took a new direction, towards highly emotional and symbolic concepts of universal significance. The nude female figure is the chief vehicle for his ideas, the form often partially concealed in the marble, but the palpitating flesh modeled in full detail with soft, yielding contours to convey the throbbing pulse of life and passion. The meanings are so obvious that titles are hardly necessary: *The Atlas*, woman bearing the burden of the world on her shoulders, *The Wonderment of Motherhood*, and *The Martyr* with arms pinioned.

Carving keystones for a livelihood led Borglum into other architectural sculpture, for he was asked to design gargoyles for a dormitory at Princeton and in 1905 to take charge of the sculpture on the Cathedral of Saint John the Divine, New York, twelve life-sized statues of the apostles on the outside and about seventy-five smaller figures inside. With Robert A. Baillie as his chief assistant and mentor in the art of stone carving, he set up a studio on the grounds to keep the work under his personal supervision. Borglum had long revered Abraham Lincoln and made a study of his physical appearance. He

1 Examples are in The Metropolitan Museum of Art, New York, and the Deering Library, Northwestern University, Evanston, Illinois.

attempted to convey Lincoln's greatness in a colossal marble bust that was finally given an honored place in the Capitol at Washington, D.C. This interpretation of the character of a national hero in more than life size presaged a later devotion to expressing the nation's ideals in monumental forms. The head of Lincoln, admired for its profound delineation of character as well as for the masterly presentation of his features, led to Borglum's selection as sculptor of a monument to Lincoln at Newark. The bronze statue shows the President in deep thought, seated on a bench in an informal pose.

A monument that called into play his knowledge of horsemanship and gave him a chance to exercise his instinct for drama was the equestrian statue of General Philip Sheridan for Washington, D.C. A moment of instantaneous action is caught and the force of the General's impassioned decision shown. The impact of the emotional intensity and the originality of the pose were immediately felt.

His first marriage had ended in divorce, and in 1909 Borglum married Mary Williams Montgomery. He bought a tract of land near Stamford, Connecticut, and for a number of years did most of his work there and took an active interest in local as well as national affairs. His idealism and generous impulses constantly drew him into battles for worthy causes, and his militant spirit helped him put up a good fight. He had always been a student of mechanics and had experimented with aeronautics. During the First World War he started and helped carry out an investigation of corrupt practices in airplane manufacture. At the end of the war, sympathizing with the struggles of the newborn republic of Czechoslovakia, he offered his land as a training camp for volunteers to fight in that struggle.

These multifarious activities did not keep him from the constant practice of his art. More and more commissions for monuments came his way. A statue of Collis P. Huntington was placed near the railroad station at Huntington, West Virginia, and near Plymouth Church, Brooklyn, one of Henry Ward Beecher with two slave girls crouching at the foot of the pedestal. Neither in these nor in other portrait statues done during this period were there any startling innovations. They are given vitality by decisive grasp of personality, made evident in arresting poses and easy, spirited modeling.

In 1921 Borglum began on a work that fostered his vision of his country's history expressed in grandiose terms. In this instance the impressiveness came as much from numbers as from scale. For a war memorial at Newark he imagined not one battle but a panoramic review, presenting the "American nation at a crisis, answering the call to arms." In a long procession packed with figures, many of them portraits of his contemporaries, he made visual his thesis that "mass action is the keynote of civilization." [2]

2 Casey and Borglum. p. 159.

Meanwhile an opportunity of even greater magnitude fired his imagination. In it both fervent concern for recording his country's history and an obsession with grandeur found an outlet. The United Daughters of the Confederacy had chosen the dominant mass of Stone Mountain in Georgia as an appropriate site for a memorial to the leaders of the Confederacy. They had approached Borglum about its possibilities, and he had enthusiastically envisioned a mighty army under the leadership of General Lee moving across the face of the mountain. After Borglum had conquered the mechanical difficulties of enlarging and projecting his designs onto the rock, carving was begun in 1923, and in January 1924 the head of Robert E. Lee was unveiled. A disagreement with the Stone Mountain Confederate Memorial Association, which had assumed control of the project, resulted in stoppage of the work. Borglum destroyed his models to prevent their unauthorized use and left the scene, setting up a temporary studio at Raleigh, North Carolina.

The sculptor was next called to San Antonio, Texas, to design a monument for the Trail Drivers' Association, two horsemen at the head of a herd of long-horn steers. While Borglum was working on Stone Mountain, an influential citizen of South Dakota had written to him outlining the possibilities for mountain sculpture in the Black Hills. In a preliminary visit Mount Rushmore was chosen as offering the best surface on which to carve a memorial to the founders of the country. After the Stone Mountain fiasco Borglum turned his attention to Mount Rushmore and the problems of carrying out sculpture of such magnitude in an inaccessible spot. Here, at last, the sculptor felt that he had a project equal to his imagination and his energies, and he marshalled all his forces. He improved his methods and went to work on a grand scale, installing machinery and employing a corps of assistants headed by Hugo Villa and his own son, Lincoln.

Gigantic heads of four presidents, carved from the rock itself, were to epitomize the country's history and constitute a Shrine of Democracy. The tremendous undertaking progressed at such a rate after the actual carving was begun in 1927 that by 1930 the head of Washington could be dedicated. In spite of many interruptions and difficulties the last head, that of Theodore Roosevelt, was dedicated in 1939. There was still finishing to be done when Gutzon Borglum died on March 6th, 1941. His son Lincoln carried the work to completion. It is for this extraordinary enterprise, in harmony with the wide sweep of his vision, that Borglum's name is best known. With immensity the principal factor, he had to depend upon the power of huge masses and strong contrasts of light and shade for his effect.

As the carving on Mount Rushmore, at first a seasonal activity, got under way, Borglum was able simultaneously to take on other commissions. In line with his patriotic themes was a pioneer group, *A Nation Moving Westward*,

for Marietta, Ohio. At the request of Paderewski he modeled a monument to President Wilson erected at Poznań, Poland, but destroyed in the Second World War. A statue of Thomas Paine for Paris that survived in concealment could be placed only after the sculptor's death. His amazing energy and facility is illustrated by his production of 170 public monuments and statues in the space of forty years. His instinct for a dramatic pose and his gift of characterization redeemed the long series of portrait statues from the banality into which they might so easily have fallen, and his fluent modeling lent them grace where smaller scale made it possible for him to give attention to detail. He schooled his impulsive temperament by thorough study of the facts relating to his subject but by rapid, direct modeling kept the vividness of a sketch and the immediacy of swiftly captured emotion.

Mares of Diomedes

Horses race forward, bodies pressed close together. All are wildly excited, ears laid back, nostrils distended, and mouths open gasping for breath. The bodies are truthfully modeled without insistent detail to give a dynamic sense of rushing movement, enhanced by the rhythmic play of muscles and the backward flow of loose masses in the manes and tails.

This group is the middle section of a larger work, modeled in Borglum's New York studio in 1904. In the complete group there are seven horses, the foremost ridden by a nude man. The galloping troop rises with a wavelike swell as it surges over a hill, the lifted head of the rearing horse forming the crest. The fore part of the lead horse is completely in the air, forelegs doubled in a gallop. At the rear, where they struggle up a slope with bodies to the ground, the mass is solider. The dramatic sweep of the whole is accomplished by variety in individual action and extraordinary virtuosity in rendering horses in motion.

Borglum had long been trying to convey the sensation of rapid motion given by a horse at full gallop. He hit upon the idea of grouping a number of horses to intensify the impression of pounding hoofs and headlong speed. "I have utilized a subject from the West—," he said, "the stealing of horses. The method is, mounting a tractable horse, entering the band, and riding about quietly until the band follows—then leading them away. I stripped the horseman of garments, both to delocalize him and also to show the play of a fine nude figure on a nude horse. The name is a convenience—the motive of the group, mainly intense controlled action." [3] By extension of idea, the work

3 Quoted by McSpadden (p. 222–223). This work is also discussed by Casey and Borglum (p. 84–85) and by Rupert Hughes (*Appleton's magazine*. December 1906. v. 8, p. 716).

also symbolized the power of the human mind over brute force. Recalling the Labors of Hercules and his taming of the man-eating mares of Diomedes, someone gave the work the title by which it is known. The original group, cast in bronze by The Gorham Company and exhibited in their Fifth Avenue window, was greeted with acclaim and awarded a gold medal at the Saint Louis exposition. It was bought by James Stillman and presented to The Metropolitan Museum of Art, where for many years it had a place of honor at the foot of the main stairway.

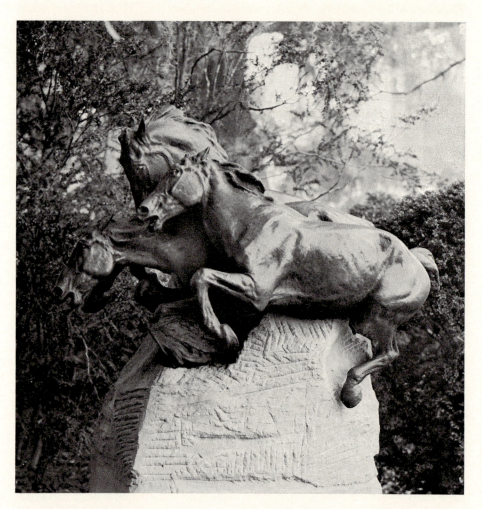

MARES OF DIOMEDES

Bronze group on stone base. Height 3 ft. 6½ in.—Length 4 ft. 8 in.—Width 2 ft. 9 in. Placed in Brookgreen Gardens in 1948.

Head of Nero

Wildly staring eyes and parted lips give Nero an expression of terror and madness. The heavy face above a short, thick neck is sketchily modeled, the sagging fleshy masses of the cheeks and the drawn brows briefly indicated. A laurel wreath has slipped askew over one ear. The sculptor has concentrated on giving the effect of intense emotion, boring the eyes deeply to make burning black holes beside the thin nose and opening another spot of deep shadow between the narrow, slack lips.

This head was part of a statuette modeled in 1902 and copyrighted the next year. Nero was represented with a flabby body precariously propped on weak legs spread far apart, a disheveled piece of drapery falling from his waist along one leg. Shoulders were bowed forward, arms outstretched and fingers taut with horror. On the original title, added to the name, were the words, "Qualis artifex pereo [What an artist dies in me]," supposed to have been spoken by Nero just before his death, when the Roman mob caught up with him. This statuette is now in the Cranbrook Academy of Art, Bloomfield Hills, Michigan. The artist is quoted as having said of it,

"Each of us puts something of his life in his work. Something in my life made my Nero possible. It has passed; it has gone out of my life. It would be impossible for me to create another Nero or to shape a being at all like him. There are some days when, absorbed in my angels, my saints, I hate my Nero; but if art is worth anything at all it must be real, and he was real at the time. As a matter of fact, I found the firebrand reincarnated in a man here in New York who had once been my friend." [4]

After the plaster model of the figure standing in his studio was broken by a fall, Borglum had the head cast separately. Presented by him to Archer Milton Huntington, it passed into the collection of The Hispanic Society of America, later going to Brookgreen Gardens on permanent loan.

Bronze head. Height 2⅜ in.—Width 1⁹⁄₁₆ in.—Depth 2¹⁄₁₆ in. Signed on truncation B . . . Placed in Brookgreen Gardens in 1945. Other example: Beloit, Wis. Theodore Lyman Wright Art Hall, Beloit College.

4 McSpadden. p. 225–226. This work is also discussed by Rupert Hughes (*Appleton's magazine*. December 1906. v. 8, p. 714) and by Leila Mechlin (*The International studio*. April 1906. v. 28, p. xl).

Frederic Remington

FREDERIC REMINGTON was born at Canton, New York, on October 4th, 1861. When he was eleven, the family moved to Ogdensburg where his father, Seth Pierre Remington, had been appointed collector of the port. His mother's maiden name was Clara Sackrider. While he was at Yale, he took a course in the School of Fine Arts and published sketches in the *Yale Courant*, although his chief distinction was on the football field. After his father's death, he decided to try his luck in the West. At the age of nineteen he set out for Montana, becoming a cowboy and then stockman on a ranch. There he began to draw the life about him, a keen eye directing a hand which gradually became skilled to put vivid action on paper accurately and effectively. He fraternized with cowboys and soldiers and was particularly devoted to horses, choosing for an epitaph the words, "He knew the horse." As a participant in the Indian warfare of the period, he was little interested in the Indian otherwise than as an opponent to the White Man and a picturesque adjunct to the Western scene.

He came back to the East in 1886, settling at New Rochelle, New York, but there was at first little market for the portfolio of sketches which he brought with him. After some had been accepted by *Harper's Weekly* and *Outing* they became increasingly popular in the magazines of the eighties and nineties. The authors who were beginning to write of Western life were glad to have an illustrator familiar with the material. Remington illustrated Theodore Roosevelt's *Ranch Life and the Hunting Trail* and some sixty other books by various writers. His technique was strengthened by study at the Art Students' League. From pen and ink as a medium he progressed to black and white wash, then to black and white oils, and finally to oils in color. The cool reception given his first exhibition of oil paintings in 1892 discouraged him, and for about ten years he gave up painting and traveled. In the company of Poultney Bigelow he visited Russia, Germany, and North Africa, studies of Russian peasants and amusing sketches of European army officers resulting from his wanderings. In 1897 and 1898 he was in Cuba with Richard Harding Davis, sketching incidents of the Spanish-American War.

While he was out of tune with painting, he turned to modeling. He carried his illustrative technique over into the group of twenty-one small bronzes, his chief concern being to depict lively action with immense gusto but no attempt at subtleties of composition. The first and most popular of them was *The*

Bronco Buster, followed by *The Wounded Bunkie* and *The Fallen Rider*. *Cowboy up the "Pike"* and *Off the Range*, a troop of galloping cowboys shooting in the air, were shown enlarged at the Saint Louis Exposition. *The Mountain Man* is a trapper in fringed buckskins on a horse carefully picking its way down a steep grade, and there are a few of Indians and soldiers. His one large work in sculpture, a statue of a cowboy, has been erected in Fairmount Park, Philadelphia. In no way monumental, it is a forceful and accurate study in arrested action. *Polo*, a small group, gave him another chance to show the varied action of horses and men in a melee. Remington returned to painting after this unsettled period, working in more harmonious colors and giving a more sensitive impression of atmosphere. He was elected an associate of the National Academy of Design and a charter member of the National Institute of Arts and Letters. He wrote and illustrated thirteen books on Western life. On December 26th, 1909, he died at Ridgefield, Connecticut. At her death in 1918, his widow bequeathed a collection of his paintings, sketches, and bronzes to Ogdensburg, New York, where they are housed in The Remington Art Memorial. Another nearly complete collection of his bronzes is in The Metropolitan Museum of Art, New York. "His sculpture was essentially illustration in bronze with the accent on character and action, and it had the same excellence as his two-dimension illustrations." [1]

The Bronco Buster

A cowboy rides a bucking bronco. One foot is out of the stirrup, and the whip is raised as the horse rears, head down and back arched. The tension of horse and rider, their straining muscles and clashing wills are transmitted in crisp modeling. The cowboy's wrinkled shirt, flapping chaps, and wide-brimmed hat are vividly recorded. The idea of trying his hand at sculpture came to Remington when he watched Ruckstull working on an equestrian statue of General Hartranft near his home at New Rochelle. "Not long after that he bought a set of modeling tools, Ruckstuhl sent him a supply of modeler's wax, and he began his 'Bronco Buster.' It was characteristic of the man that his first attempt should be a subject difficult enough as a technical problem to have daunted a sculptor of experience and a master of technique." [2] This was in 1895, for in that year he wrote to Poultney Bigelow, ". . . when you Europeans get your eyes on my bronze you will say: 'Ah! there! America has got a winner.' It's the biggest thing I ever did, and if

1 Mahonri Young in the *Dictionary of American biography.* New York, 1935. v. 15, p. 497.
2 Thomas. p. 361.

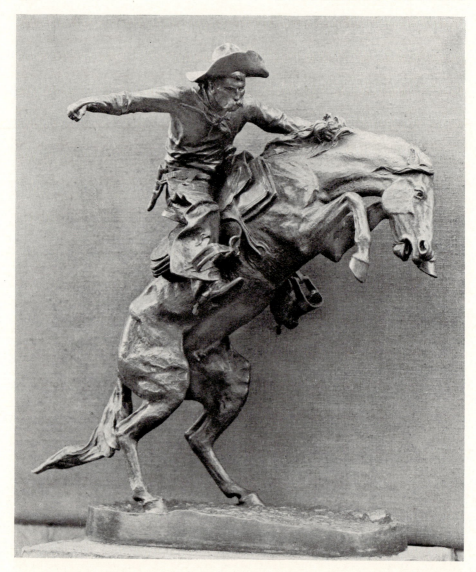

THE BRONCO BUSTER

Bronze equestrian statuette. Height 1 ft. 11½ in. Base: Length 1 ft. 3 in.—Width 7½ in. Signed on base at right: *Frederic Remington* Founder's mark: ROMAN BRONZE WORKS N.Y. Placed in Brookgreen Gardens in 1937. Other examples: Amherst College; New York. The Metropolitan Museum of Art (two versions); Ogdensburg, N.Y. The Remington Art Memorial (two versions); Oshkosh, Wis. Paine Art Center and Arboretum; Tulsa, Okla. Philbrook Art Museum (E. W. Marland Collection).

some of these rich sinners over here will cough up and buy a couple of dozen, I will go into the mud business." [3] First cast in 1895 and copyrighted on October first, the statuette was later considerably modified, some detail eliminated, the action improved, and the modeling made smoother. The example at Brookgreen is the revised version. It was immediately popular and went into a large edition of over 300 copies cast in two sizes; the Rough Riders chose it as a parting gift to Theodore Roosevelt when they were mustered out in 1898. There are slight differences in individual copies, for "He often made minor last-minute changes in the models, which accounts for the little variations that are frequently to be noticed in different casts of the same subject." [4]

Alexander Phimister Proctor

LIKE DALLIN a native of the West, Alexander Phimister Proctor has been one of its best interpreters. From the first his aim has been to make honest, direct transcripts of animals and people. Himself a man of action, characteristic action and lively motion have absorbed his attention. Born to Alexander and Tirza (Smith) Proctor at Bozanquit, Ontario, on September 27th, 1862, he spent the early part of his life at Denver, Colorado. Here he became an ardent hunter and student of the habits of wild animals, sketching them in the Rocky Mountains. In 1887 his formal art training began in New York with classes at the National Academy of Design and the Art Students' League. By 1891 he was modeling small bronzes of animals arrested in some typical movement. He was less interested in the forms themselves than in what they betrayed of the nature and habits of the creature. His vivid impressions of the lean, nervous shapes of the stalking panther called *Fate*, the timid *Fawn*, and the *Dog and Bone* were rapidly sketched. His long familiarity with wild life and his thorough comprehension of animal forms enabled him to give his creations vitality as well as to present their bodily structure with accuracy. The Columbian Exposition gave him a chance to produce spirited equestrian statues of a cowboy and an Indian. When that was over, he had a period of study at Paris with Puech and Injalbert and then returned to New York,

3 Bigelow. p. 48.

4 Remington, Preston. *The bequest of Jacob Ruppert: sculpture.* In New York. Metropolitan museum of art. *Bulletin.* July 1939. v. 34, p. 170.

where he was employed by other sculptors, in particular by Saint-Gaudens to work on the horse for the Logan Monument.

Proctor shared with MacNeil the first award of the Rinehart Scholarship and spent the four years from 1896 to 1899 at Paris, working at Julian's and Colarossi's academies to perfect his technique. The *Salon* jury of 1898 accepted his spirited and romantic *Indian Warrior* on a restless horse. Groups of his bronzes won gold medals at the Paris Exposition of 1900, where he made the quadriga for the United States pavilion, and at the Saint Louis Exposition.[1] A pair of panthers mounted on gateposts at Prospect Park, Brooklyn, was the first in the series of animal statues designed for entrances. The lifted heads and tense forms give them an architectural as well as a dramatic quality. The same ability to make animals monumental without losing any of their reality is shown in the lions of the McKinley Monument at Buffalo, dedicated in 1907, and the pair of couchant tigers for Nassau Hall, Princeton University, which won a medal of honor for sculpture at the Architectural League exhibition in 1911. The charging bison placed on the Q Street Bridge, Washington, D.C., are in a livelier manner.

After his return from Paris he had taken a studio at New York, but in 1914 he again journeyed westward, living in Oregon, Idaho, and California. For Western states he executed a series of monuments which commemorate types and heroes of an early day. In Oregon, where he lived for a time at Pendleton, were erected between 1919 and 1922 *The Circuit Rider*, on horseback studying a Bible, at Salem; the buckskin-clad *Pioneer* at the University of Oregon; and *Theodore Roosevelt as a Rough Rider* at Portland. At a later date an equestrian statue of Sheriff "Til" Taylor was modeled for Pendleton. Two more equestrian statues, the Indian, *On the Warpath*, and *The Buckaroo* were placed in Denver Civic Center. In large groups where several horses and people are brought together he subdued his realistic vigor to a calmer tone, more in accord with the simplifying trend of the next generation. The basic soundness of structure is still there, but the contours are smoothed to a more even flow, and the movement is orderly and sustained. The equestrian group, *The Pioneer Mother*, is at Kansas City, the Robert E. Lee Memorial, showing the general on horseback accompanied by a young soldier, at Dallas, Texas, and a group of seven mustangs at the University of Texas.

From 1925 to 1927 Proctor was artist in residence at the American Academy in Rome, and the following year he spent at Brussels. He then came

1 Some of his small bronzes are in the Brooklyn Museum; the Los Angeles Museum of Art (on loan); The Metropolitan Museum of Art, New York; The National Gallery of Canada, Ottawa; and the City Art Museum, Saint Louis.

back to New York and a country home at Wilton, Connecticut. After 1936 his travels took him to the state of Washington, to Texas, and Alaska. He spent his last years at Palo Alto, California, where he died on September 4th, 1950. He was a fellow of the National Sculpture Society, and a member of the National Academy of Design and the National Institute of Arts and Letters.

Trumpeting Elephant

An elephant strides forward, head raised trumpeting. His trunk is lifted and his tail switching. In spite of loose skin and ungainly motion, realistically copied, there is a strong impression of power.

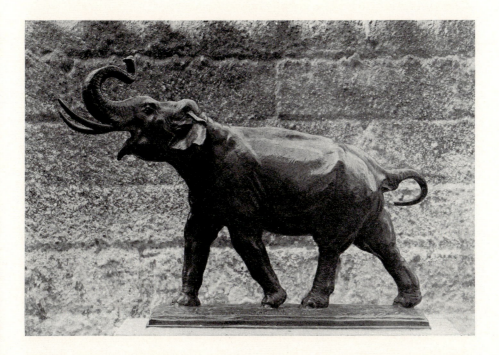

TRUMPETING ELEPHANT

Bronze statuette. Height 10½ in. Base: Length 11 in.—Width 3½ in. Signed on base: COPYRT · 08 · A. PHIMISTER PROCTOR. Founder's mark: GORHAM CO. FOUNDERS OUS Placed in Brookgreen Gardens in 1936.

Pursued

An Indian on a horse galloping with all four feet bunched, head stretched forward and tail flying in the speed of flight, turns to look behind him. A tomahawk is gripped in his hand, and a quiver is slung at his back. The group is freely modeled.

Bronze equestrian statuette. Height 1 ft. 4½ in. Base: Length 10¼ in.—Width 5 in. Signed on base at back: A PHIMISTER PROCTOR At right end: © 1915 AND 1928 Founder's mark: GZZ GORHAM CO. Placed in Brookgreen Gardens in 1934.

Hermon Atkins MacNeil

AMONG THE FIRST of the men who turned to the American scene for sculptural subjects, finding their most obvious source of inspiration in the life of the Indian, was Hermon Atkins MacNeil. This new orientation was fostered by the World's Fair at Chicago, where the sculptor-decorators were called upon to extol the pageant of their own country. MacNeil was born at Chelsea, Massachusetts, on February 27th, 1866, the son of John Clinton and Mary (Lash) MacNeil. He began his studies at the Massachusetts Normal Art School, Boston, and after teaching at Cornell University for three years, continued them at Paris in 1888, with Chapu at the Académie Julian and with Falguière at the École des Beaux-Arts. Upon his return to the United States he worked with Martiny for the Columbian Exposition, settled at Chicago, and taught at the Art Institute.

His interest in the American Indian began at Chicago with a Sioux from Buffalo Bill's Wild West Show whom he used as a model, and he made a trip to the Southwest to study the Indians in their natural surroundings. These studies bore fruit when with A. Phimister Proctor he received the first award of the Rinehart Scholarship and spent the four years from 1896 to 1899 at Rome. The results of those years were *Out from Chaos came the Dawn*, *The Moqui Prayer for Rain*, *A Primitive Chant*, and *The Sun Vow*. He drew upon Indian folklore for his dramatic subjects, treated in the colorful, slightly impressionistic manner, with warm surfaces, softly merging planes, and pleasing variations of texture, which he had learned at Paris. In the United States again, he won a gold medal at the Buffalo Exposition, and the two Indian figures of *The Coming of the White Man* for Portland, Oregon,

sustained the reputation established at Rome. The Saint Louis and San Francisco expositions required his services; an elaborate fountain was his share at the Louisiana Purchase and *The Adventurous Bowman*, a spirited figure atop a column, at the Panama-Pacific.

The demand for architectural sculpture and memorials gradually crowded out his first choice of subject matter. This kind of work required a more formal handling, but he continued to enliven it with vivid touches. The realism of his portrait statues is tempered by a romantic conception and picturesque use of detail. One of the earliest was the McKinley Memorial at Columbus, Ohio, placed in 1907, an exedra with a bronze portrait statue at the middle and symbolic groups at the ends. Later he made several statues for the Capitol, Hartford, Connecticut, *Ezra Cornell* for Cornell University, and *Lincoln the Lawyer*. In war memorials for Albany, Flushing, and Whitinsville, Massachusetts, he used the semi-classic symbolic figures already traditional in American sculpture through the influence of Saint-Gaudens and French, placing them against backgrounds in low relief. His architectural sculpture conformed to the prevailing neo-Renaissance mode in the panels for the façade of the City Art Museum, Saint Louis; the relief of *Washington as Commander-in-Chief* on the Washington Arch, New York, was organized into a more regular scheme; while the frieze for the Missouri State Capitol returned to American Renaissance canons. For this prolific and varied work The Architectural League of New York in 1917 awarded him a medal of honor, one which he had designed, and in 1919 and 1920 he returned to the American Academy in Rome as visiting professor.

Other work gave him a chance to use his flair for expressive action. On the pylons of the Soldiers' and Sailors' Memorial at Philadelphia he carved battle scenes below allegorical panels in low relief, and for the Père Marquette Memorial at Chicago he grouped a missionary, an explorer, and an Indian in a vigorous composition. During the decade of the thirties the sculptor was busy with a number of important commissions. The emphasis is on the narrative in the relief, *The Pilgrim Fathers*, for Waterbury, Connecticut, with its central patriarch standing out from a crowd and the ships' sails in the background. The statue for the George Rogers Clark Memorial at Vincennes, Indiana, is a handsome figure done with gusto. The Monument to the Confederate Defenders of Fort Sumter at Charleston, South Carolina, has two figures in a modified classic style, and the classic manner again predominates in the formal arrangement of the east pediment of the Supreme Court Building, Washington, D.C., the decorative elements kept in exact balance, while the rich modeling of the individual figures enlivens the strict measure of the design.

MacNeil's career as a medalist began with Indian subjects on a medal for

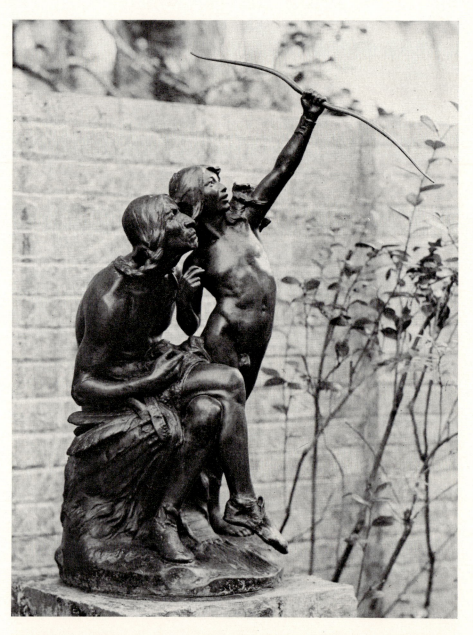

THE SUN VOW

Reduction of a bronze group. Height 3 ft. Signed at back: *H A MacNeill* [*sic*] On base at right: THE SVN VOW. Founder's mark: ROMAN BRONZE WORKS N-Y- Placed in Brookgreen Gardens in 1934. Other examples: The Baltimore Museum of Art (original plaster model); Chicago. Art Institute (first casting); Hartford. Wadsworth Atheneum; Montclair Art Museum (second casting); New York. The Metropolitan Museum of Art; Norfolk, Va. Museum of Arts and Sciences; Pittsburgh. Carnegie Institute; Reading, Pa. Public Museum and Art Gallery; Saint Louis. City Art Museum; Washington, D.C. The Corcoran Gallery of Art (third casting).

the Pan-American Exposition in 1901, and in 1916 he received the commission to design the United States quarter dollar. It is interesting to note that in the 1931 issue of the Society of Medalists, for whose medals each artist seems to choose the theme nearest his heart, he returned to an Indian subject of his Roman days, incorporating the Moqui snake dancer into a composition called the *Prayer for Rain.*

MacNeil died on October 2nd, 1947. Because his studio had for many years been at College Point, Long Island, in 1966 a park there was renamed MacNeil Park in his honor. He had been president of the National Sculpture Society, and a member of The Architectural League of New York, the National Academy of Design, and The American Academy of Arts and Letters.

The Sun Vow

An old Indian is seated on a skin thrown over a rock, watching the flight of an arrow which a boy standing by his side has just loosed from a bow aimed upward. A feather headdress lies on the old Indian's knees. This ceremony was in use among the Sioux for testing the prowess of their young men. If the youth, aiming directly at the sun, shot straight and far enough so that his arrow was lost from sight, he qualified as a warrior. This group was developed by MacNeil in 1899 during his stay at Rome from a sketch which he had made at Chicago. Although Indian subjects were at the height of their popularity, it stood out from among the others because of its romantic theme and colorful modeling, the pictorial use of detail adding variety of texture without detracting from the unity of the composition.[1]

Into the Unknown

A winged female figure is seated sidewise on a classic capital, sheltered in the sweep of her wings, her face turned inward into the block as she holds a chisel against the marble with her left hand. Her left knee is raised and her right foot braced under the angle volute of the capital. A piece of drapery falls over her left shoulder and between her thighs.

1 The group is discussed by Lorado Taft (*The history of American sculpture.* p. 443–444), Florence Finch Kelly (p. 554), and Gardner (New York. The Metropolitan museum of art. *American sculpture.* p. 96).

This figure, symbolizing the mystery of artistic creation, was exhibited at the National Academy of Design in 1912 under the title *Inspiration*. A design based on it was adopted as an emblem of the National Sculpture Society at the time of their 1923 exhibition.

White marble statue. Height 5 ft. 1½ in. Base: Width 3 ft. 5 in.—Depth 2 ft. 6½ in. Signed on mallet: H A MAC NEIL On base at front: INTO THE VNKNOWN Placed in Brookgreen Gardens in 1948.

Solon Hannibal Borglum

DIFFERING FROM the men who looked at life on the plains with dispassionate eye and gave an objective view of its outward forms, it remained for Solon Hannibal Borglum, progressing from studies of horses and riders in action, to attempt to give a more profound interpretation of the West. He was born at Ogden, Utah, on December 22nd, 1868. His father and mother, James de la Mothe and Ida (Michelson) Borglum, were Danes who had come to this country only a few years before. After a year on a ranch in California at the age of fifteen, Solon was placed in charge of a ranch owned by his father in western Nebraska. After he had been drawing horses on wrapping paper, his brother Gutzon, who had already become an artist, visited him in 1894 and suggested that he follow the same career. Learning some of the fundamentals from his brother, he spent a few months on a ranch at Santa Ana painting a portrait and then hired a room for a studio. Painting portraits and giving lessons in painting supported him for nearly a year, until he felt the need of more systematic instruction.

With the help of his brother he went to Cincinnati in 1895 and entered the Art Academy to study drawing. His unabated love for horses led him to seek out the United States Mail stables, where he was allowed to draw and model. A group which he showed to Rebisso won his interest and, later, a prize. On a small scholarship Borglum went to Paris, studied for a few months with Puech at the Académie Julian, and had criticisms and encouragement from Frémiet. Borglum was now entirely given over to sculpture and found a stable where he could use the horses as models. The group in violent action, *Lassoing Wild Horses*, and a horse in the wind called *Winter* were accepted for the *Salon* in 1898.[1] Horses continued for some years to be his prime source

1 An example of the former is at The Detroit Institute of Arts, of the latter in The Cincinnati Art Museum.

of inspiration. His life-sized *Stampede of Wild Horses*, the plaster of which is in The Cincinnati Art Museum, and *The Lame Horse* won him honorable mention at the *Salon* of 1899. Even in certain early works such as the *Rough Rider*, he tried to make his composition more compact by turning the horse's body in rhythm with the rider's movement.

In 1899 he revisited Western scenes, spending the summer on Crow Creek Reservation. The results of this sojourn, *On the Border of the White Man's Land* and *Burial on the Plains*, show a less literal dependence on his intimate knowledge of animals and the desire to add to the superficial likeness a deeper meaning. There appear the close-knit composition and the impressionistic swirling surfaces which are typical of his most personal work. He often chose a setting in snow or storm in order to take advantage of the blurred outlines and the sweep of the wind over huddled forms, as in *The Blizzard, Snowdrift*, both of which are at The Detroit Institute of Arts, and *The Last Round-Up*. Later works in a similar vein are *Washington: 1753*,[2] and *The Command of God to Retreat*, Napoleon retreating from Moscow. The increasing lack of definition in modeling may be a token of the prevalent enthusiasm for Rodin. Borglum's work won silver medals at the Paris Exposition in 1900 and at the Buffalo Exposition in the following year, a gold medal at Saint Louis.

With his fellow sculptors he was drawn into the sculptural decorations of the exposition grounds at Saint Louis and at San Francisco. In 1907 two equestrian monuments by him were unveiled, one to General John B. Gordon at Atlanta, Georgia, and the other to Captain "Bucky" O'Neill of the Rough Riders at Prescott, Arizona. Five colossal busts of Civil War generals were made for Vicksburg National Park, Mississippi, and a picturesque figure of Jacob Leisler in broad-brimmed hat and wind-swept cloak for New Rochelle, New York. Neither these nor the mysterious hooded figure called *The Spirit of Death* for the Schieren Memorial, Green-Wood Cemetery, added to his artistic stature. After a few years in New York he had moved his home and studio to "Rocky Ranch," Silvermine, Connecticut, where he could live a country life not too far from the city. During the World War Borglum served as a Y.M.C.A. secretary in France, was gassed, and awarded the *Croix de Guerre* by the French Government for bravery under fire. He was in charge of the department of sculpture in the A.E.F. educational system. On his return to New York he founded the School of American Sculpture, basing the teaching on his study of comparative plant and animal forms, *Sound Construction*. His death occurred at Stamford, Connecticut, on January 31st, 1922. Among his last works were three for Saint Mark's-in-the-Bouwerie,

2 There are examples in The National Gallery of Canada, Ottawa, and at the Iowa Memorial Union, University of Iowa.

New York, two figures of Indian chiefs conceived as *Inspiration* and *Aspiration*, left unfinished at his death, and a fountain figure, *Little Lady of the Dew*. He was an associate of the National Academy of Design and a member of the National Sculpture Society.

On the Border of the White Man's Land

An Indian has crawled to the edge of a cliff to spy from beneath his horse, sheltered by its lowered head. He lies on the ground wrapped in a blanket, his left hand clutching a gun. The horse's tail, to which an eagle's feather is tied, is blown between its legs, completing the curve made by the bent neck and the Indian's half-raised body. The sculptor has concentrated attention on the compact massing of the bodies of horse and man and the impression of tense

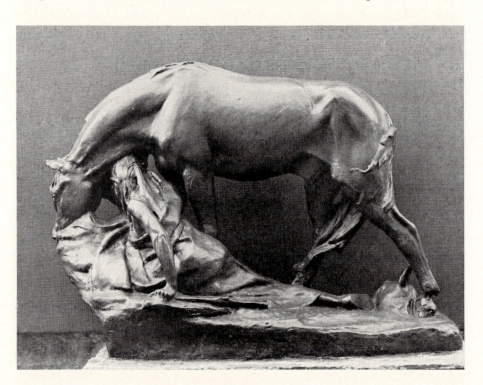

ON THE BORDER OF THE WHITE MAN'S LAND

Bronze group. Height 1 ft. 7 in. Base: Length 1 ft. 11¼ in.—Width 9¼ in. Signed on base at back: Solon Borglum On base at front: On The Border of The White Man's Land Founder's mark: GORHAM CO. FOUNDERS GRC OAVH Placed in Brookgreen Gardens in 1943. Other example: New York. The Metropolitan Museum of Art.

watchfulness, modeling the forms broadly without exact detail. This work is one of several themes developed from observations made during a summer on Crow Creek Reservation, South Dakota, in 1899. A study called *The Scout* that preceded it was modeled from Black Eagle, one of General Custer's scouts employed to search out hostile Indians. The committee choosing works to be shown at the Paris Universal Exposition in 1900 were so impressed by *On the Border of the White Man's Land*, even in an unfinished state, that they waived the entrance date and placed it after the exhibition was in progress; it won a silver medal for the sculptor.

Fighting Bulls

A domestic and a wild bull press against each other with locked horns, their forequarters close to the ground, their hind legs braced, and their bodies arched with the effort. This group is a study of action in Borglum's earlier, more realistic manner. It was exhibited at the Louisiana Purchase Exposition.

Bronze group. Height 4¼ in. Base: Length 1 ft. 8¼ in.—Width 2¼ in. Signed on base at right: *Sol. H. Borglum* © *1900*. Founder's mark: AMER. ART F'DRY. N.Y. Placed in Brookgreen Gardens in 1937. Other example: New York. The Metropolitan Museum of Art.

Paul Troubetzkoy

PAUL TROUBETZKOY was born at Intra, Lago Maggiore, on February 16th, 1866, the son of a Russian prince and an American woman, Pierre and Ada (Winans) Troubetzkoy. From his boyhood he chose sculpture as a vocation, and after a few lessons in both painting and sculpture, impatient of conventional methods, began to work independently at Milan, recording his own observations in his own manner. Painting would have been his choice of a profession, had his brother Pierre not already pre-empted that field, and his sculpture kept a painterlike quality, concerned rather with action, temperament, and the play of light than with the shapes of things. It was to animal sculpture that he first turned, and a work shown at the Brera in 1886 was a study of a horse. *The Indian Scout*, exhibited at Rome in 1894, won him recognition and a gold medal.

Troubetzkoy soon widened his field by producing animated, spontaneous

portrait busts and statuettes. The bust of the painter Segantini, dating from 1895, has the baroque virtuosity of a Boldini painting. Beginning in 1893 a series of full-length figures, a statuette of Madame Horneimer unites the charm of gracile form and ornate frills. It establishes a style from which the sculptor made few departures. His statuettes are like snapshots rather than finished portraits, for he wanted to preserve in the bronze the essential nature of his people and chose unguarded moments to catch the instantaneous flash of personality. The head and arms are often delicately modeled, but the clothed figure, sketched with rapid, rough-edged strokes in the clay, has little definite form, only the shimmer of broken light, suggesting color, texture, and movement. The pictorial point of view occasionally betrayed him into such *genre* scenes as *The Milanese Fiacre in the Snow*.

In 1897 he went to Russia and established himself at Moscow, where his portrait studies had a great vogue among the Russian nobility, for while his humanitarian theories urged him towards the unstudied pose, his aristocratic discrimination gave elegance and distinction to all he touched. It was his tenderness for humanity which led him to dwell on the warm intimacy of parents and children and the simple affection of children and animals. His vegetarianism prompted a few didactic works, *How Can You Eat Me?* and *Ghouls*. Several busts and equestrian statuettes were the result of his friendship with Tolstoy, whom he visited on his estate. Troubetzkoy's anti-academic creed, which caused him to leave his students to their own devices, made his term as professor at the Moscow Art Academy brief. The novelty of his impressionistic technique, with its disregard for detail and surface finish, with its breaking up of the planes for the sake of coloristic effects, had caused the failure of several models offered in competition for monuments, only one, to Senator Cadorna for Pallanza, having been accepted. In 1901 he received the contract for an equestrian statue of Czar Alexander the Third, which was dedicated at Leningrad in 1909. It was a demonstration that the sculptor's ability was not limited to work on a small scale, but that he could compose in the large and dispense with vividness and action in exchange for solidity and power.

The group of works shown at the Paris Exposition in 1900 received a grand prize and won him critical appreciation in France, so that in 1904 he transferred his studio to Paris and thereafter made it his headquarters. His instinct for character had full play in portrait statuettes of the world of art, letters, and fashion, since many notables, including Rodin and Anatole France, sat for him. There were trips to London, where he modeled a bust of Bernard Shaw, and to Stockholm, where he and Zorn exchanged portraits. In 1911, when an exhibition of his work was held at New York by The American Numismatic Society, the sculptor visited America and returned to stay

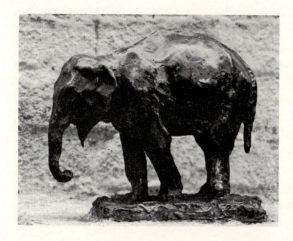

ELEPHANT

Bronze statuette. Height 7¾ in. Base: Length 7 in.—Width 4¾ in. Signed on base at back: *Paul Troubetzkoi 1889* Founder's mark: C. VALSUANI Cire Perdue

Placed in Brookgreen Gardens in 1934.

from 1914 to 1920. He spent some time in California and made lively statuettes of cowboys on bucking broncos. He also received the commission for a monument to General Otis at Los Angeles, erected in 1920, and for one to Dante at San Francisco. There are works by him in several American museums, statuettes of the Spanish painter Sorolla and of the dancer La Argentina being in the collection of The Hispanic Society of America at New York. The later years of his life were divided between Paris and a villa at Lago Maggiore. Two more monuments were erected in Italy, a statue of Puccini at La Scala, Milan, and a war memorial at Pallanza. He died at Suna, Lago Maggiore, on February 12th, 1938.

Elephant

An elephant without tusks is standing quietly, one forefoot behind the other, back humped and trunk lowered. The date shows that this work was done while Troubetzkoy was living at Milan.

Bessie Potter Vonnoh

BORN AT Saint Louis, Missouri, on August 17th, 1872, the daughter of Alexander C. and Mary (McKenney) Potter, Bessie Onahotema Potter studied with Lorado Taft at The Art Institute of Chicago and was one of his assistants on the decorations for the Columbian Exposition in 1893. It was there that she saw the portrait statuettes of Paul Troubetzkoy which inspired her to develop a similar *genre*. From studies of young women, the puffed

sleeves and full skirts of the costumes lending themselves to pictorial composi-
tions, she progressed to a somewhat broader range of subjects, although her
field remained limited to the fragile charm of girls and the tender sentiment of
mothers and children. By 1898 some of her most characteristic works, *The
Dance*,[1] *Girl Reading*, and *A Young Mother*[2] had made their appearance.
There were periods of travel abroad, a few months at Paris in 1895 and at
Florence in 1897, but no study with European masters. A heroic bust of
Major General Crawford was ordered from her for the Smith Memorial,
Fairmount Park, Philadelphia. On September 17th, 1899, she married the
painter Robert Vonnoh and thereafter made her home in New York. A group
of a mother and children, *Enthroned*,[3] won the Shaw Prize of the National
Academy of Design in 1904. Her work became more and more popular until in
1913 the Brooklyn Museum invited her to exhibit there.

Mrs. Vonnoh abandoned modern costume in favor of classic draperies in
some of her work, the *Girl with Garland*, *Beatrix*, *An Ideal*, and others. She
also began to model the nude, as in the three dancing girls called *L'Allégresse*
at The Detroit Institute of Arts, which was awarded the Watrous Gold Medal
of the National Academy of Design in 1921, and gave increased attention to
this side of her art, choosing only girls for her subjects. In the gentle spirit
which animates her work there is some kinship to Herbert Adams, though the
daintiness of treatment and lightness of touch are peculiarly her own.

From the statuette she advanced to life-sized statues. A bird fountain, first
of several, was made for Ormond Beach Park, Florida. The bird bath for the
Roosevelt Bird Sanctuary at Oyster Bay, Long Island, which dates from
1925, is composed of two children, the girl holding above her head a bowl
towards which birds and animals creep. In this and the group of children for
the fountain erected to the memory of Frances Hodgson Burnett in Central
Park in 1937 there is an anecdotal tendency which appeared in earlier
statuettes such as the girl and butterfly of *A Chance Acquaintance* and the
basin with a girl and turtle called *The Intruder*. She exhibited *Sea Sprite*, a
fountain study of a little girl riding on a fish, at San Francisco in 1929 and in
1931 made for Dr. Cole at Tarrytown a portrait group of three children
placed on a wall above a pool. After her husband's death in 1933, Mrs.
Vonnoh married Dr. Edward L. Keyes, a noted urologist. She survived him

1 Examples are owned by Brooklyn Museum, The Art Institute of Chicago, The Amer-
ican Academy of Arts and Letters and The Metropolitan Museum of Art at New York,
The Newark Museum, Carnegie Institute at Pittsburgh, and Rochester Athenæum.

2 Brooklyn Museum, The Art Institute of Chicago, The Montclair Art Museum, The
Metropolitan Museum of Art, and the Fine Arts Gallery, San Diego, own examples.

3 There are examples in the Brooklyn Museum, The Metropolitan Museum of Art,
and The Corcoran Gallery of Art, Washington, D.C.

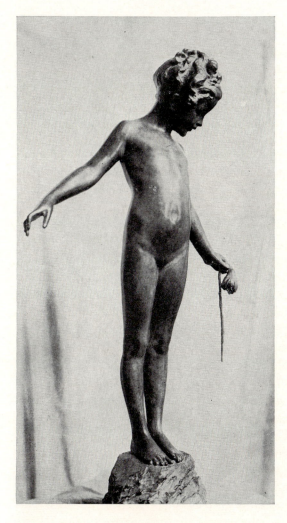

WATER LILIES

Bronze statuette. Height 2 ft. 5¼
in. Signed on base at back: *Bessie
Potter Vonnoh*
Placed in Brookgreen Gardens in
1934.

six years and died on March 8th, 1955. She was a fellow of the National
Sculpture Society, and a member of the National Academy of Design and the
National Institute of Arts and Letters.

Water Lilies

A girl stands on a rock, looking down at a water lily drooping from her
hand. The hair is in a mass of loose curls on top of the head. Surfaces are
impressionistically blended so that details are indistinctly seen, as if through a
veil. This statuette, intended for a lily pool, was first exhibited in 1913 and
awarded the National Arts Club Prize of the National Association of Women
Painters and Sculptors in 1920.

Henry Clews, Junior

HENRY CLEWS, JUNIOR, was a phenomenon in the history of American sculpture, taking a course entirely divergent from that of his compatriots. His father came from England as a young man, founded his own brokerage firm, and rose to an influential position in the world of finance. His mother was Lucy Madison (Worthington) Clews of Kentucky, and through her he inherited the romantic and artistic tendencies that finally determined his career. There was also an artistic strain in his father's family, since his grandfather, James Clews, had been a Staffordshire potter. Henry Clews, Junior, was born in New York on April 23rd, 1876. After an education in private schools and at Amherst College, where he graduated in 1898, he pursued his studies further at Columbia University and abroad at the Universities of Lausanne and Hannover. Upon his return to New York he entered his father's firm and tried unsuccessfully to adapt himself to a business career.

His acute sensitivity brought about strong emotional responses to both the humor and the bitterness of life. In an effort to crystallize and put these emotions in concrete form, he turned to painting and took a small studio on East Nineteenth Street in which, without benefit of art school or the guidance of other artists, he developed his own technique. By 1907 he began to exhibit his paintings, a preference for black and tones of gray and for shadowy backgrounds betraying his admiration for the aesthetics of Whistler.

An instinctive sense of form, unsatisfied by painting, led him to try his hand at sculpture. Still working quite alone, in a Montmartre studio at Paris he produced enough pieces to show at New York in 1909. They were small heads in marble and bronze, some of them studies of types rather than true portraits. Governed by a desire for the expression of character and mood, he used in these early works a sketchy technique and fluent, impressionistic modeling. The source of this style, the omnipresent influence of Rodin, whose studio he often visited, was almost inescapable at this period. The Rodin vein is also obvious in a tendency to allegory, a group by Clews, *The Blind*, being a study of both physical and spiritual blindness.

In portrait busts, beneath the freely handled surfaces, Clews kept a sure feeling for mass and for the true shapes of skulls. The head of a rugged fisherman called *Portrait of Sam* in the Whitney Museum of American Art, modeled at Newport in 1911, already shows virtuosity in the way in which the clay has been manipulated—put on in long, free strokes, the

direction shaping the desired form, piled on roughly for cheekbones or pushed in for hollows. The sculptor's appreciation of the regular, delicate features of the composer, Frederick Delius, has resulted in a work of great beauty and harmony, limited to a mask, in the Metropolitan Museum, New York.

Clews's art, intellectual in its origins, was almost from the beginning a criticism of the society within which it was produced. He took issue with the faults and foibles of his contemporaries and came off bruised in the encounter. In his last exhibitions at New York, in 1913 and 1914, caricatures of ugly types and personifications of bizarre qualities were frequent, given titles like *Rough Diamond Hypocrisy* and *Imp of Preciosity*. A series of so-called deities, exemplified by *The God of Spiders* and *The God of Flies*, consisted of imaginary heads with characteristics exaggerated to point up special evils. In these heads Clews's expressive modeling was particularly effective, for with the tilt of a nose or the lift of an eyebrow he could quickly call attention to a salient trait.

This mordant satire and his striking exaggerations failed to please the critics, while the prefaces he wrote for his catalogues voicing his displeasure with contemporary art and his aim towards a better form, stated in words of his own invention, confused and irritated them. Although his ability was admitted, appreciation was submerged in annoyed attacks on his point of view. Clews replied with vitriolic comments on the obtuseness of his critics, satirizing them in *The Blind*, and the breach between the sculptor and his public widened until in disgust he decided to live in France permanently.

As the climax to this first phase of Clews's work came *The God of Humormystics*, a life-size bronze statue exhibited at New York in 1916 and later placed in the courtyard at La Napoule. In protest against a materialistic civilization founded on the cold facts of science, it calls attention to intangible sources of inspiration such as those carved over a window near by: myth, mystery, mirth.

Parallel to Clews's disillusioned comments on human frailty ran a vein of idealism and devotion to pure beauty. Its best expression is the bust called *The Virgin of the Mancha*. A portrait of his second wife shows the same sensitive response to beauty and the ability to capture and preserve it.

During the First World War Clews stayed in Paris. In these terrible years his experience of suffering humanity and his disgust with those who made capital of war and its victims so distressed his spirit that he decided to find a quieter atmosphere in which to live. In 1918 he bought the château at La Napoule on the Bay of Cannes and set out to create within it a retreat in harmony with his own temperament. He and his wife rebuilt the towers and replaced the modern house by one more in keeping with the older structure. He carved in the stones the denizens of an imaginary world, symbolizing or

satirizing the one that he had put behind him, and embodying in this micro-
cosm his vision of the universe and of humanity.

In designing sculpture for architectural use, Clews faced a new problem, to
which the methods he had previously used were ill adapted. To find a more
concise means of expression with clearer definition of outlines and planes, he
turned to earlier masters of the art. The main arched doorway could at first
glance be mistaken for a Romanesque portal, so fresh is the imaginative
verve, so sure the instinct for decorative values. The sculptor has selected
different parts of animals, birds, fishes, and reptiles and ingeniously recom-
bined them. Pouchy froglike bodies are endowed with fierce beaks, owlish
eyes, ribbed fins, and no end of textured passages suggested by fur, feathers,
skin, or scales. The capitals of a cloister around the courtyard were carved
with similar grotesque creatures set back to back, made up of large heads on
rounded bodies, feathered and winged. Birdlike shapes bent into scrolls,
rotund fish, complacent owls, fantail pigeons, and many other natural forms
were abstracted and conventionalized to decorate corbels, overdoors, basins,
and urns.

At the same time that Clews was building into the château the creatures of
his imagination, he was carving separate figures and groups that enlarged
upon similar themes. *The Family*, done in 1922, gives the sculptor's idea of
prehistoric man, woman, and child, with as yet undeveloped bodies and
unawakened intelligence. Fabulous creatures embody specific traits. The hip-
po-headed *Casino-Crat*, sheathed in feathers cascading into a train, suggests a
pompous society matron, and *The Cat-Woman*, inspired by a Baudelaire
poem, emphasizes destructive feminine vices with her feline head and menac-
ing talons. Like medieval carvers Clews set up a mirror of nature, giving
back like an imperfect glass a distorted vision of life but at the same time
throwing highlights on rare beauties. He shared with them delight both in the
marvelous and in the wonders of the visible world, representing insects and
crustaceans with as much zest as larger animals.

The work done at La Napoule is a complete departure in technique from
Clews's earlier manner. Compact compositions, stylized forms, and emphasis
on decorative details are new qualities. The materials now preferred by the
sculptor influenced his methods. Choice of a hard stone like porphyry made
simplified forms essential, while verd antique and gray bardiglio marble,
beige limestone, and strongly grained walnut invited decorative treatment to
bring out their inherent beauty. The original shapes of his grotesque,
round-bellied statuettes showed fondness for ovoid and bulbous forms like
Chinese gourd or pyriform vases with elongated necks.

The key to interpreting the symbolism in Clews's sculpture is conveniently
at hand. First stated in the catalogues of his exhibitions, his views and preju-

dices were aired at length in the satirical play *Mumbo Jumbo* and its lengthy
introduction, written at La Napoule in 1922. In it he expressed his distaste
for the shallow commercialism of American culture as he saw it, with its
accompanying charlatanism in art, and laid them both to what were to his
mind the basic evils—democracy, science and technology destroying hand-
crafts, and irreligion.

With the completion of the château and its ornamentation Clews exhausted
his satirical decorative vein and returned to portrait sculpture. For this last
series of works he marshalled all the insight and expert technique acquired
during his productive career. From 1933 to 1935 he modeled, for casting in
bronze, heads of friends whose personalities interested him: the Mayor of
Mandelieu, Count Gautier-Vignal, and Martin de Selincourt among others.
They are powerfully modeled, facial characteristics and features rendered
with skill and discrimination. One of the sculptor's subjects, the art critic
Pierre Borel, described the impression made upon him by the sculptor:

"He was witty, subtle, sparkling and, as concerned a simpleton or a fool,
capable of bitter irony. Never shall I forget that face molded by meditation,
the overlarge towering forehead under bristling hair lifted by the wind of the
spirit, and his glance, one of the clearest and most intelligent that ever fell
upon me." [1]

After a long illness the sculptor died at Lausanne on July 28th, 1937, and
received burial in a tower of the château built by him. Although the building
was somewhat damaged during the Second World War, Mrs. Clews removed
and hid the carved capitals of the cloister. She later replaced them and
established the La Napoule Art Foundation, Henry Clews Memorial, inaugu-
rated in 1951 and incorporated under the Regents of the University of the
State of New York, for the development of cultural relations between France
and the United States. The majority of Clews's work can still be seen in its
proper setting, created by him at La Napoule.

The Thinker

The thinker is represented as an aged man, his flesh wasted away in the
lifelong search for truth. Over the gnarled skeleton the muscles are stretched
in taut cords under sagging skin. He is tense with effort—the body drawn
together, breath sucked in, shoulders hunched. One leg is twined around the
other with the toes clenched. One hand is pressed flat against the thigh, the
other slightly extended with fingers pinched together as if seizing a tenuous

1 Borel. p. 12, *tr.*

idea. The sex organs are replaced by a skull to indicate that all the life force
has been sent to the brain. The head is tremendously developed at the back,
with naked, bulging forehead, furrowed cheeks, and narrow chin ending in a
straggly beard; one eye is open to the external world, the other closed for
concentration on the inner life. The skull is crowned by a peacock with spread
tail, emblem of the vanity of knowledge, with the owl of wisdom at the back.
All the resources of the sculptor's remarkable skill in modeling have been
gathered together for this tour de force. With superb mastery, every detail of
the withered body has been brought to life to impress upon the beholder the
ravages of continuous mental striving. The thinker stands on a volume of
Mother Goose, representing the legends and folklore of mankind, the store-
house from which his thoughts are drawn. Below the book is the generous
form of Mother Nature, the source of life. She is crouched in a mound,
hatching her innumerable brood, her Oriental face bland and inscrutable.
Spread on her back is a bat, the imp of perversity, an emblem of evil.

On the base that he created for this statue, Clews epitomized his conception
of the forces by which the thinking person has evolved and the varieties of
civilization that have led up to his existence. Each face of the tall rectangular
shaft is occupied by a grotesque Humpty-Dumpty-like creature with a small
head on a swelling paunch propped up on thin legs. All four creatures have,
like the thinker above, one eye closed and one open. The creature at the front
is a marabou resting on one leg, symbolizing meditation. Perhaps it repre-
sents the false philosopher, wearing the appearance of learning over shallow-
ness of thought. On the left side is an old woman with legs crossed and hands
folded beneath the rotund belly. A decoration is hung from a ribbon across
one shoulder, for she represents the war profiteer who has won honors
through the deaths of others. The figure at the back is an ugly man with
hands piously crossed on his breast and left leg doubled up. He is the
hypocrite who while preaching peace promotes war for his own advantage.
The man on the right side, with only one leg, supports himself on crutches. A
wrinkled face with a lank beard is topped by a liberty cap. He is the crippled
victim of the wars promoted by the other two.

Up the corner angles are strung four series of statuettes, one above the
other, representing the major forces controlling civilization. Religion is per-
sonified by an ascetic man deep in contemplation, standing on the extended
tongue of a frog. Above him a vain old woman places a coronet on her own

THE THINKER

Aluminum statue on bronze base. Height 15 ft. 1 in. Base: Width 3 ft. 4½ in.—
Depth 3 ft. 4½ in. Founder's mark: ROMAN BRONZE WORKS INC Placed in Brook-
green Gardens in 1952.

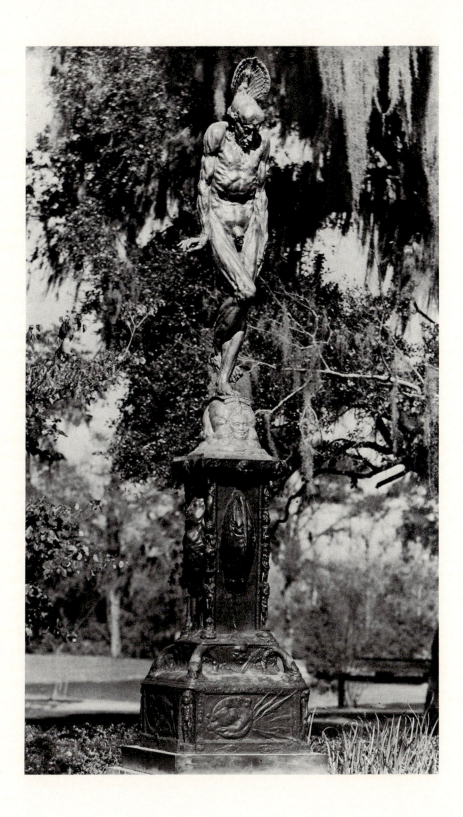

head; she also is a support of the church in spite of her gross materialism. Behind her the angle colonnette develops into the figure of a monk, on whose outthrust head stands the Virgin, a slender figure of gentle beauty.

The next row of figurines, at the left, begins with a hunchbacked old woman in a dunce's cap, a symbol for socialism. Behind her is another columnar figure with outstretched head, the labor agitator, upholding the infant with childish theories, while above him a monkey tries to fit the top hat of government on his head.

Education is represented in the next series of figures by a woman standing on the bowed shoulders of a man. Above her, supported on the extended head of a professor in cap and gown, is a young fop with a decoration hung around his neck, the fulfillment of the family's aspirations towards higher learning and social success.

The last caryatid group begins with the family—primitive man, woman, and child. Still higher are a squatting ape and a paunchy old man with a wooden leg, a helmet on his head and a sword in his hand, to show how man's struggles to attain a higher degree of civilization inevitably culminate in war, that puts an end to his upward climb and plunges him into revolution and chaos.

The base of the plinth is square, with a horizontal panel on each side depicting the eternal battle of life, all forms of life fighting to exist and reproduce their kind. On the front the conflict of the artist with his critics is imagined as a globular fish swollen with the multitude of his creative ideas, who is pierced by the beaks of his critics, a host of lean garfish.

The other struggles are between pairs of creatures—alligators, wasplike insects, and two peacocks. In niches at the corners between the panels are four grotesque statuettes, two male and two female. One is an old man with a large, wrinkled head, eyes closed, a medal hung on a scarf across his breast, typifying a high dignitary; another is a seated man in a fringed cloak resting his chin in his hands, the pensive intellectual. The worst female characteristics are again embodied in the repulsive cat-woman with elongated talons. The harpy, attracting by the eternal lure of sex, is satirized in the other female figure with hands holding up her breasts, great horns springing from her brows. The predatory nature of human existence is again underscored in the heads on every side of the top molding, each one with mouth stretched to devour another, as if to illustrate the saying that man slays the thing he loves.

A hollow molding decorated on each side with a caricatured head connects the two parts of the plinth. At each corner the transition from the narrower to the wider section is accomplished by lobsterlike creatures with bodies arched and human heads bowed down on bent arms to make griffes at the lower corners. The sculptor's imagination, seconded by his magical touch, has not

flagged for a moment in the invention of charming details for borders, moldings, and backgrounds. Delicately modeled in low relief with skilled symmetry of mass and interplay of line, squatting frogs, fishes, birds, and insects are ranged in rows to make rhythmic patterns.

The statue itself was modeled at Paris about 1914, the base done later at La Napoule. The original life-sized model was presented to Brookgreen Gardens by the sculptor's widow.

Study for *The Thinker*

Clews had never been satisfied with his first conception of *The Thinker* and continued to experiment by means of sketches in which his idea was carried still further, the body more ravaged by decay and the feeling of strain intensified. One of these sketches diverges from the statue only in that it presents an older man, shoulders more bowed, chest fallen in, and abdomen distended. Crowning the bald skull is a peacock's spread tail with a female figure in the middle.

Aluminum statuette. Height 1 ft. 11¼ in. Signed on top of base at left, in monogram: HC Founder's mark: ROMAN BRONZE WORKS INC Placed in Brookgreen Gardens in 1952.

Study for *The Thinker*

Another sketch shows a still older man with even more wizened body. The shoulders are narrowed beside the hunched back, the head bowed on the breast. The fanciful headdress and the small skull have not been added. On the front panel of the square base an insect with spread wings is modeled in low relief, and another is incised on one side.

Aluminum statuette. Height 1 ft. 2½ in. Base: Width 4 in.—Depth 4 in. Signed on base at back, in monogram: HC Founder's mark: ROMAN BRONZE WORKS INC Placed in Brookgreen Gardens in 1952.

The Duchess

A nude old woman stands mincingly, one knee slightly bent, a fan raised in one hand, the other extended with affected grace. A string of beads is slung like a baldric over the right shoulder. Above an aristocratic face, long nosed and thin lipped, the hair is drawn upward in a high pompadour bound with

pearls and topped by an ostrich plume. Elegant posture and haughty manner contrast sharply with the aged body, the skeleton apparent beneath sagging flesh and wrinkled skin, modeled in utmost detail. A tall, rectangular base has panels framed by classic pilasters. On the front two flamingos, comically echoing the lady above them, pose in prideful attitudes on stilted legs.

Aluminum statuette. Height 1 ft. 8½ in. Base: Width 4 in.—Depth 4 in. Signed on top of base at back, in monogram: HC Founder's mark: ROMAN BRONZE WORKS INC Placed in Brookgreen Gardens in 1952.

Karl Bitter

TOWARDS the end of the nineteenth century there was an influx of able decorative sculptors from Europe, attracted by the demand for sculptural ornament on buildings and monuments, and in the magnificent houses which were then being built. Among these sculptors was Karl Bitter from Vienna, whose work came to have more than transient value.

He was born on December 6th, 1867, in the suburb of Rudolfsheim and christened Karl Theodore Francis, although he later dropped the two middle names. His father was Carl B. Bitter, a chemist; his mother's maiden name, Henriette Reitter. He attended the Gymnasium in Vienna, and after trying his hand at stonecutting in a stoneyard near his home, entered the School of Applied Arts in 1882 and later the Academy of Fine Arts. The men with whom he studied were August Kühne and Edmund von Hellmer, and he gained some experience in decorative modeling on the numerous public buildings which were being erected in Vienna at that time. Called for three years' service in the army when he was twenty, he served one and then left Austria secretly, embarking for New York.

On his second day in this country he found employment with a firm of architectural modelers. Within the year, sponsored by the architect Richard Morris Hunt, he had taken his own studio. His sketch for one of the bronze doors of Trinity Church won in competition, and Hunt employed him on the interior carved decorations of the Collis Potter Huntington house on Fifth Avenue and on the Administration Building for the Columbian Exposition at Chicago. Numerous commissions, all characterized by fertile invention, exuberant action, and wealth of detail, followed: a pediment and terra-cotta reliefs for the Pennsylvania Station, Philadelphia; the sculptural ornament for Biltmore, the Vanderbilt estate in North Carolina, and for New York

residences; three colossal stone atlantes for the Saint Paul Building, New York,[1] and four caryatids and six portrait medallions for the façade of The Metropolitan Museum of Art. For all this activity he had established a large studio at Weehawken, New Jersey, where he employed many assistants to carry out his designs. The Chicago Exposition decorations had been such a pronounced success that he was appointed director of sculpture for the Buffalo, Saint Louis, and San Francisco expositions. At the first two the sculpture which he exhibited won gold medals; at the last, a medal of honor.

After the monument to Dr. William Pepper for the University of Pennsylvania had given him a chance to make a portrait statue, he determined that his work should be of a more personal and lasting character and set out to carve and model other memorials and monuments. The enigmatic draped *Thanatos*, the Hubbard Memorial at Montpelier, Vermont, and the Villard Memorial at Sleepy Hollow, a smith resting from his labors, are single figures drawn from his imagination and full of poetic feeling. In the decorative arrangement of trees in the background of the Villard Memorial there is an echo of *art nouveau*. A major triumph was the equestrian statue of Franz Sigel on Riverside Drive, New York, unveiled in 1907, impressive in its restrained force and quiet dignity. His sculpture on buildings now began to show a distinct break with his previous flamboyant style. Designed with strong vertical lines, definite masses, sober grouping, and some degree of stylization, as in the pediments for the Wisconsin State Capitol, the groups for the First National Bank, Cleveland, and his statues for the Brooklyn Museum façade, it marks the beginning of modern architectural sculpture. Another monument, that to Carl Schurz on Morningside Drive, New York, designed in 1909, for the first time in America made use of figures based on the archaic Greek, with flat-surfaced relief and calligraphic folds, which were to have such success with Manship and his colleagues of the American Academy in Rome. An original conception was the perforated screen with seated figures framed under arbors for the Lowry Memorial at Minneapolis, in which the arbitrary treatment of the figures, as in some of his work for buildings, showed a knowledge of German architectural sculpture of the Secession group.

Realistic portraiture was continued in the memorials to Dr. Angell and Dr. Tappan at the University of Michigan, while the statue of Jefferson for the University of Virginia, his third representation of this noted American, was based on wide reading and a sympathetic grasp of the subject; one of his last works, it was inaugurated in 1915. Where earlier fountains, the *Boy Stealing Geese* for the Vanderbilt Estate, the Schiff Fountain, and *The Goose Girl* for the Rockefeller Estate, Pocantico Hills, were full of life and gaiety, the figure

1 When the building was torn down in 1958, Bitter's sculpture was given to the city of Indianapolis, to be placed in a park.

for the Pulitzer Memorial Fountain, New York, had a classic serenity. Bitter was struck by an automobile as he was leaving the opera and died on April 10th, 1915. In addition to his own tremendous output, he was always active in furthering the interests of his fellow sculptors. He was twice president of the National Sculpture Society and a member of the Art Commission of the City of New York and of the National Institute of Arts and Letters. In 1914 the Architectural League of New York gave him the medal of honor in sculpture. Bitter's work is even more important as a signpost than for its own excellence for, first of all, he caught the changing tide which was to swing from the realism and elaboration of the early twentieth century to the simplification and stylization of the post-war period.

Plaza Fountain Figure

A woman stands with her body slightly bent and one foot raised, a basket from which she is about to scatter fruit held in both hands and swung to one side. Her hair is arranged in rows of tight ringlets above her face. In the completed statue a drapery has been added below the basket and a snood over the curls. The graceful figure is often called Abundance. It was to celebrate the completion of the plaster model to surmount the Pulitzer Memorial Fountain in the Plaza, New York, that Bitter took his wife to the opera on the evening when he was fatally injured. The finished statue, enlarged from the model by Karl Gruppe, was erected in the Plaza in 1916 above the series of stepped limestone basins which carry the water.

Sketch model in bronze. Height 2 ft. On base at left: © Founder's mark: GORHAM CO 10 Placed in Brookgreen Gardens in 1937.

Isidore Konti

ISIDORE KONTI, one of the European decorative sculptors who were so active in this country late in the nineteenth and early in the twenieth century, was born at Vienna on July 9th, 1862. His parents, Ignatz Lajos and Rosalie Konti, were of Hungarian stock; his father, having fought against Austria, was forced to serve in the Austrian army. After living with his family at Szombathely, Hungary, the son entered the Vienna Academy when he was sixteen and studied with Edmund von Hellmer. Further study was in the

Meisterschule of Karl Kundmann. In 1886 a scholarship took him to Rome for two years, where there was instilled in him an enthusiasm for the Italian Renaissance which he never forgot. He was employed on the decoration of some private buildings at Vienna and carved a marble bust of the Emperor Francis Joseph for a Jewish charitable institution before he left for America in 1891. Going directly to Chicago, he found work on the sculpture for the Columbian Exposition. After that was over he came to New York and entered the studio of Karl Bitter as an assistant.

His facile groups turned out at high speed—graceful, sweet-faced girls with softly clinging and swirling draperies in effective poses—were well adapted to exposition use. In 1900 he had his own studio for the sculpture which he was doing for the Buffalo Exposition. For the Saint Louis Exposition, where he won a gold medal, he made more than twenty different groups, including many for fountains and a dramatic work called *The Despotic Age*, the plaster model for which is in the City Art Museum, Saint Louis. Decorative sculpture by him with the same qualities of grace and elegance and the baroque richness of counter-curving lines ornamented many New York buildings. It may be seen in a relief on the door of Grace Church. In Washington he carved capitals and panels for the Pan-American Building in addition to the symbolic group representing South America and above it a relief of San Martín and Bolívar. Another pictorial relief, *Beale and Carson Hailing Stockton's Flagship*, is in the National Collection of Fine Arts. The statues of Justinian and Alfred the Great on the Cleveland Court House were assigned to him.

Although monumental sculpture was less suited to his talents, he occasionally received commissions for portrait statues and memorials, on which wherever possible he tried to use the allegorical figures and reliefs in which he was expert. He carried out the McKinley Memorial at Philadelphia from a sketch by Charles Lopez, modeled a statue of Governor F. T. Nicholls for Baton Rouge, Louisiana, and the Anastasius Grün Memorial for Ljublana, Yugoslavia. In Yonkers, where for many years he had his studio, are his tablet to World War I soldiers, the Hudson-Fulton Memorial, and a statue of Lincoln. The recumbent effigy of the Reverend Morgan Dix is in Trinity Church, New York; the figures of the Gothic tomb of Bishop Horatio Potter, in the Cathedral of Saint John the Divine.

The pleasant fancy which had evoked so many fountain figures for the expositions continued to find employment. *The Brook*, a comely nude gracefully bending, above a ring of ducks and babies, was acquired for the Untermyer Estate, Yonkers, in 1903. Three other fountains were made for Audubon Park, New Orleans. Of his small bronzes with delicately modulated surfaces, *The Genius of Immortality*, a pensive male figure, was bought by

the Italian Government. Other examples are in The Metropolitan Museum of Art, New York, and The Detroit Institute of Arts. *Orpheus* is on loan to The Baltimore Museum of Art from the Peabody Institute, *Dying Melodies* is in the museum at Oberlin College, and dancing figures are in the Montclair and

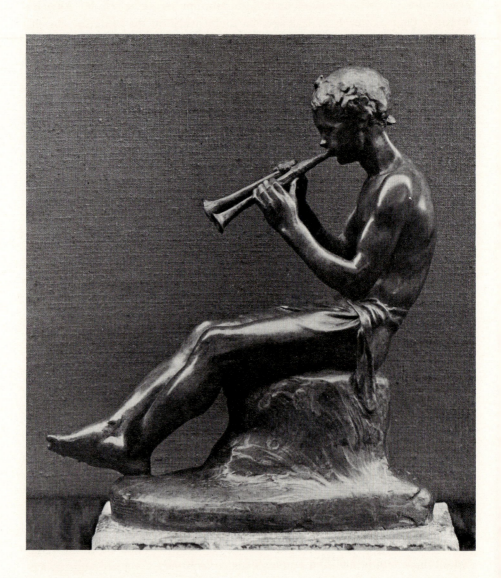

YOUNG FAUN

Bronze statuette. Height 1 ft. 2 in. Base: Length 10 in.—Width 5½ in. Signed on base at right: *I. Konti* Founder's mark: ROMAN BRONZE WORKS Placed in Brookgreen Gardens in 1937.

Newark museums. Konti was a member of the National Sculpture Society, The Architectural League of New York, and the National Academy of Design. His death occurred at Yonkers on January 11th, 1938.

Young Faun

Seated nonchalantly on a rock, his ankles crossed, a graceful boy is playing double pipes. A soft drapery is wound about his loins, and in his hair is a wreath of leaves. The delicacy of handling Konti learned from the Renaissance sculptors whose work he saw when he was in Italy.

Attilio Piccirilli

WHEN GIUSEPPE PICCIRILLI and his wife, Barbera (Giorgi), came from Massa, Italy, to New York in 1888, they brought with them not only their family, but a traditional European method of working as a group. With his six sons Piccirilli established a marble-cutting studio which not only carried out the designs of others but contracted for sculpture independently. Three of the sons, Attilio, Furio, and Horatio, became creative sculptors. Attilio, the eldest, was born at Massa on May 16th, 1866. He studied at the Accademia di San Luca in Rome from 1881 to 1888, and after coming to this country gained experience as an assistant to various sculptors before becoming the head of the Piccirilli studio. In 1898 he made his debut as an artist with the McDonogh Monument for New Orleans, a portrait statue with, on the pedestal, a boy and girl bringing flowers. The contract for the Maine Monument of 1901 was won in competition. This ambitious undertaking, upon which he worked for over ten years, is placed at one of the entrances to Central Park, New York. It is a tall pylon preceded by the prow of a ship, with groups of figures around the base and Columbia in a shell drawn by sea horses at the top. One of these groups is a tender *Mater Amorosa*, a mother with her child, which the sculptor has shown as a separate composition and used for his own mother's monument at Woodlawn Cemetery. On the Firemen's Monument, Riverside Drive, New York, is a spirited scene in low relief and a group at each end, one of which, the mourning mother, has the emotional quality of a Renaissance *Pietà*. The chief element of a war memorial for the city of Albany

98

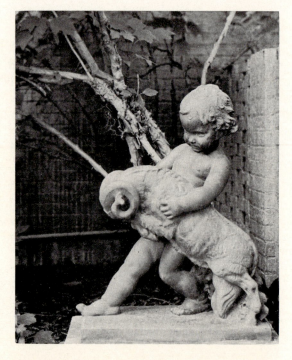

Laughing Boy and Goat

Lead group. Height 2 ft. 7 in.
Base: Length 1 ft. 11½ in.—
Width 1 ft. Signed on base at
 back: *A Piccirilli*
Placed in Brookgreen Gardens in
 1937.

is a neoclassic draped figure. The realistic tradition was followed in portrait statues of Governor Allen for the State House, Baton Rouge, and of President Monroe, ordered for Venezuela in 1896 and finally placed at Charlottesville, Virginia, in 1931.

Architectural works had always figured largely in the studio's output, and among those of which Attilio is the author are the statues of Indian Literature and an Indian Law Giver for the façade of the Brooklyn Museum. Dignified neoclassic figures in a spacious grouping make up the pediment for the Wisconsin State Capitol. The lunettes on the H. C. Frick residence, Fifth Avenue, New York, are in a gayer, pictorial vein, with a rich play of light and shade. Two reliefs were cast in glass, a new material for sculpture on a large scale, and placed over the doors of the Palazzo d'Italia, Rockefeller Center, New York, in 1935.[1]

A more personal expression are figures of an unearthly purity entirely in keeping with the American tradition, in which the coolness and smooth sweep of the marble are preserved in the finished statue. *Fragilina*, a kneeling girl with lovely lines and a spiritual face left half-veiled in the stone, is in The Metropolitan Museum of Art, New York. Another, *The Flower of the Alps*, a graceful nude with upflung arms, arched against a cliff, won the Widener Gold Medal of the Pennsylvania Academy in 1917. *Un Sogno di Primavera*

1 These reliefs were destroyed in 1968 when the door was remodeled.

was acquired by the Richmond Academy of Arts after winning the Saltus Gold Medal of the National Academy of Design in 1926. *Una Fanciulla*, also called *Una Vergine*, is carved with the same softly modulated transition from one plane to another; it was awarded the Watrous Gold Medal at the National Academy of Design exhibition in 1928 and first prize for sculpture at the Grand Central Art Galleries in the following year. The sculptor's achievement was rewarded with a gold medal at the Panama-Pacific Exposition, and in 1932 the Jefferson Presidential Medal was bestowed on him in recognition of his services as a United States citizen. Piccirilli died at New York on October 8th, 1945. He was a member of the National Academy of Design, the National Sculpture Society, The Architectual League of New York, and the Accademia dei Virtuosi del Pantheon, Rome, and president of the Italian-American Art Association.

Laughing Boy and Goat

A chubby boy is leaning backward, both hands grasping a curling horn and a shoulder of a goat which rears on its hind legs. The boy's body is softly modeled; his rumpled hair and the animal's shaggy coat are lightly suggested. This group was designed in 1936, not as a commission but on a creative impulse of the sculptor's. There are two other examples, one cast in bronze and the other cut in marble.[2]

Furio Piccirilli

FURIO PICCIRILLI was born at Massa, Italy, on March 14th, 1868. He came to the United States with his parents in 1888. Educated at the Accademia di San Luca, Rome, like his brother Attilio, he shared responsibility for the figure sculpture in the family's many commissions. Attilio, in listing the special abilities of each of his brothers, described Furio as a "bas-relief sculptor."[1] He has been considered the most creative and the best modeler of them all. His work won honorable mention at the Buffalo and silver medals at the Saint Louis and Panama-Pacific expositions. His chief contribution at San

2 Lombardo. p. 265–266.
1 New York. The Metropolitan museum of art. *American sculpture*. p. 94.

Francisco was four ably composed groups of many figures for the Court of the Seasons.

In 1920 he designed the sculptural decoration of the Parliament House, Winnipeg, Canada. It included a seated statue of Pierre Gaultier de Varennes in which pictorial use was made of the elaborate eighteenth-century costume.

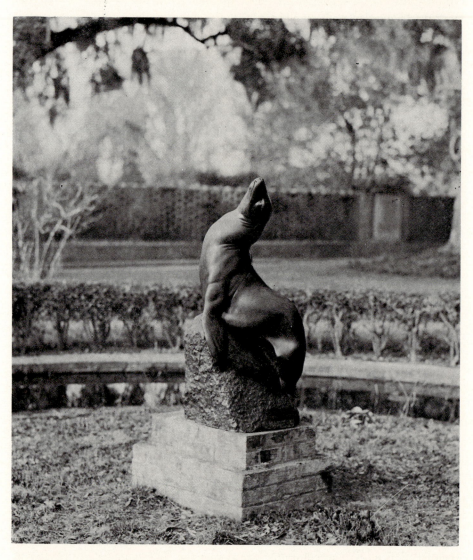

SEAL

Black marble statue. Height 3 ft. 6 in. Signed on base at back: FVRIO PICCIRILLI Placed in Brookgreen Gardens in 1937. Other example: New York. The Metropolitan Museum of Art.

A statue of Murillo, a long cloak giving stability to the figure, was sculptured for the Fine Arts Gallery, San Diego. Conceived in a modified Renaissance style, with delicate low relief, is a *Madonna*, and a merry *Baby Faun* has the sensitiveness of a Florentine fifteenth-century work. *Saint Cecilia* is in Saint Agnes's Church, New York. He also made a number of animal studies. In 1921 Furio went to Rome and married a cousin while there. After a few years he came back to New York and planned to remain permanently. Hoping that the climate would be better for his son's health, he returned to Rome in 1926 and stayed there until his death in 1949. He was a member of the National Academy of Design and an associate of The Architectural League of New York.

Seal

A seal is balanced at the top of a rock, the head lifted and the lithe body bent backward in a series of flowing curves. The hind flippers cling to the rock while the front flippers brace the body. In the modeling are preserved all the elasticity and fluid motion of the creature. The example in the Metropolitan Museum is dated 1927. This statue was awarded the Speyer Prize at the National Academy of Design exhibition in 1929.

Horatio Piccirilli

HORATIO PICCIRILLI, fifth of the famous sculptor brothers, was born at Massa (Carrara), Italy, on June 21st, 1872, to Giuseppe and Barbera (Giorgi) Piccirilli. He was still a boy when the family moved to New York in 1888 and consequently too young to have gone to the same art schools in Italy as his brothers. He learned his profession in the family studio and also studied with a French sculptor active in New York, Edourad Roiné. As his skill increased, he took a more important part in some commissions, often shared with his brother Masaniello, called Tom. The large residences that were being built along upper Fifth Avenue in the early twentieth century required impressive interior decorations, for which the skilled carving of the Piccirilli Brothers was in demand. Horatio, independent of the studio, was employed on the house of Senator William A. Clark, furnishing decorative sculpture in marble, stone, and majolica. Panels modeled in Renaissance style were exhibited in 1900 at the New York Architectural League.

When the Palace of the Fine Arts was being built for the Saint Louis Exposition in 1904, Horatio supplied eleven medallions representing famous artists to be placed on the façade. While Attilio carved lunettes for the H. C. Frick mansion erected on Fifth Avenue, New York, in 1913 and 1914, Horatio worked on the interior. The vaulted ceiling of the hall is covered with marble elaborately carved. A wealth of motives taken from the Renaissance repertory fills the spaces between panels flanked by seated nude figures. In the panels are pastoral scenes of children playing with a stag, a satyr and a cupid, a nymph and cupids, and a girl bathing. Figures and ornament are richly modeled in low relief, the outlines accented. Two other rooms are fitted with marble door frames and cornices in Renaissance style, some overdoor panels being filled with a splendid array of panoplies and trophies, oak and laurel sprays, and fruit swags.

After the First World War through the flourishing decade of the 1920's, Piccirilli Brothers were employed on many major schemes of architectural decoration, in which Horatio was included, since he was the one most highly skilled in carving ornament. Familiar with historical styles and adept in creating sculpture to harmonize with architecture, he could change with equal ease from carving Romanesque capitals for the aisles of Saint Bartholomew's Church, New York, to the classical ornament on the Lincoln Memorial at Washington, D.C. The capitals, enriched with a variety of intricate detail, include figures handled in a stylized manner, with flattened folds and sharp outlines, deeply undercut. The tripods on the two buttresses flanking the stairs to the Lincoln Memorial, his special contribution to the work, are composed of classical motives of acanthus leaves, eagles, and lions' heads, swelling from low to high relief, skillfully carved with flowing contours and refined details. Classical motives were again required for the new building of the New York County Court House and for the addition to the Stock Exchange.

Another important undertaking of the Piccirilli Studios was a large portion of the carving on Riverside Church, New York, conceived in French Gothic style. They carved the portal with its many reliefs and statues, gargoyles, and other details. Horatio developed the rich ornament, spending a year and a half on the chancel screen of Caen stone, made up of delicate Gothic tracery. In a departure from their usual medium, the Piccirillis designed ornamentation to be carried out in bronze for the state capitol at Baton Rouge, basing their scheme on the magnolia, state flower of Louisiana.

Horatio Piccirilli, in the few independent works that were his own creations, abandoned all remembrance of past styles and worked in a spirited, impressionistic manner. A *Bronze Cock*, shown at the National Sculpture

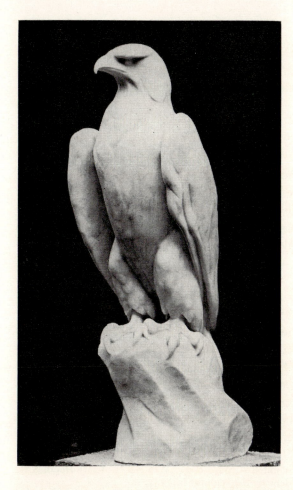

EAGLE

Carrara marble statue. Height 2 ft. 10¾ in. Base: Width 11¾ in. —Depth 12 in.
Placed in Brookgreen Gardens in 1948. Other example: San Francisco. California Palace of the Legion of Honor (black marble).

Society's 1923 exhibition, lifts his head proudly to crow, his feathers whirling in irregular patterns. When after the death in rapid succession of the other brothers the studio was closed in 1946, Horatio retired. A member of the Modelers and Sculptors of America, he was president of the organization for three terms. The sculptor died on June 27th, 1954.

Eagle

An eagle is perched on a rock, wings barely lifted away from his body, head turned a little to one side. Across the swelling breast and on the powerful wings, feathers are vaguely suggested in order not to disturb the massive shape. The beak is sharply hooked and keen eyes are deep set under beetling, feathered brows.

The first version of this work, carved in black marble under the title *Black Eagle*, was awarded the Ellin P. Speyer Memorial Prize at the National Academy of Design exhibition in 1926.

Barberini Candelabrum

The candelabrum is composed of a gadrooned basin raised on a stem made up of rows of acanthus leaves and set on a tall, four-sided plinth. At the lower corners are griffes of winged lions' paws. A classical deity, standing in profile or with back partly turned, is carved in low relief on each side of the base: Zeus with staff and thunderbolt; Aphrodite in a long girt chiton, carrying a flower; Athena in breastplate and helmet; and Ares wearing a helmet and holding a spear.

Modeled in 1900 by Furio and Horatio Piccirilli at the request of their father, Giuseppe, the candelabrum was sent to Italy to be carved and returned to the Piccirilli Studios for finishing. It is freely adapted from two Roman specimens in the Vatican called the Barberini candelabra from having once been in the Barberini Palace. The American sculptor has equaled his Roman forebear in mastery of the chisel, cutting lacy edges on the plumy acanthus leaves and richly modeling the images of the gods. At the same time he has changed the proportions and increased the effect of classical purity by introducing more plain leaves and undecorated members.

Carrara marble candelabrum. Height 8 ft. 6 in. Base: Width 3 ft. 3 in.—Depth 3 ft. 3 in. Presented to Brookgreen Gardens by the sculptor in 1952.

Janet Scudder

TOWARDS THE END of the nineteenth century, as the sculptor's vision moved from classic Greece to Renaissance Italy, it saw a more human and intimate way of treating the statue, and from this new vision garden sculpture sprang. The piping of MacMonnies's *Pan* summoned a horde of merry children, Pans, and fauns to enliven American gardens. First noting these new themes in MacMonnies's Paris studio Janet Scudder made them her special field, and other sculptors followed her example. She was born at Terre Haute, Indiana, on October 27th, 1873. Her parents, William Hollingshead and Mary (Sparks) Scudder, christened her Netta Deweze Frazee Scudder, but

she took the name of Janet when she entered the Cincinnati Art Academy at the age of eighteen. There she studied drawing and wood carving with Rebisso for three years. Going to Chicago she worked in a wood-carving factory before entering Lorado Taft's studio as an assistant on his work for the Columbian Exposition, her share receiving a bronze medal. Her admiration for MacMonnies's fountain at the Fair led her to Paris, where during a stay of three years she studied at the Académie Colarossi and fulfilled her ambition by working in MacMonnies's studio. Returning to New York she received a commission for the seal for the New York Bar Association and modeled some architectural ornament. She again went to Paris to excute a commission for a portrait in bas-relief. Several of her portrait medallions were accepted by the Musée du Luxembourg, the first time this honor was accorded an American woman.

On a visit to Italy, Donatello's *Singing Boys* and Verrocchio's *Boy and Fish* crystallized her aim "to please and amuse the world." [1] In her Paris studio she created the *Frog Fountain* and took it to New York to start a career modeling fountains. It was bought by Stanford White, through whom she received more orders. These early years of struggle Mabel Dodge Luhan epitomized as follows: ". . . years and years and years in a brown holland apron, in dusty studios; no money and poor light, no money and small amounts of food—years of it, until she saw her 'Boy with Fish' or her 'Boy with Flute' standing, cinquecento, in the Luxembourg, or in some American-Italian garden." [2] After the first success her work rapidly became popular. The *Fighting Boys Fountain* was acquired by The Art Institute of Chicago, and *Young Diana* was given honorable mention at the Paris *Salon* of 1911. At the Panama-Pacific Exposition a group of her works won a silver medal. The *Shell Fountain* was placed on the estate of Mrs. Harold McCormick, Lake Forest, Illinois, and a *Young Pan* on that of J. D. Rockefeller, Pocantico Hills, New York. The ingenuous gaiety of the pert children whom she liked to model was tempered by an insistent feeling for style, which led to sleek surfaces and emphasis on line. Her later work tended towards stricter formality both in composition and treatment of detail.

Most important of her architectural work was a statue of Japanese Art for the façade of the Brooklyn Museum, which also owns a group of her bronzes. She continued to model busts in terra cotta, portrait reliefs, and medals, notably that for the Indiana Centennial. She divided her time between America and France, where for some years she had a country house at Ville

1 Scudder. p. 165.
2 Luhan, Mabel (Ganson) Dodge. *Movers and shakers.* New York [ᶜ1936]. p. 90–91. (Her *Intimate memories.* v. 3)

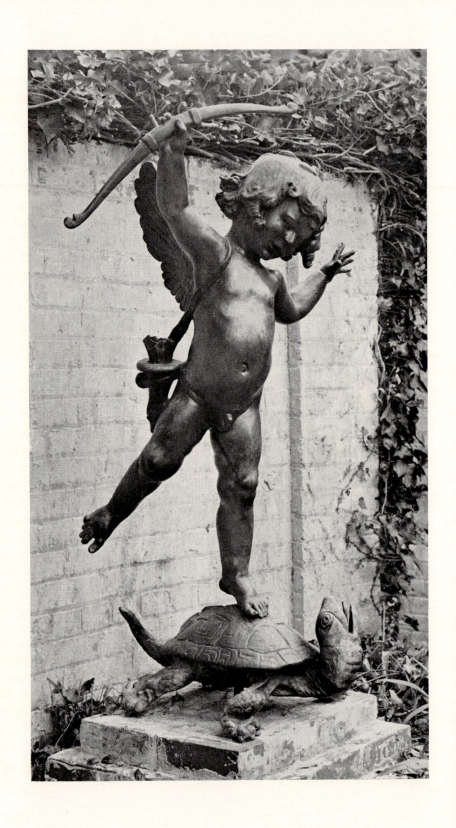

Tortoise Fountain

Bronze statue. Height 4 ft. ½ in. Placed in Brookgreen Gardens in 1950. Other examples: The Baltimore Museum of Art (small size; on loan from the Peabody Institute); Richmond, Ind. The Art Association.

d'Avray. During World War I she was actively engaged in relief work, helping to organize the Lafayette Fund and another to assist French authors. She was made a *chevalier* of the Legion of Honor in 1925. Further recognition was the award of the Olympiad medal at Amsterdam in 1928 and a silver medal at the Paris Exposition in 1937. In the later part of her life, dissatisfied with the lack of color in sculpture, she turned to painting. Her last works in sculpture were in an entirely different vein, a serene *Mother and Child* and a quiet *Angel* with a Gothic simplicity of line for the Church of Bethesda-by-the-Sea, Palm Beach, Florida. She died on June 9th, 1940, at Rockport, Massachusetts. She was an associate of the National Academy of Design and a member of the National Sculpture Society and the Union Interalliée, Paris.

Tortoise Fountain

Cupid is poised tiptoe on one foot upon a turtle's back, both arms raised, a bow in the right hand. From his shoulders spring short wings shaped like butterfly wings, the long outer feathers ending in curls at the tips. The body is chubby; the hair falls around the face in loose ringlets as he gazes down at the upturned head of the turtle. The short nose, dimpled cheeks, and half-parted, smiling lips are modeled with soft transitions, as are the eyes. This statuette is typical of the merry garden figures that the sculptor delighted in producing. It was one of those done when she was first inspired by Italian Renaissance sculpture after a visit to Florence in 1908.

Seated Faun

A smiling young faun is seated, playing the double pipes. Little horns spring from the brow between unruly tufts of hair. The goat hoofs are crossed, and the end of a skin thrown over the seat is draped across one thigh. The childish form is smoothly modeled, the hair treated in a decorative linear manner.

Bronze statue. Height 3 ft. 2½ in. Signed on base at left: *Janet Scudder 1924.* Founder's mark: Alexis Rudier Fondeur. Paris. Placed in Brookgreen Gardens in 1940. Other example: Brooklyn Museum.

Frog Baby

A lively boy prances on one foot, the other foot and both hands lifted, while he smiles down at three frogs squatting with raised heads. Water lilies are twined in his hair. It is this figure, modeled at Paris in 1901, which began the series of gay fountains for which the sculptor is best known. Of the four life-sized examples, two were sold to Stanford White for his clients. The sculptor tells how a child model was accidentally admitted to her studio and how she was captivated by the gaiety with which he danced about. "In that moment a finished work flashed before me. I saw a little boy dancing, laughing, chuckling all to himself while a spray of water dashed over him. The idea of my Frog Fountain was born." [3]

Bronze statuette. Height 1 ft. ¼ in. Signed on base at back: JANET SCUDDER Placed in Brookgreen Gardens in 1936. Other example: New York. The Metropolitan Museum of Art (bronze statue).

Victory

A slender girl's form flies through the air with lifted wings, one foot alighting on a globe. A wreath is raised in the right hand. This figure, for which Irene Castle posed, was first entitled *Femina Victrix* and exhibited at the National Academy of Design in 1915; it was intended for a National Suffrage Fountain to have been erected at Washington, D.C.

Bronze statuette. Height 2 ft. 2½ in. Placed in Brookgreen Gardens in 1936.

Willard Dryden Paddock

WILLARD DRYDEN PADDOCK was born at Brooklyn, New York, on October 23rd, 1873. He studied with Herbert Adams and at Pratt Institute. In 1895 he was the first person sent by Frederick Pratt to study in Europe for two years on a scholarship. Before he had his own studio at Paris he worked in the Académie Colarossi and the Académie Julian, receiving instruction in painting from Courtois and Girardot. During his stay there he exhibited a

3 Scudder. p. 172.

bas-relief portrait at the *Salon*. A second traveling scholarship took him to Italy in 1908. He painted landscapes and tried mural painting at Florence. Roman bronzes at Pompeii and Herculaneum aroused his enthusiasm and inspired him to try his own hand at small decorative objects. He also experimented with patination.

After his return to New York he had his first exhibition in 1912, showing small bronzes with nude figures delicately fashioned into such useful objects as andirons, candlesticks, letter seals, and table fountains. Copies of a medal that he made of the singer Putnam Griswold were presented to members of

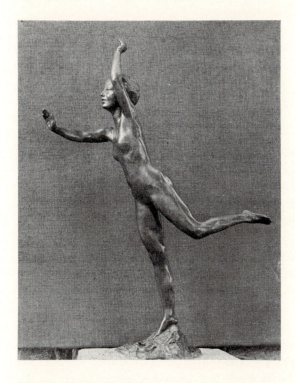

VICTORY OF SPRING

Bronze statuette. Height 25 ¼ in. Signed on base: © 192 . . . BY Willard Paddock Presented to Brookgreen Gardens by Miss Paddock in 1958.

the memorial committee of the Metropolitan Opera Company. A bust of a young girl is in the Brooklyn Museum. Bas-relief, handled in a painterly manner, was often the method that he chose to execute memorials such as that to Alfred Noble in the Engineering Society's Building, New York, and one to Presidents Orr and Jessup in the New York Chamber of Commerce. The most important of his few works in large scale is a memorial to Noah Webster at Amherst College, Massachusetts, unveiled in 1914, which took the form of a seated figure in an exedra. A war memorial at Pratt Institute is a flagpole with heads around the base representing the various branches of military service.

Fountains and bird baths were natural subjects for his gentle sentiment and soft modeling. A memorial to Edward C. Mershon in the General Hospital at Saginaw, Michigan, is a wall fountain, modeled in high relief with a woman holding a pedestal topped by a basin from which two children are drinking.

Paddock moved to South Kent, Connecticut, in the 1930's. He died at Brooklyn on November 25th, 1956.

Victory of Spring

A girl is poised on one foot, with head lifted and arms upraised, symbolizing the spirit of spring arriving in triumph.

A. Stirling Calder

ONE OF THE FIRST American sculptors to lay special emphasis on the decorative qualities of his art was Alexander Stirling Calder. He was born at Philadelphia on January 11th, 1870, the son of Margaret (Stirling) and Alexander Milne Calder, a sculptor of Scots birth who designed the sculpture for the City Hall of Philadelphia. After studying with Thomas Eakins and Thomas Anshutz at The Pennsylvania Academy of the Fine Arts from 1886 to 1890, Stirling Calder went abroad and continued from 1890 to 1892 in Paris with Chapu at the Académie Julian and with Falguière at the École des Beaux-Arts. On his return to the United States he became an instructor at the Pennsylvania Museum School of Industrial Art. His first commission won in competition was a monument to Dr. Samuel Gross for Washington, D.C.; the next, six heroic statues of noted Presbyterians for the Witherspoon Building, Philadelphia. He could have acquired none of his decorative methods from the French masters with whom he studied, but his early works, such as the marble sundial placed in Fairmount Park in 1905, reveal a certain kinship with the *art nouveau* movement, just then in its heyday, in their free adaptation of natural forms into loosely connected asymmetric designs. The frieze with figures of the zodiac on this sundial forecast the interest in intricate pattern which later found expression in a Byzantine lectern and Celtic crosses used as memorials. He made charming busts and statues of children, such as *Man Cub*, examples of which are in The Metropolitan Museum of Art, New York, and at the Pennsylvania Academy, and produced many and varied studies of the nude male form.

During a stay at Los Angeles in 1907 and 1908 he modeled his first strictly architectural work, spandrel figures in Spanish Renaissance style for Throop Polytechnic Institute, Pasadena. A little later he moved his studio to New York and taught at the National Academy of Design and the Art Students' League. In 1915 his special abilities found an outlet at the Panama-Pacific Exposition, where he was made acting chief of the department of sculpture. He designed the *Fountain of Energy* and the huge groups of the nations of the East and West, on which he was assisted by Roth and Lentelli. Even with the realistic handling of his early compositions he kept in the finished work the freshness and spontaneity of the sketch. He concentrated on the impression of life and movement conveyed by the rhythmic attitudes of the figures, using detail only to strengthen the design of the whole. In the works for the exposition he could let his imagination revel in elaborate combinations of spirited forms.

Architectural sculpture too greatly hampered his freedom of invention, and it is in fountain and garden figures and a few commemorative statues in which he could allow his imagination full play that his art reaches its finest expression. The Depew Memorial Fountain at Indianapolis he undertook after Bitter's death in 1915, keeping only his predecessor's general idea of a ring of dancing boys and girls and creating a new motive for the central figure, a naiad clashing cymbals. About the same time he designed the rich sculptural decoration of the boat-shaped island at Vizcaya, the James Deering estate at Miami, Florida, which included terminal figures and mermaids at the prow. The Swann Memorial *Fountain of the Rivers*, placed at Philadelphia in 1924, is composed of radial reclining nudes with birds and fishes behind their heads. Many single studies of great charm such as *The Little Dear with the Tiny Black Swan* and *The Last Dryad*, conceived in the same fanciful strain, illustrate the sculptor's ability in producing graceful and vital compositions.

He returned to a more formal style for other architectural sculpture, the relief of Washington as first president for the arch at Washington Square, given to New York City in 1918, and the frieze panels for the Missouri State Capitol, on which the linear patterns are strongly marked and the figures carved with heavy musculation. In monuments which allowed him to re-create semi-legendary or fictional characters, he brought to bear the full force of his dramatic instinct. The statue of Leif Ericsson for Reykjavik, Iceland, which won the medal of honor of The Architectural League of New York in 1932, is a mighty forward-looking figure in chain armor and wind-swept cloak standing on a pedestal like the prow of a ship.[1] For a Shakespeare Memorial he chose to contrast a despairing Hamlet and jesting Touchstone.

1 A replica is at the Mariners' Museum, Newport News, Virginia.

Calder's method progressed from the realistic manner of the nineteenth century, to which was added from the beginning his personal sense of decorative values, towards an increased stylization of detail, although in the broad outlines of the form he always kept close to nature. In his later work the simplification of surface became more marked, together with the use of sharp edges to define planes and accentuate pattern. He combined to a rare degree the originality of a quick imagination, strong feeling for design, and the vitality of a keen dramatic sense. Calder died at New York on January 6th, 1945. He belonged to the National Academy of Design, the National Sculpture Society, and the National Institute of Arts and Letters. He was also a charter member of the New Society of Artists.

Nature's Dance

On a ringed sphere a woman is poised on one foot, the other knee bent and the body turned in the movements of the dance. A choir of birds rises from beneath her feet to her lowered hand. The other arm is raised to her bent head. The rhythmic movement of arms and legs is woven into an intricate pattern. The statue was completed in 1938 from an earlier sketch.

Tragedy and Comedy

Hamlet, seated in a curule chair, leans his head against the knife held in his hand, as, with knit brows and nervously plucking fingers, he muses. Touchstone, with his head thrown back laughing, sits at Hamlet's feet, an arm flung over his knees, a bauble held in the other hand. There are gilded bells on his cap and bauble. The two figures epitomize Tragedy and Comedy. The heroic bronze was erected in Logan Circle, Philadelphia, as a Shakespeare memorial in 1928. It was awarded the McClees Prize at the exhibition of The Pennsylvania Academy of the Fine Arts in 1932.

Study model in bronze. Height 3 ft. Base: Width 1 ft. 2 in.—Depth 1 ft. 6 in. Signed on chair at right: *Calder* Placed in Brookgreen Gardens in 1934.

Model Adjusting Her Girdle

Bending slightly to fasten her girdle, a woman stands in an unstudied pose. Her hair is drawn back smoothly and gathered into a loose mass at the nape of

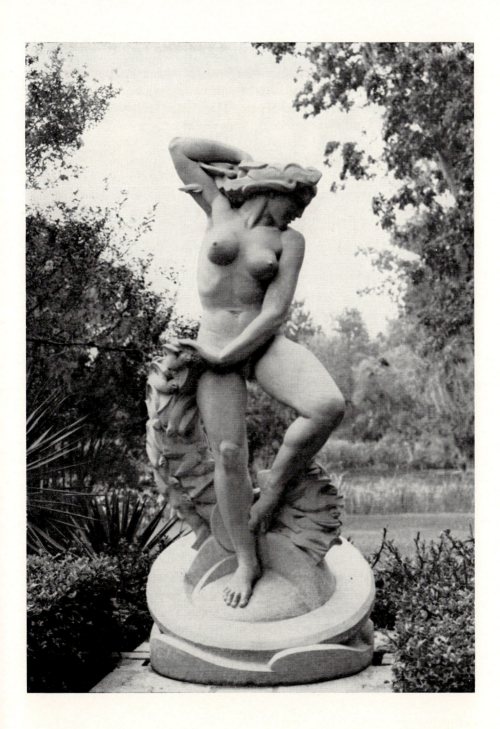

NATURE'S DANCE

Limestone statue. Height 6 ft. 8 in. Signed on sphere at back: A S C Placed in Brookgreen Gardens in 1941.

the neck. In this sketch the sculptor has translated with complete naturalness the easy grace of the model. Clothes are thrown over a wicker stool beside her, and shoes and hose lie on the floor behind. The plaster model was exhibited at the National Arts Club, New York, in 1936.

Bronze statuette. Height 1 ft. 7 in. Base: Width 7 in.—Depth 7 in. Signed on base at right: *Calder* 1943 Placed in Brookgreen Gardens in 1946.

Leo Lentelli

LEO LENTELLI, born at Bologna, Italy, on October 29th, 1879, practiced his profession at Rome before coming to the United States in 1903. He was studio assistant to several American sculptors in New York and did the figures of the Saviour and sixteen angels in modified Gothic style for the reredos of the Cathedral of Saint John the Divine. Martiny, with his rococo style, left a permanent mark in the free use of ornament, fluttering draperies, and elaborate counter bends. In 1911 Lentelli's work won the Avery Prize at the Architectural League exhibition. The following year he became a naturalized citizen. He was selected as one of the many sculptors who provided sculptural ornament for the Panama-Pacific Exposition. The association with Stirling Calder helped him to develop a decorative style of his own, which was crystallized in his *Water Sprite*, and to choose cement as a favorite medium. His long-limbed figures with hair and draperies in loose frills like seaweed made striking fountain statues and lent themselves well to architectural decoration. The surfaces were left rough for the sake of variety of texture and to give an effect of spontaneity.

After the exposition was over, Lentelli stayed at San Francisco until 1918 and taught at the California School of Fine Arts. During this period he made the ornament for the Orpheum Theater at Saint Louis and for two public library buildings at San Francisco. On the Dennis Sullivan Gateway at Denver, Colorado, are two-figure groups depicting pioneers.

With his removal to New York he became an instructor at the Art Students' League and continued his production of architectural decorations like

FAUN

Bronze statue. Height 5 ft. Signed on base at right: LEO. LENTELLI. SC. © 1931. Founder's mark: QIEL THE GORHAM CO. CIRE PERDUE Placed in Brookgreen Gardens in 1934.

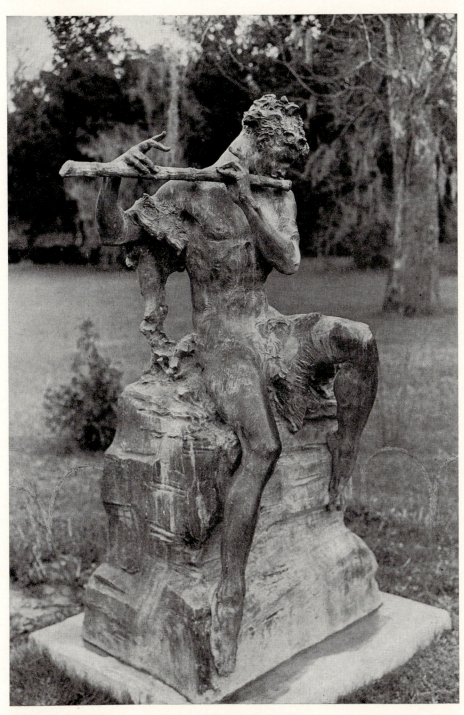

that for the Steinway Building, New York.[1] A panel of children's figures ornamented a frieze on the Free Academy building at Corning, New York. The sculptor received the Avery Prize of The Architectural League of New York several times and in 1922 its medal of honor. Ornamental figures included *Bagnante*, a *Diana*, *Leda* and a sundial which won the Watrous Gold Medal at the National Academy of Design exhibition in 1927. *The Archer* is in the San Francisco Museum of Art.

He collaborated with Henry M. Shrady on the equestrian statue of Robert E. Lee for Charlottesville, Virginia. In the benign figure of Cardinal Gibbons for Washington, D.C., the decorative element is accented in the carved chair and the graceful folds of the cassock. Important architectural works in recent years were the crowning features of the Italian and International Buildings at Rockefeller Center. In the government program of decorating public buildings, there was assigned to him sculpture for the post offices at North East, Pennsylvania, and Oyster Bay, Long Island. Lentelli retired to Italy in 1955 and died at Rome on December 31st, 1961. He was a fellow of the National Sculpture Society, a member of The Architectural League of New York, and an associate member of the National Academy of Design.

Faun

A faun is seated on a rock, his feet braced against it, as he plays on a reed pipe. An end of the skin thrown around him falls over his right arm. A squirrel sits beside him, holding a nut in its forepaws. The sculptor's boldly impressionistic style and the ornamental use of curling hair and fur are well exemplified. The statue was created for the Boca Raton Club in Florida and three examples cast.

James Earle Fraser

THE ART of low relief which Saint-Gaudens had so greatly developed was also cultivated by many of his pupils, and among them James Earle Fraser, at the beginning of his career, achieved particular distinction. He was born to Thomas Alexander and Cora E. (West) Fraser at Winona, Minnesota, on November 4th, 1876. As a boy he traveled with his father, a railroad builder,

1 The lunette of the Steinway Building was covered over when the building was sold.

through the West and spent ten years on a ranch in South Dakota. At an early age he began carving in material obtained from a chalkstone quarry near his home. These pieces showed such promise that he was encouraged to go to Chicago and enter the studio of Richard Bock, studying drawing in night classes at the Art Institute. He left in 1895 to study at the École des Beaux-Arts, Paris, under the instruction of Falguière.

The portrait which he exhibited in 1898 not only won a prize but made such a favorable impression on Saint-Gaudens that he invited Fraser to help in his studio. Fraser worked on the statue of Sherman at Paris, returned to the United States with Saint-Gaudens, and continued to be his assistant until he started out for himself in 1902 with a studio in New York. From 1906 to 1911 he taught at the Art Students' League. One of his first important medals was that specially designed for presentation to Saint-Gaudens at the Pan-American Exposition in 1901. For his medallic work he received the Saltus Award Medal of The American Numismatic Society in 1919. The relief of the children of Harry Payne Whitney on horseback, often compared to Saint-Gaudens's rendering of similar subjects, does not suffer by this comparison, holding its own in the charm of the conception and the subtlety of the modeling. Many other sensitive reliefs and portrait busts of children proved Fraser's rare ability to catch their individuality as well as their fragile beauty. The same mellow carving characterizes several more imaginative works done about the same time, before 1910, a mask of a girl and the head of Mary Garden as Mélisande. Some faint trace of Rodin's vogue is discernible in the softness of the outlines and the unfinished edges. With these belongs in spirit the *Head of a Young Artist* in The Metropolitan Museum of Art, New York, the expression brooding and the features finely chiseled.

The bust of Roosevelt, for which through Saint-Gaudens's recommendation he received the commission in 1906, was an immediate success in vivid, informal characterization. It was followed by a series of penetrating studies of heads of old men, like the *Basque* in the collection of The Hispanic Society of America, New York, always ugly and often pathetic, done in a swift, sketchy manner. Memories of his boyhood in the West had been recalled in the equestrian statue of an Indian for the Saint Louis Exposition and on the five-cent piece of 1913, for which Fraser used as types a buffalo and an Indian head.

Both his grasp of character and his colorful technique were called into play by a series of monuments, the statues of Alexander Hamilton for Washington, D.C., of Thomas Jefferson for the State Capitol of Missouri, and of the explorers Meriwether Lewis and William Clark also for Missouri, each one distinctive, the costumes unobtrusive but worked out with a suggestion of decorative detail which enhances their charm. The John Ericsson Monument

at Washington, D.C., consists of a portrait statue seated below three symbolic figures grouped around the tree of the universe. For this work the King of Sweden made Fraser a knight of the Order of Vasa. The pictorial groups of discoverers and pioneers for the Michigan Boulevard Bridge at Chicago are rounded out by flying figures. Departures into the semi-classic field are the

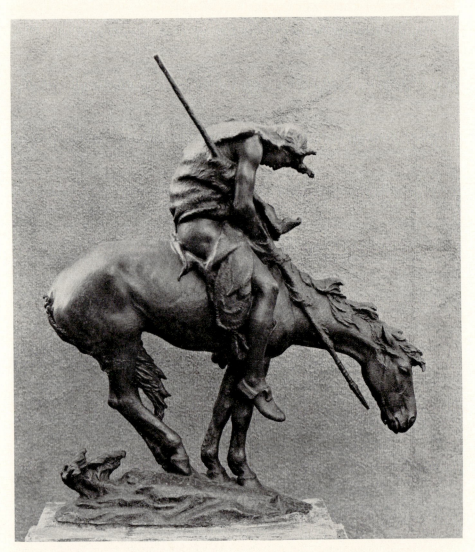

THE END OF THE TRAIL

Bronze equestrian statuette. Height 3 ft. 4 in. Base: Length 1 ft. 11 in.—Width 8 in. Signed on base at back: © 1915 J. E. FRASER. SC. Placed in Brookgreen Gardens in 1934. Other examples: The Detroit Institute of Arts; Saint Louis. City Art Museum; Waupun, Wis. (equestrian statue).

male figure erected as a memorial to John Hay at Cleveland, Ohio, in 1914 and the monumental *Victory* for the Bank of Montreal, a helmeted woman holding a sword and laurels, the drapery stylized to accord with the architecture of the building. A work finely imagined and forcefully executed, the crouching figure pouring water over a wheel called *Primitive Inventor of Water Power*, was made for Niagara Falls. In 1925 the Architectural League awarded him a gold medal of honor for his *Canadian Officer* at Winnipeg.

The haunting cast of tenderness and melancholy vanished from his later sculpture as impressionistic modeling was discarded for the precise outlines and harder surfaces which came into favor. In spite of a more formal treatment, his conception of his subjects remained essentially romantic. Pediments and massive figures for the National Archives Building, the Supreme Court Building, and the Commerce Building, Washington, D.C., again demanded a stately neoclassic manner. The heroic marble statue of Franklin for the Franklin Institute, Philadelphia, unveiled in 1938, allowed the sculptor to return to his favorite field, characterization. At the New York World's Fair in the next year the colossal figure of George Washington which dominated the main axis was his work, and two years later his imposing equestrian statue of Theodore Roosevelt with two attendant figures was placed in front of the Roosevelt Memorial at The American Museum of Natural History, New York. Two heroic groups of men and winged horses representing the arts of peace, placed at the entrance to Rock Creek Parkway, Washington, D.C., won for the sculptor in 1951 a joint award with Leo Friedlander, sculptor of equestrian groups for the Arlington Memorial Bridge, of the medal of honor of the National Sculpture Society. Striking characterization distinguishes Fraser's statue of General George S. Patton, Jr., in battle dress, for the United States Military Academy at West Point and of the Mayo brothers in surgeon's gowns for Mayo Memorial Park at Rochester, Minnesota.

The American Academy of Arts and Letters awarded Fraser their gold medal of honor for sculpture and the Century Association also a gold medal. He was vice-president of the National Institute of Arts and Letters from 1925 to 1929 and both president and, later, honorary president of the National Sculpture Society. He died at Westport, Connecticut, on October 11th, 1953.

The End of the Trail

An Indian wrapped in a skin, a lowered spear held loosely in the bend of his arm, is bowed on his horse's back. The horse shrinks before the wind, head hanging, mane and tail blown forward. Enlarged from an earlier composition, the original of this group was erected in temporary form at the

Panama-Pacific Exposition, San Francisco, in 1915, where it was awarded a gold medal; it was later moved to Visalia, California, and an example set up in bronze at Waupun, Wisconsin. The emotional force of this "moving parable of a losing people" [1] made it widely known. The statuette at Brookgreen, modeled later, is somewhat simplified.

Adolph Alexander Weinman

ARCHITECTURAL SCULPTURE, with the restraint which it imposes and the opportunity which it offers for rhythmic treatment of mass and line, has found one of its strongest exponents in Adolph Alexander Weinman. He was born at Karlsruhe, Germany, on December 11th, 1870, to Gustav and Katharine Hyacinthe (Weingaertner) Weinman. His early education was in the Volksschule of his native town and the public schools of New York City, to which he was brought by his widowed mother at the age of ten. Apprenticed to Frederick Kaldenberg, a carver of wood and ivory, when he was fifteen, he attended art classes at Cooper Union in the evening. His studies at the Art Students' League brought him to the attention of Saint-Gaudens, who was teaching there. Without European study Weinman entered the studio of Philip Martiny when he was twenty years old. He later assisted Olin Warner for a short time, being engaged on the bronze doors for the Library of Congress. After Warner's death he worked with Saint-Gaudens until 1898. Several years were spent in the studio of Charles Niehaus, and another period with Daniel Chester French, Weinman's work on the New York Custom House groups meriting his signature added to the author's. In 1904 he opened his own studio.

The display of European medals at the Columbian Exposition and his work on the Library of Congress doors stimulated his interest in medallic art and led him to begin a series of portraits in relief, several of them delightful studies of children, and official medals Greek in their purity of design. Noe writes of them, "A study of these medals will show a development which has been consistent in reaching toward better things. Portraiture, which is the

1 Adams, Adeline Valentine (Pond). *The spirit of American sculpture.* p. 96.
"The sculptor acknowledges as his text these words of Marion Manville Pope: *The trail is lost, the path is hid and winds that blow from out the ages sweep me on to that chill borderland where Time's spent sands engulf lost peoples and lost trails.*" (Perry. p. 36). It is also discussed by McSpadden (p. 281–282), in *James Earle Fraser* (p. 57), and in *Kennedy quarterly* (1965. v. 14, no. 2, p. 22, 26–27).

chief objective in the earlier medals, is achieved with a growing sense of ease and power in each succeeding design. The composition steadily grows more skilful and the problems faced become more complicated without the result being the less happy." [1] Weinman is the author of the United States dime and half dollar of 1916. His medallic work won him in 1920 the J. Sanford Saltus Medal of The American Numismatic Society, which he had designed.

The Destiny of the Red Man, a dramatic group of Indians and a buffalo, made for the Saint Louis Exposition, first brought him notice. The Maryland Union Soldiers' and Sailors' Monument, Baltimore, was another success, although the influence of Saint-Gaudens is evident. The statue of General Macomb unveiled at Detroit in 1908 is in a much more original style, the uniform and forward-blowing cloak lending themselves to decorative treatment in the clear-cut flowing lines which became characteristic of his subsequent work. The statues of Alexander Cassatt [2] and Samuel Rea in the Pennsylvania Station, New York, where Weinman also did all the sculptural ornament, were more formal, but that of Colonel Vilas at Vicksburg, Mississippi, again gave him scope for his imagination. Two statues of Lincoln, one standing and one seated, in the modified realistic tradition, were created for Kentucky. In 1913 The Architectural League of New York awarded him a gold medal of honor for sculpture.

His early architectural sculpture, such as the panels for the Morgan Library and the façade of the Municipal Building, New York, is composed in the classic-Renaissance manner, but the feeling for line and pattern and the masterly elaboration of decorative passages are already to be seen. For the tympanum of the Madison Square Presbyterian Church, now destroyed, the design suggested by H. Siddons Mowbray, an Italian Renaissance style based on Della Robbia was adopted. Stylizing tendencies became steadily stronger in his work for the decoration of buildings, and it may be that the wavy line of *art nouveau* had a formative influence in the emphasis on linear qualities. On the pediments for the Wisconsin and Missouri capitols, and the sphinxes for the Scottish Rite Temple, Washington, D.C., natural forms are reduced to a decorative scheme. In the frieze representing *The Terror of War* and *The Glory of Peace* for the Elks National Memorial Headquarters at Chicago, the calligraphic curves of the lines have been accentuated by a definite separation of planes, the figures, their surfaces modeled in very low relief, being almost cut out against the background. Although the crisp drawing of the muscular bodies owes something to Greek vase painting, there is a hint of Far-Eastern art in the irregular scrolling of details, as had

1 Noe. p. 9.
2 The statue of Cassatt was presented to Rensselaer Polytechnic Institute, Troy, New York, when the station was remodeled in 1966.

previously been apparent in the clouds of the Pegasus medallion used on the Saltus Award Medal.

Sculpture for the neoclassic buildings at Washington erected in the thirties, friezes for the Supreme Court Room and pediments for the National Archives and Post Office Buildings, again called for a formal plan, but within the bounds of spaced and balanced masses the sculptor introduced a variety of rhythmic movement and interplay of flowing lines. He was among the sculptors who worked on the Capitol of Louisiana, carving reliefs of the activities and resources of the state beside the entrance. Bronze doors for The American Academy of Arts and Letters, New York, placed in 1938, received a powerfully organized and spirited design.

Weinman's pleasant fancy and dynamic touch show to good advantage in a group of compositions where imagination and colorful modeling are blended. The winged figures of *The Rising Sun* and *The Descending Night* for the Panama-Pacific Exposition, most popular among his works, are composed in upward soaring and downward curving lines eloquent of morning and evening moods. The sea urchins and water centaurs for a fountain at Jefferson City, Missouri, are stylized into the broken, sweeping lines which are typical of the sculptor's later work. One of the last of his monuments that he could see in place was a memorial to Oscar S. Straus, with a relief portrait and allegorical figures, erected in the plaza of the Commerce Department Building, Washington, D.C., in 1947. Weinman died at Port Chester, New York, on August 8th, 1952.

He was active in furthering the interests of American sculpture in general. He served on the New York City Art Commission and the National Commission of Fine Arts and from 1928 to 1931 was president of the National Sculpture Society. He was a member of The Architectural League of New York, the National Academy of Design, and The American Academy of Arts and Letters. In 1930 the American Institute of Architects awarded him the Fine Arts Medal, and in 1948 the National Sculpture Society, a medal of honor.

Riders of the Dawn

The joyous spirit of a new day and the vigor of youth are embodied in two stallions ridden by young men. The horses plunge forward, half rearing, with forelegs doubled and heads tossing. One rider leans back to draw a bow while the other turns sidewise, blowing a conch. The powerful muscles of horses and men swell with effort, making intricate patterns of light and shade. Beneath the horses is the rayed disc of the rising sun, with water curling in

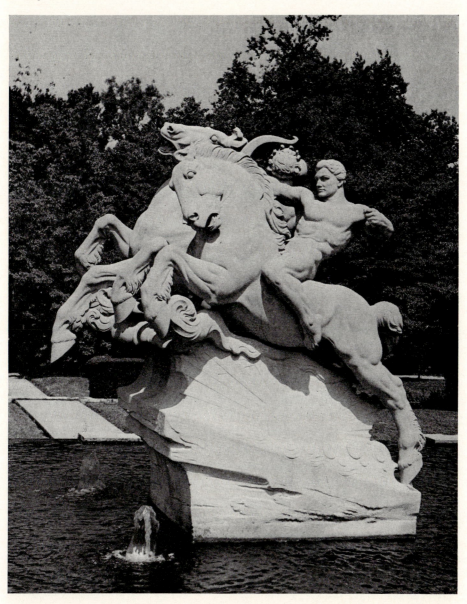

RIDERS OF THE DAWN

Limestone group. Height 10 ft. 9 in.—Width 6 ft.—Length 6 ft. 2 in. Signed on base at right: A · A · WEINMAN SC · Placed in Brookgreen Gardens in 1946.

scrolls around it and rising beneath the horses in plumes of spray. A heron rides one crest, and two dolphins plunge into a curling wave. This work, created especially for the central pool in the Dogwood Garden, was awarded the Watrous Gold Medal by the National Academy of Design in 1945.

Narcissus

A young faun with the legs of a goat lies along a shelving rock, raised on an elbow, one hand braced on an oak stump, his shoulders thrust forward and his head tilted to one side as he smiles at his impish reflection. He has pointed ears, and a wreath of flowers crowns his head behind two little horns. In the gay, insouciant posture, there is a pleasing pattern of counter bends which is enriched by decorative modeling. It was first shown in the National Sculpture Society's exhibition at New York in 1923 and was given the Widener Gold Medal of the Pennsylvania Academy three years later.

Tennessee marble statue. Height 3 ft. 9 in. Base: Length 3 ft. 4 in.—Width 2 ft. 1 in. Signed on base at front: A. A. WEINMAN FECIT Bronze statue placed in Brookgreen Gardens in 1934, replaced by marble in 1941. Other example: West Palm Beach, Fla. The Norton Gallery and School of Art (bronze statue).

Duet

A satyr is seated on a rock, playing on a pan pipe as he bends towards a young faun lying beside him with arms crossed, looking up at him. The faun resembles the one called *Narcissus*, but the twisted oak branch behind the figures, with its echoes of Chinese and Japanese art, makes the design more intricate.

Bronze group. Height 2 ft. Base: Width 1 ft. 7½ in.—Depth 1 ft. Signed at back: A · A· WEINMAN · SC 19 Ⓒ 24 Founder's mark: QWD GORHAM CO FOUNDERS CIRE PERDUE Placed in Brookgreen Gardens in 1934.

Aphrodite

The nude goddess kneels on one knee, resting on a drapery thrown over a rock. Both hands are raised to her wind-blown hair as she turns her head to look downward. The statuette was modeled in 1936.

Bronze statuette. Height 2 ft. 2 in. Signed on base: Ⓒ A · A · WEINMAN · SC · Presented to Brookgreen Gardens by the sculptor in 1940.

Water Urchin

A laughing boy's head is turned to the left, in his shaggy hair a wreath of water lilies. An open-mouthed fish curves around the top of the wave-marked base at the right. This head is a detail from one of the fish-tailed creatures designed in 1927 for a fountain on the grounds of the Capitol, Jefferson City, Missouri.

Bronze head. Height 1 ft. ¾ in. Signed under shoulder at left: A · A · WEINMAN SC. Presented to Brookgreen Gardens by the sculptor in 1935.

Womboli

A solemn Indian child, clothed in a loose, round-necked garment, stares intently ahead. The hair, parted in the middle, is tied in two locks behind the ears. The oval base is patterned with conventional ornament in flat relief, including masks, birds, a bear, and a fox. The name means "Little Eagle." The bust was modeled at Colonel Cummings's Indian Show at Coney Island in 1902, as one of several studies of Indian types for *The Destiny of the Red Man* for the Louisiana Purchase Exposition.

Bronze bust. Height 8½ in. Signed at back: A · A · WEINMAN · Presented to Brookgreen Gardens by the sculptor in 1936.

Pegasus

A powerful horse, magnificently winged, springs to the left into the air. Below him, at the left, are clouds against a rising sun. The musculature of the horse and the flowing mane and tail are rendered with vigor and charm of line. The clouds lie in the broken strata of Chinese convention. There is a border of a leaf scroll and flowers. This design forms the center of the reverse of the Saltus Award Medal modeled by the sculptor for The American Numismatic Society and first awarded in 1919; as a colored terra-cotta roundel it decorated the façade of the sculptor's studio after 1924; the silver medallion, an exact reproduction of the model for the terra cotta, was made about 1930.

Silver medallion. Diameter 5⅞ in. Signed at lower right: A · A · WEINMAN ·· FECIT · © Presented to Brookgreen Gardens by the sculptor in 1939.

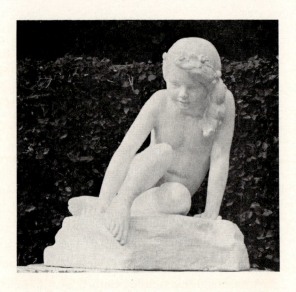

GIRL BY A POOL

White marble statue. Height 2
ft. Base: Width 1 ft. 9 in.—Depth
2 ft. Signed on base at back:
FRANCES GRIMES SC. 19 © 36
Placed in Brookgreen Gardens in
1937. Other example: The To-
ledo Museum of Art (bronze
statuette).

Frances Grimes

FRANCES GRIMES, born at Braceville, Ohio, on January 25th, 1869, the daughter of Francis Stanley and Ellen Frederika (Taft) Grimes, early showed an interest in drawing, modeling, and carving, so that after she had graduated from high school she went to Brooklyn to study at Pratt Institute. There she found in Herbert Adams a sympathetic teacher and after her graduation in 1894 became his assistant. This thorough training both in modeling and marble cutting made it possible for her to find employment in Saint-Gaudens's studio from 1900 till his death in 1907. So great was his confidence in her ability that he designated her to complete his caryatids for the Albright Art Gallery. During the time she was working for Saint-Gaudens she had been encouraged to do independent work, which took the form of portrait heads and portraits in low relief, particularly of children.

She took her own studio in New York in 1908 and matured her knowledge by travel in France, Italy, and Greece. An overmantel for the Washington Irving High School, New York, epitomizes her best qualities. The three reading girls are seated in a simple, effective grouping, and the sweet, serious faces evoke a dreamy atmosphere. Two panels of singing girls have the same fragile charm. *Boy with Duck* and *Girl by a Pool* are both fountain figures of gentle gaiety. For her medallic work she was awarded a silver medal at the Panama-Pacific Exposition; a year later, in 1916, she received the McMillin Prize of the National Association of Women Painters and Sculptors and in 1920 their National Association Medal for sculpture. Among her many

portrait reliefs are that of William Barnes in the Decatur and Macon County Hospital, Decatur, Illinois, and one of Henry Waters Taft in the Town Hall, New York. A portrait bust of Bishop Potter is in Grace Church, New York, and those of Charlotte Cushman and Emma Willard in the Hall of Fame. A memorial to General Nelson A. Miles has been placed in Washington Cathedral. She was a fellow of the National Sculpture Society and an associate of the National Academy of Design. Miss Grimes died at New York on November 9th, 1963.

Girl by a Pool

A girl is seated, bracing herself with both arms as she dips one toe in the water. Her hair, bound with a wreath of flowers, falls over her shoulder. The ground is lightly patterned with flowers. One of the poetic aspects of childhood is caught in the natural position and the smiling absorption of the face, and the form is carved with soft modulations. A small bronze of the same subject is dated 1913.

Elsie Ward Hering

THE TRADITIONS of fine workmanship established by Saint-Gaudens were carried on by his many pupils, in whose progress he was deeply interested. One of them was Elsie Ward, born on a farm near Fayette, Missouri, on August 29th, 1872, the daughter of Thomas and Alice Talbot Ward. She received her early education at Denver, Colorado, and began the study of art with Ida M. Stair, Samuel Richards, and Henry Read. From 1896 she studied sculpture at the Art Students' League, New York, for two years, when Saint-Gaudens was teaching there, winning first prize for a statue of Youth. She also had some instruction from Daniel Chester French and Siddons Mowbray before going to Paris in 1898. After her return to Denver she modeled several portraits and then entered Saint-Gaudens's studio at Cornish, New Hampshire, as an assistant, helping to finish much of the sculpture done towards the end of his life. After his death, when the relief of angels behind the figure of Christ which Saint-Gaudens had been making for the George F. Baker Memorial at Kensico Cemetery was left incomplete, she "with infinite care and patience, developed this composition from details suggested by the Morgan Tomb figure, the 'Amor Caritas,' and the like, until, at last, she

128

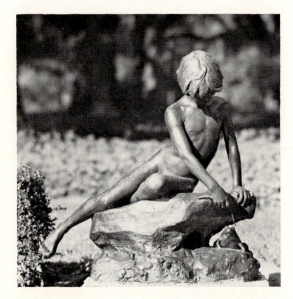

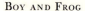
produced an astonishingly beautiful and poetic result, filled with the spirit of his work." [1]

In 1910 she married another of Saint-Gaudens's sculptor assistants, Henry Hering, and lived in New York until her death on January 12th, 1923, doing little independent work but helping in her husband's studio. Although she had a special liking for portrait busts and reliefs such as that of her mother, she also produced some decorative figures. Early commissions were the Huguenot Group for the Charleston Exposition, where her work received a silver medal, and a *Mother and Child* in front of the Woman's Building at the Saint Louis Exposition. Erected permanently at Saint Louis is her statue of George Rogers Clark. In 1922 she was working on the Isom Memorial Tablet for the public library, Portland, Oregon. A baptismal font of her own design, a child angel in soft draperies, holding a shell, stands as a memorial to her in Saint George's Church, New York.

Boy and Frog

A smiling boy with tousled hair is leaning on a rock, supported by one arm. In the other hand he holds a stick with which he is teasing a frog squatted in a crevice of the rock below him. This statue, modeled at Paris, was exhibited at The Pennsylvania Academy of the Fine Arts in 1901 and awarded a bronze medal at the Saint Louis Exposition.

1 Saint-Gaudens, Augustus. *The reminiscences.* v. 2, p. 354–355.

Charles Keck

ANOTHER PUPIL of Saint-Gaudens inherited some of his realistic and pictorial tendencies. Charles Keck was born in New York City on September 9th, 1875, to Henry and Elizabeth (Camerer) Keck. He was a student at the Art Students' League and the National Academy of Design and also studied with Philip Martiny. From 1893 to 1898 he was an assistant in Saint-Gaudens's studio. He then won the Rinehart Scholarship and spent the years from 1900 to 1904 at the American Academy in Rome. Saint-Gaudens still followed his career with interest and wrote him criticisms of his work. While Keck was abroad he also pursued his studies in Greece, at Florence, and at Paris. Upon his return to the United States he opened a studio in New York and began the production of a long series of monuments, memorials, and architectural decorations. American background seems to have had more weight than European schooling. Although he dealt in the symbolic commonplaces of the period, he brought them, as well as portrait statues, to life with nervous movement and veristic touches.

Among the statues made in 1909 under Daniel Chester French's direction for the façade of the Brooklyn Museum there fell to his share the statue of Muhammad, or *The Genius of Islam*, a heavily draped figure holding the Koran and the sword. The shadowed face strikes a dramatic note above the long deep folds and the ornamental lettering of the book. Other sculptural decorations were made for the State Education Building at Albany, including a circle of lifelike children for a candelabrum base.

The group of symbolic figures which began with the *America* of the Allegheny Memorial at Pittsburgh was continued in the *Amicitia* unveiled at Rio de Janeiro in 1931, though sculptured some ten years earlier, and the Liberty Monument at Ticonderoga, New York, dedicated in 1924. Both the latter statues are on circular pedestals surrounded by figures in high relief. The *Liberty* at Ticonderoga is less conventional, emerging from a background of shrubbery, with a fold of drapery flying behind her. Symbolic figures for other war memorials are treated in a simpler manner than in his earlier work. The *Victory* at Montclair, New Jersey, standing in front of a flag, won the medal of honor of the Architectural League in 1926; the *Angel* of the Shriners' Peace Monument at Toronto, Canada, holds two palms aloft.

Two of Keck's monuments are at Charlottesville, Virginia. In the equestrian statue of Stonewall Jackson, the horse is represented in rapid stride, and the whole composition gives the effect of swift forward motion. The group of

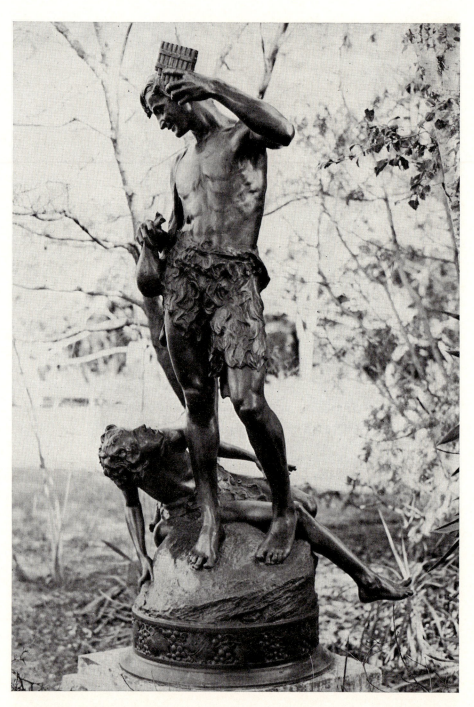

FAUNS AT PLAY

Bronze group. Height 6 ft. 7 in. Signed on base at back: CHARLES KECK. SC.
Founder's mark: QIHL GORHAM CO. FOUNDERS Placed in Brookgreen Gardens in
1934.

Lewis and Clark, depicting the two explorers in the costumes of frontiersmen, an Indian squaw guide crouching behind them, is treated in a sketchy, impressionistic manner. The efforts of Booker T. Washington to improve the conditions of his people are symbolized by a group at Tuskegee, Alabama, in which he is shown lifting a drapery from a crouching Negro. A statue of Father Jogues, the discoverer, was erected at Lake George and one of the World War chaplain, Father Duffy, in Times Square, New York, for which the Masonic Order gave the sculptor the Grand Lodge Medal for Distinguished Achievement. The sculptor's architectural work was continued with bas-reliefs depicting the settlement of the Middle West on the William Rockhill Nelson Gallery of Art, Kansas City, Missouri, where his equestrian statue of Andrew Jackson also stands. Keck's statue of Alfred E. Smith, with a relief depicting *The Sidewalks of New York* on the base, presides over the housing project in New York City dedicated to him. Keck died at Carmel, New York, on April 23rd, 1951. He was a fellow of the National Sculpture Society, and a member of The Architectural League of New York, The American Numismatic Society, and the National Academy of Design.

Fauns at Play

A skin wrapped around his loins, a faun stands with a syrinx raised in one hand while the other holds the end of a wineskin slung from his shoulder over the open mouth of a younger faun who lies curled about his feet. This work was modeled as a fountain for J. J. Raskob's estate at Centreville, Maryland, and set in a marble basin carved with a frieze representing his children at play. The example at Brookgreen is the only replica. It was exhibited at The Architectural League of New York in 1921. Although Keck has not done much garden sculpture, his brisk manner strikes a vivacious note.

Henry Hering

HENRY HERING was born in New York City on February 15th, 1874, to Michael and Magdalene (Compter) Hering. From 1894 to 1898 he studied at the Art Students' League and in 1900 and 1901 at the École des Beaux-Arts and the Colarossi Academy in Paris. He had worked for Philip Martiny before he became a pupil of Saint-Gaudens in 1900, with whom he continued to be associated until the latter's death in 1907. He helped install Saint-

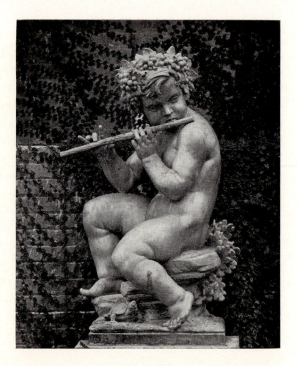

WOOD NYMPH

Aluminum statue. Height 3 ft. 10
in. Base: Width 1 ft. 9¼ in.—
Depth 1 ft. 4¼ in. Signed on base
at right: HENRY HERING SCULP-
TOR © 1932 Founder's mark:
THE GORHAM CO FOUNDERS
Placed in Brookgreen Gardens in
1936.

Gaudens's work at the Buffalo Exposition and worked on the coinage designs entrusted to him. This apprenticeship perfected him as it had Weinman and Fraser in the art of low relief. He produced a few medals of clear and harmonious design and in portrait plaques often adopted Saint-Gaudens's method of showing the person almost at full length, seated in profile in a chair. Among the works done by 1912 is one of his finest, a serenely beautiful head of a boy, Roger Platt, the delicate contours of the face and the crisp curls ably rendered. Classic traditions governed Hering's dancing *L'Allegro* and a *Diana* running.

His first major architectural work produced independently was the Civil War Memorial for Yale University in 1913. The panels of allegorical figures have a classic simplicity and repose, while Saint-Gaudens's training can be seen in the purity of the modeling and the careful finish. Many commissions for architectural decorations filled the next ten years. A series of symmetrical classic figures for the Field Museum at Chicago was done in 1916 and 1917. There were also symbolic statues for Federal Reserve banks in several cities. Chicago claimed the greater part of his later work. It includes the pictorial groups *The Defense of Fort Dearborn* and *The Regeneration of Chicago after the Great Fire* done in 1928 for the south pylons of the Michigan Boulevard Bridge, a pediment for the Civic Opera House, and sculpture for the Union Station, seated allegorical figures in the manner of Daniel Chester French. The 1929 Indiana State War Memorial at Indianapolis, *Pro Patria*, took the

form of a youth striding forward with an unfurled banner floating around him. Four reliefs for the Civic Center at Indianapolis are formal and archaistic in treatment. In this group of sculpture by Hering is a seated statue of Lincoln. With Lentelli, Hering was in charge of arranging the National Sculpture Society exhibition at San Francisco in 1929 and showed there a large group of his works. Hering died on January 15th, 1949. He was a fellow of the National Sculpture Society and a member of The Architectural League of New York, the National Academy of Design, and the Art Commission of New York.

Wood Nymph

A child with a wreath of grapes in the hair sits sidewise on a rock, playing a pipe. Behind the rock springs an oak branch and at the base a turtle lifts its head.

Wood Nymph

A child, the head framed by bunches of pine needles and cones, sits sidewise on a rock, playing panpipes while a frog listens. An oak branch grows from the rock.

Aluminum statue. Height 3 ft. 8½ in. Base: Width 1 ft. 9¼ in.—Depth 1 ft. 4¼ in. Signed on base at left: HENRY HERING SCULPTOR © 1932 Founder's mark: THE GORHAM CO FOUNDERS N.Y. Placed in Brookgreen Gardens in 1936.

Evelyn Beatrice Longman

THE ONLY WOMAN admitted as an assistant in Daniel Chester French's studio was Evelyn Longman. She was born at Winchester, Ohio, on November 21st, 1874, and christened Mary Evelyn Beatrice. Her father, Edwin Henry Longman, was a musician of English stock who had resorted to farming for an existence; her mother, Clara Delitia (Adnam) Longman, was Canadian by birth. Miss Longman had some schooling in Chicago, where at the age of fourteen she went to work in a wholesale house. Evenings of study at the Art Institute and the stimulus of the Columbian Exposition inspired her

to save for more education. At the end of seven years she was able to attend Olivet College, Olivet, Michigan. When she had spent a year and a half studying German and painting, she discovered her true vocation and enrolled in the modeling classes of Lorado Taft at The Art Institute of Chicago.

After a year of study she began to teach and, upon graduating with the highest honors, conducted the summer class in sculpture. A year later, in 1900, she left for New York. She assisted MacNeil and Konti on the decorations for the Pan-American Exposition and similar work before she entered French's studio. She seems to have had no leanings towards the realistic side of French's art, but during her association with him she developed a taste for the classic style and evolved her own distinctive purity of line.

She began an independent career after three years, although she kept her connection with French. The *Victory* for the Saint Louis Exposition marked her appearance as an individual sculptor. Two years later came a visit to Italy and an honorary degree from Olivet College. In 1906 she won in competition the contract for doors for the United States Naval Academy at Annapolis and by 1911 had completed the Wellesley College Library doors. The former are richly ornamented, with an allegorical relief on each valve and smaller panels above and below; the latter, of a soberer design, have single figures in classic style. This classicism was fostered by collaboration with the architect Henry Bacon, their first joint work being for the Panama-Pacific Exposition, where she designed the *Fountain of Ceres*, a drum carved with girls in floating Grecian draperies and a single figure at the top; they were also responsible for the Illinois Centennial Memorial column at Chicago.

During this time Miss Longman was modeling busts of girls, smoothly designed rather in the manner of Herbert Adams, and bas-reliefs in the established Saint-Gaudens tradition. The first had been the Storey Memorial of 1905 in Lowell Cemetery, representing Silence, and the Ryle Memorial tablet for Paterson, New Jersey, an angel holding a portrait plaque. Then and later she often used the seated figure in profile, as in the reliefs of Theodore C. Williams with an angel beside him, which was awarded the Watrous Gold Medal of the National Academy of Design in 1923. On that of D. C. French she introduced behind the figure a frieze of his principal works. Quite different from the other busts of girls is *Bacchante Head*, a gay study of Margaret

VICTORY

Reduction in bronze. Height 2 ft. 5½ in. Signed on globe at back: EVELYN B. LONGMAN 1908 Founder's mark: QCWH GORHAM CO Placed in Brookgreen Gardens in 1936. Other examples: Chicago. Art Institute, Union League Civic and Arts Foundation (bronze statue); Indianapolis. The John Herron Art Institute; New York. The Metropolitan Museum of Art; Saint Louis. City Art Museum (bronze statue); The Toledo Museum of Art.

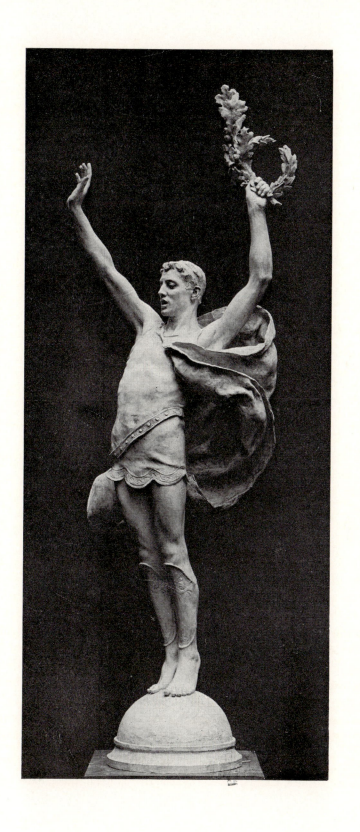

French, decoratively treated and cleanly modeled.[1] She has done some heads of men, strongly characterized, such as the *Ivan Olinsky* which won the Shaw Prize in 1926, one of Edison in the Deutsches Museum, Munich, and one of the Negro singer John Wainwright, at Hampton Institute.

It was about the time of the Panama-Pacific Exposition that she began to model the figures which embody her private vision of universal themes. *The Future*, in the Parthenon, Nashville, Tennessee, won the Shaw Prize of the National Academy in 1918, the W. M. R. French Gold Medal of The Art Institute of Chicago in 1920, and the Widener Gold Medal of The Pennsylvania Academy of the Fine Arts in the following year. In the same thoughtful vein are *Destiny* and *Nature*, while *Consecration* has a deeper emotional content. She repeated her early success with *Victory* in the male figure *Electricity* surmounting the American Telephone and Telegraph Building, New York, and a later work, *Song of the Pines*, has the same vitality and sense of physical energy coupled with a measure of reserve. On June 28th, 1920, Miss Longman married Nathaniel Horton Batchelder, headmaster of The Loomis Institute, Windsor, Connecticut, where she thereafter had her studio. Much of her subsequent work was done for Connecticut towns: war memorials for Naugatuck and Windsor, the Spanish War Memorial in the form of Victory on a ship's prow and the Monument to Pioneers of Industry at Hartford. In 1933 she carved the decorative frieze for the Post Office and Federal Building, Hartford. In the midst of these serious commissions she found time for a few cheerful fancies such as the *Boy and Fish Fountain* on the Rockefeller Estate at Pocantico Hills, New York, and the *Sea Horse and Baby Fountain*. She was the first woman sculptor elected to full membership in the National Academy of Design. Miss Longman was also a member of the Connecticut Academy of Fine Arts, and The American Numismatic Society, and a fellow of the National Sculpture Society. She and her husband retired to Cape Cod in 1949, and she died there on March 10th, 1954.

Victory

A young man stands on tiptoe on a globe, his body arched outward, shouting exultantly. Both arms are raised, an oak spray and a laurel wreath held in the left hand. He is clad in a short tunic with a sword belt and in acanthus-patterned greaves. A cloak fastened over his right shoulder is blown sidewise behind the figure. His short, loose curls are bound with a fillet. The

1 It is also called *Peggy*. There are examples in The Norton Gallery and School of Art, West Palm Beach, Florida, and at The John Herron Art Institute, Indianapolis.

original statue was designed for the dome of Festival Hall at the Saint Louis Exposition in 1904 and the reduction made later from the study. The verve of the figure makes appropriate its adoption as a trophy by the Atlantic Fleet.

Rudulph Evans

RUDULPH EVANS was born at Washington, D.C., on February 1st, 1878, the son of Frank L. and Elizabeth Jeanette (Grimes) Evans. He began his art studies at the Corcoran Art School in Washington and continued them at the Art Students' League, New York. In 1905 he went to Paris, attending the Académie Julian and the École des Beaux-Arts and receiving instruction from Falguière, Puech, and Rodin. An impressionistic mask of Maude Adams, dating from 1906, shows the influence of Rodin. Establishing a studio in Paris, he stayed there until about 1917, when he transferred his residence to New York. In 1912 a fountain group of a maiden and swans was commissioned for the Rockefeller Estate at Pocantico Hills, New York.

His work, *The Golden Hour*, was awarded a bronze medal at the Paris *Salon* of 1914, and in 1915 it was acquired for the Musée du Luxembourg and a marble replica by The Metropolitan Museum of Art, New York. This statue of an adolescent girl, with a slight drapery about the lower part of the figure, is in the classic tradition of calm poise and serenity, but there is individuality in the head and in the confidence of the easy pose. Several full-length studies and torsos exemplify his restraint and ability in presenting the nude in a harmonious form. Other statues for memorials and gardens keep to the classic vein. The memorial to Clarence M. Woolley at Detroit, that to Jean Webster McKinney at Greenwich, Connecticut, and the William Rieman Memorial at Green Bay, Wisconsin, are draped figures with regular features and quiet attitudes.

Dignified portrait busts and statues are idealized representations, with little attempt at subtleties of characterization. Among the most successful are portraits of children, whose soft contours lend themselves to refinements of modeling. The statue of Robert E. Lee is in the Capitol at Richmond, Virginia; those of J. Sterling Morton and William Jennings Bryan in the Capitol at Washington, D.C.; one of John B. Pierce was made for the Pierce Foundation at New Haven. His portrait busts of Whittier, Longfellow, George Bancroft, and Grover Cleveland are in the Hall of Fame, New York University. In 1941 his model won the competition for a heroic bronze statue of Jefferson to be placed in the Thomas Jefferson Memorial, Washington,

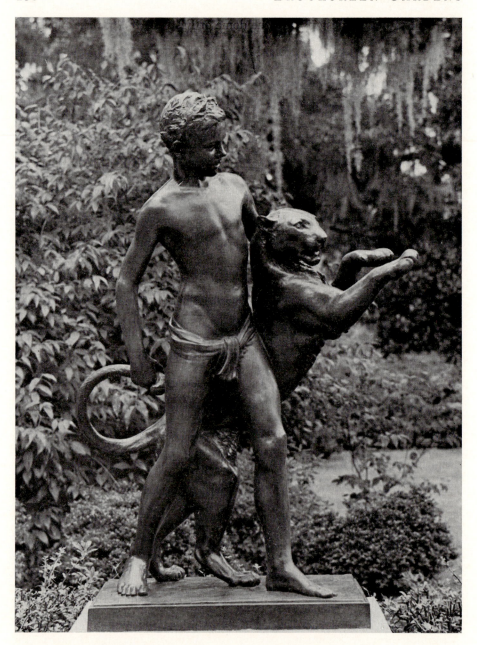

BOY AND PANTHER

Bronze group. Height 4 ft. 9 in. Signed on base at right: $\frac{R}{EVANS}$ No. 2. Founder's mark: GARGANI ·· FDRY. N.Y. Placed in Brookgreen Gardens in 1937.

D.C. At the dedication of Baruch Houses in New York City a bust of Bernard Baruch by Evans was unveiled. Evans was made a *chevalier* of the Legion of Honor in 1934 and a *cavaliere* of the Order of the Crown of Italy. He was an honorary member of the National Sculpture Society and a member of the National Academy of Design and of the National Institute of Arts and Letters. He died on January 16th, 1960.

Boy and Panther

A boy is walking forward with a panther rising on its hind legs beside him. One arm supports its body, and the other hand grasps the end of the curled tail. The equilibrium of the two figures and their firmly modeled bodies make a fine composition. This group, an interpretation of Kipling's *Mowgli*, was originally designed for the garden of Frank A. Vanderlip, Scarborough, New York. It was awarded the Watrous Gold Medal at the winter exhibition of the National Academy of Design in 1919.

Athlete

A muscular youth stands with a spear held in his right hand, the butt resting on the ground. His left hand is slightly extended, palm up, as if acknowledging applause. The sturdy body is of classic proportions, with narrow hips, broad shoulders, and thick torso. His hair in short unruly locks is bound with a narrow fillet. He has a long, straight nose and full chin. The eyes are deeply hollowed out beneath a narrow forehead, and small ears lie close to the head.

This statue was done in 1915 to present the harmonious beauty of a fine physique. The model was at the time champion middleweight wrestler and javelin thrower of Italy.

Bronze statue, with hair and tip of spear gilded. Height 7 ft. 9½ in. Base: Width 1 ft. 8 in.—Depth 1 ft. 8 in. Signed on base at back: R EVANS Founder's mark: ROMAN BRONZE WORKS N-Y- Placed in Brookgreen Gardens in 1950.

Haig Patigian

HAIG PATIGIAN was born in the city of Van, Armenia, on January 22nd, 1876, the son of Avedis and Marine (Hovsepian) Patigian. He received his early education from his parents, who were teachers in the American Mission School. As a young man he came to the United States and settled in San Francisco. In sculpture he was self-taught except for criticisms from Alix Marquet during a period of study at Paris in 1906 and 1907. His *Ancient History*, later owned by the Bohemian Club, San Francisco, was exhibited at the Paris *Salon*. One of the most prominent of the sculptors working on the West Coast, he was called upon for innumerable monuments, architectural sculpture, and portrait statues and busts. Among the first was the McKinley Monument for Arcata, California. Some memorials and decorations for the Machinery Palace and the Palace of Fine Arts at the Panama-Pacific Exposition, where he received a medal for distinguished services, made his sculpture widely known. The lavish ornament of the Machinery Palace gave the sculptor an opportunity to demonstrate his strong sense of form and balanced design. His architectural work was continued in ten figures of the arts and sciences for the tympanum of the M. H. de Young Memorial Museum and a pediment for the Metropolitan Life Insurance Building, San Francisco. On this pediment the curving lines of the seated figures in high relief, the soft drapery, and a background rich in detail form an ordered composition. Skillful handling of relief was again shown on the neoclassic bronze shaft, *Allegory of Achievement*, presented to Charles M. Schwab by the shipbuilders of the Pacific Coast. A heroic statue of General Pershing was made for San Francisco and a seated *Lincoln* for the Civic Center there.

In 1929 Patigian's work received recognition in the East when his bust of President Hoover was placed in the White House at Washington. Subsequently a heroic statue of Thomas Starr King was commissioned for Statuary Hall in the Capitol, and the aeronautics pediment of the Department of Commerce Building was entrusted to him. Of a less official character, the products of his own imagination, are symbolic subjects. *Friendship* is represented by two powerfully modeled male figures back to back, clasping hands.[1] Heroic groups and figures with allegorical titles were commissioned for the Golden Gate Exposition. Definitely in the classic tradition, his modeling is

1 The original plaster is in the collection of The American Academy of Arts and Letters; a bronze is at the Olympic Country Club, San Francisco.

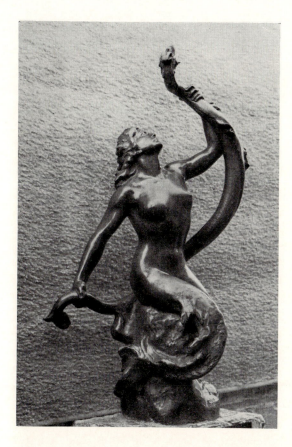

NEREID

Bronze statuette. Height 2 ft. 2½
in. Signed on base at front: HAIG
PATIGIAN 1928 Founder's mark:
CALIF. ART BRONZE FNRY. L·A·
Placed in Brookgreen Gardens in
1937.

distinguished by warmth and color and, in male nudes, emphasis on powerful
muscular development. Portrait statues are treated in a moderately realistic
manner. The sculptor was a member of the International Jury of Awards for
sculpture at the Tenth Olympiad in 1932, and in 1939 received the Founders'
First Prize and Logan Medal of the Society for Sanity in Art, San Francisco.
He was a member of the California National Guard, belonged to the National
Sculpture Society, the National Institute of Arts and Letters, and the Société
des Artistes Français, and was an honorary life member of the Bohemian
Club, San Francisco. He died on September 19th, 1950.

Nereid

A nereid with legs terminating in fins is seated on a rock. Behind her back
curves the body of a sea serpent, as she gazes up at its raised head supported
in one hand, while the other hand is lowered to grasp the tail. The richly
modeled surfaces of the figure merge into the less defined masses of the hair
and fins.

Robert Ingersoll Aitken

ROBERT INGERSOLL AITKEN was born to Charles H. and Katherine (Higgins) Aitken at San Francisco on May 8th, 1878, and his early life was spent there. Except for a visit of a few month to Paris he received his only formal art education during a year at the Mark Hopkins Institute with the painter Arthur F. Mathews and the sculptor Douglas Tilden as instructors. When Aitken was eighteen he opened his own studio, receiving commissions for some decorative work. His first important achievements were the *Victory* crowning the column erected in honor of the American navy after the Battle of Manila and a monument to McKinley, both at San Francisco. He taught at the Mark Hopkins Institute from 1901 to 1904 and worked in France from then until 1907. Upon his return to the United States he settled in New York and became an instructor at the Art Students' League and director of the schools of the National Academy of Design. A bust of William Howard Taft exhibited in 1910 shows the fluent handling, the suppression of inelegant detail, and the unified artistic effect which are the qualities of the many busts made much later for the Hall of Fame at New York University. Imaginative works such as the embracing figures called *The Flame*, which received the Barnett Prize of the National Academy of Design in 1908, and a figure against a rough-hewn background, *A Creature of God till now Unknown*, have the emotional content and the sensuous surfaces made popular by Rodin.

At the Panama-Pacific Exposition of 1915 Aitken had a chance to reveal his true stature in the robust nudes of the *Four Elements* and the *Fountain of the Earth*, in which he developed an elaborate allegory. The latter won the Architectural League's medal of honor for sculpture. These successes found an echo in later work. The composition of the Elements, half-reclining figures in a setting of appropriate attributes, was repeated in the colossal bronzes representing the Missouri and Mississippi rivers for the Missouri State Capitol, and the intricate pattern of standing figures which surrounded the *Fountain of the Earth* in the *Fountain of the Arts and Sciences*, also for Jefferson City. Symbolism is also present in the Gompers Monument at Washington, D.C., where two groups of figures clasping hands above the labor leader's head make a compact design. Another subject to Aitken's taste was the group of *Light Dispersing Darkness* for the General Electric Company at Nela Park, Cleveland, Ohio. Two nude figures, male and female, rise above crouching hooded forms, joining torches. For the dramatic tableau which makes up the George Rogers Clark Monument at Charlottesville, Virginia, the Indian

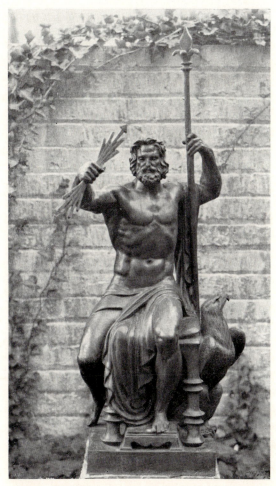

ZEUS

Bronze statuette. Height 3 ft. 4
in. Signed on base at right,
within a circle: △ Founder's
mark: GORHAM CO FOUNDERS
Placed in Brookgreen Gardens in
1934.

fighter is on horseback, with Indians grouped before and trappers behind.
The Watrous Gold Medal of the National Academy of Design, which the
sculptor himself created, was awarded to him for this work in 1921. The free
style of the portrait busts is carried out in the statue of Robert Burns at Saint
Louis, in which he is represented as the peasant poet with sheaves of wheat
and a sickle beside him. Aitken's Memorial to Pioneer Lumbermen is in
Huron National Park, Michigan, and his equestrian statue of Major General
O. O. Howard at Gettysburg.

A pediment for the United States Supreme Court Building and symbolic
figures at the entrance to the National Archives Building, Washington, D.C.,
in neoclassic style like the architecture, and a frieze of famous artists for the
Columbus Gallery of Fine Arts carried on his architectural work. He went to
France as a captain in the United States Army during World War I, and a
group of war memorials departs from his usual manner in a literal presenta-
tion of soldiers in action. Among them is *The Marine* of Parris Island, South

Carolina. His medallic work includes the fine Panama-Pacific Medal, the fifty-dollar gold piece struck at that time, and the Missouri Centennial half dollar. He is also the author of a few graceful and spirited decorative figures such as *The Wounded Diana* and *The Find*, a mermaid and satyr fountain group. A *Bacchante* is in the Baltimore Museum of Art and a *Tired Mercury* in the City Art Museum, Saint Louis. The clue to his sympathies is given in his statue of Michelangelo carving the *Day* for the Medici tomb, which indicates the source of his muscular nude figures in heroic style used to express abstract ideas. He served as president of the National Sculpture Society, vice-president of the National Academy of Design and of the National Institute of Arts and Letters, and a member of The Architectural League of New York and the Union Internationale des Beaux-Arts et des Lettres. Aitken died on January 3rd, 1949.

Zeus

The powerful form of the god is seated on a low throne, one foot resting on a footstool. In one hand he holds a staff, and raised in the other a sheaf of thunderbolts. A piece of drapery falls in regular pleats over one shoulder and across the thighs. An eagle stands by the throne. The sketch model was designed for a heroic figure to surmount the American Telephone and Telegraph Building, New York, where Evelyn Longman's standing figure was finally placed. It was especially cast by The Gorham Company for their exhibit at the Panama-Pacific Exposition in 1915.

Edith Barretto Parsons

MRS. PARSONS was born at Houston, Virginia, as Edith Barretto Stevens on July 4th, 1878, the daughter of John Henry and Emily Gilman (Hoffman) Stevens. Her teachers at the Art Students' League were Daniel Chester French and George Grey Barnard. There she won a sculpture prize and a scholarship for the years 1901 to 1902. By 1904 she had made a candlestick of a girl asleep under a poppy, *Figure of Spring*, and *Spirit of Flame*. For the Saint Louis Exposition in that year she was entrusted with the figures for the Liberal Arts Building. *Earth Mother* was exhibited at the National Academy of Design in 1908, the year of her marriage to Howard Crosby Parsons. The

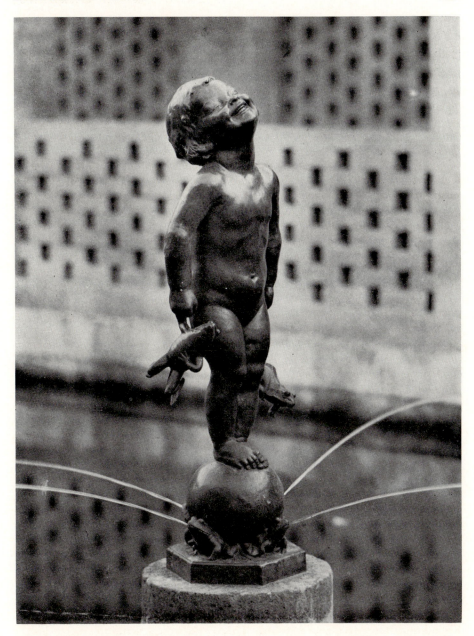

FROG BABY

Bronze statue. Height 3 ft. 3½ in. Founder's mark: #26 ROMAN BRONZE WORKS N.Y. Placed in Brookgreen Gardens in 1934. Other example: Muncie, Ind. Ball State Teachers' College.

sculptor made many busts and some memorials, one at Saint Paul, a fountain to John Galloway at Memphis, and a monument to the soldiers of World War I at Summit, New Jersey.

Better known from their wide circulation are her fountain figures of merry babies. One of them is in Forest Lawn Cemetery, Los Angeles, and another in Harkness State Park, near New London, Connecticut. *Joy Fountain*, two children peering over the rim of a bowl, is on an estate at Old Westbury, Long Island. The *Turtle Baby* is in the Cleveland Museum and *The Bird Baby* on the grounds of the Brooks Memorial Art Gallery, Memphis, Tennessee. Their brothers and sisters, the *Laughing Frog Baby*, the *Fish Baby*, and the *Duck Baby* ornament many gardens. Mrs. Parsons, who was a fellow of the National Sculpture Society, died on September 26th, 1956, at New Canaan, Connecticut.

Frog Baby

A baby girl stands with both feet together on a globe resting on four frogs. She looks upward laughing, a frog held by one leg dangling from each hand. Feet and toes are squeezed together to hold in her mirth over the capture of the frogs. The chubby forms and infectious merriment of childhood are engagingly recorded. It was exhibited at The Architectural League of New York in 1917.

Tait McKenzie

ROBERT TAIT MCKENZIE was born at Almonte, Ontario, on May 26th, 1867, the son of the Reverend William and Catherine (Shiells) McKenzie. He was educated for the medical profession and was given the degree of doctor of medicine at McGill University in 1892. He began his career immediately as medical director of physical education and demonstrator in anatomy at the University. This work was broken only by brief periods as a ship's surgeon and as house physician to the governor-general of Canada. In 1904 McKenzie came to the United States as a professor and director of the department of physical education at the University of Pennsylvania, a post

which he held until 1930. He then became research professor of physical education, a subject about which he wrote several books.

His interest in the development of the body led him to model, in 1902, a figure called *The Sprinter*, as an athletic type [1] and *The College Athlete* from a series of student measurements as a canon of perfect proportion. After this initial experiment, Dr. McKenzie persevered as a sculptor, producing many statuettes of athletes engaged in all manner of sports. He has modeled *The Plunger, The Ice Bird, The Discus Thrower, The Pole Vaulters*, and groups such as *The Eight* and *The Onslaught*, a football scene.[2] In all these figures he sought to reproduce as accurately as possible the lean nervous physique of American young men, selecting some moment in the action when the subject was gracefully poised. The medallion of three hurdlers called *The Joy of Effort*, commemorating the Olympic Games of 1912, was presented to Sweden and placed in the stadium at Stockholm.

From this special field he made further advances in the art of sculpture. His statues of the youthful Franklin and of the Reverend George Whitefield, the dramatic pose of the figure heightened by the billowing sleeves of the gown, were made for the University of Pennsylvania campus; a seated statue of Dean West for Princeton University. McKenzie's war memorials, such as those at Cambridge, England, at Edinburgh, Scotland, and at his birthplace in Canada, are realistic studies of soldiers in uniform. During the war he was engaged in research on the physical rehabilitation of wounded soldiers, including the making of masks for the disfigured. In 1927 he was given the contract for a statue of Wolfe to be erected at Greenwich, England. He died at Philadelphia on April 28th, 1938. Hussey writes of him:

"In his normal occupation of supervising the physique of the students at the University of Pennsylvania, training its athletes and embodying their forms in sculpture, one cannot say when he is artist and when scientist. It is not claimed that his work possesses the specialized aesthetic significance of some modern work . . . At heart McKenzie is a thinker before he is an artist, a scientist before a sculptor, yet beauty for him is not a thing apart from life, but organically one with humanity . . . Beauty for him is the human form in perfect health seen in graceful movement." [3]

1 There are examples in the Fitzwilliam Museum, Cambridge, England, and in the Yale University Art Gallery.

2 All these are in the large collection of his works in the Yale University Art Gallery; *The Ice Bird* is also at Amherst College, *The Onslaught* at the University of Pennsylvania, *The Flying Sphere* in the City Art Museum at Saint Louis, and *The Competitor* in The National Gallery of Canada, Ottawa.

3 Hussey. p. v.

THE YOUTHFUL FRANKLIN

Model in bronze. Height 3 ft. Signed on base at left: *R. Tait McKenzie 1914*
On front: 1723 1706 The YOUTHFUL FRANKLIN 1790 Founder's mark: OIDK
GORHAM CO Placed in Brookgreen Gardens in 1934. Other examples: Chapel Hill.
The University of North Carolina; The Newark Museum.

The Youthful Franklin

The young Franklin strides forward with a sturdy walking stick in one
hand and a bundle in the other, looking eagerly ahead. He is dressed in
colonial costume. The dates on the base are 1706, his birth; 1723, the year he
arrived at Philadelphia, having walked from Amboy to Burlington; and 1790,
his death. The original statue, a gift of one of the classes to the University of
Pennsylvania, stands on the campus there. It was commissioned in 1910 and
unveiled in 1914, being given honorable mention at the Panama-Pacific
Exposition in 1915. The sculptor's account of the making of the statue is as
follows:

". . . the figure was 'first modeled in clay in the nude, in preparation for
which a week or so was spent in studying the walking pose by having the
model walk up and down and stopping the pace at different stages of the step.

" 'After the figure was completely modeled in the nude, it was draped with
the costume, which was obtained after much searching, and by consulting the
standard works on the costumes of the period, as well as by the kind assist-
ance of the late Howard Pyle, who made a number of sketches showing the
probable costume of a boy of that time . . . The shoes were modeled from old
and discarded shoes obtained from the . . . shoemaker, so that the creases
would be those actually produced by much wear.' " [4]

"Its animation largely proceeds from the upward tilt of the head, and its
turn to the right. From the head two swirling lines are carried downwards in
the folds of the coat that echo the eager pace of the figure." [5] For the face, the
Houdon bust, rejuvenated, was used as a model. On the base of the original
statue are Franklin's words, "I have been the more particular in this descrip-
tion of my journey that you may compare such unlikely beginnings with the
figure I have since made there."

4 Eberlein. p. 256.
5 Hussey. p. 52.

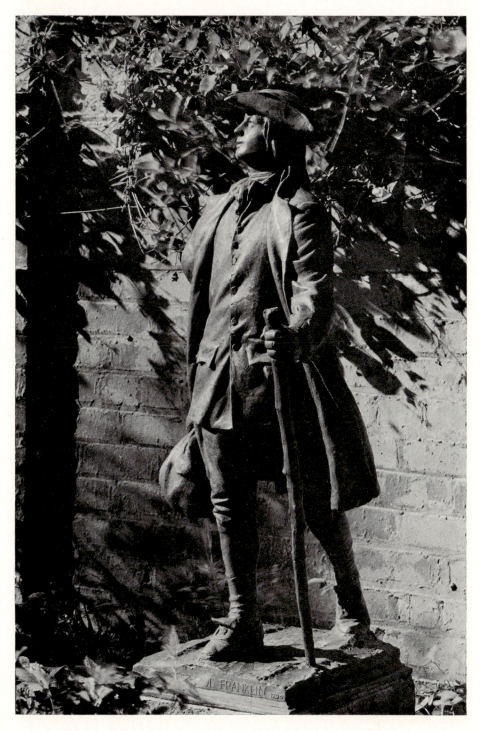

Charles E. Tefft

CHARLES EUGENE TEFFT was born at Brewer, Maine, on September 22nd, 1874. As a young man he came to New York and studied at the Artist-Artisan Institute, becoming instructor in modeling there in 1898. His teachers had been Blankenship and F. W. Ruckstull. Later he worked as an apprentice to J. Q. A. Ward and came under the influence of Saint-Gaudens, whom he most admired and followed. Like many of his contemporaries he was employed on sculpture for the Pan-American Exposition at Buffalo. His *Lake Erie* and *Lake Superior* for the electric tower won special commendation for vigor of modeling. The latter was a male figure casually seated astride a dolphin-decorated pedestal, a downturned water jar under one arm. Soon afterwards the Saint Louis exposition again gave him an opportunity. A symbolic *Iowa* for the Terrace of the States and *Renaissance Art* for the façade of the Palace of Fine Arts fell to his lot. In them he followed the prevalent neoclassic manner. A fountain for the New York Botanical Garden brought forth different qualities. Set in a monumental stair at the head of a long slope, it was conceived in the spirit of Italian baroque fountains, with the surging movement of galloping horses and muscular riders. The Fort Lee Battle Monument, dedicated in 1908 to the valor of the Continental Army, consisted of realistic figures of a soldier and a drummer boy scaling the Palisades and peering over a pile of rocks.

Tefft's studio was established for a time at Tompkinsville, Staten Island, and later at Guilford, Maine. Ill health prevented him from pursuing his career to the fullest extent and made it possible for him to produce only a few major monuments. A memorial of the First World War at Belleville, New Jersey, unveiled in 1922, took the form of a Victory holding palm and shield. The quiet standing figure and classic draperies are in the ample monumental style of the followers of Saint-Gaudens. Four years later Tefft was chosen director of sculpture for the Sesqui-Centennial Exposition at Philadelphia. A statue of William H. Maxwell, former superintendent of New York schools, was modeled for The American Museum of Natural History. Tefft followed the example of Saint-Gaudens by seating his subject in a thronelike chair and adding the dignity of a heavy robe. A statue of Hannibal Hamlin, Lincoln's vice-president, was entrusted to the sculptor and erected at Bangor, Maine, in 1927, financed by public subscription. In the same city the Peirce Memorial commemorating the lumber industry took the form of a group of river drivers

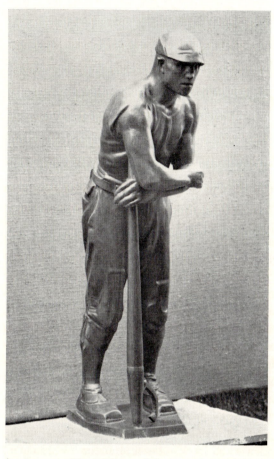

RIVER DRIVER

Height 1 ft. 10¾ in. Base: Width
7 in.—Depth 6½ in. Signed on
base at right: C. E. TEFFT.
Placed in Brookgreen Gardens in
1950.

in the act of breaking a log jam. A work to which the sculptor devoted much care and thought was *Lincoln in Prayer*.

In 1949 Tefft spent the winter at the Brazilian Embassy in Washington aiding the Ambassador's wife, Maria Martins, with her sculpture. At the same time he was perfecting his own conception, *The Power of Thought*, which was to have been erected in Brazil. For the last three years of his life he lived with a nephew at Presque Isle, Maine, where he died on September 20th, 1951.

River Driver

A lumberman stands, both arms crossed, leaning on his peavey, looking intently ahead. An undershirt and loose pants to below the knee hardly disguise his muscular form and wide, powerful shoulders. He wears heavy boots and a cap with the visor turned down over a low forehead. A small head, with small eyes, a broken nose, and a crooked mouth, is set on a thick neck.

The modeling is realistic but greatly simplified. When Tefft lived in Maine, the spring log drive down the Penobscot River was a familiar sight. One of the rugged lumbermen inspired this graphic characterization of a river driver, a study done in preparation for the group forming the Peirce Memorial at Bangor, erected in 1925.

Abastenia St. Leger Eberle

ABASTENIA ST. LEGER EBERLE was born at Webster City, Iowa, on April 6th, 1878, the daughter of an army doctor, Harry A. Eberle and his wife Clara Vaughan (McGinn) Eberle. Her youth was spent at Canton, Ohio, and in Puerto Rico. There she observed native life and scenes and began to record them in clay. These efforts were supplemented in 1899 by three years' study at the Art Students' League with Kenyon Cox, C. Y. Harvey, and, in particular, George Grey Barnard. She had also some criticisms from Gutzon Borglum. In 1904 and 1905 she modeled the human figures and Anna Vaughn Hyatt the animals for a few groups done in collaboration. Their *Men and Bull* was awarded a bronze medal at the Louisiana Purchase Exposition, and *Boy and Goat Playing* was shown the next year. In 1907 and 1908 she was in Italy having some of her work cast and in 1913 at Paris. For a space, at the end of her student days, she had worked in the classic manner and modeled impressionistic studies of dancers in fluttering veils, and Indian subjects, but she soon returned to simple human themes.

Animated by the writings of Jane Addams and by the desire to produce work of social as well as artistic significance, she began to frequent the lower East Side of New York City. Establishing a studio on Madison Street in 1914, she interpreted the people who lived there, especially children. A series of statuettes reveals them in their daily activities, in gay or somber moods. The sense of rhythm which had shaped the flying draperies of her *Dancer* was transferred to the lively motions of little girls stepping to ragtime or riding on roller skates.[1] In quieter themes such as *The Bath Hour*, *Little Mother*, and *The Stray Cat*, a warm sympathy pervades the skillfully arranged groups. More specifically didactic are a few works, among them *The Ragpicker* and *Pinioned*. *Yetta and the Cat Wake Up* has the grace and intimate charm of

1 *Ragtime* is at The Detroit Institute of Arts; *Girl Skating* in The Metropolitan Museum of Art, the Whitney Museum of American Art, New York, and at the Rhode Island School of Design.

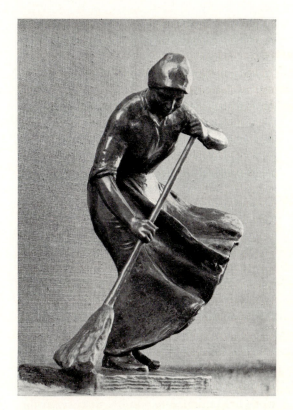

THE WINDY DOORSTEP

Bronze statuette. Height 1 ft. 2 in. Signed on base at back: *A · S? L · Eberle*
Placed in Brookgreen Gardens in 1934.
Other examples: Baltimore. Peabody Institute (on loan to The Baltimore Museum of Art); The Newark Museum; Pittsburgh. Carnegie Institute; Worcester Art Museum.

Greek terra cottas. A new departure was the sturdy athlete of the trophy for the Pacific and Asiatic fleets. Although her subjects fall into the category of *genre*, she has given them a largeness and freedom of treatment far removed from the implications of triviality contained in that term. Her work is impressionistic in the scant attention to detail and the concentration on mass and movement. After 1919 she was in ill health and able to do little work. In these years her interest turned to garden figures, *Boy Teasing Fish* winning a Garden Club of America Prize in 1929. Two years later a small bronze was awarded the Lindsey Morris Memorial Prize by the Allied Artists of America. She was a member of the National Sculpture Society and an associate of the National Academy of Design. She died at New York on February 26th, 1942.

The Windy Doorstep

A woman with her head bound in a kerchief is sweeping, her skirts and apron blown to one side. The statuette was modeled at Woodstock, New York, in 1910, and exhibited the same year at the National Academy of

Design, where it won the Barnett Prize. In addition to a direct statement in form and movement, "the piece," as the sculptor said, "was the expression of a subjective reality—though I myself was not aware of it at the time. Later I realized why the idea of 'sweeping something out' had been so insistent." [2]

Mahonri Young

MAHONRI MACKINTOSH YOUNG was born at Salt Lake City, Utah, on August 9th, 1877, the son of Mahonri M. and Agnes (Mackintosh) Young and a grandson of Brigham Young. His grandfather had been deeply interested in the arts, and his father had some skill as a wood carver. The family lived at the Deseret Woolen Mills, outside the town, where Mahonri modeled birds and animals in clay. When he was seven his widowed mother moved to the city, and he reluctantly attended public school. Realizing that he could draw, he determined to become an illustrator and entered the class of James T. Harwood. From drawings in *Harper's*, *Scribner's*, and *Century* he learned more, and a life of Millet, whose work he continued to admire, discovered for him form, space, light, and movement. Dallin's visit to Salt Lake City to execute a monument to the pioneers of Utah gave him an impulse towards sculpture. Young got a job on the *Salt Lake Tribune* with a chance to do some drawing and saved enough money to go to New York at the age of twenty-two.

After studying at the Art Students' League he went to Paris and worked at the Académie Julian. In the beginning he devoted himself to drawing and painting, but after a visit to Italy turned to sculpture. His first bronzes, *The Shoveler* and *Man Tired*, done from memory with the aid of small sketches, set the pattern for what he wanted to do and attracted favorable comment at the American Art Association exhibition. They were followed by *Bovet Arthur—a Laborer*, which some years later, in 1911, won the Barnett Prize of the National Academy of Design; an example is in The Newark Museum. He occasionally attended sketch classes at the Delécluse Academy and had some criticism from Injalbert at Colarossi's. An injury to his thumb while he was boxing checked his modeling and turned his attention to water color, in which he was influenced by Jongkind.

He returned to Salt Lake City, where he received a commission for a monument to the sea gulls which devoured the locusts. In 1912 a trip to

2 Letter of July 7th, 1937.

teaching at the Art Students' League and elsewhere. He contributed the article on modeling to the *Encyclopedia Britannica* and several biographies of sculptors to the *Dictionary of American Biography*. He was a fellow of the National Sculpture Society, and a member of the National Academy of Design, the Society of American Etchers, and the National Institute of Arts and Letters.

The Driller

A driller in singlet, loose trousers, heavy boots, and leather apron presses down on a drill, bending slightly forward, one foot braced backward. The solidity of the figure and the breadth and truth of the modeling all add to the feeling of power.

The Rigger

The rigger is poised on a girder, holding block and tackle in one hand, waiting to make it fast to another girder. In the tense, slightly bending figure, there is a play of swinging lines. It was modeled in 1922.

Bronze statuette. Height 2 ft. 2½ in. Signed on front of base at right: MAHONRI Thumbprint on top of base. Placed in Brookgreen Gardens in 1936. Other examples: The Detroit Institute of Arts; The Newark Museum.

Sally James Farnham

SALLY JAMES FARNHAM was born on the family estate at Ogdensburg, New York, on November 26th, 1876, to Colonel Edward Christopher and Sarah Welles (Perkins) James. Her father, a noted trial lawyer who practiced first at Ogdensburg and later in New York, took her with him on many European trips, with the result that while a child she became familiar with museum collections, finding a special interest in sculpture. With riding and hunting favorite recreations, she came to know intimately the structure of horses and dogs in her life at Ogdensburg. As a child her only artistic interest was cutting out paper figures of people and animals. She went to public schools and later attended Wells College. After 1896, when she married Paulding

Farnham, painter and designer of silverware for Tiffany and Company, her home was at Great Neck, New York.

It was in 1901 during a period of enforced quiet in a hospital that she discovered a talent for modeling. To relieve the tedium and provide an outlet for pent-up energies she began to shape some plasticine that had been given her and found this activity absorbing and exciting. The new interest did not leave her when she was well. She took a statuette of a Spanish dancer that she had modeled to Frederic Remington, whom she had known at Ogdensburg, to ask his opinion of her talent. He encouraged her to persevere. Taking a studio, she carried on a career as a sculptor at the same time that she was bringing up three children. Without formal training other than criticisms from fellow sculptors such as Henry M. Shrady, Augustus Lukeman, and Frederick Roth, she developed her own technique and gradually progressed from statuettes and portrait busts to larger things. Her first commission was a *Bacchic Maiden* for a fountain to be placed in Colonel Emerson's garden at Baltimore. As a pendant to Remington's *Paleolithic Man*, modeled in 1906, she created a *Paleolithic Woman*, crouching in a cave, ready to hurl a rock at an intruder. A stay on a ranch in British Columbia turned her thoughts to the same subjects that her early mentor, Frederic Remington, had delighted in. Several studies of cowboys riding bucking broncos, and a hilarious, galloping group called *Pay Day* in the same mood as Remington's *Off the Range* were the result. One of these cowboy statuettes, dated 1905, is in the collection of The Frederic Remington Memorial at Ogdensburg.

A series of monuments established her position in the ranks of sculptors. Ogdensburg chose her, as a native daughter, to design a Soldiers' and Sailors' Monument unveiled in 1905. A classic winged Victory raised on a shaft, a soldier at the base, it followed a well-established tradition. The clinging drapery and billowing flag behind the figure added a flamboyant liveliness that was to be characteristic of her work. Other war memorials, two in cemeteries at Rochester, New York, and one at Bloomfield, New Jersey, followed.

Her talents were turned in an entirely different direction when she was called upon to design a frieze for the Governing-Board Room in the new building of the Pan American Union at Washington, D.C., inaugurated in 1910. In four long panels of pictorial reliefs she set forth decisive events of the discovery, exploration, and settlement of the New World. Figures in low and high relief in brisk action are combined with bas-relief landscape settings as if paintings had been translated into sculpture. This work brought other commissions destined for the same building. When the governments of Colombia and of Peru wished to present portraits of national heroes for the Hall of Patriots, they chose Sally Farnham to model busts of Antonio José de Sucre

and Hipólito Unanue to be carved in marble. These recreations of national patriots spiritedly evoke the characters of the soldier and the scholar. A replica of the Sucre bust was erected at Rio de Janeiro, together with one of Miguel Hidalgo.

Mrs. Farnham's knowledge of South American history and personalities, gained through these undertakings, was called upon for a far more important work. In 1916 the Venezuelan Government planned to replace a poor statue of Simón Bolívar that had formerly stood in Central Park, New York, by one of artistic merit and organized a competition to choose a sculptor. Mrs. Farnham's model was the first choice, and she set to work on a life-sized equestrian statue. A rare accomplishment for a woman at that time, it was unveiled in 1921 and hailed with great acclaim. Her love for and experience with horses made it possible for the sculptor to represent a spirited, high-stepping mount with proudly arched neck and tossing mane. She used the General's handsome uniform and flowing cape to increase the atmosphere of pomp and circumstance, while concentrating attention on Bolívar's coura-geous bearing and nobility of expression, vividly suggesting his fiery nature. In gratitude for her splendid portrayal of the Liberator, Venezuela gave the sculptor the decoration of the Order of the Bust of Bolívar.

A hero of a different sort was commemorated at San Fernando Mission, California, where in 1925 a monument to Junípero Serra by Mrs. Farnham was erected. The intrepid Franciscan missionary is shown striding along, resting his hand on the shoulder of a boy convert. In the following year another war memorial, dedicated to the heroes of the First World War, was unveiled at Fultonville, New York. At intervals the sculptor returned to her favorite equestrian subjects. *Policeman in the Rain* was chosen by the New York mounted police for presentation when the force wished to honor some distinguished person. *Will Rogers on His Pony*, a statuette modeled in 1938, shows the famous humorist, a lariat in his hands and a quizzical smile on his face, seated easily in the saddle as his horse nibbles the grass.

A long list of portrait busts of notable persons is an indication of the wide range of friends and acquaintances attracted by Mrs. Farnham's warm per-sonality and sparkling humor. She was privileged to record the features of three presidents—Theodore Roosevelt, Harding, and Hoover. For the first she was compelled to use studies from glimpses caught at a cabinet meeting. President Harding granted her and Neysa McMein permission to work simul-taneously in the executive chamber, the one modeling, the other sketching. Records of the friendship of the two artists are portraits of each other, each in her own medium. Mrs. Farnham portrayed Marshal Foch when he visited this country, and her bronze bust of Senator W. A. Clark found a place in the Corcoran Gallery of Art, Washington, D.C. Included among her sitters were

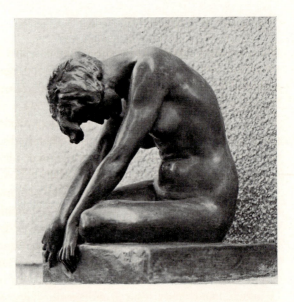

The End of the Day

Bronze statuette. Height 11¼ in.
Base: Width 8¾ in.—Depth 9¼
in. Signed on base at right: Sally
 James Farnham
Presented to Brookgreen Gardens
by Mrs. James Meehan in
 1943.

musicians and actors, such as Jascha Heifetz and Lynn Fontanne. All her
portraits were good character studies and done with a flourish that gave them
animation. After a long illness the sculptor died at New York on April 28th,
1943.

The End of the Day

Weariness and grief emanate from the bowed figure of a woman, sunk to
the ground with arms falling loosely over the knees. Her head bends heavily
downward, disheveled masses of hair shadowing classic features. The slack
muscles of the tired body are softly though realistically modeled.

This figure originated as a memorial to Vernon Castle erected at Wood-
lawn Cemetery in 1922 by his widow and dancing partner, Irene Castle.

Edwin Willard Deming

EDWIN WILLARD DEMING was born at Ashland, Ohio, on August 26th,
1860, the son of Howard and Celestia Velutia (Willard) Deming. His
grandfather had traveled from Sandisfield, Massachusetts, to Ohio in a cov-
ered wagon, and when Edwin was six months old the family moved farther
west, settling at Geneseo, Illinois, on a tract of land that had been part of the

Fox and Sac Indian reservation. As a child he became familiar with the Indians and, after spending some time among them in Indian territory, determined to devote his life to recording their beliefs and customs. He had practiced drawing and modeling with native clay, and when in 1880 a few months studying business law at Chicago failed to stir his enthusiasm, he turned to art. His art studies began at the Art Students' League, New York, in 1883 and continued in the next year at Paris, with Boulanger and Lefebvre at the Académie Julian.

After this conventional beginning he returned to the West to take up his life work of interpreting Indians and animals in painting and sculpture, although he was first employed in painting the cycloramas which were then popular. The year 1887 was spent among the Apache and Pueblo Indians of the Southwest and the Umatillas of Oregon; later Deming visited the Crows and the Sioux. On October 22nd, 1892, he married Therese Osterheld of Yonkers, New York, and took her on a wedding trip to New Mexico and Arizona. She came to share his interest in Indian life and wrote more than eleven books about them, on four of which her husband collaborated. They traveled in Mexico and Yucatan and continued to spend much of the time among the Indians of the United States and Canada. Deming was adopted by the Blackfeet, and on a later visit his entire family of six children was taken into the tribe. During World War I he was made a special instructor in marksmanship, commissioned a captain in the United States Army, and appointed senior officer in the camouflage department of the Infantry School of Arms first at Camp Perry, Ohio, and then at Camp Benning, Georgia. His design for a target was adopted as the standard. After this interruption he returned to his vocation, joining an expedition to Colombia and exploring the Matalone Indian country in 1921.

His murals of Indian life are in The American Museum of Natural History. Other paintings are *The Prayer of the Arrow*, in the Mission House of the Church of the Ascension, New York; *Gouverneur Morris Addressing the Constitutional Convention*, in Morris High School, New York; *Braddock's Defeat* and the *Discovery of Wisconsin* in the Wisconsin Historical Society Building at Madison. His *Landfall of Jean Nicolet* was adopted for the design on the Wisconsin Tercentennial stamp. His work won honorable mention at the Buffalo Exposition in 1901 and at Turin in the next year, a bronze medal at the Louisiana Purchase Exposition, and a silver medal at Philadelphia. While his paintings treat of Indian folklore, with special emphasis on the spiritual and mystical aspects, his small bronzes, mostly done between 1905 and 1910, are chiefly of animals. Bears are the subjects of *Bear Cubs Nursing* and *Mutual Surprise*, a pet cub encountering a snapping turtle. An example of the latter is in The Metropolitan Museum of Art, New York. There are

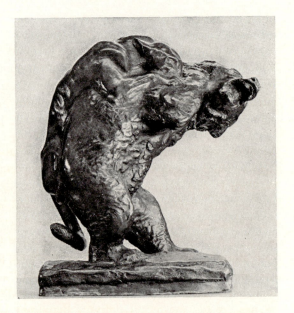

THE FIGHT

Bronze group. Height 7¾ in.
Signed on base at right: *copy-righted 1906 by* E W DEMING
Founder's mark: ROMAN BRONZE
 WORKS
Placed in Brookgreen Gardens in
 1937.
Other examples: Charleston, S.C.
Gibbes Memorial Art Gallery;
New York. The Metropolitan
 Museum of Art.

several studies of coyotes, an ibex, a mountain sheep, and a bison, one of which is in the Brooklyn Museum. *Manaboza*, the Indian Orpheus followed by wolves, the *Sioux Warrior*, and a sundial of a kneeling Indian for a garden at Fairfield, Connecticut, carry on his major interest. The intervals between his excursions into Indian country he spent in his apartment in New York and his house at Redding, Connecticut. Deming died at New York on October 15th, 1942. He was a member of many societies, including the Society of Mural Painters, the National Arts Club, the Society of Washington Artists, and the Explorers Club.

The Fight

A bear rises on its hind legs and bends forward under the weight of a mountain lion which has leaped on its back and is tearing its shoulder. In this group the sculptor has recreated a fight seen by a friend of his, an Indian. "He was watching a deer trail when he saw a grizzly coming down the trail and coming towards him from the opposite direction was a mountain lion. When they met the lion jumped on the grizzly's back and began to bite and claw the grizzly. The grizzly stood on his hind legs, growling, and reached back and nearly pulled the lion's leg off. When they parted their skins were so torn that the Indian did not skin them." [1]

1 Letter of March 18th, 1941.

Eli Harvey

AMONG THE early American sculptors of animals is Eli Harvey, born at Ogden, Ohio, a Quaker settlement, on September 23rd, 1860, the son of William P. and Nancy M. Harvey. Because he enjoyed the country around him, he was impelled to draw and paint what he saw. He succeeded so well that he was admitted to an advanced class when he entered the Art Academy of Cincinnati in 1884. He studied painting with John Noble and sculpture with Rebisso, earning his tuition by painting portraits during the summer. For one of his first orders, from an old Quaker, his payment was seventy-five sheep. His European studies were at Paris from 1889 to 1900. For painting he had as his masters Lefebvre, Benjamin Constant, and Doucet at the Académie Julian and Delance and Callot at the Académie Delécluse, while for animal sculpture he worked under the direction of Frémiet at the Paris zoo, the Jardin des Plantes.

He exhibited a landscape in the Paris *Salon* of 1895 and a pastel, *Orpheus Charming the Animals*, in 1899, winning a gold medal with it in the Paris-Province Exhibition of 1900. Thereafter he devoted himself to sculpture, chiefly of animals, although he was also the author of portrait busts. Some of the animal studies were shown at the Paris *Salons* at the end of the nineteenth century and were awarded bronze medals at several American exhibitions. The bulk of Harvey's work was produced during the early years of the twentieth century, when his studio was in New York, a comprehensive exhibition in 1912 including thirty or forty pieces. From 1901 to 1903 he modeled the sculptural ornament for the lion house at the New York Zoological Park. A standing elk for the Order of Elks was placed in club houses and cemeteries throughout the United States, and copies of a *Jaguar Rampant* were ordered for the high schools of New York City; there is also one in The Newark Museum. Lions were modeled for the Eaton Mausoleum at Toronto, a gorilla for the New York Zoological Society, a bull's head for a fountain at the Queensboro Bridge Market, New York, and in 1923 a brown bear as a mascot for Brown University. He has also combined human and animal figures in *Discord*, a struggle between a lion, a python, and a man, and in the *Prometheus* of 1901. The American Numismatic Society in 1917 commissioned him to design a medal with an eagle on the obverse to commemorate the entry of the United States into the World War. After 1929 he lived at Alhambra, California, where he died on February 10th, 1957.

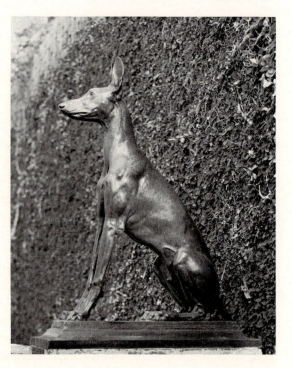

ADONIS

Bronze statue. Height 3 ft. 3 in.
Base: Length 2 ft. 7¼ in.—
Width 1 ft. Signed on base at
right: *Copyright · 1905 · by Eli
· Harvey ·* At left: ELI · HARVEY
· SC · 1905 On front: ADONIS
On top: *Young Greyhound 8
months Old* Founder's mark:
THE GORHAM CO FOUNDERS
Placed in Brookgreen Gardens in
 1934.
Other example: Los Angeles Mu-
seum of Art.

For the most part Harvey preferred to model lions, and he portrayed them
in many moods, most successfully in attitudes of repose. A group in The
Metropolitan Museum of Art, New York, *Maternal Caress*, a lioness bending
her head in a protective curve over the cub in her forepaws, has genuine
feeling. A statuette of a lioness is owned by the Cranbrook Academy of Art,
Bloomfield Hills, Michigan, and a *Greyhound Recumbent* by The Cincinnati
Art Museum. *African Elephant Scenting Danger* is in the National Collection
of Fine Arts at Washington, D.C. All these works are transcribed from life
with painstaking fidelity. Harvey was a member of the New York Zoological
Society and an associate of the Société Nationale des Beaux-Arts, Paris.
Collections of his works are in the Los Angeles County Museum of Art and
The Clinton County Historical Society, Wilmington, Ohio.

Adonis

A young greyhound, lean and tense, is seated on his haunches, the forefeet
braced, the head raised and ears lifted as he gazes intently ahead. His tail
curves over a molded base. Other examples have on the base low reliefs of
racing greyhounds and at the front a fantastic lion mask.

Young Lion With Rabbit

A lion half crouches in a defiant attitude, ears laid back, one paw on the body of a rabbit. Although modeled at Paris in 1897, one of his earliest works in sculpture, the statuette was not cast in bronze until 1904.

Bronze statuette. Height 6½ in. Base: Length 7 in.—Width 3⅛ in. Signed on base at right: *Eli · Harvey · Paris · 1897 ·* At back: *Copyright · 1904 · by · Eli · Harvey ·* Founder's mark: Roman Bronze Works N.Y. 1904 Placed in Brookgreen Gardens in 1937.

Frederick George Richard Roth

FREDERICK GEORGE RICHARD ROTH was born at Brooklyn on April 28th, 1872, to Johannes and Jane Gray (Bean) Roth. He received his early education at Bremen, since his father returned to Germany when Frederick was two years old. Foregoing a career in his father's cotton business, he studied art with Edmund von Hellmer at the Academy of Fine Arts, Vienna, until 1892 and with Meyerheim at the Berlin Academy till 1894. From 1890 he was professionally engaged as a sculptor. Though he continued to spend much time abroad, he established a studio in New York and won attention at the Buffalo Exposition of 1901 with the furious action of his *Roman Chariot Race* and with the two large animal groups, *Resting Buffaloes, Stallion and Groom,* and a small bronze, *Elephant and Trainer.* He also had a part in the Saint Louis Exposition and collaborated with Calder and Lentelli on the groups of the nations of the East and West for the Panama-Pacific Exposition. The eagles on the triumphal arch erected at Madison Square for the return of the American troops after World War I were his work. From 1915 to 1918 he was instructor in modeling at the National Academy of Design.

The small bronzes in the Metropolitan Museum, New York, done between 1905 and 1909 show his interest in representing animals in motion and the gentle sense of humor which led him to choose as subjects performing elephants and pigs straining at their tethers. He did not disdain to apply his art to useful objects such as andirons and book ends. Early in his career he experimented with pottery as a medium for sculpture, studying the technique at the Staffordshire potteries and for a year at Stuttgart. He modeled and glazed small groups and decorated bowls with animal figures, working at first

independently and later in collaboration with the Doulton Potteries. A *Polar Bear*, a *Seal*, *Watch Dog*, and a *Highland Terrier* were among them. Some of these works show a moderate geometrical stylization which he continued to employ occasionally, as in the winged horse on a spandrel of the Arch of Nations at the Panama-Pacific Exposition and the finely architectural tigers for the Princeton athletic field. The low relief panels on the new buildings of the Central Park Zoo have something of the technique of his work in tile. The planes are kept very simple and flat and the outlines of the figures sharply cut out, the details sketched in with a few definite strokes. A *Dancing Bear* and a *Dancing Goat* for the terrace are simplified enough to give them ornamental value and accent their playful mood.

In the greater part of his work he would rather present animals in their natural guise, and his fluent modeling catches the impression of the living creature, while the fur is rendered with effective simplifications. Among the statues treated in this more realistic manner are *Justin Morgan*, a horse for the government horse farm at Middlebury, Vermont, and *Balto*, in Central Park, New York, the Eskimo dog that carried serum to Nome in 1924, a work which won the Speyer Prize of the National Academy of Design in that year. The *Columbia Lion* at Baker Field, New York City, was given in 1924 by the Class of 1899 as a symbol of the University, and small replicas are presented each year to honor distinguished alumni. *The Elephant* won a National Arts Club prize in 1931, and in the same year the sculptor received the C. C. Rumsey Memorial Prize. Lifelike portrait busts in which he emphasized the salient characteristics of the model and eliminated unnecessary detail varied his production.

Roth's first essay of the equestrian monument, the horse for Lukeman's *Kit Carson* at Trinidad, Colorado, in 1910, was a preparation for the equestrian statue of Washington dedicated at Morristown, New Jersey, in 1928. The pensive cloaked figure is mounted on a sturdy horse, at rest but for the alert head. As chief sculptor of the Parks Department of New York City under the Works Progress Administration from 1934 to 1936 he designed two monuments for Central Park playgrounds with characters from *Alice in Wonderland* and *Tales from Mother Goose*, handling the story-telling themes with ease. His *Saint Francis* was awarded the Speyer Prize of the National Academy of Design in 1942. He belonged to the New Society of Artists, was president of the National Sculpture Society, and a member of the National Academy of Design, The Architectural League of New York, and the National Institute of Arts and Letters. He died at Englewood, New Jersey, on May 22nd, 1944.

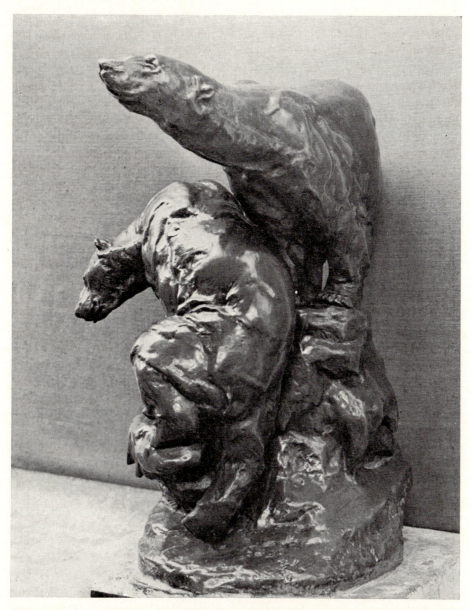

POLAR BEARS

Bronze group. Height 2 ft. Base: Length 1 ft. 5½ in.—Width 1 ft. 4½ in. Signed on base at back: F. G. R. ROTH © Founder's mark: THE GORHAM CO Placed in Brookgreen Gardens in 1934. Other examples: Amherst College; The Detroit Institute of Arts; New York. The American Academy of Arts and Letters (small).

Polar Bears

A polar bear stands on a block of ice, with lifted head and muzzle thrust forward. Another, the head lowered, clambers up a spur of ice towards its companion. While the form and movement are consistently true to nature, the broad planes and rippling edges of fur add a decorative quality. Roth was working on this group in his studio at Brussels as early as 1905, and it was largely by virtue of this achievement that he was elected to the National Academy of Design in 1906. It was awarded a National Arts Club prize in 1924.

Anna Hyatt Huntington

ANNA VAUGHN HYATT was born at Cambridge, Massachusetts, on March 10th, 1876, the daughter of Alpheus and Audella (Beebe) Hyatt. Her father was a very eminent paleontologist of his time and a pupil of Louis Agassiz. Her first study was with Henry Hudson Kitson at Boston. Later she came to New York and had a few months at the Art Students' League under the instruction of Hermon MacNeil and after that some criticisms from Gutzon Borglum. She modeled domestic animals on a farm at Porto Bello, Maryland, and wild animals at the New York Zoological Park. In 1907 she was working at Auvers-sur-Oise and the next year completed in Italy a large lion for Dayton, Ohio.

An equestrian statue of Joan of Arc, for which the sculptor was decorated with the purple rosette by the French Government, was erected on Riverside Drive, New York, in 1915; the model had been awarded honorable mention at the Paris *Salon* in 1910. She made a wall statue of Joan of Arc for the Cathedral of Saint John the Divine in 1922. In the same year she was made a *chevalier* of the Legion of Honor and a citizen of Blois, France, and her *Diana of the Chase* was awarded the Saltus Medal.

The animal sculpture that has been her special field throughout her career has consistently won awards in exhibitions, beginning with the Shaw Prize of the National Academy of Design for *Bulls Fighting;* later the Academy gave the Watrous Gold Medal to *Fillies Playing.* The Pennsylvania Academy awarded their gold medal to *Greyhounds Playing*, and the Allied Artists of

America theirs to *Nanny and Twins.* In 1958 Mrs. Huntington granted a request from the 353rd Fighter Day Squadron based at Myrtle Beach, South Carolina, by presenting them with a *Black Panther* designed especially for the squadron; whenever it is transferred, this bronze statue accompanies it.

After her marriage to Archer Milton Huntington in 1923, she shared his enthusiasm for Spain. Her equestrian statue of the Cid Campeador was presented to the city of Sevilla in 1927, and replicas were erected on the grounds of The Hispanic Society of America, New York, as well as in several other cities. More works by her added to the monumental character of the Hispanic Society's terrace: animal groups in bronze and marble and two huge reliefs carved in limestone representing Don Quixote and Boabdil on horseback. The Spanish Government recognized her achievements by decorating her with the Grand Cross of Alfonso the Twelfth in 1929, and the Academia de Bellas Artes de San Fernando at Madrid elected her a corresponding member, an honor not before given to a woman.

The equestrian statue, because it permits a study of the horse in relation to its rider, has always been one of her primary choices. A statue of Sybil Ludington, the girl Paul Revere of Connecticut, riding to alert the countryside of the approach of British soldiers attacking Danbury, has been erected at Carmel, New York. One of the Cuban patriot José Martí, showing him at the moment when he was mortally wounded riding into battle at Dos Ríos, was unveiled in Central Park, New York, at the head of the Avenue of the Americas, in 1965. In front of the Illinois Building at the second New York World's Fair stood a statue of the young Lincoln studying as he rode his horse, entitled *The Prairie Years;* the statue's permanent location is in a park at New Salem, Illinois. A statue of General Israel Putnam for Redding, Connecticut, is in progress.

Mrs. Huntington developed for the University at Madrid a group called *The Torchbearers*, to signify the continuance of civilization from one generation to another, with a rider passing on to his fallen companion the torch of enlightenment. Erected in 1955 as a joint gift with her husband a few months before his death, this work, added to earlier activities in behalf of Spanish culture, inspired more tributes to the Huntingtons in Spain. The city of Barcelona, which had already made Mrs. Huntington a member of the Real Academia de Bellas Artes de San Jorge, erected a monument to them on which was a double portrait relief by Enrique Monjo; another monument by Juan de Avalos has been projected for Madrid.

In Mrs. Huntington's studio at Bethel, Connecticut, quick sketches in plasticine crowd the shelves, many of them to be worked up for casting in bronze or aluminum. Her sculpture has been distributed among museums throughout the United States. *The Flight into Egypt*, an unusual venture into

religious subject matter, is in the Marble Collegiate Church, New York, and the National Shrine of the Immaculate Conception, Washington, D.C.

Mrs. Huntington has been the recipient of many honors. Among the most uncommon are a gold medal for distinction in sculpture from The American Academy of Arts and Letters, which organized a retrospective exhibition of her work in 1936, and a special medal of honor from the National Sculpture Society in recognition of her achievements as a sculptor and in appreciation of her unfailing interest in her fellow sculptors. In 1958 the Unión de Mujeres Americanas designated her as "Woman of the Americas," and Who's Who of American Women included her name among the fourteen most prominent women of 1960. Syracuse University and The University of South Carolina have given her honorary degrees.

Fighting Stallions

Two horses, rearing on their hind legs, are striking each other with their front hooves and biting. One has sunk his teeth into the other's neck as it throws back its head in pain. Their muscles are taut with struggle, and manes and tails disordered in the combat. One nude rider clings desperately to a horse's back, while the other, thrown to the ground, protects his head with an upthrown arm.

Don Quixote

Don Quixote, an emaciated figure in tattered trousers, wearing a breast-plate and a cloak thrown back from his shoulder, sits astride a lanky, shaggy Rocinante. The knight holds a broken lance in his right hand, the butt resting on the ground. A long neck, wrinkled like a turkey cock's, rises from bowed shoulders, and a lean chin protrudes below a strongly aquiline nose and cadaverous, deeply wrinkled cheeks. Deepset eyes under bushy brows gaze dreamily ahead, absorbed in visions. Large ears stand out from the sides of the head, which is bald except for a narrow fringe of short hair. The dispirited horse rests with forefeet braced, haunches sunk, tail between the legs, and head bowed as he nibbles at the shaft of the spear.

Aluminum equestrian statue. Height 15 ft. 1½ in. Base: Length 8 ft. 8 in.—Width 3 ft. 5 in. Signed on base at back: *Anna Hyatt Huntington Bethel, Conn. 1947* Founder's mark: ROMAN BRONZE WORKS INC N.Y. Placed in Brookgreen Gardens in 1949.

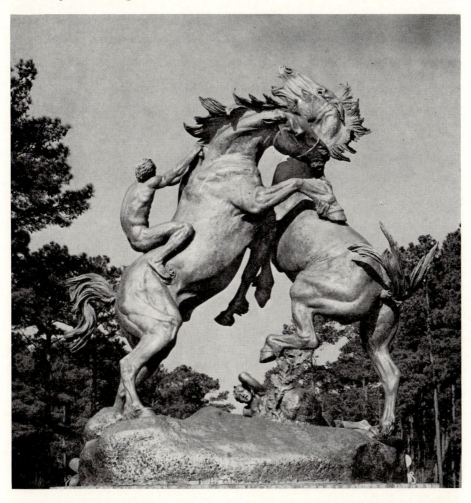

FIGHTING STALLIONS

Aluminum group. Height 15 ft.—Length 12 ft.—Width 6 ft. 4 in. Signed on base at right: *Anna Hyatt Huntington Stanerigg 1950* Placed in Brookgreen Gardens in 1951. Other example: San Marcos, Texas. State Teachers' College.

The Visionaries

A man and a woman are seated on a bench poring over a plan laid on their laps. At his left are a parrot and a monkey, books and scrolls. A Scotch deerhound lies beside her. Filling the arms of a draped cross-shaped upright

behind them is a tree with birds and animals in the branches. This symbolic group was designed to commemorate the founders of Brookgreen Gardens.

Limestone. Height 10 ft. 5 in. Base: Height 1 ft. 8 in.—Width 12 ft. 10 in.—Depth 5 ft. On base at front: THE VISIONARIES At left: ARCHER MILTON HUNTINGTON 1870 1955 On back:

THE SILVER GARDENS

Gray oaks of mystery!
 Beneath their cloister arches in pale rose
The morning creeps, Epiphany of day,
 Filling the breathing depths with prophecy.
In lambent light and lyric preparation
 To raise again the holy hymn of dawn.

A thousand choristers,
 Intone their endless canticles of birth,
By flowered founts of woven shadows luring,
 Haunted of footfalls of the fox and fawn,
Here loves chill not the hands that reach to them,
 As roses of renown sting in the gathering.

Come to the silver gardens of the South,
 Where whisper hath her monarchy, and winds
Deftly devise live tapestries of shade,
 In glades of stillness patterned,
And where the red-bird like a sanguine stain,
 Brings Tragedy to Beauty.

 A.M.H.

Diana of the Chase

The goddess stands tiptoe on a globe, gazing upward, the bow raised in the left hand, the right hand drawn back after releasing the string. Her hair, in short curls, is bound by a fillet. A piece of drapery falls from her right arm around her body. A hound leaps upward between her feet. Soon after completion, in 1922, the statue was awarded the Saltus Medal for Merit by the National Academy of Design.

Bronze statue. Height 8 ft. Signed on base at left: ANNA-V-HYATT HUNTINGTON Founder's mark: KUNST' F'DRY' N.Y. Placed in Brookgreen Gardens in 1934. Other examples: Austin, Tex. University of Texas; Cambridge, Mass. William Hayes Fogg Art Museum; Evanston, Ill. Northwestern University; Hagerstown, Md. The Washington County Museum of Fine Arts; Havana, Cuba. Palacio de Bellas Artes (aluminum statue); The New-York Historical Society; New Orleans. Audubon Park; Syracuse University; Tokyo.

The Young Diana

Supported on the tails of three dolphins with their bodies twisted together is a shell with a voluted umbo. On top of the volute is poised the young Diana. She looks upward beyond the bow extended in one hand, the other drawn back from loosing the string. A quiver hangs from her shoulder, and a piece of drapery girdles her form at the front. Her short hair is blown forward around her face. The statue was modeled about 1924 for John Hays Hammond's house in Washington, D.C.

Bronze statue. Height 7 ft. Signed on base at right: ANNA HYATT HUNTINGTON Founder's mark: KUNST' FDRY. NY. Placed in Brookgreen Gardens in 1934. Other examples: Charlotte, N.C. Queens College; Ticonderoga, N.Y. The Fort Ticonderoga Garden; San Diego, Calif. Fine Arts Gallery.

Youth Taming the Wild

A young man subdues a horse, pressing against its side braced by one foot, as a raised hand grips the rope halter. The horse has started to rear, one forefoot lifted, the tail arched, the mane tossing, and the ears laid back. A short cape blows away from the man's shoulders against the horse's side. The group was modeled about 1927 from an earlier sketch made about 1914 for a pair to be placed on gateposts. It was adapted as a memorial to Collis P. Huntington at Newport News, Virginia.

Limestone group. Height 13 ft. 4½ in. Base: Length 6 ft. 9 in.—Width 6 ft. 3½ in. Placed in Brookgreen Gardens in 1933. Other examples: Chapel Hill. The University of North Carolina (bronze reduction); San Diego. Fine Arts Gallery (bronze reduction).

Joan of Arc

Joan of Arc has risen in the stirrups, as her horse, with head held high, marches forward. She gazes at the cross-shaped hilt of the sword raised in her right hand. She is clad in plate armor, the visor of her helmet raised. The sculptor has chosen to represent the Maid before her first battle at Orléans. The life-sized plaster statue gained for the sculptor honorable mention at the Paris *Salon* of 1910. In 1914 this model was selected for the erection of a statue to Joan of Arc on Riverside Drive, New York. The bronze statue, in which the earlier design was considerably altered, was unveiled on December 6th, 1915. For this achievement the artist was decorated by the French Government. Other awards given for it were the Rodin Gold Medal of the

Plastic Club, Philadelphia, in 1916, and the Saltus Medal for Merit of the National Academy of Design in 1920.

Reduction of a bronze equestrian statue. Height 4 ft. ¾ in. Base: Length 2 ft. 4½ in. —Width 1 ft. 1 in. Signed on base at right: *Anna V. Hyatt* Founder's mark: THE GORHAM CO FOUNDERS Q408 Placed in Brookgreen Gardens in 1934. Other examples: Blois, France (bronze statue); The Cleveland Museum of Art (small model; variant); Dallas Museum of Fine Arts (small model); Gloucester, Mass. (bronze statue); New York. Riverside Drive (bronze statue); Pittsburgh. Carnegie Institute (reduction); Quebec. Plains of Abraham (bronze statue); San Francisco. The California Palace of the Legion of Honor (bronze statue).

The Cid Campeador

The Spanish hero rides forward on his proudly stepping horse, Babieca. Clad in chain mail, he stands in the stirrups, a shield on one arm, a pennanted lance uplifted in his right hand. The Cid is represented as he might have appeared during the siege of Valencia in 1094. The original statue was presented to the city of Sevilla in 1927.

Reduction of a bronze equestrian statue. Height 4 ft. 8 in. Base: Length 2 ft. 4½ in. —Width 1 ft. 1 in. Signed on base at back: *Anna Hyatt Huntington 1927* Placed in Brookgreen Gardens in 1934. Other examples: Buenos Aires (bronze statue); New York. The Hispanic Society of America (bronze statue); San Diego. Balboa Park (bronze statue); San Francisco. The California Palace of the Legion of Honor (bronze statue); Sevilla. Glorieta de San Diego (bronze statue).

The Centaur Cheiron

A centaur striding up a bank turns to shoot an arrow, aiming downward. The man-horse's body is powerfully muscled, with curly hair down the front and back of the human torso. Hair and beard are in tight curls.

Brass statuette. Height 4 ft. 2 in. Base: Length 2 ft. 9 in.—Width 1 ft. 2½ in. Signed on base at back: *Anna Hyatt Huntington 1936* At front: *Cheiron*. Placed in Brookgreen Gardens in 1941.

A Female Centaur

A female centaur bounds forward, head and shoulders thrown backward, about to cast a weapon held in the right hand. An animal skin flies back from the left hand. The hair sweeps up in tight locks from primitive features.

Brass statuette. Height 3 ft. 9½ in. Base: Length 2 ft. 8¾ in.—Width 1 ft. 2½ in. Signed on base at back: *Anna Hyatt Huntington 1936* Placed in Brookgreen Gardens in 1941.

Reaching Jaguar

On the top of a rock is a jaguar, his hind feet braced, looking downward as he reaches down the face of the rock with his left forefoot. The body is curved slightly to the left. This subject, originally conceived in 1905 or 1906 and modeled life size at Auvers-sur-Oise in the following year, was given final form in 1926. It was shown in plaster at the Paris *Salon* of 1908 and awarded the sculpture prize at the Woman's Art Club exhibition, New York, in 1910.

Bronze statue on limestone base. Height 5 ft. 4 in. Placed in Brookgreen Gardens in 1932. Other examples: New York. The Metropolitan Museum of Art (bronze); New York Zoological Park (stone); Newport News. The Mariners' Museum Park (marble); Paris. Musée National d'Art Moderne.

Jaguar

A jaguar is crouching on a rock, his hind legs gathered under him, his forepaws and head bent over the edge of the rock as he gazes downward. It was modeled in 1907 at Auvers-sur-Oise as a companion piece to the *Reaching Jaguar*. Both these statues are studies of Señor Lopez, a jaguar from Paraguay acquired by the New York Zoological Society in 1902, whose "great size, graceful proportions, and . . . ferocity . . . are almost legendary among the staff of the Zoological Park even today." [1]

Bronze statue on limestone base. Height 5 ft. 1 in. Placed in Brookgreen Gardens in 1932. Other examples: New York. The Metropolitan Museum of Art (bronze); New York Zoological Park (stone); Newport News. The Mariners' Museum Park (marble).

Jaguar Eating

A jaguar squats on the ground, clutching a piece of meat in both spread forepaws, as with head turned slightly sidewise he gnaws at the bone. His powerful neck is arched, and his ears are laid back. Like the other two jaguars, it was modeled at Auvers-sur-Oise in 1907.

Bronze statue. Height 1 ft. 5 in. Base: Length 3 ft. 4 in.—Width 1 ft. 3½ in. Signed on base at right: ANNA HYATT HUNTINGTON Founder's mark: KUNST FOUNDRY N.Y. Placed in Brookgreen Gardens in 1934.

1 New York zoological society. *Bulletin.* December 1st. 1937. v. 40, p. 198.

Great Dane

A great Dane is seated with the forefeet together close to the body and the chest out, the head raised and the ears pricked up. A collar is buckled under the chin.

Granite statue. Height 4 ft. 2½ in. Placed in Brookgreen Gardens in 1932. Other examples: North Salem, N.Y. Hammond Museum; Tulsa, Okla. Philbrook Art Center (bronze).

Great Dane

Another dog is also seated with the forefeet together, but the muzzle is lowered and the ears are laid back. The collar is buckled at the back. Earlier versions of these two statues were exhibited at the National Academy of Design in 1909 and at the Paris *Salon* in 1911.

Granite statue. Height 4 ft. 2½ in. Placed in Brookgreen Gardens in 1932. Other examples: North Salem, N.Y. Hammond Museum; Tulsa, Okla. Philbrook Art Center (bronze).

Lion

A lion is seated with the head back and a globe held between the forepaws.

Bronze statue. Height 4 ft. 5 in. Base: Length 3 ft. 6½ in.—Width 1 ft. 7¾ in. Placed in Brookgreen Gardens in 1932. Other examples: New York. The Hispanic Society of America (stone); Newport News, Va. The Mariners' Museum Park (stone; heroic size).

Lion

This lion is exactly like its companion. These statues were modeled in 1930 for the entrance to The Hispanic Society of America, New York, where in the same year they were replaced by examples in stone.

Bronze statue. Height 4 ft. 5 in. Base: Length 3 ft. 6½ in.—Width 1 ft. 7¾ in. Placed in Brookgreen Gardens in 1932. Other examples: New York. The Hispanic Society of America (stone); Newport News, Va. The Mariners' Museum Park (stone; heroic size).

Brown Bears

Three bears are playing. One risen on its hind legs, one foot on a log, is sparring with another, seated. A third, leaning against the log, is licking a hind foot.

Aluminum group. Height 3 ft. 9 in. Base: Length 4 ft. 3½ in.—Width 2 ft. 10 in. Signed on base at right: *Anna Hyatt Huntington 1935* Founder's mark: GORHAM CO FOUNDERS Placed in Brookgreen Gardens in 1939. Other examples: New York. The Hispanic Society of America (marble); Richmond, Va. Hospital of the Medical College of Virginia (stone).

Jaguars

A jaguar, with feet braced, is lifting in its mouth a dead tapir, the body dragging against its forelegs. Another, snarling, crouches with one foot on the prey.

Aluminum group. Height 2 ft. 8 in. Base: Length 4 ft. 3½ in.—Width 2 ft. 10 in. Signed on base at right: *Anna Hyatt Huntington 1935* Founder's mark: GORHAM CO FOUNDERS Placed in Brookgreen Gardens in 1939. Other example: New York. The Hispanic Society of America (marble).

Wild Boars

A wild boar, forefeet raised on a rock, is standing guard over two young animals. One is sleeping, and the other stands with lowered head, eating.

Aluminum group. Height 3 ft. 7½ in. Base: Length 4 ft. 3½ in.—Width 2 ft. 10 in. Signed on base at right: *Anna Hyatt Huntington 1935* Founder's mark: ROMAN BRONZE WORKS · N.Y. Placed in Brookgreen Gardens in 1939. Other example: New York. The Hispanic Society of America (marble).

Vultures

One vulture perches with spread wings on the carcass of a llama, while another, with wings slightly lifted, bends forward to tear at the animal.

Aluminum group. Height 3 ft. 1 in. Base: Length 4 ft. 3½ in.—Width 2 ft. 10 in. Signed on base at right: *Anna Hyatt Huntington 1935* Founder's mark: ROMAN BRONZE WORKS · N.Y. Placed in Brookgreen Gardens in 1939. Other example: New York. The Hispanic Society of America (marble).

Alligator Fountain

Four alligators lie sleeping, head to tail, around an open flower. The fountain was modeled in 1937.

Aluminum group. Length 4 ft.—Width 4 ft. Founder's mark: ROMAN BRONZE WORKS. N.Y. Placed in Brookgreen Gardens in 1937.

Macaw Preening

A macaw grasps the perch with both feet, wings slightly lifted for balance and tail stretched out, as with lifted head he runs one tail feather, bent in a circle, through his beak.

Bronze statuette. Height 2 ft. 10 in. Base: Width 8¼ in.—Depth 8¾ in. Signed on base at back: Anna Hyatt Huntington 1936 Placed in Brookgreen Gardens in 1952. Other example: Norfolk, Va. Museum of Arts and Sciences.

Macaw Stretching

A macaw balances on one foot, the other drawn back and extended against a wing stretched downward. The long tail is curved a little forward, the head bent to one side as the bird looks upward with an inquisitive expression. Both these birds were planned to be used as wind vanes.

Bronze statuette. Height 2 ft. 3⅝ in. Base: Width 8 in.—Depth 8 in. Signed on edge of base at back: Anna Hyatt Huntington 1936 Placed in Brookgreen Gardens in 1952. Other example: Norfolk, Va. Museum of Arts and Sciences.

Winged Horse

The horse stands proudly with left foreleg lifted and right hind leg doubled up, head and tail up and neck arched.

Bronze wind vane. Height 6 ft. 5 in. Placed in Brookgreen Gardens in 1951.

Winged Bull

A winged bull stands with right foreleg and hind leg doubled up, head lowered, and wings lifted. His neck is heavily wrinkled and his tail bent in a loop. The body is modeled in detail but flattened to catch the wind.

The wind vanes of both horse and bull are planned with strong, decorative silhouettes. The wing feathers are laid in a slightly stylized pattern. The animals stand on horizontal standards ending in spear heads. The vertical shafts are set in pedestals formed of four sections shaped like conventionalized fish bodies with petal-shaped noses, scrolls around the eyes, and the double scrolls of the tails bent outward to support the letters marking the four quarters of the wind. These wind vanes were made for Miss Annie R. Tinker's garden at East Setauket, Long Island.

Bronze wind vane. Height 6 ft. 5 in. Placed in Brookgreen Gardens in 1951.

Spout for Drinking Fountain

With lifted wings a duck steps forward from a clump of cattail rushes, the bill a waterspout. A frightened frog leaps away from its feet. This relief is attached to a marble drum carved with oak branches. Intended as part of the base of a statue by an unknown sculptor, it was found in the Piccirilli Brothers' studio when the building was dismantled. It was acquired for Brookgreen Gardens and adapted as a drinking fountain, with the aluminum relief by Mrs. Huntington added.

Aluminum relief. Height 1 ft. 10 in.—Width 1 ft. 6¼ in. Signed at right: A · H · H · 1953 Marble drum placed in Brookgreen Gardens in 1952; aluminum relief added in 1953.

Entrance Gates

The gates are formed of a row of vertical bars ending in scrolling and bordered by a band of S-scrolls. Between the bars are oval medallions containing at the middle the letters B and G; at the left an eagle, a fox, and a fawn; at the right a wild goose, a turtle, and an alligator.

Iron. Height 7 ft. 9 in. Width of each valve 5 ft. 4 in. Placed in Brookgreen Gardens in 1934.

Owl and Penguin Gates

Designed like those at the entrance, these gates are composed of five bars to each valve, the central bar split to give space to an oval medallion.

Iron. Height 5 ft. 10 in. Width of each valve 3 ft. 4¼ in. Placed in Brookgreen Gardens in 1934.

Museum Building Gates

Also designed like those at the entrance, these gates are composed of five bars to each valve, the central bar split to give space to an oval medallion.

Iron. Height 7 ft. 8 in.—Width of each valve 2 ft. 11⅜ in. Placed in Brookgreen Gardens in 1934.

Diana Pool Wicket

Similar in design to the larger gates, it is a single valve composed of five bars with a central medallion. All these gates were designed in 1934.

Iron. Height 2 ft. 3½ in.—Width 2 ft. ½ in. Placed in Brookgreen Gardens in 1934.

Albert Laessle

ALBERT LAESSLE was born at Philadelphia on March 28th, 1877, to Henry Christian and Caroline Louise (Metzger) Laessle. He graduated from Spring Garden Institute in 1896 and from Drexel Institute in the following year. At the Pennsylvania Academy, where he studied with Thomas Anshutz and Charles Grafly, he won the Stewardson Prize. His choice of animals, particularly the smaller creatures, as subject matter began in his student days with a group of a turtle and a crab. The turtle was so realistic that the sculptor was suspected of having cast it from the life, but a later group, *Turtle and Lizard*, done in wax disproved this accusation. An example is in the collection of The Pennsylvania Academy of the Fine Arts. The Cresson Traveling Scholarship enabled him to spend the years from 1904 to 1907 in Europe, chiefly at Paris, working with the help of criticisms from Michel Béguine.

After his return to Philadelphia Laessle worked with Grafly for a number of years and in 1921 became an instructor at the Pennsylvania Academy, a post which he held until his resignation in 1939. The meticulous finish and telling use of detail typical of Japanese craftsmen have been adapted to many of his small bronzes like the *Blue-Eyed Lizard*, the *Locust and Pine Cone*, and *Frog and Katydid*.[1] His preference is for lean, nervous forms in action,

1 The first is represented in the collection of the Pennsylvania Academy; the other two are on loan to The Baltimore Museum of Art from the Peabody Institute.

distinctly recorded. The appearance of birds fascinated him, as in the *King-fisher* and *Heron and Fish*,[2] and he accentuated almost to the point of grotesqueness peculiarities of structure and irregular surfaces such as the stiff tufts of hair of the goat and the bristling feathers of the bronze turkey. *Victory*, an aggressive eagle striding, with lifted wings, dated 1918, is in The Metropolitan Museum of Art, New York.

Among the honors given him by the Pennsylvania Academy is the Fellowship Medal in 1915 for *Billy*, a statue of a goat. He also received gold medals at the Panama-Pacific Exposition and the Philadelphia Sesqui-Centennial Exposition. Several of his jolly animals have been placed in the open air at Philadelphia and a group in Johnson Square, Camden. The same vitality distinguishes his portrait busts. The monument to General Pennypacker, erected in Logan Square, Philadelphia, has a virile striding figure atop an involved composition of a gun carriage flanked by tigers. His impeccable technique and fine feeling for design show to good advantage in a number of medals, prominent among them the medal of honor of the Concord Art Association with a pine cone and an eagle on the two sides, the Widener Medal for the Pennsylvania Academy, and the Philadelphia Sesqui-Centennial Medal. Among the societies to which he belonged are the Société des Amis de la Médaille d'Art of Brussels, the National Sculpture Society, the National Academy of Design, and the National Institute of Arts and Letters. Laessle retired to Miami, Florida, where he died on September 4th, 1954.

Laurvik wrote of the sculptor's work: ". . . the finished art of Albert Laessle commands the respect and admiration of all who esteem good sound craftsmanship above pyrotechnical display. He achieves a decorative effect by emphasizing the realistic aspect of his subjects . . . No one in America has so closely studied the characteristics of frogs, turtles, lizards, crabs, beetles, katydids, fishes and barn fowls as Laessle, and he has presented his studies with something of the flavor of a humorous naturalist who observes the tragedies and comedies enacted in his little kingdom." [3]

Penguins

Two penguins stand close together, their heads tipped backward until they touch, the wings slightly lifted, and the feet turned inward. The texture of feathers and webbed feet is skillfully indicated. The comic appearance of the

2 An example of the one is in the museum at Reading, Pennsylvania; of the other at the Carnegie Institute, Pittsburgh.

3 San Francisco. Panama-Pacific international exposition, 1915. Department of fine arts. *Catalogue de luxe*. San Francisco [ᶜ1915]. v. 1, p. 60.

birds has been gaily transmitted in lifelike modeling. They were awarded the Widener Gold Medal by the Pennsylvania Academy in 1918 and honorable mention by The Art Institute of Chicago two years later.

Bronze group. Height 3 ft. Base: Width 2 ft. 3¾ in.—Depth 1 ft. 8½ in. Signed on base at back: ALBERT LAESSLE GERMANTOWN. PHILA 1917 Founder's mark: ROMAN BRONZE WORKS. N.Y. Placed in Brookgreen Gardens in 1937. Other examples: Philadelphia. Zoological Gardens; San Francisco. California Palace of the Legion of Honor.

Dancing Goat

On a clump of rushes through which a snail, a turtle, and other marsh creatures crawl, a goat prances on his hind legs, forefeet waving in the air and neck arched. The stiff hair rises in a ridge down the back, with a braid at each side. A collar, an end hanging between the forelegs, encircles the neck. The horns are tipped with knobs.

Turning Turtle

A turtle is raised on two legs and balanced by the head as it tries to turn from one side to the other. This statuette was done in 1905 during Laessle's stay at Paris. He says, " 'I had become so much interested in the type of subject upon which I had chanced . . . that I took care not to depart from it entirely. I had no difficulty in obtaining turtles in Paris. At that time many families had turtles which were imported from Algiers and kept in the cellars to eat insects. Our *concierge* lent me his turtle, and I made a careful study which I sent to the *Salon* under the name 'Turning Turtle.' . . . Because of the peculiarity of the subject and the accuracy of the craftsmanship, the jury refused to believe that it was modeled.' " [4]

Bronze statuette. Height 7⅞ in. Base: Length 10¾ in.—Width 8½ in. Signed on base: ALBERT-LAESSLE PARIS 1905. Founder's mark: QIER GORHAM CO. Placed in Brookgreen Gardens in 1934. Other example: New York. The Metropolitan Museum of Art.

Duck and Turtle

A duck starts from the nest, quacking, as a turtle, creeping on it from behind, seizes a wing. The group was awarded the McClees Prize of the Pennsylvania Academy in 1928.

Bronze group. Height 1 ft. 3 in. Base: Length 2 ft. 4¼ in.—Width 1 ft. 8 in. Signed on base at left: ALBERT LAESSLE GERMANTOWN PHILA. Placed in Brookgreen Gardens in 1937. Other example: Camden, N.J. Johnson Square.

4 Miller. p. 25.

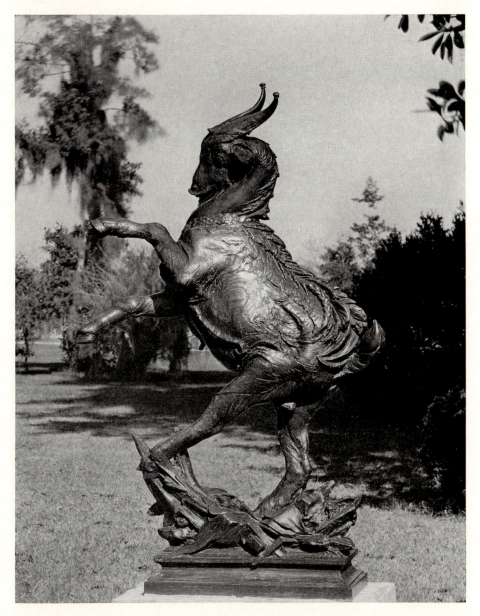

DANCING GOAT

Bronze statue. Height 4 ft. Signed on base: ALBERT LAESSLE 1928 PHILADELPHIA
Founder's mark: ROMAN BRONZE WORKS N-Y- Placed in Brookgreen Gardens in
1937. Other example: Camden, N.J. Johnson Square.

Grace Mott Johnson

GRACE MOTT JOHNSON was born in New York City on July 28th, 1882, the daughter of Alfred Van Cleve and Laura (Mott) Johnson, both parents being of New England ancestry. Her mother died when she was two years old, and her father remarried. A Presbyterian minister who had resigned from his church in order to study and teach according to his own convictions, he became a recluse and retired first to his father's home near Yonkers and then, in 1900, to a farm at Monsey, Rockland County, New York. The children neither went to school nor played with other children but received their education from their father. The eldest daughter, Grace, had been interested in animals and had begun to draw them by the time she was four. She tried modeling and carving in soap and plaster and after seeing Rosa Bonheur's *The Horse Fair*, she determined to be a painter of animals. She became thoroughly familiar with domestic animals while working on the farm. At the age of twenty-one she left home to study art. After she had worked independently making memory sketches of the animals in the New York Zoological Park, she entered the Art Students' League and became a pupil of MacNeil, J. E. Fraser, and Gutzon Borglum. In the animal sculpture which she chose as her field, her aim was to make her subjects alive. Her knowledge of horses was increased by a summer on a stock farm at Columbus, Ohio, in 1908, and by a special study of Percherons at Paris in 1909, a result of which, a plaster bas-relief of a Percheron, was exhibited at the *Salon* the next year.

Upon her return to the United States she made her home at Woodstock, New York. For a number of years she frequented the circus and modeled elephants, such as *Mighty of Ringling Circus*. *Bebe* was carved from a block of plaster, and a frieze cut directly in stone. Among other subjects are monkeys, a Mongolian wild horse, and a zebu bull as well as domestic animals. After 1917 she spent part of the time in New Mexico. Upon a visit to Egypt in 1924 to study camels and Arab horses, she was greatly impressed by the simplicity and sense of design of Egyptian sculpture. The sculptor avowedly took as her models the prehistoric drawings in the caves of Altamira, Spain, and Egyptian reliefs for carvings in plaster which are drawn with deeply incised lines and sparely modeled in broad planes. Some reliefs and figures in the round have been cast in bronze.

184

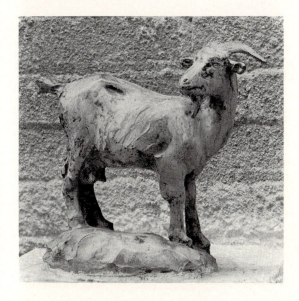

GOAT

Bronze statuette. Height 10 in.
Base: Length 8 in.—Width 4 in.
Placed in Brookgreen Gardens in
1934.

Her work was shown at the Whitney Studio Club in 1919 and again at New York in 1935. In the latter exhibition there were experiments in polychromy on plaster statues of animals and, as a new departure, several heads of Negroes, of whom she had been making a special study; one was *Mary Moore*, a bronze bust of a child. Her *Chimpanzee* won the third Anna Hyatt Huntington Prize of the National Association of Women Painters and Sculptors in 1935, and *Sleeping Lamb* first prize in 1936. In her animal studies Miss Johnson was concerned with giving the character of the subject succinctly, with little regard for amenities of surface finish. She did not use posed models either of animal or human subjects but worked almost entirely from memory in drawing, painting, and sculpture. In the last years of her life she gave up her studio and devoted her time to working for civil rights, although she never lost her interest in nature and animals and continued to make a few sketches. She kept her independent spirit and wry sense of humor until her death on March 12th, 1967.

Goat

The goat stands with its head turned back. The sculptor has emphasized characteristic form and action, leaving the surface sketchily modeled.

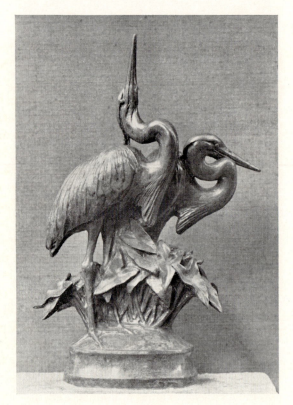

COCOI HERONS

Bronze group: Height 1 ft. 3 in.
Signed on base at back: PAUL
HERZEL Founder's mark:
ROMAN BRONZE WORKS N.Y.
Placed in Brookgreen Gardens in
 1936.

Paul Herzel

PAUL HERZEL was born to Frank and Katherine (Raesner) Herzel at Tillowitz, Silesia, Germany, on August 28th, 1876. When he was about seven years old he was brought by his family to Saint Louis, Missouri. As a boy he showed his artistic bent by drawing on the margins of his schoolbooks and modeling in clay found near his home. After his father's death he went to work for the American Brake Company, where he was employed as a machinist from the time he was fourteen until he was twenty-eight. At the age of twenty-two he began to study painting at the Saint Louis Art School in the evenings and, for a time, during the day. He was one of the organizers of the Brush and Pencil Club and continued to study there. Experiments in catching the action of wild animals by means of plasticine sketches led to the modeling of a few statuettes.

After a trip to Europe spent in visiting the museums in Paris and copying Velázquez's paintings at Madrid, he came to New York. Here he began to study sculpture at the Beaux-Arts Institute of Design, paying his way by installing their architectural exhibitions. While he was still in Saint Louis he had begun to sketch the animals in Forest Park Zoo, and in New York he frequented the Central Park Zoo, painting and modeling as well as sketching. Later he spent all his spare hours at the Bronx Zoo, working on a wide variety of animal models. Two of his paintings, *Blesbok* and *White-Tailed Gnu*, were acquired by the New York Zoological Society. In 1915 he won Mrs. H. P. Whitney's "Struggle Prize" and also the Barnett Prize of the National Academy of Design for *The Struggle*, a boa constrictor strangling a tiger. The Pompeian Bronze Company asked permission to reproduce some of his small models as ash trays and book ends; for them he designed *The Pirate*, *Bucking Horse*, and other subjects. *Riveter* is in the Moscow Museum of Modern Western Arts. The animal groups, often composed with Barye's fondness for violence as in *Lion and Zebra* and *The Struggle*, show in their understanding of anatomy and character the sculptor's many years of patient observation. Composed with more emphasis on design are *Cocoi Herons* and *The Chant*. A few cowboy and Indian subjects in lively action give variety to his work. Herzel died on May 11th, 1956.

Cocoi Herons

In a clump of water plants two herons are resting. One has its head drawn back on the long, curved neck; the other stands with its bill pointed upward. The long feathers on their backs and the pointed leaves of the plants make a harmonious pattern. This group won a Garden Club of America Prize in 1930.

The Chant

Their forefeet raised on a mound of rocks, a lion and lioness stand, their heads lifted, roaring. Their bodies are at right angles, and the lion's head rises above his mate's shoulders. Something of the menace of their powerful voices is conveyed in the restrained force of the two beasts.

Bronze group. Height 1 ft. 4½ in. Base: Length 1 ft. 4 in.—Width 1 ft. 2½ in. Signed on base at back: P HERZEL 1914 THE CHANT Placed in Brookgreen Gardens in 1936.

Lone Wolf

LONE WOLF was born on Birch Creek, Blackfeet Reservation, Montana, on February 18th, 1884. His father, James Willard Schultz, took the name Apikuni (Far Away Robe) when he was adopted into the Blackfeet tribe and married a Blackfoot woman, Fine Shield. Their son, Hart Merriam Schultz, preferred to be known by his Indian name. James Willard Schultz wrote many stories of his life among the Blackfeet, some of which his son came to illustrate. Lone Wolf's grandfather, Yellow Wolf, taught him to draw and paint on buckskin and to shape clay figures of buffaloes, horses, and other animals. When he was employed as a cowboy his sketches of range life, drawn to amuse his fellow cowboys, attracted attention to his talents. Encouraged by Charles Russell and Thomas Moran he decided to make painting his profession. He entered the Art Students' League in 1910 and continued his studies at The Art Institute of Chicago. At the Grand Canyon and at Glacier Park he had tepee studios from which he sold his work. In 1922, sponsored by August Heckscher, he came to New York and held an exhibition of his paintings. About this time he turned to sculpture and after a few private lessons modeled some groups which were cast in bronze, among them an Indian hunting buffaloes and a cowboy riding a bucking bronco. Three of his paintings of Indian life are in the collection of the University of Nebraska. Line drawings and colored plates from his paintings illustrate Marion E. Gridley's *Indians of Yesterday*, published in 1940.

Camouflage

An Indian is lying flat on his horse's back, peering out from under a buffalo skin. He holds a spear in both hands. The horse's head is disguised with a buffalo mask and horns. By this device an Indian could stalk a herd of buffalo without alarming them or remain disguised on the war trail. Lone Wolf heard the story of the buffalo camouflage from his grandfather when he was a small boy, remembered it, and used it for the subject of this bronze, cast in 1929.

Bronze equestrian statuette. Height 1 ft. ¼ in. Base: Length 9½ in.—Width 5½ in. Signed on base at back: LONE WOLF [wolf's mask] © Founder's mark: QHIF GORHAM CO. FOUNDERS CIRE PERDUE Placed in Brookgreen Gardens in 1939.

James L. Clark

AMONG THE MEN associated with The American Museum of National History who applied the art of sculpture to taxidermy and achieved an unprecedented truth and artistic effect in mounted groups is James Lippitt Clark, born at Providence, Rhode Island, on November 18th, 1883. Both his parents, Herbert Willis and Ella Amanda (Brown) Clark, were of New England stock. After attending public schools he was employed in the designing room of The Gorham Company. The serious interest in art which was aroused there was cultivated by study at the Rhode Island School of Design. It was through his excellent modeling of animals that in 1902 he was asked to become a member of the staff of The American Museum of Natural History, to devote his talents to mounting specimens. Every morning before he went to work he was at the Central Park Zoo and every weekend at the Bronx Zoo, studying and sketching. His knowledge of animals and their habits was increased by many field trips, beginning with an expedition to Wyoming in 1906 to study the antelope, the buffalo, and smaller creatures. His first sale was a *Reclining Lion;* another work was an *African Rhinoceros.*

After traveling through Europe to visit museums and zoological parks, in 1908 he embarked on his first African venture, resigning from the Museum to go with A. Radclyffe Dugmore on an expedition to take photographs for *Collier's Weekly*, and made the first motion pictures ever to record wild life in Africa. He spent fourteen months, chiefly in Kenya Colony, and then joined Carl Akeley, who was preserving for The American Museum of Natural History the elephants shot by Theodore Roosevelt, and himself brought back many specimens of big game.

The new methods of taxidermy which were being developed were carried out in the studios which he established in New York upon his return. Here he mounted specimens and groups for Theodore Roosevelt and other big-game hunters as well as for museums and devoted part of his attention to sculpture. From this time on his life has been a constant succession of journeys to far places, with time out only to prepare the material collected. In 1912 and 1913 he went to New Brunswick to hunt moose, deer, and caribou, in the next year secured and mounted a group of elk from Yellowstone Park, and three years later was in Alberta after grizzly bear. He was associated with Carl Akeley in the production of a new camera, which was manufactured for the United States Government during World War I.

With his wife Clark visited Africa in 1923, after he had returned to the Natural History Museum in full charge of preparation work, and two years later collected a group of Osborn caribou in the Cassiar district of British Columbia. At the end of another two-year interval he helped organize the Morden-Clark Asiatic Expedition, which from Bombay crossed the Himalayas into the *Ovis poli* country and traversed Central Asia. Mongols captured him, but he escaped and reached Peking in January 1927. The record of his adventures is set down in his books, *Trails of the Hunted* and *Good Hunting*. He is also the author of *The Great Arc of the Wild Sheep*. Other expeditions to Africa were the Carlisle-Clark to collect a group of lions and the O'Donnell-Clark to the Sudan for a group of giant eland. The Fleischmann-Clark Indo-China Expedition of 1936 again took him to the Far East. The Second World War halted for a time expeditions to other countries, but Clark used his experience to develop special clothing and survival equipment for aviators forced down in remote spots. In 1947 came an opportunity to return to Africa with the Wilbur-Clark Central African Expedition for exploration of little-known territory. Two years later Clark retired from the museum and devoted his time to shorter trips, writing, and sculpture.

Clark has perpetuated in bronze the appearance of many of the rare animals which he observed on his trips. His subjects range from the *Alaskan Kadiak Bear* and the *Osborn Caribou* of the Yukon, the *Penguin* and *Townsend's Seal* of the Galapagos Islands, to the *Ovis Poli* of Central Asia. An *African Rhinoceros with Tick Birds* was given to Theodore Roosevelt for his trophy room at Sagamore Hill. An *African Buffalo* was placed in the Nairobi Club as a memorial to Captain Frederick Selous, a gift from the New York African Big Game Club. Clark's *Ibex* from the Thian Shan Mountains, an example of which is owned by the Rhode Island School of Design, was awarded the Speyer Memorial Prize of the National Academy of Design in 1930. An unusual venture into figure sculpture is an equestrian statuette of a Tartar falconer with a golden eagle on his wrist for hunting, based on a photograph taken at Urumchi in Western China. In a series of bas-reliefs designed to be set into the walls of a trophy room he caught the elegant silhouettes of African animals and even in shallow modeling kept the play of powerful muscles. A collection of his bronzes has been presented to the Explorers' Club, New York, by one of the members. Clark's lifelong study of the anatomy and habits of animals enables him to transcribe faithfully in bronze both their bodily structure and their characteristic movements.

His great accomplishment for the American Museum of Natural History has been the creation of the Vernay-Faunthorpe Hall of Asiatic Mammals, the Akeley African Hall, and the North American Hall of Mammals, which present habitat groups in settings of unexampled beauty. His achievement was recognized by the Museum by giving him the title, director of arts,

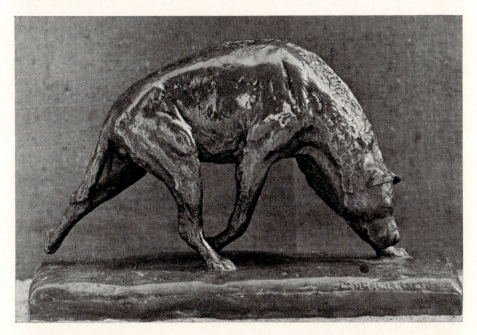

SPOTTED HYENA

Bronze statuette. Height 6 in. Base: Length 9¾ in.—Width 4 in. Signed on base:
JAS·L·CLARK·03· Founder's mark: GORHAM CO. FOUNDERS ODYE Placed in
Brookgreen Gardens in 1936.

preparation and installation, and making him an active member of the director's cabinet. In 1933 the honorary degree of doctor of science was conferred on him by West Virginia Wesleyan College. The Campfire Club gave him a gold medal and the Boy Scouts of America, their Silver Buffalo Award.

He is a member of many societies connected with art and natural history, including the National Sculpture Society, and a fellow of the American Geographical Society and of the New York Zoological Society.

Spotted Hyena

A hyena is running with its head close to the ground, following a trail.

It was Clark's custom to make a sketch model of each animal before proceeding with the full-sized form on which to mount the skin. The occasion for this study of a hyena, done only a year after the sculptor's arrival at the Museum of Natural History, was mounting a hyena that had died at the zoo. It shows the sculptor's ability to impart a sense of motion when a knowledge of muscle and bone structure was animated by a vivid concept of the living creature.

Robert Henry Rockwell

ROBERT HENRY ROCKWELL, another who has approached sculpture by way of taxidermy, was born to Hiram W. and Mary E. (Calhoun) Rockwell on October 25th, 1885, at Laurens, New York. The family went to Ireland while he was a child, and he attended district school in County Donegal and Foyle College, Londonderry. Life on a farm awakened a keen interest in domestic and wild animals, with the result that when he returned to America at the age of sixteen he eventually became an apprentice in a taxidermist's shop at New York. From there he went to Rochester, New York, being promoted to chief taxidermist in another firm.

After passing a civil service examination he was appointed to the staff of the National Museum, Washington, D.C., and later worked on some of Theodore Roosevelt's African collection. During the twelve years when he was chief taxidermist at The Brooklyn Institute of Arts and Sciences he collected specimens of animals in Mexico, Alaska, and Newfoundland. He also began to try his hand at small sculpture. After modeling a horse he went to the Metropolitan Museum to study sculptured horses, especially those by Gutzon Borglum. In Brooklyn, MacMonnies's *The Horse Tamers* particularly impressed him. He resigned from the Brooklyn Museum in 1923 to join a sea-going expedition sponsored by the Cleveland Museum to collect oceanic birds and animals. Sailing from New London on the three-masted schooner *Blossom* they spent a year and a half visiting all the islands of the Cape Verde group. They hunted lions and antelope in Africa, stayed a month on South Trinidad Island, and visited Rio de Janeiro before returning to New York.

He then joined the staff of The American Museum of Natural History and accompanied Carl Akeley as chief assistant on his last African expedition, when they collected the first six groups for the Akeley African Hall. For eleven years Rockwell was almost continuously engaged on this great project, having prepared two-thirds of the animals represented there and designed many of the groups. He also worked on the moose, brown bears, and other groups for the North American Hall and the Indian Hall, having designed and prepared in all twenty-seven large mammal groups.

In 1942 Rockwell retired and moved to the Eastern Shore of Virginia. Just before World War II he went on a third collecting expedition with Mr. and Mrs. Richard K. Mellon, trips with them having been to the Yukon for Dall

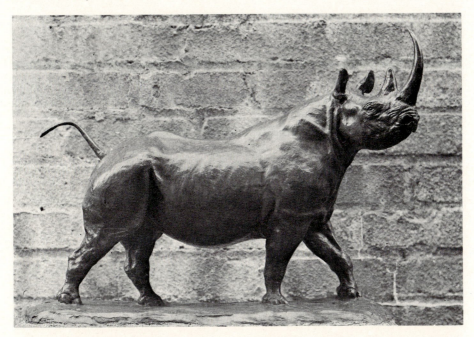

BLACK AFRICAN RHINOCEROS

Bronze statuette. Height 1 ft. 3 in. Base: Length 1 ft. 8 in.—Width 7 in. Signed
on base at right: ROBERT H. ROCKWELL 1937 Founder's mark: ROMAN BRONZE
WORKS INC Placed in Brookgreen Gardens in 1952.

sheep and to the Alexander Archipelago for bears. Rockwell told the story of
his adventures in a book, *My Way of Becoming a Hunter*.

Among the small bronzes that have been an outcome of his extensive
observations of animal life is one of the race horse *Phar Lap*, which won first
prize at an exhibition, *The Horse in Art*. *A Woodland Tragedy*, two stags
deadlocked in a mortal fight, is in the Brooklyn Museum. In recent years
Rockwell has given his attention to ceramic sculpture and has not only
designed his own models but has also made the molds, cast, glazed and fired
each piece. The result has been about fifty animal and bird figurines, the
latest being of a tigress with two cubs.

Black African Rhinoceros

A rhinoceros strides forward, left forefoot about to take a step, head lifted
and turned slightly to one side, menacing horn in the air and ears and tail
lifted in a suspicious, defiant attitude. The animal's anatomy is depicted in
realistic detail, displaying muscles in action and wrinkled skin.

About 1934 this study of a bull rhinoceros was first modeled in solid wax, together with others of a cow and a calf, as a miniature sketch for the arrangement of the habitat group in the African Hall of The American Museum of Natural History, New York, where they are mounted in scenery representing the northwestern slope of Mount Kenya. Some ten years later the sculptor remodeled the figure and cast it in hollow wax, from which the unique bronze casting now at Brookgreen was taken. Rockwell's extensive knowledge of the rhinoceros he gained from observing these animals while on an expedition in Africa with Martin Johnson.

Survival of the Fittest

A moose at the right is braced in a defensive position, the head lifted and one forefoot raised to fend off the attacker. The other moose presses forward with lowered head, digging into the opponent's shoulder with one antler. They were modeled after an intensive study of the life, habits, and anatomy of moose in Alaska during the autumn of 1938, made as a design for the life-sized group in the North American Hall of The American Museum of Natural History. Carl Rungius, who painted the background, suggested the pose and contributed many helpful suggestions. Two of the small bronzes were cast in 1940.

Bronze group. Height 1 ft. 8½ in. Base: Length 2 ft. 6½ in.—Width 1 ft. 3 in. Signed on base at back: 1940 ROBERT H. ROCKWELL On front: Survival of the Fittest Founder's mark: GARGANI FDRY. N.Y. Placed in Brookgreen Gardens in 1940.

African Elephant

An elephant is running, trunk uplifted, ears outspread, and tail swinging. All the details of structure are carefully represented. It was modeled in 1935 as a sketch for one of four life-sized elephants made in taxidermy for the Akeley African Hall at The American Museum of Natural History. The sculptor was so interested in the sketch that he decided to complete it; a unique cast was exhibited at the National Academy of Design in 1938.

Bronze statuette. Height 2 ft. 1¾ in. Base: Length 2 ft. ½ in.—Width 7½ in. Signed on base at back: R. H. ROCKWELL Founder's mark: ROMAN BRONZE WORKS. N.Y. Placed in Brookgreen Gardens in 1940.

Louis Paul Jonas

LOUIS JONAS was born at Budapest, Hungary, on July 17th, 1894, to John and Julia Jonas. He attended art school at Budapest before coming to the United States at the age of fourteen to join his brother, who had opened a taxidermy studio at Denver. Later he went to New York, where Carl Akeley employed him to help mount the African elephants for The American Museum of Natural History. At the same time he continued his studies at the National Academy of Design in the classes of Hermon MacNeil and George Bridgman, learning that mass, line, and feeling were as important as structure. During World War I he enlisted in the Camouflage Corps of the United States Army, and at the end of his period of service returned to Denver.

In 1926 Jonas again left Colorado for New York to prepare Akeley's *Indian Elephant Group* and *The Gaur Ox* for the Museum of Natural History. His sculpture began to appear in the exhibitions of the National Academy of Design, where *Temper*, a bull elephant, and *The Challenger*, were shown. A portrait of the Australian race horse Phar Lap was done with great fidelity of detail. He had completed by 1930 a bronze group for Denver Municipal Park, *Commemorating the Grizzly Bear*, a bear on her hind legs protecting a cub, in which a decorative effect is gained by the smooth swirls in which the hair is laid. He also designed a memorial fountain for the Humane Society at New Rochelle, New York. With two of his brothers he established a taxidermy studio at Yonkers, later moving to Mount Vernon. There he developed several dioramas that were bought by the Maharajah for the Baroda State Museum.

Since sculpture attracted him more than taxidermy, he left the studio at Mount Vernon and found one for himself in an abandoned railroad station at Mahopac, New York. There he began to make a series of animal statuettes for educational use in schools and museums. An intensive study of dogs resulted from a commission to portray one of Anna Hyatt Huntington's Scottish deerhounds. Jonas also designed poodle gateposts for an estate at Darien, Connecticut.

During World War II he designed dioramas for the Textron Corporation to illustrate the use of their nylon products in warfare; these dioramas were shown to promote drives for the sale of bonds. Another diorama showed the D-Day operation. He moved his studio to a site near Hudson, New York,

195

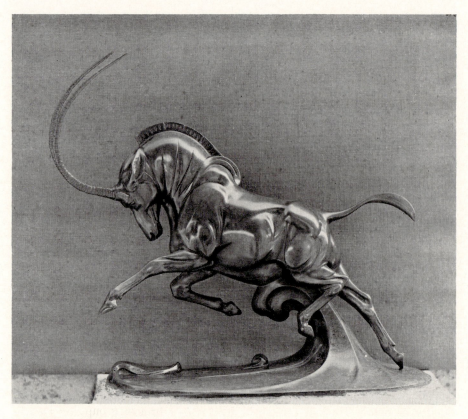

GIANT SABLE ANTELOPE

Bronze statuette. Height 1 ft. 3 in. Base: Length 1 ft. 3 in.—Width 7 in. Signed on base at right: © L P J SC 1928 Founder's mark: ROMAN BRONZE WORKS·N.Y. Placed in Brookgreen Gardens in 1934.

where, assisted by members of his family and a large staff, he continued to make small animal figures in a special resilient ceramic preparation cast in plaster molds. For a realistic effect they are colored and given glass eyes. At the New York World's Fair in 1964 his life-sized, authentic re-creations of dinosaurs were shown by the Sinclair Oil Company as part of their display, and afterwards they were sent on tour throughout the country.

Commissions for sculpture included a bronze fountain group of seals for the Denver Zoo and a black bear with cubs, cast in Fiberglas for gateposts in the Children's Park at Denver. Jonas's admiration for Barye resulted in several action groups in taxidermy which he calls "sculptodermy," one of them an African lion attacking a Cape buffalo, and another a lion slapping a coiled python, adapted from Barye's bronze.

Jonas is a member of the American Association of Museums and the New York Zoological Society.

Giant Sable Antelope

The antelope, the long horns curving over the back, is leaping forward with lowered head. The forms are stylized, and the figure is raised on a wavelike support.

Jaguar

A jaguar is lying with both forelegs outstretched. One hind leg is lifted and the head turned back to lick the under side. The figure is modeled without a base.

Bronze statuette. Height 5 in.—Length 12 in.—Width 4⅛ in. Placed in Brookgreen Gardens in 1937.

Crane Fountain

Three cranes are standing back to back, necks bent and heads raised to support on the tips of their beaks a broad water-lily pad serving as a basin; in the center the flower petals frame a drinking fountain. From narrow bases, scrolling leaves rise to support the birds' legs and tails. Their bodies are flattened and the feathers conventionalized to curving lines. The birds have decorative silhouettes of eccentric curves.

This fountain was designed in 1940 and two copies cast in 1947.

Bronze group. Height 3 ft. 6 in. Base: Length 2 ft. 4 in.—Width 2 ft. 8 in. Placed in Brookgreen Gardens in 1950.

Jack Metcalf

JACK METCALF was born at Neuilly, France, on September 1st, 1910, the son of Colonel Walter W. and Dorothy (Prindle) Metcalf. Although he has never studied sculpture, he has long practiced modeling and has also painted in oils and in water color. Formerly an asssistant to Louis Paul Jonas in the Jonas Brothers Studios of taxidermy, he became a partner in a firm which was trying to encourage the use of fine arts and sculpture in the decoration of interiors.

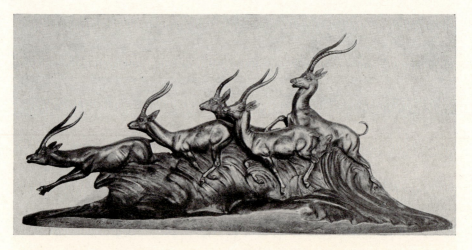

GAZELLES RUNNING

Bronze group. Height 6¼ in. Base: Length 14 in.—Width 3⅞ in. Signed on base at back: JACK METCALF 1929 Founder's mark: ROMAN BRONZE WORKS N.Y. Placed in Brookgreen Gardens in 1937.

Gazelles Running

A herd of five gazelles rushes through tall grass. Their flight is in a wavelike motion which begins with the forward-stretching body of the one in the lead and rises to the animal bounding at the rear.

Victor Frisch

VICTOR FRISCH was born at Vienna in 1876, the son of Professor Baron Josef von Frisch, physician to Emperor Francis Joseph, and his wife Minna. After studying medicine at Vienna, he entered the Academy of Fine Arts at Munich. He worked in both painting and sculpture under the instruction of Heinrich Zügel and Ludwig Herterich. His early work, inspired by the paintings of Carrière, had soft contours veiled in the stone. When Rodin passed through Munich in 1894, his interest was aroused by a fountain piece which Frisch exhibited having this quality, which Rodin too had adopted from Carrière. Feeling that they had something in common, he invited the Austrian to work in his studio. For twelve years Frisch was Rodin's pupil and assistant

DANCE

Bronze statuette. Height 1 ft. 8½ in. Base: Length 11⅞ in.—Width 6 in. Signed on base: VICTOR FRISCH SC Founder's mark: A KUNST FOUNDRY N Y Placed in Brookgreen Gardens in 1937.

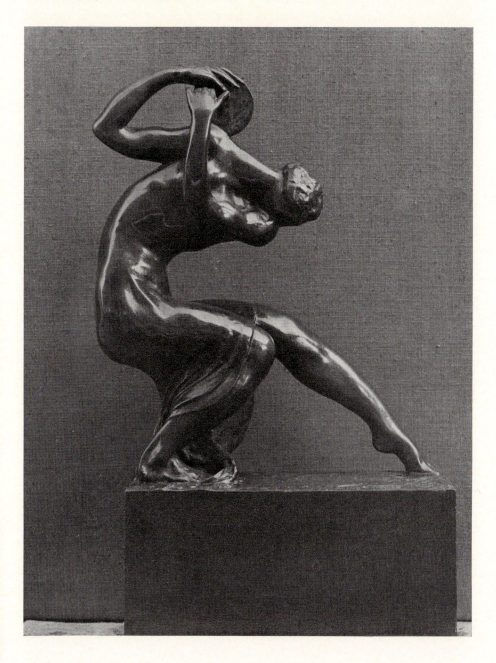

and continued to be associated with him after opening his own studio in Paris. His monument to Émile Verhaeren, which he won in competition with Rodin, is in Brussels, and he made some statues for the Church of Saint Barthélemy, Lyons. His bust of the master, lost during World War I, had been intended for Rodin's grave. At the outbreak of the war, being an Austrian, he was interned. Transferred to Switzerland towards the end of the war, he directed the Maison des Artistes at Geneva. Later he returned to Vienna and created the Beethoven *Eroica* monument for the Volksgarten. Works in European museums are his *Despair of Mankind* at Vienna, *Narcissus* in the Glyptothek, Munich, *Head of an Old Man* formerly in the Musée du Luxembourg, and *Berceuse* and *Déluge* in the Petit Palais, Paris.

Emigrating to the United States in 1925, he later became a citizen. His monument to Lucius N. Littauer is at Gloversville, New York, and he continued the series of portrait busts of distinguished people, including members of the Austrian royal family, begun in Europe. A sympathetic mask of Pavlowa in *The Dying Swan* is one of the best known. Although in his many imaginative small figures and plans for monuments indications of his apprenticeship with Rodin can be seen, Frisch's strong sense of design gives them distinction. He received gold medals for work exhibited at Paris, Munich, and Vienna and was elected to the Legion of Honor. He was a member of the Société Nationale des Beaux-Arts, the Secession in Munich and Vienna, the National Sculpture Society, and The Architectural League of New York. He died at New York on October 10th, 1939, just before the publication of his book on Rodin.

Dance

A long-limbed dancer bends forward over one pointed foot and strikes a tambourine raised above her shoulder. Drapery sweeps about the rhythmic curves of her form. Tambourine and hair fil'et are gilded.

Chester Beach

ONE OF THE few American sculptors to adopt Rodin's vibrating surfaces throughout his work is Chester Beach, born at San Francisco on May 23rd, 1881, to Chilion and Elizabeth (Ferris) Beach. After he had graduated in the course of architectural modeling at the Lick Polytechnic School, he worked as

a silver designer for four years, at the same time studying in the night drawing classes of Mark Hopkins Institute. He moved to New York before going to Paris in 1904, where he studied at the Académie Julian and then worked in his own studio. The marbles *River and Sea* and *Young Nymph*, which won the Barnett Prize of the National Academy of Design in 1909, as well as several small bronzes were of this period. In 1907 he returned to New York and bought the house and studio on East Seventeenth Street that had once belonged to an earlier sculptor, Thomas Ball. Bronze statuettes of laboring men, such as *The Stoker* in the Brooklyn Museum, were made at this time. 1911 and 1912 were spent at Rome, where he produced the marbles *The Sacred Fire*, a draped figure shielding a lamp, in the collection of The American Academy of Arts and Letters, New York, and *Beyond* in the California Palace of the Legion of Honor, San Francisco.

In his early works, seeking for the expression of ideas and emotions, desiring to fix the impermanent in stone, he resorted to involved compositions left partly buried in the marble. He was not dominated by this precedent, as the form is often completely expressed with realistic detail. Delightful fragments without the burden of symbolism are two heads of babies in tears and laughter. An impressionistic treatment suits the flowing lines and broken masses of works inspired by spray, clouds, and mists in which he has interpreted these impalpable shapes in the terms of human figures. *Surf*, a bronze statuette, is in The Newark Museum; the marble *Cloud Forms* is in the Brooklyn Museum. *Rising Sea Mists* won the Watrous Gold Medal of the National Academy of Design in 1926.

The sculptor's affinity for the fluid movement of water came to pervade many of his decorative figures, where unfinished statement is abandoned and delight in form for its own sake has taken precedence. *The Glint of the Sea*, awarded a medal of honor by the Architectural League in 1924, and *The Leaping Spray* both have this underlying motive, which still prevails in the *Fountain of the Waters* in the Fine Arts Garden of The Cleveland Museum of Art. As the subject for his imposing group at the New York World's Fair he chose *Riders of the Elements*. In *Sea Horse*, given the Potter Palmer Gold Medal of The Art Institute of Chicago in 1925, the eccentric curves and angles of the sea horses on the base are repeated in the bent knees and crooked arms of the man holding a boy on his shoulders.

The fondness for abstract ideas found legitimate outlet in the *Service to the Nation* group for the American Telephone and Telegraph Company, New York, a powerful male figure with coils of wire behind the head, and above it a globe supported by personifications of War and Peace. The *Torch Race* of the Greek Games for Barnard College, a running girl in a clinging tunic, is generalized to typify the college girl. He carved in marble a reredos for Saint

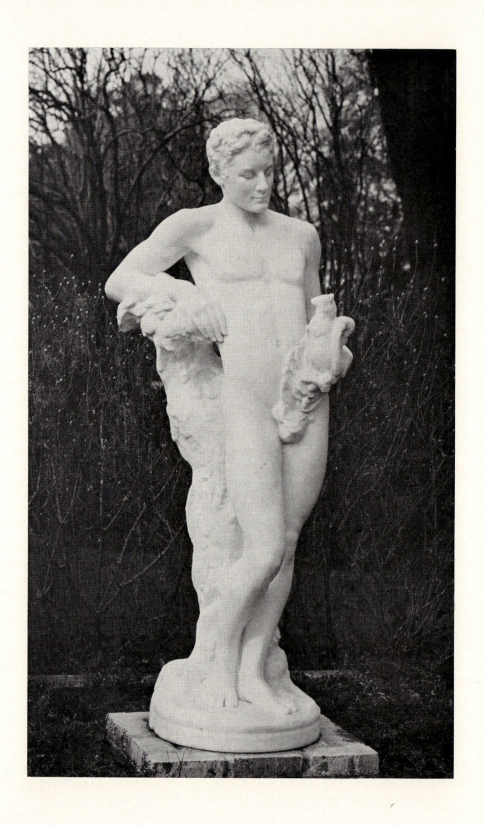

SYLVAN

White marble statue. Height 5 ft. 8½ in. Placed in Brookgreen Gardens in 1932.

Mark's in the Bouwerie and a relief of children as a memorial for Babies Hospital, Columbia Presbyterian Medical Center, New York.

A versatile artist, he used many materials, interested in solving the different problems that each one presents. His portrait busts may be carved in marble, like those of his wife *Eleanor*, in The Art Institute of Chicago, and his great-grandmother, modeled in clay for terra cotta, or cast in bronze. Five bronze busts by him are in the Hall of Fame, New York University. He also carved ivory statuettes, some of them portrait studies of children. His work in medallic art was rewarded in 1938 with the Lindsey Morris Memorial Prize of the National Sculpture Society for a medal on war and peace, the twelfth issue of the Society of Medalists, and in 1946 by the Saltus Medal of The American Numismatic Society. In 1927 and 1928 Beach was again at Rome, and in his later years he spent the winters traveling, recording his impressions in lively sketches. The rest of the time he lived in the country house that he had built at Brewster, New York, where he died on August 6th, 1956. His last work, done in the previous year, was a relief portrait of Benjamin F. Fairless, a former president of United States Steel Corporation. Beach had been president of the National Sculpture Society and was a member of the National Academy of Design, The Architectural League of New York, The American Numismatic Society, and the National Institute of Arts and Letters.

Sylvan

A young man leans against an oak trunk, resting his elbow on the top, as he smiles down at a squirrel perched on a branch which curves about his waist. By the easy pose, with relaxed muscles, and the care-free mood, the sculptor has suggested the atmosphere of a sunny glade. The light plays over minute variations of surface to give the luminous quality of flesh.

Anna Coleman Ladd

ANNA COLEMAN WATTS, the daughter of John S. and Mary (Peace) Watts was born on July 15th, 1878, at Bryn Mawr, Pennsylvania, although she lived for twenty-three years in Paris and Rome. Her early education was at Miss Yeatmann's School and with private teachers. About 1900, without

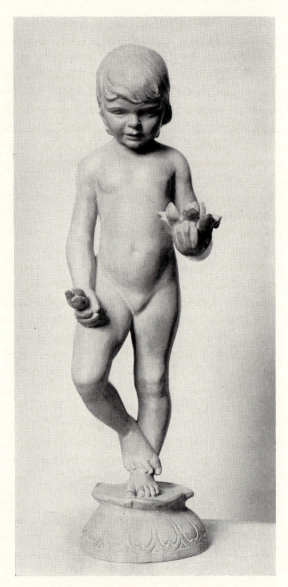

LOTUS FLOWER

Bronze statuette. Height 2 ft. 3
in. Placed in Brookgreen Gardens
in 1936. Other example: Phila-
delphia. Print Club.

recourse to schools, she began to model from the life. Aided by criticisms
from Rodin, Ettore Ferrari, Emilio Gallori, and Charles Grafly, she worked
independently both abroad and in this country. On June 26th, 1905, in
Salisbury Cathedral, England, she married Maynard Ladd, a Boston physi-
cian.

Her work began with fountains and portrait busts. She was exhibiting by 1907 and in 1913 had her first one-man shows at New York, Washington, and Philadelphia. At Rome in 1914 she made a bronze statuette of Eleanora Duse for which the actress posed. *Wind and Spray* fountain, a ring of dancing figures, was modeled for the Panama-Pacific Exposition, where her work won honorable mention. Her *Sun God Fountain* and *Leaping Sprites* were placed in gardens at Manchester-by-the-Sea, Massachusetts, and *Triton Babies* in the Boston Public Gardens. Many other fountain subjects also sprang from her fertile imagination. Portrait busts formed another large part of her work, one being in the Isabella Stewart Gardner Collection, Boston; others were of such famous persons as Anna Pavlowa, Ethel Barrymore, and Duse. Soldiers' monuments designed by her have been erected in several Massachusetts towns, the Studebaker Memorial at South Bend, Indiana, and the Aldrich Memorial at Grand Rapids, Michigan. From 1917 until after armistice Mrs. Ladd was in France, where she organized the American Red Cross studio to make portrait masks for disfigured soldiers. In 1923 she received an honorary degree of master of arts from Tufts College.

Her most typical works are those which have a symbolic content, for she was as interested in the thought embodied in the sculpture as in the manner in which the thought was clothed. Where in her earlier work a lighter fancy dictated the theme—the sun god slaying the python of winter, ocean lifting a tiny sail on his palm, a woman piercing a man's breast like a sword—in her later work the idea took on a deeper significance. *Peace* is a stern figure clutching the throat of War, who kneels on a prostrate youth; *Vision* shows the young Christ at the feet of His Mother; and there is also a *Young Christ* with humanity held like a child in His arms. Mrs. Ladd published two novels, both in 1912, *Hyeronymus Rides* and *The Candid Adventure*. She was a member of the National Sculpture Society and a *chevalier* of the Legion of Honor, and received the Serbian Order of Saint Sava. She died at Santa Barbara, California, on June 3rd, 1939.

Lotus Flower

A baby girl stands on one foot on a lily pad, the other foot propped against her ankle. She holds an open flower in the right hand; a bud is clutched in the other, resting against the thigh. The hair is swept in soft waves across the forehead and across the nape of the neck. The face, looking downward, wears an intent expression.

Gertrude Vanderbilt Whitney

GERTRUDE VANDERBILT was born in New York City on April 19th, 1877, the daughter of Cornelius and Alice Claypoole (Gwynne) Vanderbilt. She received her education from tutors and at the Brearley School. In 1896 she married Harry Payne Whitney. Some time after her marriage she started upon her career as a sculptor, studying with Hendrik C. Andersen and James Earle Fraser. Later she attended the Art Students' League and, going to Paris, worked under the instruction of Andrew O'Connor. In 1907 she took a studio in New York. An *Aztec Fountain* designed in 1912 was placed in the court of the Pan-American Union Building, Washington, D.C., and the pictorial *El Dorado Fountain* at the Panama-Pacific Exposition. *Head of a Spanish Peasant* was acquired by the Metropolitan Museum, New York.

Her first commission for the monumental sculpture for which she is so well known was the Titanic Memorial for Washington, D.C., won in competition. A simply draped figure with the arms spread in the shape of a cross, it represents sacrifice. At the outbreak of the war in 1914, Mrs. Whitney established a hospital at Juilly, France, for wounded soldiers. From her war experiences she modeled a series of studies of soldiers, one of which, *Red Cross*, is in the Musée des Invalides, Paris. This material served as a basis for the war monument erected on Washington Heights, New York, and for her achievement as an "interpreter in sculpture of the American character as it found expression in the great war" New York University granted her an honorary degree of master of arts in 1922. Following the Titanic Memorial she conceived other monuments in a simplified heroic style: the Columbus Monument at Palos, a cloaked and hooded figure embracing a cross, for which there was conferred on her the grand cross of the Order of King Alfonso XII; and a war memorial, a soldier standing on the back of an eagle, at Saint-Nazaire, France. In a more romantic vein, the equestrian *Buffalo Bill* at Cody, Wyoming, scouts for Indians in all the picturesque trappings of the Wild West, and *Peter Stuyvesant*, leaning on his stick, doughtily surveys Stuyvesant Square, New York. For the first New York World's Fair she

CARYATID

Sketch in bronze. Height 1 ft. 11 in. Signed on base at right: *Gertrude V Whitney 1913* Founder's mark: C.VALSUANI CIRE PERDUE Placed in Brookgreen Gardens in 1936. Other example: New York. The Metropolitan Museum of Art.

206

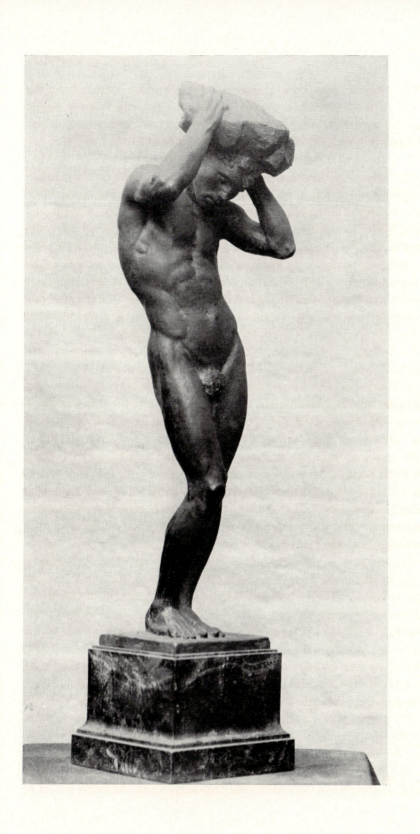

designed *The Morrow*, two youthful figures and huge wings soaring from the
tip of an arc. In the figures and groups which were not destined for public
monuments she tried to achieve an intensity of emotional expression aided by
vaguely defined masses and flickering surfaces, a treatment referable to her
teacher, O'Connor, and ultimately to Rodin. Aside from her own work Mrs.
Whitney devoted much time and attention to encouraging other American
artists. The Whitney Studio Club, begun in her studio in 1914, evolved into
the Whitney Museum of American Art. In 1923 she was awarded the medal
of the New York Society of Architects, in 1932 a bronze medal by the
American Art dealers Association, and in 1940 a special medal by the
National Sculpture Society. She received honorary degrees from Tufts Col-
lege and Russell Sage College. She was a member of the National Sculpture
Society and an associate of the National Academy of Design. She died at New
York on April 18th, 1942.

Caryatid

A male figure stands with shoulders bowed, both hands lifted to support a
heavy weight on his head. It is the sketch for one of the three statues carrying
a basin of fish heads and sea grapes forming a fountain which in 1913 was
awarded honorable mention at the Paris *Salon* and the next year the National
Arts Club Prize of the National Association of Women Painters and Sculp-
tors. Originally modeled for the Arlington Hotel, Washington, D.C., the
marble fountain was presented to McGill University, Montreal, in 1931 as a
symbol of international good will. A bronze replica is at Lima, Peru. A smaller
bronze version is in the Whitney Museum of American Art.

Malvina Hoffman

MALVINA HOFFMANN was born in New York City on June 15th, 1885,
the daughter of the pianist Richard Hoffman and his wife, Fidelia Marshall
Lamson. Her father was English by birth and her mother of a New York
family. While she was at the Brearley School, Miss Hoffman began to draw
and paint. She first studied painting with John W. Alexander, then turned to
sculpture and joined a class that Herbert Adams and George Grey Barnard
taught. Gutzon Borglum gave her helpful criticisms when she made a bust of

her father and encouraged her to carve it in marble. The finished work was accepted for exhibition at the National Academy of Design.

In 1910 she went to Paris, where, after persistent efforts, she was accepted as a pupil by Rodin. On his advice she spent a year in New York studying dissection at the College of Physicians and Surgeons, returning to Paris to work from 1911 to 1914. It speaks well for the strength of her own inspiration that while in such close contact with Rodin she should have been so little carried away by his individual style. From him she learned to give vitality and emotion to her creations, but the clarity of her mind kept them firmly tied to actuality. Several later works which show the glowing surfaces and emotional intensity associated with his example are *Mort Exquise*, *The Prayer* in the collection of The Art Institute of Chicago, and *Offrande*, which won the Widener Gold Medal of The Pennsylvania Academy of the Fine Arts and the Barnett Prize of the National Academy of Design.

In order to become thoroughly grounded in the technical processes of sculpture, she studied bronze casting, chasing, and finishing at foundries and with the Italian sculptor Emanuele Rosales. Through her acquaintance with members of the Russian ballet, Pavlowa in particular, she began to use moments from their dances as subjects and became the first to interpret in sculpture the art of contemporary dancers, capturing in bronze their rhythmic movement and vivid action. *Russian Dancers* was awarded first prize at a Paris exhibition. Returning to New York after war was declared in 1914, she devoted a large part of her time to Red Cross work and continued her studies of the dance, which immediately found favor in the public eye. *Bacchanale Russe*, awarded the Shaw Memorial Prize by the National Academy of Design in 1917, was placed in the Luxembourg Gardens, Paris, but destroyed in World War II. *Pavlowa Gavotte*,[1] *La Péri*, and *Les Orientales* all interpret dance movements. A frieze of twenty-six panels in low relief depicted Pavlowa in *Autumn Bacchanale*. Miss Hoffman made many portrait studies of Pavlowa, a mask in wax being awarded the Watrous Gold Medal of the National Academy of Design in 1924, and other portraits, fountains, and statuettes varied her work. *The Sacrifice*, a mother kneeling at the head of a crusader in armor, was given to Harvard University as a war memorial by Mrs. Robert Bacon. Unusual among Miss Hoffman's works in the severity of the composition, it has the austere beauty of medieval tomb sculpture.

In 1919 a mission for the American Red Cross and the American Relief Administration took Miss Hoffman to Yugoslavia, where she made the *Modern Crusader*, a portrait of Colonel Milan Pribicevic, now in The Metropolitan Museum of Art, New York. Three studies of Paderewski as man, artist,

1 There are examples in The Metropolitan Museum of Art, New York, the Stockholm Art Museum, and The Cleveland Museum of Art.

and statesman received wide acclaim. One version is at the American Academy in Rome, another in Steinway Hall, New York. Her marriage to Samuel Bonarios Grimson, English violinist, a portrait of whom had been one of her earliest works, took place on June 6th, 1924. In the same year she received the commission for two stone figures, *To the Friendship of English-Speaking Peoples*, over the entrance to Bush House, London. In New York again, she carved a head of John Keats in marble, which was acquired by the University of Pittsburgh, and a portrait of Meštrovic which went to the Brooklyn Museum. Her meeting with the Yugoslavian sculptor led to a stay in Zagreb in 1928 to study architectural and monumental sculpture with him. The influence of his teachings can be seen in a plaster model for a monument against war called *Four Horsemen of the Apocalypse* and in *Elemental Man*.

A visit to Africa, where she carved in wood and marble heads of native people, beautifully simplified,[2] prepared the way for her largest commission. In 1930 she undertook to model for the Field Museum of Natural History a series representing the races of man, which finally included one hundred and five heads and full-length figures. This enterprise involved five years of intensive effort and travel in many countries, where the subjects were modeled. In each case she chose some attitude which would be expressive of the race and succeeded by insight and imaginative force in giving these truthful studies artistic value. Her account of this work, *Heads and Tales*, was published in 1936. On her travels the dance continued to fascinate her, and she brought back statuettes of some of the remarkable dancers of the East, such as those of Bali and Cambodia. Later she modeled a number of dancers, as well as helping to organize an international exhibition of the dance in art, and making a sculptured drum, *Dances of the Races*, for the New York World's Fair.

In 1948, after World War II, Miss Hoffman was selected as the sculptor for the American War Memorial Building at Épinal in the Vosges Mountains of France. Her principal contribution was two panels, in low relief, incised, on the façade, designed "To represent modern warfare and the apotheosis of battle and its aftermath." One depicted soldiers advancing in battle formation; the other, the dead welcomed by an angel, interpreting a line from *Pilgrim's Progress*, "So he passed over, and all the trumpets sounded for him on the other side." For this project the sculptor adopted strong linear patterns. When she was asked to provide sculpture for the façade of the Joslin Clinic for Diabetes at Boston, she epitomized the history of medicine in a series of reliefs portraying many famous physicians. Again she chose a

2 *Martinique Woman* and *Senegalese Soldier* are in Brooklyn Museum and The American Museum of Natural History, the latter also at Amherst College.

method to agree with the stark simplicity of the building—low relief with incised outlines.

These architectural commissions were less congenial to her than expressing her own observations of action and motivation. A bullfight seen on a trip to Spain in 1953 so impressed Miss Hoffman that she later recaptured some of its decisive moments in a group of small bronzes. Throughout her life her interest in people sparked a desire not merely to record features but to go further and sound the depths of personalities. Her subjects ranged from the simple humanity of artisans at Paris to the complexities of highly civilized men and women. On these portrait busts she expended her gifts of insight and her skill in lifelike modeling. She died in the studio that she had used for many years, 157 East Thirty-fifth Street, New York City, on July 10th, 1966.

Many honors rewarded her achievements. Colleges and universities granted her honorary degrees; she received the French decoration of the *Palmes Académiques*, and the Serbian Order of Saint Sava. In 1935 she was selected a "woman of achievement" by the New York League of Business and Professional Women and two years later awarded a gold medal by the American Woman's Association. She was named "woman of the year" by the American Association of University Women in 1957. The National Sculpture Society in 1964 awarded her its medal of honor, rarely given.

Boy and Panther Cub

A youth wearing a wreath of grapes stands on tiptoes, one leg behind the other and the body slightly turned. A spray of grapevine falls across the front of his body. The statuette stands on a drum patterned with a grapevine and scrolls, resting on a three-legged base with claw feet and panther masks between. The life-sized figure was done in 1915. "The first figure I built in 157 [East Thirty-fifth Street] was that of a young bacchus holding a panther cub in his arm and crushing a bunch of grapes with his uplifted right hand. Water was piped to these grapes from inside the life-size bronze figure, which later was set in a pool on Paul Warburg's estate in Hartsdale. Frequent trips to the Zoo were needed to make studies of the panther cub. . . ."[3] Two other examples in large size were cast.

Bronze statuette. Height 1 ft. 8½ in. Signed on base at right: © 1915 MALVINA· HOFFMAN Founder's mark: ROMAN BRONZE WORKS N-Y- Placed in Brookgreen Gardens in 1938. Other example: The Cleveland Museum of Art (bronze statue).

3 Hoffman. *Yesterday.* p. 153.

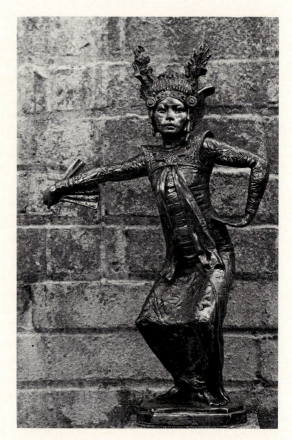

BALI DANCER

Golden bronze statuette. Height
1 ft. 5 in. Signed on base at right:
© MALVINA HOFFMAN Found-
er's mark: ROMAN BRONZE
WORKS N.Y. Placed in Brook-
green Gardens in 1937.

Bali Dancer

The dancer is in the elaborate costume of a temple dancer, with a horned
headdress and a tight bodice and skirt. The knees are bent and the left hand
turned towards the hip in a graceful gesture, the right hand extended holding
a fan. The statuette was modeled in the village of Den Pasar from the dancer
Ni Polog in 1932, when Miss Hoffman was gathering material for the Hall of
Man series. A head of Ni Polog done at the same time is in the Field Museum
of Natural History, Chicago.

Andaman Islander

Squatting on a rock, a Negrito draws a long bow held to his left. Miss
Hoffman describes the islander and her representation of him as follows:

"It was in the port of Rangoon that I had the good fortune to study a few
little Negritos from the Andaman Islands. They were on a sailing ship, and

our local adviser assured me that they were good representatives of their tribes. The figure I modelled of an Andaman Islander shows the little Negrito hunter seated on a rock, trying out the elasticity of his bow. This typical weapon is of a very special design, not found in any other part of the world. Very stiff and powerful, the wood is carefully selected and shaped with a primitive sort of adze, and finally smoothed off with the edge of a sharp shell. When drawn, the upper half of the bow bends towards the body, but the lower end, which when relaxed is slightly bent away from the body, becomes practically straight. The Andaman Islands are . . . in the Bay of Bengal (Indian Ocean), just north of the Nicobar group of islands, southwest of Burma." [4] The statuette was made in Calcutta one-third life size and enlarged at Paris for the Field Museum.

Original model in bronze. Height 1 ft. 11¾ in. Base: Width 1 ft. ½ in.—Depth 8 in. Founder's mark: ALEXIS RUDIER FONDEUR PARIS Placed in Brookgreen Gardens in 1937. Other example: Chicago. Field Museum of Natural History (bronze statue).

Robert A. Baillie

ROBERT ALEXANDER BAILLIE gained a special place among sculptors as their interpreter in stone, since life-long work with stone cultivated to a high degree his instinct for its most effective handling. Coming from a family in which carving was traditional, he combined the skill of experience with the wider outlook resulting from a professional education. He was born at Newton-Stewart, Wigtownshire, Scotland, on October 10th, 1880, the son of Alexander and Helen K. Baillie. In this region, the southwest corner of Scotland, many granite quarries encourage the craft of stonecutting. The first in the family to engage in this occupation was Robert Baillie's grandfather. His son Alexander was trained to be a stone carver and came to be foreman for the Scottish sculptor John Rhind.

In 1889 his son, J. Massey Rhind, came to America. He established a studio at Closter, New Jersey, and soon had many orders for monuments and architectural sculpture. Included in his output were a great number of ecclesiastical carvings such as reredoses and altars. To do this work, he called upon Alexander Baillie, who then emigrated to the United States and settled at Closter.

4 Hoffman. *Heads.* p. 294.

Robert, the third son, was taken into the studio as an assistant when he was fourteen, given lessons in modeling by his father, and employed on the Gothic ornament which was their specialty. This period of apprenticeship lasted for two or three years, until he felt the need of further instruction and went to Cooper Union. He attended both day and night classes, having George T. Brewster for an instructor during the last two of the four years that he was there. Karl Bitter chose him to help on the sculptural decorations for the exposition at Saint Louis. On his return to New York, Baillie designed some of the big capitals in the Cathedral of Saint John the Divine, New York City. Gutzon Borglum, who was working at the same time on a series of angels for the cathedral, admired the capitals and invited Baillie to work with him in his studio.

At this period in his career Borglum was engaged on architectural projects such as the North America group and a relief for the façade of the Pan American Union Building, Washington. Baillie collaborated with him, working on architectural drawings and carving in stone for nearly ten years. When Borglum began work on Stone Mountain, Baillie left him and settled at Closter, hoping to launch on a career as a portrait sculptor. In 1909, while still associated with Borglum, Baillie had carried out his first independent commission, which had been for architectural carving on the interior of Grace Church, Brooklyn, New York. Gothic capitals, corbels, and a door were carved in place by hand.

A bust of Frances Willard in marble for the library at Ocean Grove, New Jersey, and a portrait relief for the school where she had taught at Lima, New York, were steps towards the career which he envisioned, but his skill as a stone carver began to attract so many orders from other sculptors that no time was left for his own creations. His personal works in later years are a few well-characterized busts such as those of his nephew, Robert Fuller, and of Homer Ferguson, then president of the Newport News Shipbuilding and Dry Dock Company. An informal portrait relief of Senator William Wood of Indiana as a fisherman was done in 1933.

The studio at Closter became a scene of constant activity, where the many different skills demanded for the handling of stone were practiced. The list of sculptors with whom Baillie worked includes many distinguished names, increasing in number as his abilities became more widely known. He carved several of Brenda Putnam's works and furnished the chapter on stonecutting for her book on the methods of sculpture, *The Sculptor's Way*, first published in 1939. For Malvina Hoffman he cut in limestone the two heroic figures over the entrance to Bush House, London, which symbolize American and British friendship and went to London to install the figures. Baillie met Anna Hyatt

Huntington when she came to Borglum's studio for some criticisms and later began to cut her works in marble and stone. During one of her periods of greatest activity, from 1923 to 1927, much of Baillie's time was given to her work. He carved her animal groups and two huge reliefs for the terrace of The Hispanic Society of America, New York. For the south façade of the Society's main building he also carved nine limestone panels by Berthold Nebel.

When Brookgreen Gardens was founded by Mr. and Mrs. Huntington in 1931 and the plan for a collection of American sculpture to be placed there was formulated, Baillie was associated with them in the development of the Gardens; he was later appointed Curator of Sculpture. He was called upon to carve a number of pieces, which were often ordered enlarged from a small sketch and executed in marble or stone especially for the Gardens. Mrs. Huntington's *Youth Taming the Wild* was cut in limestone, Edmond Amateis's *Pastoral* interpreted in the warm tones of pink Tennessee marble, and A. A. Weinman's *Riders of the Dawn*, carried out in limestone as the central group in the Dogwood Garden.

Baillie was no mechanical copyist but made certain modifications in order to translate plaster models into stone. In some cases only a sketch was supplied for him to develop completely. Since he had to follow the varying styles of the sculptors for whom he worked, he had to be sensitive to their special qualities as artists and faithful to their individual modes of expression. The unusual quality of Baillie's achievements was recognized when in 1951 he was elected an honorary fellow of the National Sculpture Society. He died on November 6th, 1961.

Vase

The vase is oval in shape. At each end two sprays of laurel twist into handles, while the leafy branches spread in a wide band across the middle of the vase. The upper part has a border of entwined flat stems, the oval interstices set with diamond-shaped facets. A wide band of gadrooning diminishes to the rectangular molded base. A cover is indicated by flat petals with smaller petals forming a bud-shaped knob.

When the Dogwood Garden was developed, these vases were designed to enhance the opening from the terrace with an ornamental finish to the posts at each side. Baillie cut them directly in limestone, without preparatory models.

Limestone. Height 2 ft. 6 in.—Length 2 ft. 9 in.—Width 1 ft. 7½ in. Placed in Brookgreen Gardens in 1950.

Vase

This vase is the same as its companion except for a band of Greek fret around the top and a different pattern of petals on the knob.

Limestone. Height 2 ft. 5¾ in.—Length 2 ft. 10½ in.—Width 1 ft. 7½ in. Placed in Brookgreen Gardens in 1950.

Vases

Choosing a marine theme, Baillie carved a frieze made up of panels with fishes around the top of each of these two vases. In place of handles there are fish heads. The bodies and the covers of the vases are gadrooned.

Limestone. Height 2 ft. 5 in.—Length 3 ft. 5 in.—Width 1 ft. 4½ in. Placed in Brookgreen Gardens in 1954.

Vase

Both these vases are carved with foliage based on the acanthus leaf, with globules and indentions at the edges, brought to a square shape in the tradition of florid Gothic carving.

Limestone. Height 2 ft. 1 in.—Length 2 ft. 10 in.—Width 1 ft. 6 in. Placed in Brookgreen Gardens in 1960.

Vase

Limestone. Height 2 ft. 1 in.—Length 2 ft. 8 in.—Width 1 ft. 5 in. Placed in Brookgreen Gardens in 1960.

Richard Henry Recchia

BORN AT Quincy, Massachusetts, and christened Ricardo Enrico, Richard Recchia is the son of Louise (Dondero) and Francesco Recchia, an expert marble carver. After two years' apprenticeship in his father's shop, Richard entered the school of the Boston Museum of Fine Arts when he was

sixteen, studying modeling and anatomy with Bela Lyon Pratt. Recognizing his talent, his teacher and Daniel Chester French sent Recchia to Europe for a year of study in Italy and at the Académie Julian in Paris during 1911 and 1912. Upon his return to Boston he became Pratt's assistant for nine years.

At the outset of his career his *Golden Age* won a bronze medal at the Panama-Pacific Exposition. He became skilled in the art of bas-relief during his years with Pratt, who had had some experience in Saint-Gaudens's studio. Much of Recchia's work has consisted of portraits in relief, such as that of Governor Curtis Guild for the Boston State House and those of Sam Walter Foss and Robert Brown for Brown University. Also in relief are panels for the façade of the Boston Museum of Fine Arts, the Red Cross Disaster model in the Red Cross Museum, Washington, D.C., and medallions of Junípero Serra, Cortés, and Balboa for Santa Barbara, California. A memorial to Governor Oliver Ames is at North Easton, Massachusetts, and one to General George Wells in the Shenandoah Valley, Virginia. For this phase of his work he received in 1939 the Lindsey Morris Memorial Prize of the National Sculpture Society. The National Academy of Design awarded him the Watrous Gold Medal in 1944 for a romantic bust of Raymond Porter.

Another field in which Recchia has found himself at home is that of imaginative figures, chiefly for gardens. A strong sense of line and a feeling of vitality govern these creations. The fleeting influence of Rodin is visible in the *Echo* of 1914, a crouching nude with wind-blown hair. An impressionistic effect of blowing wind and drifting sand surrounds the realistically modeled figures of the *Singing Boy* and the *Flute Boy*. An ideal head, *Youth*, and a bronze entitled *Down and Out* are in the J. Breckenridge Speed Memorial Museum, Louisville, Kentucky. Works of symbolical content are *Flight of the Soul* and a tribute to his first wife, Anita Diaz, called *In Memoriam*. After her death, Recchia married Kitty Parsons, an artist and author. Increasingly simplified contours and modeling characterize later figures, *The Offering*, *Ariel*, and *Flight*, a boy shooting an arrow upward, which won a gold medal and the cross of merit at the Bologna International Exposition, 1931. Reduced to still simpler terms are *Great Horned Owl*, *The Vulture*, *Leaping Frog*, and other animal studies.

An equestrian statue of General John Stark, extremely dramatic in conception though moderately stylized in treatment, was dedicated at Manchester, New Hampshire, in 1948. Recchia has also designed a monument to Mother Goose. The sculptor has been active in artistic movements in Boston. He is a member of many associations, a charter member of the Guild of Boston Artists and the founder of the Boston Society of Sculptors. He is also a fellow of the National Sculpture Society and a member of the National Academy of Design.

Baby and Frog

A huge frog leaps forward in grotesque motion. A laughing girl astride its back grasps its upper jaw in both hands, her body braced against the speed of their leap. The nubbly body and taut muscles of the frog are modeled in detail, contrasting with the smoother forms of the girl and her wind-swept hair. The large bronze, now in the sculptor's garden at Rockport, Massachusetts, was made in 1923, his daughter and a live frog, many times enlarged, being the models. At the 1939 New York World's Fair it was placed at the entrance to "Gardens on Parade." Only two examples of the reduction have been cast, the other being in the possession of the sculptor.

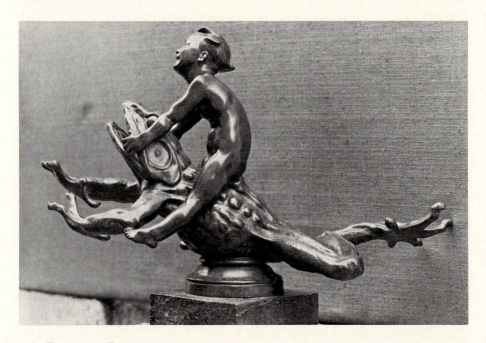

BABY AND FROG

Reduction in bronze. Height 1 ft. 2½ in. Signed on base: R. H. RECCHIA © Placed in Brookgreen Gardens in 1936.

Bashka Paeff

ALTHOUGH she was born at Minsk, Russia, on August 12th, 1893, Bashka Paeff was brought to the United States by her parents, Louis and Fannie (Kischen) Paeff, while she was an infant. They came to Boston, and Miss Paeff has lived there all her life. She graduated from the Massachusetts Normal Art School and studied sculpture with Bela Pratt at the Boston Museum School of the Fine Arts, where her work merited scholarships. At the beginning of her career she won competitions for war memorials, one to Massachusetts chaplains placed in the Hall of Fame of the State House, Boston, and another erected by the State of Maine at Kittery. The latter is a large bronze relief of a woman brooding over the fallen.

In 1930 Miss Paeff went to Europe and stayed two years, traveling and working in a studio at Paris. She had some criticisms from Naoum Aronson. A head of a child carved in marble and a fountain group of two children playing were exhibited at the Paris *Salon*. After her return to the United States she married Professor Samuel Montefiore Waxman.

Miss Paeff has made many portrait busts and bas-reliefs, some of them cast in bronze, others carved in marble. Physicians, educators, and musicians have predominated among her subjects. A bronze bust of Justice Oliver Wendell Holmes is at Washington, D.C., and one of Jane Addams in Hull House, Chicago. The majority of her work is concentrated in the Boston area. A portrait of Dean James Barr Ames is in the Harvard Law Library and one of A. J. Philpott in the Boston Museum of Fine Arts. Memorials by this sculptor often take the form of bas-relief portraits. Among them are those of Edward MacDowell at Columbia University, of Arthur Foote in the New England Conservatory of Music, and of James Geddes, Jr., at Boston University.

The sculptor does her own marble carving for portrait busts such as that of Justice Brandeis for Brandeis University, of Dr. Esther Loring Richards for Johns Hopkins University, and one of Roland Hayes. The bust of Joseph J. Perkins has been placed in Perkins Chapel, Southern Methodist College, Dallas, Texas. That of her sister, Sonia Paeff Silverman, is in the Dartmouth College Art Gallery, and a head of a child, *Steffie*, was awarded a prize by the Academic Artists Association. A portrait relief of Ella Fohs, carved in marble, is in the Boston Museum of Fine Arts and one of Dean Bernice Brown Cronkhite in the Radcliffe Graduate Center, Cambridge, Massachusetts.

In addition to people, Miss Paeff has portrayed some animals. The Harvard Class of 1933 commissioned from her a statue of President Lowell's cocker

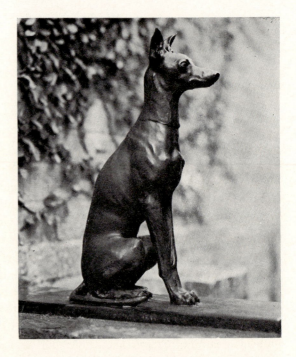

Whippet

Bronze statuette. Height 1 ft. 3½
in. Base: Length 1 ft. 6¾ in.—
Width 6½ in. Signed on left edge
of base: BASHKA PAEFF·SC·1919·
Presented to Brookgreen Gardens
by Samuel M. Waxman in 1961.

spaniel, Phantom, as a gift to him. A bronze statue of President Harding's
Airedale, Laddie Boy, is owned by the Smithsonian Institution.

The sculptor's favorite creations are fountains, in which she can give her
imagination free rein, using children's figures to express the joy of life. The
John E. Warren Memorial Fountain is at Westbrook, Maine, and the Julius
Rosenwald Memorial Fountain at Ravinia, Illinois. A *Boy and Bird Fountain*
is in the Boston Public Gardens. At Ipswich, Massachusetts, a bronze sundial
is entitled *The Three Wise Men*, and another at Cedar Rapids, Iowa, is called
Children of Light. Miss Paeff was named one of five women of achievement
by the Business and Professional Women's Club, Boston. Her work received
both first and second prizes at the Scituate, Massachusetts, Art Festival in
1960. She is a member of the Guild of Boston Artists and the National
Sculpture Society.

Whippet

The dog is a lifelike study of a whippet, seated with head raised alertly
and ears up. Scotty belonged to Mr. C. G. Rice of Ipswich, Massachusetts.
His wife ordered the statuette as a surprise Christmas gift, arranging to have
Scotty smuggled into Miss Paeff's studio for sittings while her husband
was at his office.

The plaster model was exhibited at the Paris *Salon* in 1931, and the
example at Brookgreen cast in bronze at Paris.

Edward McCartan

EDWARD MCCARTAN was a unique figure in American sculpture. Although many other sculptors composed in graceful linear patterns, no other had so close a kinship with eighteenth-century France. Among the men of that period, it is Houdon to whose genius his own had the closest affinity. McCartan was born at Albany on August 16th, 1879, to Michael and Anna (Hyland) McCartan. Herbert Adams was his teacher at Pratt Institute, George Grey Barnard and Hermon MacNeil, at the Art Students' League. His Paris studies, beginning in 1907, were three years at the École des Beaux-Arts, where Injalbert was his instructor. He had practical training as an assistant to Adams and MacNeil before he took his own studio in New York about 1913.

There is evidence of an early admiration for Rodin in the group of a mother and child entitled *The Kiss*, ideated at Paris about 1908 and finished ten years after. The emotional force and the vague, soft modeling of the flesh have no counterparts in his later work. He received the Barnett Prize at the National Academy exhibition in 1912 for a fountain. In *The Spirit of the Woods*, for the Pratt Estate at Glen Cove, Long Island, a nymph dancing with a baby faun in her arms, and *Girl Drinking from a Shell* the nude is still realistically treated, although the rhythmic design is paramount; an example is in the Reading Public Museum.

By 1920 with the *Nymph and Satyr* McCartan's mature style crystallized. The forms are purified and the lucid composition polished to a glowing brilliancy of line. The few ornamental passages, the hair, the basket of fruit, and the satyr's wreath are finished with sparkling clarity of detail. The same qualities irradiate the swinging curves of the *Girl with Goat*, the *Diana* with a hound straining at the leash, the *Dionysus*, the *Girl and Greyhound*, and the lyric symmetry of *Isoult*. Another *Diana* with a fawn beside her has the long limbs and sloping shoulders which French sculptors since Jean Goujon have delighted to represent. In a fountain figure of 1931, seated with a globe in the hands, the head and the drapery are stylized in accordance with archaistic conventions. The forms of *The Bather*, in the collection of the Pennsylvania Academy, are simplified to give firmer surfaces and more emphasis on mass.

Excursions into other, alien territory are the Eugene Field Memorial dedicated at Chicago in 1922 and the monumental clock for the New York Central Building at New York done in 1928. Although the pictorial subject of the Field Memorial was uncongenial to him, McCartan invested with great

221

charm the two sleepy children and the fairy with diaphanous draperies and butterfly wings hovering over them. The two supporting figures for the clock, with less clearly ordered linear rhythms than his other work, suggest more immediately eighteenth-century French masters, Pigalle in particular. McCartan's interest in perfecting ornamental detail led to an association with the school of the Society of Beaux-Arts Architects with the special aim of training craftsmen in the technique of decorative modeling and carving. He continued his architectural sculpture with panels for the New Jersey Telephone Company Building, Newark, and a pediment for the Department of Labor and Interstate Commerce Building, Washington, D.C. A member of many art societies, he was president of the Concord Art Association and first vice-president of the National Academy of Design. He was a fellow of the National Sculpture Society and a member of The American Academy of Arts and Letters. The gold medal of honor of the Allied Artists of America was awarded to him in 1933. McCartan died on September 20th, 1947. Cortissoz has defined the essential quality of his work in the following words:

"Throughout, the sculptor makes you feel his reserve, his selective taste, that same handling of form, I repeat, which belongs to the cool, calculating, fastidious Houdon. It is upon just such refined, rarefied work that the benison of style descends. This distinction of style is what gathers together and validates all of McCartan's traits as a sculptor." [1]

Dionysus

See Frontispiece

Dionysus, crowned with ivy, stands nonchalantly, one knee sharply bent, hand on hip. He holds a thyrsus over the head of a panther which curls behind his legs. A piece of drapery is flung over his left wrist and thigh. The classic harmony of the figure is enlivened by the rhythmic curves of the composition, with its finely ordered balance of line. This group, originally designed in 1923, was enlarged and remodeled for Brookgreen in 1936.

Gilt bronze group. Height 6 ft. 3 in. Signed on base at back: *E. McCartan 1936* Founder's mark: ROMAN BRONZE WORKS N-Y- Placed in Brookgreen Gardens in 1938.

Diana

The goddess strains backward as she holds in leash a greyhound leaping ahead. Raised in her other hand is a small gilt bow. A gilded fillet and crescent bind her hair. The statuette, originally modeled in 1920, was

1 Cortissoz. *The sculpture of Edward McCartan.* p. 243.

awarded a medal of honor by the Concord Art Association in 1925. It was enlarged for a garden at Greenwich, Connecticut, in 1928. Cortissoz writes of this work:

"He is a child of Houdon, say, simply in that it is natural to him to compose in terms of an animated mundane elegance and to stress in his figures the precious quality of line. The Diana is perhaps his outstanding triumph in this regard. Its contours have a delectably pure and flowing linear distinction. How spare and refined the lovely figure is!" [2]

Bronze statuette. Height 1 ft. 11 in. Signed on base at right: E· MC CARTAN 19 © 22 N°. 2 Placed in Brookgreen Gardens in 1934. Founder's mark: ROMAN BRONZE WORKS N-Y- Other examples: Cambridge, Mass. William Hayes Fogg Art Museum; Canajoharie Art Gallery; New York. The Metropolitan Museum of Art.

Diana

Diana, standing at ease, holds in one hand a long bow, the other end of which rests on the ground. Her right hand caresses the head of a fawn behind her.

Bronze statuette. Height 1 ft. 11 in. Signed on base at back: E. MC CARTAN 1924 N°. 2 Founder's mark: ROMAN BRONZE WORKS N-Y- Placed in Brookgreen Gardens in 1934. Other example: New York. The Century Association.

Harriet Whitney Frishmuth

HARRIET WHITNEY FRISHMUTH was born at Philadelphia on September 17th, 1880, the daughter of Frank B. and Louise Otto (Berens) Frishmuth. She received her early education in private schools at Philadelphia, Paris, and Dresden. In 1900 she went to Paris to study sculpture, first as a pupil of Rodin and then of Gauquié and Injalbert. After working in Berlin as an assistant to Professor Cuno von Euchtritz, she pursued her studies further with Hermon A. MacNeil and Gutzon Borglum at the Art Students' League, New York. She began to exhibit at the Paris *Salon* in 1903, but her first important commission was a portrait relief of Dr. Abraham Jacobi for the New York County Medical Society in 1910. The *Saki Sundial*, modeled at

2 Cortissoz. p. 242.

Paris in 1913, begins the series of lyrical figure studies for which the sculptor is so well known. Although Rodin's influence can be discerned in the warm and colorful surfaces of these nudes, there is nothing vague or indefinite in the vibrant figures delicately poised or flying into the air in an ecstasy of abandon; the lines are always clear and singing, and the touches of ornament delightfully crisp. Desha, the dancer, has been one of Miss Frishmuth's favorite models.

Extase, an upward-straining figure, was given an award in 1919, and an example was acquired by the Wadsworth Atheneum, Hartford, Connecticut. *Fantaisie*, a nymph and a satyr, was awarded the Watrous Gold Medal of the National Academy of Design in 1922. At the Grand Central Art Galleries in 1928, the Bush Prize went to her *Sweet Grapes*, a work that in 1966 was also given the first award of the Council of American Artist Societies. In *The Dancers* and *Slavonic Dancer*, the angles of arms and legs make a rhythmic pattern. The gay mood and verve of Miss Frishmuth's statues have made them appropriate ornaments for gardens, and small versions have gone into many museums. *Joy of the Waters*, *Play Days*, awarded a gold medal by the Garden Club of America in 1928, and *Humoresque* are sprightly fountain figures. *Crest of the Wave* has been placed in the Botanical Gardens at Saint Paul, Minnesota. *The Bubble*, a statuette done in 1929, received the Catherine Lorillard Wolfe Art Club's gold medal for sculpture when it was first exhibited in 1966.

A few draped figures, the Walden Memorial sundial, *Roses of Yesterday*, at Hackensack, the Dill Memorial for Bridgewater, Massachusetts, entitled *Beyond*, erected in 1931, and the Morton Memorial *Aspiration*, at Windsorville, Connecticut, are infused with gentle sentiment. A statue of Christ is at Denver. The automobile emblem called *Speed* is a successful essay in simplification, and the hair and drapery of the *Globe Sundial* are also somewhat stylized, although in general the artist's fancy eludes such restrictions. She was commissioned to model a portrait bust of Woodrow Wilson for the Capitol at Richmond, Virginia. She has made medals for the Garden Club of America and The New York Academy of Medicine. She is a fellow of the National Sculpture Society and a member of the National Academy of Design and The Architectural League of New York.

Call of the Sea

One arm flung upward and the other grasping a fish's upper jaw, a laughing girl rides forward kneeling astride its back.

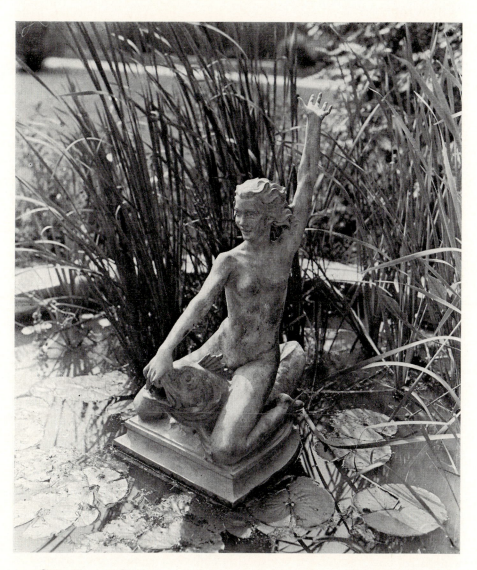

CALL OF THE SEA

Bronze group. Height 3 ft. 10 in. Base: Width 1 ft. 9½ in.—Depth 1 ft. 9½ in.
Signed on base at right: HARRIET W FRISHMUTH—1924 Founder's mark: GORHAM
CO FOUNDERS Placed in Brookgreen Gardens in 1936. Other example: Tulsa,
Oklahoma. Philbrook Art Center.

The Vine

A girl is poised on tiptoe with her head and shoulders bent backward. A grapevine is looped from an extended hand to the other behind her head. There are bunches of grapes around her feet. This work received the Shaw Memorial Prize at the winter exhibition of the National Academy of Design in 1923. One of Miss Frishmuth's most popular statues, it has been placed in private gardens at Riverside, Connecticut, Port Chester, New York, and Cincinnati, Ohio.

Bronze statuette. Height 12½ in. Signed on base at left: © 1921 HARRIET W. FRISHMUTH Founder's mark: GORHAM CO FOUNDERS OBWS Placed in Brookgreen Gardens in 1934. Other examples: Los Angeles County Museum of Art (bronze statue; on loan); New York: The Metropolitan Museum of Art (bronze statue).

Grace Helen Talbot

THE SCULPTOR who best caught Harriet Frishmuth's awareness of the rush and sparkle of life is Grace Helen Talbot. She was born at North Billerica, Massachusetts, on September 3rd, 1901, her mother, Lily Shippy, being a painter. After receiving her early education at the Spence School, New York, she studied with Miss Frishmuth for three years. Her studies continued with Solon Borglum and for a year at Paris. She traveled extensively in France, Italy, Greece, the Balkans, and Morocco. In 1922 she won the Avery Prize at the Architectural League exhibition and three years later the Joan of Arc Medal given by the National Association of Women Painters and Sculptors for *The Huntress Maid*. Her work was first exhibited as a whole at New York in 1928. She had a studio at Syosset, Long Island. The garden figures and statuettes which comprise the major part of her work are full of dash and vitality. Composed in long, slim lines, with impressionistic touches, they emphasize the grace of the young girls and swift animals used as models. After Miss Talbot's marriage to Darley Randall in 1928, they lived in France for several years before returning to the United States.

Adolescents

A slender girl stands on tiptoe, bending down to a young stag which nuzzles her hand. Both youthful figures are poised in arrested motion, giving a sense of wildness and vibrant life.

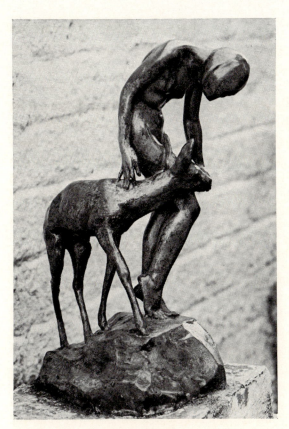

ADOLESCENTS

Bronze group. Height 12¼ in. Signed on base at back: G. H. TALBOT 1923 © Founder's mark: ROMAN BRONZE WORKS N.Y. Placed in Brookgreen Gardens in 1936.

Albin Polášek

ALBIN POLÁŠEK was born at Frenštát in Moravia, later Czechoslovakia, on February 14th, 1879, the son of Josef and Petronila (Knezek) Polášek. As a boy he practiced painting and carving and at the age of sixteen became an apprentice in the shop of a furniture maker at Vienna, where he developed skill in decorative wood carving. When he came to the United States in 1901 to join his brothers, who had settled in Minnesota, he carried on his trade in altar factories at Dubuque, Iowa, and Lacrosse, Wisconsin. The sculpture that he saw on a visit to the Saint Louis Exposition, especially that by Charles Grafly, aroused in him a desire to be a sculptor. He was accepted at The Pennsylvania Academy of the Fine Arts, had Grafly as one of his teachers, and made rapid progress. In 1907 and for two succeeding years he won Cresson traveling scholarships that allowed him to travel and study in Europe. He was a fellow at the American Academy in Rome from 1910 to 1913 and traveled in central and northern Europe, England, and Greece.

Although both Grafly and Daniel Chester French invited him to work in their studios, he preferred to develop his art in his own way. When he came back to the United States, he stayed in New York for three years, until an invitation to become head of the department of sculpture at the Art Institute took him to Chicago in 1916. With an interval as visiting professor at the American Academy in Rome in 1930 and 1931, when he also visited Greece, Egypt, and the Holy Land, he worked at Chicago until his retirement in 1943.

From his first teacher, Grafly, he learned decisive modeling and the forceful presentation of character in portrait busts such as that of Charles W. Hawthorne which was given the Logan Medal of the Chicago Art Institute in 1917. This portrait and those of three other artists are in the Hall of American Artists at New York University. His childhood in the Carpathian mountain region impressed upon him a sense of the elemental forces of nature that inspired many of his imaginative concepts. Having lived close to the earth, his thoughts revolved around fundamental ideas. The work of his Roman period was a group of robust nudes in quiet poses, including *The Breeze* and *The Maiden of the Roman Campagna. The Sower*, also a product of his Roman years, proved his mastery of the male form; the heroic bronze, which won honorable mention at the Paris *Salon* in 1913, is at The Art Institute of Chicago.

The sculptor ranged easily from the beauty of women to the rugged power of men's figures. Among his statuettes of lovely female forms are a Tanagra-like seated figure called *Aspiration*, receiving a kiss from a winged head, which was awarded the Widener Gold Medal of the Pennsylvania Academy in 1914 and acquired by The Detroit Institute of Arts; *Fantasy* in The Metropolitan Museum of Art, New York; and the upward-soaring *Unfettered* at The Art Institute of Chicago, which won the Logan Medal of the Institute in 1925. Some small bronzes like *The Musician of the Sea* have the precision and fine detail of silversmith's work.

Memorials in the form of portrait statues are those to Governor Yates at Springfield, Illinois, and to J. G. Batterson at Hartford, Connecticut. A memorial to Theodore Thomas in Grant Park, Chicago, dedicated in 1924, is outside his usual manner; standing in front of an exedra on which an orchestra is carved in low relief, a classical figure with a Greek head and stylized draperies symbolizes music. A statue of the German dramatist Lessing was also erected at Chicago, and a spiritual representation of Father Gibault placed at Vincennes, Indiana.

Polášek often returned to visit his native town. Thoroughly versed in the folklore of the country, he decided to make an image of Radigast, the Slavonic god of harvest, to place on the mountain above Frenštát. To this he added

heroic bronzes of the saints who brought Christianity to Moravia, Cyril and Methodius, replicas of two that he had made for the Cathedral of Saint Paul, Minneapolis. In recognition of this gift he was given a diploma by the Czechoslovak National Council. A memorial to Czechoslovak legionnaires, also at Frenstát, is *Primeval Struggle*, a primitive man dominating a savage wolf. When a statue of President Wilson was to be erected at Prague, Polášek was chosen to make it. For this accomplishment the Czechoslovak Government decorated him with the Order of the White Lion. The statue was

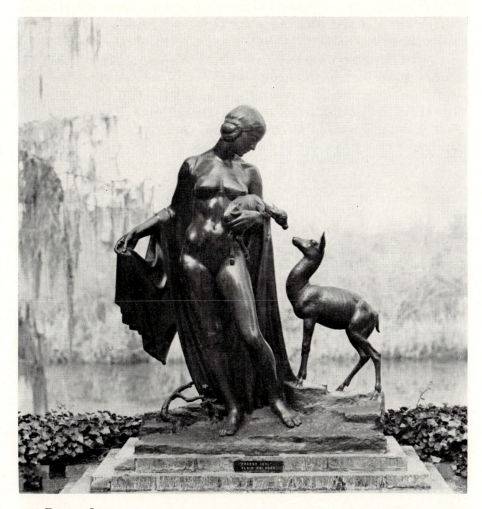

Forest Idyl

Bronze group. Height 5 ft. 8 in. Base: Width 4 ft. ½ in.—Depth 1 ft. 6 in. Signed on base at left: *Albin Polášek 11–1930* Placed in Brookgreen Gardens in 1932. Other examples: Muncie, Ind. Ball State Teachers' College; West Palm Beach, Fla. The Norton Gallery and School of Art (small bronze group).

destroyed in World War II. As a monument to President Masaryk at Chicago, the sculptor chose to represent a medieval knight on a majestic horse, like those legendary heroes waiting in the depths of Mount Blanik to come forth and rescue their homeland.

The ecclesiastical sculpture in which Polášek had early had experience was in demand. Late in life he spent more than ten years on a series for Saint Cecilia's Cathedral at Omaha, Nebraska. A colossal gilded bronze crucifix over the main altar was finished in 1940, a *Madonna of the Corn* was carved in white marble, and statuettes of saints on a pulpit were of white oak. Polášek was also a painter and a musician, for he had a fine voice. He received many honors. In 1939 the National Institute of Immigrant Welfare gave him an award of merit for his contribution to American culture. He was a fellow of the National Sculpture Society and a member of the National Academy of Design and served for a while on the Board of Art Advisers of the State of Illinois. He died at Winter Park, Florida, on May 19th, 1965. His house, containing some of his sculpture, has been deeded to the state as a museum.

Forest Idyl

A girl stands with her face turned in profile looking down at a doe which raises its head towards a fawn held in her arms. With her other hand the girl lifts an end of the drapery falling from her shoulders in looped folds behind her form. The pyramidal outline and the open spaces between make a graceful silhouette. This group was modeled at Rome in 1930 from a small bronze which had been exhibited by 1924.

Man Carving His Own Destiny

A powerful man is by his own efforts freeing his body from a stone block. All but his legs have emerged, as with tremendous effort he raises a primitive hammer to strike the chisel held against his thigh.

The idea of this statue haunted the sculptor for many years. He first thought about it and made a sketch when he was a student at the Pennsylvania Academy. "Man chiseling himself, struggling to hack out his own character, carving his future by the effort of his will—it was a part of his life, just what he himself had done, and into this composition he threw his whole soul, expressing himself more fully than he had ever done before." [1] At

1 Sherwood. p. 178.

Chicago in 1920 he modeled a new version, four feet high, posing for it himself. Many replicas of this version were distributed; both the Union League Civic and Arts Foundation, Chicago, and the Graphic Sketch Club, Philadelphia, own examples. Eight years later he remodeled it in colossal size, ". . . quite different from any of the others. It was barbaric and altogether Slavonic in the character of figure and face and decoration." [2] Cast in plaster, it was acquired by the Dallas Museum of Fine Arts. In the version at Brookgreen the sculptor refined his concept still more.

Limestone statue. Height 7 ft. 10½ in.—Width 3 ft. 3 in.—Depth 2 ft. 7 in. Signed at right: ALBIN POLASEK·SC·1961 Presented to Brookgreen Gardens by the sculptor, in plaster, in 1960; carved by Robert A. Baillie and Arthur E. Lorenzani; placed in 1962.

Mario Korbel

A SCULPTOR who has developed an individual classic manner is Mario Joseph Korbel, born at Osik, Bohemia, later a part of Czechoslovakia, on March 22nd, 1882, to Josef Korbel, a clergyman, and his wife Katherina (Dolezal) Korbel. He began studying decorative sculpture in the country of his birth, coming to the United States at the age of eighteen. Five years later he returned to Europe to continue his studies at Berlin, Munich, and Paris. He came back to the United States, staying for a time in New York, then at Chicago, and settling in New York in 1913. During World War I activities in behalf of recognition of Czechoslovakian independence took him to Cuba, where he remained for two years. The artistic results of the visit were a statue of *Alma Mater* for Havana University, a draped figure seated on a throne, having the lovely head with deep-set eyes far apart, straight nose, and full clear-cut lips which characterizes so many of his statues. He also made a medal of President Menocal and a fountain for his garden.

In the United Sates again he was called upon to provide the sculpture for the terrace and garden of the George Booth Estate at Birmingham, Michigan, in 1922, including figures called *Music*, *Dawn*, *Eve*, and *Morning and Evening*. He returned to his native country to execute this commission, establishing a studio at Prague. There he also worked on the bust of Saint Theresa of the Child Jesus which Mr. and Mrs. Nicholas F. Brady presented to the Vatican in 1925 and on sculpture for their estate on Long Island. A statue of Saint Theresa was destined for the Cathedral at Prague.

2 *Idem.* p. 394.

Beginning as an impressionist, interested in movement and coloristic effects, Korbel soon developed his own mode. In general his serene nudes have an aloofness from emotion, a purity of outline, which link them to neoclassic tradition. The actual modeling, however, has a vibrancy of gently varied surfaces closely translating the warmth of flesh. The features and the hair are treated with an impressionistic, hazy blending of contours and avoidance of hard outlines. Even portrait heads receive this mellow carving, which emphasizes beauty rather than individuality. In *The Kiss* for the Ziegler Estate, Noroton, Connecticut, his style swings away from classic coldness to impassioned fervor, though the composition is still kept in exact balance. Rhythm is the chief consideration in the two figures moving in a slow dance called *Andante* and *The Three Graces*,[1] while the classic quality is most apparent in *Nocturne* and several torsos.[2] The McPhee Memorial at Denver, Colorado, takes the form of a draped figure with straight lines, like a Greek Kore. He designed a soldier's monument erected by the state of Illinois in Georgia and a medal on the Liberation of the Czechoslovak Republic. Three portrait reliefs in gilded bronze of the Cullen family were made for the Ezekiel W. Cullen Administration-Auditorium Building of the University of Texas at Austin in 1952. Korbel died on March 31st, 1954. He was a member of the National Sculpture Society, The Architectural League of New York, and the National Academy of Design. He was also elected to the Legion of Honor.

Sonata

Kneeling on one knee, a girl holds a lyre in one arm. Her head is thrown back, her eyes closed, and her hand drawn back from the plucked string. A soft drapery is laid over one knee and across the stool which supports her. The lyre is patterned in low relief with anthemions and a Greek fret. Entitled *Music*, the figure was designed for the George G. Booth Estate, Birmingham, Michigan. A version in bronze won the Goodman Prize at the Grand Central Art Galleries, New York, in 1929.

1 Small models of *Andante* are in The Cleveland Museum of Art and The Detroit Institute of Art; the large bronze is in The Metropolitan Museum of Art.

2 *Nocturne* is in The National Gallery of Canada, Ottawa; a torso in bronze is owned by The Art Institute of Chicago. *Vanity and Modesty*, in bronze, and a reclining figure, in marble, are in The Cleveland Museum of Art.

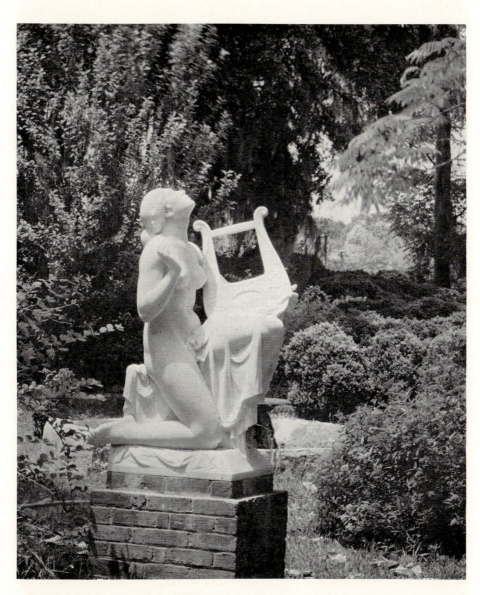

SONATA

White marble statue. Height 4 ft. 1 in. Base: Length 2 ft.—Width 1 ft. 5½ in.
Signed on base at right: MARIO KORBEL Placed in Brookgreen Gardens in 1934.

Night

A girl is seated half reclining, resting on her elbow, her drowsy head with closed eyes and parted lips falling to her shoulder. Her other hand raises an end of the filmy drapery which falls in deep thin folds about her form.

From the small bronze of 1921 an earlier version in marble was made at Prague in 1922–1923 for the Manhasset estate of Nicholas F. Brady.

White marble statue. Height 3 ft. 1 in. Base: Length 5 ft. 3⅛ in.—Width 2 ft. 2⅜ in. Signed on base at right: MARIO KORBEL 19–33 Placed in Brookgreen Gardens in 1934. Other example: Chicago. Art Institute (bronze statuette).

Arthur Emanuel Lorenzani

ARTHUR EMANUEL LORENZANI was born at Carrara, Italy, on February 12th, 1886, to Edward and Theresa (Merli) Lorenzani. While he was attending the Reale Accademia di Belle Arti in Carrara, his *The Slinger*, a study of a muscular figure in action, won for him the Rome Prize in 1905, so that he could do further work at the Istituto di Belle Arti there. Two years later this statue won the sculpture prize at the International Exposition, Parma; it is now in the Gallery of Modern Art, Carrara. Coming to the United States in 1913, he became a citizen and continued his career as a sculptor, specializing in fountains for gardens and in portraits. *Dawn, Young Mother*, and the *Golden Age* are smoothly modeled garden figures, and portrait busts show the same careful workmanship. Lorenzani has described the sculptor's methods in *Carving a Portrait in Marble*.[1] He also models portrait busts for casting in bronze, such as *Norman Lane*, a head of a boy, and another head of a smiling youth. Boys have also been the subjects of portrait reliefs. A bronze bust of John F. Kennedy which caught much of the spirit of the young president was unveiled at the M. Labetti Post of the Veterans of Foreign Wars, Staten Island, in 1964. *Children of War* looking down at a skull won a prize given by Mrs. H. P. Whitney in a competition for a war memorial. A bronze portrait of a champion harness horse, *Kinney Direct*, is in a private collection at Kansas City, Missouri.

Lorenzani made his skill in marble carving available to other sculptors. He

1 *National sculpture review.* Summer 1962. v. 11, no. 2, p. 21–23.

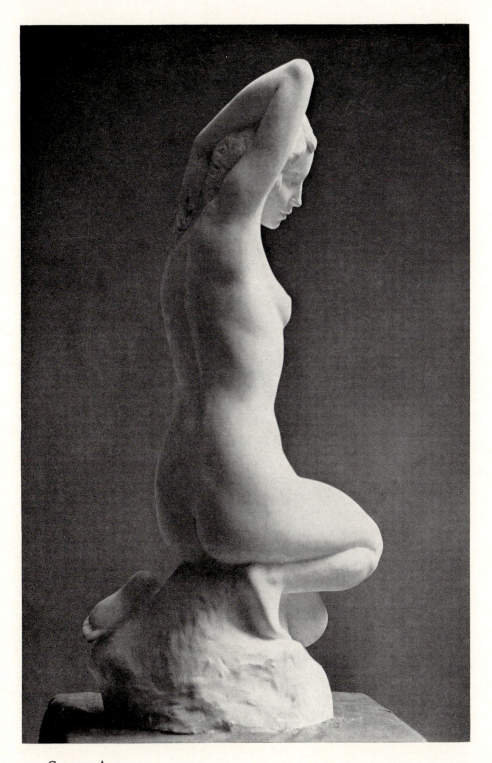

GOLDEN AGE

Bronze statuette. Height 1 ft. 9½ in. Signed on base at left: A. E. LORENZANI SC.
N.Y. Placed in Brookgreen Gardens in 1937.

not only carved Keck's war memorial at Brooklyn but also carved in place the same sculptor's panels on both the Court House and the Art Museum at Kansas City, Missouri. At Brookgreen he cut De Francisci's *Children and Gazelle* and Nicolosi's *Dream*. Lorenzani has taught sculpture at the Staten Island Institute of Arts and Sciences. He is a fellow of the National Sculpture Society and a member of the Allied Artists of America and the American Artists' Professional League.

Golden Age

A young girl is kneeling, both hands behind her head, which is turned slightly to the left. The delicate features, which have a dreamy expression, and the youthful forms are subtly modeled. It was created at New York in 1922 and two copies cast, of which the second is owned by the sculptor.

Bryant Baker

PERCY BRYANT BAKER was born in London, England, on July 8th, 1881, the son of John Baker, sculptor, and his wife Susan (Bryant) Baker. He comes of a long line of builders and carvers. Both his grandfather and his father worked on the wood and stone carving in Westminster Abbey. As an apprentice to his father, Bryant continued the family tradition by carving statues in Gothic style for Beverley Minster. Some of the carving on the Victoria and Albert Museum in London was also his work. To complete his formal education he studied from 1901 to 1907 at the City and Guilds Technical Institute and for another four years at the Royal Academy of Arts. *Italian Peasant* won first medal for portraiture in sculpture at the 1910 exhibition of the Royal Academy of Arts, London. In the same year a summons from Queen Alexandra gave an impetus to his career. After she had seen his bust of the Lord Chamberlain, she sent him a telegram which was the prelude to a commission for a marble bust of Edward VII for the Queen and a statue of the King erected at Huddersfield in 1912. Another royal commission was a bust of Prince Olaf for the Queen of Norway.

Following the example of his brother Robert, also a sculptor, Baker came to the United States in 1916 and continued the array of commemorative

statues and portrait busts that had been so successful in England. Comprehensive exhibitions of his work were shown at The Corcoran Gallery of Art, Washington, D.C., in 1919 and at New York in 1923. The realistic monument to the pioneer woman, the commission for which he won by popular vote in a competition, was unveiled in 1930 on the Cherokee Strip, Oklahoma. Baker's mastery of lifelike portraiture created such a demand that his sculpture has been placed in ten countries and in forty states in America. In all his portraits he has maintained the simple, dignified presentation that he believes appropriate. He had carved a recumbent effigy of Archdeacon Hemming Robeson for Tewkesbury Abbey before leaving England, and he used this form for the tomb of Bishop Freeman in Washington Cathedral, carved from Tennessee marble. Many of his works are in public buildings in Washington. He is the author of two statues of Delaware patriots for Statuary Hall in the Capitol. In the main hall of the Supreme Court Building are four marble busts of chief justices. Six portraits have been ordered from him for the National Portrait Gallery.

Colossal bronze statues of Grover Cleveland and Millard Fillmore were placed at City Hall, Buffalo, in 1932, and the *Young Lincoln* in Delaware Park three years later. Another colossal bronze, that representing the first president as master of the lodge, was made for the George Washington Masonic National Memorial Building at Alexandria, Virginia. The state of Virginia ordered from him four marble busts and one of bronze for the Capitol at Richmond; that of Alexander Hamilton Stephens the sculptor considers one of his best. A large group of portrait busts was for Atlanta, Georgia; four are in the Supreme Court Building and thirteen of heroic size in the state capitol. His bronze statue of Chief Justice John Marshall is in front of the County Office Building at Warrenton, Virginia, and one of Chief Justice Edward D. White at New Orleans. Baker is the only sculptor to have made a full-length bronze statue of John F. Kennedy, over life size, which has been erected at McKeesport, Pennsylvania. Three busts of other presidents of the United States are his work, that of Herbert Hoover being in the library of the University of Brussels. After a heroic bust of Winston Churchill had been exhibited at the Salon des Artistes Français, Paris, in 1958, one example was acquired for the Smithsonian Institution and another for the Church of Saint Mary the Virgin re-erected at Westminster College, Fulton, Missouri, after it had been damaged by bombs in London. A bronze portrait of Gerard Swope won the Lindsey Morris Memorial Prize at the National Sculpture Society's exhibition in 1962.

In another phase of his work Baker followed the dictates of his imagination. *Eros* and *Memory*, softly modeled heads, were done before he left

England and acquired by art galleries at Manchester and Hull. A freer play of fancy and an increased stylization characterized garden sculpture, as in *L'Après-midi d'un Faune* and *Nymph and Faun. Music*, a youth with a lyre, won the Daniel Chester French Medal of the National Academy of Design in 1963.

Baker is a member of the National Academy of Design and a fellow of the National Sculpture Society. He has been elected an honorary fellow of the Royal Society of British Sculptors.

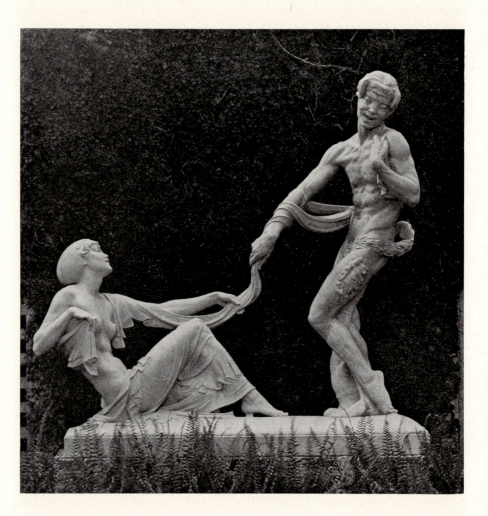

L'APRÈS-MIDI D'UN FAUNE

Tennessee marble group. Height 6 ft. 9 in. Base: Length 6 ft. 4½ in.—Width 2 ft. ¾ in. Signed on base at right: *Bryant Baker Sculptor 1934* Placed in Brookgreen Gardens in 1934.

L'-Après-midi d'un Faune

A slender nymph seated on the ground leans backward laughing up at a faun who stands at the right. Both pull at a piece of drapery cast over their shoulders and held in their outstretched hands. The features are delicately accented and the hair gracefully stylized; the edges of the clinging draperies are set in formal pleats. The small bronze from which this was enlarged was modeled between 1927 and 1933. The sculptor himself cut the marble, assisted by Abram Belskie.

Ernest Bruce Haswell

ERNEST BRUCE HASWELL was born at Hardinsburg, Kentucky, on July 25th, 1889, to Coleman Eskridge and Emma (Board) Haswell. He was a pupil of the landscape painter Meakin and the sculptor Clement Barnhorn at the Cincinnati Art Academy from 1906 to 1910, and of Paul Dubois and Victor Rousseau at the Académie Royale des Beaux-Arts, Brussels, for the next two years. At the outbreak of World War I he returned to Cincinnati and opened a studio there.

He is the author of a bas-relief of Spinoza for Hebrew Union College at The Hague and of many memorials for Cincinnati and other Ohio towns. The Northcott Memorial is at Springfield, Illinois, and the Moorman Memorial at Louisville, Kentucky. A portrait bust and figures shown in 1916 were in soft porcelain, and there was also work done for the Rookwood Pottery. The Nippert Athletic Memorial was placed in the stadium of the University of Cincinnati in 1924. A memorial to the compiler of the McGuffey readers, a portrait bust on a shaft with a group of children at the base, was unveiled in 1941 at Oxford, Ohio. Haswell made reliefs clearly designed in broad planes for the decoration of buildings, such as those for the Times-Star Building Cincinnati, and others including six portraits for the Ohio State Building, Columbus. Sculpture for the restored Cathedral of Saint Peter in Chains at Cincinnati and also for the Episcopal Saint Paul's Cathedral was entrusted to him.

Fountains, sundials, and bird baths for private gardens constituted a major part of his work. By a moderate degree of stylization he produced decorative effects, preferring smoothly rounded surfaces and patterns of soft curves. A

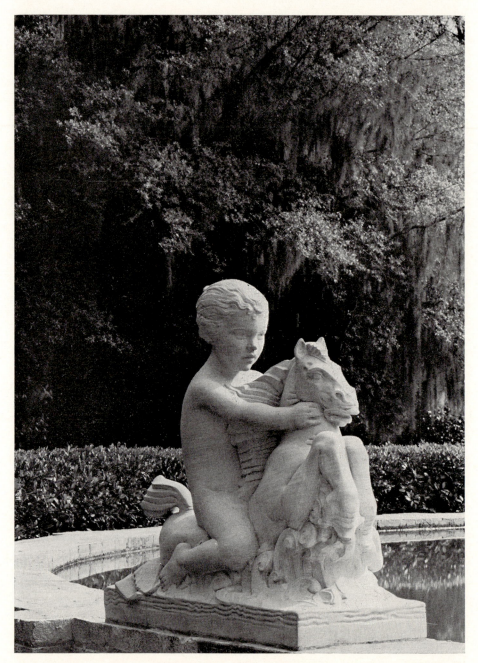

LITTLE LADY OF THE SEA

Limestone group. Height 2 ft. 10 in. Base: Length 2 ft. 11 in.—Width 1 ft. 2½ in.
Placed in Brookgreen Gardens in 1934.

medal for Miami University was completed in 1936; in that year the sculptor was working on two portraits of donors for a wing of the Cincinnati Museum and on the Procter Memorial, a portrait statue combined with bas-reliefs. His medallic work also included the Fine Arts Institute Medal and the McDowell Medal, which was awarded to the artist in 1939. His design was adopted for Procter and Gamble's Lava and Camay soap bars.

Haswell taught at the University of Cincinnati from 1923 to 1959 and at the College-Conservatory of Music, later incorporated into the university, from 1960 to 1965. Completely absorbed in his profession, he spent the mornings teaching, the afternoons in his studio, and divided the evenings between teaching night classes and more work in the studio. He also gave lectures and wrote articles about sculpture. Haswell was a charter member and first president of the Professional Artists and the Duveneck Society of Cincinnati and a president of the Cincinnati Art Club. He died on October 18th, 1965.

Little Lady of the Sea

A child is riding astride a sea horse which has its forefeet lifted and its tail curled in a volute. She holds the reins in one hand and reaches forward with the other to grasp the horse's neck. The wind blows back her hair and the horse's mane, and the waves rise and curl beneath them. This group, originally entitled *Little Lady Godiva*, was modeled at Cincinnati in 1929 for the Tyler Field gardens, for which it was completed in bronze. Another bronze is in a garden at Rochester, New York.

Beatrice Fenton

BEATRICE FENTON has spent the greater part of her life in Philadelphia, where she was born on July 12th, 1887, the daughter of the distinguished eye specialist, Thomas Hanover Fenton and his wife Lizzie Spear (Remak) Fenton. It was Thomas Eakins, a friend of the family, who detected a sculptural quality in her early drawings and encouraged her to develop that talent. She studied at the School of Industrial Art and The Pennsylvania Academy of the Fine Arts, winning the Stewardson Prize and the Cresson Traveling Scholarship for 1909 and 1910. She exhibited several busts at the

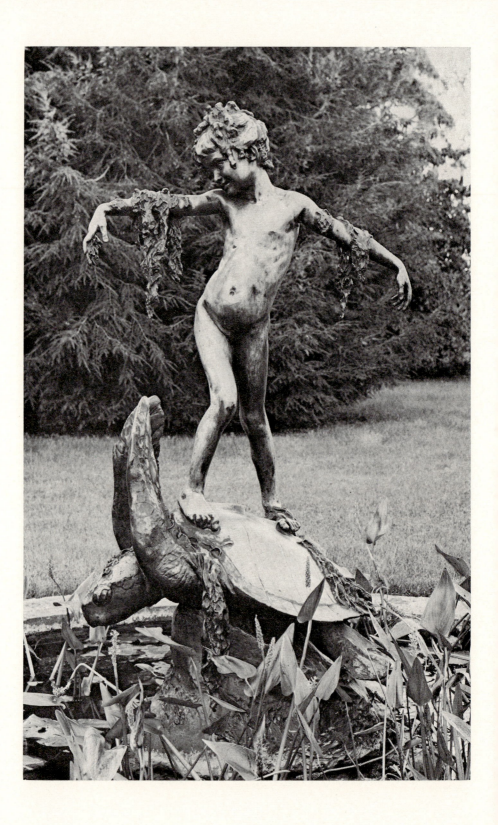

Panama-Pacific Exposition in 1915, that of Peter Moran winning honorable mention. A portrait of her father is owned by the Art Club, Philadelphia.

Her principal works have been fanciful and lively fountains. *A Fairy Fountain* and *Seaweed Fountain* are at Philadelphia and *Wood Music* in a park at Wilmington, Delaware. *The Nereid Fountain*, an airy figure with uplifted arms poised on one toe on the back of three dolphins, was shown at the National Sculpture Society's 1929 exhibition. Realistic figures, anatomically detailed, are softened by touches of sketchily modeled ornament. An Ariel sundial has been placed in the Shakespeare Garden of the University of Pennsylvania. She delights in the contrast of firm young forms and the delicate intricacy of flower and plant shapes. A memorial to Ely Kirke Price in Rittenhouse Square, Philadelphia, is a sundial composed of two children holding up the head of a sunflower, the stalk trailing between them, a poetical reminder of the fleeting joys of sunshine. The Fairmount Park Art Association commissioned from her two fountain pieces for the park, placed in 1964. She chose for her subject groups of angel fish swimming through coral reefs, which were placed in a pool at each side of her *Seaweed Fountain*.

The excellence of her studies of animals has been recognized by prizes: an alabaster *Penguin* received a medal from the Da Vinci Alliance and a *Demoiselle Crane*, the Violet Oakley Memorial Prize of the Woodmere Art Gallery. A *Shoebill Stork* and a *Wattled Crane* are in the collection of the Pennsylvania Academy and a *Leopard* in the Woodmere Art Gallery, Chestnut Hill. Small bronzes include *The Oarsman*, made as a trophy for the Arundel Boat Club at Baltimore, and studies of athletes and dancers. *Runner* was invited to the sculpture exhibition in connection with the Olympic Games held in California in 1933.

Memorials have taken the form either of busts or of plaques. Her bust of William Penn is at the Penn Club and one of Felix Schelling at the University of Pennsylvania. A relief with a figure of a girl has been placed in the Enoch Pratt Free Library, Baltimore, as a memorial to the poet Lizette Woodworth Reese. Miss Fenton's design was the one chosen for the Alben W. Barkley Congressional Medal. She made four large figures in limestone for the gateways of the Children's Hospital at Philadelphia. For some years Miss Fenton taught at the Moore Institute of Art, from which she received the honorary degree of doctor of fine arts in 1954. She is a member of the National Association of Women Artists and a fellow of the National Sculpture Society.

SEAWEED FOUNTAIN

Bronze group. Height 6 ft. 2 in. Base: Length 2 ft. 9 in.—Width 2 ft. Signed on base at back: *Beatrice Fenton Sc. 1920.* © *1922 B. F.* Founder's mark: GORHAM CO. FOUNDERS. Placed in Brookgreen Gardens in 1934.

Seaweed Fountain

A laughing young girl is riding on the back of a sea turtle which leaps forward with front flippers raised. Seaweed drips over her lifted arms and the turtle's back. Her curls are caught up loosely on the top of her head. The original of this group was awarded the Widener Gold Medal of The Pennsylvania Academy of the Fine Arts in 1922 and was erected in Fairmount Park, Philadelphia, the same year. It also received the Fellowship Prize of the Pennsylvania Academy and a bronze medal at the Sesqui-Centennial Exposition, Philadelphia.

Brenda Putnam

BRENDA PUTNAM was born at Minneapolis on June 3rd, 1890. She is the daughter of Charlotte Elizabeth (Munroe) and Herbert Putnam, for many years librarian of the Library of Congress, and the granddaughter of the publisher George Palmer Putnam. She early showed an interest in sculpture. Her art studies began at Boston from 1905 to 1907 where Paxton and Hale were her teachers of drawing at the Boston Museum Art School and Mary E. Moore and Bela Pratt her instructors in modeling. Later work in sculpture was with James Earle Fraser at the Art Students' League, New York. She studied drawing from the life with E. C. Messer at the Corcoran Art School, Washington, D.C. In 1910 and 1911 she began to exhibit, showing *Music: Le Luthier de Crémone*. The involved compositions of these years show a trace of Rodin's influence. A bronze relief of Forbes-Robertson as *Hamlet* was finished by 1914.

There soon began to appear the series of merry children as fountain and sundial figures in which the artist adapted a Renaissance theme with spirit and virtuosity without borrowing any of the mannerisms of fifteenth-century sculptors. *Water-Lily Baby* won honorable mention at Chicago in 1917 and a sundial with a child astride a sea horse, the Barnett Prize of the National Academy of Design in 1922 and the Widener Gold Medal of the Pennsylvania Academy in the following year. In 1920 she modeled *Mischievous Faun*, a dashing figure in a decorative composition, which is now in the Dallas Museum of Fine Arts. She also specialized in bas-reliefs of children, among

them the head of three-day-old Desmond, framed in a pointed fold of cloth. Certain small bronzes, *The Spear Dance* and studies of animals, are vigorously and freely modeled.

Her interest in music, already betrayed in the subjects of some of her early works, led to the making of several busts of musicians in characteristic attitudes full of life and temperament. In preparation for that of Bodanzky she made many sketches in the form of portrait statuettes. The bust of Pablo Casals is in the collection of The Hispanic Society of America, and others of the group are Harold Bauer and Ossip Gabrilówitsch.

About 1927, dissatisfied with the limitations of baby figure subjects and a realistic style, she spent a time at Florence working with Libero Andreotti and upon her return to New York investigated the theories of Archipenko. The result of this interlude is seen in a greater tendency to simplify the composition and the details, although there is no skimping or distorting of natural forms. *The Child in the Vineyard* is a static figure holding conventional swags of heavy fruit. In *Midsummer*, which won the Watrous Gold Medal of the National Academy of Design in 1935, the ripe forms of the figure and the dreamy face are expressed in a masterly way. The *Puck* done for the Folger Shakespeare Library at Washington, D.C., is more stylized and in the gay mood of earlier work. The sprite, with slant eyes and curly hair, kneels sidewise in the position of an archaic Victory, a pleated drapery thrown over one knee. A sculptured mural of a woodsman and a farmer was made for the post office, Saint Cloud, Minnesota.

A memorial to the women of Virginia, commissioned by Dr. Rosalie Slaughter Morton for Spring Hill Cemetery at Lynchburg, took the form of a columnar group of three figures in classic draperies, symbolizing the qualities of loving kindness, fortitude, and faith. Robert A. Baillie enlarged it from the working model and carved it in marble, ready for dedication in 1943. In the meantime, as a patriotic effort after the outbreak of World War II, Miss Putnam had taken a job as a draftsman with Sperry Gyroscope Company. The exacting work brought on a severe attack of shingles in her right arm and hand that hindered her work in sculpture, although she was still able to carry out a few commissions.

Her design for a Congressional Gold Medal to be awarded to Fleet Admiral Ernest Joseph King won in a competition. When the House of Representatives decided to install sculptured plaques commemorating great lawgivers above the doors to the visitors' gallery, Miss Putnam was chosen to execute those representing Solon, Tribonian, and Maimonides. Her last sculpture, done in 1952, was a bust of Susan B. Anthony for the Hall of Fame, New York University. She is a member of the National Academy of Design and a fellow of the National Sculpture Society, of which she has been secretary. She

has written a book on the methods of sculpture, *The Sculptor's Way*, and *Animal X-Rays; A Skeleton Key to Comparative Anatomy*.

Sundial

A roguish boy and a kid stand on the upper edge of a segment of a sphere set with spokes, a foot of each resting on the hub. As the boy holds the goat's forefoot and grasps an ear, their figures continue the circular pattern of the wheel. Around the curved edge of the wheel are the hours, and from the center of the hub springs the gnomon, supported by a winged boy on clouds. The capital of the marble pedestal has on two sides rams' heads butting, and on the other two, the head and forefeet of a goat cropping foliage.

White Mouse

A mouse is seated with shoulders and head turned sharply to one side. One foot rests on the coiled tail.

Bronze statuette. Height 2¾ in. Signed on base at back: B+PUTNAM Placed in Brookgreen Gardens in 1940.

Communion

An old woman leans her head against a chicken held caressingly to her shoulder. In her other hand is a dish, from which she has been feeding the flock. Her features are irradiated by the sweetness of her expression.

Bronze statue. Height 4 ft. 4 in. Signed on base at back: BRENDA PUTNAM 1939 Placed in Brookgreen Gardens in 1941.

Study in Drapery

The seated figure of a girl in a simple evening gown has been chosen to display the varied fall of a soft material. She is in a sidewise position, with shoulders slightly bowed and head turned downward. One sandaled foot is

SUNDIAL

Bronze on Georgia pink marble pedestal. Height 2 ft. 7 in.—Width 1 ft. 8¾ in. Signed at back: BRENDA PUTNAM, SC 1931 © Placed in Brookgreen Gardens in 1934.

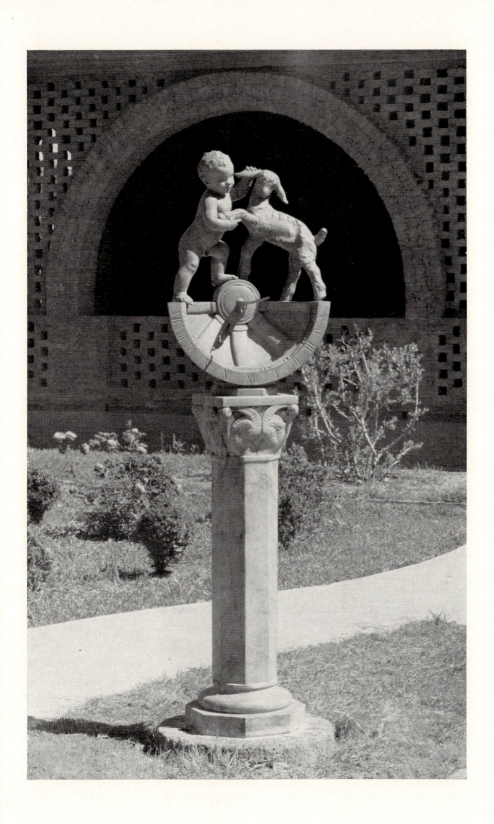

raised on a footstool, while the other is propped against the stepped base. The low-cut gown clings to the torso and lies in long, curving folds over the knees. A scarf is draped behind her, falling from an uplifted to a lowered hand. The slender form is well defined beneath the drapery, but the face is only summarily indicated.

The sculptor made this study to demonstrate methods of modeling for the chapter on drapery in her book *The Sculptor's Way*, where the steps in its development are illustrated.

Aluminum statuette. Height 1 ft. 6½ in. Base: Width 1 ft. ⅞ in.—Depth 6¾ in. Placed in Brookgreen Gardens in 1952.

Laura Gardin Fraser

LAURA GARDIN was born at Chicago, Illinois, on September 14th, 1889, the daughter of John Emil and Alice (Tilton) Gardin. She attended the Horace Mann School in New York and in 1907 entered the Art Students' League for a four-year period. Her instructor there was the sculptor James Earle Fraser, whom she married on November 27th, 1913. During World War I she was a captain in the Ambulance Service Motor Corps. In 1916 she won the Barnett Prize of the National Academy of Design for *Nymph and Satyr*.

From this time on a constant succession of awards has signalized her achievements. Animals have been her favorite subjects for sculpture: *Reclining Elks* were made for the Elks National Memorial Building, Chicago, and *Snuff*, a puppy, was acquired by the Wadsworth Atheneum, Hartford, Connecticut. She modeled a portrait of the race horse, Fair Play, for the Joseph E. Widener Estate, Lexington, Kentucky, and several statuettes of polo ponies, one of which was used as the International Polo Pony Trophy. A polo player was designed for the United States Polo Association Trophy. Her work includes a few baby subjects, such as the *Grape Baby Fountain* in the Rose Garden, Delaware Park, Buffalo, and a charming figure study, *Simplicity*, awarded the Watrous Gold Medal by the National Academy of Design in 1930. She was the sculptor of an equestrian group representing the parting of Lee and Jackson at Chancellorsville for Wyman Park, Baltimore. Two allegorical groups in bronze, *Air* and *Water*, were for the Elks National Memorial Building, Chicago, and four of heroic size, for the Theodore Roosevelt Bridge at Washington, D.C.

She is, however, best known as a medalist, with a long list of medals and

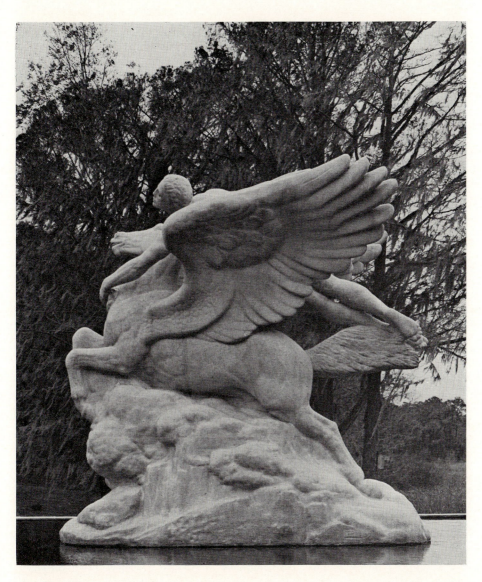

PEGASUS

Granite group. Height 15 ft. 3 in. Base: Length 15 ft. 9 in.—Width 7 ft. 8 in.
Signed on base: LAURA GARDIN FRASER 1946–1951 SCULPTOR; E. H. RATTI CARVER
1954 Placed in Brookgreen Gardens in 1953.

commemorative coins to her credit. For them she received the Saltus Medal of the National Academy of Design in 1924 and the Saltus Award Medal of The American Numismatic Society in 1926. They are notable for fidelity to the subject combined with distinction of design. Commissions for the Lindbergh Congressional Medal and the George Washington Bicentennial Medal she won in competition. She designed half dollars for the Alabama Centennial, the Fort Vancouver Centennial, and the Oregon Trail (in collaboration with her husband), and the Grant Memorial gold dollar and half dollar. To her was entrusted the first issue of the Society of Medalists, in 1931, on which she used a hunter with an Irish setter and on the reverse a ruffed grouse. Animals have also figured on her medals for the Irish Setter Club, the Morgan Horse Club, and a relief for the Bide-a-Wee Home for Animals. Other important medals are the Morse Medal for the American Geographical Society, one for United States Army and Navy chaplains, and one for the National Institute of Social Sciences. For the National Geographic Society she executed the Byrd Special Medal of Honor in 1930 and for the National Sculpture Society a special medal of honor for Daniel Chester French. The American Numismatic Society marked the celebration of its centennial by issuing a medal designed by Mrs. Fraser, and Congress commissioned her to design a gold medal to be presented to General George C. Marshall. Coinage for the Philippines was struck from her designs in 1947. She demonstrated the evolution of one of her works for the University Film Foundation's production, *The Making of a Medal*.

Her last work, three bronze panels for the library of the United States Military Academy at West Point, unveiled in 1966, dramatizes the pageant of American history by means of units that are both decorative and pictorial, tellingly arranged in a grand pattern.

She was a fellow of the National Sculpture Society, and a member of the National Academy of Design and the National Institute of Arts and Letters. Mrs. Fraser died on August 13th, 1966.

Pegasus

A winged horse springs from a mass of clouds, forelegs bent and head lifted in the upward rush. He soars on massive wings, bearing a rider lightly stretched along his back. The sculptor envisioned this group to symbolize the person born with vision and imagination, who is "floating along with Pegasus, symbol of inspiration, through the clouds and over the heights."

The granite blocks of which the group is composed were set up in the Gardens after they had been roughed out, and the carving was finished in place.

Baby Goat

A kid stands with feet braced, back arched, tail and head up, as if about to caper. The shaggy hair is lightly indicated, and the little figure is full of spirit and gaiety. It was awarded the Shaw Memorial Prize at the winter exhibition of the National Academy of Design in 1919.

Bronze statuette. Height 7¼ in. Base: Length 6⅜ in.—Width 3½ in. Signed on base: © 1919 LAVRA GARDIN FRASER Placed in Brookgreen Gardens in 1936.

Pietro Montana

PIETRO MONTANA was born at Alcamo, Italy, on June 29th, 1890. Coming with his parents to the United States as a youth, he preferred work in a factory to entering a schoolroom when he did not speak the English language. A chance visit to The Metropolitan Museum of Art determined him to become an artist. He drew from instruction books in the evenings until, when he was nineteen, he discovered the school of Cooper Union. After a few months' study he won a prize for drawing from the antique and later took many other prizes. Although painting was his first ambition, he also studied modeling, taught by George T. Brewster. In order to relieve him of the necessity of factory work, an elder brother fitted out for him a small photographic studio. Here he continued to paint and model while pursuing his new trade and his evening studies. His sculpture began to be accepted at exhibitions, and a commission for a monument made it possible for him to take a larger studio and devote himself to sculpture. War memorials by him are a realistic *Minute Man* for East Providence, Rhode Island, *The Doughboy* for Heiser Square, Brooklyn, a neoclassic *Victory with Peace* for Freedom Square, Brooklyn, and *The Dawn of Glory*, a figure casting off enshrouding drapery, at Highland Park, Brooklyn, New York. Another World War Memorial was ordered for Mirabella Imbaccari, Sicily. His monument to Pedro Perea is in Puerto Rico.

This realistic manner obtains in a relief, *The Refugees*, symbolic compositions such as the Indian and dead horse called *The Last Appeal*, and the disillusioned haggard *Knight of Peace and Disarmament*. The group, *Saint Francis of Assisi and Three Brothers* is sincerely felt. In a few garden pieces, such as the sleeping child and fawn of *Mutual Confidence* and the faun riding an antelope of *Adventurous Afternoon*, detail is largely suppressed to allow

for broader surfaces and a less pictorial approach. The treatment of portrait heads ranges from the emphasis on character in *My Father* to the serenity and smooth finish of two girls' heads. His work won prizes at exhibitions of the Hudson Valley Art Association, that in 1958 for *Youth*, a bust of a boy, and also from the American Artists' Professional League. *The Dawn of Love*, a baby held in his mother's arms, received awards both from the National Academy of Design and the National Sculpture Society. A group of medals was awarded the Lindsey Morris Memorial Prize of the Allied Artists of America in 1938, and a relief of three scholars entitled *Philosophic Dispute*, the prize of the same name given by the National Sculpture Society in 1959. This society gave him the Herbert Adams Medal in 1962.

In 1947 Montana was appointed resident artist to teach painting and sculpture at Fordham University; a number of memorial tablets and plaques there are his work. For the chapel he designed Stations of the Cross, carved in white oak. His relief portrait of Pope Pius XII was placed in Keating Hall. Among statues of saints by Montana are *Saint Expeditus* for the Church of Saint Patrick, Fort Worth, Texas; *Saint Michael* for the Eymard Preparatory Seminary, Hyde Park, New York; and the titular for the Church of Saint

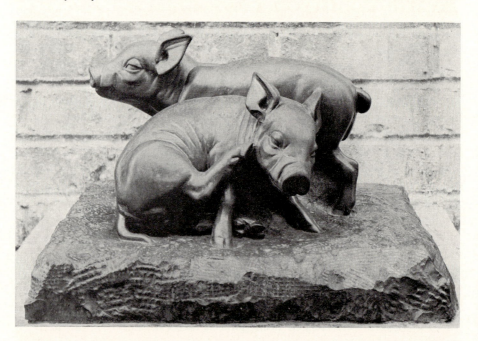

ORPHANS

Black Belgian marble group. Height 9¼ in. Base: Length 1 ft. 4¼ in.—Width 1 ft. ¼ in. Signed on base at back: *Pietro Montana* Placed in Brookgreen Gardens in 1937.

Jean Baptiste, New York City. He had a share in the sculpture for the Shrine of the Immaculate Conception, Washington, D.C. In 1962 Montana retired and went to live at Rome. He is a member of the Allied Artists of America and a fellow of the National Sculpture Society.

Orphans

Two little pigs are huddled together. One stands while the other scratches its cheek with its hind foot. The group was awarded the Watrous Gold Medal of the National Academy of Design in 1931. When in that year the sculptor was asked by a member of the Department of Agriculture to model a specific type of hog, he looked for a specimen in a New Jersey stockyard. There he was touched by the sight of these two motherless pigs, keeping close together for companionship, and modeled them life size.

Avard Tennyson Fairbanks

AVARD TENNYSON FAIRBANKS, somewhat like Lorado Taft before him, has played the double role of creative sculptor and apostle of the art of sculpture to the Middle and Far West. He was born at Provo, Utah, on March 2nd, 1897, of a pioneer family of New England stock, his parents being John B. and Lily Annetta (Huish) Fairbanks. He began to study sculpture at the age of thirteen, when his copy of Barye's *Lion and Snake* attracted the attention of James Earle Fraser and won the boy a scholarship at the Art Students' League with Fraser as his teacher. Two studies of animals modeled at the New York Zoological Park procured for him a second scholarship; another was exhibited at the National Academy of Design in 1911. Two years later he went to Paris to study at the École des Beaux-Arts with Injalbert, the Académie Colarossi, and the École de la Grande Chaumière until the outbreak of the war forced him to return to the United States. Other artists from whom he received instruction were the *animaliers* A. Phimister Proctor and Charles R. Knight; his father, who was a painter living at Salt Lake City; and his brother J. Leo Fairbanks, professor of art at Oregon State College. The large group of Fairbanks's works shown at the Panama-Pacific Exposition consisted chiefly of animal subjects, but this interest did not survive the pressure of more ambitious undertakings. At the beginning of his professional career in 1918 he did a number of large studies in the Hawaiian Islands, among them

the *Hawaiian Motherhood Fountain*, *The Blessing of Joseph*, and decorative friezes on the Hawaiian Temple at Laie, Oahu.

His career as an organizer of the teaching of sculpture in universities began when in 1920 he was appointed assistant professor of art at the University of Oregon, a position which he held for seven years. His stay was interrupted by a period of study at Yale University, from which he received a bachelor's degree in 1925, and by a year in Italy as a fellow of the Guggenheim Foundation in 1927, working chiefly with Dante Sodini at Florence. In 1929 he was given a master's degree by the University of Washington. He left Oregon that year to become associate professor of sculpture and resident sculptor at the University of Michigan. The University bestowed on him the degree of doctor of philosophy in 1936. While instructing others he found time to execute important public memorials in the American tradition of elevated ideas combined with realistic details. His *Doughboy* was adopted by Idaho as a state memorial, and a *Service Memorial* was commissioned by Oregon State College. Works in relief were two sets of bronze doors in the United States National Bank, Portland, and *The Holy Sacrament* designed as a tabernacle door for Saint Mary's Cathedral, Eugene, Oregon. A marble fountain, *The Awakening of Aphrodite*, is also at Eugene, in Washburne Gardens. The principal figure of the *Ninety-first Division Memorial* at Fort Lewis, Washington, is a modern crusader, while two soldier guards and a Red Cross nurse helping a wounded man complete the group.

Many of the themes of his memorials are drawn from the period of Western expansion in which his own family had taken part. The *Pioneer Mother Memorial* is at Vancouver, Washington; *Winter Quarters*, at Omaha, Nebraska, shows the pioneer and his wife huddled under a windswept cloak, while *New Frontiers* for Salt Lake City is a sturdy, hopeful family group. Several medals and many portraits have come from his studio, including a bust of Ezra Meeker for the University of Oregon and one of Dean G. Carl Huber for the University of Michigan, and a relief of Dean Everett V. Meeks for Yale University. Fairbanks modeled both a bust and a statuette of Mackenzie King when he was prime minister of Canada. Among the sculptor's imaginative creations are *La Primavera*, *The Bird Boy*, *Nebula*, and *Rain*.

During World War II Fairbanks was associated with the Ford Motor Company, working in engineering and personnel at the Willow Run Bomber Plant. The company promoted him to public relations representative and after the war employed him in the Design and Styling Division of Engineering Research at their Dearborn offices. Because of his success in design, the American Society of Automotive Engineers asked him to organize courses in industrial design as part of the extension service of Michigan University's College of Engineering.

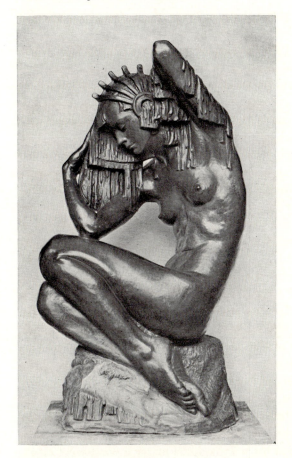

RAIN

Bronze statue. Height 3 ft. 6 in.
Base: Length 1 ft. 9 in.—Width
1 ft. 4¼ in. Signed on base at
right: *Avard Fairbanks 1933*
Founder's mark: ROMAN BRONZE
WORKS N.Y. Placed in Brook-
green Gardens in 1936.

When he was appointed professor of sculpture at the University of Utah in 1946, one of his duties was to organize a College of Fine Arts, of which he was the first dean. After eight years he was made consultant in fine arts and resident sculptor so that he might have more time for creative work. A number of major commissions were executed during this period, in particular a series of studies of Lincoln, one of which is a heroic bronze statue representing him as a young woodsman in New Salem State Park, Petersburg, Illinois, and another a marble head in the United Nations' buildings at Geneva, Switzerland. For all his interpretations of Lincoln he was given an honorary degree by Lincoln College, Lincoln, Illinois, and the Lincoln Diploma of Honor from Lincoln Memorial University at Harrogate, Tennessee. Three statues by him were commissioned for Statuary Hall in the Capitol at Washington, D.C. A heroic bronze statue of Lycurgus was presented to the Hellenic Nation by the Knights of Thermopylae and unveiled at Sparta in 1954. For this achievement King Paul gave him the Medal of the Knights of Ther-

mopylae; the Mayor of Sparta presented a medal of Lycurgus and made him an honorary citizen of Sparta.

After his retirement from the University of Utah, Fairbanks went to the University of North Dakota in 1965 as consultant in fine arts and sculptor in residence. For the campus of this university he made a group to carry out the theme, an invitation to learning; a figure representing Alma Mater and a group of students are combined. The sculptor has designed many other monuments and executed many portrait busts and medals.

Fairbanks is a member of The Architectural League of New York and a fellow of the National Sculpture Society, which awarded him the Herbert Adams Memorial Medal in 1954.

Rain

The figure of a girl is gracefully curved in circular rhythms, the knees drawn up and the arms behind the downbent head. From the headdress and over the arms drip runnels of water. The statue embodies the sculptor's idea of rain, "It enfolds itself and drops to earth to give growth and beauty to life."

Helen Journeay

HELEN JOURNEAY was born at Piermont, New York, on December 1st, 1893. Her father's name was William Harsell Journeay. After graduating from Barnard College in 1915, she began the study of sculpture, encouraged by Mahonri Young. She moved to Baltimore, worked under the instruction of J. Maxwell Miller for seven years, and won a European scholarship in 1927, visiting England, Belgium, France, and Italy. The Maryland Institute then provided her with a studio and models in order that she might carry out her work on a larger scale. A Crucifixion group, *Dawn*, and a life-sized figure of a woman with a dove, quietly and simply treated, were modeled at this time. In 1930 she opened her own studio at Baltimore in the winter and in a log cabin in the pine woods near Odenton, Maryland, from May until November. She sculptured garden figures in bronze and cast stone, small decorative objects in mahogany, and portrait heads of children in terra cotta. *Mother and Child*, sturdily proportioned and broadly modeled, was awarded a Junior League Prize in an exhibition by Maryland artists at The Baltimore Museum of Art in

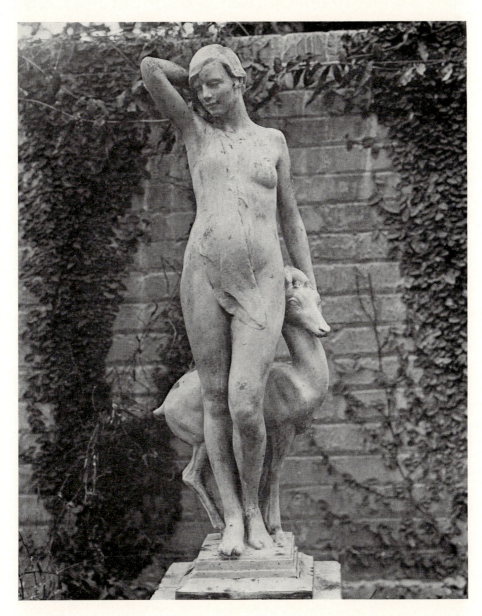

DAWN

Bronze statuette. Height 3 ft. 1½ in. Signed on base at back: *Journeay* Founder's
mark: BTEZ GORHAM CO FOUNDERS Placed in Brookgreen Gardens in 1934.

1935. In the next year a panel for a wall fountain, a girl and swan, was given first prize for the best work in any medium. The Wilson Levering Smith Medal received a prize in a competition sponsored by the Friends of Art, and a portrait head, *Young Joan*, the Maryland Institute Medal in 1938. Her work was exhibited at the Friends of Art House in 1937. She died at Baltimore on January 2nd, 1942.

Dawn

A girl stands with her hand raised to her head, which is turned slightly downward. Her flowing hair falls down her back, and a piece of drapery is thrown over her shoulder. Behind her, her hand caressing its raised head, stands a fawn. This statuette was exhibited at The Pennsylvania Academy of the Fine Arts in 1931.

Charles Cary Rumsey

CHARLES CARY RUMSEY was born at Buffalo, New York, on August 29th, 1879, the son of Laurence Dana and Jennie (Cary) Rumsey. A nephew of the sculptor Seward Cary, he early chose sculpture as a profession, going to France at the age of fourteen to study with Paul Wayland Bartlett for two years. After returning to Boston he continued his art studies at the Boston Art School with Bela Pratt and attended Harvard University, from which he graduated in 1902. Another period of study at Paris with French masters, Frémiet chief among them, ended in 1906, when Rumsey settled in New York. A collection of his work was shown at New York in 1917, just before his career was interrupted by service in the World War. A member of the American teams which competed in international matches from 1913, his skill at polo directed his interest towards the modeling of horses; among his works were several studies of mounted players, such as F. S. von Stade and Harrison Tweed. John E. Madden's mare Nancy Hanks is commemorated by a statue in the equine graveyard, Lexington, Kentucky.

HOUND

Bronze statue. Height 2 ft. 1 in. Signed on base at right: *C. C. Rumsey* Founder's mark: ROMAN BRONZE WORKS N.Y. Placed in Brookgreen Gardens in 1936. Other example: The Cleveland Museum of Art.

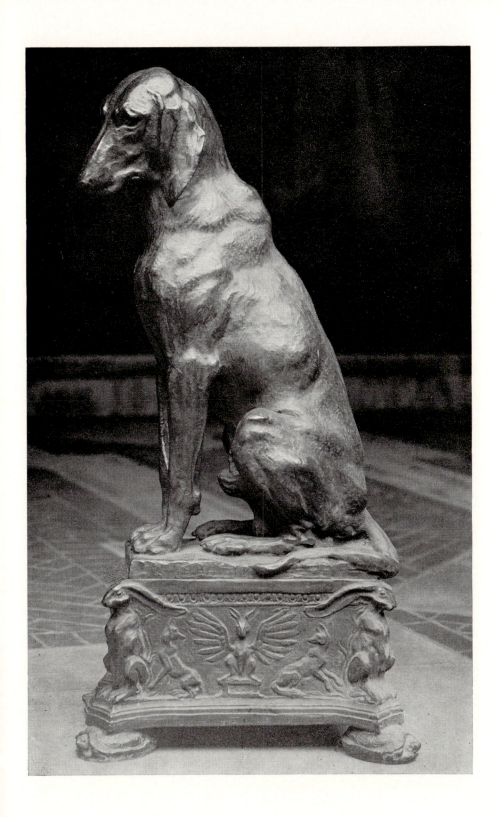

Rumsey's active interest in sports, boxing as well as polo, no doubt contributed to his preference for forms in movement. It was perhaps his association with the French animal sculptor Gardet that led him to choose mainly animal subjects, such as the heroic *Smithtown Bull*, and bulls and bison for reliefs and statuettes. *The Dying Indian*, a bronze statue owned by the Brooklyn Museum, is on horseback, mount and rider haggard and failing; the roughness of the finish heightens the emotional effect. A group of plunging horses ridden by nude men was called *The Wave*. There were also some nude figures for garden pools; a group called *The Three Ladies;* a girl bending to touch her foot, placed in a garden at Glen Cove, Long Island; and a crouching male figure called *The Source*. His frieze, *The Buffalo Hunt*, was placed on the approach to the Manhattan Bridge, New York, in 1916. Other works in relief were friezes in colored cement with the figures drawn in sharp outlines and with slight modeling on the flat surfaces, one of them for the stadium of the Rice Memorial Playground, Pelham Bay Park, New York. An equestrian statue of Pizarro was shown at the Panama-Pacific Exposition, where it won a bronze medal. After the sculptor's death in an automobile accident on September 21st, 1922, his widow had the statue cast in bronze and presented it to the town of Trujillo, Spain; she later sent a replica to Lima, Peru. The last work upon which the sculptor was engaged was the Brownsville Soldiers' and Sailors' Memorial for Brooklyn, on which was a relief of Victory, arranged in a stylized pattern. It was awarded a special gold medal of honor by the New York Society of Architects in 1923.

Although Rumsey is said to have admired such diverse masters as Frémiet, Dalou, and Rodin, there is little in his output which betrays these enthusiasms, unless Frémiet's equestrian statues of historical personages be considered a precedent for the *Pizarro*. Particularly in his later work, the one influence which is apparent in a modified form is that of Bourdelle. From him are derived the rugged outlines, rough surfaces, and archaic conventions in detail. *The Centaur*, an archer shooting from horseback, has something of the asymmetrical composition and of the suggestion of elemental force typical of the French sculptor. The pose of the Brownsville *Victory* is quite like that of the *Genius of National Defense* of Bourdelle's Mickiewicz Monument. *Pagan Kin*, a reclining nude of ripe forms and compact masses, shows interest in another post-Rodin trend, that of Maillol; the sketch model is in the Whitney Museum of American Art. A retrospective selection of Rumsey's works was included in the exhibition of the Société Nationale des Beaux-Arts at Paris in 1927, where the sculptor's "ardor, his lyric transport" attracted attention.[1]

1 *Beaux-arts.* June 15th, 1927. 5. année, no. 12, p. 189, *tr.*

Hound

A dog is seated on his haunches, his head slightly turned.

Hound

The dog is exactly like his companion, except that the head is turned in the opposite direction and the tail is at the other side. These statues were designed about 1910 as andirons for the home of Mrs. E. H. Harriman at Arden, New York. The bases are sculptured with rabbits and foxes and placed on tortoise supports.

Bronze statue. Height 2 ft. 1 in. Signed on base at right: *C. C. Rumsey* Founder's mark: ROMAN BRONZE WORKS N.Y. Placed in Brookgreen Gardens in 1936. Other example: The Cleveland Museum of Art.

Edith Woodman Burroughs

EDITH WOODMAN was born at Riverdale-on-Hudson on October 20th, 1871, the daughter of Webster and Mary M. Woodman. At the age of fifteen she entered the Art Students' League, where she studied drawing with Kenyon Cox and modeling with Saint-Gaudens. After three years she was able to earn her own living by making decorative figures for churches and by teaching. During this youthful period her inventiveness was constantly employed in designing sketches for fountains and statues. On September 5th, 1893, she married at Sittingbourne, England, the painter Bryson Burroughs, who later became curator of paintings at The Metropolitan Museum of Art, New York. She spent two years in Paris, working under the direction of the sculptor Injalbert and the painter Luc Olivier Merson. Travels in the cathedral towns of France and a journey into Italy aroused an enthusiasm for Gothic sculpture, particularly that of Chartres, Rheims, and Amiens.

In 1907 she won the Shaw Memorial Prize of the National Academy of Design with *Circe*, a bronze statuette. Her work followed the prevalent trend of fidelity to the model, with a near-baroque richness of detail, until in 1909 she again visited Paris and came under the influence of Maillol and that group

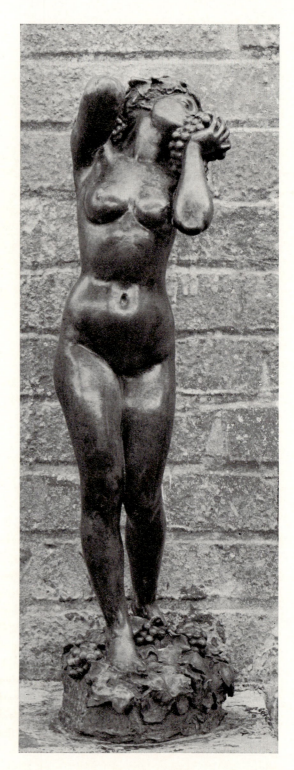

BACCHANTE

Bronze statuette. Height 2 ft. ½
in. Signed on base at left: *Edith
Woodman Burroughs* Founder's
mark: ROMAN BRONZE WORKS
Placed in Brookgreen Gardens in
1937.

of sculptors who were seeking a simpler means of expression. These aims are embodied in her later work, which, thoughtful in mood, is carried out with economy and restraint. The statue of an adolescent girl, *At the Threshold*, in The Metropolitan Museum of Art, New York, is a good example of her mature style. For the Panama-Pacific Exposition she was commissioned to execute a *Fountain of Youth*, another young figure of gentle charm, and a gay *Fountain of the Arabian Nights*, comprising several well-designed decorative groups. The work which she exhibited there won a silver medal. The first comprehensive showing of her sculpture was in New York in 1915, a total of thirty-nine pieces. Among them were fountain figures of babies, all with grave faces and in quiet poses, and many portrait heads. Her death occurred at Flushing, Long Island, in the following year, January 6th, 1916. She was an associate of the National Academy of Design and a member of the National Sculpture Society, which paid her the tribute of a commemorative exhibition.

Bacchante

A slim bacchante stands on a heap of grapevines, holding a bunch of grapes to her lips and dangling another over her shoulder. The tilted head and the turn of the body give an impression of joyful abandon.

Jo Davidson

JO DAVIDSON was born in New York on March 30th, 1883. His parents, Jacob S. and Haya (Getzoff) Davidson, were of Russian Jewish stock, and his early life on the East Side was one of poverty. When he was fifteen he was earning his own living and studying drawing at an evening class in a high school. A year later, a scholarship made it possible for him to enter the Art Students' League, where George deForest Brush was teaching. He supported himself by making drawings in burnt wood. After three years his family decided that he should have a profession and sent him to the Yale School of Medicine. When a chance visit to the clay room of the School of Fine Arts turned his attention to sculpture, he returned to New York and the modeling class at the Art Students' League. His teacher, Hermon A. MacNeil, took him into his studio as an assistant and put him to work on groups for the Saint Louis fair. He went to the fair himself and earned money by working in side shows and at Atlantic City as a boardwalk artist and sand sculptor.

MY NIECE

Bronze statue. Height 3 ft. 11 in. Signed on base at back: JO DAVIDSON © Paris
1930 Founder's mark: C. VALSUANI CIRE PERDUE Placed in Brookgreen Gardens
in 1936.

In 1905 he received his first commission, for a *David*, and went to Paris
two years later. A few weeks at the École des Beaux-Arts satisfied any desire
for academic study, and a Hallgarten Scholarship made it possible for him to
continue his work independently. After a figure had been refused by the *Salon*
he took a walking trip to Switzerland and revised his ideas of sculpture. On
his return to Paris he fell in with the Post-Impressionists, though he reverted
to Rodin in using an impressionistic technique for statuettes on broadly
human themes such as *Toil*, propounding " 'That a work of art is the
expression of an emotion. That plastic art is a form of expression by which
emotions can be made visible.' " [1] He learned to work rapidly so that he would
be able to express his thoughts as they came. *Violinist* was accepted for the
autumn *Salon* in 1908, and the next year *La Terre*, a realistically modeled
figure which sought for massiveness, was given a place of honor; the statue is
in The Hackley Art Gallery, Muskegon, Michigan. He returned to the United
States for exhibitions of his work at New York and Chicago and made a low
relief panel of classical dancing figures for the Neighborhood Playhouse, New
York.

When the Germans invaded Belgium in 1914, he accompanied a war
correspondent to the front. His experiences confirmed his interest in subjects
close to reality, sketches made at the Belgian Front and some small bronzes,
including studies of Breton peasants. There was in his work an increasing
simplicity of statement as he viewed his subjects more as living individuals
and less as vehicles for emotion. Compassion and sympathy were still the
springs of his genius, but he found his means of expression in a broader, more
basic grasp of form. He had always had a flair for portraiture, an ability to
present, along with the physical appearance, the innate qualities of the sitter
with startling clarity. He wrote, "I often wondered what it was that drove me
to make busts of people. It wasn't so much that they had faces that suggested
sculpture. Perhaps I wasn't thinking in terms of sculpture as such. What
interested me was the people themselves—to be with them, to hear them speak
and watch their faces change." [2] His interest in political and military chiefs
gave him the idea of making a plastic history of the war by a series of portrait
busts, and in 1918 he began with the Allied leaders. His bust of Woodrow

1 *Jo Davidson*. In *Current literature*. January 1912. v. 52, p. 99.
2 Davidson. *Between sittings*. p. 117.

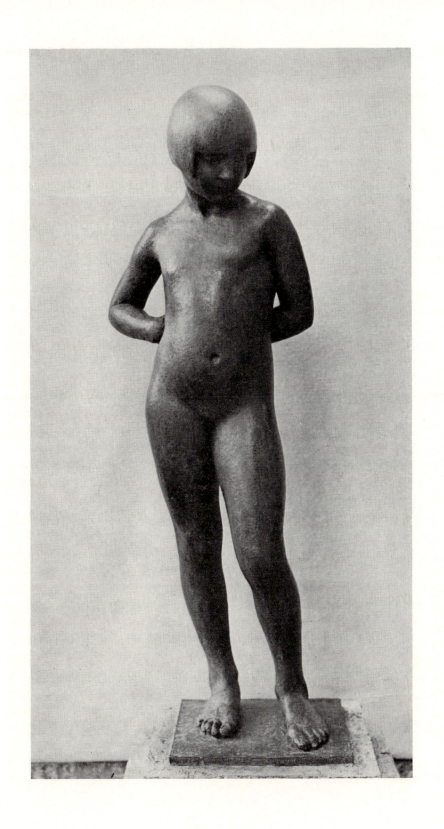

Wilson is in the Musée National d'Art Moderne, Paris; *Marshal Foch, General Pershing*, and *General Joffre* in the Musée des Invalides, Paris; *Clemenceau* in the California Palace of the Legion of Honor, San Francisco. Lincoln Steffens says, "He came back from subjects with more than a likeness . . . Jo Davidson knows and has put into his great gallery of our times the sympathetically understood victors and victims of a critical period of the world's history." [3] At the Genoa Conference in 1922 he portrayed the Russian delegates and a little later made a trip through Russia modeling the heads of Soviet leaders. At Paris he was associated with the people who were sponsoring the newer artistic movements, and from among this group made a contemplative figure of Gertrude Stein and a bust of Mabel Dodge.

His portrait busts were increasingly in demand, until a list of his works reads like an international *Who's Who*. Although for the most part he approached the personality before him frankly and directly, occasionally in heads of children and of women he emphasized the sculptural qualities by simplifying to smooth planes. He also used the warmer tone of terra cotta and sometimes added a touch of polychromy. A colossal marble bust of John D. Rockefeller in the Standard Oil Building, New York, is a candid vision of the aged man. The portrait bust of Marshal French was erected as a monument to him at Ypres, Belgium. A group of English men of letters exhibited at London in 1931 included George Bernard Shaw, Somerset Maugham, and Aldous Huxley. In portrait statues his vision had the same unflinching truthfulness. Those of La Follette and Will Rogers are in the Capitol, Washington, D.C., while that of Rogers is also at Claremore, Oklahoma. The *Walt Whitman* for Bear Mountain Park, less literal, imagines the poet walking along the road.

As the sculptor's interest in social experiments had led him to Russia in 1924, so in 1938 he visited Loyalist Spain and brought back portrait heads of the leaders of the movement which were shown at New York. A group of water colors resulted from a visit to the West Indies in 1940, and the next year he was in South America making a series of portraits of rulers for the Pan American Union, Washington, D.C. He did not entirely abandon the other phase of his art but continued to create a few figure studies fine in their truth and simplicity. A *Torso* is in the Whitney Museum of American Art. He was awarded the Maynard Prize for the best portrait at the National Academy of Design exhibition in 1934. The new state of Israel attracted his sympathies, the result being a series of portraits called *Faces of Israel*. The National Institute of Arts and Letters, of which he was a member, gave a retrospective exhibition of his portrait busts in 1947. The French Government made him a *chevalier* of the Legion of Honor. He was also elected to the

3 Steffens. v. 2, p. 836.

National Sculpture Society and the National Academy of Design. For many years he made his home in France, with annual visits to New York. He died at his estate near Tours on January 2nd, 1952.

My Niece

A girl stands in an easy pose, her hands clasped behind her back, looking downward. Her straight hair is cut short, with a bang across the forehead. This figure, also given the title *Aged 10*, is firmly modeled with finely balanced volumes.

Eugenie Frederica Shonnard

EUGENIE FREDERICA SHONNARD was born at Yonkers, New York, on April 29th, 1886, the daughter of Major Frederic Shonnard, who had served in the Volunteer 6th New York Artillery during the Civil War. Her mother, Eugenie (Smyth) Shonnard, was a descendant of Francis Lewis, signer of the Declaration of Independence. While studying with Alphonse Mucha at the New York School of Applied Design for Women, Miss Shonnard began to model, a head of her instructor receiving high praise. She then attended James Earle Fraser's classes at the Art Students' League. In 1911 she went to Paris to continue her studies with the help of criticisms from Bourdelle and Rodin. She often exhibited at the Paris *Salons* from 1912 to 1923.

Although her first works had been portrait reliefs, she soon turned to animals and birds as models. For these she early adopted simplified contours in order to emphasize the essential form and temperament of each subject. Within broad outlines the planes are subtly varied to give the impression of living substance. There are two poses of a timid rabbit, *Co-Co*, and a proud cat of Egyptian impassivity. A bust of the gorilla Dinah was acquired by the New York Zoological Society. The sculptor's instinct for ornament found expression in many studies of birds, alone and in groups. The elongated lines of wading birds like the heron particularly suited her, and many statues of them went to adorn private gardens. One group is at a French *château*, another in the Colorado Springs Fine Arts Center. In sculpture of human beings Miss Shonnard has been especially attracted to self-contained races with a stoic philosophy of life. The *Head of a Breton Peasant* in The Metro-

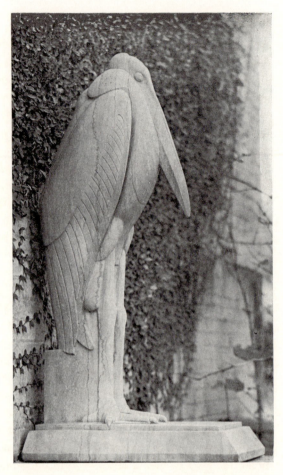

MARABOU

Napoleon gray marble statue.
Height 4 ft. 6 in. Base: Length
2 ft. 5½ in.—Width 1 ft. 5¾ in.
Signed on base at left: *Eugenia*
 [sic] *Shonnard. Sc.*
Placed in Brookgreen Gardens
 in 1937.

politan Museum of Art, New York, in which interest is concentrated in the worn but indomitable face, is devoid of *genre* triviality. Her thoughtful outlook is reflected in the serene head called *An Inner Calm;* a *Mother and Child* is rich in emotional value. Garden statues include a simplified figure of a woman with doves, entitled *Little Confidences.*

Invited in 1926 by Edgar L. Hewett, director of the School of American Research, to visit New Mexico and model Pueblo Indians, she had an exhibition at the Museum of New Mexico in 1927. Since then she has made her home in Santa Fe. On July 26th, 1933, she married E. Gordon Ludlam. A new group of heads and statues of Pueblos was included in a showing in 1937. Chiefly carved in wood, these figures of dignified men and women wrapped in the broad folds of blankets have a monumental quality appropriate to the primitive people whom they represent. A *Pueblo Indian Woman* is at the Colorado Springs Fine Arts Center, and a head of an Indian woman, carved in sandstone, in the Museum of New Mexico, Santa Fe. Miss Shonnard was chosen to represent New Mexico in the First National Exhibition of

American Art at Rockefeller Center, New York, with *Pueblo Indian Mother and Child*.

She is also a painter and water-colorist and has carried on her early work in applied design by carving doors and furniture and making designs for iron-work. Decorative wooden panels for the post office at Waco, Texas, were ordered from her under the public buildings program of the federal govern-ment. Miss Shonnard also carved in wood liturgical objects and architectural ornament for Mrs. Frederick M. P. Taylor's chapel in the Black Forest near Colorado Springs. A large panel for the Ruth Hanna Memorial Wing of the Presbyterian Hospital at Albuquerque, New Mexico, is of terra cotta. *Youth in the Desert*, carved in sandstone, represents a girl standing tenderly holding a bird in her hands and surrounded by forms that suggest desert growths; it is at the School of Mines, Socorro, New Mexico.

About 1954 Miss Shonnard developed a material that she calls keenstone, resembling sandstone, in which she carved an altar and reredos in a style based on traditional art of the Rio Grande Valley for a statue of the Virgin called *La Conquistadora* in Rosario Chapel at Santa Fe. She used the same material for architectural details of Saint Andrew's Episcopal Church at Las Cruces, New Mexico.

Architectural sculpture has not taken up all her time. A bronze bust of Miguel Chavez is in Saint Michael's Church and two of chief justices in the Supreme Court Building at Santa Fe. The poet Witter Bynner owns a portrait bust of himself by Miss Shonnard. She has continued her portraits of Indians with heads in which character is brought out by sensitive modeling within broad planes. On a head of a Tesuque Indian carved in coral wood the strong features and the ornamental headdress compliment each other. The sculptor prefers such rough-textured materials as terra cotta and coarse-grained stone for both portraits and studies of animals. She often reduces the shapes to simple masses accentuated by linear detail. At the New Mexico State Fair in 1940 she received a grand prize for the best work of art in any medium. When the Museum of New Mexico had an exhibition of her work at Santa Fe in 1954, she was made honorary fellow in fine arts of the museum and of the School of American Research. She is a fellow of the National Sculpture Society and a member of the Société Nationale des Beaux-Arts and the Société du Salon d'Automne, Paris.

Marabou

The bird stands with long legs together, the shoulders hunched, the head and heavy bill sunk on the breast. The planes are smoothly rendered, wing feathers drawn with parallel strokes. The legs are strengthened by a solid

block against which they are carved in relief. On a French critic the statue made this impression, "Her marabou philosopher, with the disproportionate head which to some people seems almost comic, is lost in meditation, disdainful of what goes on around him." [1] An early version, a pair designed for gateposts, was modeled in 1915.

Co-Co

A rabbit is squatting, the head warily erect, one ear cocked up and one laid back. The statuette is modeled simply but true to the living form.

Bronze statuette. Height 11 in. Base: Length 7 in.—Width 4½ in. Signed on base at front: *Eugenie F Shonnard Paris 1920* At left end: © *1920 by E F Shonnard* Founder's mark: ALRONI RADICE Paris cire perdue Placed in Brookgreen Gardens in 1937.

Co-Co

A rabbit crouches with the head sunk on the shoulders and the ears laid back.

Bronze statuette. Height 6¾ in. Base: Length 7¼ in.—Width 4½ in. Signed on base: *Eugenie F Shonnard* At end: © *1924 by E. F. Shonnard* Founder's mark: ALRONI RADICE Paris cire perdue Placed in Brookgreen Gardens in 1937. Other example: Paris. Musée National d'Art Moderne.

Julie Chamberlain Yates

JULIE CHAMBERLAIN (NICHOLLS) YATES, the wife of Colonel Halsey E. Yates, was a sculptor who specialized in portraits and garden figures. She was born at Saint Louis, Missouri, the daughter of Charles C. and Julie Chamberlain Nicholls, and was educated in private schools there and at Saint Mary's Institute. She studied art at the School of Fine Arts, Saint Louis, with George Zolnay. Later at Paris she was a pupil of Rodin and Bourdelle. Her work was accepted for exhibition at the Paris *Salon d'Automne* in 1909. She traveled extensively in Europe and the United States and from 1924 to 1929 had a studio in New York. She was a member of the Artists' Guild of Saint Louis and the National Arts Club. Her death occurred at Governor's Island, New York, on November 4th, 1929.

1 Chassé. p. 95.

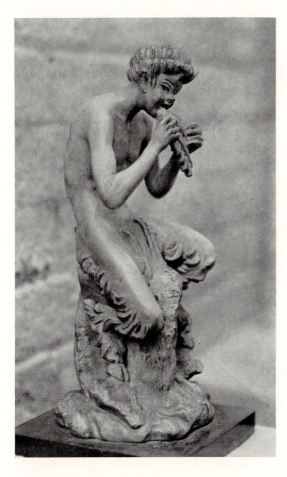

PAN

Bronze statuette. Height 11¾ in.
Signed at back: J. YATES Founder's mark: GORHAM CO. FOUNDERS OGOW
Placed in Brookgreen Gardens in 1936.

Pan

Casually poised on a rock, the young Pan is playing his pipes. Small horns sprout among the bushy locks above his Puckish face, and tufts of hair fringe his goat legs.

Hunt Diederich

WILLIAM HUNT DIEDERICH was born at Szent-Grot in Hungary on the estate of his father, Kurt Diederich, on May 3rd, 1884. His mother, Elinor (Hunt), was a daughter of the Boston painter, William Morris Hunt. After his father's death his mother took him to Switzerland, where he went to

GOATS FIGHTING

Bronze group. Height 3 ft. 1 in. Base: Length 1 ft. 2 in.—Width 1 ft. 2 in. Signed
on base at right: *H Diederich* Placed in Brookgreen Gardens in 1937. Other exam-
ple: New York. The Metropolitan Museum of Art.

school at Vevey and Lausanne. At the age of sixteen he was taken to Boston
and entered at Milton Academy while he lived in his grandfather's house.
Since his lively temperament was not compatible with school discipline, he
left after two years for a stay in the West, working as a cowboy on ranches in
Wyoming, New Mexico, and Arizona. This experience is reflected in some of
the subjects of his bronzes and decorative objects. Entering the Pennsylvania
Academy, where in 1908 he won the Stewardson Prize, he was a fellow
student of Manship's, and the two spent a summer together in Spain.

Diederich, from that point, embarked on his cosmopolitan career. After a
trip to Africa, he went to Rome and from there to other European capitals,
Paris in particular, for a period of ten years. As a child he had delighted in
cutting silhouettes of animals, and animals continued to be his favorite sub-
jects. His *Greyhounds*, exhibited at the autumn *Salon* in 1913, won him the
commendation of the critics and insured his election to the *Salon d'Automne;*
there are examples in the Seattle Art Museum and the Whitney Museum of
American Art. His personal style crystallized at an early date, its sophisti-
cated elegance of line comparable to Viennese decorative art. An excellent
craftsman, he did not hesitate to adapt his striking designs to all kinds of
utilitarian objects. The Metropolitan Museum of Art, New York, has a series
of his silhouettes cut in paper. He applied the same technique to iron weather
vanes, chimney pots, brackets, grilles, and fire screens. A cock-fight design
for cross-stitch embroidery was awarded the Julius Rosenwald Textile Prize
in 1925, and two faïence plaques were given the medal of honor in design and
craftsmanship at the Architectural League exhibition in 1927.

His sculpture in the round has the same skillful interplay of lines as his
work in the minor arts, but even when the form is subjected to considerable
interpretation and simplification, the method serves to emphasize the charac-
teristics of the subject. Long, abruptly broken lines and sharp-edged planes
bring out nervous energy and agility. His preference was for spirited action:
polo players, jockeys, wrestlers, scenes from the bullfight, animals playing or
struggling. The *Jockey* on a prancing horse, the warily circling *Fighting
Goats*, have both distinction of linear design and a feeling of spirited life.[1]
Spanish Horseman in the Phillips Memorial Art Gallery, Washington, D.C.,
with less attenuated forms, effectively presents the dignity of the cloaked rider

1 *Jockey* is in the Seattle and Newark museums, *Fighting Goats* in The Cleveland
Museum of Art.

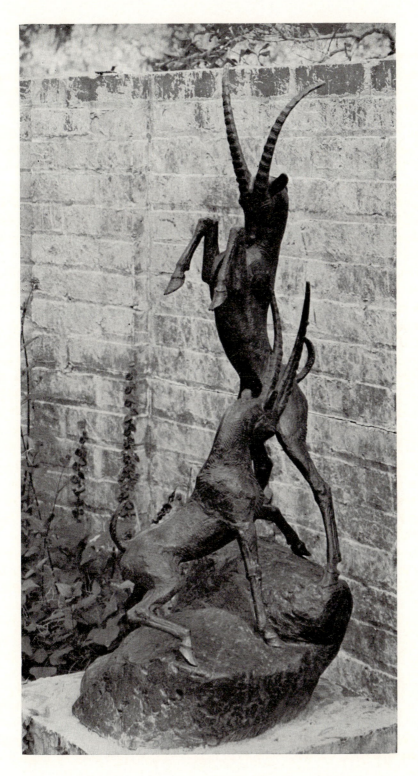

on his soberly stepping horse. The *Cats* have lost none of their felinity by the process of simplifying the planes of their bodies. He modeled a *Three Horse Fountain* and a few garden pieces, like *L'Après-midi d'un Faune* and *Diana and Hound*.

His *Pegasus with Messenger* was commissioned for the post office, Westwood, New Jersey. In the last years of his life he was engaged on a low relief in bronze of a man and a horse with other domestic animals, silhouetted, for a façade of the headquarters of the American Society for the Prevention of Cruelty to Animals, New York; it was completed by John R. Terken. Diederich died at Tappan, New York, on May 14th, 1953. He was a member of the Société du Salon d'Automne, Paris, and of the National Institute of Arts and Letters.

Goats Fighting

Two angular goats oppose each other. One stands on its hind legs, forefeet lifted, head down, looking at the other, which, crouching on spread legs, threatens with its long horns. The sharp outlines and tense movements of their lean bodies are brought into an elaborate contrapuntal harmony. It was modeled and three examples cast at Paris in 1938, when the sculptor was working in wrought iron in Belgium and France; the style was influenced by that medium.

Alice Morgan Wright

AN EXPERIMENTER who has followed an individual bent is Alice Morgan Wright, among the earliest of American sculptors to attempt cubistic interpretations. She was born at Albany, New York, on October 10th, 1881, the daughter of Henry Romeyn and Emma Jane (Morgan) Wright. After graduating from Smith College in 1904, she studied at the Art Students' League with Hermon MacNeil, Gutzon Borglum, and James Earle Fraser, her work showing so much promise that it was awarded the Saint-Gaudens Prize in 1909. Working in Paris at the Académie Colarossi she had criticisms from Injalbert. After her student days she began trying out the possibilities of semi-abstract forms to embody her ideas. Drawing on the Bible, Homer, and Shakespeare for the literary sources of her themes, she has tried to shape the

stone into forms in which universal ideas are implicit. The doom which beauty may bring haunts the form of Helen in a shadowy chorus of *The Trojan Women.* The passionate figure of Medea is swept into whirlwind shapes belied by the clenched hands of unswerving purpose. This statue was awarded the National Arts Club Prize at the exhibition of the National Association of Women Painters and Sculptors in 1923. A quieter tragedy of loss and unfulfillment is suggested by the pensive head and half-emergent form of Eurydice, a work exhibited in a one-man show at New York in 1937. The sinister *Lady Macbeth*, wrapped in a cloak, moves like an evil Fate.[1] A springtime flight of birds is released in *The Evening and the Morning were the Fifth Day;* straining, pushing men symbolize the Faith that moves mountains; and a tense upright figure between two contorted forms represents the struggle between *The Flesh and the Spirit.*

Interspersed with these creations in which the mind has played so large a part are others done in a traditional manner which take delight in pleasant forms, such as a garden figure of the boy Pan in the Harmanus Bleecker Library, Albany, and the National Collection of Fine Arts, Washington, D.C. *Off-Shore Wind* is a running girl in Grecian draperies. For portrait heads the sculptor used both realistic and somewhat conventionalized styles. Three portrait reliefs by her are at Smith College; a bas-relief was awarded the Barnett Prize of the National Academy of Design in 1920. James Earle Fraser has said that she ". . . was among the first to make sculptural use of architectural forms and exceedingly stylized shapes, with the human figure as a basic unit. The sculptor definitely wished to instil in the forms something deeper, and she used the method which seemed best to express the idea she was pondering at the time, with the result that she has arrived at an entirely individual point of view." [2] She is a fellow of the National Sculpture Society. Russell Sage College gave her the degree of doctor of humanities.

"I am the Captain of my Soul"

Above a tumult of wings a youth is poised, his outstretched arms guiding their flight. The work was modeled about 1920 at Wilton, Connecticut.

Bronze statuette. Height 1 ft. 5¼ in. Base: Length 11¼ in.—Width 10 in. Signed at back: WRIGHT Founder's mark: GORHAM CO FOUNDERS OIZV Placed in Brookgreen Gardens in 1937.

1 Examples are in The Newark Museum and the Folger Shakespeare Library, Washington, D.C.
2 Sterner. *Alice Morgan Wright.* p. [3]

Trygve Hammer

TRYGVE HAMMER was born at Arendal, Norway, on September 6th, 1878, the son of Christopher Notvig and Caroline (Dreyer) Hammer. From 1895 to 1898 he studied at the Royal Arts and Trade School, Oslo, and had instruction in modeling from Mathias Skeibrok. Subsequently he was engaged as an interior decorator in Norway. He traveled in Germany, Austria, and Switzerland, working at decorative painting and wood carving before he came to the United States in 1903. He supported himself by designing for interior decorators while continuing his studies in the evening at the Art Students' League, the National Academy of Design, and the Beaux-Arts Institute of Design, receiving instruction from MacNeil, Calder, and Solon Borglum. His special interests were in wood carving and modeling. He became a naturalized citizen in 1913 and opened his own studio in 1917. He designed many rooms, chiefly in the Norwegian style, for private homes, a Scandinavian Room for the University of Pittsburgh, the Scofield Memorial Library for The American-Scandinavian Foundation, New York, and the Norse Grill for the Waldorf Astoria Hotel, New York. For the Trophy Hall at Princeton University he made a series of athletic trophies. He also made designs to be executed in stained glass—a memorial window for the Crescent Athletic Club, Brooklyn—and in ceramics. Decorative panels are often intricate patterns based on the interlace of Norse carvings.

His special interest in design was carried over into his sculpture in stone. Portrait heads and animal subjects are blocked out in large masses with sharply defined planes, while the severity of this method is softened by the flowing lines uniting the forms. A bust of Henrik Ibsen was modeled for a proposed monument; a *Head of a Man*, carved in wood, is in the Brooklyn Museum, and a *Baby's Head* in The Newark Museum. The Roosevelt Memorial for Tenafly, New Jersey, includes a pair of grizzly bears and a panel of a woodland scene. Decorative panels in metal and ceramics for the Stewart Building on Fifth Avenue, New York, were destroyed when the building was remodeled. Hammer's work in wood carving is exemplified in a carved and polychromed reredos for the Zion Episcopal Church, Douglaston, Long Island. He designed various memorials, one of the most recent being that to Robert W. de Forest at Cold Spring Harbor, Long Island. He died on June 28th, 1947.

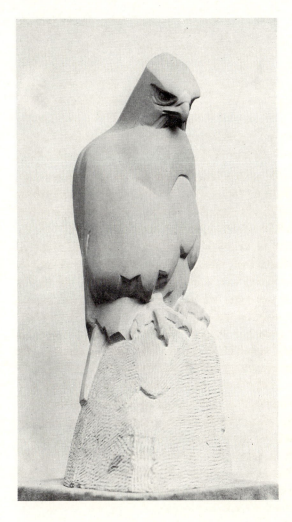

Hawk

A hawk is hunched on a rock, the head turned slightly to one side, the eye keen and watchful. The bird's form is reduced to smooth surfaces with definite edges, the masses of feathers suggested by breaks at the lower part of the figure. The model was a tame hawk which the sculptor had in his studio in Palisades Park, New Jersey. It was first modeled in clay in 1913 and not till 1920 carved in a block of bluestone taken from a remodeled building on Broadway. Pairs are used on gateposts to estates at Grosse Pointe, Michigan, and Wianno, Massachusetts. This statue was the subject of a poem by Ethel Everett, inspired by the way in which the sculptor has caught the fierce, untamable spirit of the bird, which is described in the last line as,

"Shuddering into his plumage, savage and silent, the hawk."

Elie Nadelman

ELIE NADELMAN, one of the artists who first began to experiment in new modes of sculpture, was born at Warsaw on February 23rd, 1882, the son of Philip and Sara (Arnstam) Nadelman. He studied at Warsaw and Munich before going to Paris about 1905, where he developed his own forms of expression in sculpture. For twelve years he lived and worked there, sponsored by Octave Mirbeau and associated with the Steins, Picasso, and others who were fostering experimentation. A series of drawings of heads and figures which he published, *Recherches de formes et de volumes*, ". . . introduced into painting and sculpture *abstract form* until then wholly lacking. Cubism was only an imitation of the abstract forms of these drawings and did not attain their plastic significance." [1] One of his first patrons was Helena Rubinstein, who gave him a commission in London in 1908 and owned a large collection of his work.

His sculpture for the most part eschews any violent break with nature. It is abstract only in that figures are reduced to a flowing smoothness of contour and the proportions refined to an undisturbed elegance of line. Theory and practice earned for him the epithet, "poet of the plastic curve." He worked out a rhythm of curves and a balance of rounded masses for statues like his *Symphony in Curves*. A few animal studies, in which he may have profited from the example of the Chinese, have an exquisite subtlety of line. A *Wounded Bull* is at the Rhode Island School of Design.

Another group of works, which the sculptor himself esteemed his most important, has Greek antecedents, for in Greek art he found unlimited harmonies in arrangements of form. The proportions and the types of these heads and torsos are based on Hellenistic figures. They have an increased aloofness from human emotion, the surface is smoothed over as in his other work, and the effect is heightened by a polish as brilliant as porcelain. *La Mystérieuse* is in the Brooklyn Museum, *Reverie* at The Detroit Institute of Arts, and *Ideal Head* at the Rhode Island School of Design.

Still another phase of his art consists of carved wood figurines caricaturing types of people: the man and woman in evening dress, the orchestra leader, the acrobat, a couple dancing the tango, all composed in rounded volumes.

1 Nadelman. *Vers la beauté plastique.* preface.

Tango is in the Worcester Art Museum and *Woman at the Piano* in a group of his works at the Museum of Modern Art, New York. For the foyer of the New York State Theater at Lincoln Center, small groups, *Two Circus Women* and *Two Female Nudes* were enlarged to a height of nineteen feet and carved in Carrara marble.

He came to the United States in 1917 and for a while taught at the Beaux-Arts Institute of Design. In exhibitions at New York the novelty of his method caught the public eye; he was among the first to introduce a creed of form for its own sake. In his studio at Riverdale, New York, he and his wife assembled a collection of native crafts of many countries, part of which has been transferred to The New-York Historical Society. He became an American citizen in 1927 and was a member of many organizations, including The Architectural League of New York and the Société du Salon d'Automne, Paris. He died at Riverdale on December 28th, 1946.

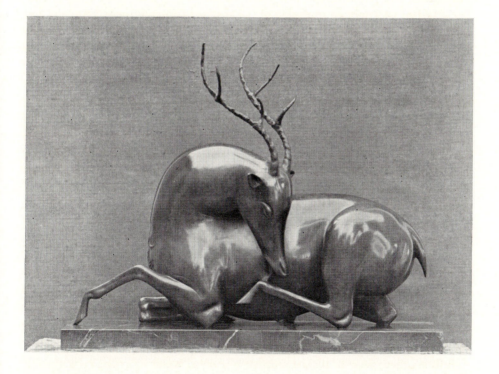

RESTING STAG

Bronze statuette. Height 1 ft. 4½ in. Marble base: Length 1 ft. 9 in.—Width 8 in. Placed in Brookgreen Gardens in 1936. Other example: The Detroit Institute of Arts.

Resting Stag

A stag is lying down with the head turned back to lick the hind foot. One forefoot is doubled under the body and the other slightly arched. The bulk of the sleekly rounded masses in flowing curves is accentuated by the delicacy of the slim legs and long antlers. Chinese sculpture, at an early period, set a precedent for this attenuation of form. This statuette was modeled before 1917. A companion piece, *Wounded Stag*, is at The Detroit Institute of Arts.

Cecil Howard

CECIL DE BLAQUIÈRE HOWARD might be considered either an American or a French sculptor, for although he was brought up in the United States and always retained his American citizenship, for thirty-five years he lived and worked in Paris. He was born at Clifton, on the Canadian side of Niagara Falls, on April 2nd, 1888. His father, George Henry Howard, was English by birth; his mother, Alice (Farmer) Howard, was also English. Both his parents were accomplished amateurs in the arts, his father being a talented musician and composer, his mother a painter. When two years after his birth the family moved to Buffalo, they became American citizens. Howard's interest in art began to develop while he was in high school, and at the age of thirteen he started attending classes at the Art Students' League and spending most of his time outside school in modeling. James Earle Fraser, who came to Buffalo as visiting instructor, taught him the rudiments of sculpture, recognized his talent, and encouraged him to continue his studies. His mother, after his father's death, preferred to live in Europe and in 1905 moved to Paris in order that her son might study there. He entered the Académie Julian, studying with Raoul Verlet, and made such rapid progress that he was given first prize in the school, and his statuette *La Fin du Jour* accepted by the critical French for exhibition in the *Salon* of the Société des Artistes Français the following year. He has said that his real education came from studying the classical sculpture in the Louvre and from living forms.

After several years of art school he began to model animals at the Jardin des Plantes and felt independent enough to rent a studio of his own. In the winter of 1909 to 1910 he continued his animal studies at Antwerp, receiving

the advice and help of Rembrandt Bugatti, a master *animalier*. When Howard came back to Paris he found a larger studio on the Avenue du Maine and launched forth as a full-fledged sculptor. Here, gradually acquiring more space, he worked for the next twenty-two years. A group of ten animal studies exhibited at the Salon d'Automne in 1910 won him membership in the society, an honor repeated two years later when he was elected to the Société Nationale des Beaux-Arts after he exhibited a life-sized group of a girl and a dog.

The First World War broke abruptly into his career. He joined a British hospital unit operating under the auspices of the French Red Cross and served in France and Serbia. He took time out from this work to make a trip to New York in 1915 to 1916 and show his sculpture at Gorham's, the first time that it had been seen in this country, aside from a statuette in the Armory Show. In sculpture of this early period, such as *The Dancers* and *L'Après-midi d'un Faune*, and in drawings he showed a special interest in linear rhythms. From modeling for casting in bronze he turned to marble and limestone, for the most part doing the carving himself, sometimes directly in the stone without previous models. In 1919 he expressed his admiration for the heroism of the French nation by designing war memorials for two small towns on the Normandy coast, Hautot-sur-Mer and Ouville-la-Rivière. They are simple obelisks, one with a Norman warrior carved in a niche on the shaft, the other with a kneeling figure of Marianne, symbolizing the French Republic, at the top. For the tomb of Aubrey Herbert in a chapel at Pixton Park, Dulverton, Somersetshire, England, he carved a traditional recumbent portrait statue of a soldier in the uniform of the First World War.

By 1925 his achievements were recognized in America when the Whitney Studio Club, New York, and the Albright Art Gallery, Buffalo, gave him exhibitions, and the Albright Gallery purchased his *Dance*, notable for strongly rhythmic movement, for the permanent collection. A bronze statuette of a supple nude figure leaning against a column, showing characteristic use of a piece of drapery to fortify the composition and carry out the rhythm, and a small group of a mother and child in Chauvigny limestone, greatly simplified for compactness of mass, became part of the collection of the Whitney Museum of American Art.

Howard's sister Marjorie had long been established in France as Paris editor successively of *Vogue* and *Harper's Bazaar*. After their mother's death in 1932 they formed a joint household in a large house with two studios and a garden at 7 rue de la Santé. The sculptor's work continued to find favor with the French public, for it adhered closely to their standards of discriminating taste and conscientious artistry. In close contact with the modern French school that in the wake of Maillol and Despiau discovered with fresh insight

new harmonies of form and volume in the frank presentation of the human figure, he probed ever deeper towards the source, finding in the play of light in varying densities of half tones and cast shadows the basic values of sculptural design. With utter simplicity of pose, he perfected his own concept of pure form, carrying with it intangible suggestions of permanence and serenity. The excellence of his results was rewarded by grand prizes for both stone and bronze in the Paris Exposition of 1937.

This steady progress in a congenial atmosphere was broken by the Second World War. Again he offered his services to the Red Cross, he and his son Noel working with the American branch to bring food and medicine to men in German prison camps. This activity made him suspect to the German authorities, and with his family he escaped from France by way of Lisbon in November 1940. At the time of the German advance he had been doing some large work in granite in a temporary studio at Paimpol. All the studio equipment and tools being used there were lost, and the works in his Paris studio had to be hidden by friends for safekeeping. Fortunately, his brother was able to receive the family in his home at Stamford, Connecticut, until the sculptor could re-establish himself and start his career over again in the United States.

The sale of a life-sized nude figure in limestone to the Whitney Museum of American Art enabled him to take a studio on Fifty-seventh Street. This statue in its serene amplitude of form demonstrates how profound had been the sculptor's study of classical ideals. In 1943 he was summoned to Washington to become attached to the Office of Strategic Services. He accompanied the United States Army as an intelligence officer during the landing in Normandy. Two years were spent in this capacity and with the Cultural Relations Service of the Office of War Information in Paris before he was free to return to New York and his own work. Recognition came to him here as it had in France. He was made a member of the National Institute of Arts and Letters, elected president of the National Sculpture Society, and chosen as an academician of the National Academy of Design. In 1944 his *American Youth*, a standing figure as austerely simple as a Greek ephebos, was given the Widener Gold Medal at the Pennsylvania Academy. Also called *The Sacrifice*, it embodies that sense of dedication felt when young men submit themselves to the hazards of war for the sake of their beliefs. Howard was selected as one of the American sculptors to be represented in the film *Uncommon Clay*.

Although his subject matter is limited, his work covers a wide range of mood and treatment. In portrait busts Howard's grasp of personality led to modes of expression ranging from the fluent impressionism of *Robert Chanler* to *Jo Davidson* seen as a Greek philosopher, a work now in the Whitney

Museum of American Art, New York. Interest in movement was concentrated on small bronzes, the interplay of boxers' bodies attracting him especially by suggesting unusual compositions. An accurate visual memory made it possible for him to watch the sport and take mental note of an instantaneous pose to be re-created at leisure. The fluidity of bronze has also been utilized for dancers with flying draperies and more fanciful creations such as a diver plunging down through undulating seaweed. Small bronzes were modeled in wax and cast directly to preserve the freshness of the original model. The sculptor himself then chased the bronze and by a slow, careful process learned from the Parisian bronze founder, Valsuani, applied patinas to enhance the special qualities of each subject and add the beauties of depth of tone and coloring. In order to give every example careful attention, the sculptor limited the number of replicas of any one model cast in bronze to four; in some cases a unique casting was made. He did some medallic work, employing exceptionally high relief in portraits for strength of modeling; the 1951 issue of the Society of Medalists was on the major theme "Peace is life; war is death." Terra cotta patinated to a flesh tone was used for a garden figure and for portrait busts in the tradition of French eighteenth-century sculpture.

Burgundy limestone, the warm color deepening to a reddish hue, was a favorite material. A life-sized figure in this material brought him the culmination of all his rewards when in 1947 his *Sun Bather* was bought by the French Government and installed in the French section of the Musée National d'Art Moderne. A reclining nude figure, the hair swept backward from the upturned face, the ripe forms are composed with easy grace, the surface gently swelling or subsiding so that the steady flow of light creates delicate nuances of shadow, this melody carried against the staccato accompaniment of crumpled drapery beneath. Membership in the Legion of Honor as *chevalier* was conferred on him in the following year. In the United States his *Boxers* won the Herbert Adams Memorial Award of the National Sculpture Society in 1953 and a male torso, *Of the Essence*, the gold medal of the Architectural League in 1955. Howard died at New York on September 5th, 1956.

Knockout

A boxer stands astride his fallen opponent. His shoulders are turned, right arm swinging free after the blow and left doubled back with fist clenched. The other boxer struggles to rise, propped on one elbow and pushing with the left arm and foot. Both men are finely proportioned, long muscles moving

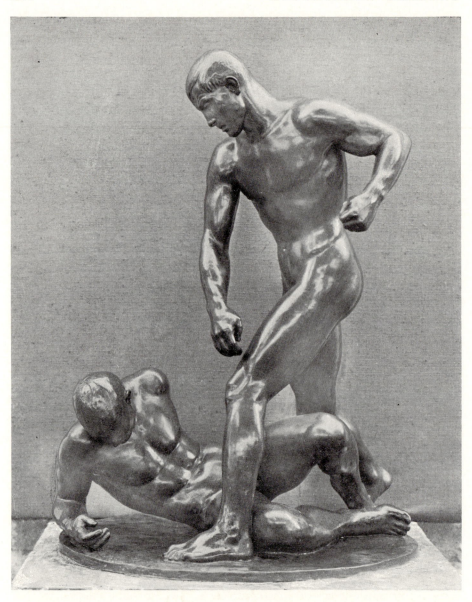

KNOCKOUT

Bronze group. Height 1 ft. 11¾ in. Signed on base at back: HOWARD and num-
bered: 3 Founder's mark: C. VALSUANI CIRE PERDUE Placed in Brookgreen Gar-
dens in 1948. Another example is in the collection of Lord Howard de Walden.

freely across the torsos and along the clean lines of legs and arms. There is interplay of rhythmic movement between the two bodies, carried from the bending posture of the standing man to the opposite curve of the man lying at his feet. This group was modeled at Paris about 1935 and cast in an edition limited to four.

Fatigue

A girl has sunk down exhausted, shoulders bowed and arms lying slack over knees doubled up against the body. A piece of drapery is wrapped around the hips, an end falling loosely to fill the space behind the feet. The softness of relaxed muscles is rendered by fluent modeling, one plane melting imperceptibly into another. Her head is thrown backward to rest on the shoulders, the lips parted as if gasping for breath and the lids drooping. Over the straight nose and firm cheekbones the skin is drawn with weariness. The hair is swept back from the forehead in a smooth cap without a break except for a few fine strands in shallow relief spreading fanwise above the ears. The features are delicately modeled, the lips with distinct edges, the nose with a firm ridge and sensitive nostrils, the eyelids undercut paper-thin. This statuette was modeled at Paris in 1923 in an edition of three examples and included among the works exhibited at New York and Buffalo in 1925.

Bronze statuette. Height 11 in. Signed on base at left: HOWARD and numbered at right: II Founder's mark: C. VALSUANI CIRE PERDUE Placed in Brookgreen Gardens in 1948.

Paul Manship

THE SCULPTOR who more than any other determined the character of at least two decades of American sculpture was Paul Manship. His remarkable perfection of technique made immediately popular the themes and ornamental treatment that he discovered in the art of older civilizations. From his example sprang the flood of archaic Greek mannerisms, so well adapted to his own polished style but less appropriate in other associations, and the vogue for orientalizing figures and details. As soon as he returned to New York in 1912 and showed his work, the new fashion was launched. Overriding the recondite experiments at Paris and London of which artists were beginning to become

aware, it captured the stronghold of the men who placed emphasis on excellence of technique. They ran to his sources hoping to discover there his singing line and the freedom and originality of his inventions.

Manship had a thorough training in this country before he embarked for Europe and the past. He was born at Saint Paul, Minnesota, on December 25th, 1885, to Charles Henry and Maryetta (Friend) Manship. He graduated from the Mechanical Arts High School and studied drawing at the School of Fine Arts there before he came to New York. In the studios of Solon Borglum and Isidore Konti he gained practical experience and at the Pennsylvania Academy had the benefit of Charles Grafly's able teaching. A walking trip through Spain in the summer of 1907 was a prelude to a broader knowledge of European culture two years later, when he won the fellowship of the American Academy in Rome and spent the next three years studying at Rome.

"Though the art of the Italian Renaissance inspired him deeply, the chief influences in his style were the Greek vases seen in Italy and the archaic sculpture which had been the revelation of a brief visit to Greece." [1] There was an immediate response to the fresh vision which illumined the group of bronzes that he brought back to New York with him. *Duck Girl*, more faithfully neoclassic than any of his maturer work, was awarded the Widener Gold Medal of the Pennsylvania Academy and placed in Fairmount Park, Philadelphia. A gay mood and full modeling with the archaistic touches limited to the hair and draperies characterized the small bronzes *Little Brother*, *Lyric Muse*, and *Playfulness*. More of a *tour de force* than these, with greater importance given to the crisp ornament almost in the manner of goldsmith's work, *Centaur and Dryad* was awarded the Barnett Prize of the National Academy of Design. The sympathetic bust of his baby, Pauline, in The Metropolitan Museum of Art, New York, has been a model for portraits of babies ever since.

A series of decorative works for gardens included twelve terminal figures of Greek heroes and deities for Mrs. Rockefeller McCormick at Lake Forest, Illinois, the *Spirit of the Chase* and the companion *Indian Hunter* and *Pronghorn Antelope* for the Herbert Pratt Estate, Glen Cove, Long Island, and a number of statues and decorative vases for Charles Schwab at Loretto, Pennsylvania. An *Infant Hercules* for a fountain at the American Academy in Rome was conceived in the spirit of the Italian Renaissance. An Oriental atmosphere pervaded the *Day and Hours Sundial* and still hovered about *The Flight of Night* and *Dancer and Gazelles*. This group with lightly poised figures and a lyric interplay of lines and open spaces was awarded the Barnett

1 Hancock. p. [1].

Prize by the National Academy of Design in 1917. The sculptor's eminent skill in a new and dynamic form of low relief with bold forms standing out strongly from the background was exemplified in panels of the elements for the New York Telephone and Telegraph Building, a memorial to J. P. Morgan at The Metropolitan Museum of Art, and an ever-lengthening series of medals. His work was halted in 1918 by a term of service with the Red Cross on the Italian front. He was annual professor at the American Academy in Rome for the year 1922–1923 and subsequently maintained a studio in Paris, where much of his work was done.

By the 1920's something of the airy grace and sheer exuberance of his early work seems to have vanished; his figures take on more solid substance. A simplification of contours and greater economy of detail leave the interest centered on the form alone, as in the *Spear Thrower*, an *Adam* and *Eve*, and *Danaë*. For all their rapid movement the *Diana* and *Actaeon* and the *Indian Hunter* for a fountain at Saint Paul, Minnesota, have a forceful sweep and monumental dignity. The *Prometheus Fountain* for Rockefeller Center, New York, is a comparatively sober rendering of the fire-giver coming down to mortals, but for the New York World's Fair his huge sundial and fountain groups of the *Moods of Time* were executed with undiminished lavishness and zest. The sculptor's love of fine ornament expended itself on such individual conceptions, sparkling with gem-like reliefs, as the armillary sphere called *The Cycle of Life* at Phillips Academy, Andover, Massachusetts, and the celestial sphere for the Woodrow Wilson Memorial, Geneva, Switzerland.

The antelope stricken by the Indian hunter was the first evidence of Manship's liking for animal sculpture. Used more and more often on decorative objects, it is an important element in *Dancer and Gazelles* and the *Diana* and *Actaeon*. The character of each bird and animal which studs the Paul Rainey Memorial Gateway at the New York Zoological Park is truthfully presented, the surface simplified only to the point where the creature's coating of fur or feathers has decorative value. The bear and deer in the arches were grouped to cap the marble posts at the sides of another gateway, that to the William Church Osborn Memorial Playground in Central Park, New York. These gates have lively scenes from Aesop's fables, with the story-telling animals silhouetted among foliage arabesques.

Less suited to his genius and appearing infrequently in the list of his works are portrait statues, such as one of Samuel Osgood for the Post Office Department Building, Washington, D.C., and a young *Lincoln* at Fort Wayne, Indiana. When he began to do portrait busts, he was more interested in formal sculptural values than in the personality of the sitter. One of his first important commissions, obtained in 1918 through the good offices of John Singer Sargent, was a marble bust of John D. Rockefeller, in which the

sculptor has made an abstraction of the aged face but kept an intent expression. In later portraits, especially profiles in terra cotta such as those of Robert Frost, Gifford Beal, and Henry L. Stimson, freer modeling has made the heads more alive. His portraits of children had always special charm, for he seemed to be attracted by their candid expressions.

After each of the two World Wars Manship was chosen by the American Battle Monuments Commission as the sculptor of a memorial. On the monument at Thiaucourt, France, erected in 1926, there is a limestone statue of an American soldier and a relief of Fame. For World War II his share, for the military cemetery at Anzio, Italy, was a heroic bronze group, *Comrades in Arms*, and allegorical reliefs suggesting Memory and Immortality.

Manship never stopped making quick sketches of any subject that caught his fancy, from Greek mythology and Indians to a girl drying her hair. Some of them he worked up to finished sculpture, like the serene kneeling *Susannah*, lyric *Spring* sailing blithely on a cloud, or a frenzied maenad racing with drapery flying around her.

In his long career Manship received almost every award given in his profession, since fame came to him early and kept him company all his life. Paramount among them were the title of *chevalier* of the Legion of Honor, the medal of honor of the National Sculpture Society, the gold medal for sculpture of the National Institute of Arts and Letters, and the international prize of the Accademia Nazionale di San Luca, of which he was a member. He was elected president of the American Academy of Arts and Letters, the Century Association, and the National Sculpture Society. He died at New York on January 31st, 1966.

Manship had the rare gift of historical imagination. He could project himself into another culture, extract its essence, and make it his own. What he took from archaic Greece was not so much the formal curls of hair and sharply folded garments as a way of seeing the human form; from Eastern art not so much certain postures as a sinuous grace, a concept of the body moving through space. These diverse elements were fused by the white heat of his imagination into something entirely his own.

Actaeon

In pain and terror Actaeon leaps forward, his body in a sharp diagonal. Antlers sprout from his forehead. One dog has sprung on his body from the rear, and another runs under his feet, with lifted snarling head. A plant with curling leaves rises beneath Actaeon's body. The eyes are blue and white enamel.

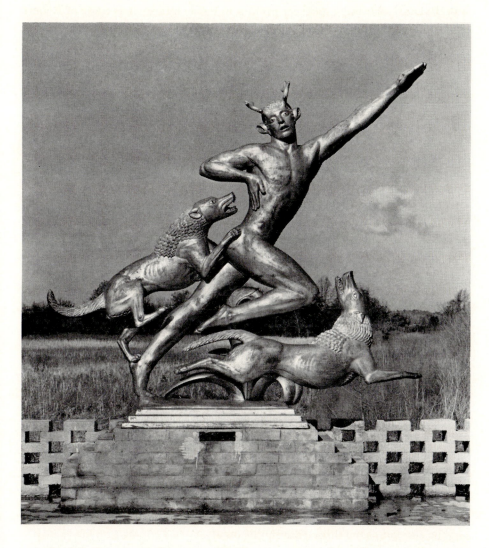

ACTAEON

Gilt bronze group. Height 7 ft. 1 in. Base: Length 3 ft. 9 in.—Width 2 ft. Placed in Brookgreen Gardens in 1936. Other examples: Andover, Mass. Addison Gallery of American Art (reduction); Muncie, Ind. Ball State Teachers' College; Pittsburgh. Carnegie Institute (small); West Palm Beach, Fla. The Norton Gallery and School of Art (heroic statue in nickel bronze); Toronto. Art Gallery (reduction).

Diana

Diana leaps forward, a curling plant frond below her. She looks back to the drawn bow in her left hand. A bit of drapery flies from her shoulders. Beneath her feet a hound races, its head turned back. The eyes are blue and white enamel. Rushing movement is graphically expressed in the figures boldly launched into space.

Both groups were sketched out by 1915, while the sculptor was living at Cornish, New Hampshire. He made several experimental studies before arriving at the final models, which were cast in bronze. The *Diana*, in heroic size, was finished at Rome in 1924; the *Actaeon*, in progress at the same time, was completed at Paris. Five reductions were made to half size.

"The Diana . . . is possibly the supreme example of the fluidity of line which Manship was able to achieve within the bounds of satisfying sculptural composition by means of perfect balance and counterpoint. It is conceived generally in one plane. Its effectiveness derives from the design of silhouette and open spaces, revealing here his debt to the Greek vase painters. Its lightness takes every advantage of bronze as a medium in contrast to many later works in which the emphasis is on solidity and volume." [2]

Gilt bronze group. Height 7 ft. 3 in. Base: Length 3 ft. 9 in.—Width 1 ft. 11½ in. Signed on base at right: . P. MANSHIP . © . 1924 . Founder's mark: Alexis . Rudier Fondeur Paris Placed in Brookgreen Gardens in 1936. Other examples: Andover, Mass. Addison Gallery of American Art (reduction); Boston, Mass. Isabella Stewart Gardner Museum (small); Muncie, Ind. Ball State Teachers' College; Pittsburgh. Carnegie Institute (small); West Palm Beach, Fla. The Norton Gallery and School of Art (heroic statue in nickel bronze); Toronto. Art Gallery (reduction).

Cycle of Life

The sundial is in the shape of an armillary sphere, an astronomical instrument composed of rings representing the great circles of the heavens. On the outside of the widest band, the belt of the equator, are the signs of the zodiac; inside are Roman numerals for the hours of the day, the time indicated by the shadow of a shaft placed at the axis of the earth, pointing due north and south, the tip of which is decorated by the North Star between two griffins. Opposite the numbers is the globe of the moon flanked by reclining figures—a

2 Hancock. p. 3. *Diana* is also discussed by Maraini (p. 194) and Vitry (p. 27–28); both groups by Murtha (nos. 166, 167).

woman representing evening, drawing a veil over her head, an owl at her feet; and a man representing morning, uncovering his head as a cock crows. On the ecliptic are the names of the divisions of the zodiac. The four elements are suggested by conventional decorative motives: water by a wave pattern, and earth by a row of mounds on the base; air by a sinuous line on one of the rings; and fire by rays and flames on the broad meridian band. On the base, within the rings, a man and a woman kneel facing each other, holding a boy standing between them with arms folded on his breast, a pivot for the globe. This group symbolizes the cycle of life encompassed by the cycle of eternity. The sphere rests on a ring of turtles, emblems of eternity. This sundial was originally designed in small size in 1920 and cast in an edition of twelve examples. It was enlarged in 1924 for the garden of Mrs. E. H. Harriman at Arden, New York, and three additional examples were cast.

Bronze armillary sphere, gilded. Height (including marble base) 5 ft. 1½ in. Diameter 3 ft. 11½ in. Signed on top of circular base: PAUL MANSHIP 1924 © Founder's mark: ALEXIS RUDIER Fondeur. PARIS. Placed in Brookgreen Gardens in 1950. Other examples: Andover, Mass. Phillips Academy; Bloomfield Hills, Mich. Cranbrook School; Cambridge, Mass. Fogg Art Museum; Saint Louis. City Art Museum (small size).

The Flight of Europa

A bull charges, borne on four dolphins. On his back rides Europa primly, looking backward, while a flying Eros whispers in her ear. The group was modeled in 1925. Stanley Casson writes, "It is inspired by several Minoan works of art, chief among them the bulls on the famous gold cups from Vaphio. But the inspiration has not tyrannized over the artist for, from these Minoan sources, he has made an original work of great rhythm. The triangular shape of the whole composition brings with it great subtleties of balance in weight and in line." [3]

Gilt bronze group. Height 1 ft. 10 in. Base: Length 11¾ in.—Width 8¼ in. Placed in Brookgreen Gardens in 1936.

Evening

A woman's form floats face downward above a bank of clouds, the body gently arched, the arms falling lightly over the bowed head. A twisted drapery drifts around her, and three owls fly above. The dreamy mood of

3 Casson. *XXth-century sculptors*. p. 53. The work is also discussed by Vitry (p. 28–29) and Murtha (no. 177).

twilight is infused into this poetically imagined figure. It was designed as one of the fountain groups, *Moods of Time*, for the New York World's Fair in 1938.

Study model in bronze. Height 3 ft. 8 in. Length 5 ft. 7 in. Signed on clouds at right: EVENING *Paul Manship sculp. 1938* Placed in Brookgreen Gardens in 1940.

Griffin

A mythological creature with the body of a lion and the wings and head of an eagle is seated on the haunches, the head turned to one side. The ears are lifted above the head, and the beak is open. The tail is curled over the back. The wings are drawn with archaic conventions and the musculation of the body decoratively treated.

Limestone statue. Height 4 ft. 2 in. Base: Length 3 ft. 7 in.—Width 1 ft. 7 in. Placed in Brookgreen Gardens in 1941. Formerly in the garden of Charles Schwab, Loretto, Pa.

Griffin

This griffin is exactly like its companion, except that the head is turned in the opposite direction. Both statues were modeled in 1917, part of the large group of sculpture which Manship was then executing for the Schwab Estate.

Limestone statue. Height 4 ft. 2 in. Base: Length 3 ft. 7 in.—Width 1 ft. 7 in. Placed in Brookgreen Gardens in 1941. Formerly in the garden of Charles Schwab, Loretto, Pa.

Adjutant Stork

A stork rests on one foot, the other half lifted. The head, with long heavy bill, is sunk on the shoulders of the compact body.

Gilt bronze statue. Height 3 ft. 4 in. Placed in Brookgreen Gardens in 1936.

Black-Necked Stork

The bird stands stiff-legged with both feet together, the neck curved and the long-billed head turned a little to the right.

Gilt bronze statue. Height 3 ft. 8 in. Placed in Brookgreen Gardens in 1936.

Crowned Crane

A crane stands on the right foot, the toes of the other foot just touching the ground. The head, crowned by a mass of upright feathers, is lifted on a curved neck.

Gilt bronze statue. Height 3 ft. 2½ in. Placed in Brookgreen Gardens in 1936.

Flamingo

The long neck and legs of the flamingo make a series of counter curves only slightly broken by the small body. The bird stands on both feet, the head lifted.

Gilt bronze statue. Height 3 ft. 8 in. Placed in Brookgreen Gardens in 1936.

Goliath Heron

A heron stands on one foot, the other raised off the ground. The neck is sharply curved so that the head, sharp beak pointing forward, rests on the shoulders. The long neck feathers form an apron in front of the body.

Gilt bronze statue. Height 2 ft. 9 in. Placed in Brookgreen Gardens in 1936.

Concave-Casqued Hornbill

A hornbill squats on short legs, wings lifted a little, tail at an angle, the large curved beak and casque almost overbalancing the body.

Gilt bronze statue. Height 1 ft. 9¾ in. Placed in Brookgreen Gardens in 1936.

Owl

An owl is seated on a stump, wings slightly raised, the head turned to the right with the two earlike tufts lifted. The smooth feathers covering head and body make a regular pattern.

Gilt bronze statue. Height 1 ft. 9 in. Placed in Brookgreen Gardens in 1936.

Pelican

A pelican stands with both feet together, the body horizontal, the long-billed head balanced on the curved neck.

Gilt bronze statue. Height 2 ft. 7 in. Placed in Brookgreen Gardens in 1936.

King Penguin

A penguin stands erect on short legs, the head raised. The wings are close to the smoothly rounded body.

Gilt bronze statue. Height 2 ft. 8 in. Placed in Brookgreen Gardens in 1936.

Shoebill Stork

A shoebill stands with one foot in front of the other, the head, with short, heavy bill, erect.

These ten statues of birds were created to form part of the Paul Rainey Memorial Gateway, erected in memory of the big-game hunter at New York Zoological Park. On the gates they are perched in the foliage at each side of the two openings. Work on these gates occupied a period of five years, carried on both at Paris and New York. The birds were modeled in 1932 and the gates dedicated on May 10th, 1934.

Gilt bronze statue. Height 3 ft. 4 in. Placed in Brookgreen Gardens in 1936.

Sherry Edmundson Fry

BORN AT CRESTON, Iowa, on September 29th, 1879, to John Wesley and Ellen (Green) Fry, Sherry Edmundson Fry is one of the eclectics associated with graduates of the American Academy in Rome, where he was a contemporary of Paul Manship. After studying with Lorado Taft at The Art Institute of Chicago from 1900 to 1902, he went to Paris. There he studied at the Académie Julian and the École des Beaux-Arts with E. Barrias and Verlet for two years, journeyed to Florence, and returned to Paris to work in

MacMonnies's studio at Giverny for another two years. His work was so well thought of that he received honorable mention at the Paris *Salon* in 1902 and a third-class medal in 1908 for his *Indian Chief*, now at Oskaloosa, Iowa, which is in a romantic vein, endowed with a wealth of picturesque accessories. As a fellow of the American Academy in Rome in 1908 he traveled and studied in Italy, Greece, and Germany for the three-year period of his scholarship before returning to the United States.

Works done prior to 1913, a wall fountain of a boy on a dolphin for an estate at Mount Kisco, New York, one of a boy on a turtle done in collaboration with C. Y. Harvey for Worcester, Massachusetts, and a group of a youth and a child, are all in the graceful, idealistic manner typical of the period. The first commission for a public monument, the *Barrett Memorial Fountain* on Staten Island, makes use of the severe conventions of archaic Greece for the folds of drapery and details, and the same influence can be seen in *Maidenhood*. Enlisting as a private in the United States Army in 1917, Fry served in the Camouflage Corps and was for a year liaison officer with the camouflage section of the French Army.

In his later work he introduced a more exotic note by resorting to the Far East. In *The Wonder of Motherhood, Fortuna, Undine*, and other garden statues, the gestures are formal, the draped figures are modeled with few breaks in the surface except for wavy folds at the edges, and the bases and decorative details are borrowed from Chinese art, while the heads remain purely occidental. In 1917 he won the Watrous Gold Medal of the National Academy of Design for *Unfinished Figure* and in 1923 the William M. R. French Gold Medal of The Art Institute of Chicago for *Fortuna*. Two monuments to Revolutionary soldiers, that to Captain Abbey at Enfield, Connecticut, and one to Ira Allen at the University of Vermont, are in a simplified realistic style, the former wrapped in an enveloping cloak with shallow, curving folds. For the Missouri State Capitol he made the crowning figure of Ceres, reliefs for the Grant Memorial at Washington, and pediments for the Frick residence, New York, and for the Department of Labor and Interstate Commerce Building, Washington, D.C. He was a member of the National Academy of Design. His home and studio were at Roxbury, Connecticut. He died on June 9th, 1966.

Maidenhood

A girl steps forward, looking down. The drapery wrapped around her legs is gathered in one hand at the side, while the end thrown over her shoulder is lifted by the other hand. The full modeling of the torso contrasts with the

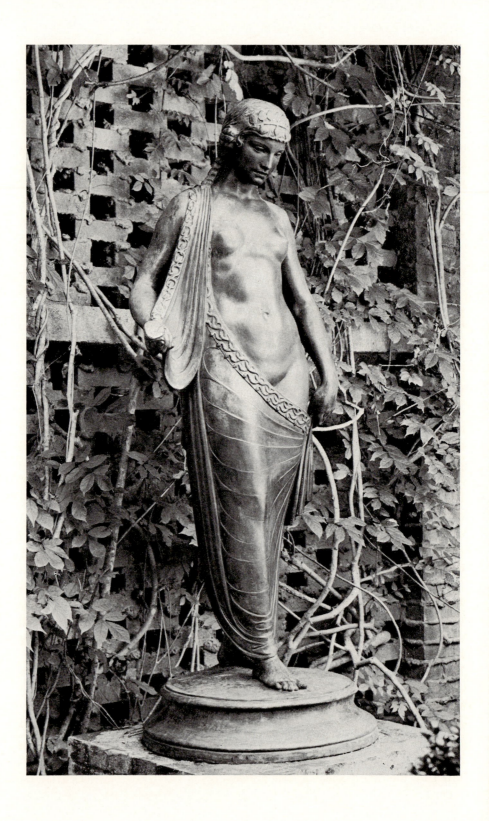

MAIDENHOOD

Bronze statue. Height 5 ft. 7¼ in. Signed on base at right: s e fry Founder's
mark: ROMAN BRONZE WORKS N-Y- Placed in Brookgreen Gardens in 1937.

smooth flat folds of the drapery, laid in a conventional manner derived from
archaic Greek art. The border pattern of linked snakes associates the figure
with Hygeia, the goddess of health. The statue was modeled in 1914 and
the first copy sold to Walter B. James for the hall of his residence in New
York,[1] while other examples are in gardens on the West Coast. It was awarded
a silver medal at the Panama-Pacific Exposition.

Edward Field Sanford, Junior

EDWARD FIELD SANFORD, JUNIOR, was born in New York on April 6th,
1886, the son of Edward Field Sanford and Anna Maria (Hopkins) Sanford,
the seventh generation of his mother's family to be born in the city. Both
parents were descended from old New York and New England families, one
ancestor having founded Newport and another Providence, Rhode Island.
When he was twenty-one he began the study of sculpture, attending the Art
Students' League and the National Academy of Design for two years. During
the next two years he studied with Laurens at the Académie Julian, Paris, and
with Professor Bernhauer at the Royal Academy, Munich, and traveled exten-
sively in Europe, looking at sculpture of all periods. After some early experi-
ments in impressionistic studies rather in Troubetzkoy's manner, in 1914 he
modeled a classic bronze *Pegasus* for the Rhode Island School of Design.

In the next year the architectural sculpture which was to be his special
interest began with two large groups of symbolic figures for the Core Mau-
soleum, Norfolk, Virginia. In the preceding two years Paul Manship, newly
returned from the American Academy in Rome, had begun to show his work,
and his fellow sculptors as well as the public were captivated by his masterly
adaptation of themes from less-known styles of sculpture, especially archaic
Greek. Impressed by this revelation of the possibilities for clear-cut sil-
houettes, ordered design, and crisp ornament, Sanford became a thorough-
going classicist, embodying the classic virtues of restraint, balance, and
symmetry.

1 This example was sold at auction in 1947.

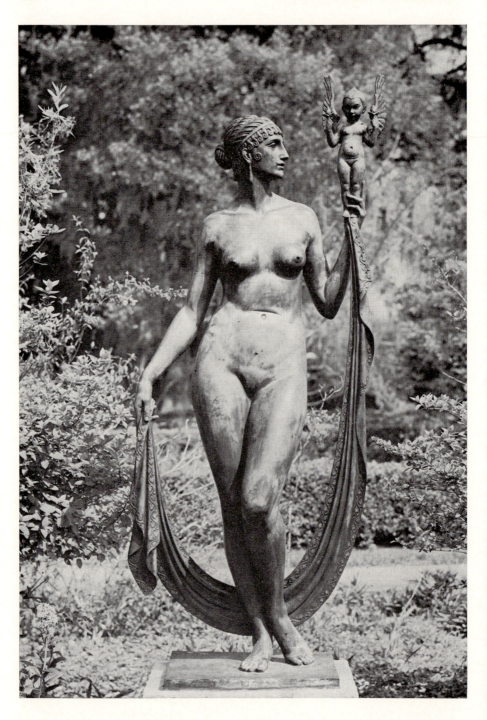

The style was especially appropriate for his greatest achievement, the sculpture for the State Capitol, Sacramento, California. To accompany the classic architecture two pediments, four colossal figures, two large bronze figures, and twenty bas-relief panels were designed. The themes of the pediments were *California Gives to the Universe* and *The World Goes to California*, offering the sculptor many chances for picturesque detail within the classic framework. The majestic, seated figures carved in stone at the entrances symbolized Floral, Romantic, Mineral, and Climatic Wealth. Among the best known of the sculptor's works are the two large bronzes, *Wisdom*, an austere figure of a bearded man holding an owl in his hand, and *Inspiration*.

While he was busy with this tremendous undertaking, Sanford was also reorganizing the department of sculpture of the Beaux-Arts Institute of Design, of which he was director from 1923 to 1925, and for which he inaugurated the Paris Prize. For the Alabama Power Company Building, in Birmingham, he designed three Gothic figures placed over the door and a finial representing Electricity. Another colossal statue was the *Victory* for the Payne Whitney Gymnasium, Yale University, a quiet figure of a young man in straightly falling draperies, holding a wreath before him. The sculptor's style was well suited to the solid composition of two groups among those around the terrace of the Bronx County Court House.

Interspersed among these works on a large scale were statuettes and fountain figures, an *Infant Hermes* for an estate at Mount Kisco, New York, and a *Nereid* to be placed at Roslyn, Long Island. In addition to works in the round he produced some reliefs, early in his career the Charles Francis Adams Memorial for Washington and Lee University and a commemorative tablet at Columbia University. Later he made the bronze façade for the Francis P. Garvan Mausoleum in Woodlawn Cemetery, New York, and bronze doors for Girard College, Philadelphia. Most noteworthy among his works in low relief is the animal frieze of twelve colossal panels for the base of the New York State Theodore Roosevelt Memorial done in 1933. The sharp outlines and simple planes are very effective. His successful treatment of animal sculpture had been presaged by the handsome *Great Dane* modeled before 1915.

Inspiration

Bronze statue. Height 6 ft. 8 in. Base: Width 1 ft. 10½ in.—Depth 1 ft. 7¾ in. Signed on base at right: EDWARD FIELD SANFORD, JR. S^c 1928 On base at left: FIRST BRONZE REPLICA AUTHORIZED BY THE STATE OF CALIFORNIA Founder's mark: ROMAN BRONZE WORKS N.Y. Placed in Brookgreen Gardens in 1946.

After ill health caused Sanford to retire from his profession in 1933, he resided in the James Semple House, Williamsburg, Virginia. His portrait of Dr. W. A. R. Goodwin is in Bruton Parish Church there. He spent the last years of his life at Saint Augustine, Florida, where he died on October 12th, 1951.

Inspiration

A woman is standing, one knee bent, her head turned in profile to gaze at a statuette of a winged child held aloft in her left hand. The child holds a lotus flower in each hand; his eyes are slanted and his hair is drawn in grooves to a peak at the top of the head. The woman's tall figure is of classical proportions, the forms well developed and the features clearly chiseled. She is partly encircled by a narrow drapery falling in a long loop behind, an end held in each hand. Lying in even folds, it is bordered with a gilded leaf scroll. Her hair is wound in a Grecian knot, bound with fillets, and edged with a double row of conventional curls. This statue, with its companion male figure, *Wisdom*, was created for the State Capitol, Sacramento, California, where they stand in the delivery hall of the State Library.

Dancer

A dancer is firmly poised on one toe, the shoulders thrown back, the other foot raised and pointed. A light skirt, open at one side, falls in smooth curves, the edge caught up in the lifted right hand. The hair is laid in flat waves and coiled in a knot. A comparatively early work, this statuette is less dependent on Greek precedent than the majority of the sculptor's creations. Drapery and hair are slightly stylized. The clever composition moves in circular rhythms cut by radial lines.

Bronze statuette. Height 2 ft. 3 in. Signed on base at left: EDWARD FIELD SANFORD JR 1917. Founder's mark: ROMAN BRONZE WORKS N.Y. Placed in Brookgreen Gardens in 1936.

Ernest Wise Keyser

ERNEST WISE KEYSER was born to S. and Helen (Wise) Keyser at Balti-
more on December 10th, 1876. His uncle, Ephraim Keyser, was a sculptor
before him. The nephew was a pupil at the art school of the Maryland
Institute, and later studied at the Art Students' League in New York, having
Saint-Gaudens as an instructor. During a period of study in Paris at the
Académie Julian and with Denys Puech, he exhibited at the Paris *Salon* in
1897 a marble bust entitled *Ophelia*. This and two heads called *Man and His
Conscience* in the vagueness of expression, the indistinct contours, and the
unfinished bases reflect the prevalent influence of Rodin. A bust of Casals is in
somewhat the same style. When his student days were ended he established a
studio at New York, producing memorials and decorative figures. The Harper
Memorial at Ottawa, Canada, took the form of a bronze statue of Sir Galahad,
an impressionistic figure in medieval costume, a cloak sweeping about him in
curving folds. The bust of Admiral Schley for Annapolis is a realistic repre-
sentation in half figure, the hands holding a telescope. Decorative subjects
included several statuettes for flower holders and fountains, among them

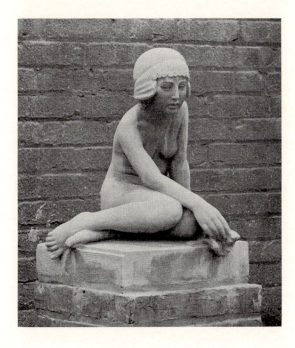

MEDITATION

Limestone statuette. Height 1 ft.
11 in. Base: Width 1 ft. 4 in.—
Depth 1 ft. 3 in. Signed on base
at back: E. W. KEYSER 1932
Placed in Brookgreen Gardens in
1934.

301

Hercules Strangling the Hydra, a standing figure wound about by serpents gripped in the hands.

After these essays in several modes, he adopted a mildly archaic method for his decorative figures in which the details were stylized to form an effective pattern carrying out the lines of the figures, which were modeled with only slight simplification. Two figures holding vases are called *Orienta* and *The Lady of the Lotus*. The latter, in The Newark Museum, is a graceful composition with pleated drapery falling from outstretched arms. A fountain for the Rice Memorial Playground at Pelham Bay Park, New York, is a group of a woman and a standing child, the draperies accenting the gracious curves of the figures; it won the gold medal of the New York Society of Architects in 1923. Keyser retired to Atlantic Beach, Florida, and died at Rome on September 25th, 1959. He was a member of the National Sculpture Society.

Meditation

A girl is seated sidewise, supported by her left arm, a flower held in the hand which droops languidly over her knees. Her hair, bound by a fillet, is arranged in a row of tight ringlets across her forehead. An earlier version was used as a fountain figure in the patio of the residence of Charles Wimpfheimer, Long Branch, New Jersey.

John Gregory

JOHN GREGORY, born in London, England, on May 17th, 1879, the son of John and Amelia Elizabeth (Read) Gregory, came to the United States at the age of fourteen. He became a pupil of J. Massey Rhind in 1900, studying with him and at night with Barnard and MacNeil at the Art Students' League for three years. Returning to London he continued his studies at Lambeth for a year and then had three years in Paris with Mercié at the École des Beaux-Arts. In New York again in 1906, he worked as assistant to MacNeil, Gutzon Borglum, and Herbert Adams. He became a naturalized citizen in 1912 and for the next three years was a fellow at the American Academy in Rome. During World War I he was at Washington serving in the camouflage section of the Navy Department. At the end of the war he was appointed associate in modeling at Columbia University and director of the sculpture department of the Beaux-Arts Institute of Design.

A purist and a classicist, he devoted himself especially to garden figures and architectural sculpture. His work is marked by invention, striking design, and clarity of execution. His debt to classic art is more apparent in the total conception of his work than in any definite borrowing of detail. *Wood Nymph* and *Bacchante*, carved for Mrs. Harry Payne Whitney's garden, stand with the figures in graceful bends, the hair stylized. *Philomela*, a poetic little figure holding tiny wings outstretched, was given the medal of honor of the Architectural League in 1921 and shown at the Concord Art Association in 1926, where the sculptor won another medal of honor. The same sure instinct for charm of silhouette, rhythmic movement, and harmonious design marks his other garden figures, notably the *Orpheus and Dancing Panther* for the Schwab Estate at Loretto, Pennsylvania, the *Toy Venus*, and *Courtship* for the Ziegler Estate, Noroton, Connecticut. *Lyric Love*, an ecstatic winged being with mellow outlines was given the Widener Memorial Medal of The Pennsylvania Academy of the Fine Arts in 1933; it is in the Browning Memorial Library at Baylor University, Texas.

His architectural commissions began in 1921 with a bronze floor plate, *The Voyage*, in archaic Greek style for the Cunard Building, New York. The Eustis Memorial in The Corcoran Gallery of Art, Washington, D.C., took the form of a relief of Sir Ector lamenting Sir Launcelot, the armored figures, the straight lines, and the severely simple background emphasizing the grave dignity of the scene. In panels that symbolize both the four seasons and the four ages of man for the Henry Huntington mausoleum, a small classical temple at San Marino, California, each is composed of two seated or kneeling figures in contrasting curves, classically draped, the formal design softened by the introduction of realistic plants. The literary source of the nine panels representing scenes from Shakespeare's plays for the Folger Shakespeare Library, Washington, D.C., demanded less reliance on classical antecedents. There is his usual open spacing with a few figures in simplified garments with rounded folds, but with more dramatic gestures and heightened emotional pitch. Even so, his preference was for such calmer themes as lend themselves to formal grouping. More strictly conventionalized and rich in detail are the Oriental figures for one of the polychrome terra-cotta pediments of the Philadelphia Museum of Art. Because they were designed to be executed in color, their purely ornamental character is stressed. An equestrian statue of General Anthony Wayne, riding grimly forward with drawn sword on a briskly stepping horse, stands in front of the museum. A memorial to Albert Beveridge is at Indianapolis. *Memory*, for the World War I shrine of the American Military Cemetery at Suresnes, France, is a quiet figure done in simple lines to carry out the pensive mood. Gregory was president of the National Sculpture Society, which bestowed on him a medal of honor in 1956,

a member of The Architectural League of New York, the National Academy
of Design, and the National Institute of Arts and Letters. He died on February
21st, 1958.

Orpheus

Between two panther cubs Orpheus is seated, holding a lyre in one hand,
the other extended towards one of the panthers. His head is in profile; a fold of
drapery falls over one thigh. The panther at the right arches its body back-
ward and spreads the claws of both lifted forepaws in pleasurable excitement.
The sculptor used a similar theme for the *Orpheus and Dancing Panther*
made in 1918 for Charles M. Schwab's garden at Loretto, Pennsylvania, but
with the inclusion of a second panther the figure of Orpheus was entirely
changed and the archaic style abandoned. Here, within the symmetrical
design, there is lively movement and fluency of modeling.

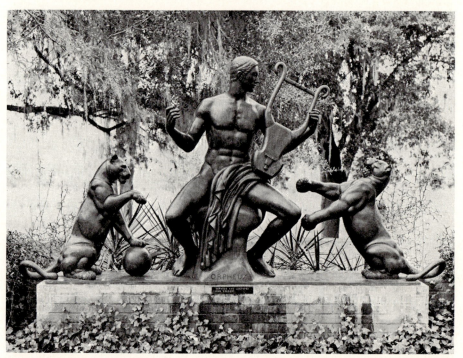

ORPHEUS

Bronze group. Height 5 ft. 7 in. Base: Length 9 ft. 7 in.—Width 1 ft. 6¾ in.
Signed on back of rock: JOHN GREGORY 1941 On front of rock: ORPHEUS Placed
in Brookgreen Gardens in 1942.

Orpheus

This group is the model from which the life-sized bronze was enlarged, with slight variations.

Group of three bronze statuettes. Height 1 ft. 4 in. Bases: Length 2 ft. 6¾ in.—Width 4¼ in. Signed on bases: *John Gregory 19* © *30 John Gregory* © *1935* N°·2· *John Gregory* © *1931 No·2·* Founder's mark: CELLINI BRONZE WORKS N-Y- NO. 2. Placed in Brookgreen Gardens in 1936.

Toy Venus

Venus, as a young girl, is kneeling on one knee on the back of a dolphin, one hand touching its upbent tail, the other resting on her knee, her head turned backward. A drapery falls over the knee and arm at each side of the figure, filling the empty spaces. The posture was no doubt suggested by an archaic Greek running Victory. The surfaces are smoothly modeled, the only decorative touches being the row of tight curls around the girl's forehead, the flat folds of drapery, and the simple ribbing of the dolphin's tail and fin. The marble original was carved about 1922 for the garden of Mrs. Egerton Winthrop, Syosset, Long Island.

Reduction in bronze. Height 1 ft. 3½ in. Base: Length 7½ in.—Width 4¾ in. Signed on base at back: *John Gregory* © *1923* Founder's mark: ROMAN BRONZE WORKS N.Y. Placed in Brookgreen Gardens in 1936.

C. Paul Jennewein

CARL PAUL JENNEWEIN was born at Stuttgart, Germany, on December 2nd, 1890, one of eight children of Louis and Emilie (Weber) Jennewein. His father was the owner of an engraving firm. Paul had little interest in school and when at the age of thirteen he refused to learn French, his father decided that it would be better if he went to work. During his apprenticeship as a museum technician he learned painting, casting, and other skills, being also allowed free time to study the history of art at the university. After three years of this rigorous training, he happened to see illustrations of work by the

architectural firm of McKim, Mead, and White which so impressed him that he decided to go to New York, hoping that he might find work with them.

Since one of the partners of a firm of architectural carvers often employed by McKim, Mead, and White was a friend of Louis Jennewein, the son entered the firm of Buhler and Lauter as an apprentice in 1907. He spent his evenings studying painting and sculpture at the Art Students' League and on week ends went out sketching. A few commissions for mural paintings, the first for the Woolworth Building, came his way.

Once again his independent spirit asserted itself, and in 1913 he set out for Europe, traveling for two years through Germany, France, Italy, and Egypt with a knapsack, sketching as he went. On his return to the United States he applied for the *Prix de Rome* but in the meantime enlisted in the National Guard. News that he had won the scholarship reached him while he was serving on the Mexican border. After he had received an honorable discharge, his years of study at the American Academy in Rome began in 1917 and lasted until 1919. When the United States entered World War I, he served with the American Red Cross in Italy.

He was captivated by the rhythm and harmony of Greek ornamental carving. The grace and charm of the Hellenistic sculpture that first attracted him are echoed in several works done at Rome, *The First Step*, a mother crouching to hold her child as he steps forward, *Repose*, a seated figure of a girl, and *Hercules and the Bull*, reminiscent of the *Farnese Bull*, which was destroyed by fire. *Cupid and Crane* [1] and *Cupid and Gazelle*, no longer dependent on classical models, establish his mastery of linear rhythm with their airy harmony of sinuous forms.

With the opening of a studio in New York in 1921, the sculptor received several commissions for monuments. The War Memorial at Barre, Vermont, is a strongly organized composition of a nude warrior seated holding a sword before him. The simple costumes of *The Puritan* for Plymouth, Massachusetts, and of *Governor Endecott* for Boston are crisply treated. His pure design and precise modeling are well adapted to architectural sculpture. He made a number of panels for the State Education Building, Harrisburg, Pennsylvania, and a frieze of winged children for the Lincoln Insurance Building, Fort Wayne, Indiana. For this phase of his work he received the architectural medal of honor at the Architecture and Allied Arts Exposition, New York, in 1927. Greco-Roman statues of Venus furnished the inspiration for a few statuettes and garden figures like the *Nymph and Fawn* and *Coral*, and for work in white-glazed porcelain. *Memory*, a head in this medium, is in the collection of The Pennsylvania Academy of the Fine Arts. *Baby with*

1 There are examples in the Wadsworth Atheneum, Hartford, Connecticut, The Newark Museum, and the California Palace of the Legion of Honor, San Francisco.

Squirrel won the medal of honor of the Concord Art Association in 1926. *The Secret*, a child whispering in the ear of a marabou, was awarded the Saltus Medal of the National Academy of Design in 1942.

For the mythological statues of the pediment of the Philadelphia Museum of Art, executed in polychrome terra cotta with the assistance of Léon V. Solon for the coloring and placed in 1932, the sculptor reverted to the severer conventions of the fifth century B.C. With the architect Charles Louis Borie, he traveled through Greece to study the use of color in Greek architecture. Buildings in nontraditional style demanded a corresponding change in the sculpture used on them. The bronze figures of the door of the British Empire Building, Rockefeller Center, New York, are sharply blocked out, and the many reliefs and columnar figures for the Department of Justice Building, Washington, D.C., display a free invention. Bas-reliefs, *Painting* and *Sculpture*, have been designed for the school of The John Herron Art Institute, Indianapolis. Distributing silhouetted figures and groups over a severely plain surface was the method also used for later works; on the New York State Insurance Fund Building, New York City, aspects of social security are represented in this way, and a series symbolizing the rights of the people was carved on the faces of a trylon at the main entrance to the District Court House, Washington, D.C.

Many other buildings in the national capital have sculpture by Jennewein. There are four plaques by him in the House of Representatives and two large allegorical figures on the façade of the House Office Building. For reliefs of Orpheus and Ceres in the center hall of the Executive Mansion, Jennewein again resorted to a neoclassic style enlivened by decorative plants, animals, and birds. On two large panels for the Fulton County Court House at Atlanta, Georgia, figures representing country people and city dwellers were set into surroundings appropriate to their occupations filling the panels above them, each incident isolated by ornamental foliage or varied shapes of buildings. A frieze for the Valley Forge Memorial Tower vividly recreates scenes of the encampment with strongly outlined figures in flat relief.

All these architectural commissions did not keep Jennewein from more personal creations, continuing his early successes. A poetic figure carved in marble, entitled *Reflection*, received both a prize from the National Sculpture Society and the Watrous Gold Medal of the National Academy of Design in 1960. His expert skill in designing for low relief and his meticulous craftsmanship made him an accomplished medalist. Elected a fellow of The American Numismatic Society, he was awarded its J. Sanford Saltus Medal in 1949 for his medallic work. He had received the medal of honor of the Pennsylvania Academy in 1939. An unusual distinction came to Jennewein in 1966, when he was chosen as one of fifty persons to receive the Golden Plate Award

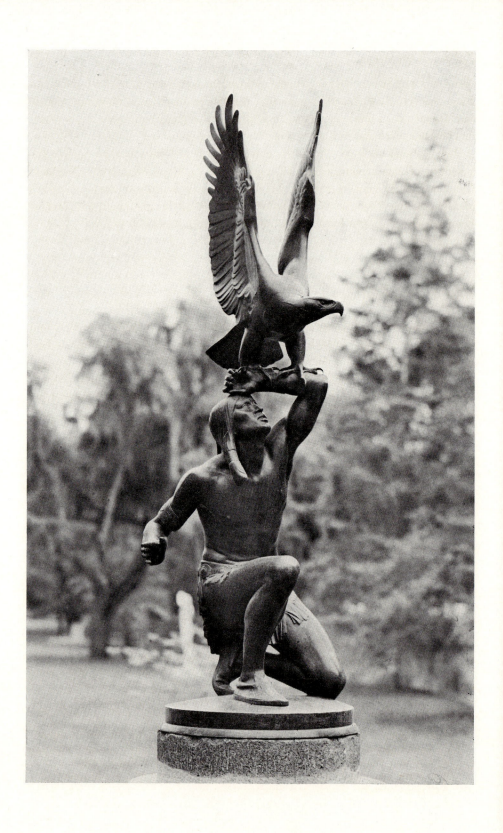

presented at Dallas, Texas, by the American Academy of Achievement. In 1967 the Artists Fellowship gave him the Benjamin West Clinedinst Memorial Medal for exceptional artistic merit, and the National Sculpture Society, their medal of honor.

Throughout his busy career Jennewein has found time to take part in the activities of many institutions. He has been a vice-president of the National Academy of Design, president of the National Sculpture Society, and a member of the Fine Arts Commission. Since 1963 he has been president of Brookgreen Gardens. He has been elected to the National Institute of Arts and Letters.

Indian and Eagle

An Indian is kneeling on one knee, one hand thrown back, the other raised to his head about to launch an eagle perched on his forearm with raised wings, spread tail, and head turned in the direction of his gaze.

This statue is a study for that erected as a war memorial at Tours, France, to signify the American Indian releasing the American eagle. It was awarded the Widener Memorial Gold Medal at Philadelphia in 1932.

Nymph and Fawn

A nymph stands gracefully with left knee bent, shoulders and head slightly bowed. The right hand is raised and the other placed on the back of a fawn at her side. A piece of drapery falls over her elbows and behind her back. The fillet in her hair and the tassels of the drapery are gilded. Modeled in 1922, this group won the competition for the Darlington Memorial Fountain at Washington. The example now at Brookgreen is the only replica. It was awarded the Fairmount Park Association Prize of the Pennsylvania Academy in 1926.

Bronze group. Height 4 ft. 10 in. Signed on base at right: C. P. JENNEWEIN Founder's mark: ROMAN BRONZE WORKS N.Y. Placed in Brookgreen Gardens in 1940. Formerly in the garden of Charles Louis Borie, Rydal, Pa. Other example: Washington, D.C. Court House Square.

INDIAN AND EAGLE

Study model in bronze. Height 4 ft. 11 in.—Diameter of base 1 ft. 5¼ in. Signed on base at right: C° 1929 C P JENNEWEIN Founder's mark: ROMAN BRONZE WORKS N.Y. Placed in Brookgreen Gardens in 1934. Other examples: Muncie, Ind. Ball State Teachers' College; Tours, France (bronze statue); Washington, D.C. National Collection of Fine Arts (plaster statue).

Cupid and Gazelle

A baby Cupid with tiny wings is perched on the back of a gazelle, one foot resting on its withers, one of the raised hands touching a horn. The gazelle stands with one slender foreleg bent, back and neck arched, the head turned slightly to one side. The girth is patterned with an incised leaf scroll, and between the curving horns is a medallion. The group, notable for decorative composition and rich modeling, was made to celebrate the birth of his first son, Paolo, while the sculptor was a student at the American Academy in Rome. It received honorable mention at the exhibition of The Art Institute of Chicago in 1921.

Bronze group. Height 2 ft. 4¼ in. Base: Length 1 ft. 6¼ in.—Width 5¾ in. Signed on top of base: C. P. JENNEWEIN ROMA · 1919 C° Founder's mark: DRIESSMANN BAUER & C°. MUNICH MADE IN GERMANY 6 Placed in Brookgreen Gardens in 1936. Other examples: The Baltimore Museum of Art; Bloomfield Hills, Mich. Cranbrook Academy of Art; Houston, Texas. The Museum of Fine Arts; The Montclair Art Museum; New York. The Metropolitan Museum of Art.

Comedy

A girl is dancing, poised on the toes of one foot, the left knee bent. With one arm over her head she holds before her face a gilt Silenus mask; the other hand is raised. This statuette was modeled in Italy about 1920.

Bronze statuette. Height 1 ft. 6 in. Placed in Brookgreen Gardens in 1936.

The Greek Dance

A dancer steps forward balanced on the toes of both feet. The figure is in profile except that the shoulders are turned at right angles, the extended arms lifted almost to shoulder height; the hands are bent backward to a vertical position and the fingers bent again horizontally. A pleated drapery is looped at the back, the ends falling over the elbows, and a cloth is wound around the head above two rows of tight curls. This statuette was done at Rome in 1926.

Bronze statuette. Height 1 ft. 6¼ in. Base: Length 1 ft. 2¼ in.—Width 4⅝ in. Signed on base at back: C. P. JENNEWEIN © Founder's mark: P.B. U. C° MUNCHEN MADE IN GERMANY 15 Presented to Brookgreen Gardens by the sculptor in 1940. Other example: San Diego. Fine Arts Gallery (silvered).

Iris

Iris, goddess of the rainbow and messenger from gods to men, is repre-
sented as a girl swiftly descending, her body bent backward in an arc. Both
arms are raised, palms inward, and the legs are pressed together. The forms
are firm, with flowing surfaces. Classic features are softly modeled, and the
hair is brushed back from the face in loose curls.

In small size the work was completed in 1938; the following year it was
enlarged with some variations for use as a garden statue. The plaster cast of
the large version has been presented to The American Academy of Arts and
Letters.

Bronze statuette. Height 2 ft. 11¾ in. Base: Diameter 4 in. Signed on base at back:
C. P. JENNEWEIN Placed in Brookgreen Gardens in 1943.

Gaetano Cecere

GAETANO CECERE was born in New York on November 26th, 1894, the
son of Ralph and Catherine (La Rocca) Cecere. His studies were with
Hermon A. MacNeil and at the Beaux-Arts Institute of Design. In 1920 he
won the *Prix de Rome*. During his period of study at Rome a tendency to
simplify forms for decorative effects was developed. Insistence on design
became paramount in the panel of *The Hunters*, where everything which did
not contribute to the pattern was suppressed. There is a suggestion of Far
Eastern styles in the *Mother and Child*, a kneeling figure with the child lying
on a fold of drapery, in which the unbroken surfaces do not distort the
underlying form. The drapery of the *Kneeling Girl* in the Norton Gallery at
West Palm Beach, Florida, is also slightly stylized. In two women's heads,
Roman Peasant and *Persephone*, which won the Barnett Prize of the National
Academy of Design in 1924, there are added to the clarity of outline and the
decorative use of headdress and curls a warmth and color achieved by skillful
variations of planes. *Francesca* was given honorable mention by The Art
Institute of Chicago in 1927.

The statue of John Frank Stevens in bulky woodsman's clothes, modeled in
large masses, was erected in 1925 in the pass which he discovered at Summit,

Montana. The heroic *Lincoln* for the Lincoln Memorial Bridge, Milwaukee, the commission for which he won in a competition in 1933, is also given simple, monumental treatment. Archaic Greek figures constitute the pediment for the Stambaugh Auditorium, Youngstown, Ohio, and on the war memorial at Clifton, New Jersey, is a classic Victory. He made use of low relief with sharply cut outlines for a band of Greek warriors around the base of a flagpole erected as a war memorial at Plainfield, New Jersey. This interest in relief found expression in a number of medals, for which in 1935 he was given the Lindsey Morris Memorial Prize of the National Sculpture Society. Among them are the Alumni Medal for Collaboration of the American Academy in Rome and the Soldier's Medal for Valor of the United States Army. Garden statues show more interest in mass than in line; the figures are quietly posed and ornamental details eliminated. He is the sculptor of the *Rural Free Delivery Mail Carrier* in the series for the Post Office Department Building, Washington, D.C., and of portrait statues of James Pinckney Henderson at San Augustine, Texas, and General Sidney Sherman, the hero of the Battle of San Jacinto, for the state of Texas.

His skill in designing for sculpture in relief was again called into play in two large limestone panels representing Industry and Agriculture for the Federal Reserve Bank, Jacksonville, Florida. In these he developed scenes of men employed on various tasks into a rich pattern. Roundels with over life-sized heads in profile of Simon de Montfort and George Mason were carved in marble for the House Chambers, Washington, D.C. A bronze portrait relief of Baron von Steuben is in the high school at Milwaukee named after him.

Cecere's sculpture has become more and more impressionistic. *Rima* is a poetical concept of bird forms merging with a dreamlike head; a second version of the same theme is a relief in half figure. *Aurora*, a vaguely defined mask directly carved in limestone, won the Leon Frost Award of the Society of Audubon Artists in 1957, and the next year another head, *The Prophet*, received the medal of honor of the Knickerbocker Artists. In works exhibited at Mary Washington College in 1963 the sculptor has carried his idea of basic form still further, leaving figures as ovoid masses of soft shapes to express such concepts as *Forces of Nature* and *Primordial Ecstasy*. *Tree of Life*, a relief in the Norfolk Museum, gives an impression of upward striving by climbing shapes. Cecere is a former director of the department of sculpture of the Beaux-Arts Institute of Design, New York. He has taught at Washington University, Saint Louis, and more recently has been associate professor of art at Mary Washington College, Fredericksburg, Virginia. He has been elected a fellow of the National Sculpture Society and a member of the National Academy of Design, where he was on the faculty of the school of fine arts.

Eros and Stag

Bronze group. Height 2 ft. 1¾ in. Base: Length 1 ft. 8 in.—Width 1 ft. 1 in. Signed on base at back: GAETANO CECERE SCULPTOR 1930 © Founder's mark: CELLINI BRONZE WORKS N.Y. Placed in Brookgreen Gardens in 1936.

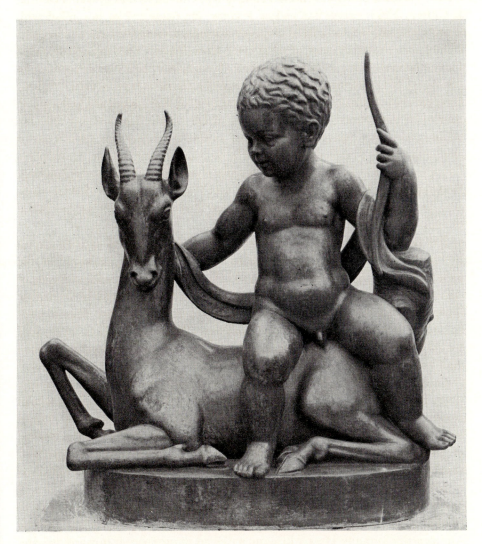

Eros and Stag

On the haunches of a reclining stag a boy is seated sidewise, holding a bow in his left hand; his right hand is placed on the back of the stag's raised head. A piece of drapery is flung over his arms and behind his back. This group was awarded a Garden Club of America prize in 1930.

Boy and Fawn

A boy with a bow held in one hand is stepping over a fawn lying in the shrubbery, which raises its head to lick his other hand. The group is compactly designed and modeled with slight stylization. It was awarded a Garden Club of America Prize in 1929 and the McClees Prize for the most meritorious composition at the exhibition of the Pennsylvania Academy in 1930.

Bronze group. Height 2 ft. 9 in. Signed on base at left: G. CECERE. 1929 © Founder's mark: CELLINI BRONZE WORKS N.Y. Placed in Brookgreen Gardens in 1934.

Allan Clark

ALTHOUGH in recent years more than one American sculptor has drawn on the art of the Orient for subject matter and ornamental features, none has made its principles so much his own as Allan Clark. Born at Missoula, Montana, on June 8th, 1896, the son of Harry Percival and Bess (Harrison) Clark, his early education was at Tacoma, Washington, where he attended high school and Puget Sound College. He studied with Albin Polášek at The Art Institute of Chicago and with Robert Aitken at the Art Students' League, New York, beginning to work independently in 1917. In 1922 he modeled a portrait bust of Madame Galli-Curci and two dancing figures, *Nymph* and *Satyr*, for her country estate. Other patrons were Ruth St. Denis and Ted Shawn, whom he represented in the *Antelope Dance*. During the next two years he made eighteen life-sized terra cotta and three heroic stone figures for the University of Washington Library in Seattle and was an instructor at the Beaux-Arts Institute of Design, New York.

In 1924 he left for three years of travel and study in the Far East, going first to Japan for four months to learn the technique of Japanese sculpture and experiment with polychromy. The figure of the famous actor Nakimura Ganjiro owned by the Honolulu Academy of Arts was done at this time. He went to Korea to study early Buddhistic art and then stayed at Peking for about nine months. His productions during this stay were several heads of Chinese, including the charming *Mei Kwei* in The Metropolitan Museum of Art, New York, carved in wood. A statuette, *Yang Kwei Fei*, represents a famous beauty of Chinese legend. Invited to join the second Fogg Museum Expedition led by Langdon Warner, he visited with them the cave chapels of

Tun Huang and Wan Fo Hsia near the Turkestan border, making some twenty drawings in color for the museum collection. Thereafter he continued to study and travel in Cambodia, Java, the Malay States, Siam, and Burma. The results of his stay in the Orient were presented in an exhibition at the Fogg Art Museum, Cambridge, which was also sent to other cities in the East and in the West. In 1930 he won the Rosenwald Memorial Prize at the Grand Central Art Galleries, New York.

He applied the Oriental technique to carving in wood heads of the Indians of the Southwest, establishing a studio on a ranch at Santa Fe. Ten of these heads were shown at New York in 1930, and one, *María of Cochití*, has been acquired by the Seattle Art Museum. A bust of Klah, Navajo medicine man, is in the House of Navajo Religion. In the Chinese and Japanese subjects his work was closely dependent on his Oriental models, but in other works he applied their smooth planes and distinction of line to his own conceptions. This rhythmic style is particularly effective in the figures of dancers such as *Kongo Voodoo* in The Metropolitan Museum of Art, New York, and the lyrical statuettes *Forever Panting and Forever Young*. It also lends itself to the interpretation of animal forms in the great Dane *Galadji von Loheland*, the *Blue Gnu*, the *Addra Gazelle*, and the Arab stallion. Later works show a larger treatment of forms, with the rhythms not so formal and less emphasis on decorative qualities. He was elected to the National Institute of Arts and Letters. Clark lost his life in an automobile accident near Delta, California, on April 17th, 1950.

Arab

An Arab stallion is stepping proudly forward, head lifted, nostrils distended and mouth open, ears laid back, and tail arched. The mane is clipped to a lightly fluted ridge.

Fire-gilt bronze statuette. Height 1 ft. 2½ in. Base: Length 1 ft. 1½ in.—Width 3¼ in. Signed on base: ALLAN⁓CLARK⁓1929 Founder's mark: P. B.U. C° MUNICH MADE IN GERMANY © Placed in Brookgreen Gardens in 1936.

Study for a Garden Pool

The Bodhisattva Avalokiteśvara is seated sidewise, braced by her left arm, her right arm resting on her bent knee. A skirt, draped in broad, shallow folds over the knees, is held by a wave-patterned girdle. Her hair is in a high knot bound with fillets. There is a jeweled necklace at her breast, and a narrow

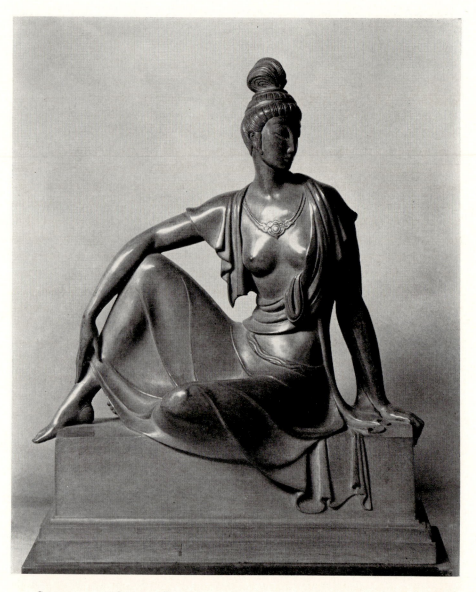

STUDY FOR A GARDEN POOL

Bronze statuette. Height 1 ft. 6½ in. Base: Length 1 ft. 3½ in.—Width 5¾ in. Signed on base at back: ALLEN [*sic*] CLARK Ⓒ N°3 Founder's mark: ROMAN BRONZE WORKS N.Y. Placed in Brookgreen Gardens in 1936. Other example: West Palm Beach, Fla. The Norton Gallery and School of Art (bronze statue).

drapery is looped over her shoulders. Girdle, necklace, and fillets are gilded. The mood of quiet contemplation is carried out by the easy posture and the soft curves of figure and drapery. The style of this statuette, which was modeled in China in 1925, resulted from the sculptor's study of Chinese art.

Gleb W. Derujinsky

GLEB W. DERUJINSKY was born at Smolensk, Russia, on August 13th, 1888, the son of Wladimir F. and Sophia A. (Artzimovitch) Derujinsky. His father was a well-known scientist and jurist, who taught at the University of Leningrad, then Saint Petersburg. When the son was sixteen he went to Leningrad to study law, beginning to draw and paint at the same time. He made such good progress that he was awarded a silver medal by the School for the Encouragement of Art. When his interest in sculpture became predominant, he was sent in 1911 to Paris, studying first with Verlet and then with Injalbert. In 1913 he entered the Imperial Academy of Art at Leningrad for a period of four years. His first enthusiasm was for Troubetzkoy, whose influence can be detected in early works; his second, for Rodin, who gave him encouragement and advice. He was a candidate for the *Prix de Rome* when the revolution broke out in 1917. Fleeing to the Crimea, he stayed with Prince Felix Youssoupoff until, with his family, he went to the Caucasus. Two years later he shipped as a sailor on a cargo boat bound for New York.

In the short space of two years he was ready to give an exhibition at a New York gallery. The National Sculpture Society elected him a member, and the Beaux-Arts Institute of Design engaged him as a teacher. Early works done in this country are *Leda*, *Icarus*, and some dancing figures posed by Ruth Page and Adolph Bolm, one of which is at The Dayton Art Institute. He received a commission for a memorial bas-relief to Senator Ryan for the Pittsburgh Court House and designed sundials and other garden sculpture. *Eve*, with the serpent coiled at her side, won a gold medal at the Philadelphia Sesqui-Centennial Exposition in 1926. For his *Egyptian Lotus Carrier* and a sundial with an Egyptian figure he adopted a severe linear style. His work was awarded a gold medal at the Paris Exposition of 1937, and in the next year *Upheaval*, a heroic figure in the throes of an upward struggle, was given the Watrous Gold Medal of the National Academy of Design.

Many of his friends are musicians, and he himself is an accomplished pianist. The rhythmic qualities and vibrant lines of his sculpture may reflect this avocation. Subjects for portraits were the pianist Alexander Siloti, Sergei Prokofiev, and Rachmaninov, for whose bust Derujinsky was given the Anna Hyatt Huntington Prize at the National Academy of Design in 1949. The sculptor also made studies of the sensitive hands of the harpist Marcel Grandjany and of a pianist. Other portraits are a bust of Theodore Roosevelt

317

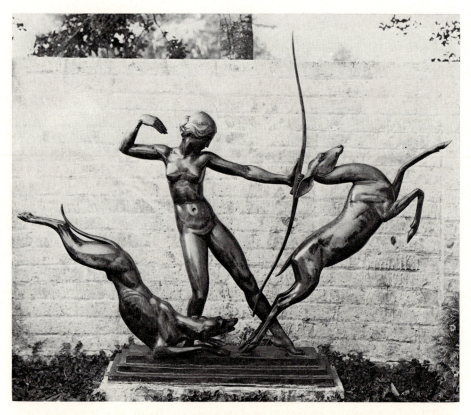

DIANA

Bronze group. Height 2 ft. 11¾ in. Base: Length 2 ft. 6¾ in.—Width 8½ in.
Signed on base at back: GLEB DERUJINSKY Founder's mark: ROMAN BRONZE
WORKS N.Y. Placed in Brookgreen Gardens in 1936.

placed in the Administration Building at the Panama Canal and also in his
birthplace at New York, one of Rabindranath Tagore carved in a block of
lignum vitae, and a bust of Franklin D. Roosevelt at Hyde Park, New York.
Derujinsky's bronze head of Sir John Lavery is in The Metropolitan Museum
of Art, New York. Eight medallion portraits in wood of former postmasters
general were made for the new Post Office Department Building, Washing-
ton.

Wood is one of his favorite materials, which he often carves directly
without a preliminary model. He has described the methods of wood carving
in an article in the *National Sculpture Review*.[1] Sometimes he cuts it with
sharp facets like a Gothic carver, at other times he polishes the surface to
satin smoothness. His wood carvings have been an excellent vehicle for

1 Summer 1952. v. 9, no. 2, p. 21–22.

religious sculpture. The Byzantine art that he knew in his youth has suggested certain conventions for the composition of scenes, but the sculptor has projected into them an emotional force that pulses through the insensible material. An *Annunciation*, carved of teakwood, is in the Fine Arts Gallery, San Diego, and another of walnut in the chapel of the Cranbrook Foundation, Bloomfield Hills, Michigan. A relief in cocobolo wood of the Virgin of the *Deësis*, interceding for the souls of the dead at the Last Judgment, won the Lindsey Morris Memorial Prize of the National Sculpture Society in 1954. The Stations of the Cross for the House of Theology at Cincinnati were dedicated in 1958. One of them, *The Descent from the Cross*, was awarded the Daniel Chester French Prize of the Allied Artists of America and a special citation from the National Sculpture Society. A gold medal was given him by the Allied Artists for an *Angel* in 1966. A Jesuit community in India ordered a *Madonna* dressed in a sari, carved of white mahogany.

All the sculptured decoration for a chapel in the School of the Holy Child at Summit, New Jersey, was executed in white porcelain; there were statues of the Virgin Mary and Saint Joseph, a Crucifixion, and Stations of the Cross. Derujinsky's statues for two churches at Washington, D.C., were carved in stone; his *Virgin and Child* is on the façade of Our Lady of Victory, and statues of Saints Bonaventure, Ignatius, and Cupertino, of marble, in the National Shrine of the Immaculate Conception. He also had a share in the sculpture for the Cathedral of Mary Our Queen at Baltimore.

With all these commissions, the sculptor has not neglected subjects that appeal to his vivid imagination. Figures have become more attenuated, the lines pulled taut by nervous energy. A spectral *Spirit of the Tree* won acclaim, *The Three Graces*, of ebony, entered the Toledo Museum of Art, and *Meditation*, carved in marble, The Fine Arts Gallery of San Diego. Derujinsky is a member of the National Academy of Design and a fellow of the National Sculpture Society.

Diana

Diana leans backward, the bow outstretched in her left hand, her right arm drawn back from pulling the bowstring. The stricken deer bounds forward, forefeet in the air, head back. Behind Diana leaps the hound, baying at the heels of the deer, head to the ground and hind feet in the air. The sweeping rush of their lithe bodies, held in balance by the firm pose of Diana, makes a delightful pattern. It was modeled about 1925.[2]

2 It is discussed by Helen Comstock (*Sculptures of Derujinsky*, p. 455).

Samson and the Lion

Samson leans backward, bending the lion's head back as he grasps both jaws. A skirt hung from his waist and stretched between his legs falls from his bent knee in wide pleats. His powerful muscles are knotted with effort. His strong face, with long nose and thick eyebrows, is bearded, and his hair blown backward in a heavy mass. The lion has been forced back on its haunches, one forepaw clawing at Samson's arm.

Limestone statue. Height 6 ft. 6 in. Base: Length 6 ft. 2 in.—Width 2 ft. 3 in. Signed on base: G. DERUJINSKY 1949 Placed in Brookgreen Gardens in 1950.

Ecstasy

A youth and a girl with linked hands sweep upward in wavelike movement. He is braced on the crest of a wave and she springs ahead of him, her body arched like a bow. Lean muscles stand out with the violent motion, and the hair flows backward in flame-shaped locks. The sculptor composed this group with the emphasis on space surrounded by figures.

Bronze group: Height 5 ft. 7½ in. Signed on base at back: G. DERUJINSKY Founder's mark: MODERN ART FDRY. N.Y. 54 Placed in Brookgreen Gardens in 1954.

Anthony de Francisci

ANTHONY DE FRANCISCI was born in Italy on June 13th, 1887, the son of Benedict and Maria (Liberante) de Francisci. After beginning the study of art there, he emigrated to the United States in 1903 and became a citizen ten years later. Soon after his arrival he continued his studies at the National Academy of Design, with George T. Brewster at Cooper Union, and with James Earle Fraser at the Art Students' League. He had varied experience as assistant to Brewster, Philip Martiny, H. A. MacNeil, Charles Niehaus, and, finally, six years in the studio of A. A. Weinman, where he got sound technical training. From 1915 he was for a number of years instructor in sculpture at Columbia University and also taught at the Beaux-Arts Institute of Design and the National Academy of Design.

Opening his own studio in 1917, he became especially well known as a medalist. For excellence in this branch of art he was awarded the Saltus Medal of The American Numismatic Society in 1927, the Lindsey Morris Memorial Prize of the National Sculpture Society in 1932, and the award of the same name given by the Allied Artists of America in 1958. He designed the United States silver dollar of 1921 and the Maine Centennial half dollar of 1920, as well as the government medals for service in Texas and for the Reserve Officers' Training Corps, the Naval Defense Button, and the warrant officers' insignia. The Congressional Medal of Honor given to General Pershing was entrusted to De Francisci. He was chosen to design the eleventh issue of the Society of Medalists, his subject being the Creation, *Fiat Lux*, and the Paul Revere Medal of 1925. Other medals are the Ohio State University Medal for Journalism, and several for engineering and industry. The medal commemorating the fiftieth anniversary of the Ford Motor Company, that presented to Herbert Hoover by the American Institute of Mining and Metallurgical Engineering, and the Bernard M. Baruch Distinguished Service Medal are all his work.

He modeled portrait plaques, including those of his fellow sculptors, Weinman and Arthur Lorenzani. A circular medallion of his daughter Gilda, with an intricate border of garland-bearing cherubs, was given the Widener Medal of the Pennsylvania Academy in 1938. *Pot of Basil*, a rhythmically composed kneeling figure, won the Watrous Gold Medal of the National Academy of Design two years later. Both the National Arts Club and the Allied Artists of America awarded him gold medals of honor for his sculpture; the latter gave its medal in 1961 for an impressive figure of Saint John the Baptist.

De Francisci also produced sculpture on a larger scale: the Independence Memorial, Union Square, New York; the Metcalf Memorial at Orange, New Jersey; the Raymond Memorial in the Engineering Society Building, and a polychrome triptych in All Souls' Church, New York. All his imaginative figures and reliefs are very decorative, often, in later years, with a slight adaptation of Eastern conventions. He modeled various garden figures for private gardens at Short Hills, New Jersey, and Cleveland, Ohio, and such conceptions as the head *Nirvana* and the nude figures *Bayadère* in The Cincinnati Art Museum and *Twilight*, all meticulously finished, with smoothly stylized detail. His *Birds in Flight* and *Dolphins* are airy compositions solidly linked but giving the effect of being surrounded by space. Two panels *Day Air Mail* and *Night Air Mail* were commissioned for the exterior of the new United States Post Office Department Building at Washington. He was a member of the National Academy of Design and a fellow of the National Sculpture Society and The American Numismatic Society. De Francisci died on October 20th, 1964.

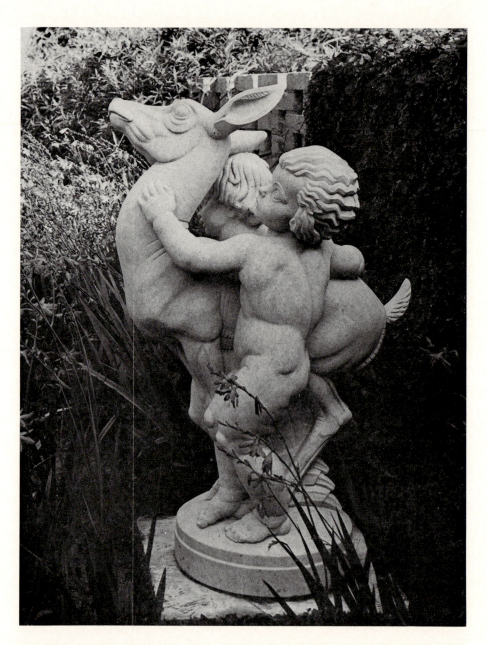

CHILDREN AND GAZELLE

Tennessee marble group. Height 2 ft. 10 in. Signed on base at back: · ANTHONY · DE FRANCISCI · Placed in Brookgreen Gardens in 1938.

Children and Gazelle

A boy and a girl stand one on each side of a gazelle, an arm over its back, the other clasping its neck. The gazelle's four feet are together and its head thrown back. Decorative use is made of the animal's tense muscles and the children's chubby forms, and the hair is set in conventional waves and curls. The group was modeled at New York and carved in 1937.

Dolphins

Four dolphins leap over the water, the foremost already plunging into it. Their streamlined bodies, with little detail to interrupt the smooth curves, form an arch. The group was modeled at New York in 1937 and a unique cast made.

Silver-plated bronze group. Height 1 ft. 1½ in. Base: Length 6½ in.—Width 4½ in. Signed on top of wave at back: ANTHONY DE FRANCISCI SC Founder's mark: ROMAN BRONZE WORKS N.Y. Placed in Brookgreen Gardens in 1937.

Joseph C. Fleri

JOSEPH CHARLES FLERI was born in Brooklyn, New York, on May 20th, 1889. His parents, Dominic and Catherine Fleri, had come from Messina, Sicily, where his father had been a contractor and builder. To make his living in the United States, like many of his countrymen, he opened a grocery store. After the son had as a schoolboy shown a talent for drawing, he was sent to Italy in 1907 to study art. The first six months he spent visiting relatives in Sicily and reveling in the beauty of Taormina. Then he went to Rome for four years, studying first at the British School and then at the Reale Accademia di Belle Arti.

After returning to New York, he had hardly begun his career when, in the First World War, it was interrupted from 1917 to 1918 by service in France with the original camouflage corps of the Fortieth Engineers, where he was in the company of many other sculptors, architects, and painters. Resuming his profession at the end of the war, he found employment with John Gregory, Edward Field Sanford, Junior, and Charles Niehaus. Niehaus was at this time

working on several war memorials and other important commissions, so that his assistant had a wide variety of experience. Fleri already had a studio and began to work out his own creative ideas. *The Dancer* was erected on the grounds of the Sesqui-Centennial Exposition, Philadelphia, in 1926. Garden figures, *Reflection* and *Lotus Fountain*, were cast in bronze and placed in private gardens. A memorial in Holy Cross Cemetery, Brooklyn, had two Angels of Grief carved in limestone.

Architectural sculpture for ecclesiastical buildings became one of Fleri's chief interests. Since during this eclectic period Neo-Gothic design was considered most appropriate for churches, he made a close study of Romanesque and Gothic styles in order to make the sculpture conform to the setting. He adopted elongated proportions and certain stylizations for draperies and hair in order to emphasize structural values while modeling faces in a more lifelike manner. In 1929 a large group of sculpture on the main entrance to Holy Cross Church, Philadelphia, was entrusted to him. A crucifix, the mourning Virgin, and Saint John were placed between the buttresses of the Gothic façade, over the door. Early Gothic style, the figures tall and straight with draperies in long parallel folds, was chosen to harmonize with the perpendicular lines of the architecture. In the same church Fleri carved a series of twelve apostles in marble to be set in the Gothic framework of the high altar. In collaboration with the architect of this church, Henry D. Dagit, he executed many other commissions for ecclesiastical sculpture. A stone statue of Saint Madeleine-Sophie Barat, foundress of the Society of the Sacred Heart, for the Roman Catholic high school in Germantown, Pennsylvania, is a dignified standing figure in nun's habit, the folds emphasizing the austerity of the figure by Romanesque conventions of narrow, straight lines and loops. The face, framed in a crimped coif, is conceived in simplified realistic fashion. *Saint Simon* and *Saint Jude*, titular saints of a Roman Catholic church in Bethlehem, Pennsylvania, though less conventionalized and with folds more softly handled, keep the same restraint and the calm of regular features in repose. In 1938 Fleri carved a Crucifixion group of five figures for the Church of Mary Immaculate Seminary in Northampton, Pennsylvania—tall statues in stylized folds accenting the verticality of the Gothic style of architecture. He had an important share in the tremendous sculptural program of the National Shrine of the Immaculate Conception at Washington, D.C., dedicated in 1959; he was responsible for twenty-six limestone figures of prophets and apostles in high relief on the buttress piers at each side of the main entrance.

In individual creations unhampered by architectural requirements, such as *The Sower* now in Brookgreen Gardens, Fleri modeled the human figure with freedom and power. His *Niobe*, her hands thrown backward behind her head in terror, is strikingly posed, and the steady pull of the muscles strongly felt

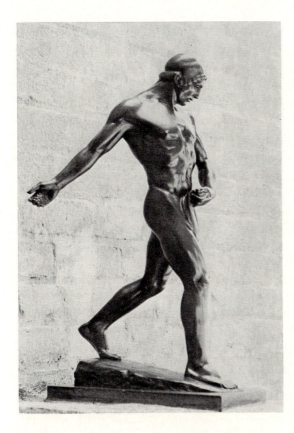

THE SOWER

Bronze statuette. Height 1 ft. 9⅛
in. Base: Length 11¾ in.—
Width 6 in. Signed on base at
left: J. C. FLERI Founder's
mark: KUNST-FDRY.
Placed in Brookgreen Gardens in
1948.

without being over-detailed. *Blacksmith* is a study in movement, simplified to
bring out the rhythmic composition. A statue of Father Isaac Jogues was
modeled for Saint Mary's School, Glens Falls, New York, and in 1940 one of
Brother Edmund Ignatius Rice, founder of the Christian Schools, for Iona
School, New Rochelle, New York. The statue of Brother Rice is a straightfor-
ward representation of him standing at ease, the Jesuit habit falling in a few
simple folds, the strong face with an intent gaze. A plaque with portraits in
low relief of Bishop Moore and Clement Moore was placed in the Newtown
High School, in the borough of Queens, New York City. Fleri was a fellow of
the National Sculpture Society. He died on December 2nd, 1965.

The Sower

A man strides forward with a wide step, his right arm flung backward,
scattering seed, in a long line parallel to the left leg. One side of the bag hung
from his waist is held by his left hand, the arm curving away from the body.
The hair is treated in an archaic convention, smooth over the head, with a

border of tight curls. The modeling of the classic face and the muscular body is slightly simplified to give a smooth flow of surface.

When Fleri was working for Edward Field Sanford, Junior, in 1925, the powerful form of a model posing for Sanford suggested the idea for this statuette. Sanford permitted his assistant to use the same model to work out his idea, made effective by the strong forward motion and broad sweep of the arm.

Georg John Lober

GEORG JOHN LOBER was born at Chicago, Illinois, on November 7th, 1892. His parents were Axel G. and Anna (Danielson) Lober. He studied in New York at the National Academy of Design and the Beaux-Arts Institute of Design, his teachers being A. Stirling Calder, Hermon MacNeil, Gutzon Borglum, and Evelyn Longman, who seems most to have influenced his development. In 1911 he won the Avery Collaborative Prize of the Architectural League and in 1924, first prize at the Connecticut Academy of the Fine Arts. Among his early works were medals, and they continued to be one of his chief interests. The National Museum of Copenhagen, Denmark, and the Administration des Monnaies et Médailles, Paris, acquired groups of them. They include the Grand Master's Medal of the Masonic Order of New York State, the medal of award of the Garden Clubs of New York State, the American Water Color Society Medal, and the reverse of the Allied Artists' medal of award.

He produced a number of memorials and portrait sculpture, a head of Frank Bacon having been acquired by the Montclair Art Museum and a bust of Theodore Roosevelt placed in the Hall of Fame at New York University. A bronze statue of George M. Cohan, showing the actor in an easy, natural pose, has been erected on Broadway at Duffy Square in New York City. Thomas Paine was the subject of a statue for Morristown, New Jersey. A portrait of Hans Christian Andersen sent to Denmark brought the sculptor great honors; the King of Denmark gave him a medal and made him a knight of the Order of the Dannebrog, and in 1952 Lober was a guest of honor of the town of Odense. The personality of Andersen fired his imagination, for he chose the author as the subject of a medal issued by the Society of Medalists and made two figures illustrating Andersen's stories, *The Princess and the Pea* and *The Emperor's Nightingale;* the originals, carved in limestone, are above the door of a sanatorium at Utica, New York, and the sculptor presented small models

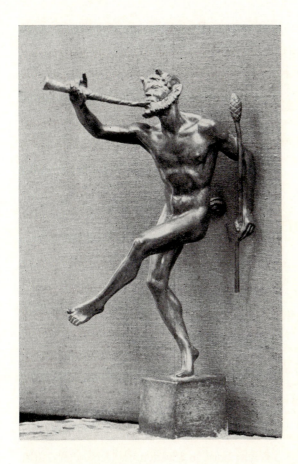

FAUN

Bronze statuette. Height 1 ft. 2
in. Signed on base at left: GEORG
LOBER N·A· ©
Placed in Brookgreen Gardens
in 1936.

to the museum in Andersen's house at Odense. A statue of him by Lober is in
Central Park, New York.

Lober occasionally dealt with religious subjects, included among them a
Byzantine Madonna in silver, a marble baptistery for the First Baptist
Church, Plainfield, New Jersey, *Saint Peter* and *Saint Paul* for the Church of
Our Lady of Consolation, Pawtucket, Rhode Island, and a heroic crucifix on
the Jefferson Davis Highway, Aquia, Virginia. His most characteristic works
are a series of decorative figures, graceful and polished. *Eve*, one of the earlier
and more realistically modeled, was given honorable mention by The Art
Institute of Chicago in 1918, and an example acquired by the Metropolitan
Museum, New York. *Amo*, a girl seated, writing the word in the sand, also
won honorable mention from the Art Institute, and in 1931 the sculpture
prize of the Allied Artists of America. Other works show a slightly more
stylized treatment of the form and freer use of ornament. *Sundial*, a kneeling
girl with the dial resting on one knee, received the Jenkins Prize for sculpture
at the Grand Central Art Galleries in 1931 and the National Arts Club medal
of award four years later. *Girl with Parrot* and *Seaweed Fountain* are other

garden statues. He was head of the sculpture department of the Grand
Central School of Art and a member of many art societies, including the
National Academy of Design, The Architectural League of New York, the
Allied Artists of America, whose medal of honor he was given in 1937, and
The American Numismatic Society. He received the American Artists'
Professional League medal of award in 1940. The National Sculpture Society
gave him its highest award, the medal of honor, in 1952. He died on
December 14th, 1961.

Faun

A faun dances with one foot raised; he blows a trumpet and holds a
cone-tipped wand in the left hand. He has two little horns and a goat tail. The
surface of this sprightly figure, modeled in 1916, is sketchily finished. The
cone, trumpet, and horns are gilded.

Hilda Kristina Lascari

HILDA KRISTINA GUSTAFSON was born in Sweden on December 18th,
1885. Beginning her studies in Stockholm, she continued them in Greece and
Southern Europe. In 1916 she came to the United States, where she married
the painter Salvatore Lascari, not long before he went to Rome as a fellow of
the American Academy in 1919. Thoroughly steeped in the spirit of late
Greek art, she distilled its essence into her own creations. No breath of
discord is allowed to disturb the harmony of these exquisite and remote
beings, every detail finished to a high degree of perfection. They began to
receive recognition when in 1926 *Awakening*, a quiet standing figure of a girl
with lowered lids, won the Watrous Gold Medal of the National Academy of
Design. In the following year, *Zephyr*, a classic head with delicately chiseled
flowing locks bound by a fillet, was awarded the National Arts Club Prize of
the National Association of Women Painters and Sculptors. *Mother and
Child*, which won the McClees Prize of The Pennsylvania Academy of the
Fine Arts in 1934, was acquired by the Philadelphia Museum of Art and the
art gallery of Amherst College. *Zephyr*, a full-length figure with tiny wings
and a bit of drapery fluttering from the arms, airily poised and crisply carved,
won the sculptor a second award of the Watrous Gold Medal in 1936. More

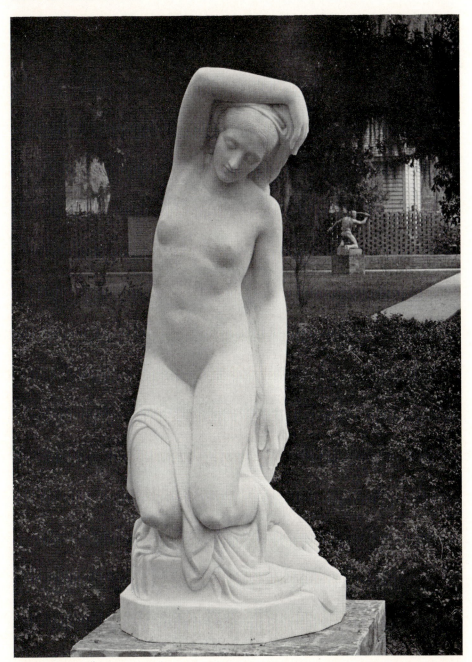

Autumn Leaves

White marble statue. Height 4 ft. Base: Width 1 ft. 5 in.—Depth 1 ft. 5½ in.
Signed on base at back: HILDA·KRISTINA·LASCARI· © 1936 Placed in Brookgreen
Gardens in 1936.

symbolic in content and architectural in composition is *Mystic Garment*, two figures holding aloft a drapery which partly enfolds their forms.

Only a few subjects, such as *Pueblo Indian Mother and Child* and *Thanksgiving*, a kneeling Puritan woman, venture outside the rarefied atmosphere of her imagination. She also received commissions for various memorials, a portrait statue of Father Nardiello for Bloomfield, New Jersey, and a relief over the door of the Museum of Art, Springfield, Massachusetts. She was a member of the National Sculpture Society and an associate of the National Academy of Design. Her death occurred in New York on March 7th, 1937.

Autumn Leaves

Autumn leaves drifting to earth are suggested in this figure of a girl sinking to her knees with eyes closed and body relaxed. A soft drapery held by one arm over the head falls behind the form and over the legs in heavy folds. An air of gentle melancholy breathes from the delicately carved form.

Joan Hartley

JOAN HARTLEY was born at Utica, New York, on January 26th, 1892, the daughter of Wilfrid and Leonora (Berry) Hartley, of New England stock. She entered the Art Students' League in 1912, studying for two years with James Earle Fraser and for another year with Robert Aitken. For a year and a half she had her own studio and received a few minor commissions until at the outbreak of the World War she joined the Army School of Nurses. In 1919 she returned to her profession, continuing to study in the evening under the instruction of Charles E. Tefft. By 1923 she was able to take a studio and work independently. A fountain statue won the Joan of Arc Medal at the exhibition of the National Association of Women Painters and Sculptors in 1925 and *Annunciation*, a kneeling figure with clear contours, the Anna Hyatt Huntington Prize in 1930–1931. She has done some small bronzes and fountain figures, one of which, *Young Sabrina*, is on an estate at Wilmington, Delaware. *Pigeon Baby* is modeled in a restrained style which emphasizes the design. Miss Hartley writes of her work, "Although I have done a few portraits, my whole interest is in the figure and in the generalization of form. I prefer stone or marble to bronze."

A Fury

A female figure kneels on the left knee, head bowed. One hand is clasped to the breast and the other raised behind the shoulder; both hold curving knives. A thin drapery encircles the form, flying out behind the back. The musculature of the lean form is sharply defined, and the hair is in a circlet of flame-shaped curls.

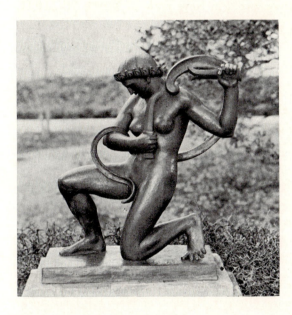

A FURY

Bronze statue. Height 2 ft. 9¾ in. Base: Length 2 ft. 5 in.—Width 1 ft. Signed on base at left: JOAN HARTLEY 1933 Founder's mark: QINQ GORHAM CO. FOUNDER
Placed in Brookgreen Gardens in 1934.

A Fury

A male figure kneels on the right knee, head bowed. The hands, one raised in front of the head and one flung back and downward, hold curving knives. A thin fold of drapery flies in a wide arc behind the figure.

Bronze statue. Height 2 ft. 10⅜ in. Base: Length 2 ft. 2½ in.—Width 11½ in. Signed on base at right: JOAN HARTLEY 1933 Founder's mark: QINR GORHAM CO. Placed in Brookgreen Gardens in 1934.

Paul Fjelde

PAUL FJELDE was born at Minneapolis, Minnesota, on August 12th, 1892, the son of Margarethe Veronica (Madsen) and Jakob Fjelde, a Norwegian sculptor who had come to this country five years earlier. His grandfather, a carpenter and wood carver, had been in the United States since 1872. After Jakob Fjelde died in 1896, his widow settled on a homestead near Bismarck, North Dakota, where the son spent his early years and began to draw and model. While visiting relatives in Minneapolis he began his art studies at the School of Fine Arts; he later attended the State Normal School at Valley City, North Dakota, where his family had moved. He had done some busts and portrait reliefs before, at the age of twenty, he became an assistant to Lorado Taft at Chicago for several years. He pursued his studies further at the Art Students' League and the Beaux-Arts Institute of Design, New York. His work won honorable mention at the Saint Paul Institute in 1918, and The American-Scandinavian Foundation awarded him a traveling fellowship in 1924 and 1925. Abroad he worked at the Royal Academy in Copenhagen and the Académie de la Grande Chaumière in Paris.

Before visiting Europe he had completed several memorials, in particular the Lincoln Monument, a heroic portrait bust on a granite pedestal, which was erected at Oslo, Norway, and Hillsboro, North Dakota. After he came back to the United States he taught sculpture at Carnegie Institute of Technology for a year before joining the staff of Pratt Institute, Brooklyn, to teach modeling, drawing, and design until he retired as professor emeritus in 1959. His skill in portraiture brought many commissions. A bronze statue of a Civil War hero, Colonel Hans Christian Heg, was erected both at Lier, Norway, and at Madison, Wisconsin. Among well characterized busts carried out with free, expressive modeling are those of W. W. Folwell in the library of the University of Minnesota, William E. B. Starkweather in the collection of The Hispanic Society of America, and Colonel Charles Lindbergh.

Fjelde's special skill in low relief composition lent itself both to portraits and to architectural sculpture. The memorial tablet to the pioneers at Council Bluffs, Iowa, depicts a covered wagon drawn in a simplified manner. A relief of John Scott Bradstreet is at The Minneapolis Institute of Arts. A bronze tablet with a head of Wendell Wilkie was placed as a memorial in the State House, Indianapolis, and on a wall in Bryant Park, New York City. In The School of Sacred Music at Union Theological Seminary, New York, the

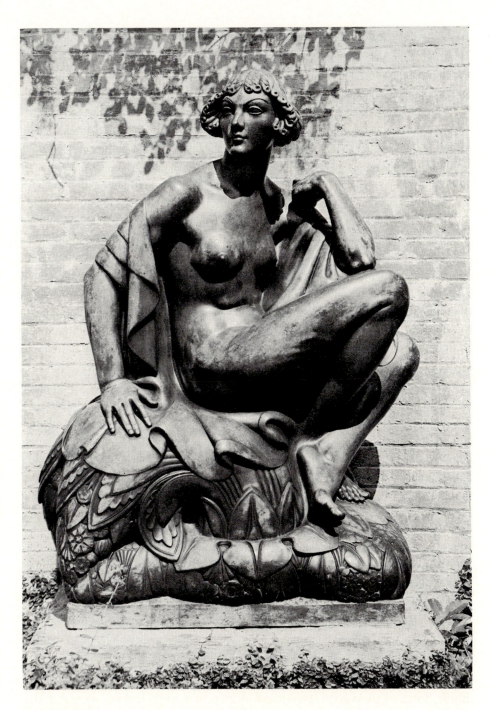

NYMPH

Bronze statue. Height 5 ft. 1 in. Base: Length 3 ft.—Width 1 ft. 7½ in. Signed on base at right: PAUL FJELDE · SCULPTOR · Placed in Brookgreen Gardens in 1937.

founder, Clarence Dickinson, is commemorated by a bronze portrait plaque. The bronze gates of Columbia University's Baker Field are enlivened with figures in pierced relief. Ornamental reliefs for the Washington School at McKeesport, Pennsylvania, are filled with figures skillfully adapted to the circular medallions. Fjelde has also done panels for the Westinghouse Monument at Pittsburgh, bronze panels for the Second National Bank, Boston, a frieze for a savings bank at East Cambridge, Massachusetts, and sculptural details for other buildings. In the exacting art of the medal Fjelde has been equally successful. His Walt Whitman medallion won the Lindsey Morris Memorial Prize of the National Sculpture Society in 1957.

His delight in carefully chosen, finely modeled ornament to add to the decorative value of his figures is shown in the *Nymph* at Brookgreen and a companion *Faun*. He applies the same crisply stylized treatment to animal sculpture, a *Raccoon* designed for ceramic having won the Pauline Law Prize of the Allied Artists of America. Fjelde is a fellow and former secretary of the National Sculpture Society and was the first editor of the *National Sculpture Review*. In recent years he has had a studio at Orleans, Massachusetts. The excellence of his sculpture has been recognized by the award of the gold medal of the American Artists Professional League and the Herbert Adams Memorial Medal of the National Sculpture Society.

Nymph

On a clump of stylized water plants a nymph is seated sidewise, the knees drawn up, one hand on the foliage beneath her, the other arm bent with the elbow resting lightly on the knee. Her head, framed in decoratively treated curls, is turned to the left. She is seated on one end of a drapery arranged in graceful folds over her shoulders. The surfaces and details are highly finished. The statue was modeled in 1932 from a small figure made the year before.

Eleanor M. Mellon

ELEANOR MARY MELLON was born at Narberth, Pennsylvania, on August 18th, 1894, to Charles Henry and Loraine W. (Roberts) Mellon. The family lived for a time at Morristown, New Jersey, and after the father's death in

1907 had an apartment in New York City. Miss Mellon's interest in sculpture led her to study with Victor Salvatore and A. A. Weinman and to attend Robert Aitken's classes at the Art Students' League. From studies with Charles Grafly at Lanesville, Massachusetts, for two summers she gained a solid foundation for the portrait heads that are a major part of her work.

The outbreak of the First World War frustrated her hope of studying in Europe. Instead she devoted her time to Red Cross work. When the war was over, sensing the need for more instruction in sculpture to get back into the swing, she took a few lessons from Harriet Frishmuth. Later she had criticisms from Edward McCartan, who sent her to The Metropolitan Museum of Art to study Italian Renaissance sculpture and whose precepts governed some of the work that she began to exhibit by 1921. A marble bust of a girl, *Helen*, included in the National Sculpture Society's 1923 exhibition, was carved with clear, firm contours, the gentle face softened by the row of curls in which the smooth cap of hair ended. With Renaissance traditions in mind, the sculptor finished the blouse with a delicate design in low relief. Other portrait busts began to win awards: *Janice* the Helen Foster Barnett Prize of the National Academy of Design in 1927; *Benjamin Kreiton*, a boy's head, a bronze medal from the Society of Washington Artists. During World War II she modeled a bust of Pilot Officer Kenneth Lee Hughes that was later placed in the Air Ministry, London, and in the private collection of Air Field Marshal Lord Tedder.

In addition to portrait busts Miss Mellon branched out into figure sculpture, beginning with *Iris*, a graceful statuette composed in elegant lines, done when she was studying with McCartan. *Mother and Child* is a standing figure that expresses protective tenderness, the gown rendered with classic simplicity. The sculptor then inaugurated a noble company of saints to embody the spiritual values that she feels to be of supreme importance. In her own words:

"When the artist approaches the field of ecclesiastical sculpture his desire is to work to the glory of God with the greatest skill, dedication and devotion. This is a very specialized field and entails something more than knowledge and craftsmanship and the ability to execute an acceptable work of art. The sculptor must feel with very deep conviction what he portrays. His work must have a spiritual quality and deeply felt emotion. The Saints are not ordinary mortals; they are dynamic spiritual beings and this must be powerfully expressed." [1]

Miss Mellon's work was shown in an exhibition at the Milch Galleries, New York, in 1948. Included was a sketch for *Saint Francis*, a large version of which is in the Norfolk Museum. The genuine spirituality and quiet beauty

1 Mellon, Eleanor Mary. *Sculpture for the church.* In *National sculpture review.* Winter 1962–1963. v.11, no. 4, p. 7.

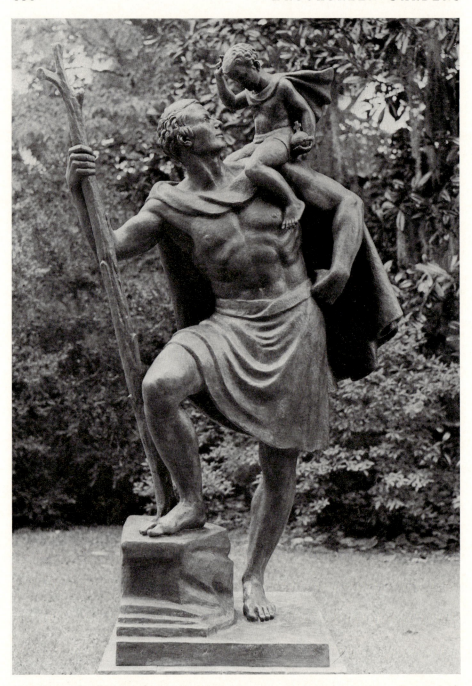

SAINT CHRISTOPHER

Bronze statue. Height 7 ft. 7 in. Presented to Brookgreen Gardens by the sculptor in 1967.

of her conceptions filled a need for ecclesiastical sculpture, with the result that her statues have enhanced many churches. *Saint John* is in the Church of Saint John in the Wilderness at Paul Smith, New York, *Saint Michael* in the Cathedral of Saint John the Divine, New York City, and *Saint Bartholomew* destined for a church in Texas.

Her portrait sculpture continued to be in demand and to win awards. A spirited bust of Giovanni Martinelli, which won a prize from the Catherine Lorillard Wolfe Art Club in 1967, is in the Metropolitan Opera House, New York, and one of Anne Sullivan at both the Industrial Home for the Blind, "Burrwood," at Cold Spring Harbor, Long Island, and at the Perkins School in Watertown. A terra cotta bust of the young actress, Mary Ellen, was given the gold medal of the American Artists Professional League and one of Cecil Howard, the sculptor, an award by the Hudson Valley Art Association.

Elected a fellow of the National Sculpture Society, Miss Mellon was secretary from 1936 to 1940 and again in 1945. She has also been on its council, one of the board of directors of The Architectural League of New York, and assistant treasurer of the National Academy of Design.

Saint Christopher

Saint Christopher is a vigorous young man, who turns his head to look up reverently to the Christ Child perched on his shoulder, gazing down into his face as He raises a hand in blessing. There is a sense of arrested motion as the saint steps up on a rock, his staff grasped in one arm while the other is braced against his hip to support the Child. The feeling of movement is increased by the short capes swept outward by the breeze.

The saint was traditionally a giant, so proud of his strength that he would only serve the most powerful sovereign in the universe. After Christopher had been converted to Christianity, he undertook to help pilgrims across a dangerous stream by carrying them on his shoulders. One evening he was summoned by a child, but as he crossed the stream he found his burden growing heavier and heavier, until the child revealed himself as Christ. The sculptor has given her work the subtitle, "Behold Saint Christopher; then shalt thou be safe," since it is believed that looking at an image of the saint will protect the beholder from sudden death during the rest of the day.

Joseph Emile Renier

JOSEPH EMILE RENIER was born at Union City, New Jersey, on August 11th, 1887, to Eleonore and Joseph Jean Renier, sculptor. After studying at the Art Students' League under the instruction of George Bridgman, Kenyon Cox, and Hermon A. MacNeil, he worked in the studios of A. A. Weinman and Attilio Piccirilli. In Paris he studied drawing at the Académie Colarossi and the École de la Grande Chaumière, and from 1911 to 1913 he was at Brussels as a pupil of Victor Rousseau and his assistant. Two years later he was awarded the fellowship of the American Academy in Rome. Because his period of study there was interrupted by two years' service with the American Red Cross, he was granted an extension of the fellowship, which allowed him to stay in Italy until 1921. After his return to the United States he had studios at Union City, New Jersey, and in New York City. From 1927 to 1941 he was associate professor of life drawing at the Yale School of Fine Arts.

He was skilled in architectural sculpture, having executed in 1933 seven metopes for the United States Post Office Department Building at Washington, D.C., and a large circular relief, *The Great Star of Texas*, for the State of Texas Building, Dallas. These reliefs are ably designed with strong linear patterns and free use of interesting details. In the medallion for Texas, delightful ornamental figures representing the various governments which have ruled the state are placed between the rays of a central star. Each of the Post Office Building metopes is a kneeling figure with supplementary details filling the square. Renier won a competition for sculpture to be carved in granite at the main entrance to the Domestic Relations Court in Brooklyn, New York. Two panels, each with a group of figures in flat relief, express the aims of the two branches of the court, the Children's Court and the Family Court. He also designed a war memorial plaque, cast in bronze for a public school at Ozone Park, New York. *Speed* for the New York World's Fair of 1939 was a man mounted on a winged horse, all parts of the composition developed in starkly horizontal lines to give a feeling of swift motion.

Design in low relief led naturally to medallic work, in which he was active. Three medals, the Omar N. Bradley Distinguished Service Award, the Medal for Merit, and the Al Jolson Award, were commissioned by the Veterans of Foreign Wars. The Civil War Centennial Medal was issued in 1961 and one commemorating Mark Hopkins two years later for the Hall of Fame series. Other noteworthy medals were for the American Society of Industrial Engi-

338

neers and the National Heart Association and those in honor of the S.S. *United States* and the submarine *Nautilus*.

Garden figures show originality of idea and gaiety of mood. *Nutcrackers*, a young faun nibbling acorns, flanked by squirrels, received a prize from the Garden Club of America in 1929. *The Waves*, a girl's figure bending under a curling breaker, won the Samuel F. B. Morse Medal in 1962, and *Leggerezza*, a nude form as light as the clouds in which it is enmeshed, the Watrous Gold Medal in 1965, both given by the National Academy of Design. *Bather* is in the Mattatuck Museum, Waterbury, Connecticut. *Young Girl* was awarded the D.C. French Medal of the National Academy of Design in 1966. Renier received the gold medal for sculpture of the American Artists Professional League. He was a fellow of the National Sculpture Society and a member of the National Academy of Design and The Architectural League of New York. He died on October 8th, 1966.

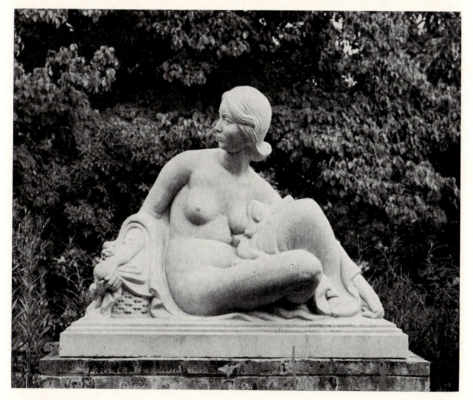

POMONA

Tennessee marble statue. Height 3 ft. 11 in. Base: Length 5 ft. ¼ in.—Width 2 ft. 3 in. Signed on base at back: *Joseph E. Renier. Sc.* © Placed in Brookgreen Gardens in 1941.

Pomona

A woman is seated in an attitude of repose, her arms falling at her sides, her head turned to gaze over her shoulder. A drapery is thrown partly around her body and over a basket of fruit under her right arm. An atmosphere of peace and plenitude radiates from the figure. The design was conceived in 1929 and the statue carved in marble in the spring of 1937. The half-size model has been cast in bronze. It was given honorable mention at the New Haven Paint and Clay Club exhibition in 1935.

Boy with Snails

A laughing boy, his head turned to the side, stands with his arms resting on two curling fronds rising behind him, a snail on each arm. The volutes of the snail shells are interestingly repeated in the fronds, the sea shell beside each foot, and the curls of his hair. The rounded muscles of the firmly modeled body carry out the design. The sketch for this figure was awarded a Garden Club of America Prize in 1928.

Bronze statue. Height 3 ft. ¼ in. Signed on base at back: Joseph E. Renier. Sc © Founder's mark: BEDFORD BRONZE FDY CO N.Y.C. Placed in Brookgreen Gardens in 1937.

Karl H. Gruppe

ALTHOUGH Karl Heinrich Gruppe was born at Rochester, New York, on March 18th, 1893, he was brought up in Holland. His father, Charles Paul Gruppe, was a painter, who after traveling throughout Europe chose Holland as the scene of his life's work and built a house at Katwijk aan Zee, near The Hague, where with his family he lived for twenty years. Charles Gruppe's wife, Helen Elizabeth (Mitchell) Gruppe, was the daughter of a clergyman living at Lakeville, near Rochester, New York. Each time that she expected a child, her father paid her passage home in order that the baby might be born in the United States. Soon after Karl's birth his mother returned with him to Holland. He went to school at The Hague until the strain of having the disturbing influence of a foreigner in the class made the Principal request that

he be sent elsewhere. He was then twelve years old, and his father entered him in the Royal Academy at Antwerp. Here he stayed for four years, studying sculpture in the afternoons with the Belgian sculptor Frans Joris. At the end of that time his father returned to the United States for the debut at Carnegie Hall of his eldest son Paul, a violoncellist, and decided to remain in this country, living in New York in the winter and at Rockport, Massachusetts, in the summer. Karl found employment with Herbert Adams, continuing in his spare time to study at the Art Students' League, where in 1912 he won the Saint-Gaudens Prize. He admired the work of Karl Bitter, and in the same year was one of a waiting list of twenty boys hoping to enter the studio at Seventy-seventh Street. In order to test his seriousness of purpose, Bitter offered to give him criticisms if he would take care of the studio. Gruppe gave it a thorough cleaning and started work on a head of his brother in order to be prepared for the promised criticism. Bitter came in to see what had been done and, impressed by his young helper's industry, took him on as an assistant. When Bitter was in charge of the sculptural decoration of buildings for the Panama-Pacific Exposition at San Francisco, he asked Gruppe to model the finial statues on the Italian towers. After Bitter's death Gruppe enlarged his figure for the Pulitzer Memorial Fountain in the Plaza, New York.

With the entry of the United States into the First World War, Gruppe joined the Marine Corps, to be stationed at Parris Island, South Carolina, where after attending the non-commissioned officers' training school he remained as a drill instructor. In New York again at the end of the war, he found a studio on Fifty-fifth Street, at the same time working for Charles Cary Rumsey. His own work, a design for a war memorial in collaboration with an architect and a painter, was rewarded by the Avery Prize at the exhibition of the Architectural League in 1920, and four years later he was elected a fellow of the National Sculpture Society. After Rumsey's death in 1922, Gruppe suggested that his unfinished work should be put in permanent form and went to Paris for three years to take charge of enlarging and casting more than a hundred sketches. As a memorial to Rumsey, he designed the International Silver Polo Cup in 1925.

Garden figures were *The Goose Girl*, strongly influenced by Bitter's fountain at Pocantico Hills; *Mimi*, a girl with a kitten, acquired for the Gallery of Fine Arts in Atlantic City; *Naiad with a Sea Shell;* and *Candor. Return of Spring* and *Play Ball*, a bronze statuette of a girl in a natural pose, throwing a ball, are recent works intended for garden settings.

A bust of Fritz Leiber, Shakespearean actor, characterized by clean modeling of the strong features and crisp accenting of edges of lips and eyebrows, was intended for Hollywood, and one of Dean Anna A. Harvey for Adelphi College, Brooklyn. For Clinton, North Carolina, Gruppe modeled a portrait

bust of a native son, William Rufus King, a former vice-president of the United States. The sculptor's delicate modeling was particularly well suited to the tender forms of children and young girls, favorite subjects for fountain and garden figures. Among his most successful portrait busts are also those of children, such as that of Bitter's granddaughter Ursula, a work awarded the Saltus Gold Medal by the National Academy of Design in 1952. Gruppe received the Dessie Greer Prize for a bust of President Eisenhower at the 1956 exhibition of the National Academy of Design. Other portraits are that of Mrs. Alex Ettl, one of the contralto Mary Davenport carved in marble, and a bronze of his brother Emile.

Gruppe had called attention to the neglect and deterioration of the monuments in New York City, with the result that the Department of Parks in 1934, with the co-operation of the National Sculpture Society and the Municipal Art Commission, undertook the task of cleaning and restoration, with Gruppe in charge of the staff of sculptors. For three years he was engaged on this undertaking, one of the most important accomplishments being to replace the crumbling base of Saint-Gaudens's Farragut Memorial by one copied from the original but carved in durable Coopersburg granite.

When work was being done on the Henry Hudson Parkway, the Parks Commission decided to complete the shaft of the Henry Hudson Memorial dedicated at the Hudson-Fulton Celebration in 1909 by placing a statue on it as had been the original intention. The statue was to have been done by Karl Bitter and was now entrusted to his former pupil. The original model had been stolen, but from records of it Gruppe was able to follow Bitter's idea of the intrepid mariner standing with legs braced as if against a rolling sea, looking into the distance with foresight and determination. The bronze statue was placed in January 1938. In the pictorial reliefs on the base, showing incidents in Hudson's career, Gruppe had, in order to make the design effective, strengthened the outlines by cutting in cameo style and simplifying planes.

For other work in relief, such as the portrait of Marcella Sembrich for the Curtis Institute of Music, Philadelphia, he had adopted the subtle low-relief manner developed by Saint-Gaudens and his followers. His ability in this field has been demonstrated in many examples of medallic art. He has done a series of portrait medals of the presidents of the New York Numismatic Club, and an issue of the Society of Medalists dedicated to international Boy Scouts. He is the author of several medals for the Hall of Fame, those of John Marshall and Gilbert Stuart and one of Mary Lyon that he carried out after a design by Laura Gardin Fraser.

Brought up as he was in the midst of the older generation of American sculptors, Gruppe has clung to their ideals of fine craftsmanship and has

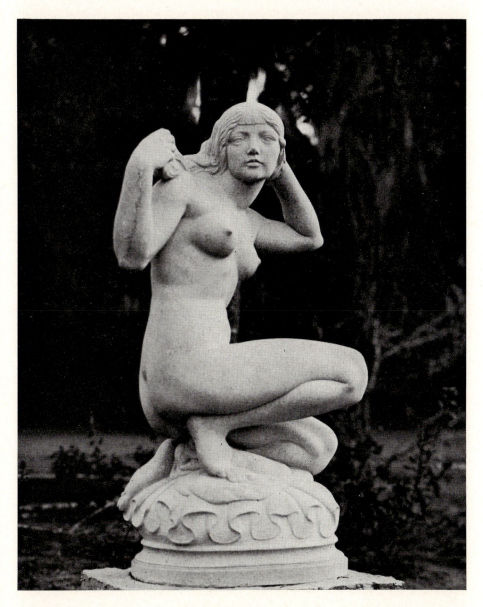

JOY

Tennessee marble statue. Height 3 ft. 5 in. Base: Width 1 ft. 7 in.—Depth 1 ft. 4½ in. Signed on base at left: KARL GRUPPE SC Placed in Brookgreen Gardens in 1948.

exemplified them in his own modeling and carving. Sensitive to scarcely perceptible variations in surface on the living model, he has preserved them in refinements of modeling and lightly suggested texture. He has also been active in organizations of artists, having served on the board of the Municipal Art Society, as the sculptor member of the Art Commission of New York, and as president of the National Sculpture Society. He is an academician of the National Academy of Design.

Joy

A girl crouches, resting on one knee, her arms raised to her head, holding in one hand the ends of her softly waving hair, lying loosely along one shoulder. The embodiment of an idyllic mood, she seems to be reveling in warm sunshine and light breezes as she looks backward with a dreamy expression. The figure is gently and naturally carved, with a free flow of surface and minute variations in the modeling of the face. There are no sharp transitions from one plane to another, but the outlines of eyes and lips are delicately accented. On top of the molded base a drapery is arranged in loose pleats.

The first, smaller version was carved from Serravezza marble at Paris in 1925 and awarded the Barnett Prize at the National Academy of Design exhibition in the following year. It was bought by Sigmund Ojerkis of Atlantic City and later acquired by Louis T. Brown of Chicago. A small replica in lithographic stone is also owned by a private collector. In carving the example at Brookgreen certain modifications were introduced for the sake of refinement in modeling and simplification of detail.

Berthold Nebel

BERTHOLD NEBEL was born at Basel, Switzerland, on April 19th, 1889. His parents, Emil and Maria (Schmidline) Nebel, brought him to New York while he was an infant, moving to New Jersey a few years later. As a young man he designed ornament for a terra cotta firm in Perth Amboy and when he was about nineteen began to study at the Mechanics' Institute in the evenings. Later he attended James Earle Fraser's classes at the Art Students' League and in 1914 won the three-year fellowship of the American Academy in Rome

with a group called *Good Government*. A product of his Roman years was a muscular group of two wrestlers. During World War I he served with the Red Cross. After his return from Rome he was for a time in charge of the school of sculpture at Carnegie Institute of Technology until he set up a studio at New York. He was engaged on architectural sculpture, the ornamentation of the dome and niches of the Cunard Building, New York, and on portrait statues, one of General Joseph Wheeler for the Capitol, Washington, D.C., and one of John Sedgwick for the State Capitol, Hartford, Connecticut. In 1923 Nebel won in a competition sponsored by the Bureau of Mines a commission for the Mine Rescue Medal and also designed the congressional First Aid Medal. The Roosevelt Memorial, a portrait relief in bronze, was placed in the City-County Building, Pittsburgh.

This work in relief prepared the way for two important commissions, bronze doors for the American Geographical Society and the Museum of the American Indian, Heye Foundation, New York, placed in 1933 and 1934. The strongly designed doors for the Geographical Society are of classical inspiration, while the others have ornament based on Indian designs and pictorial panels with scenes of Indian life. To do this work Nebel moved his

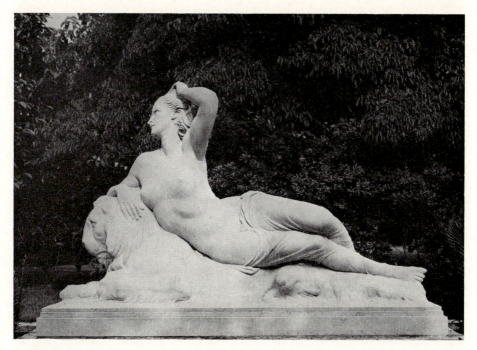

NEREID

Gris de Alicia marble group. Height 4 ft. 8 in. Base: Length 7 ft.—Width 2 ft. 4 in. Placed in Brookgreen Gardens in 1945.

studio to Westport, Connecticut. He spent ten years on nine large limestone panels installed in 1939 on the south façade of the main building of The Hispanic Society of America; each is carved in low relief with a figure representing one of the civilizations that have flourished in Spain. Later work was a bronze statue of Alexander Brown for the Brown Brothers Building on Wall Street, New York. Nebel continued medallic sculpture with the thirty-second issue of the Society of Medalists, for which he chose as his subject the atomic bomb, and with one depicting the yacht *Mayflower II*. He invented and patented machines for enlarging and reducing sculpture. His death occurred on April 4th, 1964. He was a fellow of the National Sculpture Society and a member of the National Academy of Design.

Nereid

A nereid reclines on the back of a lion, her head turned as she gazes to the left. One arm is laid on the animal's head, and the other hand is raised to touch her hair. A clinging drapery covers her legs.

Bailey Ellis

HIS WHOLE LIFE unselfishly dedicated to fostering interest in art by teaching as well as by example, Joseph Bailey Ellis was born at North Scituate, Massachusetts, on May 24th, 1890. His parents were Walter Bailey and Harriet (Kimball) Ellis. He was preparing to enter college after finishing his early education in private schools at Boston, when this step was prevented by a severe illness. For the sake of his health his parents took him to Switzerland for a year. When he returned to Boston, instead of going to college as he had intended, he entered the Massachusetts Normal Art School and studied there for three years. For the remainder of his art education he alternated between Europe and America, spending two years at the academy in Rome, another back at Boston in the school of the Museum of Fine Arts, and another at the École des Beaux-Arts in Paris. At Boston his teachers were the painter and writer Albert H. Munsell and the sculptor Bela L. Pratt; at Paris, Victor Peter and Injalbert.

After one more year working in the master studio at the school of the

Boston museum, Ellis felt ready to embark upon his profession. In 1915 he married Christine Bullard of Brookline, Massachusetts. From the outset, teaching interested him as much as his own creative pursuits. He organized the Modern School of Art at Boston and during the summer directed the Sawyer's Island Art School at Boothbay, Maine. During the First World War he was in the Ordnance Department stationed at Washington, D.C., and upon his return to civilian life turned definitely to teaching art as a career. Further experience as supervisor of drawing and manual training in the public schools at Lexington, Massachusetts, and as instructor for the summer session of the College of Education at the University of Chicago fitted him for an appointment as organizer and first director of the Department of Applied Art at the Carnegie Institute of Technology, Pittsburgh. In 1923 he was put in charge of the Sculpture Department, a post that he held for the rest of his life. Many articles by him in *The Carnegie Magazine* from 1928 to 1946 reflect his ardent championship of the study of sculpture and generously celebrate successes of his students.

Aside from teaching, Bailey Ellis took an active part in community activities, since he believed that art was a natural interest important to everyone. As president of the Associated Artists of Pittsburgh he was instrumental in having sculpture and crafts included in their exhibitions. He founded the Sculptors' Society to further the interests of sculptors and became its first president. In order to correlate all these activities and bring those participating in them together, he helped start an Arts and Crafts Center, being chairman of the board of directors until 1947. He was also chairman of the arts and skills program for the Red Cross at Deshon Veterans' Hospital, Butler, Pennsylvania.

These multifarious occupations undermined his health to such an extent that in 1947 he retired from his professorship on leave of absence. Associates and former pupils, in recognition of his services to the cause of art, inaugurated the Ellis Medal in his honor. To be awarded annually for the greatest contribution to the furtherance of art in Pittsburgh, it was given to Ellis himself as the first recipient. After a long illness Bailey Ellis died of heart disease on January 24th, 1950.

His genial personality won the affection and confidence of his pupils, and his enthusiasm and encouragement stimulated them to do their best. Many later became *Prix de Rome* winners. Ellis's own sculpture consisted of portrait reliefs, decorative fountain figures, and symbolic representations of the four seasons to be used on a sundial. There were some experiments in less conventional forms of expression, such as *The Wonder Bird* carved in wood, a free impression of a bird shape, that won a prize for creative sculpture.

Water Buckaroo

As if dominating a bucking bronco, a child sits astride a dolphin poised on the crest of a wavelike scroll. Gripping with turned-in toes, she bends forward, one arm laid across the fish's head while the other is raised in air. The fish's tail is lifted behind her back. The child's form is simply modeled, the hair blown back from the face in flat, scrolling locks. The fish is stylized for greater decorative value, the body fluted and the eyes round and staring. The spirited action and blithe mood of this fountain figure were suggested by a remembered pose of the sculptor's baby daughter seated in a bird bath.

Bronze statue. Height 3 ft. 4 in. Founder's mark: ROMAN BRONZE WOREKS [sic] INC NY
Presented to Brookgreen Gardens by Mrs. Joseph Bailey Ellis in 1953.

Edmond Amateis

EDMOND ROMULUS AMATEIS was born of American parents in Rome, Italy, on February 7th, 1897, the son of Louis and Dora (Ballin) Amateis. His father, a sculptor, architect, and teacher, was born at Turin and came to the United States in 1883. He was head of the department of fine arts at George Washington University, Washington, D.C., and founded the school of architecture there. The bronze doors for the west entrance to the Capitol are his work. He was the sculptor of a number of monuments, including one to the defenders of the Alamo at Austin, Texas, and another to the heroes of the Texas Revolution at Galveston.

Edmond Amateis received his early education in the public schools of Washington, D.C. His studies at the Beaux-Arts Institute of Design, New York, begun in 1916, were broken by service in the 77th Field Artillery, 4th Division of the United States Army from April 1917 to August 1919, when he fought in the battles of Château-Thierry, Saint-Mihiel, and the Meuse-Argonne. While he was in the army, as part of the Sorbonne Detachment, he was able to spend four months at the Académie Julian with Jean Boucher and Paul Landowski as his teachers. A second period of study at the Beaux-Arts Institute was combined with work in the studios of Henry Shrady, who was then engaged on the Grant Memorial for Washington, and John Gregory. In 1921 Amateis won the fellowship of the American Academy in Rome for

three years. From among the wealth of sculptural styles which surrounded him, he was most drawn to the Italian Renaissance, leaving to his fellows the colder classic and severe archaic. Direct results of his Roman environment are the two reliefs *Madonna of the Jewel* and *Perseus and Medusa*, with their adaptation of the Donatellesque art of delicate low relief. His instinct for good composition and his skilled modeling are shown in the group *Pastoral*. *The Bather*, devoid of ornament but finely rhythmic, is another work which was modeled about this time.

With the opening of his studio in New York came many commissions for architectural sculpture, in which his powers of design were given full scope. For the Baltimore War Memorial he executed two aquatic war horses and for the Buffalo Historical Society Building a pediment and twelve metopes, both harmonizing with the classical architecture of the two buildings, although for the metopes subjects from local history were chosen. Further works of this kind were a colossal relief for the Rochester Times-Union Building, the long panel on the front of the Kansas City Liberty Memorial done in 1933, a pair of griffins for the Acacia Life Insurance Building, and a relief and spandrels for the Department of Labor and Interstate Commerce Building, Washington, D.C.

His flair for garden sculpture found expression in numerous fountain and garden figures. The *Four Seasons* were designed for Mrs. R. R. McCormick's garden at Chicago, *Summer* having been awarded the Avery Prize by the Architectural League in 1929. The fresh charm of the Gothic period breathes from the fountain statues for the R. B. Mellon Estate at Pittsburgh. Other garden figures were placed on the Julius Fleischmann Estate at Cincinnati and the Carl Schmidt Estate at Mill Neck, Long Island. *Circe*, a woman astride a beast, took the McClees Prize of the Pennsylvania Academy in 1933. Amateis kept pace with the times in reducing detail to the minimum, his later work being composed in bold masses and hard outlines. *The Three Bears*, exhibited in 1937, and the groups of *Paul Bunyan*, *Johnny Appleseed*, and *Strap Buckner* for the 1939 New York World's Fair are full of humor. Works commissioned by the Treasury Art Projects are a portrait relief of Eliphalet Remington for the post office at Ilion, New York, three reliefs for the Madison Square Postal Station, New York, and four panels for the Federal Court House and Post Office, Philadelphia. Another granite relief was for the entrance to the Veterans Administration Building, Columbia, South Carolina. The subject chosen was Thomas Green Clemson teaching scientific farming to a group of country people.

Amateis's contribution to the monuments planned by the American Battle Monuments Commission was an Angel of the Peace supporting a child, as a

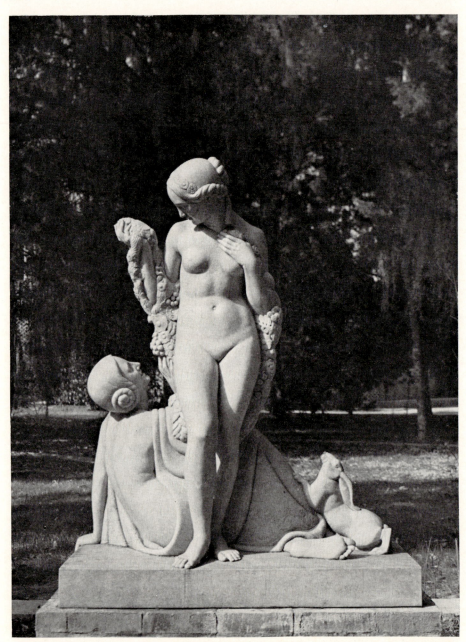

PASTORAL

Tennessee marble group. Height 4 ft. 6½ in. Base: Length 3 ft. 6¾ in.—Width 1 ft. 9¼ in. Signed on base at right: EDMOND AMATEIS Placed in Brookgreen Gardens in 1937.

symbol of future generations, designed in simple architectural lines. Carved in limestone, it dominates a plain wall at Draguignan, France. Two different kinds of sculpture were done for the polio treatment center at Warm Springs, Georgia. Reliefs in brick, one of Anne Sullivan and Helen Keller, the other of Franklin D. Roosevelt and a patient, ornament the entrance court to the auditorium. Bronze portrait busts of scientists who developed a vaccine are grouped on the wall of the Polio Hall of Fame. A similar but different set is in the lobby of The National Foundation at New York City. Of these, the busts of Dr. Albert Sabin and Dr. Jonas Salk have been acquired for the National Portrait Gallery of the Smithsonian Institution, Washington, D.C. An appealing figure, *Our Lady, Queen of the Universe*, was carried out, life size, in polyester resin and Fiberglas for the College of Saint Elizabeth, Convent Station, New Jersey. Amateis has also been successful in reliefs on a small scale. For his medal of General Marshall he received the Lindsey Morris Memorial Prize of the National Sculpture Society.

Amateis built a home and studio at Brewster, New York, where he lived until he retired to Florida in 1961. In his new environment he has experimented with engraving marine creatures on plexiglass so that they seem to be suspended in their own element. He has continued his avocation of crossbreeding rhododendrons, one of his new varieties having been awarded the Max Schling Silver Medal and first prize by the New York Horticultural Society. The illustrations in David Leach's *Rhododendrons of the World* are his work. Amateis was for a time associate in sculpture at Columbia University. He is a past president of the National Sculpture Society and a member of the National Academy of Design and the National Institute of Arts and Letters.

Pastoral

A girl stands looking down and holding in both hands a garland of flowers which falls at her back. Another smiling girl is seated behind her, over her form a drapery with a lightly incised floral pattern on the border. A rabbit at her feet lifts its head to complete the triangular outline. The interplay of flowing lines and the soft modulations of the forms are heightened by the rich passages of ornament. The group, originally called *Mirafiore*, was modeled at Rome during the summer of 1924.

Walker Hancock

WALKER KIRTLAND HANCOCK was born at Saint Louis on June 28th, 1901. His parents were Anna (Spencer) and Walter Scott Hancock, a noted lawyer. In 1917 he won a scholarship at the Saint Louis School of Fine Arts, where he studied with Victor Holm and E. H. Wuerpel. Further studies were in the School of Fine Arts at Washington University and at the University of Wisconsin. He then went to The Pennsylvania Academy of the Fine Arts, having Grafly as a teacher. Here he won the Cresson Traveling Scholarship in 1922 and 1923 and in 1925 the *Prix de Rome*, which took him to the American Academy in Rome for three years. Upon his return he became an instructor at the Pennsylvania Academy and eventually head of the sculpture department. There are in his early work echoes of other periods in art which he has found significant. *The Bagpipe Player*, with its idyllic charm and easy modeling, might be a Greco-Roman bronze. The bust of *Toivo* in the City Art Museum, Saint Louis, shows the influence of the Italian Renaissance in the delicate beauty of the head and the contributing decorative value of the shallow folds and embroidered border of the smock.

Among garden pieces, in which he is especially interested, is a *Bird Charmer*, an Indian kneeling with a bird on each wrist, for the zoological gardens at Saint Louis, which won the Fellowship Prize of the Pennsylvania Academy in 1932. Simple and natural renderings of children's forms characterize the fountain figures *Seaweed*, a bronze statuette in the collection of the Pennsylvania Academy, and *Water Lily*. A triton fountain is in the Parrish Art Museum, Southampton, Long Island. In a more serious vein, a figure for the Bowker Memorial Fountain in All Saints' Church, Worcester, Massachusetts, is the Good Shepherd kneeling to rescue a lamb.

Architectural sculpture, a prominent part of his work, includes a frieze for the City Hall, Kansas City, monumental rhytons for Girard College, Philadelphia, and heroic groups for the Saint Louis Memorial Building. Hancock carried out one of the pediments designed by A. A. Weinman for the Post Office Building, Washington, D.C. A memorial at Montreal to the founders of the Bell Telephone Company of Canada has figures representing various methods of communication, reliefs in Istrian stone silhouetted against black marble.

During World War II Hancock served as captain in military intelligence and for two years overseas as an officer in Monuments of Fine Arts and Archives. After the war he was commissioned to do several memorials. For

352

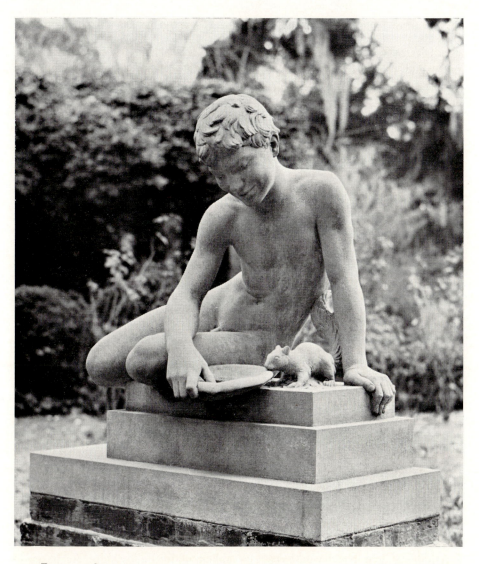

BOY AND SQUIRREL

Batesville marble statue. Height 3 ft. 2 in. Base: Length 3 ft. 2 in.—Width 1 ft. 7 in. Signed on base at back: WALKER HANCOCK ROMA MCMXXVIII Placed in Brookgreen Gardens in 1934.

the Lorraine American Cemetery at Saint-Avold, France, his part was three angels of victory on the tower. A moving tribute to the employees of the Pennsylvania Railroad in the Philadelphia station is a compassionate angel, great wings pointed upward as he bears a soldier out of the flame of battle.

A statue of Bishop White for the Gothic Chapel of the Divinity School of the Protestant Episcopal Church at Philadelphia is because of its destination architecturally conceived. It combines a head only moderately stylized with a

rigid figure in a straight garment with parallel vertical folds. A number of portrait statues of business men have been ordered from him by their companies, such as that of Paul Weeks Litchfield for the Goodyear Research Building, Akron, Ohio, and of Milton S. Hershey for the school named after him at Hershey, Pennsylvania. One of Judge Frank L. Brown is in the Municipal Court, Philadelphia, and another of Alben Barkley in the State Capitol, Frankfort, Kentucky. These straightforward presentations of men in modern clothes gave him little chance for originality, but in that of John Paul Jones for Fairmount Park, Philadelphia, he gave a striking impression of the doughty seaman's character. A portrait bust of Stephen Collins Foster was modeled for the Hall of Fame, New York University, and one of Booth Tarkington has been acquired by The John Herron Art Institute, Indianapolis.

For his medallic work he received the Saltus Medal of The American Numismatic Society. The expeditionary medal of the United States Marine Corps, the United States air mail flyers' medal of honor, and both the inaugural medals for President Eisenhower were entrusted to him. His design for the Society of Medalists was awarded the Lindsey Morris Memorial Prize of the National Sculpture Society in 1941.

In his figure sculpture, using for models the Finnish boys near his home on Cape Ann, Massachusetts, he has developed a sturdy simplicity. His interests have narrowed to the solid forms of athletic young men, fully but broadly modeled. *The Diver* won the Barnett Prize of the National Academy of Design in 1936, and *Ahti*, a portrait head, the Proctor Prize in 1942. His *Young Lobsterman*, a bronze bust, is in the collection of the Pennsylvania Academy.

For two terms, from 1956 to 1957 and from 1962 to 1963 Hancock was sculptor in residence at the American Academy in Rome, of which he is a trustee. He has been given the gold medal of honor of the Pennsylvania Academy and in 1952 was elected president of its Fellowship. He has also received the medal of achievement of the Philadelphia Art Alliance and the Herbert Adams Memorial Award of the National Sculpture Society, of which he is a fellow. He has been elected to the National Academy of Design and the National Institute of Arts and Letters.

Boy and Squirrel

A boy is seated sidewise, his legs crossed, leaning on one arm. He smiles down at a squirrel which walks cautiously over an oak twig to eat from a shell held in his right hand. The statue was modeled while he was at the American Academy in Rome.

Joseph Kiselewski

JOSEPH KISELEWSKI was born to Blasius and Sophie (Wollney) Kiselewski at Browerville, Minnesota, on February 16th, 1901. He began his art education at the Minneapolis School of Art from 1918 to 1921. The next four years were spent in New York, working and studying at the National Academy of Design and the Beaux-Arts Institute of Design, where he received the Paris Prize. This award enabled him to work for a year in Paris under the instruction of Paul Landowski and Henri Bouchard. Having won the competition for the *Prix de Rome*, he was a fellow at the American Academy in Rome from 1926 to 1929. He had practical experience when he was employed by Lee Lawrie for four years before going to Paris. Lawrie's meticulous craftsmanship set a standard of perfection to which Kiselewski has rigorously adhered. This schooling is easily discernible in the clear-cut designs and precise detail of his work. A first sketch is carefully modeled in hard plasticine so that it can be enlarged to full size without modifications. For architectural sculpture a small-scale mock-up in accurate detail shows how the finished work will look in its setting. For the garden of Saint Joseph's Church at Browerville he modeled statues of Christ and an angel with lifted wings, and for Rosary College, River Forest, Illinois, a statue of the Virgin and Child in garments with Byzantine straightness of line. Another heroic figure of Christ was for Bishop's Monument, Fargo, North Dakota. A venture into realistic sculpture was the heroic statue of General Pulaski for Milwaukee, Wisconsin. A historical relief in simplified linear carving was part of the decoration on the George Rogers Clark Memorial at Vincennes, Indiana. *Dawn*, a simply modeled nude figure, was awarded the Watrous Gold Medal of the National Academy of Design in 1937.

His special gifts found fuller expression in architectural sculpture. Three medallions, *Beauty*, *Inspiration*, and *Imagination* for the Lyman Allyn Museum, New London, Connecticut, in sharply defined planes, have breadth of composition, clarity of outline, and attractive decorative touches. The memorial sundial to Katrina Ely Tiffany at Bryn Mawr College and the Jessie L. Eddy Memorial at Tarrytown, New York, are also in low relief, with the emphasis on line. Kiselewski is the author of two of the massive groups for the Bronx County Court House, *Victory* and *Peace*, erected in 1932 in a modern version of the classic style, and eleven works for the metropolitan housing project, New York City. In the fisheries pediment for the Commerce

355

Building, Washington, D.C., from a sketch by James Earle Fraser, there is skillful grouping, and the nets and fish have ornamental value. Other buildings in Washington have sculpture by Kiselewski. There are four marble plaques representing early lawmakers in the House Chamber of the Capitol. Granite reliefs at each side of the entrance to the General Accounting Office are designed in flat planes with two friezes of sharply silhouetted figures representing professions and industries. A limestone panel symbolizing Justice, a flying figure in stylized draperies, ornaments the façade of the City and Municipal Courts, New York City, dedicated in 1961. *Moses* for the Law College of Syracuse University was carried out in terra cotta.

Kiselewski had a share in a major collaborative project for a religious institution on which several sculptors were employed. Around the main entrance to the Domestic Chapel at Loyola Seminary, Shrub Oak, New York,

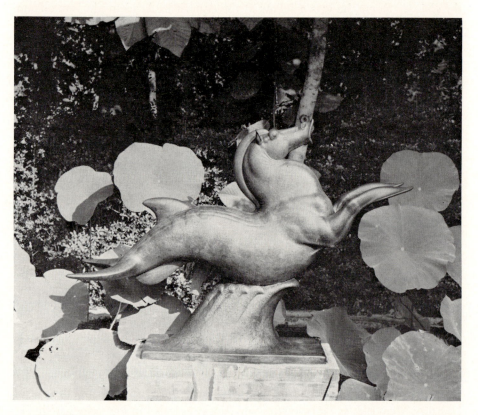

SEA HORSE

Bronze statue. Height 3 ft. 9 in. Base: Length 2 ft. 11 in.—Width 1 ft. 2 in. Signed on base: © J. KISELEWSKI Founder's mark: GARGANI FNDRY N.Y. Placed in Brookgreen Gardens in 1937. Other example: Sterling Forest Gardens, N.Y. (On loan).

are fourteen pierced limestone panels with scenes from the lives of Jesuit saints. This work received the silver medal of the Architectural League in 1955. The sculptor had to rely on his imagination to create a statue for a public school in New York City named after John Peter Zenger, an early newspaper publisher who fought for freedom of the press. Since no portrait existed, Kiselewski envisaged a strong personality with determination in the set of his jaws and strengthened this impression by a simplified treatment of the figure.

Experiments in designing sculpture especially to attract children resulted in two green granite frogs with invitingly broad backs for the kindergarten entrance at the same school. Bronze bears in the playground of Carver House, commissioned by the New York City Housing Authority, perch on easy slopes of tree trunks that encourage climbing.

One of Kiselewski's most impressive statues was done for the Battle Monuments Commission after World War II. *Peace* in the Veterans Cemetery, Margraten, Holland, is the essence of quietness and resignation. It was awarded the Daniel Chester French Medal of the National Academy of Design in 1961. In the following year a bust of Sinclair Lewis won for Kiselewski a second award of the Academy's Watrous Gold Medal. He is a fellow of the National Sculpture Society and a member of The Architectural League of New York and the National Academy of Design.

Sea Horse

A fabulous creature with the head and shoulders of a horse and flippers for legs rides forward on the crest of a wave. The body is gracefully curved, the front flippers raised, and the mouth open in a trumpet shape. The smooth curves and flowing lines of the rounded body convey an impression of easy motion. This work, modeled at New York, was completed in 1937. Four copies were placed in pools as fountains by the Radio Corporation of America at the New York World's Fair of 1939.

George Holburn Snowden

ANOTHER GRADUATE of the American Academy in Rome who has devoted himself largely to architectural sculpture is George Holburn Snowden, born at Yonkers, New York, on December 17th, 1902, to George and Mary (Winn) Snowden. Choosing sculpture as a profession in 1921, he won the

English Fellowship and received the degree of bachelor of fine arts from the Yale School of Fine Arts in 1926. He also had instruction from A. A. Weinman, with whom he was later to collaborate. His promise was immediately recognized by the awarding of a prize by the New Haven Paint and Clay Club and the Otis Elevator Prize by the Beaux-Arts Institute of Design. The next year a formal figure with pleasantly stylized details, *Flora*, which was done at the Yale School of Fine Arts, won for him the *Prix de Rome*. Products of his three-year stay at Rome were a polychrome relief of the Madonna in Byzantine style, a neoclassic *Circe*, and an aviation monument, interestingly imagined as a powerful male figure launching a winged youth, the muscles conventionalized to a linear pattern, the strong horizontal and vertical thrusts indicating lightness and speed.

Upon opening a studio in New York the sculptor obtained several important commissions for architectural sculpture. Two of the monumental groups for the Bronx County Court House, showing the same feeling for precise design, were his work. Two pediments for the Drink Hall at Saratoga Springs made use of the spring waters as a central motive, flanked by symbolic figures. Here as in the pediment for the United States Post Office Department Building, Washington, D.C., designed by Weinman, his thorough training with that master of architectural sculpture enabled him to compose his groups with an unbroken interplay of line and a careful limitation of the main surfaces to a few broad planes. The whole is enriched by many touches of bold linear ornament. He is also the author of fourteen reliefs for the natural history and fine arts museums, Springfield, Massachusetts, six panels for the Southern New England Telephone Company Building, New Haven, and three monumental groups of the Labors of Man for the 1939 New York World's Fair. A Yale memorial tablet is in Pershing Hall, Paris, France; another memorial, at Rome, Italy. *Phenomenon*, a colossal Medusa head, was awarded the Watrous Medal of the National Academy of Design in 1941.

Snowden taught at the Yale School of Fine Arts for fifteen years, until he moved to Los Angeles in 1945. Since then much of his sculpture has been done for churches, many of them in California. The style of the building has often required a conventionalized treatment, as in the *Consecration of Saint Ambrose* for the church dedicated to him at Los Angeles and a statue of the Virgin Mary for Our Lady of Fatima at Paramount. For the Church of Saint Theresa at Alhambra, Snowden designed panels with scenes from her life. Statues of the Virgin Mary, Saint Joseph, Saint Timothy, and four Apostles were made for Saint Timothy's Church at West Los Angeles. The project that required the largest amount of his sculpture was the National Shrine of the Immaculate Conception at Washington, D.C. In niches on the east and west porches and on the apse sixteen statues of saints carved in limestone, heroic in size, were designed to harmonize with the Romanesque

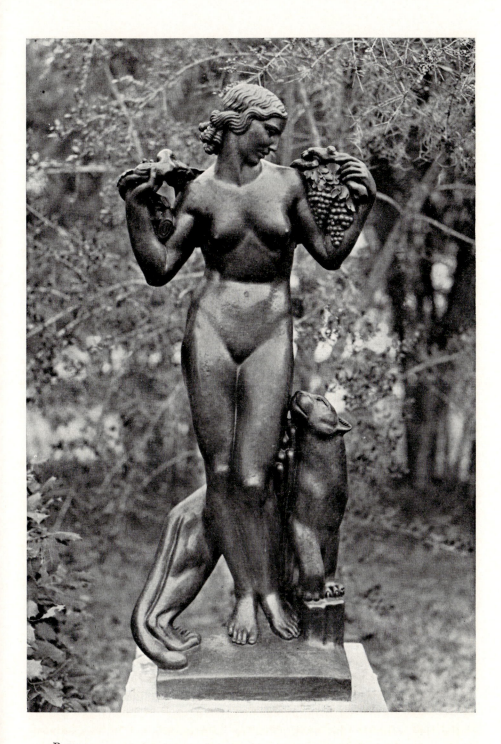

PLAY

Bronze group. Height 2 ft. 9¾ in. Signed on base at right: G H SNOWDEN—SCULP—
Founder's mark: Bedford Bronze Fdry N.Y. Placed in Brookgreen Gardens in
1936. Other example: Saratoga Springs. Drink Hall.

spirit of the architectural setting without losing the impression of distinct personalities. He was also the author of a statue of the Immaculate Conception above the main altar. With the other sculptors engaged on this church he received the Henry Hering Memorial Medal of the National Sculpture Society in 1961.

The Yankee Division Memorial to Major General Clarence R. Edwards is a portrait statue on the grounds of the Capitol at Hartford, Connecticut. Snowden also designed the China Service Medal of the United States Navy. He is president of the American Institute of Fine Arts, a fellow of the National Sculpture Society, and a member of the National Academy of Design.

Play

A girl stands in an easy posture with a branch of grapevine, held in both hands, carried like a yoke across her shoulders. Her smiling face is turned in profile, gazing down at a panther curling behind her legs and stretching upward.

Play

A man has both arms raised holding a net of fish over his shoulders. He looks down at a seal behind him which stretches upward towards the fish. Originally entitled *Earth* and *Water*, these statues were designed for the Drink Hall at Saratoga Springs. They are composed in a formal scheme, and the planes are clearly delineated.

Bronze group. Height 2 ft. 9¾ in. Signed on base at left: SNOWDEN_1934 Placed in Brookgreen Gardens in 1936. Other example: Saratoga Springs. Drink Hall.

Wheeler Williams

WHEELER WILLIAMS was born in Chicago, Illinois, on November 3rd, 1897, the son of Lawrence and Adèle H. (Wheeler) Williams. After studying sculpture at the Art Institute, he entered Yale and graduated in 1919 as of the class of 1918, his studies having been interrupted by service as a lieutenant in the U.S. Balloon Corps during World War I. He then turned to architecture, received his master's degree from Harvard in 1922, and in the

same year the medal of The American Institute of Architects. The work in sculpture which he had continued at Harvard with John Wilson earned second place with honorable mention in the *Prix de Rome* competition of 1922. Thereupon he chose sculpture as his profession and spent the next eight years in Paris, where he studied at the École des Beaux-Arts with Jules Coutan before taking his own studio. Since his return to the United States in 1928 he has had a studio in New York, though much of his work has been done in California.

Early commissions were for work in relief, tablets to the French explorers and pioneers on the Michigan Boulevard Bridge, Chicago, a medal for Phillips Exeter Academy, and the Plimpton Medal for Yale. A later medal was that for the International Society of Arts. In 1930 he won the international competition for the pediment of the National Library of Brazil and completed another for the Interstate Commerce Building, Washington, D.C., which has a handsome figure of Mercury. Reliefs for the Canal Street, New York, and Bay Shore, Long Island, post offices were done for the Federal Works Agency. His *Steeds of the Imagination* form part of the Readers' Digest Tower, Chappaqua, New York. His architectural training is apparent in the ordered compositions, firm modeling, and clear-cut outlines of his sculpture for buildings.

During World War II Williams served as a lieutenant commander in the United States Naval Reserve. His share in the series of memorials erected by the American Battle Monuments Commission in Europe after the war was for Cambridge, England. As buttresses against a wall inscribed with the names of missing soldiers stand four heroic statues carved of Portland stone, representing the branches of the armed forces. Sculpture by Williams has enhanced important building throughout the United States. *Venus and Manhattan*, the goddess floating above a recumbent male figure as an allegory of the enlightenment brought to the city through the arts of other lands, ornaments the façade of the Parke-Bernet Galleries, New York City. A group symbolizing the family makes up the *Wave of Life Fountain* in front of the Prudential Building at Houston, Texas. In 1941 he was chosen by the Ellen Phillips Samuel Memorial Commission to create a monument, *Settling of the Seaboard*, for Fairmount Park, Philadelphia. Three marble statues for niches on the façade of the Brooks Memorial Art Gallery, Memphis, Tennessee, allegories of Spring, Summer, and Autumn, were dedicated in 1962.

Portrait busts by Williams distinguish two of New York City's approaches: that of Clifford Holland at the entrance to the Holland Tunnel and one of Othmar Ammann on the Manhattan side of the George Washington Bridge. The sculptor has memorialized famous men in both statues and busts. A statue of Senator Robert A. Taft was made for the Taft Memorial Carillon at

Washington, D.C., and a portrait relief for the Indian Hill Cemetery at Cincinnati. Busts of Admirals Halsey and Hewitt are at the United States Naval Academy, and one of another admiral, Luis de Flores, at the United States Navy's Training Device Center at Port Washington, Long Island, was dedicated in 1965. A statue of Colonel Robert R. McCormick was erected at Baie Comeau, Canada, and a heroic head of him placed in the lobby of the Tribune Tower at Chicago. A spirited statue of Commodore John Barry at Wexford, presented to Ireland in 1956 by the United States, appropriately faces seaward, the officer's cloak blown back by the wind.

Many fountain and garden pieces, one with his reliefs and architectural sculpture in decorative value, are quickened to greater warmth and humanity by the sculptor's sympathetic imagination. *Maya*, first designed for his own garden at Versailles, was placed in the Modern Garden at the Century of Progress Exposition, Chicago. A naturally modeled group of the Three Graces with linked hands formed the *Rhythm of the Waves Fountain* for the Grosse Pointe Yacht Club, Detroit, Michigan. The companion statues of the Four Seasons were given a more stylized treatment, with simplified planes in flat-folded draperies. For a venture in making garden sculpture more widely available, Limited Editions of American Masterpieces of Garden Sculpture, he designed eight sprightly statues of children, the *Childhood of the Gods*. The *Fountain of Youth* is in the court of the Norton Gallery, West Palm Beach, Florida. The McEwan Fountain for the Children's Orthopedic Hospital at Seattle, Washington, comprises bronze groups of merbabies and baby dolphins. Another designed to please children is a Lion-Cub Drinking Fountain in the Kansas City zoo. On an island in the main street of Kansas City is a large fountain, *The Muse of the Missouri*, the grace of the nymph accentuated by the net held behind her, spilling fish around her feet.

He is equally interested in animal forms and has modeled, among other subjects, pairs of giraffes, police dogs, greyhounds, and gatepost roosters. Two groups of dolphins were designed for the library of the S.S. *America*. Keenly aware of the varied possibilities of different materials for his highly finished works, he has employed lacquered bronze for effects of polychromy, white-glazed porcelain for decorative figures, and for the many portrait busts which he has modeled preferably terra cotta, following the technique of eighteenth-century French sculptors. His years in France schooled him in fine craftsmanship and left on his art an impress of rarefied beauty.

Williams has received many awards for the excellence of his work, including gold medals from the National Arts Club and the American Artists Professional League. The Herbert Adams Memorial Medal was given by the National Sculpture Society in 1962 in recognition of his contributions to American art and his leadership in establishing the *National Sculpture Re-*

view, which began publication while he was president of the Society. He is a member of the National Academy of Design and has been vice-president of The Architectural League of New York.

Black Panther

A black panther draws back snarling, the powerful muscles tensed and the legs slightly bent. The eyes are green lacquer. The statue was modeled at Hollywood.

Oxidized silver-plated bronze statue. Height 2 ft. Base: Length 4 ft. 3½ in.—Width 12⅛ in. Signed on base: *Wheeler Williams 1933* Founder's mark ROMAN BRONZE WORKS N.Y. Placed in Brookgreen Gardens in 1936. Other example: Palm Beach, Fla. Society of the Four Arts.

Black Panther

A companion panther advances in long strides, the ears laid back. These statues were awarded the Speyer Prize of the National Academy of Design in 1940.

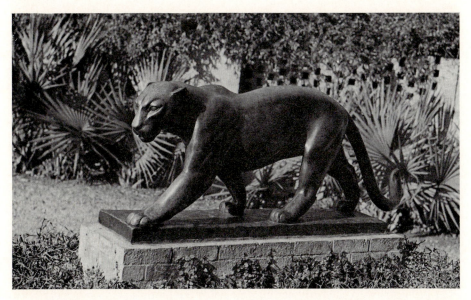

BLACK PANTHER

Oxidized silver-plated bronze statue. Height 2 ft. Base: Length 4 ft. 3⅞ in.—Width 12⅛ in. Signed on base: *Wheeler Williams 1933* Founder's mark: ROMAN BRONZE [WORKS] Placed in Brookgreen Gardens in 1936. Other example: Palm Beach, Fla. Society of the Four Arts.

Childhood of the Gods

The child Neptune stands with a trident in the right hand, his left foot on a dolphin, a bit of drapery over his left shoulder. The figure is modeled in relief from the statuette belonging to the *Childhood of the Gods* series that inaugurated the Limited Editions of American Masterpieces of Garden Sculpture in 1940. This medallion was presented to those who sponsored the plan.

Aluminum medallion. Diameter 5 in. Signed in field at lower right: W. W. 1940 Legend, around, · CHILDHOOD · OF · THE · GODS · —TOKEN · OF · ADOPTING · SPONSORSHIP Placed in Brookgreen Gardens in 1948.

Pan

The young Pan is seated sidewise on a tree trunk, braced by one foot. With head turned backward on his shoulder he is playing a pipe. He has goat hooves, pointed ears, and two little horns springing from his ringlets. A frog squats between his feet.

Lead statue. Height 2 ft. 9 in. Signed on base at back: · PAN · NO · 1 · · ⓒ · WHEELER · WILLIAMS · Founder's mark: M. SCOMA FDRY BKLYN. N.Y. Placed in Brookgreen Gardens in 1940.

Neptune

The young god stands with one foot on a dolphin, a trident in his right hand. A piece of drapery is flung over his left shoulder. His hair is in tight ringlets.

Lead statue. Height 2 ft. 9 in. Signed on base at back: NEPTVNE · NO · 5 · ⓒ · WHEELER · WILLIAMS · 1939 · Placed in Brookgreen Gardens in 1940. Other example: Muskegon, Mich. The Hackley Art Gallery.

Amphitrite

A little girl with the body ending in a fish's tail holds a shell to her ear with both hands. Her parted hair is tied at the nape of the neck. Behind her, upright, is a starfish.

Lead statue. Height 2 ft. 9 in. Signed on base at back: AMPHITRITE · NO · 5 ⓒ · WHEELER · WILLIAMS · 1939 · Placed in Brookgreen Gardens in 1940.

Mercury

Mercury, as a boy, springs forward over a rainbow, caduceus in the right hand, the left extended. There is a short cape over his shoulders and the winged petasus over his crisp curls. A tortoise stands beside his foot.

The eight statues of the *Childhood of the Gods*, of which these four are a part, are the first issue of the Limited Editions of American Masterpieces of Garden Sculpture, planned to "help American sculptors reach a larger audience and make it possible for more American homes and gardens to have fine examples of our native sculpture." [1] Bronze molds from which a number of lead copies could be cast were financed by sponsors.

Lead statue. Height 2 ft. 9 in. Signed on base at back: · MERCVRY · © · NO · 2 · WHEELER · WILLIAMS · Founder's mark: M. SCOMA FDRY [BKLYN.] N.Y. Placed in Brookgreen Gardens in 1940.

Sea Lion

A sea lion is perched on a stone pedestal, both front flippers braced over the top, neck lifted with nose in air. His tail is bent around to the right. The muscles ripple smoothly under the glossy skin. This fountain was designed for a home in Regent Park, London, with the addition of a spun copper ball supported on the water spouting from the seal's nose. The model was Charlie, a famous trained seal, who obligingly came to the studio and posed.

Bronze statue on base of Virginia greenstone. Height (including stone base) 5 ft. 5 in. Base: Length 1 ft. 7½ in.—Width 1 ft. 4 in. Signed under body at left: #2 *Wheeler Williams* 1938 Presented to Brookgreen Gardens by Mrs. E. Gerry Chadwick and placed in 1951.

Food

A duck stands with head expectantly raised and turned sidewise, the bill open. The head and shoulders and a patch on the wings are green; bill, eyes, tail and feet, black; and a ring around the neck, gold.

Lacquered bronze statue. Height 1 ft. 6½ in. Signed on base at right: *Wheeler Williams 1930* Founder's mark: ROMAN BRONZE WORKS. N.Y. Placed in Brookgreen Gardens in 1936.

1 Arden gallery, *New York. Childhood of the gods; eight garden sculptures in lead by Wheeler Williams. N.A.* [New York] 1940. p. [5].

Drink

A companion to *Food*, the duck has the tail tipped up and the head bent downward to drink. The feathers are brown with touches of gilt. There is a little blue on the tail feathers and green on the wings. The eyes and feet are black.

Lacquered bronze statue. Height 1 ft. 6¼ in. Signed on base at back: *Wheeler Williams 1930* Placed in Brookgreen Gardens in 1936.

Sidney Waugh

IN ADDITION to producing a large amount of architectural sculpture, Sidney Biehler Waugh has contributed to a new departure in American art by making sculptural designs for engraved and molded glass. He was born at Amherst, Massachusetts, on January 17th, 1904, the son of Frank Albert and Alice (Vail) Waugh. His father, a landscape architect, was professor of horticulture and landscape gardening at Massachusetts State College. Getting his early education from the Amherst schools, Sidney entered the school of architecture of Massachusetts Institute of Technology when he was sixteen. After three years there he went to Europe, studying at the Scuola delle Belle Arti, Rome, in 1924, and spending the next three years in Paris, where he was a pupil of Bourdelle and assistant to Henri Bouchard. He was appointed sculptor for the American Battle Monuments Commission and modeled a *Virgin of the Annunciation* for the church at L'Évêque and a decorative group for the Barcelona Exposition. His work was awarded a medal at the *Salon de Printemps* in 1928. In the following year he won the scholarship of the American Academy in Rome and while there sculptured a *Saint Martin* which was acquired by the King of Italy for his private collection.

After Waugh's return to the United States in 1932 his chief work was architectural sculpture, done largely for federal buildings at Washington, D.C. One of the pediments of the Post Office Department Building, designed by A. A. Weinman, was executed by him. A statue of a stage driver in the same building is his work, as also a figure for the U.S. Attorney General's Conference Room and groups for the National Archives Building and the Federal Reserve Board Building. A faculty for making clothes serve a sculptural purpose dignifies his bronze statue of Mirabeau Bonaparte Lamar at

Richmond, Texas. *The Heavens* and *The Earth*, powerful male figures, are the subjects of limestone reliefs for the Buhl Planetarium, Pittsburgh.

Becoming associated with the Steuben Division of the Corning Glass Works in 1933, he made for them designs to be engraved on bowls and vases which have entered many museum collections. The *Agnus Dei Vase* and *Gazelle Bowl* are in The Metropolitan Museum of Art, the *Europa Bowl* at Cleveland, the *Trident Punch Bowl* at The Art Institute of Chicago, the *Venus Vase* in the Toledo Museum, and the *Zodiac Bowl* in the Victoria and Albert Museum, London. For figures in the round he prefers animal subjects, such as the decorative *Pigeons*, *Angel Fish*, *Horse*, and *Fawn* molded by the Steuben Glass Company. These handsome pieces have been extensively used for official gifts. President and Mrs. Truman presented the *Merry-Go-Round Bowl* to Princess Elizabeth of England as a wedding gift. Members of his Cabinet had a cup specially made for President Eisenhower signalizing incidents in his career, and one for Kwame Nkrumah on the occasion of the independence of Ghana was engraved with figures representing the four freedoms. The fluidity and clarity of his line, wrought by a poetic imagination into spirited compositions, make his work especially suitable to the lucid medium of glass. From his experience in the glass factory he wrote two books on the art of glass making.

During World War II Waugh served with the United States Army as a captain in military intelligence, receiving a Bronze Star for his bravery under fire when obtaining information. While he was attached to a French unit in the Italian campaign he was twice awarded the Croix de Guerre. For his success as officer in charge of Italian affairs for the military government of Florence and chief of the monuments and fine arts section of the Fifth Army, he was made a knight of the Order of the Crown of Italy. After the war was over, he had another mission for Italy—sculpture on the monument in the American Military Cemetery at Florence, a compassionate *Spirit of Peace* brooding over the fallen from the top of a high pylon.

Established again in his studio in New York, Waugh continued both architectural and monumental sculpture simultaneously with his work for Steuben Glass Company. In contrast to the lightness and elegance of designs for glass, forms in stone are powerfully expressed in large masses and blunt, angular shapes. Ornamental features are often composed in separate units, like the signs of the zodiac around the Mellon Memorial Fountain at Washington, D.C. Two large reliefs in laminated cherry wood are silhouetted on the walls of the main banking room of the Bank of Manhattan on Fifth Avenue, New York City. In the main court room of the United States District Court at Washington, D.C., four marble statues of famous law givers stand as solidly as pillars.

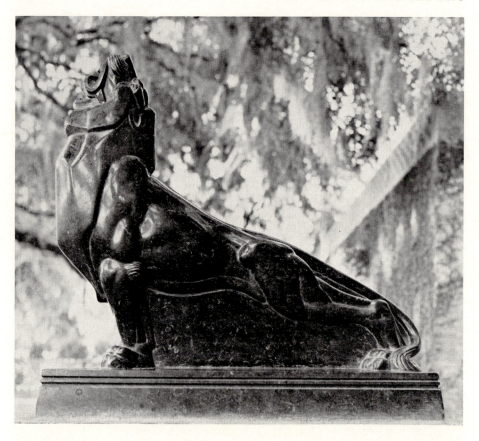

LION

Black granite statuette. Height 2 ft. ½ in. Base: Length 2 ft. 2¾ in.—Width 8 in.
Placed in Brookgreen Gardens in 1936.

A few portrait statues in bronze keep the rugged monumentality of sculpture in stone. A dramatic statue of General Pulaski with drawn sword stands near the Philadelphia Museum of Art. On those of Daniel Coit Gilman and Dr. Welch for Johns Hopkins University, Baltimore, two of Waugh's last works, the voluminous academic gowns lend weight and stability to their imposing presences.

Amherst College conferred on him an honorary degree of master of arts in 1939 and the University of Massachusetts that of doctor of fine arts in 1950. The National Sculpture Society, of which he served a term as president, awarded him the Herbert Adams Memorial Medal not only for his own achievements but also for his service to the art of sculpture, and The American Numismatic Society gave him the Saltus Medal for his medallic work. He was

active in the conduct of many institutions, having been a trustee of the American Academy in Rome, a member of the New York City Art Commission, and on the advisory committee of the architectural school of Massachusetts Institute of Technology. He was elected to the National Academy of Design and the National Institute of Arts and Letters. He died at New York on June 30th, 1963.

Lion

A lion is roaring, head uplifted and body outstretched. Carved in sharply defined planes, the monumentality of the sculpture has been reinforced by a solid block of marble left beneath the animal's body. The power and fierceness of the beast have not been diminished by the stylized character of the carving. The sculpture was done in 1933.

Albert Stewart

ALBERT T. STEWART was born at Kensington, England, on April 9th, 1900, the son of Melville and Arabella (Campbell) Stewart, both of whom were involved in music and the theater. They came to the United States in 1908 but died before they had been here many years. Their son, left an orphan, earned his living drawing comic strips. His talent was recognized and brought to the attention of Edwin de T. Bechtel, lawyer and collector, who made it possible for him to continue his art studies and also helped him get commissions in order to start his career. In addition to attending the Beaux-Arts Institute of Design, Stewart developed his knowledge of animals by drawing them at the Central Park and Bronx zoos in New York. During World War I he went to Canada and joined the British Air Force. On his return to New York he decided on sculpture as a profession, even though he had begun as a painter. He worked for MacMonnies and in Manship's studio both at New York and at Paris, where he stayed for two years. This experience developed his craftsmanship but did not submerge his artistic personality. Unattracted by lightly flowing movement or the charm of exotic ornament, he depended for his effects on the cubic solidity of bulk. Although he used some archaizing conventions, his inspiration came more from life than from antiquity, as his animal sketches, some done at the Berlin zoo in 1928, clearly show.

In 1927 *Silver King*, a polar bear of massively rounded forms, won the Speyer Prize of the National Academy of Design. This recognition was

followed in the next year by the Widener Gold Medal of The Pennsylvania Academy of the Fine Arts for *Polar Bear*. There were awarded in rapid succession a Garden Club of America Prize, the Barnett Prize of the National Academy of Design, and the Avery Prize of the Architectural League for *Leda and Swan*. Mr. Bechtel gave examples of his bronze *Hawk* and *Silver King* to the Metropolitan Museum, New York, and another group of his sculpture, including *Herons*, to the Reading, Pennsylvania, museum. At Thiaucourt, France, a sundial set up as a memorial to American soldiers had a massive eagle by Stewart as gnomon.

Since his geometric style was well suited to sculpture in relief, he received many orders for architectural sculpture. He designed baptistery doors for Saint Bartholomew's Church, New York, historical panels for the City Hall and Court House at Saint Paul, Minnesota, and panels for the Municipal Auditorium, Kansas City, Missouri. On the friezes of Buffalo City Hall groups of people move at various tasks in a rhythmic alternation of verticals and diagonals. Stewart's share in the federal fine arts program was panels depicting minting processes for the San Francisco Mint, reliefs of the building trades for the Home Owners Loan Corporation Building, Washington, D.C., and a pediment for the Department of Labor and Interstate Commerce Building. A few elements in bold grouping fill the pediment in a novel manner, a handsome male figure and a powerful bull the center of the composition. Panels of one or two people at their daily tasks set up a strong play of light and shade along the upper part of the façade of the Nassau County Court House at Mineola, New York. A special commission was for carved wooden eagles to support a piano that Steinway and Sons gave for the White House.

In 1939 an appointment as head of sculpture studies and lecturer on the humanities at Scripps College, Claremont, took Stewart to California, where he built a house at Padua Hills and spent the rest of his life. He began to experiment with new forms of sculptural expression, moving further and further away from literalness. Except for a life-sized bronze in Hollywood Park at Inglewood, which showed the race horse *Swaps* at full gallop, his animals in ceramic, terra cotta, and wood tended to concentrate on peculiar configurations or the interplay of shapes and textures.

Animals also figured largely in decorative reliefs, often carried out in ceramic. Those set into a brick wall of the Los Angeles County Fair Grounds at Pomona were carved in green brick before firing. Also in ceramic were figures embodying stages in the history of law on the Los Angeles County Court House. Carved in stone on the Scottish Rite Temple at Los Angeles are groups of figures following the history of freemasonry from ancient Egypt to modern times. The sculptor blocked out his figures in architectonic schemes but made good use of the costumes of each period to relieve the severity. For

narrative panels on the Fort Moore Memorial he left his figures lightly engraved but emphasized silhouettes by deeply incised lines that cast strong shadows. Several of his last works for buildings—groups symbolizing the family on Home Savings and Loan Buildings at Pasadena and Torrance—are

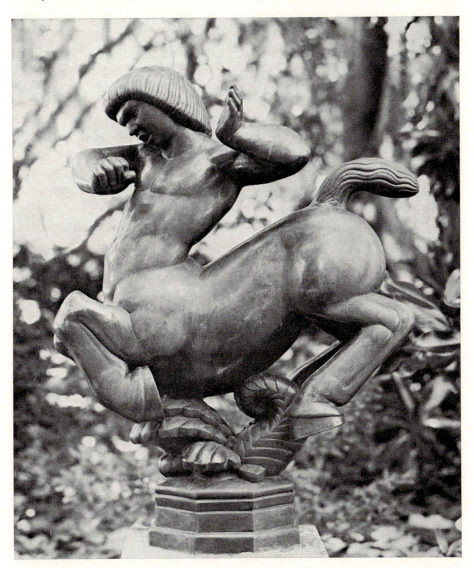

YOUNG CENTAUR

Bronze statuette. Height 2 ft. 5½ in.—Width 1 ft. 11 in. Signed on base at left: A · STEWART · Founder's mark: ROMAN BRONZE WORKS N.Y. Placed in Brookgreen Gardens in 1936. Other example: Claremont, Calif. Scripps College (ceramic).

figures strikingly elongated to make them both more expressive and in harmony with the buildings on which they are placed.

Stewart began to use such an attenuated form as early as 1943 for *Christ the Teacher* at Claremont Community Church. It is in his sculpture for churches that some of his most original and deeply felt work has been done. In an article on ecclesiastical sculpture he stated his belief that the prime concern of the artist in work for the church should be "to indicate the fundamental traditions of Christianity in the art expressions of his contemporary period." [1] Not content with returning entirely to Gothic or Renaissance art for his models, he tried to evolve his own personal way of expressing ideas, though he often adapted earlier forms that agreed with his own thoughts. Many of his figures of Christ and Biblical characters are carved with the hard planes and sharp angles of Gothic sculpture which, especially in tragic themes, induce an emotional response. Done in this way, with silhouettes starkly cut out, are Stations of the Cross for the Church of Our Lady of the Assumption at Ventura. The American Academy of Arts and Letters gave Stewart a grant in 1955 "in recognition of the power and directness of his animal sculpture and the forceful design of his ecclesiastical carvings." Most impressive is a refugee memorial erected at Gouda, Holland, in 1964, where a sense of anguish for indomitable spirits emanates from the monumental folds of a long cloak in which two figures are huddled together for mutual support.

Stewart ranged widely in his restless search for significant forms, from pre-Columbian art to Henry Moore. Where he was not bound by a specific site, he could let his creative impulses function freely. In the last year of his life he made many sketches and studies in plaster for a theme called *Eternal Primitive*, a hieratic mother and child embodying his idea of the essential maternal spirit revered by all men. Less epochal subjects were a poetic *Man and Nature*, a slender figure enmeshed in natural forms, and a soaring *Birds in Flight*. Stewart died on September 23rd, 1965. He was a member of the National Academy of Design and a fellow of the National Sculpture Society.

Young Centaur

A sportive centaur is galloping, all four feet in the air. One hand is clenched before his lowered head, the other drawn back. Foliage rises beneath his body. A cheerful fancy dictated the awkward gambols of this half-grown creature with compact muscles and large hooves. It was modeled in 1931 and the same year was awarded the Helen Foster Barnett Prize of the National Academy of Design.

1 *American artist*. December 1954. v. 18, no. 10, p. 55.

Baby and Rabbits

A curly headed little girl with a bunch of grapes raised in her right hand holds a grape temptingly above the head of a rabbit seated beside her foot, looking upward; another rabbit crouches at the other side. The forms of child and animals are modeled with simplicity and naturalness. The group has also been called *Little Bacchante*.

Bronze group. Height 2 ft. 10 in. Signed on base at back: ALBERT STEWART 1936 Placed in Brookgreen Gardens in 1937.

Orpheus and Tiger

Orpheus kneels on one knee, striking a raised lyre. His head is turned backward looking down at a tiger which lies behind him, its head lifted caressingly against his back. Although the composition is one of angles and blocks, the sense of the moving effect of the music is given by the ecstatic lift of the beast's head.

Bronze group. Height 8 in. Base: Length 11¾ in.—Width 5 in. Signed on base at right: STEWART Founder's mark: KUNST FOUNDRY N.Y. Placed in Brookgreen Gardens in 1936.

Fawn

The tiny creature lies with all four feet bunched under it, the head, with lifted ears, turned slightly backward. Its young body is modeled in smooth curves.

Aluminum statuette without base. Height 11¾ in. Placed in Brookgreen Gardens in 1936.

Jaguar

This small study is of the animal licking a raised leg. Interest is centered on the action, and there is little detail.

Bronze statuette. Height 3¹⁄₁₆ in. Base: Length 2⅛ in.—Width 2⅛ in. Signed on base at back: STEWART Placed in Brookgreen Gardens in 1937.

Benjamin Franklin Hawkins

BENJAMIN FRANKLIN HAWKINS was born at Saint Louis, Missouri, on June 17th, 1896. At the Saint Louis School of Fine Arts he studied with Victor Holm and in New York at the Beaux-Arts Institute of Design with Lee Lawrie and at the Art Students' League with Leo Lentelli. He chose architectural sculpture as his special field, establishing a studio in New York. By 1929 he had completed decorative figures for a high school at Little Rock, Arkansas, *Minerva* for the University of Michigan, and the sculptural details of Washington Hall at West Point. Later commissions were the entrances to the City Bank–Farmers' Trust Company Building, New York, metal grilles for the post office, Albany, New York, and monumental figures for the

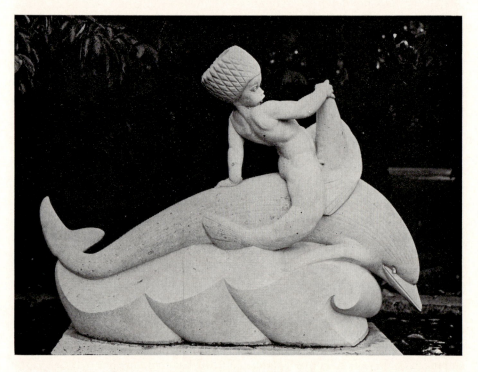

TRITON ON DOLPHIN

Limestone group. Height 3 ft. 6 in. Base: Length 3 ft. 10 in.—Width 1 ft. ½ in. Signed on wave at back: BENJ. HAWKINS SC. Placed in Brookgreen Gardens in 1937.

374

Federal Building, Saint Louis. He was commissioned by the Federal Works Agency to do sculpture for the post office, Hyannis, Massachusetts. A War Memorial at Milwaukee departs from the architectural series, and another work is a heroic group of Samson and the Lion, the diagonal composition inspired by Bourdelle, and the pattern of muscles strongly emphasized. He is a fellow of the National Sculpture Society.

Triton on Dolphin

A solemn young triton with fins for feet and a stiff crown of hair rides a dolphin, one leg hooked over the dorsal fin. He leans backward, one hand grasping the fin and the other resting on the fish's back. The dolphin plunges over the crest of a wave. The spirited group is crisply stylized with sharply defined planes. The wave is indicated as a series of smooth curves, the dolphin's sides are marked with even, parallel lines, and the triton's hair with regular crosshatching. It was designed as a fountain for the Colorado Springs Day Nursery and awarded the Avery Prize by the Architectural League in 1933.

Donald De Lue

As in earlier times, Donald Harcourt De Lue learned his profession chiefly in the studios of older sculptors. He was born at Boston on October 5th, 1897. Given a scholarship by Bela Lyon Pratt, he studied for several years in the school of the Boston Museum of Fine Arts. Richard Recchia and Robert P. Baker both employed him when he had gained enough skill to be useful as an assistant. With the outbreak of the First World War, many of the projects that these sculptors had in hand were brought to a standstill. Feeling the need of wider horizons, De Lue left as soon as possible for Paris, where he found work with several French sculptors of the academic school, such as Alfredo Pina. After five years at Paris, De Lue was invited by Bryant Baker, Robert's brother, then in England, to come and work for him. He stayed only a short time before returning to the United States. He was again employed by Bryant Baker, who had established a studio in New York.

Although De Lue's occupation as assistant to other sculptors allowed him little opportunity to develop his own ideas, he was constantly studying, drawing, and laying a solid foundation in the techniques of sculpture. As his

powers matured he began to take part in competitions for large-scale architectural sculpture, and in 1941 finished granite panels symbolizing Law and Justice for the Philadelphia Court House. Both are seated figures, heavy draperies clinging to the muscular forms and falling in tubular folds to make strong vertical lines. In these reliefs the sculptor's instinct for massive forms shaped into bold designs found full expression. Other works for Philadelphia were a fountain for the gardens of the Federal Reserve Bank, an urn with a vigorous Triton rollicking amid a school of fish, and *The Alchemist* for the Chemistry Building of the University of Pennsylvania, a cheerful travesty of a dyspeptic sage bundled in a heavy cloak intently observing a retort, designed to amuse the students who pass through the door below it. This less formal sculpture gave De Lue's imagination freer rein and showed his own personal concept of form, while a lively sense of humor imparted zest to these creations. For the Science and Engineering Building at Carnegie Institute of Technology, Pittsburgh, he modeled portrait reliefs of Benjamin Franklin and Josiah Willard Gibbs and for the Christian Herald Building in New York City, a relief of a mother with her children.

As soon as De Lue's work began to appear in exhibitions, it attracted attention and in 1942 won the Avery Prize for small sculpture, given by The Architectural League of New York, and the Lindsey Morris Memorial Prize for work in low relief, awarded by the National Sculpture Society. In the two following years, while recipient of a Guggenheim Fellowship, he worked on an ambitious project for a Hall of Our History planned by the architect Eric Gugler but halted by the war in Korea. During the Second World War, under the auspices of the Citizens' Committee for the Army and Navy, he designed a relief of Saint Michael in armor, adopted by the commandos as their emblem; kneeling statues of Saint Michael and a Knight Crusader were placed as candle holders in chapels at West Point and Arlington. De Lue was given a grant by the National Institute of Arts and Letters to carry on his creative work in 1945 and elected a member the following year. The National Sculpture Society elected him president for a three-year term from 1945 through 1947.

The Harvey Firestone Memorial, an exedra erected on a hill at Akron, Ohio, in 1951, contained six panels by De Lue. Appropriate allegorical male and female figures planned to fit long rectangular spaces and modeled with clear outlines and broad planes subtly varied for colorful effects, they were carved in granite and set at intervals around the back of the seat. For this achievement the Architectural League awarded a gold medal to the sculptor. He used a similar plan for a memorial to Edward Hall Crump at Memphis, Tennessee. The bronze statue stands in front of an exedra carved with two symbolic figures in long panels.

Two war memorials are very different in character. That for Virginia Polytechnic Institute is a group of three reliefs for the front wall of a chapel. They symbolize the spirit of God in man, the central figure borne upward against the palm of a great hand, one at the left at work with a plow, that at the right kneeling in prayer. The focal point of the memorial for the cemetery at Omaha Beach, Saint-Laurent, where American troops first landed in Normandy during the Second World War, is a male figure in bronze, twenty-two feet high. Mounting skyward in an ascending spiral, with upturned, yearning face and outflung arms, this figure expresses the noblest aspirations of the men to whom it is dedicated. It embodies the spirit of the lines from *The Battle Hymn of the Republic*, "Mine eyes have seen the glory of the coming of the Lord," which are lettered near it. Reliefs on great bronze urns at both ends of the encircling colonnade call attention to the historic significance of the site and symbolize the belief that life is eternal. The thought that went into the evolution of this figure is demonstrated in the film *Uncommon Clay*, where the sculptor is shown trying innumerable small sketches in a model of the monument before making his final selection. For it the sculptor shared in the Henry Hering Memorial Medal of the National Sculpture Society.

De Lue has done important religious sculpture, such as Stations of the Cross in Carrara marble for Loyola Seminary at Shrub Oak, New York, for which he shared a second Hering Medal, and another series in Portuguese rose marble for the Chapel of the Sisters of Saint Joseph at Willowdale, Canada. Reliefs of the life of Saint Joseph were carved in granite monoliths for his shrine in Holy Sepulcher Cemetery, Chicago, and scenes relating to the cult of the Sacred Heart for a shrine at Hillside, Illinois. In the Church of the Epiphany, New York City, is his marble statue of Saint John the Baptist.

A heroic bronze statue of George Washington as president and Masonic Grand Master was ordered for New Orleans Civic Center by the Grand Lodge of Louisiana, and replicas were placed in several other cities. A different idea of the first president, dedicated in 1967 at Valley Forge, shows him kneeling in prayer. As a tribute to the boy scouts, a bronze group of a scout between two symbolic figures occupies a conspicuous position between the Washington Monument and the White House at Washington, D.C. The Sons and Daughters of the Confederacy chose De Lue as the sculptor of a Confederate Memorial in Gettysburg National Military Park, a stirring figure of a soldier rushing into battle, carrying the Confederate flag and rallying his comrades.

One of the few permanent monuments erected at the New York World's Fair in 1964 as the theme of the fair is *The Rocket Thrower*, a muscular figure launching a rocket into a constellation. This work won for him the Golden Plate Award of the Academy of Achievement, presented each year at

Dallas, Texas, to fifty men of remarkable accomplishments. A colossal bronze male figure holds its own against the skyscrapers of the Prudential Center at Boston as he reaches upward to express man's highest aspirations. Many honors have been showered upon the sculptor. He was the recipient of the National Sculpture Society's Herbert Adams Memorial Medal for his work as a whole in 1967, and in the same year his *Phaeton* won the Samuel F. B. Morse Medal of the National Academy of Design, of which he is a member.

De Lue's work in general is in harmony with modified classic tendencies particularly appropriate for architectural sculpture. In his case the classic strain is well diluted, though he has used something of the strong musculature of archaic Greek sculpture to strengthen the patterns of his figures, a device rediscovered by Bourdelle. Other sculptors of the older generation whom he admires are Alfred Janniot and to some extent Milles and Meštrović, since they do not break abruptly with the steady flow of evolution. He himself prefers to work in the broad stream of tradition, letting his art grow naturally from the great achievements that went before. From this starting point De Lue has evolved his own idiom, in which forms, swelling or flowing, take precedence over line. As an example, the wings of his eagles are softly rounded masses on which only the bold outlines of feathers are suggested. As if his own *North Wind* were blowing through them, a feeling of power inflates his forms and lends them buoyancy.

Icarus

Icarus, terrified at the failure of his waxen wings under the heat of the sun, is falling from the sky. The sculptor has graphically expressed the feeling of a down-rushing body, doubled up under the pressure of the air, with wings pointed upward and legs parallel to them. A sense of tension is conveyed by bulging muscles and strained tendons. The wings are represented with soft shoulders edged by a row of undetailed feathers and tipped by long, smooth pinions. The hair is blown upward in a solid mass between the wings above a face looking downward in startled horror, eyes staring and mouth agape. The features are stylized: strongly arched brows above a straight nose, slanting eyes over high cheekbones, and open mouth edged with definite ridges. To provide a base for the figure and intensify the airy atmosphere, the body seems to be plunging into a cloud forced upward along the legs. It was this work, exhibited at the Allied Artists of America in 1946, that won for the artist a medal of honor.

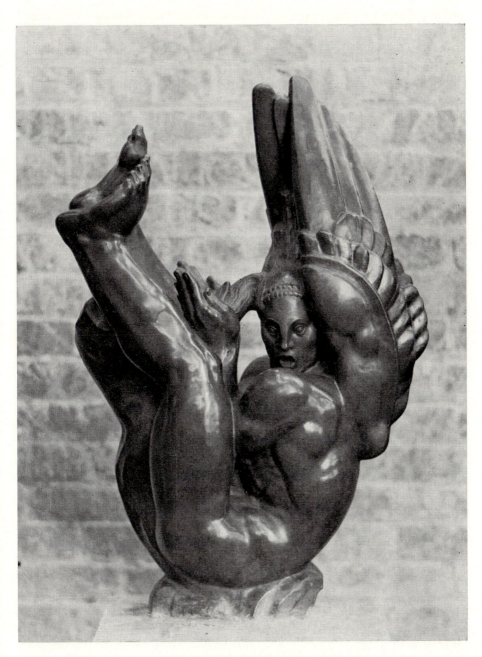

ICARUS

Bronze statue. Height 2 ft. 6½ in. Base: Width 10¼ in.—Depth 7 in. Signed on base at back: De Lue 1945 Placed in Brookgreen Gardens in 1948.

Nathaniel Choate

NATHANIEL CHOATE was born on December 26th, 1899, at Southboro, Massachusetts, the son of Edward Carlile and Gertrude M. (MacNeil) Choate. Preparing for college at Morristown, New Jersey, he entered Harvard University. There Edward Forbes and Paul Sachs guided his artistic education, and he studied painting with Denman Ross. After graduating in 1922, he went to Paris to continue his study of painting, working at the Colarossi and Delécluse academies. He also traveled in Italy and considered becoming a portrait painter or a mural decorator, but after a visit to Greece in 1924 decided to make sculpture his profession. From 1925 to 1927 he was at Boston, holding the position of art editor of *The Youth's Companion* and studying sculpture with John Wilson. In 1927 he returned to Europe, staying there, with only short visits home, until 1930. He then tried living in New York but soon went to Italy to be near the marble quarries.

The results of a journey to Morocco and the Sudan in 1932 were shown in an exhibition at New York two years later. The thirty-three works in sculpture included studies of animals, native types, and portrait heads, chiefly cut in marble and stone, the material chosen to suit the subject. After that time he lived chiefly in the United States, settling at Phoenixville, Pennsylvania. The originality and imaginative invention already apparent in the first showing were even more evident in his second exhibition at New York in 1938. Keeping the surfaces very simple, he depended largely upon the arrangement of forms and on silhouette for effect. A *South Sea Fisher* from this group, carved of Spanish onyx, is in the collection of the Honolulu Academy of Arts. His ability to extract sculptural values from his models had been recognized the year before by The Architectural League of New York, when he was awarded their medal of honor in design and craftsmanship for excellence in the craft of stone carving and design. He made bas-reliefs for the Federal Building at the New York World's Fair of 1939. A relief, *The Four Winds*, was commissioned for the Pittman, New Jersey, Post Office by the Federal Works Agency. He taught at the summer school of The Pennsylvania Academy of the Fine Arts. In 1941 he founded the Aldham Kilns and thereafter gave most of his attention to designing for ceramics, creating figures, birds, and animals in china and porcelain until the kilns were destroyed by fire in 1947. He continued to exhibit sculpture, chiefly animal studies such as a rhinoceros group, *Makoko*, a gorilla, and a Diana monkey. His share in a

380

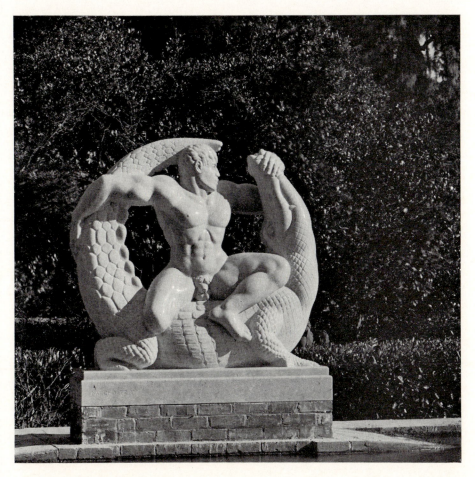

ALLIGATOR BENDER

Italian marble group. Height 5 ft. 1¼ in. Base: Length 5 ft.—Width 1 ft. 11½ in.
Signed on base at left: NAT. CHOATE · 37 Placed in Brookgreen Gardens in 1938.

battle monument at Luxembourg was emblems of the four Evangelists on
stone pylons and bronze pool ornaments. He died at New York on August
21st, 1965. He was a member of the National Academy of Design and The
Architectural League of New York, which awarded him a gold medal.

Alligator Bender

A man is seated on the back of an alligator, his legs gathered under him.
With his left hand he grasps the jaw, and his right arm curves around the
tail, bending the creature's body in a circle. His powerful muscles are con-
tracted, and the radiating lines of the arms and legs are contrasted with the

curving frame of the alligator. The patterning of the scales adds a decorative note. A small group was originally carved in mahogany at New York about 1926. In enlarging it, the sculptor made it heavier and the man more robust to look like a Seminole Indian. He took the half-size model to Querceta, near Carrara, Italy, in the spring of 1937, carving it in marble during the summer and autumn.

Orpheus and Eurydice

Leaning against a twisted oak, Orpheus lifts his hand from plucking the strings of his lyre, while two squirrels creep forward from the tree trunk to listen. Opposite, Eurydice half reclines, buoyed on the tips of pine branches, her hand languidly outstretched towards Orpheus. An owl, symbol of darkness and despair, flies from the tree, and two others perch on the trunk. A dreamy melancholy enfolds the two, his face filled with longing, hers already withdrawn into other-worldly abstraction. The rich forms are developed with masterly skill and with the trees make an intricate open pattern of irregular, flowing lines. The moment in the legend is the parting after Orpheus had rescued Eurydice from the underworld. The pact has been broken by his turning to look at her, and she is again being separated from him.

Bronze group. Height 5 ft. 1 in. Bases: Length 4 ft. 3 in.—Width 1 ft. 7 in. Placed in Brookgreen Gardens in 1954.

Frances Bryant Godwin

FRANCES BRYANT GODWIN was born at Newport, Rhode Island, in 1892, the daughter of Harold Godwin, painter and editor, and his wife, Elizabeth Love (Marquand) Godwin. Her maternal grandfather was the philanthropist Henry G. Marquand, and a great-grandfather was William Cullen Bryant, whose statue by Herbert Adams in Bryant Park, New York, she unveiled in 1911. Her father was interested in sculpture, having studied with Saint-Gaudens and at Paris with Poisson. Frances Godwin attended the Art Students' League and had James Earle Fraser and A. Phimister Proctor as teachers. The family had houses in New York and at Roslyn, Long Island, often spending summers at Lenox, Massachusetts, where the daughter had a studio.

She has done by preference lifelike sculpture of dogs and horses, since she was an excellent horsewoman, freely modeled with a sensitive touch and with sympathetic understanding of the animals' characters. At Aiken, South Carolina, where her father had a winter home, she sculptured a number of thoroughbreds in the native clay of the region. An especially successful work was a statuette of Harry Worcester Smith on his fine thoroughbred Strongbow, exhibited at Aiken in 1931 with other sculpture by Miss Godwin. In addition to studies of horses, she showed a head of a Negro girl, *Blanche*, and a bronze hawk with outspread wings. In her father's house at Roslyn there is a bust of her sister and in the garden, a fountain statue of a little girl, *Ellie*, both of which are her work. She has also done some interesting drawings of driftwood.

Mare and Foal

A mare is grazing, her body sheltering a colt that stands beside her and rests its head on her back. For this study, done in the 1930's, Miss Godwin took her own mare as a model and added the foal to make an interesting group.

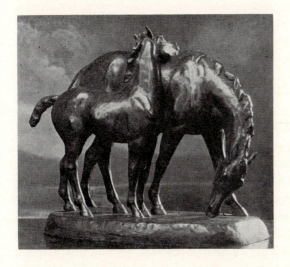

MARE AND FOAL

Bronze group. Height 12¾ in. Base: Length 1 ft. 2¼ in.— Width 8 in. Signed on base at back: F. B. GODWIN Founder's mark: ROMAN BRONZE WORKS. N.Y.
Placed in Brookgreen Gardens in 1940.

Joseph L. Boulton

JOSEPH LORKOWSKI was born at Forth Worth, Texas, on May 26th, 1896. His great-grandparents had been driven from their estates in the partition of Poland, escaping with their lives but salvaging only easily portable valuables and being reduced to the condition of peasants dependent on their own efforts for a living. It was with this background that his grandfather, Albert Lorkowski, was born, in rank a peasant but inheriting the tastes of his father, an accomplished musician. He faced the reversal of the family fortunes by turning to cabinetmaking and carpentry to help support the family. As soon as it was possible, Albert brought his family to America and settled at Detroit.

Francis, his eldest son, hearing that the government was offering land in Texas and that work in the building trades was available, took his wife and moved to Fort Worth, where he established himself as a contractor and builder. Their third child, Joseph, was three years old when he discovered that the clay of the river bed near his home was plastic and began to try to shape it. When he was taken to see a circus performance on his fourth birthday, the animals made such an impression on him that he spent the rest of the summer modeling them in clay from memory. In this way he acquired a taste for sculpture that he never lost.

When Joseph was seven, his father gave him a small rifle, with the result that while providing game for the larder the boy could study closely the structure of animals. His interest was directed towards taxidermy, and from a course of lessons published by the Northern School of Taxidermy he learned to mount his game or tan the hides for rugs. He continued his taxidermy even when, attracted by a future in business, he left school at the age of eleven and went to work for his father. Francis Lorkowski died in 1909. Joseph, then a youth of thirteen and a half, took over his father's contracts for houses under construction and completed the work, thereafter continuing to support his mother, two sisters, and a younger brother by working as a carpenter, doing taxidermy, and making an occasional piece of sculpture. Some of these works are now in the museum at Fort Worth.

In 1915, when he was no longer needed at home, Joseph came to New York and enrolled as a student in the school of the National Academy of Design. He found work in the studio of Hermon A. MacNeil, also studying in his spare time at the Art Students' League and at the Beaux-Arts Institute of Design. When the United States entered the First World War, Lorkowski

enlisted in the Marine Corps and served in the fifth regiment until he received an honorable discharge at the end of hostilities. He then returned to Mac-Neil's studio.

His services during the war resulting in some physical impairment, he came under the care of a Philadelphia physician who, recognizing the signs of failing health and learning of the young man's family history, talent, ambition, and lack of educational opportunities, placed before his mother an offer legally to adopt him. After full consideration, Mrs. Lorkowski joined in asking that the court grant the petition. When the legal formalities had been completed, Joseph Lorkowski took the name Joseph Lorkowski Boulton. For the restoration of his health an appropriate site near Redding, Connecticut, was found, where a wholesome outdoor life brought about the expected improvement. Working a short time each day, he built by his own labor a house and studio where he carried on his chosen profession. After his marriage to Helen Woodbury, they lived in Ridgefield for nine years, until they moved to Westport in 1966.

One of Boulton's best-known works is *Prairie Fire*, four frightened horses sniffing smoke-laden air, which won the Helen Foster Barnett Prize in the 1921 exhibition of the National Academy of Design. Several commissions followed: a memorial tablet representing old Fort Worth was ordered by the Daughters of the American Revolution for that city, and *The Devil Dog*, a marine charging, was placed in the Marine Barracks at Washington, D.C. Boulton's work in relief includes a number of medals. One was of the race horse Native Dancer, others were designed for colleges. The American Academy of General Practice and The Medical Society of the State of Pennsylvania, as well as the Instituto de Cultura Puertorriqueña of Puerto Rico ordered medals from him.

The wild surroundings in which the sculptor lived gave him constant opportunities to observe animal life, the theme that most interests him. He portrays both domestic animals and the creatures of the forest, catching them in their most characteristic attitudes and movements and bringing out with fluid strokes in the clay the sleek ripple of fur or the sweep of feathers. No creature is too small to command his attention—white-footed mice, a fledgling bird, a cat sleeping on its back, squirrels, and a woodchuck. Not only is the individuality of each one re-created, but often they are combined into groups with a captivating interplay of line and movement. *Hop*, a bronze mouse, is in the collection of The Detroit Institute of Arts. *Butterfly*, which won an award from the Academic Artists Association at Springfield, Massachusetts, in 1959, was acquired by the Museum of Fine Arts there. *Performer*, a study of a trained bear, received the John Newington Award of the Hudson Valley Art Association in 1960. This association gave the sculptor the Archer Milton

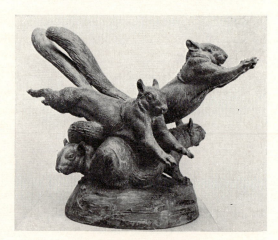

SPRINGTIME FROLIC

Aluminum group. Height 1 ft.
4½ in. Base: Diameter 12½ in.
Signed on base at front: J L
BOULTON Founder's mark:
ROMAN BRONZE WORKS. INC.
N.Y.
Presented to Brookgreen Gardens
by the sculptor in 1964. Other
example: Trenton. New Jersey
State Museum.

Huntington Award two years in succession, in 1963 for *Rivals*, which was
also awarded the gold medal of honor, and in the following year for *Lion
Cubs*. A group of monkeys huddled together, entitled *Apprehension*, is in the
Mid-Fairfield County Youth Museum at Westport, Connecticut. The marsh
lands near Westport gave him a chance to study birds. A group is owned by
the Blauvelt Foundation, Trenton, New Jersey. Several subjects related to
Indian life found a place in the Southern Plains Indian Museum at Ana-
darko, Oklahoma. They are a bronze relief called *Vanishing Herds*, *Prayer
for the Herd*, *Sun Blessing*, and a portrait of Logan Billingsley, who was
active in Indian affairs.

Boulton has also done some figure studies and portrait busts, among them
that of the late Dr. A. C. Morgan of Philadelphia, which is now at the
Philadelphia County Medical Society. His bust of Seneca Egbert, for many
years associated with the University's School of Medicine, is owned by the
University of Pennsylvania. In recent years Boulton has experimented with
oils and water colors in addition to working in sculpture. He is a member of
many artists' associations, including the Allied Artists of America and the
American Artists Professional League, and a fellow of the National Sculpture
Society.

Springtime Frolic

Four squirrels are playing, two leaping over the backs of their crouched
comrades. The flying bodies swing upward in an arc, and the whole group is
instinct with life and spirit. Each squirrel has an individual character; one is

scratching its ear, and another is scolding. This work won the Watrous Gold Medal at the National Academy of Design exhibition in 1953 and also the gold medal of honor of the Hudson Valley Art Association and an award from the Connecticut Classic Artists in 1960.

Rabbit Nest

Carved on the flat top of an irregular block, six baby rabbits are huddled together in a nest of grass and ferns. Their eyes are closed, and each one lies in a different position; one on its back, another curled into a ball, a third on its side, and the one in the middle crouched with its head rising above the others. The sculptor tells how he came to model this group as follows:

"Our thirteen acres of picturesque Connecticut hills, valleys and rocks are an ideal haven for wild life, and my moments of diversion from my sculpture are spent wandering about our property and observing our small tenants. It was on one of those trips that I saw a cottontail rabbit in the brush pile. She wouldn't budge, so I was curious and prodded the brush. Then I found she was covering a nest of young rabbits about eight days old. I threw a net over the whole and brought them to the studio, where I placed them in a large-meshed wire cage. With plenty of food and water, they fed and slept and stretched and were our contented guests for the next three days, while I was making a clay model and then carried cage and all back to the brush pile, opened the door, and left them to their own devices."

Marble group. Length 12½ in.—Width 9 in. Signed on end: J L BOULTON Placed in Brookgreen Gardens in 1952.

Madeleine Park

A SCULPTOR whose career was devoted chiefly to representing animals was Madeleine Park. She was born at Mount Kisco, New York, on July 19th, 1891, to Edwin Bennett and Mary Elizabeth (Sutton) Fish. After receiving her early education at Blair Academy, Blairstown, New Jersey, she began the study of sculpture at the Art Students' League in New York City. Her marriage to Harold Halsted Park of Katonah, New York, in 1913 and the birth of three children brought a temporary halt to her career as an artist, except for a bronze bust of her son done during this period. In the 1920's,

when her children were growing up, she resumed her studies with neighbor sculptors, Frederic Guinzburg, A. Phimister Proctor, and Lawrence Tenney Stevens. She also had some instruction from Naum Los, whose art school was in New York City.

Animals soon became her favorite subjects. Not only horses and dogs of all kinds were models, but also the winter quarters of Barnum and Bailey's Circus at Bridgeport gave her a chance to observe excellent specimens of wild animals. Later, whenever the circus was at Madison Square Garden or in a near-by city, she continued to model the animals, being one of the few persons allowed inside the guard rails. Such was her rapport with them that one would sometimes recognize her after a long lapse of time. She delighted in the variety of shapes that they offered, from stiff-legged giraffe to supple cats, with fluid forms difficult to capture in clay. One of her statuettes of giraffes, representing the animal lying down, is in the Rochester Memorial Art Gallery. Best of all she liked the elephants, for their bulk lent itself well to the solidity of sculpture.

Her work began to receive recognition when in 1932 a statuette of May Worth's resin-back circus mare, Mollie, was awarded a prize by the American Women's Association. A few years later Mrs. Park was elected a fellow of the National Sculpture Society. She exhibited her work frequently and had one-man shows throughout the country. Since some of her bronzes were cast at Paris and at Rome, she occasionally showed pieces in those cities.

Franklin Delano Roosevelt kept her *Katonah Donkey* on his desk while he was president, and after his death it found a permanent place in his library at Hyde Park. Another Democrat, President Truman, also acquired a donkey, *Francis*. Wherever there was a collection dedicated to the circus, her work found a place. *Cutie*, a performing elephant in a ruff and frills, is in the museum of the Historical Society at Somers, New York. Others are *Resin-Back Act* in the John and Mable Ringling Museum at Sarasota, Florida; *Circus Ring* in the Circus World Museum at Baraboo, Wisconsin; and *Boston*, a giraffe, in the Herzberg Circus Collection of the public library, San Antonio.

In 1937 a trip around the world took Mrs. Park to South America, Europe, Africa, and Asia, so that she could watch some animals in their wild state. Types of people also attracted her, since the work for which she received the Malvina Hoffman Award from the Pen and Brush Club in 1938 was a *Balinese Head*. At a later date she returned to Africa for further travels, and because of her interest in distant countries she became a member of the Society of Women Geographers. Her knowledge of animals brought her a new and difficult assignment in 1948, when Hunt Brothers Circus commissioned her to go to India to collect animals. She brought back five elephants and a panther named Brutus.

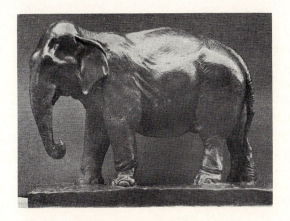

MODOC

Bronze statuette. Height 1 ft.
Base: Length 1 ft. 4¾ in.—
Width 6¾ in. Signed on base at
back: Madeleine Park
Presented to Brookgreen Gardens
in 1962 by Sylvia Park Kellogg,
Barbara Park Bausch, and H.
Halsted Park, Jr.

The Hall of Fame of the Trotter at Goshen, New York, acquired her *Pacer "Good Time,"* the Hammond Museum at North Salem, New York, her *Twin Lakes Farm Colt;* and the Whitney Gallery of Western Art at Cody, Wyoming, a *Steer and Cowboy.* Mrs. Park made busts of Osceola and of Vice-President Charles Curtis for the National Hall of Fame for the American Indian at Anadarko, Oklahoma, and an *Indian Dancing Girl* is in the Katonah Public Library. The National Academy of Design elected her an associate in 1960, the year in which she died. She was struck by a heart attack while she was attending a circus performance at Sarasota, Florida, on April 1st, 1960.

Modoc

The Indian elephant that served as a model for this work is owned by Ringling Brothers, Barnum and Bailey Circus. This elephant has been appearing on a television program entitled *Daktari.*

Hazel Brill Jackson

FROM CHILDHOOD Hazel Brill Jackson has been drawing and modeling animals. Although she was born at Philadelphia to William Henry and Lizbeth Lee (Stone) Jackson on December 15th, 1894, her family took her to Italy when she was a child. Her early education was in the Scuola Rosatti at Florence. During her school years she spent what time she could at the zoo, drawing by preference lions and tigers. The strong impression made upon her

by Thorwaldsen's *Lion of Lucerne* when she was a child may have planted in her mind the idea of becoming a sculptor. When the first World War broke out, she returned to the United States and lived at Boston, spending four years in the Boston Museum School of Fine Arts. She studied sculpture with Bela Lyon Pratt and Charles Grafly. Two early works, *Starling* and *Pelican*, were acquired for the permanent collection of the Concord, Massachusetts, Art Association. A memorial plaque, a portrait relief, is in Andover Theological Seminary at Newton Center, Massachusetts.

After the war Miss Jackson went back to Rome and worked in the studio of Angelo Zanelli, who was then completing part of the monument to Victor Emmanuel II. Later she had her own studio on Via Margutta. For the Italian Alpine Club, of which she was a member, she designed a trophy in the form of a chamois and an Alpine memorial tablet that was erected at Turin. Some of her subjects were animals seen in the countryside, a *Roman Work Horse* and *Roman Oxen*, in which the interplay of long, curving horns adds a flourish to the massiveness of powerful bodies. She also made a statue of Mussolini's favorite jumper, Ned. Miss Jackson became a member of the Circolo Artistico di Roma and exhibited both at Rome and at Florence.

Coming back to the United States in 1935, she settled at Newburgh, New York, where she has her home and studio. Sculptured portraits of horses and dogs have engaged much of her attention, her understanding of them revealed in the personality so clearly expressed in each one. A group of a mare and a foal, *"Play-Day"* and *"Romance,"* won the Ellin P. Speyer Prize awarded by the National Academy of Design in 1945, and *Indian Antelope* the same award in 1949.

A recent commission, *Curiosity*, depicts a cat playing with a lobster. This work illustrates the sculptor's habit of associating contrasting forms and her lively interest in characteristic movement. *Saint George and the Dragon* gave her an opportunity to relate the supple twistings of the dragon to the compact body of the horse. Even in small-scale works she has achieved a feeling of largeness. Several equestrian statuettes are expanded to more elaborate groups by the addition of secondary figures beside the horse and rider. *Don Quixote*, now in the main library at Wellesley College, is accompanied by Sancho Panza, with sheep and a windmill massed on the base to round out the composition and complete the story. It was awarded the Mahonri Young Memorial Prize by the National Academy of Design in 1965. Miss Jackson's imagination, aroused by a historical incident, led to a dramatic portrayal of Joan of Arc's horse, entitled *Compiègne, 1430*, at the moment after the rider had been dragged from the saddle. She has drawn on mythology and literature for such subjects as *Circe*, kneeling beside the pig into which she has transformed one of Odysseus' companions, the *Dog Argos*, and *Ichabod*

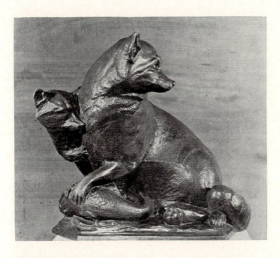

THE LISTENERS

Bronze group. Height 1 ft. 4½
in. Base: Width 1 ft. 5½ in.—
Depth 1 ft. 2 in. Signed on base
at front with dragonfly.
Presented to Brookgreen Gar-
dens by the sculptor in 1964.
Other example: Newburgh Pub-
lic Library.

Crane. The Crusader has been placed at Vassar College as a memorial to
Margaret Sherwood Mantz and *Pampelune* at Dartmouth College as a me-
morial to Walter Brooks Henderson.

Miss Jackson has carved panels in wood and made portraits in relief. Only
a few examples of each work are cast. In addition to sculpture she has done
wood engraving. She is a member of the National Academy of Design and a
fellow of the National Sculpture Society.

The Listeners

This group resulted from the sculptor's observation of a raccoon family
that lived in her icehouse at Newburgh for several years. The mother, who
has just caught a fish held under her paw, turns her head watchfully as two
young raccoons crowd against her. The work won the Ellin P. Speyer Prize at
the National Academy of Design exhibition in 1963 and the American Artists
Professional League Prize at the Smithsonian Institution, Washington, D.C.,
a year later. Four castings were made.

Heinz Warneke

AMONG THE foreign-born sculptors who have made themselves notable
in this country, Heinz Warneke first became known for animal sculpture. He
was born near Bremen, Germany, on June 30th, 1895, to Heinrich and Anna
(Ritterhof) Warneke. His home was in a farming district where there were

many domestic animals to watch. Throughout his school days, especially
during vacations at his grandfather's home near great forests, animals and
birds enthralled him. He did his best to capture their shapes and characteristic
movements in pencil or crayon. In visits to the colonial museum at Bremen his
scrutiny of African sculpture, followed later by study of Egyptian sculpture,
had a bearing when he began to work out simplified planes for his own
sculpture, aimed toward "a brief, strong statement." [1]

At the age of sixteen he entered the Stadtische Kunstgewerbe Schule at
Bremen and two years later enrolled at Berlin in the Akademie der Bildenden
Künste directed by Bruno Paul. A vital influence was that of Karl Blossfeldt,
whose studies of the development of plant forms inspired him to seek for more
than faithful representation in his own art. Occasional themes drawn from the
plant world, skunk cabbages in *Spring Growth* and ferns uncurling in
Through the Loam Upward, evidence a continuing interest. Professor Haver-
kamp taught him portrait and figure sculpture, and from Professor Wackerle
he learned a decorative approach to art and the technique of stone and wood
carving. During vacations he put his knowledge to practical use, carving
ornaments and working in a silver factory to learn casting processes.

When World War I began in 1914, Warneke was sent to Bucharest to
serve on the commission in charge of war memorials. At the end of the war,
returning to Berlin after a perilous escape, he was allotted a master studio in
the Kunstgewerbe Museum, where he evolved his own technique in carving
wood and brass and worked toward a clean style. The difficulties of living in
Germany during the post-war years of inflation induced him to leave Berlin in
1923. He emigrated to the United States, going at once to join friends at Saint
Louis, and in 1930 became a citizen. The year after his arrival in this country
he won first prize for sculpture at the Saint Louis Artists' Guild and for
several years following took other honors there. While he was living at Saint
Louis he received commissions for an eagle on the façade of the Masonic
Temple, Fort Scott, Kansas, and a relief for the façade of the City Club
Building, Saint Louis.

Dissatisfied with commercial work, he moved to New York in 1927, where
a successful exhibition made it possible for him to return to the kind of
sculpture that he wanted to do. Part of each year he spent at Paris. *The
Water-Carrier*, a nude figure kneeling, carved of hard stone, won him the
Logan Prize of The Art Institute of Chicago in 1930. *Wild Boars*, originally
exhibited at the Tuileries, received the Widener Gold Medal from The
Pennsylvania Academy of the Fine Arts in 1935 and entered the Chicago Art
Institute's collection, which also acquired his *Three Hissing Geese*. The

1 Nathan. p. 55.

group of two wild boars, carved in Belgian granite, reflects an impression of his childhood, when he watched the boars "sitting in the dark of the forest edge listening and sniffing before the charge into the open fields." [2] *Orangutan Thinking*, carved in Belgian marble, has been acquired by the Addison Gallery of American Art at Andover, Massachusetts, and a bronze group, *Pelicans*, by the Norfolk Museum of Arts and Sciences. These works show the sculptor's sensitivity to the qualities of materials and his preference for direct carving in stone, brass, and wood. A rare empathy enables him to understand both human beings and animals and his masterly craftsmanship, to convey his ideas and emotions. His works are sparely composed with flowing surfaces defined by sharp outlines, confirming his own words, "My personal inclination is toward the quiet and simple and the direct statement. But by all means a statement, and if possible one dear to the heart or mind of the artist." [3] A gentle humor often leads him to underline odd appearance or a sprightly attitude.

In 1932 Warneke and his wife bought a seventeenth-century farm house in East Haddam, Connecticut, which they restored and furnished in keeping with the period. He worked for ten years in the studio that he built and kept the place as a summer home after he moved to Washington. Among commissions won in competition under the Treasury Department's art program were a statue of a railway express mail carrier for the Post Office Department Building and a relief of Lewis and Clark for the Department of the Interior Building. Three groups, *Negro Mother and Baby*, *Negro Man—the Provider*, and *Bear Cubs*, were completed in 1938 for the Harlem-McCombs Housing Project, New York. A group of two bear cubs tumbling in play was carved for the Washington Zoological Gardens. His statue, *The Immigrant*, was among the first works commissioned for the Samuel Memorial in Fairmount Park, Philadelphia. Pennsylvania State University asked him for a statue of their symbol, the Nittany Lion, for the campus; he did the carving in place as a demonstration for the students. One of Warneke's most powerful works, *The Prodigal Son*, carved in granite with telling simplicity, was begun at Paris and continued over a period of years. It has been placed in the Bishop's Garden of Washington Cathedral as an eloquent expression of the spirit of compassion.

Warneke was called to Washington in 1942 to head the sculpture department at the Corcoran School of Art. He has designed a pediment with the Last Supper and reliefs depicting the Flight into Egypt and the Entry into Jerusalem for medallions in the spandrels of the south portal, Washington Cathedral. In these scenes, placed high above the viewer, he had to compose

2 Warneke. p. 78.
3 *Idem.* p. 79.

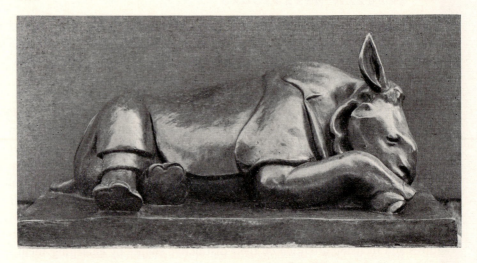

YOUNG RHINO

Bronze statuette. Height 9½ in. Base: Length 1 ft. 11½ in.—Width 1 ft. 1 in.
Signed on base at left: CORNELIA CHAPIN. 1946 Placed in Brookgreen Gardens
in 1948.

Day, a boy riding home on a tired work horse, modeled in terra cotta, both
simply and naturally handled.

The commission for a crucifix to be placed above the high altar of the
Cathedral of Saint John the Divine, New York, presented an entirely new
problem. Inspired by early Romanesque crucifixes in which Christ is repre-
sented in majestic dignity, she imagined *Christ the King*, crowned and
clothed in a long tunic falling in conventional linear folds.

As soon as her work was seen at New York, Miss Chapin's artistry won
recognition. In addition to the many awards that she received, she was elected
a fellow of the National Sculpture Society and a member of the National
Academy of Design. From 1951 to 1953 she was the sculptor member of the
Art Commission of the City of New York. She retired to Lakeville, Connecti-
cut, in 1954.

Young Rhino

A young rhinoceros is lying with both hind feet on one side of his body,
head between the forelegs, ears up, and eyes partly closed. The sculptor has
modeled the surfaces covered by heavy skin in broad planes, breaking them
where the major ridges fall, around the neck, behind the shoulders, along the

sides, and at the tops of the legs. The disproportionate size of legs and feet and the smooth texture of the skin denote immaturity.

The model for this work lived in the Vincennes zoo near Paris. There the sculptor made sketches of him. Later in her New York studio she worked out the sculpture in cast stone. It was first shown at the National Academy of Design in 1946 and chosen for the Sculpture International at Philadelphia. The example at Brookgreen was cast in bronze from the original model in cast stone.

Erwin Springweiler

THE SON of a master goldsmith, Frederick Springweiler, and his wife, Erna (Kircher) Springweiler, Erwin Frederick Springweiler served an apprenticeship as a worker in metals before he became a sculptor. He was born at Pforzheim in the Black Forest of Germany, a town famous for the making of jewelry, on January 10th, 1896, and when he was old enough was sent to the school of arts and crafts in his native town. In spite of his father's opposition to an artist's career, he determined to become a sculptor. No sooner had he gone to Munich and enrolled at the academy for study with the sculptor Hermann Hahn than the First World War broke out and interrupted his studies. When the war was over, he resumed his trade as a metalworker but continued to study sculpture, with Fritz Wolber as a teacher.

In 1922 he left Germany and went to Havana, Cuba, to join relatives. There he spent two years, modeling chiefly portraits. Then he came to New York and furthered his professional education by attending the Beaux-Arts Institute of Design. His special abilities brought him many orders to design metalwork for public buildings, and it was because of this expert knowledge that he was employed by Paul Manship and Herbert Haseltine to put the finishing touches on bronzes. Before his arrival in this country Springweiler's work had been in a modified realistic vein, with a lyric sweep of line. Gradually he began to eliminate detail and concentrate attention on major elements of form. *Icarus*, modeled in 1933, boldly launched in an arc in mid-air, was the first figure to show this new approach.

Under the auspices of the Federal Works Agency he modeled three reliefs of prehistoric pachyderms, designed by Charles Knight, for the Pachyderm House in the zoological gardens at Washington, D.C. They were well liked, and the sculptor was asked to model a statue of a great anteater to be placed in front of the Small Mammal House. His *Mountain Goats*, erected in the

court of the Federal Building at the New York World's Fair, showed a male goat standing guard on a cliff above a mother and baby. Their bodies were designed in blocky forms that echoed the angular shapes of the rock. Other works were designed for post offices under the government-sponsored fine arts program from 1937 to 1940. A relief of William Penn in bronze and aluminum was installed at Chester, Pennsylvania; a granite *Eagle*, keeping a fierce aspect in spite of simplified forms, in the Highland Park branch at Detroit, Michigan; and a decorative *Bird Hunt* carved in relief from mahogany at Manchester, Georgia. In 1949 a bronze *Bull* won the Avery Prize given by the Architectural League for small sculpture and *Cubs at Play*, the Anna Hyatt Huntington Prize of the National Academy of Design.

Animals are Springweiler's favorite models, and from a study of natural forms he chooses postures or groupings that allow interesting arrangements of masses and planes. Peccaries; tiger cats; a mother bear rising, snarling, to protect a cub caught in a trap; and cubs at play have been among his subjects. He likes to keep his compositions moving by combining animals facing in different directions or with bodies interacting for varied pattern. Detail is reduced to a minimum in order to allow surfaces to flow smoothly and to leave the emphasis on volume and broad planes. *Doves on Perch* was awarded the Speyer Prize of the National Academy of Design in 1959. Skill in modeling the human form was demonstrated in *Young Mother*, a seated figure monumental in conception but warmly tender in expression.

Ability to abstract combined with experience in metalworking gave him special advantages as a medalist. For this phase of his work he was awarded the Lindsey Morris Memorial Prize by the National Sculpture Society in 1937. The same year he was elected a fellow of the Society. His medal for the 1941 issue of the Society of Medalists was dedicated to intrepid explorers of the North and South Poles, the heroic character of their exploits emphasized by scenes of the polar regions, snowy wastes and ice floes inhabited only by polar bears and penguins. He designed for the United States Government the Naval Reserve and George M. Cohan Congressional gold medals, and in 1947, one struck in honor of Brigadier General William Mitchell, founder of the air force. In a medallion entitled *Carpe Diem*, Springweiler made bold use of foreshortening to depict the onrushing horses drawing the chariot of the sun god.

Several summers were spent working at the MacDowell Colony, Peterborough, New Hampshire, where the sculptor also turned to painting as a medium of expression. For some years Springweiler was an industrial designer. When he retired in 1961 he used this experience to adapt streamlined designing to his own creative work. He says, "I experimented for some time in this way in my sculpture to the point of abstract and for this, as material I

Mussolini to be e
model. Although
was so favorably i
made it possible fc

The sculptor a
new public held a
Since it attracted l
Jersey, where at
making silver jew
demand that he w
gal Alley that had
and silver jewelry
compelled to mov
seen and admired
ment. At this jun
Street so that he
work on a small s

Manca applies
meticulous crafts:
which they can
Sleeping Girl, w:
Artists of Americ
snarling, an intric
the fringe of hair
Association, Phil:
ceived the Speyer

For the East (
1961, to those wh
an eagle swoopin
waves; the upswe
speed and power.
National Academy
in bronze, chisele(
was adopted as tl
tional Trust for H

In Verazzano F
portrait of the na\
modeled a gate t(
Flushing Meado\
grounds into a de
When The An

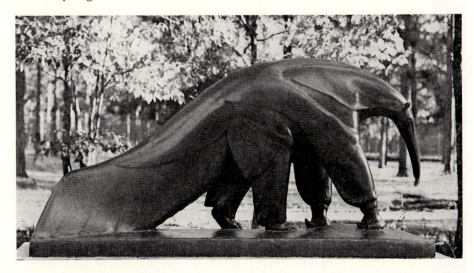

GREAT ANTEATER

Bronze statue. Height 2 ft. 9 in. Base: Length 5 ft. 8 in.—Width 1 ft. 9 in. Signed on base at right: SPRINGWEILER Founder's mark: MODERN ART FDRY NY Placed in Brookgreen Gardens in 1949.

used wood. . . . I choose a nice piece of wood and develop the form, using accidental growth and color in the design; often [I] add bright metal pieces." [1] He also works in ceramic.

The National Arts Club gave him a medal of honor in 1956 and their sculpture prize ten years later. He was elected an academician of the National Academy of Design in 1967. His home and studio are at Carinthia Heights, near Wyandanch, on Long Island.

Great Anteater

The animal is walking forward, back curving in a shallow arch from the tip of the long nose to the end of the heavy tail, with long fringes sweeping the ground. While faithfully recording the creature's build and the impression of unhurried persistence in its measured progress, the sculptor has simplified his treatment of the fur as it lies in wavy drifts. Broad, flowing planes are defined by ridges, and the free edges are lightly indented to suggest masses of hair. The strange, elongated shape and the smooth, enveloping coat have been utilized in a pleasing combination of line and form.

When sculptured decorations for the zoological gardens at Washington,

1 Letter of July 10th, 1967.

D.C.
statu
direc
The
Bron
livin
can l
minc
worl
sens
versi
anim

Al

ALF
son c
worl
servi
enter
with
bran
lost-
later
Rom
visit
patr
Italy
E
tion
worl
succ
time
Italy
plac
time
oppo

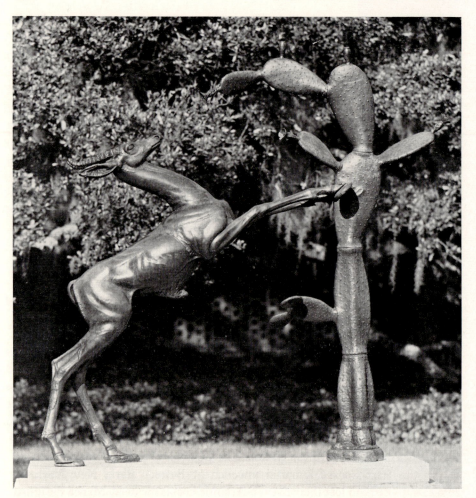

GAZELLE AND CACTUS

Bronze group on marble base. Height 5 ft. 11 in. Base: Length 5 ft. 7 in.—Width 1 ft. 9½ in. Signed on base beside left hind leg: A. MANCA Founder's mark: ROMAN BRONZE WKS. INC. Placed in Brookgreen Gardens in 1950.

in 1967, it was in recognition of his excellence in medallic art. He is the author of the official medal of the Vatican Pavilion at the New York World's Fair of 1964, which had Michelangelo's *Pietà* on the obverse and portraits of Popes Paul VI and John XXIII on the reverse. He again portrayed Paul VI on medals struck to commemorate the Pope's gift of the papal tiara to Cardinal Spellman in recognition of American charity and his visit to the United Nations on a peace mission in 1965. Manca has created a series called *Masterpieces in Medals* on each of which he has represented a great artist

and his most famous work, beginning with Leonardo da Vinci's *Mona Lisa*. Manca is a fellow of the National Sculpture Society and a member of the National Academy of Design.

Gazelle and Cactus

A gazelle rears on its hind legs, both forefeet braced against a tall thick stalk of prickly pear. The topmost branch bends towards its head, raised on a long neck. The straight line of this flowering branch is continued in the head and long horns, with ears laid parallel. The animal's slim body is modeled with great variety of delicate detail. Muscles are edged with narrow rows of incised lines or irregular locks in low ridges; beneath the body longer hair hangs in a mass of coarse locks. The cactus is patterned with equal care, thickly covered with spiny dots and the older part at the bottom given a coarser texture. The gazelle's horns and the cactus buds are gilded. The idea was developed, cast in small size, and enlarged while the artist was working at Rome. It was exhibited at the World's Fair, New York, in 1939 and awarded the medal of honor by the Allied Artists of America in 1943.

Katharine Lane Weems

KATHARINE WARD LANE was born in Boston, Massachusetts, on February 22nd, 1899, the daughter of Gardiner Martin and Emma Louise (Gildersleeve) Lane. She received her early education at the May School. In addition to studies at the school of the Boston Museum of Fine Arts, she had instruction from Charles Grafly, Anna Hyatt Huntington, and Brenda Putnam. She had completed a *Black African Rhinoceros* by 1921 and by 1924 began to exhibit. Two years later her *Pygmy African Elephant* won a bronze medal at the Philadelphia Sesqui-Centennial Exposition and the Boston Museum of Fine Arts acquired an example. In the next year, at the Pennsylvania Academy exhibition, the Widener Memorial Gold Medal was given to *Narcisse Noir*, a statuette of a whippet. Both the Boston Museum and the museum at Reading, Pennsylvania, own examples of this bronze. Fourteen works were shown at Boston in 1928. In addition to greyhounds and whippets, she has often portrayed horses, among them *Seaton Pippin* and the Clydesdale stallion *Lord Monstone*, for which the Joan of Arc Gold Medal of the Na-

tional Association of Women Painters and Sculptors was given her in 1928. Three years later their Anna Hyatt Huntington Prize was awarded for *April*, a study of a goat. Her work has also been given honorable mention at the Paris *Salon* in 1928, the Barnett Prize of the National Academy of Design in 1932, and the Avery Prize of the Architectural League in 1942.

In *From Clay to Bronze*, a motion picture produced by the University Film Foundation for the Boston Museum of Fine Arts in 1930, she demonstrated the processes of sculpture, showing the creation of *Dark Warrior*. In 1933 she finished three friezes and some thirty individual animals carved directly in the brick on The Biological Laboratories at Harvard University in a technique based on Chinese tomb carvings of the Han Period, and the following year completed three doors for this building. Later she modeled two large bronze statues of an Indian rhinoceros to be placed at each side of the entrance. Her early realistic work showed an instinct for design, while later creations such as the *Bear* for the Spee Club, Harvard University, a *Stretching Antelope*, and the dog of the Lotta Fountain, Boston, have an increased simplification into definite planes with resulting decorative values.

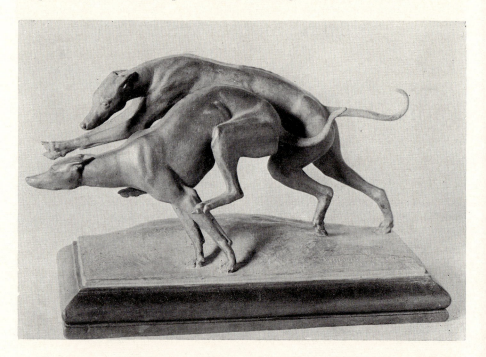

GREYHOUNDS UNLEASHED

Bronze group. Height 10 in. Base: Length 1 ft. 3½ in.—Width 7 in. Signed on base at right: KATHARINE W. LANE.~1928~ © Founder's mark: ROMAN BRONZE WORKS N-Y- Placed in Brookgreen Gardens in 1934.

In 1947 she married F. Carrington Weems and subsequently lived in New York, spending summers at Manchester, Massachusetts. Her special gift for revealing artistic values in natural forms brought her signal honors, and her animal sculpture continued to win prizes. *The Guardians*, a study of two dogs quietly alert, received the National Arts Club's gold medal for sculpture in 1961, and *Bee Sting*, a dog with back smoothly rounded as he licks a front leg, the Speyer Prize of the National Academy of Design two years later. Her *Kangaroo* was acquired by the Pennsylvania Academy and *Greek Horse* by The Baltimore Museum of Art. Another work was purchased by the Glenbow Foundation at Calgary, Canada. She gave a collection of her animal sculpture and drawings to the Museum of Science at Boston; the group consists of forty works, selections from which are shown in rotation in a special gallery opened in 1965.

The sculptor's feeling for design has been effectively used on medals. The United States Government commissioned from her the Legion of Merit Medal and the Medal for Merit. For the Massachusetts Institute of Technology she made the Goodwin Medal. In 1960 her theme for an issue of the Society of Medalists, "God Made the Beasts and Every Winged Fowl," gave her an opportunity to represent an American mountain lion on one side and geese flying through clouds on the other; it was awarded the Saltus Medal of the National Academy of Design and the Lindsey Morris Memorial Prize of the National Sculpture Society the same year.

Mrs. Weems served on the Massachusetts State Art Commission from 1941 to 1947 and on the council of the National Sculpture Society, of which she is a fellow. She is also a member of the National Academy of Design and the National Institute of Arts and Letters as well as many other societies connected with the arts.

Greyhounds Unleashed

Two greyhounds are racing side by side, one rising on the forefeet, the other on the hind feet. Their heads are outstretched and their bodies rise in unison as they surge forward in a burst of speed.

Whippet

A whippet is worrying a piece of cloth held between its forefeet. The curve of the haunches and the arched neck are brought to a rectangle by the folded

cloth. This statuette, done in 1925, won first prize at the National Junior League exhibition, New York, in 1927.

Bronze statuette. Height 8½ in. Base: Length 1 ft. 1¾ in.—Width 4 in. Signed on base: KATHARINE W. LANE. Founder's mark:—·KUNST FOUNDRY· N-Y. Placed in Brookgreen Gardens in 1934. Other example: Boston, Mass. Museum of Fine Arts.

Doe and Fawn

A doe is standing as her fawn feeds, its sprightly body filling the space beneath her with contrasting angles.

Bronze group. Height 11½ in. Base: Length 10 in.—Width 5 in. Signed on base at right: KATHARINE W. LANE At end: 1927 Founder's mark: ROMAN BRONZE WORKS N-Y- Placed in Brookgreen Gardens in 1934.

Circus Horse

A heavily built horse is dancing, the neck arched, the head reined in by straps from bit to girth. The clipped mane, thickly feathered fetlocks, and clubbed tail are gilded. The pompon and the ribbon binding the tail are red. It was awarded the Speyer Prize at the National Academy of Design exhibition in 1931.

Bronze statuette. Height 1 ft. 6 in. Base: Length 2 ft.—Width 7¼ in. Signed on base: KATHARINE W. LANE At end: 1930 Founder's mark: © GHLO GORHAM CO. FOUNDERS CIRE PERDUE Placed in Brookgreen Gardens in 1936.

Gertrude Katherine Lathrop

GERTRUDE KATHERINE LATHROP, daughter of Cyrus Clark and Ida Frances (Pulis) Lathrop, was born at Albany, New York, on December 24th, 1896. Mrs. Lathrop was a painter of landscapes and still life. Another daughter, Dorothy Pulis Lathrop, is a painter and a writer and illustrator of children's books. The three artists shared a studio in the family home at Albany. Miss Lathrop studied at the Art Students' League in 1918 with Solon Borglum and at his School of American Sculpture from 1920 to 1921. She also, in the summer of 1925, had instruction from Charles Grafly at

Gloucester. Studies of animals, particularly young creatures, have been her specialty, though her work includes many portrait busts and reliefs. She exhibited first in 1921 at the National Academy of Design, and in 1924 received honorable mention from The Art Institute of Chicago for *Nancy Lee*, a kid, an example of which is in the National Collection of Fine Arts, Washington, D.C. *Banjo*, a horse in bronze, was in the tack room of Troop B, 121st Cavalry, at Albany until the cavalry was disbanded.

The Anna Hyatt Huntington Prize of the National Association of Women Painters and Sculptors was awarded in 1933 to *King Penguin*, which has a flourish of swinging line, with touches of patterning at the edge of the body and the lifted wings. Pairs of this model have been used on gateposts at Locust Valley, Long Island, and Beverly, Massachusetts. *Young Lamb*, the uncertainty of the newborn animal, the bony shape and nubbly fleece charmingly rendered, was given the Speyer Prize of the National Academy of Design in 1936; the next year it took the Crowninshield Prize at the Stockbridge Art Exhibition. Fondly amused by the oddities of pets, she has portrayed an Abyssinian guinea pig and has often used as models the Pekingese that she and her sister raise, since she delights in the natural patterns in which their softly waving hair lies. A study of a puppy won the gold medal of the American Artists Professional League in 1950, and in the same year the sculptor received the Lindsey Morris Memorial Prize of the Allied Artists of America. A recent work is the head of another pet, an Afghan hound with handsome fringes of silky hair. A pair of flying squirrels, jewel-like in their miniature perfection and appropriately cast in solid silver, is in the collection of the Albany Institute of History and Art.

She has written, "I think that I chose to model animals because of their infinite variety of form and texture and their great beauty, for even the homeliest of them have beauty, yes, even the wart hog with his magnificent tusks." [1] From curly fur and smooth feathers she extracts lilting line and sweeping contours, dashingly modeled. The American Academy of Arts and Letters gave her a grant in 1943, and the National Institute of Arts and Letters elected her a member.

Portraits of children, such as the relief of Anna Eleanor Dall, show the same liking for the subject and the decorative values of features and hair. A head of a woman, *Elizabeth*, won the gold medal for sculpture at the 1951 exhibition of the American Artists' Professional League. She designed a flagpole with low reliefs of marching soldiers as a World War Memorial for Albany in 1933 and a wrought-iron grille for the Detroit Public Library.

Miss Lathrop's rigorous sense of design, carried out with a delicate touch and enlivened by a fertile imagination, lent itself to medallic art. Her models

1 Lathrop. p. 8.

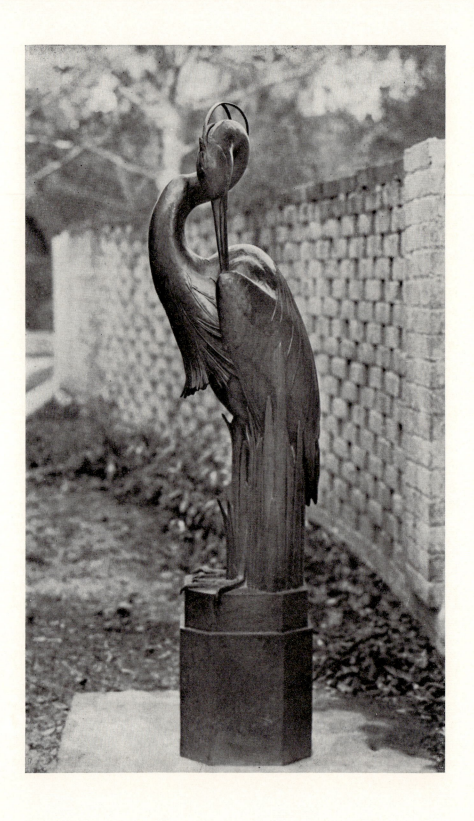

were chosen for half dollars, one for Albany in 1936 commemorating the two hundred and fiftieth anniversary of the granting of the charter, and one for New Rochelle in 1937, commemorating the two hundred and fiftieth anniversary of the settlement of the city in 1688. Two medals for the Garden Club of America gave her an opportunity to develop graceful flower shapes. Because of the excellence of the Cervantes Medal for The Hispanic Society of America, she was made a corresponding member of the Society and awarded the Sorolla Medal. Commissions for other medals came from the Mariners' Museum at Newport News, Virginia, and the National Steeplechase and Hunt Association. The subjects of medals for the Hall of Fame were, appropriately, Agassiz and Audubon. She received the Lindsey Morris Memorial Prize of the National Sculpture Society in 1944, and The American Numismatic Society, of which she is a member, awarded her the J. Sanford Saltus Medal in 1950 for her medallic work. In 1954 she and her sister moved to a studio at Falls Village, Connecticut, that had once belonged to Ezra Winter. She is on the Advisory Board of the Society of Medalists, a fellow of the National Sculpture Society, and a member of the National Academy of Design.

Great White Heron

A heron stands in a clump of reeds, pecking under one wing. The breast feathers make a fringe above the legs, and the two feathers of the crest are arched over the bent neck. This statue won the Shaw Prize at the winter exhibition of the National Academy of Design in 1931. The sculptor has combined two of these handsome birds in another work, *Great White Heron Fountain.*

Bozie

A French bull terrier puppy is seated with head lifted and ears raised.

Bronze statuette. Height 12½ in. Diameter of base 8¾ in. Signed on base at back: G. K. LATHROP Sc. © 1926 Founder's mark: R.B.W. Placed in Brookgreen Gardens in 1934.

GREAT WHITE HERON

Benedict nickel statue. Height 4 ft. 1 in. Signed on base at back: G. K. LATHROP. © Founder's mark: THE GORHAM CO FOUNDERS Placed in Brookgreen Gardens in 1935. Other example: New York. Cosmopolitan Club (marble).

Saluki

The Persian gazelle hound, Sag Mal Haroun-al-Raschid of Kayenne, stands squarely on four feet, the head lifted. The body is smooth, but the tail and ears are finely feathered, and there are tufts of hair on the legs. The mound under his front feet is patterned with flowers.

Bronze statuette. Height 1 ft. 8½ in. Base: Length 1 ft. 6½ in.—Width 8½ in. Signed on base at back: G. K. LATHROP. © 1928. Founder's mark: ROMAN BRONZE WORKS N-Y- Placed in Brookgreen Gardens in 1938.

Sammy Houston

A baby donkey is standing, one hind foot advanced and the tail lifted. It won the Barnett Prize at the winter exhibition of the National Academy of Design in 1928 and honorable mention at the exhibition of the National Association of Women Painters and Sculptors in 1930–1931.

Bronze statuette. Height 1 ft. 3¼ in. Base: Length 10¼ in.—Width 4⅞ in. Signed on base at left: G. K. LATHROP. © 1925 At left end: –1928– At right end: SAMMY HOUSTON Founder's mark: GORHAM CO FOUNDERS OGEX Placed in Brookgreen Gardens in 1934. Other examples: Albany Public Library. Children's Room; Houston, Tex. Public Library. Children's Room.

Fawn

A slender fawn stands, drawing slightly back, four feet spread and head lowered.

Bronze statuette. Height 7¾ in. Base: Length 6⅝ in.—Width 4¼ in. Signed on base at back: G K Lathrop © 1928. Founder's mark: GORHAM CO FOUNDERS OGEZ Placed in Brookgreen Gardens in 1937.

Conserve Wild Life

On one side a pronghorn kneels in front of a large cactus plant in flower.

On the other, a wood duck stands towards the right with head turned back, smoothing its feathers. Fern fronds uncurl below and behind it. Above is the legend, CONSERVE WILD·LIFE. In low relief, these subjects are decoratively modeled with clear silhouettes and delicate details edging the simple main forms. The subject was chosen by the sculptor for the eighteenth issue

of the Society of Medalists in 1938 as a plea for renewed efforts to prevent the extinction of birds and animals now surviving in greatly reduced numbers. Two species threatened with extinction but saved by prompt action are represented. This medal received the Anna Hyatt Huntington Prize for Sculpture from the National Association of Women Painters and Sculptors in 1943 and an award from the Allied Artists of America in 1964.

Bronze medal. Diameter: 2⅞ in. Signed on reverse at lower right: G K LATHROP ©
Founder's mark: THE SOCIETY OF MEDALISTS EIGHTEENTH ISSUE 1938—GERTRUDE K.
LATHROP, SCULPTOR MEDALLIC ART CO. N.Y. BRONZE Presented to Brookgreen Gardens by the sculptor in 1946.

Brookgreen Gardens Medal

On the obverse a Carolina parakeet is perched on a magnolia seed head, extracting seeds. The downturned head and tail swing the body to conform to the circular shape of the medal. Around is the legend, BROOKGREEN GARDENS.

On the reverse a stag is couched with the antlered head turned to look backward. At each side, the space is filled by a magnolia seed head and flower. This medal won the gold medal of honor for sculpture given by the Allied Artists of America in 1965.

Bronze medal. Diameter 3 in. Signed in exergue: G. K. LATHROP Founder's mark: Medallic Art Co. N.Y. BRONZE Placed in Brookgreen Gardens in 1965.

Marion Branning

MARION BRANNING graduated from the Rinehart School of Sculpture, Baltimore, in 1929. While a student she won two scholarships for European travel. She has taught modeling, jewelry, and metal work at the Maryland Institute.

Doe

A doe is lying with a sleeping fawn curled between her forelegs. With lifted head she gazes down at it. The forms are modeled in broad planes.

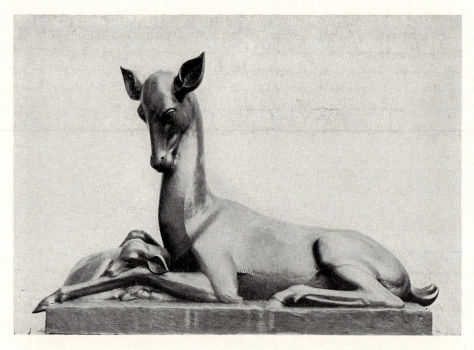

DOE

Bronze statue. Height 2 ft. 6¼ in. Base: Length 3 ft. 6 in.—Width 1 ft. 3 in.
Signed on base at back: *Marion Branning* Placed in Brookgreen Gardens in 1936.

Bruce Moore

ONE OF THOSE expert animal sculptors who have received their early
training from Albert Laessle, E. Bruce Moore was born at Bern, Kansas, on
August 5th, 1905, the son of Elmer Bowdle and Edna Browning (Wooten)
Moore. He attended The Pennsylvania Academy of the Fine Arts from 1922
to 1926, where he studied with both Laessle and Grafly and received the
Cresson Traveling Scholarship in 1925 and 1926. He was also elected to the
Fellowship of the Academy. Moore returned to Wichita, Kansas, to practice
his profession and to teach at the Wichita Art Association for two years, until
a Guggenheim Fellowship awarded in 1929 and again in 1930 enabled him
to pursue his creative work at Paris. There he had some criticisms from Cecil
Howard. He returned to Wichita for a time and then worked as an assistant in

the Westport, Connecticut, studio of James Earle Fraser. The city of Wichita contains many of his early works: portrait busts at the Consistory and the Medical Society, and sculptural designs and terra-cotta decorations on a high school. A *College Girl* was modeled as a scholarship trophy for the Women's Pan-Hellenic Council, Kansas State College.

Moore spent two years at Rome before opening a studio in New York. In 1943 he received a grant from the National Institute of Arts and Letters. He was director of the Rinehart School of Sculpture at Baltimore for a year before entering the United States Army to serve from 1943 to 1945. He returned to New York and later moved to Washington, D.C. His bronze statue of Brigadier General "Billy" Mitchell stands in the Air Museum of the Smithsonian Institution. Moore was the sculptor for the Honolulu World War II Memorial, on which a statue of a woman holding a laurel branch stands like a figurehead on the suggested prow of a Navy carrier.

In his animal sculpture he has developed a spirited and decorative style peculiar to himself. His attenuated black panther, which won the Widener Gold Medal of the Pennsylvania Academy in 1929, arches its back in rage, while the hair falls into wavy fringes along the outlines of the body. There are examples in the Whitney Museum of American Art, New York, and The Wichita Art Museum.

In the *Pelican Fountain* the feathers are translated into original patterns. This decoration is no conventional treatment derived from historic schools of art but one suggested by the creature's own covering of fur or feathers. With it goes a sly humor which animates birds and animals with sportive life. A pair of tigers, heroic in scale, is to be cast in bronze for Princeton University. His sketches of animals, begun at the Bronx zoo and continued at Washington, have an equal vitality of line. One of his prints, *White Lily*, has been acquired by the National Collection of Fine Arts, Washington, D.C.

Since his lucid, animated drawings were effective when transferred to glass, Steuben Glass chose him to design a number of pieces. His *Aerialists* on a vase give an illusion of acrobats flying in space. Animals continue to be favored subjects for this medium: *Ngatuny*, a lion leaping after native spears-men, and *Chui* a leopard. An elephant is represented in low relief on a thick slab of glass cut in the shape of the animal. Poetic concepts are *Moth and Flame* and also *The Dragonfly*, to illustrate a poem by Louise Bogan. Western subjects are a *Rain Dance* and a group of three bowls with typical animals of the plains, the prairie, and the woodlands.

This interest in Western scenes is again apparent in the design of the Walter Beech Memorial Doors for the Wichita Art Association. The theme is the prairie, with an Indian ghost dance and a buffalo herd on one panel, and a pioneer and antelopes on the other. The sculptor stated his intention in his

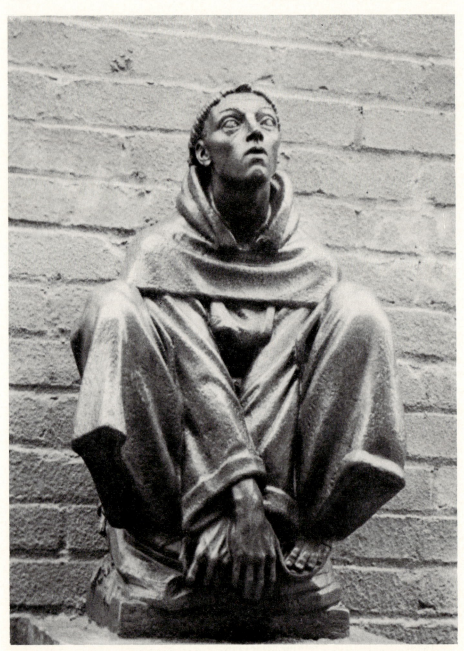

SAINT FRANCIS

Bronze statue. Height 2 ft. 1¾ in. Base: Width 11¾ in.—Depth 9¼ in. Signed on
base at back: 1936 WESTPORT #2 BRUCE MOORE Placed in Brookgreen Gardens
in 1948. Other example: The Wichita Art Museum.

own words, "The open spacing and rhythmic patterns emphasize the spacious grandeur and nostalgic moods of these great grass lands." [1] The Osgood Hooker Memorial Doors, in bronze, have been installed in the south tower of Grace Cathedral, San Francisco, and another pair is in progress for the north tower.

Moore is also an accomplished medalist, and for this phase of his art he received the Saltus Medal of The American Numismatic Society, of which he is a fellow. He designed the Campbell Medal for the Division of the Blind at the Library of Congress, the Samuel F. B. Morse Medal of the National Academy of Design, and the Wichita Art Association medal of honor, which he himself received. He is a fellow of the National Sculpture Society and a member of the National Academy of Design and the National Institute of Arts and Letters.

Saint Francis

Saint Francis, deep in self-forgetful contemplation, is squatting with both knees doubled up, his arms hanging between them, hands crossed. His eyes are turned upward, brows furrowed and lips parted in a rapt expression. The ascetic face is bony and hollow cheeked, with long nose and large eyes. The dropped cowl covers his shoulders and frames his head, while the heavy habit falls in loose folds from the bent knees. The hands are lean and muscular. There is in the whole figure an intenseness of life which reveals a high quality of imagination. The original work was designed for The Friends of Art, Wichita, Kansas, as a memorial to L. W. Clapp, the example at Brookgreen being the only other cast. This work was awarded the Helen Foster Barnett Prize at the National Academy of Design exhibition in 1937.

Chico

A monkey crouches on its forelegs, forefeet together, watching a grasshopper. The haunches are lifted, and the curve of the back is continued by the tail, which ends in a curl. The animal is tense with curiosity. The irregular curves of the head, the shaggy hair and frilled edges are modeled in baroque rhythms. This statuette was created at Wichita, Kansas, in 1927.

Bronze statuette. Height 10 in. Base: Length 1 ft. 2½ in.—Width 6½ in. Signed on base at back: o 19– BRUCE MOORE 27 o Founder's mark: GARGANI FDRY. N.Y. Placed in Brookgreen Gardens in 1936.

1 Wichita art association. *Commemorative issue, 1920–1965.* [Wichita, Kansas, 1965] p. 4.

Pelican and Fish

A pelican is huddled on a rock, head thrown back, a fish clutched in the bill. The grotesque posture, with the feet turned inward, the tail spread against the rock, and the neck swelling above the slightly lifted wings, together with the triumphant gleam in the eyes, is amusingly rendered. Decorative use is made of the varying texture of skin, feathers, and bill. This work, begun in 1934 and finished in 1935 at New York, was awarded the Speyer Prize of the National Academy of Design in the latter year. It was designed as a memorial to Mrs. C. A. Sloan and placed in a small park at Pratt, Kansas, as a public fountain. The one at Brookgreen is the only replica.

Aluminum statue. Height 3 ft. 6 in.—Diameter of base 1 ft. 3½ in. Founder's mark: THE GORHAM CO FOUNDERS Placed in Brookgreen Gardens in 1936.

Dolphin

The dolphin is sliding down the crest of a wave accompanied by flying fishes, the bubbles rising along its sides. The patterning of the scales on the long oval of the body is marked by crosshatching. The sculptor started work on the *Dolphin* while he was at Paris on a Guggenheim Fellowship; it was completed at Westport, Connecticut, in 1935 and two examples cast.

Bronze statuette. Height 1 ft. 3¼ in. Base: Length 4¾ in.—Width 4½ in. Signed on base at back: BRUCE MOORE Ⓒ Founder's mark: GARGANI FDRY. N.Y. Placed in Brookgreen Gardens in 1936.

Gaston Lachaise

GASTON LACHAISE was born at Paris on March 19th, 1882, the son of Jean and Marie (Barré) Lachaise. His father, a cabinetmaker who had come from Auvergne, started him on the road to craftsmanship by entering him in the École Bernard Palissy when he was thirteen. He studied there for three years, his teachers being Moncel and the director, Aubé, before he went to the École des Beaux-Arts, working in the *atelier* of Gabriel Jules Thomas. He attributed a more lasting influence to the hours he spent in the Louvre. Meeting

his future wife, an American girl who became the directing force in his life and art, he decided to come to America and set out to earn money for the trip. He accomplished his aim by working a year for René Lalique, adapting flower and plant forms to the *art nouveau* style of decoration then in vogue. On January 13th, 1906, he arrived at Boston and, after some other efforts, found work in the studio of Henry Hudson Kitson for a period of seven years. While he was engaged in modeling uniform trimmings for Kitson's Vicksburg Monument and the ornament on the Irish harp of the Patrick Collins Memorial, he began to evolve some original works in his own studio, sensing in the new country a vigor and forceful impulse to creation which he had not felt before. Kitson moved to New York and, after finishing some work for his employer, Lachaise followed in 1912.

In a small studio he worked out his own ideas and began to envisage his conception of Woman as a cosmic force. Recognizing his skill as a craftsman, Manship employed him in carrying out some of his highly finished ornamental designs, such as that on the pedestal of the *Nymph and Centaur* and the border of the Morgan plaque in the Metropolitan Museum. In 1913 Lachaise married Isabel Nagle and exhibited a few of his figures in clay at the Armory Show. A one-man exhibition in 1918 and reproductions of his work in *The Dial* began to foster a cult for his more personal work among the intelligentsia. His success as Manship's assistant brought him several commissions for decorative work, two peacocks for the Deering Estate, Miami, Florida, a frieze of singing and dancing boys for the American Telephone and Telegraph Building, New York, and panels of the four seasons for the house of the architect, Welles Bosworth, at Locust Valley, Long Island. *Dolphins*, leaping through a wave-crest, and a *Seal* embodied the flowing curves in which he delighted.[1] His *Sea Gull* was erected as a United States Coast Guard Memorial in the National Cemetery at Arlington. When Rockefeller Center was being built he tried architectural sculpture on a large scale with panels for the Radio Corporation of America and International Buildings. In 1923 he moved his residence from New York to Georgetown, Maine.

Keeping pace with these commissions came the embodiment of his own visions. He says, " 'Woman,' as a vision sculptured, began to move, vigorously, robustly, walking about lightly, radiating sex and soul." Such are the standing figures which were begun in 1912 and continued through the next

1 Examples of the *Dolphins* are owned by the University of Nebraska; The Hackley Art Gallery, Muskegon, Michigan; and the Whitney Museum of American Art; the *Seal* is in the Whitney Museum of American Art and the Phillips Memorial Art Gallery, Washington, D.C.

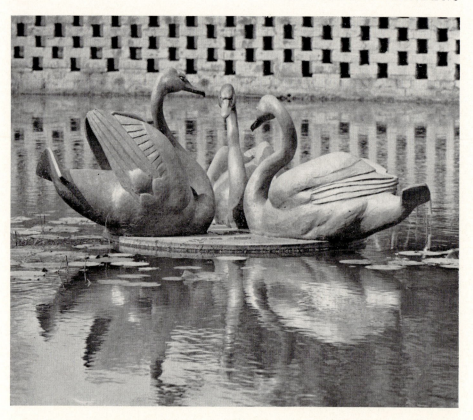

SWANS

Aluminum group on bronze base. Signed on base: G. LACHAISE © 1931 Placed in Brookgreen Gardens in 1938.

decade. To the sculptor the heavy torso with pendulous breasts and enormous hips, poised on slim legs tapering to narrow ankles and tiny feet, was a symbol of fertility and power. Of a huge reclining figure in stone intended to surmount a hill, which fulfills Gaudier-Brzeska's dictum "Sculpture is the mountain," he writes, "Soon she came to forceful repose, serener, massive as earth, soul turned toward heaven, 'La Montagne'!" Still other figures in the round and in relief shown as floating in the air "entirely projected beyond the earth, as protoplasm, haunted by the infinite, thrust forth man, by means of art, toward the eternal." [2] In earlier figures, such as the *Aphrodite* in The Toledo Museum of Art, his concern is with the graceful play of long curving lines and rounded forms, not unlike those with which Nadelman was experimenting. A *Standing Woman* is in the Whitney Museum of American Art, *Walking Woman* in the Honolulu Academy of Arts, and *La Force Eternelle*

2 Lachaise. p. XXIII.

in The Smith College Museum of Art. Later he turned his attention to problems of relating exaggeratedly heavy masses such as those of the colossal torso in the Museum of Modern Art, New York.

His work echoes his expressed enthusiasm for the steatopygous figurines of prehistoric sculpture and the voluptuous shapes and formal gestures of Hindu goddesses, but to the contemporaries whom he admired, Lehmbruck, Epstein, and Brancusi, there is no recognizable debt. Heads of women with brooding expressions avoid regular beauty; the heavy features are broadly modeled, the hair treated in large masses, eyes and mouth defined with undulating lines. They initiated a type widely copied. In contrast, some vital portrait heads such as that of John Marin in the Boston Museum of Fine Arts and one of Marianne Moore in The Metropolitan Museum of Art, New York, are incisively modeled with brisk strokes. His apotheosis of woman with a companion man was embodied in a monument for Fairmount Park, Philadelphia, only the sketch for which was completed at the time of his death in New York on October 18th, 1935. Retrospective exhibitions of his work were held in that year at the Museum of Modern Art, New York, and in 1963 at the Los Angeles museum.

Swans

Three swans are floating in a circle, facing each other, the wings of one lifted, the others at rest. The forms are modeled with little detail, the wing feathers suggested by a few parallel lines. The smooth bodies and curving necks make a graceful pattern. Modeled between 1930 and 1935, the group was originally commissioned for the garden of Philip Goodwin at Locust Valley, Long Island.

Robert Laurent

ROBERT LAURENT was born at Concarneau, France, on June 29th, 1890, the son of Louis and Yvonne (Fraval) Laurent. A budding talent was detected by Hamilton Easter Field, painter and writer, who brought Laurent to New York with his whole family when he was twelve years old and supervised his education. He had access to the varied art collection which Field's catholic tastes had assembled and in 1907 went to Rome with Field and Maurice

Sterne. The instruction which he received from them was supplemented by work at the British Academy and by an apprenticeship to Giuseppe Doratori, wood carver and frame maker. He also studied at Paris with Frank Burty before returning to Brooklyn in 1910 and making frames for artists. During 1917 and 1918 he enlisted in the United States Navy Aviation Corps and went to France as an interpreter.

His friends' discoveries of the qualities of Negro, primitive, and Eastern sculpture left their impress on his work, eclectic in its search for new combinations of forms. His first carvings were decorative panels of Brooklyn Heights scenes for a room in the Field house. Before he died in 1922 Field deeded his estate to Laurent. In flower and plant shapes carved from wood he achieved a variety of curving, flamelike compositions. One of these, *Water Plant*, took the Logan Purchase Prize in Applied Arts of The Art Institute of Chicago in 1924. From birds and animals, too, he derived a number of sleek, ornamental forms. A *Duck* is in The Newark Museum and the Whitney Museum of American Art; a *Pigeon* is owned by Vassar College. Primitivism finds its reflection in certain reliefs of human figures among trees or in panels of single figures. Various carvings in alabaster are made up of voluminous rounded forms in compact masses with traces of Oriental conventions in the features and decorative passages. *The Wave* and *The Bather* are in the Brooklyn Museum; *Salome* in the art museum at Indiana University. The sculptor likes to carve in alabaster because its translucence gives it a vibrant quality and says, " 'I have always preferred cutting direct in materials having an irregular shape." [1]

Later work, dealing with the human form, took on a monumental character. In his desire for vital expressiveness, he abandoned ingratiating curves for abrupt transitions, mannered features, and angular postures. His *Goose Girl* in aluminum was commissioned for Radio City Music Hall in 1932. *The Awakening*, a girl rousing, and *Kneeling Figure*, which won the Logan Purchase Prize of The Art Institute of Chicago in 1938, were acquired by the Whitney Museum of American Art.

Sculpture for the Treasury Art Projects was *Shipping*, a limestone relief for the Federal Trade Commission Building, Washington, D.C., and *The Transportation of the Mail* for the Garfield, New Jersey, post office. One of the groups made for Fairmount Park, Philadelphia, by the Samuel bequest was entrusted to him. Entitled *Spanning the Continent*, it consists of a pioneer man and woman putting their shoulders to a wheel.

Laurent taught at the Art Students' League, The Brooklyn Institute of Arts and Sciences, the Corcoran Art School, Washington, D.C., and Vassar College before going to Indiana University as professor of fine arts in 1942.

1 Kent. *Robert Laurent.* p. 47.

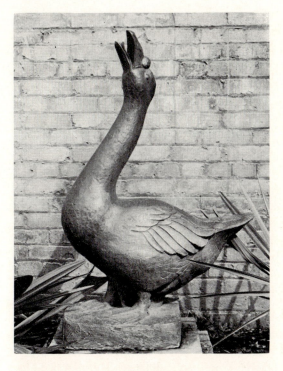

GOOSE

Bronze statue. Height 3 ft. 5 in.
Base: Length 1 ft. 3½ in.—
Width 11½ in. Placed in Brook-
green Gardens in 1936.

From 1954 to 1955 he was artist in residence at the American Academy in Rome. During the summer he was for many years director of the Ogunquit School of Painting and Sculpture in Maine, and when he retired from the University of Indiana in 1961, he returned to his home near there.

Several of Laurent's works were done for Indiana University. An *Allegory of Music*, a group of two girls singing and playing the guitar, carved in limestone, is in the auditorium, and in front of it is a fountain with a *Birth of Venus* in bronze, the recumbent figure curving in a crescent shape. A large relief in stone entitled *Veritas Filia Temporis* is an allegory of truth and time represented by a woman and an old man reaching out to each other over the rays of the sun. Laurent also designed a fountain for Saint Andrew's Cathedral, Honolulu.

In the exhibition of Indiana artists at the John Herron Art Institute and at the Hoosier Salon in Indianapolis he won first prizes several years in succession and in 1952, the Mr. and Mrs. Samuel R. Harrell Prize for sculpture. Two years later he also won first prize for sculpture at the J. B. Speed Art Museum, Louisville, Kentucky. He is a fellow of the National Sculpture Society, a member of the American Society of Painters, Sculptors and Gravers, and the Sculptors' Guild, vice-president of the Salons of America, and president of the Hamilton Easter Field Art Foundation.

Goose

The goose has its head raised and beak open. The long neck curves slightly backward over the heavy body. The wing feathers are laid in a smooth pattern, and the others are slightly indicated on the rough surface. This is the same model used for the one accompanying the *Goose Girl*, placed in Radio City Music Hall, New York, in 1932.

Vincent Glinsky

VINCENT GLINSKY was born in Russia on December 18th, 1895, the son of Wolf and Sonia (Sherfman) Glinsky. When he was eight years old the family came to America to join relatives in Syracuse. There he went through grammar school and high school and as a boy showed an aptitude for art, his water colors being prized by teachers and schoolmates. He planned to become a sculptor, and the only one living in Syracuse allowed him to frequent the studio and do odd jobs there. He entered the University of Syracuse but, when he found that the nearest thing to sculpture taught there was ceramic art, left with the determination of going to New York to study. The outbreak of the First World War delayed his plans, and he passed the time making plaster statuettes of Hindenburg and the Kaiser that found a ready sale at three dollars each and by 1916 had brought him enough money to go to New York. Arriving there completely without friends or knowledge of the city, he finally made his way to Cooper Union, passed the examination, and began his studies in earnest. He soon changed to the Beaux-Arts Institute of Design, where he had criticisms from John Gregory, Gertrude Vanderbilt Whitney, A. A. Weinman, McCartan, and others. He supported himself by working for a dealer in antiques, copying furniture and carving cupids for gardens. His employer sympathized with his ambitions and allowed him to work in the morning so that he had time for study in the afternoon. Since he was not satisfied with the designs he was making for architectural sculpture in school projects and disappointed that they never won prizes like his other work, he went to Columbia University to study with Alfred Githens, concentrating on sculpture in relation to architecture. Working for other sculptors, among them John Gregory and Charles Cary Rumsey, he began to get

practical experience. His industrious, frugal habits earned him the title of the "salami and bread" sculptor among his fellows. His special training he put to use working for architects, chiefly for Albert Kahn of Detroit, rapidly turning out decorative panels, models for bronze doors—anything needed in any style. He continued his own creative work on week ends in his studio on Fourteenth Street. Kahn felt that Glinsky was capable of better things than these hasty routine productions and urged him to go to Europe.

With the money that he had saved, enough to finance him for two years, Glinsky took ship for Italy in June 1927. Landing in Naples, he stayed six weeks, going to Pompeii almost every day, entranced by its beauty. His next stop was Rome, where he took a studio and began to evolve his own creations. He also joined a group in Professor Lipinsky's studio in order to draw from the model. He steeped himself in the classic art of Rome, finding his special goddess in the ripe forms and superb modeling of the Venus of Cyrene in the Museo Nazionale. In order to perfect his art and redeem it from the superficiality of the high-speed methods to which he had been accustomed, he decided to limit his output to several pieces a year and to bring each one to the highest possible degree of excellence. He bought marble blocks and began to do his own carving. After a year and a half he left Rome and traveling by way of Florence and Venice reached Paris. Here he stayed for another year, modeling in terra cotta, having other pieces cast in bronze, and carving in marble. With twenty-two works collected and a group of drawings, a one-man show was arranged for him by Madame Zak.

After his return to New York this group of sculpture and drawings was shown to the American public. Among them were the meditative, lyrical creations appropriately entitled *The Riser* or *Awakening*, *The Dreamer*, *Symphony*, and *Repose*. In these his affinities with Hellenistic art can be strongly felt. Full, rich forms succeed each other in a slow rhythm of deliberate or arrested movement. Bland surfaces melt one into another without sharp edges or abrupt transitions. In common with contemporary French sculptors he adapted to a modern idiom the qualities that he admired in classic sculpture, keeping its harmony and serenity while suppressing detail and filling out or elongating proportions better to express a mood. The impression made by these works brought Glinsky a Guggenheim Fellowship.

These personal conceptions were varied from 1930 to 1940 by architectural commissions for the Federal Works Agency program, six historical reliefs for a post office at Hudson, New York, and another for one at Weirton, West Virginia. In this he celebrated the Pony Express and the sheep-raising activities of the region in an entertaining relief with a pyramidal group of the express rider and a man and a woman above a decorative row of rams lined up full face.

Portrait busts had always been part of his *œuvre*, and one of Vice-Admiral Adolphus Andrews, modeled during the Second World War, led him into a new, wartime occupation. The portrait itself presented many difficulties, since the sculptor was compelled to work in the Admiral's office, without formal sittings, studying the head as best he could in intervals between the Admiral's other activities. Through this association he was asked to use his ability in drawing on Diesel construction in the Navy Yard. Since he knew nothing about mechanical drawing, he was sent to learn the technique at the College of the City of New York and then set to making free-hand drawings of Diesel sections, a task upon which he was employed for four years.

At the end of that time he was free to resume his own career and returned to the unhurried elaboration of the subjects that he preferred. *Adagio* and *Melody* continued the dreamy, poetic inventions of his earlier period. In order to carry on his work, he was awarded a grant by The American Academy of Arts and Letters in 1945. The fluid movement of a figure in profile, issuing from the stone, justifies its title, *The River. Mother and Child* is composed in broad planes with little definition. The sculptor won the Avery Award of the

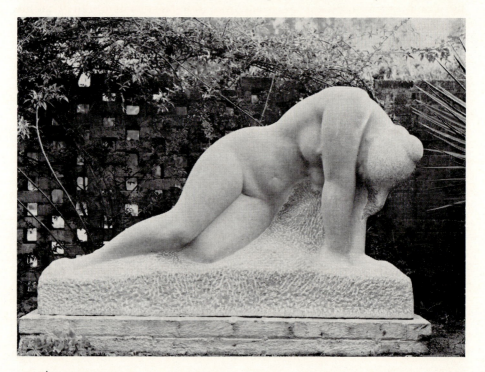

AWAKENING

Tennessee marble statue. Height 3 ft. 1 in. Base: Length 5 ft. 1 in.—Width 1 ft. 7½ in. Placed in Brookgreen Gardens in 1950.

Architectural League in 1956 and two years later the medal of honor of the National Arts Club. *Fugue*, a lyrical form carved in marble, with contrasting textured and polished surfaces, was awarded the gold medal of the National Sculpture Society in 1967.

Wood is also a favorite medium, and for this he uses a different technique of impressionistic forms worked out in flat planes and sharp edges to accord with the natural cleavage of the material. *The Lumberman* for the post office at Union City, Pennsylvania, a relief cut out without a background, was in a simplified realistic style, but other subjects, *Passacaglia*, a statuette of Tosca-nini conducting, and *Dance of Lysistrata* depend for their effect on rhythm of movement and suggestion of mood. In other wood carvings, such as *Symphonic Poem*, Glinsky has left his forms partly veiled in the wood, bringing out broad planes with broken or melting edges and half-expressed detail for emotional effect. *The Orbit* is symbolic of human exploration of the outer atmosphere, and *Space* is an elongated figure reaching upward. *The Thunder* expresses fear and protection in a simple columnar group of a woman with children pressed against her. *November, 1963*, a man covering his face with his hand, is a statement of grief over the assassination of President Kennedy.

Special commissions were panels for elevator doors in the National Institute of Health at Bethesda, Maryland. In shallow relief, emphasizing geometrical patterns, they represent aspects of medical science. A limestone group of Saint Bernadette kneeling before Our Lady of Lourdes is in a shrine at Saint Paul's College, Washington, D.C., and *The Waters of Life*, water dripping from the fingers of a pair of hands, is at the entrance to All Faiths' Memorial Tower in George Washington Memorial Park at Paramus, New Jersey. Glinsky made the bust of Wilbur Wright for the Hall of Fame, and one of Eleanor Roosevelt that has been placed in the Labor Department at Washington, D.C., and in the museum at Norfolk, Virginia.

With the title of assistant professor Glinsky teaches sculpture at his studio as part of the Division of General Education program of New York University. He is a fellow of the National Sculpture Society and a member of the Audubon Artists. He has been executive secretary of the Sculptors Guild and a vice-president of The Architectural League of New York.

Awakening

A woman is beginning to rouse from deep slumber. Half reclining, with difficulty she languidly raises her heavy shoulders, propped on both hands. Her head is bowed and her face hidden between her arms. The marble block

is left rough beneath the figure, one hand still sunk in the marble as if the effort to release it were too great, the feet and the knot of hair also left unpolished. The voluptuous body is languorous with sleep, warm flesh imitated by the rosy tone of marble carved with freedom and vitality. In setting the mood of this work, the sculptor has intended not only to give the feeling of physical awakening but also to convey the effort of freeing a creative thought, as if the form were slowly forcing its way out of the marble.

The first, smaller version in Serravezza marble was finished for the artist's 1930 exhibition at New York, and was seen in many other exhibitions, winning the Widener Gold Medal at the Pennsylvania Academy in 1936. When it was ordered in a larger size for Brookgreen Gardens, Glinsky modified it slightly, strengthening it by leaving the mass of marble beneath the figure, and carved it himself. In this form it was again shown at the Pennsylvania Academy of the Fine Arts in 1948 and awarded the Dr. Herbert M. Howe Memorial Prize.

Oronzio Maldarelli

ORONZIO MALDARELLI was born at Naples, Italy, about the year 1892, the son of a goldsmith, Michael Maldarelli, and his wife, Louisa (Rizzo) Maldarelli. The family came to New York about 1900. Oronzio received his art education by attending evening classes in the schools of the National Academy of Design and Cooper Union, where he studied drawing and painting, and the Beaux-Arts Institute of Design, for sculpture. While preparing himself for his profession he worked as a jewelry designer. His early work, *Charity* and *Labor*, for the Municipal Building, Plainfield, New Jersey, and various memorials were in the modified classic tradition, and some garden figures were conceived in a slightly stylized decorative vein. From this conventional beginning he has advanced farther and farther into new fields of experimentation. Both stylization and decorative qualities were increasingly emphasized in the clear-cut lines of certain groups, *Spring* and *Eternal Love*. *A Head of Saint John* is in the City Art Museum, Saint Louis. *Resignation*, which won a Fairmount Park Association prize at the Philadelphia Open Air Exhibition in 1930, and *Reflections* return to a fuller treatment of form but show originality of composition. Awarded a Guggenheim Fellowship to continue his creative work in Paris from 1931 to 1933, Maldarelli returned with

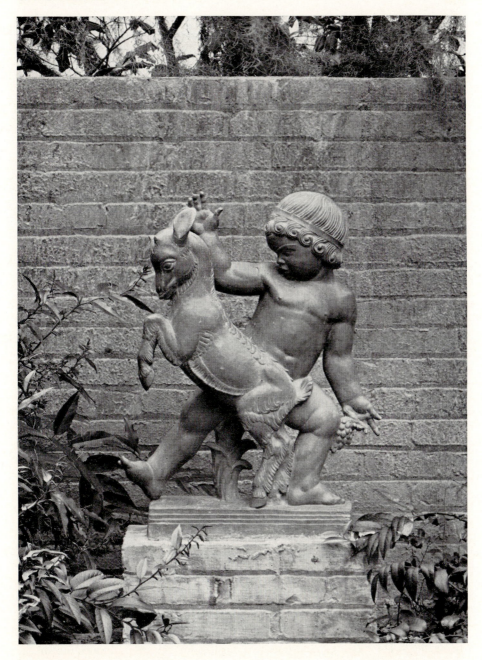

Two Kids

Lead group. Height 2 ft. 4½ in. Base: Length 1 ft. 5 in.—Width 6¾ in. Placed in Brookgreen Gardens in 1937.

a group of figures which, abandoning any complete representation, resorted to solid masses and very little definition of forms. His aims are expressed in his own words in a prefatory note to an exhibition of his work held in 1934, "I should like those who view my work to learn to look at sculpture for its own formal meaning, to sense the volume, rhythm, the balance of repeated shapes, and the play of lights and shadows on the sculpture." Soon he found such abstractions too cold and returned to a fuller treatment of the nude in which the solid structure is retained, while melting surfaces give a sensuous pleasure and radiate serenity and inner grace. In 1941 *Barbara*, a girl's head carved in limestone, was awarded the Logan Prize and purchased by The Art Institute of Chicago.

Less personal works destined for special settings were the ceiling for the Center Theatre at Rockefeller Center, New York, on which he worked in collaboration with architect and decorator, the figure of an air mail postman for the Federal Post Office Building, Washington, D.C., and the sculptural decoration of the post office at Orange, Massachusetts. Two heroic figures, *Fra Angelico* and *The Spinner* were at the 1939 New York World's Fair. He won a competition for a statue in marble of the Madonna to be placed in the Lady Chapel, Saint Patrick's Cathedral, New York, made a pathetic, emaciated crucifix for Loyola Seminary at Shrub Oak, New York, and a limestone relief of Saint Francis in clear outlines and simple planes for the Church of Saint Francis at Biddeford, Maine. Sculpture in high relief was for the Hartford Public Library and *Unity of the Family*, rhythmically co-ordinated, on the façade of the New York State Insurance Fund Building in New York City; both were carved in marble. For the James Weldon Johnson Houses in New York City he devised a gay *Spirit of Youth*, two girls playing ball, lightly poised with an airy interplay of legs and arms.

Maldarelli received a second Guggenheim Fellowship in 1943 and five years later an award from The American Academy of Arts and Letters for his sculpture, "which reanimates the rhythms of nature with distinguished simplicity and balance of form." One of his nudes, *Bianca No. II*, which won the Widener Gold Medal at the Pennsylvania Academy in 1951, was purchased by The Metropolitan Museum of Art, New York; a *Reclining Figure* had been bought earlier. He made sketches in terra cotta but preferred to put his sculpture in final form by carving in stone, where he could take advantage of the natural mass and leave the surface either rough or as delicately finished as he wished. He liked to combine two figures in related volumes, as in the bronze *Gemini* or in *Companions*, two girls in half figure, carved of rock maple. He also made some studies of animals, especially goats and horses, and of birds. *Flight*, two birds circling in the air, was made for the Martin Bird Bath at Central Park Zoo. *Bird Forms* carved in marble and *Birds in Flight*,

cast in bronze, were ordered by the American Export Lines for two of their ships.

He taught at Sarah Lawrence College and was professor of sculpture at Columbia University until he retired, two years before his death on January 4th, 1963. A retrospective exhibition of his work was held at the Paul Rosenberg Gallery a few months later. He was one of the founders of the Sculptors Guild, a fellow of the National Sculpture Society, a member of the National Institute of Arts and Letters, and an associate of the National Academy of Design.

Two Kids

A boy leans sidewise, braced against one foot, his hand to the head of a kid which rears in the opposite direction, so that their bodies make a pattern of diagonals. In the other hand the boy holds a bunch of grapes. The crisply stylized curls of his hair are bound with a fillet. The edges of the goat's hair are patterned in low relief. The formal design and ornamental treatment of details give this group a decorative quality.

Lawrence Tenney Stevens

LAWRENCE TENNEY STEVENS was born at Brighton, Massachusetts, on July 16th, 1896, the son of Arthur Lawrence and Florence (Wilson) Stevens. He began his studies at the school of the Boston Museum of Fine Arts, where Bela Pratt was his teacher for two years. His career was interrupted by the World War and by work in the Mexican oil fields. Later he studied with Charles Grafly and modeled an equestrian statuette in bronze of Mrs. Ashton de Peyster. He won the *Prix de Rome* for the years from 1922 to 1925, also traveling in Greece, Egypt, and the Near East. The eclecticism of the American Academy and the impressions made by his travels affected the sculpture done at Rome. *Echo* is a bust in the style of the Florentine Renaissance, while the group entitled *Renascence*, a man and a woman supporting a child against a round halo, contains suggestions of East Indian sculpture. The archaistic manner is paramount in a relief of the Baptism of Christ for the Congregational Church, Brighton, Massachusetts. Egypt is the source of the hieratic posture and the drapery molded to the form in the life-sized bronze figure of a woman called *Alba*, purchased for the museum at Muncie, Indiana. A bronze

Falcon was acquired by King Victor Emmanuel. *Football Player* was presented by Henry Colgate to Colgate University, and *The Spirit of the Aeroplane*, a winged figure supported by a bronze globe, was made to celebrate the first world flight.

When he returned to this country, establishing a studio at Bedford, New York, he carved a *Diana* in limestone for the Brewster Estate, Mount Kisco, New York. On a visit to Morocco in 1928 he carved a portrait head of one of the Sultan's guards in ara wood, and *Fatima*, an Egyptian woman fruit vendor. A triptych for Saint Matthew's Church, Bedford Village, was executed in carved and polychromed wood. A statue of the chemist John Harrison, commissioned by the Fairmount Park Association, is at the University of Pennsylvania. He has also designed a medal of John Harrison to be awarded by the Chemical Markets Magazine and the international competition medal of the Eastman Kodak Company. Bronze doors for the Fine Arts Building at Scripps College, Claremont, California, depict the life of man in thirty-two panels, and two life-sized sea lions of ceramic operate as fountains in a patio pool. In 1932 he made three plaques for Yellowstone National Park to mark newly named mountain peaks. Among his portrait sculpture are two colossal heads of the poets Charles Erskine Scott Wood and his wife Sara Bard Field carved in stone for their estate at Los Gatos, California. Portrait heads of children he often casts in silver.

In 1936 he had charge of the sculpture for the Texas Centennial Exposition, executing three colossal statues, two pylon figures, and a whimsical animal fountain called the *Texas Woofus*. For the 1939 New York World's Fair a statue of Walt Whitman, the prophet, with raised arms, was cut from an apple tree. Animal sculpture has been one of his chief interests; *Black Panther* in glazed pottery was modeled for Radio City Music Hall in 1932, and a *Polar Bear* is in The Newark Museum. In 1935 he exhibited water colors of a bear-hunting trip in Wyoming and in 1937 traveled through the West in a trailer fitted up as a studio. With his independent spirit and fondness for outdoor life, he found the West to his liking; he lived on a ranch in Wyoming and hunted mountain lions in Arizona. In 1942 he took part in Douglas Project 19 of the United States Army Air Force, creating forms in sheet metal to repair broken planes. This mission took him to Eritrea and the Sudan in Africa.

After the war ended, he settled at Tulsa, Oklahoma, taught at the Philbrook Art Center, and made war memorials for both Tulsa and Oklahoma City. Other sculpture at Tulsa was for the Perry Clinic—two heroic-sized reliefs in stone symbolizing Medicine and Dentistry—and for the Chamber of Commerce a frieze carved directly in limestone that records the development of the city. A plaque at Woodward, Oklahoma, served as a memorial to the

lives lost in two wars and a tornado. For the Woodmen Accident and Life Company at Lincoln, Nebraska, a family group in the palm of a colossal hand, carved in relief, represents "the protecting hand." A statue of Will Rogers of heroic size is in the park named after him at Oklahoma City.

In 1954 Stevens moved to Tempe, Arizona. Several architectural commissions were carried out in terra cotta, which he and his wife themselves fire. Reliefs of fighting bucks with horns locked, designed in a few planes with strong outlines, are on panels above the windows of a bank at Phoenix. Two large reliefs in a bank at Palm Springs, California, develop the theme, "The desert is the test of the worth of your spirit," in small sections that tell the story of the region in a graphic style of silhouetted forms. The sculptor has continued his studies of animals, often executed in terra cotta, with simplified forms and the contrast of patterned details. A series of bronze groups planned

BAT

Bronze statuette. Height 1 ft. 4 in. Signed underneath: L. T. STEVENS SC. BEDFORD 1929 Placed in Brookgreen Gardens in 1935.

to show the events of a rodeo began with *The Cutting Horse*, a cowboy lassoing a calf, in bronze and silver on a black marble base, placed in the Valley National Bank at Phoenix. Stevens is the Western representative of the National War Memorial Advisory Committee and a fellow of the National Sculpture Society.

Bat

A bat is represented in an attitude of defiance, the wings spread, the body curved forward, and the mouth open. The statuette is supported on a globe. When the sculptor found his studio at Bedford Village infested with bats, he staged a hunt to get rid of them. Struck by the expression of rage on the face of the last one killed, he immediately modeled it. Ordered cast for the rock garden of Mrs. Joseph P. Cotton, Mount Kisco, it was set on a cylindrical base carved with night creatures and flowers.

Dorothea Denslow

DOROTHEA HENRIETTA DENSLOW was born in New York City on December 14th, 1900, the daughter of Henry Carey and Cornelia Julia (Smith) Denslow. The family moved to Hartford, Connecticut, where Dorothea was a pupil of her father, a painter. Later she studied at the Art Students' League and had a studio in New York. Her sculpture includes a bronze fountain figure at Richmond, Virginia, *Mischief*, in the same playful manner as the two groups at Brookgreen and a memorial plaque for the Beth Moses Hospital, Brooklyn.

Concerned over the difficulties that sculptors experienced in getting started in their profession, Miss Denslow turned her studio into a place where young sculptors could carry on creative and experimental work. She founded the Clay Club in 1928 and devoted all her energies to it. During World War II she opened a Sculpture Canteen for service men, providing free instruction and materials. The club reorganized as the Sculpture Center in 1944 and a few years later moved to new quarters, with both studios and exhibition space. Miss Denslow continues to be the director.

She was a member of the jury for the Fulbright sculpture award in 1958 to 1960 and belongs to the Connecticut Academy of Fine Arts.

Pelican Rider

An imp with pointed ears and goat tail is seated on the back of a pelican, one foot on the ground, the other over the bird's wing. The pelican's bill is turned to touch the imp's hand, and its wings are slightly lifted to support him as it joins in the fun.

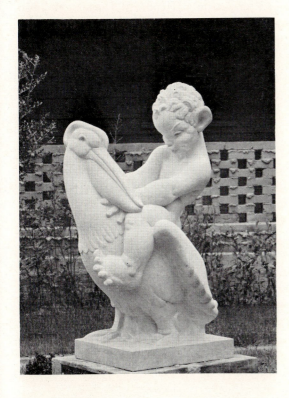

PELICAN RIDER

Tennessee marble group. Height 2 ft. 6¾ in. Base: Length 1 ft. 2 in.—Width 11¼ in. Signed on base at right: DOROTHEA DENS-LOW

Placed in Brookgreen Gardens in 1938.

Playmates

Another grinning imp with sprouting horns, pointed ears, and a goat tail stands behind a penguin, both arms around its neck. The bird's small wings are raised. The dimpled cheeks, slanting eyes, and large feet of the merry imps are exaggerated to add to their amusing character.

Tennessee marble group. Height 2 ft. 6 in. Base: Length 1 ft. 2¼ in.—Width 12 in. Signed on base at right: DOROTHEA DENSLOW Placed in Brookgreen Gardens in 1938.

Eugene Spalding Schoonmaker

EUGENE SPALDING SCHOONMAKER was born in New York City on November 30th, 1898. His art education included study with the sculptors Leo Lentelli and Lee Lawrie and the painter Henry McCarter. He also attended the Beaux-Arts Institute of Design. There is sculpture by him in the library of the University of Cincinnati and a memorial at Yale University. He was a member of the Clay Club of New York. He moved to the state of Washington, where he died about 1952.

The Hunt

A striding hunter turns backward, lifting a horn to his lips, while with his right hand he grasps a deer leaping forward beside him. A short cloak falling from his shoulders and a spreading plant under the deer's body round out the composition, with its spirited movement and interesting play of diagonals. The treatment of the surface is moderately simplified and the hair and drapery folds stylized. The group has also been given the title *Actaeon*.

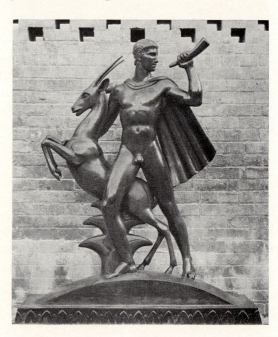

THE HUNT

Bronze group. Height 4 ft. 9 in. Base: Length 4 ft. ½ in.—Width 1 ft. 5½ in. Signed on base at back: EVGENE SCHOONMAKER 1936 Founder's mark: ROMAN BRONZE WORKS N.Y.
Placed in Brookgreen Gardens in 1937.

436

Joseph Arthur Coletti

JOSEPH ARTHUR COLETTI was born at San Donato, Italy, on November 5th, 1898, the son of Dominick and Donata (Cardarelli) Coletti. Brought to the United States at the age of two, he was educated in the public schools of Quincy, Massachusetts. In 1915 he entered the Massachusetts Art School for two years of study, followed by two more at the Northeastern Preparatory School. In 1923 he was graduated from Harvard University, having majored in fine arts, and that summer was awarded a fellowship by the University for travel and study in Europe. From 1924 to 1926 he was again in Europe and attended the American Academy in Rome as Sachs Fellow of Harvard University.

He was a pupil of John Singer Sargent and his assistant on the sculptured ceilings of the Boston Public Library and the rotunda of the Museum of Fine Arts. This experience prepared him for other architectural sculpture undertaken independently, such as that for the chapel, Saint George's School, Newport, Rhode Island, which included among the sixty-three pieces a figure of Saint George in the Gothic style, and a tympanum for Mercersburg Academy in Pennsylvania. His *Saint George* is also in the Pitti Palace at Florence, Italy. His preference for ecclesiastical sculpture is further shown by a *Virgin and Child* in Emmanuel Church, Newport, Rhode Island, and a figure of the Christ. On the Cathedral of Mary Our Queen at Baltimore there fell to his share, among the many sculptors employed, the important statue of the Virgin Mary crowned by angels over the main portal, flanked by reliefs of the Nativity and her Assumption, and also reliefs over the two doors at the sides. On the interior he was responsible for eleven of the panels on the life of Christ carved in heroic size on the limestone arches above the side aisles. For all this work Coletti used strong linear rhythms of curving lines that with deep shadows would carry a long way and still make the subjects intelligible. This sculpture earned him the Henry Hering Memorial Medal of the National Sculpture Society. He was also in charge of the sculpture for the North Transept Portal of the Cathedral of Saint John the Divine, New York, as yet incomplete. A statue of Saint Joseph was for Saint Joseph's Seminary at North Easton, Massachusetts. Other works are the Archibald Cary Coolidge Memorial for the Widener Library and sculpture for the narthex of the Harvard World War Memorial Chapel, both at Cambridge. Two panels, *Riveters* and *Granite*, were made for the Thomas Crane Public Library,

438

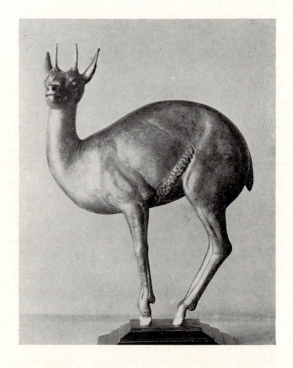

KLIPSPRINGER

Bronze statuette. Height 1 ft. 2
in. Base: Length 6¾ in.—Width
5½ in. Signed on base at right:
 J·A·C·©
Placed in Brookgreen Gardens in
 1936.

Quincy, Massachusetts, and *Cranes* for the pediment. A mural with *Farmers and Geese* as the subject is in the Mansfield, Massachusetts, post office.

A number of portrait statues have been commissioned from Coletti. One of Ferdinand Gagnon is in Lafayette Park, Manchester, New Hampshire, and a memorial to the same man at Quebec. The Commonwealth of Massachusetts ordered from him one of Senator David I. Walsh for the Esplanade, and another of General Edward Lawrence Logan for Logan International Airport, Boston. A bronze statue of Father McGivney, founder of the Knights of Columbus, was erected by them at Waterbury, Connecticut. A World War II memorial, *Mourning Victory*, is in Lafayette Park at Salem, Massachusetts.

Coletti is the author of several medals for Harvard University: the Eugene Dodd Medal for the School of Architecture, the Alumni Association Medal, the Glee Club Medal, and the Edward W. Bok Medal. Others are that celebrating the centennial of Paderewski and one for Vermont Academy.

Because of his profound knowledge of the subject, he was asked to write the articles on stone carving, carving tools, and sculpture techniques for the 1954 edition of the *Encyclopedia Britannica*. In 1932 he won a first prize medal at the Boston Tercentenary Fine Arts Exhibition. Coletti was elected an honorary member of the Harvard Chapter of Phi Beta Kappa in 1948. He is a fellow of the National Sculpture Society and a member of The Architectural League of New York and the Medieval Academy of America. The Italian government made him a *cavaliere ufficiale* of the Ordine al Merito.

Klipspringer

The animal, one of the antelope family, is poised with all four feet together, the back arched, the neck sharply curved, and the head raised. The ears are lifted parallel to the spiky horns. A fringe of hair patterns the smooth body. It was modeled in 1927 from studies made at the London Zoo the year before.

Bruno Piccirilli

BRUNO PICCIRILLI, of the third generation of the family to work in the United States, is the son of Ferruccio and Hilda (Battelli) Piccirilli, born in New York on March 30th, 1903. As a boy he worked in the family studio, acquired by practice a sound knowledge of technique, and learned by association with the many sculptors who frequented the studio. From 1920 to 1925 he also studied at the National Academy of Design and the Beaux-Arts Institute of Design, winning the Paris prize in 1924 with a doorknocker in Renaissance style. Ferruccio Piccirilli went back to Italy with his family in 1926 and settled down in a villa at Pietrasanta. Bruno accompanied them, studying for a year at the American Academy in Rome. In 1928 he returned to New York to carry on his profession, and by the following year he was ready to show his work in the exhibition of the National Sculpture Society at San Francisco, including a fountain statue of Pan as a boy for the estate of Angelo Patri at Paterson, New Jersey.

As one of the family group he was employed with his uncles on the sculpture of Riverside Church, New York, where they carved the great western portal with its many statues, the part that fell to Bruno's share, together with eighty statuettes for the chancel screen and other figure sculpture. Without reference to cathedral sculpture of the early Gothic period, the style in which the building was carried out, except for the convention of narrow, straight folds, the sculptor drew freely upon his imagination in order to design these statues to harmonize with their architectural setting. He took full advantage of the stonecutter's abbreviations to bring out strong lines and sharp accents. His special training in ecclesiastical sculpture he put to further use by collaborating with John Angel on architectural carving for the Cathedrals of Saint John the Divine and of Saint Patrick in New York. Piccirilli composed some of the statues for the Saint John the Divine portal in a less formalized manner than he had used for Riverside Church, working with

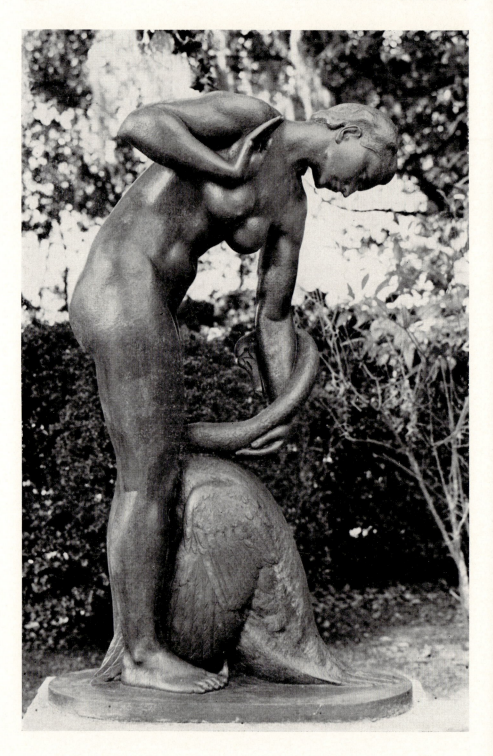

Angel in his studio at Sandy Hook, Connecticut. Until Angel's death Piccirilli continued to assist him on the tympanums of the National Shrine of the Immaculate Conception at Washington, D.C., and on heroic figures of the four Apostles for the cathedral at Saint Paul, Minnesota.

A relief for the post office at Marion, North Carolina, was done under the auspices of the Federal Works Agency in 1939. Entitled *Unity*, it symbolized communication between the members of a family by a few figures modeled in a simplified manner. A bronze memorial tablet with a portrait in relief at Wheaton College, Norton, Massachusetts, was dedicated to Priscilla Guild Plimpton, and another mural relief in terra cotta, representing Christ gathering the children to Him, was placed in Mount Carmel School, Poughkeepsie, New York. Piccirilli made four bas-reliefs with symbols of the Passion for All Saints' Episcopal Church, Baldwin, Long Island, and a *Pietà* for the Pecci Chapel at Florence, Italy.

Terra cotta is a favored medium, especially for garden figures, because it lends itself to the even surfaces and balanced volumes preferred by this sculptor. He also paints in oils. Piccirilli taught for a year at the Beaux-Arts Institute of Design and in 1940 established his home and studio on the campus at Vassar College, Poughkeepsie, where he is now instructor of sculpture. Elected a fellow of the National Sculpture Society in 1936, he has served on the council, and since moving to Poughkeepsie he has been president of the Dutchess County Art Association.

Leda and the Swan

Leda stands bending over the swan at her feet. The bird's body is pressed against her legs, and the wings are brought forward embracing them. The long neck is intertwined with her extended left arm. Her other hand is drawn back against her shoulder in a startled motion. The classic theme, that has offered sculptors so many possibilities for varied interplay of form and concentrated emotion, has here been used in a graceful pattern of complimentary, flowing curves. Emotion has been subdued to a serene, idyllic mood. The girl's slender, rounded body is richly modeled with full forms. Her hair is in soft, vaguely defined masses; the bird's feathers are patterned with shallow modeling and engraved lines. When the sculptor modeled this work in 1945, he had in mind peaceful garden surroundings such as that in which it is now placed.

LEDA AND THE SWAN

Bronze group. Height 4 ft. 1½ in. Base: Length 2 ft. 6 in.—Width 12½ in. Signed on base at left: *Bruno Piccirilli* 1945 © Placed in Brookgreen Gardens in 1946.

Abram Belskie

ABRAM BELSKIE was born of Russian parents, Max and Sarah (Itovitch) Belskie, at London, England, in 1907, but while he was still an infant his family moved to Glasgow. When he left school at the age of fourteen he was apprenticed to a Scotch painter and sculptor, William Petrie. During the three years spent in his studio, Belskie attended evening classes and eventually with the help of scholarships enrolled for full time study of modeling and sculpture at the Glasgow Art School for a period of three years. The John Keppie Traveling Scholarship which he won in 1926 gave him a chance to study for a time at Paris, Florence, and Rome. Another award was the John Edward Burnett Prize. From 1927 to 1929 he served as an assistant to several Scotch sculptors, Alexander Proudfoot, Benno Schotz, and Archibald Dawson, and was a temporary instructor at the Glasgow School of Art.

Coming to the United States in 1929 he became an assistant to John Gregory, working for him for three and a half years on the panels for the Folger Shakespeare Library at Washington, D.C. Belskie also assisted Malvina Hoffman. Robert A. Baillie then engaged him for work in his stone-carving establishment at Closter, New Jersey. Here he was given the use of the studio to carry out his own creations. He is an American citizen, and it was in this country that his artistic convictions took shape. *Big Jim*, a study of one of the workers at the Newport News shipyard, and *The Pirate*, a bronze bust, are in the Mariners' Museum at Newport News. *Three Hebrew Youths* in a memorial to Robert Louis Stroock at the New York Jewish Theological Seminary are reduced to columnar shapes in a setting of Egyptian motives.

In 1939 Belskie began collaborating with Dr. Robert L. Dickinson of the New York Academy of Medicine in the making of three-dimensional medical models for educational purposes. There are sets in the American Museum of Natural History and a number of other museums. With Dr. Dickinson he is co-author of a *Birth Atlas* in sculpture. He described his cancer teaching models in an article in *The American Journal of Surgery* for March 1949, written jointly with Leonard B. Goldman.

Belskie not only made these models scientifically accurate, but he also

CHRIST CHILD

White marble statue. Height 3 ft. 3¾ in. Base: Width 12½ in.—Depth 12½ in. Signed on base at back: ABRAM BELSKIE. SC. 1934 Placed in Brookgreen Gardens in 1935. Blessed by the Reverend Henry De Saussure Bull in 1936.

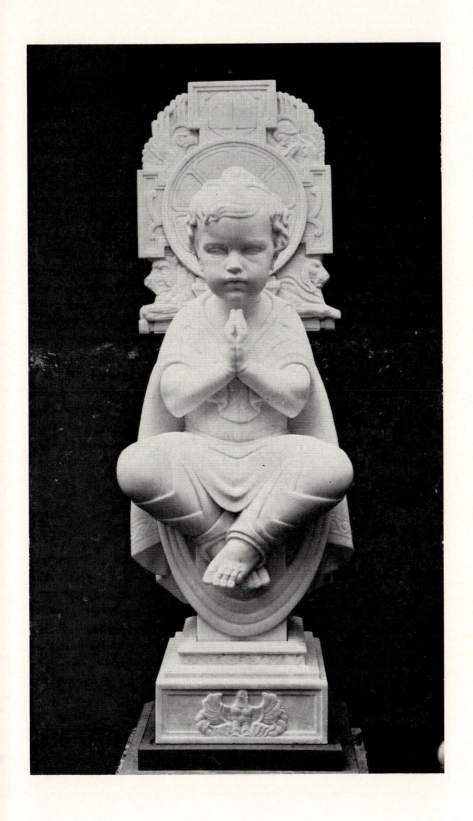

performed the difficult feat of making them artistic. His ability in this special field earned him academic status at the Academy of Medicine. His medical associations led to other sculpture commissions. A life-sized bronze statue, three-quarter length, *The Surgeon*, signifying dedication to the advancement of medicine, was unveiled at the entrance to the Ethicon Building at Somerville, New Jersey, in 1962. Many portrait busts have been made for research foundations and laboratories. One of Dr. Dickinson is at the Academy of Medicine and that of General Robert Wood Johnson in the Johnson and Johnson Laboratories.

Skill in relief design brought the sculptor the Lindsey Morris Memorial Prize of the National Sculpture Society in 1951 for *The Anatomist*. His medallic work received other awards, the Mrs. Louis Bennett Prize of the National Sculpture Society in 1956, the Saltus Award of The American Numismatic Society, of which Belskie is a fellow, in 1959, and the Golden Anniversary Prize of the Allied Artists of America in 1963. Many of these medals are connected with medicine, such as the Columbia-Presbyterian Medical Center's award for distinguished service, and the centennial medals both of the Lenox Hill Hospital and the New York Obstetrical Society.

Imaginative themes have continued to attract him. *Chiron and the Baby Asclepius*, a centaur holding up an infant, carved in blocky forms, is at the Jewish Theological Seminary; a *Symmelus Siren* plays with a fish-tailed baby, and a *Mother and Child* is designed with subtle rhythms of curves. Belskie is a fellow of the National Sculpture Society and a member of the National Academy of Design.

Christ Child

The Christ Child sits with feet crossed and hands folded in prayer. His robe and the mantle over His shoulders are arranged in conventional folds, and a piece of drapery is looped beneath His feet. Behind the head is a cruciform halo with the stylized symbols of the evangelists filling the angles. On the upper arm of the cross the tablets of the law are superimposed on a three-branched candlestick. In low relief on the front of the base is a spread-winged phoenix, on the right side the Good Shepherd, and on the left the Virgin and Child. This was the first of the sculptor's works to be publicly exhibited.

The Moonbeam

On a rectangular pedestal sits a girl, her feet crossed, her head turned upward over her shoulder, one hand at her breast. A piece of drapery in flat

folds is laid around the thighs, one end draped on the pedestal, the other falling over her wrist. The figure is realistically modeled in detail, but the symmetrical composition, the highly finished surfaces, and conventional drapery folds give it decorative value.

White marble statue. Height 3 ft. 7½ in. Base: Width 1 ft. 6 in.—Depth 1 ft. 3 in. Signed on base at right: ABRAM BELSKIE SC. 1937 Placed in Brookgreen Gardens in 1937.

Janet de Coux

JANET DE COUX was born at Niles, Michigan, on October 5th, 1904. Her father, the Reverend Charles John de Coux, was an Episcopal clergyman whose ancestors were Quakers and Tories; her mother, whose maiden name was Bertha Wright, was born on a farm in Wisconsin. Four years after Janet's birth the family moved to Grand Rapids and again four years later to Pittsburgh, where they settled on a farm outside the city. At the Carnegie Institute of Technology, Pittsburgh, she studied with Joseph Bailey Ellis from 1925 to 1927, then for a short time at the Tiffany Foundation, Oyster Bay, Long Island. She found a place as an assistant in C. P. Jennewein's studio and broadened her experience working for Aristide Cianfarani at Providence and for Alvin Meyer at Chicago on his panels for the Capitol, Columbus, Ohio. After assisting Gozo Kawamura, who was employed by James Earle Fraser, she entered the latter's studio. During her apprentice years she continued to study in the evenings, at the New York School of Industrial Art, the Rhode Island School of Design, and The Art Institute of Chicago.

The summer of 1935 she spent on a bicycle trip to England and the Continent. Since 1936 she has been working independently in her family home at Gibsonia, Pennsylvania. Although her first works were decorative figures, she has subsequently given her attention to biblical characters, endeavoring to bring out their human qualities within the architectural form. An individual touch gives her strongly organized works originality. The heads *Moses* and *Aaron* were given an award by the Associated Artists of Pittsburgh in 1936, *Sarah and Abraham* a prize by the Pittsburgh Society of Sculptors five years later. In 1938 she received a Guggenheim Fellowship, renewed in 1939, to enable her to carry on her creative work, and in 1944 a grant from The American Academy of Arts and Letters. The Widener Gold Medal was awarded to her by the Pennsylvania Academy in 1942 for *Deborah's Song.*

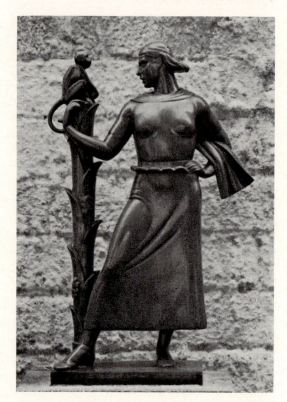

SOUBRETTE

Bronze statuette. Height 1 ft. 2
in. Signed on base at back: JA-
 NET de COUX
Placed in Brookgreen Gardens in
 1936.

As resident instructor at the Cranbrook Academy of Art from 1942 to
1945 she came in contact with the sculpture of Milles and found its simplifi-
cations congenial. In later work she abandoned the rich forms and flowing
lines of her early style in favor of more rigidly simplified forms. Much of her
work has been for churches, a number of them in Pennsylvania. A *Saint
Benedict* for Saint Vincent's Archabbey, Latrobe, is a columnar figure build-
ing up to a powerful, ascetic profile. For the Church of Saint Scholastica at
Aspinwall she carved statues of the saint in a starkly linear manner expressive
of asceticism and spirituality. She could develop her ideas of design in altars
with all their appointments for a chapel at Saint Barnabas Mother House and
the Church of Saint Thomas-in-the-Field at Gibsonia and for the Brookline
Methodist Church and the Chapel of Saint Margaret Hospital at Pittsburgh.
For her carvings she often uses granite, polishing its heavy masses to a
lustrous glow, as for Madonnas at Manhasset and Fisher's Island, New York,
and a *Baptism of Christ* for Bethel Park, Pennsylvania. A heroic bronze
statue of William Penn was commissioned for the William Penn Memorial
Museum at Harrisburg.

The National Sculpture Society awarded her the Lindsey Morris Memorial Prize in 1943 for a bas-relief. Other works in relief are a *Saint Angela* for the College of New Rochelle, New York, and others for the Sacred Heart School, Pittsburgh, and the post office at Girard, Pennsylvania. Miss de Coux won many awards in exhibitions at Pittsburgh, being named artist of the year in 1951. The State of Pennsylvania recognized the importance of her work by naming her a Distinguished Daughter of Pennsylvania in 1954. She is a member of the National Academy of Design and a fellow of the National Sculpture Society.

Soubrette

A young woman stands at ease, the right leg thrown sharply forward, the left hand on the hip. A simple dress molds the figure, the surface broken by a row of fluting at the waist. The end of a scarf around her neck flies out over her left arm. Her short, straight hair is held by a wide band. With her right hand she touches the top of a stump beside her, sheathed in leaves and bunches of berries, on the top of which sits a monkey. The original idea is carried out with simplicity. It was modeled in 1931.

Adam

A little boy kneels on one knee, one hand to his shoulder, an apple-tree branch held against his knee in his other hand, his head turned to the right. His sturdy body is held very straight; the smooth locks of hair end in ringlets around the head.

Lead statue. Height 2 ft. 3¾ in. Signed on base at back: JANET DE COUX 1930 ©
Placed in Brookgreen Gardens in 1937.

Eve

A little girl sits cross-legged, ready to bite an apple in her right hand raised to the shoulder, the left arm close to the side. Her bobbed hair stands out in stiff edges from beneath a fillet. The forms are a little softer than those of the boy. The two figures, used on gateposts at Brookgreen, are composed to give a columnar effect without sacrificing their baby roundness.

Lead statue. Height 2 ft. 3¾ in. Signed on base at back: JANET DE COUX 1930 ©
Placed in Brookgreen Gardens in 1937.

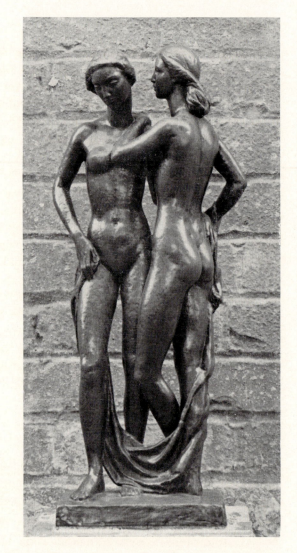

MILDRED AND ELEANOR

Bronze group. Height 1 ft. 8 in. Signed on base at back: *C. Ort-mayer, Sc.* Founder's mark: A- BASKY F'DRY- N-Y- Placed in Brookgreen Gardens in 1937.

Constance Ortmayer

CONSTANCE ORTMAYER was born in New York on July 19th, 1902, the daughter of Rudolph Ortmayer, a lithographer from Chicago, Illinois. In 1926 she began the study of sculpture with a year in the studio of the Austrian-American sculptor Franz Plunder. She received a scholarship which enabled her to spend five more years in the Royal Academy of Fine Arts, Vienna, under the instruction of Josef Müllner. Some of her work was accepted for exhibition at the *Wiener Secession*. She has traveled extensively

in Austria, Germany, Italy, Belgium, France, and England. *Aprilis* received the first Anna Hyatt Huntington Prize of the National Association of Women Painters and Sculptors in 1935. She was for a time technical adviser in sculpture for the Section of Painting and Sculpture of the Treasury Department. Sculpture done under the Federal Works Agency was for post offices—a relief, *Arcadia*, at Arcadia, Florida, and one representing Alabama agriculture at Scottsboro.

In 1937 she went to Winter Park, Florida, to teach sculpture at Rollins College. The college appointed her a professor in 1947 and awarded her a medal of honor for distinguished service. She was made head of the art department in 1965. Miss Ortmayer continued her creative sculpture, working towards more simplified form while keeping refinement of modeling and elegance of line. A group of a mother and child entitled *Grant Us, O Lord, a Lasting Peace* received an award of merit for the best work in any medium at the annual exhibition of the Florida Federation of Art in 1948.

Medallic work includes the design for the Stephen Foster half dollar, a medal for the Florida Academy of Sciences, and four medals for Rollins College. Miss Ortmayer is a member of the National Sculpture Society and the Florida Federation of Art, and an honorary member of the Orlando Ceramic Society.

Mildred and Eleanor

Two girls stand in attitudes of easy intimacy. One rests her arm on the other's shoulder and whispers in her ear. The figures are tall and slender, the position of the limbs an interplay of linear rhythms. A drapery looped from one to the other, falling about the feet, unites them. The group was modeled in 1931, while the sculptor was a pupil at the Royal Academy of Vienna, as a study in composition, the arranging of two figures into a good design. Only one example was cast.

George Frederick Holschuh

GEORGE FREDERICK HOLSCHUH was born in Germany on November 19th, 1902. He studied at The Pennsylvania Academy of the Fine Arts, from which in 1933 and 1935 he was awarded the Cresson Traveling Scholarship, and in Germany. He has done architectural sculpture for schools at Philadel-

phia and for the Finance Building, Harrisburg, Pennsylvania. Two children's heads by him are in the *Süddeutsches Museum*. He was professor of art and aesthetics at Cedar Crest College, Allentown, Pennsylvania, and is now associate professor of art at Florida State University, Tallahassee, Florida. He belongs to the Fellowship of the Pennsylvania Academy and has served as president of Associated Florida Sculptors.

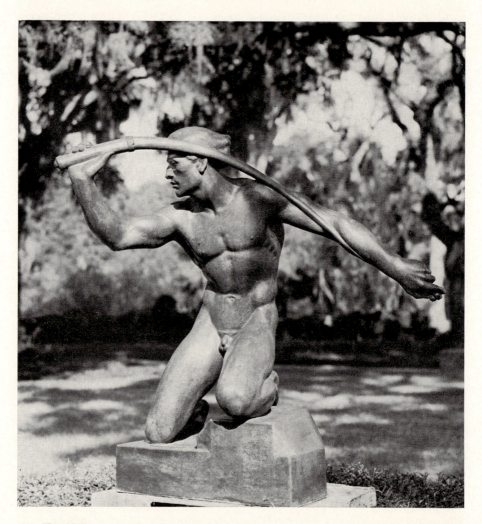

THE WHIP

Bronze statue. Height 3 ft. 7½ in. Base: Width 2 ft. ¾ in.—Depth 1 ft. 4 in. Signed on base at right: G·FR·HOLSCHUH Founder's mark: KUNST F. N-Y-C Placed in Brookgreen Gardens in 1936.

The Whip

A man kneels, his body slightly curved to the left, bending a whip stretched between his extended hands. The muscles are taut on the lean frame, and the arc of the whip repeats the curve of the figure. This statue was exhibited at the National Academy of Design in 1937.

Robert J. McKnight

ROBERT JOHNSON MCKNIGHT was born at Bayside, Long Island, on February 26th, 1905, the son of Arthur Maxwell and Clara (Johnson) McKnight. He is a great-grandnephew of the sculptor J. Q. A. Ward, and his mother was an amateur sculptor. When he was thirteen the family moved to Springfield, Ohio, and it was *The Indian Hunter* by Ward in the cemetery at Urbana which first stirred his ambition to become a sculptor. He graduated from Yale University in 1927 and received a degree from the Yale School of Fine Arts five years later. Subsequently he worked for a year in Bouchard's studio at Paris and later was an assistant to Charles Keck in New York. He has also studied with Carl Milles. In 1932 he won the fellowship of the American Academy in Rome. Later he was director of The Memphis Academy of Arts, Memphis, Tennessee. One of his most successful portrait busts is that of Katharine Hepburn. He has produced some smartly stylized animal sculpture and a lively group of Ichabod Crane and the headless horseman. For Central Lake, Michigan, he designed an iron muskellunge and a figure of *Old Man River*.

During World War II McKnight enlisted in the United States Army as a private, rose to the rank of first lieutenant in the Aviation Engineers, and served in England, Africa, and Italy. After his return to Ohio as a civilian he was a member of the Springfield City Planning Commission and the Clark County Planning Commission. In 1949 he made an industrial design survey of Mississippi for the Rockefeller Foundation and also won a prize from *Electronic Magazine* for one of the five best electronic designs of the year.

In addition to industrial design he has done some portrait painting and executed a few sculpture commissions. John F. Kennedy was the recipient of a bust of himself by McKnight in 1962. The sculptor was assistant professor

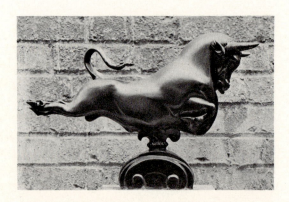

BULL

Bronze statuette. Height 1 ft. 1¼
in. Base: Length 6½ in.—Width
4¼ in. Founder's mark: DRIESS-
MANN, BAUER & C°. MUNICH
 BAVARIA
Placed in Brookgreen Gardens in
 1937.

of art at Wittenberg University, Springfield, Ohio, from 1949 to 1953 and in
1964 received an appointment as director of the Brooks Memorial Art Gal-
lery, Memphis, Tennessee. He is a member of the National Sculpture Society.

Bull

A bull charges, head lowered, forefeet doubled under the chest, hind legs
extended, tail up. The forward thrust of the powerful body and the sweeping
lines of the back and hind legs give an impression of force and speed. The
deep wrinkles of the head are modeled in detail, and the horns and tail are
gilded. The sculptor has carved the same subject in wood. The *Bull* was
modeled while McKnight was studying at the American Academy in Rome,
inspired by the Minoan bulls of Cretan art seen on a trip to the eastern
Mediterranean. The original was of plaster, gold-leafed, with imitation ivory
horns. The sculptor worked on it for six months, gradually simplifying the
anatomy for the sake of purer form but trying to keep the essential structure
and action.

George Winslow Blodgett

GEORGE WINSLOW BLODGETT, who signed his sculpture George Wins-
low, was born on March 10th, 1888, at Faribault, Minnesota, to Charles
Webster and Edna Laura (Winslow) Blodgett. Both his parents were of pio-
neer stock, his father descended from an Italian family which had settled in
England. His mother was of English descent. He turned pioneer at the age of
nineteen and started for the Pacific Northwest, where he lived a frontier life,

engaged for twenty years in lumbering, heavy construction, and ranching in the Cascade Mountains of Western Oregon. During World War I he served in the Intelligence Section of the 8th Infantry, 8th Division, stationed at Brest, France.

In 1926, realizing that the life in Oregon was finished, he consulted David Seabury about a change of vocation, and when creative work was recommended, chose sculpture. He worked all night before a mirror modeling a bust of himself and followed this effort with an imaginary study of Mrs. Marcus Whitman. These works showed so much promise that he was urged to continue. After two weeks' study at the Beaux-Arts Institute of Design, New York, and ten days at the Académie Julian, Paris, he worked independently in Paris for two and one-half years.

Envisioning a great hall of sculpture of the American Indian, he went to Santa Fe in 1929 and began to model intimate studies of the Pueblo Indians, his intention being to produce life-size in bronze a hundred or more studies of the head, the torso, and the dance figures of the Southwest Indian. The results of his work were shown at the Brooklyn Museum and in New York in 1933. His original idea broadened to a plan, never realized, for a gallery of the American Indian at Washington, D.C., to contain a survey of Indian arts and crafts by the Indian artist and also representation in painting and sculpture of them by American artists. He was not interested in types nor ethnological problems but in the character and spirit of the individual Indian, embodied in

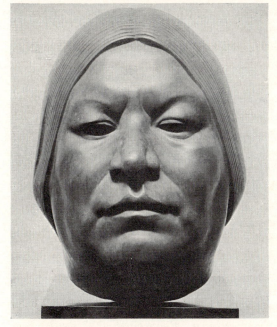

HEAD OF A TEWA INDIAN,
ALBERT LUJAN

Bronze. Height 10¼ in.
Placed in Brookgreen Gardens in
 1934.
Other example: New York. The
Metropolitan Museum of Art
 (first casting).

harmonious sculptural form. The head, *Ascensio Chama*, is in the Denver Museum, *José Rey Calavasa* in the Seattle Museum, and several other portrait heads at the Laboratory of Anthropology, Santa Fe, New Mexico. He died about 1959.

Head of a Tewa Indian, Albert Lujan

The broad, inscrutable face of the Tewa Indian, Albert Lujan, is framed in smooth hair. The first example was made in 1931 from the original model of 1930.

Joseph Nicolosi

JOSEPH NICOLOSI was born at Caltabellotta, Sicily, on August 4th, 1893. He came to the United States in 1912 and served in the United States Army during World War I. From 1915 to 1919 he studied at the Beaux-Arts Institute of Design, New York, with Solon Borglum, Edward McCartan, John Gregory, and other American sculptors, winning bronze medals in 1917 and 1919, five second medals, and honorable mention many times. By 1929 he had completed a memorial to Dr. Marcus B. Heyman for the Manhattan State Hospital and World War memorials for New Brighton, Pennsylvania, and Morristown, New Jersey. A war memorial for his native town was designed in 1931. In the next year he received the second prize for sculpture at the Art Center of the Oranges Exhibition. Among the portrait busts which he modeled are those of Edgar Lee Masters and Fiorello LaGuardia; a portrait statue of Charles Atlas is entitled *The Triumph of Health*. Twelve bas-reliefs were commissioned for New York City high schools, and in 1934 the anniversary medal presented to Dr. William J. O'Shea by the New York Academy of Public Education was made.

Nicolosi's work also includes garden subjects, such as the piping boy, *Fountain of Youth*, for the Hersloff Estate, Llewellyn Park, New Jersey, and a series of lightly draped figures with increasingly simple forms, from *The Awakening* and *Joy of Motherhood* to *Evening Meditation*. For the City and County Building, Denver, Colorado, he designed an eagle with lifted wings, stylized to an architectural treatment, and for the Federal Works Agency, sculpture for the post office, Mercersburg, Pennsylvania. *The Pioneer*

Teacher is in the DeWitt Clinton High School, New York. Religious subjects include *The Living Word*, Christ with outstretched arms saying, "Come unto Me," and *Hymn to the Sun*, Saint Francis kneeling, the wide sleeves of his habit spreading like wings from his uplifted arms. Later work had a symbolic content: *Cosmic Mother*, embodying the regenerating principles in life, and *Peace*, a pyramidal group of man, woman, and child.

About 1950 Nicolosi moved to Los Angeles, where he made a series of bas-reliefs of people famous in the world of sports for the Los Angeles Memorial Coliseum Court of Honor. A statue of the Virgin Mary as Queen of Angels was placed in San Fernando Junior Seminary. Polychrome figures representing the four dramatic arts are in the Peabody Auditorium at Daytona Beach, Florida. Sculpture by Nicolosi went to such distant places as Caracas, Venezuela, and Guatemala. One of his last works, before his death on July 13th, 1961, was a medallion with the portraits of Queen Elizabeth II of

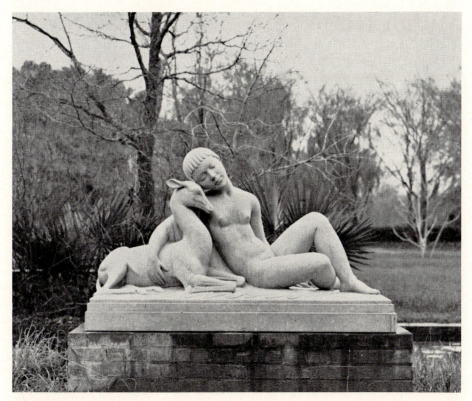

DREAM

Tennessee marble group. Height 2 ft. 11½ in. Base: Length 5 ft. 2½ in.—Width 1 ft. 11¼ in. Signed on base at right: J. NICOLOSI—SC. Placed in Brookgreen Gardens in 1937.

England and Prince Philip, presented to the Prince by the Art Patrons
Association of America. Nicolosi was a member of the National Sculpture
Society, The Architectural League of New York, and the American Artists
Professional League.

Dream

A girl reclines with eyes closed, one arm around a fawn resting at her side,
her cheek against its head. A drapery over her arm lies beneath them in
scalloped folds. The rhythmic curves of the two figures, the relaxed body and
drooping head, embody tranquil repose.

Milton Horn

MILTON HORN, born near Kiev, Russia, on September 1st, 1906, to
Pinchos and Bessie (Komar) Horn, was brought to the United States in 1913,
his family settling at Taunton, Massachusetts. While at school there he also
studied drawing and painting with Alfred Haynes. At the age of thirteen he
spent a summer in New York studying at the Educational Alliance and upon
his return to Taunton modeled a bronze memorial tablet and continued to
draw and paint. His work in sculpture was furthered by instruction from
Henry Hudson Kitson in Boston during week ends and vacations. In 1922
Horn entered the evening classes at the Beaux-Arts Institute of Design, New
York, working for decorators and art dealers during the day. When he was
awarded a Tiffany Foundation Fellowship in 1925, he devoted the time to
making studies of plants in drawing and sculpture.

His first important commission, two years later, was a carved ceiling for
the Lenthéric Salon in the Savoy-Plaza Hotel, New York, with semi-classic
figures in incised relief. The next year he became associated with a firm of
architects and married Estelle Oxenhorn. His garden sculpture began to find
place on private estates near New York at Orange, New Jersey and on that of
Mr. and Mrs. Charles E. F. McCann at Oyster Bay, for which he made four
groups and ten single figures of playful children. A deep interest in other
periods of sculpture led him to work in the Egyptological department of the
Brooklyn Museum from 1932 to 1933 under the direction of Jean Capart. He
assembled a private collection of Chinese, Indian, and Gothic sculpture and
contributed articles to the Museum *Quarterly*. His own sculpture, paintings,

and brush drawings that demonstrated his mastery of line were presented in one-man exhibitions in the Brooklyn Museum, at New York, and at Boston.

Commissions under the Works Progress Administration and the Treasury Art Projects were six reliefs carved in mahogany for Seward Park High School, New York, a relief in teakwood for the post office, Swarthmore, Pennsylvania, sculpture for the post office, Whitinsville, Massachusetts, and a maple-wood relief at Iron River, Michigan. Appointed artist in residence at Olivet College in Michigan under a Carnegie Grant in 1939, he held that post for ten years. During that period he collaborated with Frank Lloyd Wright by creating a relief mural in the Wall residence at Plymouth, Michigan, and continued to exhibit both sculpture and drawings. When he decided to give up teaching to devote his entire time to sculpture, he chose Chicago as the center for his work.

Since then his chief interest has been architectural sculpture, for his work became increasingly in demand for schools and other public buildings. He carved a relief mural in wood for the Blythe Park School at Riverside, Illinois, and a reredos in limba wood for the chapel of Reynolds Memorial Hospital at Glendale, West Virginia. Reliefs for the University of Pennsylvania and the Woman's Medical College at Philadelphia were of limestone.

A desire to revive the representation of figural images as an integral part of synagogue architecture led to exhaustive research, until from many sources Horn found conclusive evidence to justify his conviction that figural sculpture was appropriate for synagogues. The first time that he put his ideas into concrete form was in 1952—a high relief for the Suburban Temple Har Zion at River Forest, Illinois, in which a multi-eyed supernatural being symbolizes the spirit of Hebrew religion dominating the earthy materialism of the beast behemoth. *Moses before the Burning Bush*, showing the vehicle for the Voice in the bush in anthropomorphic form, was the subject of a bronze relief on the façade of Temple Israel at Charleston, West Virginia. Another innovation was a figural holy ark in the same synagogue and one with figures carved in mahogany for the South Shore Temple, Chicago. An ark reredos for the All Faiths Chapel in the Medical Center Hospital of West Virginia University at Morgantown ingeniously combines elements that make it suitable for the rituals of the major religions. For this university Horn also created reliefs in Georgia marble on the sides of pylons at the entrance to the Basic Sciences Building.

Several firms commissioned sculpture for their buildings at Chicago, and there are three bronze groups on the façade of the national headquarters building of the Congress of Parents and Teachers. The city ordered from him a symbolic sculpture for a parking facility, and in 1966 Horn completed a huge relief, cast in bronze, for the lobby of the new Central District Water

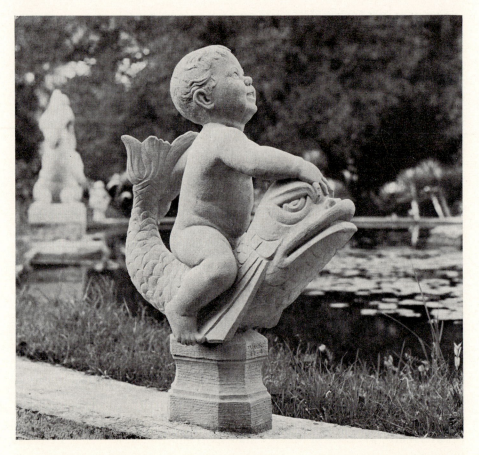

BOY WITH DOLPHIN

Limestone group. Height 2 ft. 9 in. Base: Length 9½ in.—Width 7 in. Signed
on base at front: M. HORN 1929 Placed in Brookgreen Gardens in 1936.

Filtration Plant. Lush forms linked in a fluid network emphasize the life-giv-
ing potency of water. In 1967 he was completing a bronze relief for the façade
of the National Bank of Commerce at Charleston, West Virginia. In all his
work a rugged vitality emanates from broken planes that flash with light. Not
only vibrant shapes animate his reliefs but also the profound ideas and emo-
tions that inform them. Horn has written extensively about sculpture and its
uses, especially when combined with architecture. In 1957, at their Centen-
nial Conference, he received an award for excellence in the fine arts from the
American Institute of Architects. He is a national vice-president of the Art-
ists' Equity Association, and a member of the National Sculpture Society, the
Sculptors Guild, and the Guild for Religious Architecture.

Boy with Dolphin

A baby boy sits astride a dolphin, grasping its head with one hand and its upflung tail with the other.

Girl with Dolphin

A plump girl baby rides a dolphin, holding its head with both hands. The fish's tail is lifted to her back. In both these groups the curving shapes of the dolphins and the babies' forms make a pleasant circular composition. The babies' laughing faces and the dolphins' grotesque heads are boldly carved.

Limestone group. Height 2 ft. 9 in. Base: Length 9½ in.—Width 7 in. Signed on base at front: M HORN 1929 Placed in Brookgreen Gardens in 1936.

Sylvia Shaw Judson

Sylvia Van Doren Shaw was born in Chicago, Illinois, on June 30th, 1897, a daughter of the architect Howard Van Doren Shaw and Frances (Wells) Shaw, poet. She was educated at the Laboratory School of the University of Chicago, the University School for Girls, and Westover School at Middlebury, Connecticut. Her first instruction in sculpture, which determined her career, was from Anna Vaughn Hyatt at Annisquam, Massachusetts, in the summer of 1915. She studied with Albin Polášek at The Art Institute of Chicago from 1915 to 1916 and again in 1918 after a trip to China and Japan with her father, where the simplicity and strength of Chinese sculpture impressed her. She had a studio at New York for one winter before going to Paris in 1920 to study with Bourdelle at the Académie de la Grande Chaumière. The French sculptor whom she most admired, however, was Maillol.

On September 2nd, 1921, she married Clay Judson, Chicago attorney. In the simplicity of her garden figures of children there is a quiet charm and sympathetic understanding of the moods of childhood. They attest her feeling that art should reflect "authentic experience, simple, homely, fresh, and vivid as the parables." At the same time they have architectural integrity, for she

also says, "I deeply believe that a work of art as well as life is better for a coherent design." [1] At the Chicago Art Institute's exhibition in 1929 *Little Gardener*, the homely adjuncts of plant and watering pot cleverly utilized in the composition, received a Logan Prize. A *Young Woman*, tall and straight as an Egyptian, is in the Dayton Art Institute. For a fountain at Ravinia, Illinois, appropriate to a music festival, Mrs. Judson modeled a figure of a girl standing with a violin in her hand. *Boy Reading* and *Apple Tree Children*, perched on branches, are in libraries at Highland Park and Lake Forest, Illinois. The Children's Zoo at Brookfield, Illinois, has her two *Farm Children*, holding their pets. In a less realistic treatment, a *Rain Tree Fountain* at the Morton Arboretum, Lisle, Illinois, and in the Junior Museum of The Art Institute of Chicago has motives woven into an intricate openwork design.

Some of her animals have been placed where they would give pleasure to children. There is a *Harbor Seal* in the Children's Hospital Medical Center at Boston, and a sheep dog and a goat of cast stone in the children's playground at Fairmount Park, Philadelphia. *Bear Cubs* won the Speyer Prize of the National Academy of Design in 1957. As part of a fountain developed as a memorial to Theodore Roosevelt on the grounds of the Chicago Zoological Society at Brookfield, Illinois, she placed four pylons topped by different pairs of horns, cast from nature and set into stylized heads. Her sculpture is often allied to architecture, as in a relief of a guardian angel over the door of the Presbyterian Saint Luke's Nurses Home at Chicago. A *Madonna* in granite is at the entrance to the Queen of Heaven Cemetery at Hillside, Illinois, and also in the Convent of the Sacred Heart at Greenwich, Connecticut.

In 1958 she won in competition the commission for a monument to Mary Dyer, Quaker martyr, which was erected in front of the State House at Boston, and went to Florence to supervise the casting in bronze. Since Mrs. Judson had joined the Society of Friends, she was well equipped to bring out the inner strength under the quiet demeanor of her subject. After her husband's death in 1960 she again worked at Florence while her Stations of the Cross were being cast directly from her models in molding sand. One series is in the Church of the Sacred Heart at Winnetka, Illinois, and another in the Church of Saint John the Evangelist at Tryon, North Carolina. She went to Egypt in 1963 to teach in the American University at Cairo and married Sidney Haskins.

A comprehensive exhibition of her work was given at The Art Institute of Chicago in 1938 and others at New York in 1940 and 1957. Recognition came to her in the form of an honorary degree of doctor of sculpture from Lake Forest College, an achievement award from the Westover School, and

1 *For gardens.* p. [7]

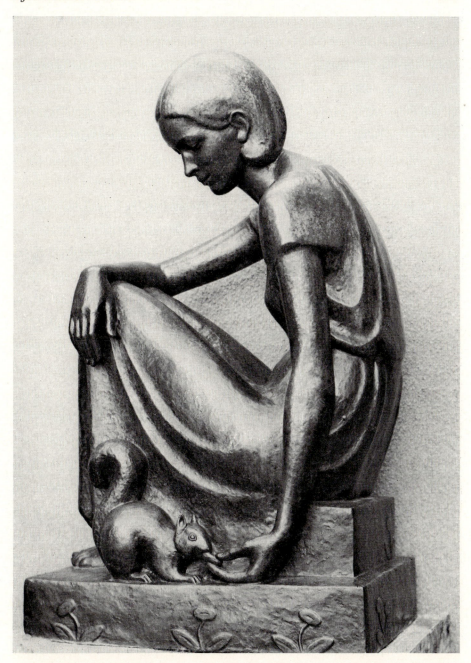

GIRL WITH SQUIRREL

Bronze statue. Height 3 ft. 5 in. Base: Length 2 ft. ½ in.—Width 1 ft. 6 in. Signed at back: s s j Founder's mark: ROMAN BRONZE WORKS N.Y. Placed in Brookgreen Gardens in 1936.

an honor award for excellence in fine arts allied with architecture from the
Chicago Chapter of the American Institute of Architects. The Garden Club of
America awarded her the Oakley Thorne Medal. She is a fellow of the
National Sculpture Society and a member of the National Academy of Design.

Girl with Squirrel

A girl is seated with one arm flung lightly over her knees. Her other hand
rests on the ground, holding a nut which a squirrel nibbles. The broadly
curving folds of a loose garment are simply indicated, and the hair smoothly
shaped. In the bend of the figure and the droop of the arms there is a harmony
of gentle curves and an atmosphere of hushed absorption. The original statue
was designed as a memorial to Belle Austin Jacobs and placed in Kosciusko
Park, Milwaukee, Wisconsin.

Marion Sanford

ALTHOUGH Marion Sanford was born at Guelph, Ontario, on February 9th,
1904, her parents, Lawrence and Lila (Hunter) Sanford, were Americans
and soon returned with her to the United States. Because of her mother's ill
health, the family moved about in search of a good climate. They stayed
longest in Warren, Pennsylvania, where her father, educated to be a scientific
farmer, experimented with raising game and fancy poultry. Here the daugh-
ter went to school until in 1922 she decided to study art at Pratt Institute in
Brooklyn. Her family was musical, her mother a singer, but none had been
artists except an English grandfather who had been a stonecutter working in
England and Canada before his granddaughter's lifetime. As a child Miss
Sanford liked to draw, and at Pratt she studied both drawing and painting.
When, annoyed at her lack of success in indicating the roundness of a thigh,
she shaped the paint with a stroke of her thumb, her instructor saw evidence
of an inclination towards modeling.

After her graduation from Pratt she returned to Warren, her artistic talent
finding an outlet in designing stage settings and costumes and in singing.
Dissatisfied with the impermanence of things created one day to be torn down
the next, she felt more and more drawn to sculpture. She educated herself by

making copious scrapbooks of clippings. Through these illustrations she became familiar not only with contemporary sculptors and their works but with earlier periods and further developed her innate sense of artistic values. She went to New York for a campaign of intensive study at the Art Students' League, with Lentelli as instructor in the daytime and Laurent in the evening, and learned the rudiments of technique. Again returning to Warren, she continued her dramatic and musical activities and created her first important work in sculpture.

Since Chautauqua was near, she had many occasions to hear fine music and to become acquainted with musicians. As a girl she went with friends to hear Georges Barrère play and, struck by his personality, vowed some day to model his portrait. This she later managed to do, for the musician, moved by her eagerness, allowed her to take photographs and granted her a few sittings. Supplied with a small amount of plasticine and a prodigious number of wooden boxes and boards for the armature, she finished the bust and took it to New York to be cast. To her surprise it was admired and bought by the Haynes Company of Boston, and another example was erected in Norton Hall at Chautauqua as a memorial to the flutist in 1952. Barrère is represented playing the flute, the bronze quick with a feeling of life and movement, the distinguished features fluently modeled.

Miss Sanford continued her professional education by working as an assistant to Brenda Putnam from 1937 to 1940, her activities including drawing illustrations in pen and ink for Miss Putnam's book, *The Sculptor's Way*. In the following year she was enabled to devote herself to her own creations through a grant from the Guggenheim Foundation; working in a studio shared with Cornelia Chapin she arrived at her own particular mode of expression. She had begun to exhibit in 1937, when her lithe-limbed kneeling *Diana*, bending backward to draw the bow, won a prize from the National Association of Women Painters and Sculptors, and by the end of her two-year fellowship she had enough pieces for a one-man show. In this group of works her private vision and special qualities had crystallized.

Inspired by memories of the farm women whom she had seen at work during her childhood, she chose for her principal subjects women engaged in homely tasks—ploughing, gathering apples, churning butter, scrubbing. In spite of the implication of *genre* in the titles, her handling of these themes is without taint of triviality or anecdote. No unnecessary detail is allowed to distract attention from the total impression. For this reason most of her women are uniformly clothed in plain dresses closely fitting to reveal the richness of natural forms and lying in soft, swinging folds to bring out the rhythmic flow of easy movements. In close contact with the earth, these

people reflect its warmth and respond to the sweep of its slow, elemental rhythms; their faces are serene with the candor of sincerity. One of the most satisfactory in simple arrangement of generous forms and suggestion of steady motion in the stirring gesture is *The Butterwoman*. The sway of rocking and the soothing rhythm of a song are clearly felt from the brooding bend of the head and the oblique push of the legs in *Lullaby*. *Harvest*, a woman bending to pick up apples and drop them in her apron, was awarded the gold medal of the Allied Artists of America in 1945 and acquired by The Pennsylvania Academy of the Fine Arts for its permanent collection. Occasionally, as in the robust form of the washerwoman bent over her tubs or the fat workman named Tiny, there is a pleasant note of humor. Expressing a profound emotion, *De Profundis* represents a woman crushed by grief, her bent shoulders and bowed head speaking eloquently of despair. This work was awarded the Watrous Gold Medal by the National Academy of Design. *Dawn*, an unaffected study of a girl seated sidewise in an easy posture looking quietly outward, won a prize from the National Academy of Design in 1947.

Miss Sanford's skill in composition and her direct approach helped her to

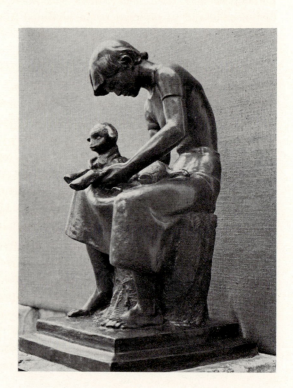

LITTLE LAMB

Bronze statuette. Height 1 ft. 7¾ in. Base: Width 10⅛ in.—Depth 11½ in. Signed on base at back: M SANFORD Founder's mark: ROMAN BRONZE CORP. N.Y. Placed in Brookgreen Gardens in 1952.

model portrait busts with penetration of character and subtlety of form. After the bust of Barrère came *Cornelia Chapin at Work* wielding mallet and chisel, and the architect Hugh Ferriss, sketching. In all these portraits the arms are included for the sake of conveying characteristic action and a greater feeling of reality. Her ability in design was further called into play for architectural sculpture. A lunette over the door of the post office, Winder, Georgia, carries on her themes from everyday life, for it depicts Negroes bringing cotton to be weighed, a few figures in an open design of clear forms. She cut in stone a relief of the Epiphany for a reredos in Saint Mary's Chapel, Faribault, Minnesota, and designed altars for churches in her home town, Warren, Pennsylvania. For the tower of the General Hospital there she carved a nine-foot figure of Hippocrates in limestone. A modern version of classic style, it is architectural in the strong vertical lines of the tunic and linear conventions for muscles and hair. In all her work she has approached her subjects with simplicity and handled them with consistent breadth of style while keeping their vitality undiminished.

After she retired to Lakeville, Connecticut, she made a portrait bust of one of her neighbors, Henry Sloane Coffin, who was for many years president of Union Theological Seminary. Miss Sanford is a fellow of the National Sculpture Society and an associate of the National Academy of Design.

Little Lamb

A barefoot girl bends over a lamb lying in her lap, encircling its body with both hands. Her short hair, smooth over the head, lies in soft irregular locks around her face. The short-sleeved dress in which she is clad clings to her body and falls in a few broad folds. The modeling throughout is simplified and reduced to the main outlines of the natural forms.

The idea for *Little Lamb* goes back to a memory of the sculptor's childhood. When the family was living in Florida, she was familiar with the sight of flocks of sheep roaming wild and starting away in fright at the approach of a human being. One day, to her surprise, a ewe with a lamb permitted her to come near it. Realizing that the sheep had been injured and was silently appealing for help, she ran for her father and took the lamb to bring up on a bottle. The animal was the girl's constant companion until its bleating interrupted her mother's vocal exercises too often. The tenderness of her care of the lamb has been evoked in the protecting bend of the girl's body and her intent gaze.

Ethel P. Hood

ETHEL PAINTER HOOD was born at Baltimore on April 9th, 1908. Her father, John Mifflin Hood, Junior, was a civil engineer; her mother, whose maiden name was Ethel Gilpin Painter, the daughter of a gifted inventor and a cousin of the noted illustrator, Howard Pyle. Ethel P. Hood's varied talents led her to try many avenues before she settled upon sculpture as a career. After a childhood spent in Baltimore, she lived in California for two years, attending schools in San Francisco and Los Angeles, and became an able swimmer. She planned to try out for the Olympic team and went to New York for intensive practice and coaching. At the same time her interest in cartooning led her to enroll in a school of illustration, where she learned to draw but received no instruction in the special branch that she wanted to study. Swimming as a major interest was abandoned when Miss Hood's family took her to Europe in the summer of 1926. In Paris she attended some classes in painting at the Académie Julian and tried her hand at writing, submitting articles to *Vogue* as a free-lance correspondent.

Back in Baltimore again, she studied the violin and received so much encouragement that she went to New York for further study and in her spare moments attended Ivan Olinsky's classes in oil painting at the Art Students' League. When she returned to Baltimore, although she still planned to become a violinist, sculpture attracted her attention. She found a studio and went to work without instruction. The results were so good that she was able to sell the third head that she modeled and the first bas-relief. Feeling that she had now found her true vocation, she put aside all her other interests and devoted herself entirely to sculpture. *Francis Whitman*, a head of a boy, was exhibited at The Baltimore Museum of Art in 1933.

Since New York seemed to offer more opportunities, she took a studio there. The first public showing of a group of works was at the Karl Freund Gallery in December 1938, offered her by Mr. Freund after he had seen her sculpture and become enthusiastic about it. In the same year she had been elected a fellow of the National Sculpture Society. Another one-man show, at the Decorators' Club, followed in January, and her work won a bronze medal in the exhibition of the Society of Washington Artists held in the Corcoran Art Gallery. *Dream of Youth*, two kneeling figures with clasped hands symbolizing the youth of Australia and New Zealand, was exhibited at Baltimore

in 1939 and placed for a time in the Anzac Garden on top of the British Building at Rockefeller Center.

Portrait studies in which she could concentrate on character and a rapid impression of personality were Miss Hood's first choice of subject matter. In order to improve her technique and to gain a more thorough understanding of the art of sculpture she studied with Brenda Putnam for two years. She now works quickly, beginning with a few poses and finishing the portrait without further reference to the model in about two weeks' time. This method keeps the freshness of the first impression and allows her to preserve her vision of a personality undisturbed by too much reworking. Her methods are direct and forceful, disregarding surface finish and refinements of detail for immediacy of effect or vivid presentation of an underlying idea. She used professional models for studies of mood and temperament—*Trouper*, *Patient Man*, *Sibyl*, *Burmese Girl*. *Patient Man* received the Clarke Award for portraiture at the exhibition of the Katherine Lorillard Wolfe Art Club in 1959. There have posed for her such distinguished persons of the stage and the musical world as Beatrice Lillie, Helen Hayes, Margaret Speaks, and Gilbert Russell. Many of these busts were shown at the Argent Galleries in 1947 as "Heads by Hood."

Miss Hood has always been interested in the structure and action of the human body and taught herself first principles from a standard textbook. She put this inclination to practical use in several compositions involving muscular figures in action. The material for *Body Blow*, a study of two boxers, she obtained by frequenting Stillman's Gymnasium and watching practice bouts. This vigorous interpretation won first honorable mention for sculpture from the Allied Artists of America in 1950 and a gold medal from the Katherine Lorillard Wolfe Art Club four years later. *September Song* is a man reaping and binding grain in rhythmic motion, while *Blow Gabriel* is a dynamic figure of the angel straining forward with uplifted trumpet. *Rhapsody for Stone*, a work charged with emotion, interweaves two figures in a harmonious pattern. A one-man show of her sculpture was held at the Pen and Brush Club in 1964. She was appointed a member of the Fine Arts Commission in 1959.

Saint Francis of the Curbs

A truck driver in working clothes rests against the fender of his truck during lunch hour, feeding pigeons. A group of birds is clustered in front of the wheel below him, and one is eating from his hand as he looks down at it with warm interest. Concentrating on the protective curve of the arms and bowed shoulders above the counter curve of the wheel, the sculptor has represented the man's form simply, keeping the solidity of the body beneath

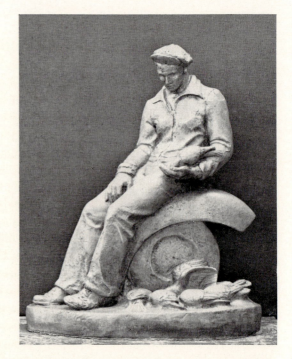

SAINT FRANCIS OF THE CURBS

Aluminum statuette. Height 2 ft.
1 in. Base: Width 1 ft. 8¾ in.—
Depth 11¾ in. Signed on base at
right: Ethel P. Hood 1947 ©
Placed in Brookgreen Gardens in
 1947.

clothing with folds indicated by a few irregular breaks and leaving the surface rough, the features summarily modeled. The pigeons on the ground, some with spread tails or lifted wings, bring animation to the lower part of the composition. This statuette was begun in 1945, when from a window of her studio, the sculptor saw a truck driver on the street below feeding pigeons and noted the contrast between his uncouth appearance and his gentle manner. She developed the idea and finished the work in 1947.

Edward Fenno Hoffman III

EDWARD F. HOFFMAN III was born at Philadelphia on October 20th, 1916. His father is an architect; his mother, Elizabeth Rodman (Wright) Hoffman, a painter. After graduating from high school the son planned to enter the business world and began working for an insurance company. This life did not satisfy him, and as he recalled his pleasure in drawing as a child, he decided to enroll in an evening class at The Pennsylvania Academy of the Fine Arts. At the same time an interest in sculpture aroused by what he had

seen in museums led him to enter Walker Hancock's class in sculpture. At once he felt that he had found his true vocation. Only two terms had been spent in night school when he was called for military service with the First Troop, Philadelphia City Cavalry, serving for five years.

His determination to become a sculptor grew ever stronger, and at the first opportunity he again enrolled in the Pennsylvania Academy, receiving instruction in modeling from Harry Rosin and Charles Rudy and learning how to carve stone from Philip Aliano. During his student years he won the Stimson Prize and honorable mention for the Stewardson Prize. In 1948 a commission for a war memorial at the Pennsylvania Hospital was awarded to him. He executed for the auditorium a low relief representing two medical soldiers giving aid to a wounded man. By means of the Cresson Traveling Scholarship, Hoffman was able to study in Europe the following summer, traveling throughout Italy and also visiting Paris and London. He obtained a Tiffany Foundation grant in 1951 and won first prize in the collaborative competition of the alumni of the American Academy in Rome.

During the next year he spent six months as assistant to Paul Manship. His own works were gateposts for Saint Alban's Church, Newtown Square, Pennsylvania, and a memorial in Lansdowne High School Athletic Stadium, designed in collaboration with the architect Roy F. Larson. The sculptor's share took the form of a low-relief panel carved in limestone. An angel turns to the ascending soul of a fallen soldier, in human form, and extends a protective arm around his shoulder, guiding him upward. On the gateposts for Saint Alban's Church a pair of lambs was carved directly in Indiana limestone from small models. The sculptor's love for animals enabled him to convey sympathetically the ingenuous appeal of the young creature, the head turned backward on a smoothly curving neck, the body treated in a simplified manner for architectural stability. In the spring of 1952 Hoffman went to La Napoule in southern France to continue his creative work in residence at the château under the auspices of La Napoule Art Foundation, Henry Clews Memorial, and stayed until 1955. From the stone carver who cut many of Henry Clews's works Hoffman learned to carve alabaster, which has become a favorite material. One of these alabasters, *Little Sister*, a girl playing with a baby, is in the collection housed in the Gallery of Modern Art, New York; The Pennsylvania Academy of the Fine Arts owns another, *The Idealists*, representing the family and its aspirations, both these works given by Anna Hyatt Huntington.

Returning to Pennsylvania, Hoffman found an abandoned power plant at Wayne that was suitable for a studio. Here he continued the many kinds of sculpture that have varied his prolific output. One of his garden figures, *Girl*

with Basin, has been placed in the herb garden of the Philadelphia College of Physicians and Surgeons, and *Saint Francis* was purchased by the Woodmere Art Gallery. *Adam and Eve* is in the Philadelphia Museum of Art, *Maternity* in the Museum of Art at Portland, Maine, and *Hercules and the Lion* in the Huntington, West Virginia, Galleries, all of these groups cast in bronze. Not content with physical beauty alone, he always tries to invest his figures with meaning. As he said in the preface to an exhibition at Newport, Rhode Island, "I want to animate my sculpture with an inner life that people can sense when observing it."

His expert skill in rendering muscular male figures was put to use in a series of portraits for the Weight-Lifters' Hall of Fame at York, Pennsylvania. A portrait bust of his father won a gold medal of honor from the Allied Artists of America in 1965, and one of his mother, the S.F.B. Morse Medal of the National Academy of Design in the following year.

Some of his most distinguished work has been on religious subjects. A *Descent from the Cross* built up in a powerful design charged with emotion, won first prize at a joint exhibition by the National Sculpture Society and the National Academy of Design in 1961; the limestone carving was acquired by Saint John's Church, Southampton, New York; a terra cotta had been placed in the American Episcopal Church at Rome, and another is in Saint John's Lutheran Church, Stamford, Connecticut. A *Holy Family* is at Saint Matthew's Roman Catholic Church, Philadelphia, and a *Saint Francis* at Trinity Church, Swarthmore, Pennsylvania. The sculptor made an appealing figure of Mother d'Ouville for the Gray Nuns of Sacred Heart Convent, Yardley, Pennsylvania. Architectural sculpture for Saint Mary's Augustinian Seminary at Villanova consisted of liturgical symbols carved in relief around the main door and other designs on an outside wall. The sculptor also made for the seminary three bronze portrait reliefs as memorials. The public library at Hanover, Pennsylvania, placed his statuette, *Winnie the Pooh*, in the children's wing.

Hoffman is a fellow of the National Sculpture Society, recording secretary of the Council of American Artists' Societies, and president of the Pennsylvania Chapter of the American Artists' Professional League.

Susan

A little girl is seated, one foot doubled under her, cuddling a rabbit in her arms. She looks down at it with a gentle smile, her toes curling in delight. Her short hair is carved in soft, irregular locks.

The pose is characteristic of the sculptor's year-old daughter, noted when

he was making small sketches of her as she played. He immediately started modeling it life size, substituting a rabbit for the doll that was the baby's plaything. Hoffman worked on the group all one winter and carved it in marble the following year. Exhibited at the National Academy of Design in 1951, it won the Helen Foster Barnett Prize. One example has also been cast in bronze.

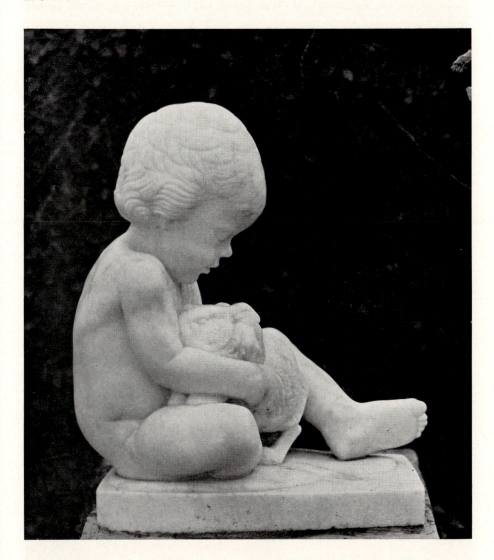

SUSAN

Imperial Danby marble group. Height 1 ft. 8 in. Base: Length 1 ft. 3½ in.—Width 8½ in. Signed on base at back: EDWARD HOFFMAN, SC PHILADELPHIA 1950 On base at front: SUSAN Placed in Brookgreen Gardens in 1951.

Saint George and the Dragon

Saint George is mounted, nude, on a horse rearing over an enormous dragon. As it turns its head to attack, he plunges a sword into its mouth.

Alabaster group. Height 10¼ in. Base: Length 8½ in.—Width 5 in. Signed on base at front: NED HOFFMAN LA NAPOULE 1954 Broken and repaired. Placed in Brookgreen Gardens in 1961.

Ralph Jester

RALPH JESTER was born on July 10th, 1901. He attended the University of Texas for one year, graduated from Yale University, and studied at the Yale Architectural School. He then went to France, where he spent the summer of 1925 at the American Academy at Fontainebleau. He began the study of sculpture in the studio of Henri Bouchard. He has contributed articles on sculpture to *The American Architect*, *The American Magazine of Art*, and the *New York American*. For twenty-five years he was associated with the motion picture industry as art director, documentary producer, and writer. During World War II he organized the Army Air Force combat film

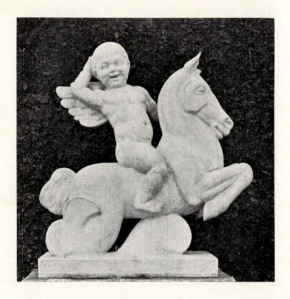

SEA HORSE AND COMPANION

Cast stone group. Height 2 ft. 9½ in. Base: Length 2 ft. 1 in.— Width 1 ft. Signed on base at right: RALPH JESTER Placed in Brookgreen Gardens in 1936.

service. In 1964 he went to Rockford College at Rockford, Illinois, where he was public relations director until he retired to Palos Verdes Estates, California, to spend his time writing.

Sea Horse and Companion

A winged boy rides a sea horse, one hand placed on its neck, the other raised to his head as he turns, smiling. The horse's neck is arched and the chin drawn back; its forelegs are bent as it leaps forward over a wave. The hind legs end in broad fins. The figures are simply modeled and the surface roughly finished.

Gustav Bohland

GUSTAV BOHLAND was born at Graslitz, Austria, on January 26th, 1897, to Wenzel and Marie Amalie (Pscherer) Bohland. His childhood was spent at Graslitz, where he early began to study music and art. Classes in the school of arts and crafts were later supplemented by visits to museums in Austria, Germany, and Italy. During the First World War he served in the Austrian army as a mounted artillery observer, winning four decorations for heroism. There being little opportunity for an artist at the end of the war, he started a small factory for art embroidery until in 1924 he emigrated to New York. He again turned to sculpture and studied at the art schools of Cooper Union, the National Academy of Design, and the Beaux-Arts Institute of Design, while acting as assistant to A. A. Weinman for four years. Working independently, by 1933 he had accumulated enough work for a joint exhibition with his wife, Eileen Parnell.

A winter spent in Florida determined him to move there, and in January 1934 he established a studio at Miami Beach, becoming an active participant in its artistic life. Through his efforts an art center was established in the Public Library and the building finished, with four reliefs by the sculptor on the façade. He modeled many portrait busts, including one of Dr. Clayton Sedgwick Cooper and a heroic-sized bronze of Carl Graham Fisher for the memorial to him. A portrait mask of the painter Ernest Lawson is in the Corcoran Gallery of Art, Washington, D.C. Large decorative bronzes are a *Boy Sower* for Thomasville, North Carolina, and a group of three for the

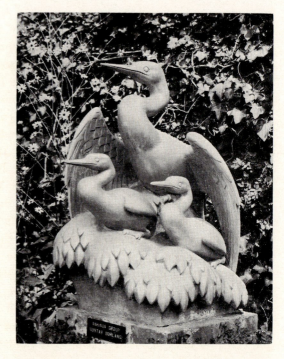

GROUP OF ANHINGAS

Aluminum group. Height 2 ft.
7 in. Signed on base: © Bohland
Founder's mark: ROMAN
 BRONZE WORKS INC. N.Y.
Placed in Brookgreen Gardens
 in 1954.

Froedtert Malting Corporation, Milwaukee. His skill as a designer of bas-reliefs and medals led to a commission for one in honor of Dr. Albert Schweitzer. Bohland died on April 22nd, 1959.

Group of Anhingas

Perched on a mass of drooping foliage, a water turkey shelters two fledglings under her lifted wings. Their sharp-beaked heads are raised on long necks that make a repetitive pattern of serpentine curves. This group of anhingas or snakebirds, first modeled in 1936, ornamented the façade of Bohland's studio.

Sahl Swarz

SAHL SWARZ was born in New York City on May 4th, 1912, to Samuel and Ida (Fass) Swarz. When he was sixteen he began to study sculpture with Dorothea Denslow at the Clay Club and later attended classes at the Art Students' League. As associate director of the Clay Club he was closely

identified with its growth and development into the Sculpture Center. Early commissions were for the Government: sculpture in terra cotta for a wall of the post office at Linden, New Jersey, ordered by the Federal Works Agency, and two figures, *Defend Freedom* and *Freedom Prosper*, for the Court House, Statesville, North Carolina, the contract won in competition. In 1941 he enlisted in the United States Army and served with the 35th Field Artillery for five years. At the end of World War II he was able to resume his profession and did a little sculpture at Paris. In order to carry on his search for a personal creative expression he went to Italy in 1951, staying at Florence, where he could work closely with a foundry.

Just before the war he had received a commission for an equestrian statue of Civil War General Daniel Davidson Bidwell to be erected at Buffalo, New York. He returned to Italy to cast the statue. At Florence mosaics of glass tesserae attracted his attention, and he decided to experiment with adapting this technique to his sculpture, evolving a special technique of mosaics set in cement on a framework of welded and brazed steel. Later he went to Pietrasanta to work out his problems in a studio of mosaic craftsmen. As subject matter the shapes of fleeing people left in the volcanic ash at Pompeii impressed him with their instantaneous transcript of life. Working in a foundry at Florence, he modeled figures in wax over refractory cores for casting direct. Some plaques were cast directly from a design modeled intaglio in founder's sand. In working out these techniques he also developed a taste for simple masses with linear movement on the surface. Because of these works, which were shown in his first one-man exhibition at the Sculpture Center, The American Academy of Arts and Letters awarded him a grant in 1955. With this and another grant from the Guggenheim Foundation he could return to Italy and work at the American Academy in Rome.

Three years later, on a second Guggenheim grant, he moved to Verona, where he could work in relative solitude, with a good foundry at hand, and let his ideas develop freely. He returned to New York to show the results of his experiments in successive exhibitions at the Sculpture Center, at Philadelphia, and Chicago. The museum at Norfolk, Virginia, acquired *Niva*, a bronze cat; the Minneapolis Institute of Arts, *Tryst;* and the Whitney Museum of American Art, *Tree of Oracles. Horse Fair*, a bronze study of bodies and legs in motion, was bought as the first Governor's Annual Purchase Award by the New Jersey State Museum at Trenton.

In 1963 Swarz decided to stay in the United States and took a studio at Cliffside Park, New Jersey. His sculpture shows a continuous search for new forms, tending towards elimination of the human image. The bronzes exhibited in 1960 were elongated and compressed into oracular statements, sometimes with overtones from the art of early civilizations, in a desire to satisfy "a

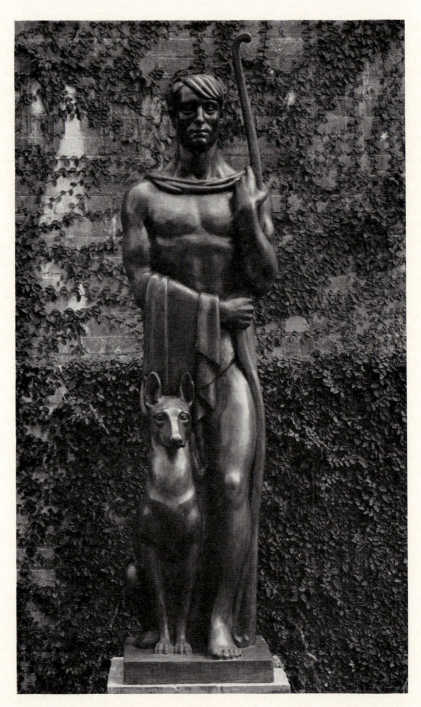

THE GUARDIAN

Bronze statue. Height 6 ft. 8 in. Signed on base at back: SAHL SWARZ 1937
Founder's mark: ROMAN BRONZE WORKS N.Y. Placed in Brookgreen Gardens
in 1937.

craving for the spiritual, mystical—primordial, if you will." [1] Six years later he showed masses of concrete caged in iron entanglements. *Landmark III*, a towering structure of irregular cubes, is in the Newark Museum. Swarz says of his sculpture, "As I grow in time, so I change according to my encounters and experiences in life and in art. My sculpture reflects this: early works were literally figurative with literal meaning; later works were less literal, abstractly figurative with symbolic meaning; recent works abstract with or without figurative connotations and meanings embodied in the forms themselves—meanings born of my inner self and my experiences to be shared by people sensitive to such form encounters. They are aware of and react to my deepest feelings, thus involving themselves creatively. The human figure is a source of inspiration as are trees, mountains, clouds and birds. To study these beautiful forms of nature with a view to comprehending nature's functional basis of creativity is to build a foundation for artistic expression. The craftsman copies them. The artist uses them interpretively and metaphorically or evolves new forms inspired by nature's processes." [2] Swarz has varied his creative work by teaching at Pratt Institute, the New School for Social Research, Brandeis University, the University of Wisconsin, and most recently at Columbia University.

The Guardian

A man steps forward, a long bow held against his left side in both hands. A cloak is hung from his shoulders and an end thrown over his right forearm. Close against his right knee sits a police dog, its ears alertly lifted.

Ruth Yates

RUTH YATES was born at Greenville, Ohio, on December 31st, 1896. She attended the Cincinnati Art Academy and the Grand Central School of Art, and in Paris she studied at the Académie Julian and with Paul Landowski. From José de Creeft she learned the technique of direct carving in stone. She carved a colossal head of Joe Louis now in the museum at Norfolk, Virginia, and in 1939 received the second Anna Hyatt Huntington Prize of the Na-

1 *Sculpture by Swarz.* p. 13.
2 Letter of January 13th, 1968.

PAN

Lead statue. Height 3 ft. 5 in.
Signed on base at right: RUTH
YATES Placed in Brookgreen
 Gardens in 1937.

tional Association of Women Painters and Sculptors for *Peasant Head*. For some time she had a studio in Greenwich Village, New York City, and then moved to Westchester County, where she was one of the founders of the Hudson Valley Art Association. She taught stone carving at the Westchester Workshop, White Plains, and in her studio at Mount Vernon. In addition to her work in stone, she has modeled many garden figures to be cast in lead. Religious sculpture included a head of Christ, *Christ in Gethsemane*, and *Saint Francis*. The Pen and Brush Club awarded her first prize in 1945 and 1949, and she also received an Art for Democratic Living Prize. Beginning in 1952, she was for a few years director of the gallery at the City Center, New York. She served two terms as recording secretary of the National Sculpture Society, of which she is a fellow, and has been a first vice-president of the Pen and Brush Club and a president of the National Association of Women Artists.

Pan

The rounded childish body of the boy Pan is held sturdily upright on curly-haired goat legs. A bunch of grapes is clasped in the curve of his arm, while he bites an apple held in his other hand.

Allie Victoria Tennant

ALLIE VICTORIA TENNANT is the daughter of Thomas Richard and Allie Virginia (Brown) Tennant. Although she was born at Saint Louis, Missouri, the family moved to Texas while she was still a child, and it was there that she began to study drawing and modeling after school and during holidays. She worked independently for a few years before coming to New York to attend the Art Students' League in 1927 and 1928, where she had instruction in sculpture from Edward McCartan and in anatomy from George Bridgman. The year 1930 she spent traveling in Europe, with lengthy stays at Rome and Paris. Three years later she again studied for a short time at the League with Eugene Steinhof of Vienna. Most of her work has been done in Dallas, where she has a studio, although she occasionally comes to New York to complete large works.

Her sculpture began to receive recognition in 1927, when *Head of a Soldier* was awarded second prize at the Texas Artists' League exhibition held at Nashville, Tennessee. From 1928 to 1930 she received the first award for sculpture in the Annual Allied Arts exhibition at the Dallas Public Art Gallery and in 1932 the first award for architectural sculpture. Her most important commission in this form of sculpture has been the *Tejas Warrior*, a heroic gilt bronze statue over the entrance to the Hall of State, Dallas, built for the Texas Centennial Exposition. She was also commissioned to execute a large panel and sea horses for the Dallas Aquarium. *April*, a figure of a girl with pigeons, which received the Garden Club Prize at the Southern States Art League exhibition in 1932, has been acquired for the garden of the Dallas Woman's Club. Other awards won at exhibitions of the Southern States Art League in 1933 and 1936 are the Birmingham Park Board Prize for a portrait head in bronze and the Houston Museum Sculpture Prize for *Negress*. In the permanent collection of the Dallas Museum of Fine Arts are a portrait of Mrs. George K. Meyer and *Negro Head*, cut directly in black Belgian marble, which was acquired through the Keist Memorial Purchase Prize.

The sculptor has completed two memorials to heroes of the Texas revolution, that of José Antonio Navarro for Corsicana, and one of James Butler Bonham for Bonham, Texas. Sculpture for the post office, Electra, Texas, was done under the Federal Works Agency. In recent years she has limited her production to portraits, memorial plaques, and garden figures. She has taught

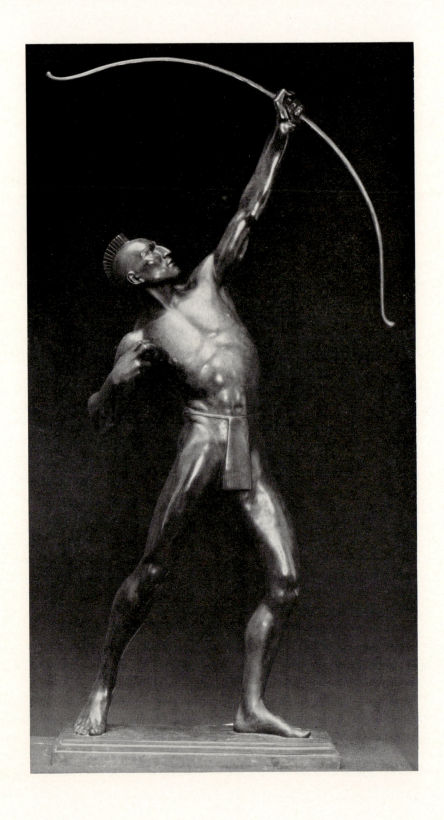

ARCHER—TEJAS WARRIOR

Study model in bronze. Height 4 ft. 5 in. Signed on base at left: ALLIE TENNANT SC © 1936 Founder's mark: ROMAN BRONZE WORKS N.Y. Placed in Brookgreen Gardens in 1937.

sculpture at the Dallas Art Institute and the Dallas Evening School. She is a fellow of the National Sculpture Society and a member of the Southern States Art League and the Dallas Art Association.

Archer—Tejas Warrior

An Indian warrior bends backward to draw a bow aimed upward. His muscular body is braced for the effort, the long diagonal of extended arm and backward-thrust leg preluding the arrow's flight. Above the strong face rises a crested headdress. This is the study model of a heroic figure created for the Hall of State, a permanent building erected at the Texas Centennial Exposition, Dallas, acquired for Brookgreen by special permission of the State of Texas.[1] The sculptor chose an Indian as the subject of her statue because Texas was named after the friendly Tejas Indians.

Robert Pippenger

ROBERT PIPPENGER was born at Nappanee, Indiana, on April 26th, 1912, the son of Clayton Pippenger. Although his family has been in this country for three generations, they are of Swiss, Alsatian, and Dutch descent. Since his pioneer grandfathers were stone masons and architects, it is not surprising that sculpture was his choice for a career. Brought up at Plymouth, Indiana, he began to paint at the age of ten and model at the age of fifteen. He studied sculpture at the art school of The John Herron Art Institute, Indianapolis, under the instruction of Forrest Stark and David Rubins. When in 1938 he received the Millikan Prize for foreign travel, he spent ten months in England, France, Italy, Greece, Yugoslavia, and southern Germany. In the next year a fellowship took him to the American Academy in Rome, but his stay was cut short by the outbreak of World War II. His *Farm Group* is on exhibition at the Marshall County Historical Society, Plymouth, Indiana.

1 ROGERS, John William. *Imposing statue of Tejas Indian by Dallas artist.* In *The Dallas daily times herald.* August 2nd, 1936.

sculpture, but instead of using Laessle's meticulous treatment, Rudy has organized his work in large masses and simplified planes. The Pennsylvania Academy purchased his *Pekin Drake* carved in Pentelic marble. Both portrait and figure sculpture have also received his attention. A *Reclining Girl* carved in marble is also in the collection of the Pennsylvania Academy, and the Philadelphia Museum of Art acquired his *Lucrece*, in bronze. An example of *The Letter*, a bronze statuette which won the Dr. Herbert Howe Prize of the Pennsylvania Academy in 1947, is in The Metropolitan Museum of Art, New York. An engaging sense of humor lightens even serious themes.

When World War II broke out, although he was beyond the age for military service, he took a job as a welder in an autogiro plant. His ingenuity seized on the opportunity to make amusing animals and insects from bits of scrap metal in his spare time. At the end of the war he received commissions for various memorials. To commemorate the men lost on tankers he represented a seaman with his duffel bag on his shoulder, erected by the Sun Oil Company at Marcus Hook, Pennsylvania. A flagpole base with five figures symbolizing the unity of the races of man was placed on the campus of the University of Pennsylvania. In 1954 he shared with Henry Kreis a war memorial for Virginia Polytechnic Institute at Blacksburg. Rudy designed symbolic figures to be carved in high relief in limestone for the four pylons on one side of a court.

Other important architectural projects, both completed in 1964 for Pennsylvania, were for the State Museum at Harrisburg and for the Lehigh County Court House at Allentown, the former depicting Penn's treaty with the Indians and famous Pennsylvanians, the latter a frieze representing Justice, with the people of the region grouped at each side of a judge.

Rudy taught himself stone carving, usually working out his theme directly in the stone without making preparatory sketches. Works in stone are a study of a mother and child called *Next Generation* and a head of Medusa. He has also carved many works in wood, such as an *Eagle* in the Audubon Shrine of Montgomery County, has modeled for terra cotta, and done his own casting in lead for small objects. Rudy served on the Pennsylvania State Art Commission, is a fellow of the National Sculpture Society, and a member of the National Academy of Design.

Joy Ride

A shouting boy is precariously seated on the back of a sow, holding on by both the animal's ears, his legs in the air. The pig is half squatted on its haunches, its mouth open, seeming to enjoy the fun. The curves of the pig and

the boy's lean form are simply yet decoratively handled. This group was modeled at New York during the winter of 1932 to 1933 from sketches made at the pig stables in Secaucus, New Jersey. It won for the sculptor the Fellowship Prize at the annual exhibition of The Pennsylvania Academy of the Fine Arts in 1935.

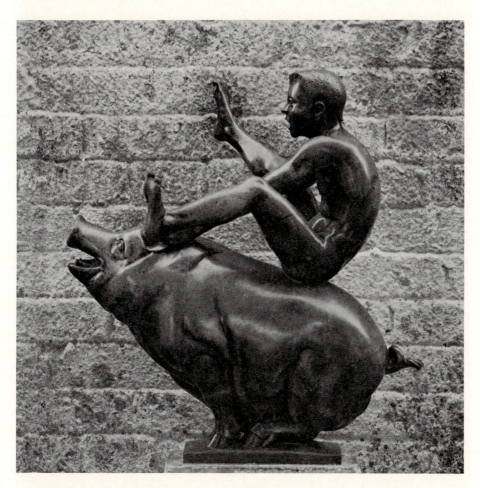

JOY RIDE

Bronze group. Height 1 ft. 8 in. Base: Length 8⅝ in.—Width 5¼ in. Signed on base: CHARLES RUDY–N.Y.–1933 Founder's mark: CELLINI BRONZE WORKS N-Y-Placed in Brookgreen Gardens in 1936.

Ralph Hamilton Humes

RALPH HAMILTON HUMES was born at Philadelphia on December 25th, 1902, to John and Grace (Gann) Humes. His father was a banker of Jersey Shore, Pennsylvania. From the time he was fifteen he worked in the lumber and sawmill business until he joined the United States Army School of Aerial Photography in 1920. He was injured there by an accidental bomb explosion which caused the partial loss of seven fingers and the loss of his right eye. While at Walter Reed Hospital, where he spent the next three years, he became interested in modeling as a physio-therapeutic treatment for his mutilated hands. After some progress had been made in rehabilitation, the Government, realizing that he had some aptitude for sculpture, paid his expenses for one term at the Rinehart School of Sculpture, Baltimore, in 1924, where J. Maxwell Miller was teaching.

Humes began the study of sculpture seriously in 1925, working his way through The Pennsylvania Academy of the Fine Arts, studying under the instruction of Albert Laessle and Charles Grafly. He twice, in 1929 and 1930, won the Cresson Traveling Scholarship for study in Europe. The influence of Laessle may have helped determine his bent, since his favorite subjects are small animals in action. Sympathy for his models and a direct approach give his works the feeling of life. *Whippet* took the Club Prize of the New Haven Paint and Clay Club in 1936 and the gold medal of the Florida Federation of Arts in 1938. The Speyer Memorial Prize was awarded him in 1937 for *Walking Bear Cub*, and in 1941 he was given the Flagg Prize of the Connecticut Academy of Fine Arts.

In 1934 he moved to Florida and two years later made a four-figure fountain in relief and entrance panels for the Coral Gables Library. He was also the sculptor of the Tony Janus Memorial at Saint Petersburg. For the Dupont family he made a portrait of a grand champion bull. An unusual commission was a figurehead for the yacht *Comanche*. The Miami Women's Club gave him a gold medal and named him sculptor of the year in 1940. His statue of Father Kino, founder of the missions in southern Arizona, is being erected at Nogales. In recent years Humes has had one-man shows of his work at Tucson, Arizona, and Orlando, Florida.

He is also an expert on conchology, having had field experience studying marine and terrestrial mollusks for twenty years. He has contributed papers on the genus *Liguus* and has given study collections of shells to schools and

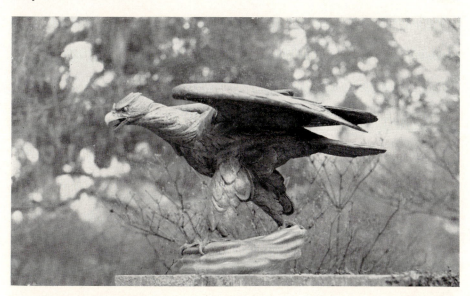

THE EAGLE'S EGG

Aluminum statue. Height 2 ft. 2 in.—Length 3 ft. 7½ in.—Width 2 ft. 6 in. Signed on base at right: R H HUMES Placed in Brookgreen Gardens in 1953.

museums. Among the societies to which he belongs are the Fellowship of The Pennsylvania Academy of the Fine Arts, the Blue Dome Fellowship, the Connecticut Academy of Fine Arts, and the National Sculpture Society, of which he is a fellow.

The Eagle's Egg

An eagle stands with wings lifted and beak open, protectively astride an egg hidden in a gnarled root. The feathers along its back are ruffled, fanning out at the top of the leg, and the tail is spread. Modeled from earlier sketches, the statue was completed in 1953.

Jumping Squirrel

A squirrel leaps forward, the tail arched, all four feet braced on an oak twig. This statuette was modeled at Peterboro, New Hampshire, during the summer of 1933; two examples were cast.

Bronze statuette. Height 10½ in. Founder's mark: ROMAN BRONZE WORKS. N.Y. Placed in Brookgreen Gardens in 1934.

Performing Goat

A young goat with a harness about the body is seated on its haunches, both forefeet waving in the air, the head cocked to one side. A rope fastened to a peg is wound around one leg. The goat was a pet of the sculptor's. The statuette was modeled at Peterboro, New Hampshire, in the summer of 1933 and one example cast.

Bronze statuette. Height 1 ft. 9½ in. Base: Length 1 ft. 2½ in.—Width 9¾ in. Founder's mark: ROMAN BRONZE WORKS N-Y. Placed in Brookgreen Gardens in 1937.

Wounded Crow

The bird has drawn back in a defiant attitude, one leg extended, the tail spread, one wing lifted, and the other wing bent forward. The head is raised and the beak open. The crow which served as a model was rescued in a corn field, its wing broken; its undaunted spirit inspired the sculptor to model this statuette, of which two examples were cast. It won the Speyer Memorial Prize of the National Academy of Design in 1932.

Bronze statuette. Height 1 ft. 1 in. Base: Length 8½ in.—Width 7 in. Founder's mark: ROMAN BRONZE WORKS N.Y. Placed in Brookgreen Gardens in 1934.

Walter Rotan

WALTER ROTAN was born at Baltimore, Maryland, on March 29th, 1912, to Adolph and Alma (Walter) Rotan. As a boy he began to attend classes in modeling at the Maryland Institute of Fine and Applied Arts, graduating from there in 1929. Later he studied with Albert Laessle at the Pennsylvania Academy, showing such promise that he was awarded tuition scholarships and in 1933 the Cresson Traveling Scholarship for study abroad. He also received a Tiffany Fund Scholarship. Association with Laessle, so accomplished in representing animal life, prepared him to carry out his own interpretations. Based on studies from life made at the zoo, he developed a special style of his own, kindled by the aesthetic qualities of the bony and muscular structure of lean, agile forms and inspired with a peculiar nervous vitality. Statuettes of gazelles and a giraffe show these qualities, while in two

fan-tail pigeons he has delighted in their pompous strut and in the texture of the feathers. One of these was given the Watrous Gold Medal of the National Academy of Design in 1942. Working at the winter quarters of the Ringling Circus, Sarasota, Florida, in 1932 he was awarded first prize in sculpture by the Ringling Art School. In 1936 he won the Barnett Prize of the National Academy of Design with a powerfully characterized head, *Mr. Brown*. The same keenness of observation is evident in other portraits and figure studies. *Herbert*, a head of a Negro boy, was purchased by the Pennsylvania Academy and in 1946 the sculptor was awarded a Fellowship Prize.

His instinct for linear design led him to refine still further his interpretations of swift animals such as antelopes. In a series of horses, the bodies have been simplified to rounded forms on slender legs with a feeling akin to that of Chinese artists. The sculptor has also emphasized smooth forms and crisp edges in some portraits; *Dorothy*, a head of a Japanese dancer, won a prize from the Allied Artists of America in 1956. In contrast, he made several studies of women expressive by modeling in a sketchy manner with rough surfaces and broken planes, dramatized by deeply shadowed eyes. Travels in the Orient and winters spent in Mexico City broadened his understanding of the sculpture of other countries. Rotan likes to do individual things in small

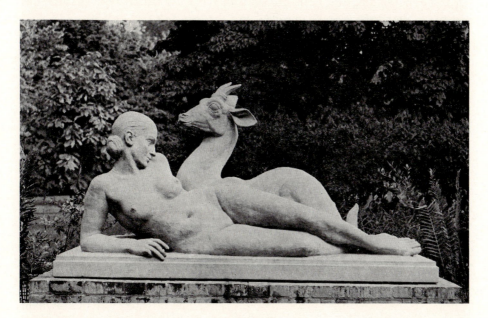

RECLINING WOMAN WITH GAZELLE

Limestone group. Height 3 ft. 7 in. Base: Length 6 ft. 7 in.—Width 2 ft. 8¼ in. Signed on base at back: W. ROTAN · 1937 · Placed in Brookgreen Gardens in 1941.

size in which he can embody his private vision and keep his personal touch on the finished work, often doing his own casting. For this reason he has had little share in public commissions. He was head of the Art Department at the Taft School, Watertown, Connecticut, from 1938 to 1953.

He is a fellow of the National Sculpture Society and belongs to the Fellowship of The Pennsylvania Academy of the Fine Arts.

Reclining Woman with Gazelle

A SLENDER WOMAN is lying with her body raised on her right elbow, her head turned towards a gazelle couched behind her, its head lifted facing hers. The group was enlarged and modeled full size by the sculptor at New York during the winter of 1936 and 1937 from a small study made the previous year.

Gazelle

A gazelle stands, the neck arched and the head back. The sculptor has treated in detail the play of muscles over the lean body, the slender legs and long neck. The horns are gilded and the eyes touched with black. It was modeled in 1935 at the Philadelphia zoo.

Bronze statuette. Height 1 ft. 5 in. Base: Length 5¼ in.—Width 3½ in. Founder's mark: ROMAN BRONZE WORKS, N.Y. Placed in Brookgreen Gardens in 1936.

Frank Eliscu

FRANK ELISCU's sculpture is remarkable for the virtuosity with which he represents lean forms in action, wrought with sharp detail to give an impression of wiry strength and nervous energy. Born in Brooklyn, New York, on July 13th, 1912, to Charles H. and Florence (Kane) Eliscu, he began when a boy to model and continued while in high school, using candles softened under the hot water faucet. He studied at the Beaux-Arts Institute of Design in the evening, until a scholarship enabled him to spend two years at Pratt Institute. Practical experience gained in the studio of Rudulph Evans gave him versatility in different mediums. As a charter member of the Clay Club, later to become the Sculpture Center, he used their facilities before he had a

studio of his own and later held several one-man exhibitions there. During the Second World War, serving with the Medical Corps, he used sculpture as an aid to plastic surgery. After the war he carried on this interest and also engaged in research into pigmentation of skin grafts, becoming a specialist associated with the New York Hospital.

Resuming his career in sculpture, he perfected an improved technique of lost-wax bronze casting that enabled him to launch his figures in air on tenuous supports, creating striking linear patterns; at the same time the muscular forms, in spite of their small scale, are solidly constructed. Each work is cast directly from the original wax model. Acrobats, dancers, animals, and marine subjects are appropriate themes for this special treatment. Taking advantage of a sabbatical leave from teaching at the School of Industrial Art in New York City, he spent the year 1952 in Italy. After his return to New York a group of small bronzes received the Mrs. Louis Bennett Prize of the National Sculpture Society. A memorial to the doctors who lost their lives in the Second World War, has been erected at Olin Hall, Cornell Medical College.

The grace and spirit of his figures led to frequent use to enliven foyers and lighten heavy walls. The commission won in competition, his Naiad diving into a pool was placed in the lobby at 100 Church Street, New York. A fountain pool in the Hippodrome Building, New York City, represents the fifth day of creation by leaping fish with crusty surfaces of shells and fossil shapes and by leaf-feathered birds rising in flight. At the same time he modeled such solid forms as the triumphant male figure, *Atoms for Peace*, for a high school at Ventura, California. His quicksilver imagination is always seeking new channels. Abhorring traditional conventions, he finds his own way of giving meaning to a figure, as when for the titular saint of Saint Christopher's Chapel on East Forty-third Street, New York, instead of the Christ Child riding on the saint's shoulder, he chose to represent Christ in the great man's heart by a cross inscribed in a concave roundel on his breast.

Since Eliscu's gay fantasies would attract children, he was asked to design a series of subjects from Aesop's fables to be placed in the schools at Santa Paula, California. In each case the children chose the fable that the sculptor was to illustrate. The one selected by the Cerebral Palsy School was *The Tortoise and the Hare*, planned and cast in bronze so that children can climb on it for entertainment and a tactile experience of sculpture.

For mural decorations Eliscu began to explore the possibilities of low reliefs in slate. The sculptor chose gray or deep red tones in Vermont quarries on which to carve with incised outlines and surfaces modeled in shallow depth to give the illusion of a third dimension. For the lobby of the Bankers Trust Building on East Forty-fifth Street, New York, he carved two horses of heroic

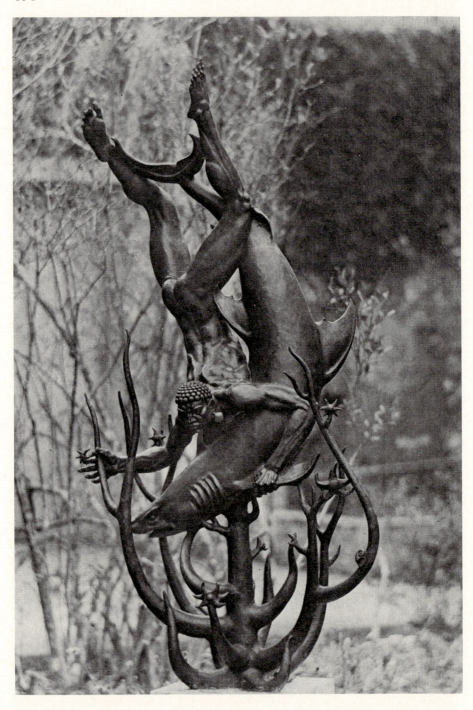

SHARK DIVER

Bronze group. Height 6 ft. Signed at back: ELISCU Founder's mark: ROMAN
BRONZE WORKS Placed in Brookgreen Gardens in 1955.

size in contrasting movement with elegant interplay of lines and planes. This
work shared in the Henry Hering Memorial award given by the National
Sculpture Society to architect, sculptor, and owner for a fine example of
artistic collaboration on a commercial building. Slate panels were also used
for the Stations of the Cross set into a wrought-iron grille in the Holy Mother
Chapel of Father Judge Mission Seminary near Lynchburg, Virginia.

Another field of experiment was modeling designs to be translated into
engravings on crystal by Steuben Glass. He tried such diverse subjects as a
carrousel, Noah, and Saint Francis; he also participated in *Poetry in Crystal*, a
creative adventure in which poet and sculptor collaborated to interpret the
same theme, the one in words, the other in forms engraved on glass.

Eliscu has described his methods in a book, *Sculpture: Techniques in Clay,
Wax, Slate* and an article, *New Casting Method for Small Bronzes* printed in
the *National Sculpture Review* (March 1952). He directed and illustrated
two books for young people written by Mickey Klar Marks, *Wax Sculpturing*
and *Slate Sculpturing*. A member of the National Academy of Design, he was
elected president of the National Sculpture Society in 1967.

Shark Diver

A muscular Negro grasps the fin of a shark as both plunge downward
through the tentacular branches of a sea plant studded with marine creatures.
The tangled bodies of fish and man in fluid motion bend backward in an arc.
Major forms are accented by strong modeling of details.

This work illustrates the preference expressed by the sculptor when he
chose *Sea Treasures* as the title for the seventieth issue of The Society of
Medalists, "I have always felt that life and movement are synonymous, and
the piece of sculpture designed with grace and movement is a beautiful thing.
Of the many themes that lend themselves to this belief, the natural beauty
of the sea is one that has always fascinated me. . . . Only within the sus-
pension of water can the human form be released to its ultimate flow of
grace and action."

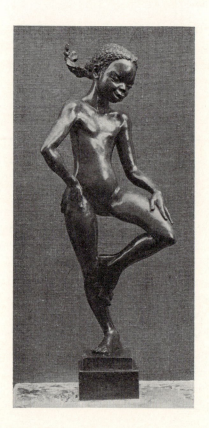

DANCING PICKANINNY

Bronze statuette. Height 1 ft. 3 in. Signed on base at back: *Muriel Chamberlin Kelsey* Placed in Brookgreen Gardens in 1937.

Muriel Chamberlin Kelsey

MURIEL CHAMBERLIN KELSEY, born at Milford, New Hampshire, spent her early years at Bethlehem. After graduating from the University of New Hampshire she worked as an assistant in the zoology laboratory there and later at the University of Vermont and began her career as an artist by making anatomical drawings as teaching aids. In 1923 she married Howard P. Kelsey. They later moved to New York, where Mrs. Kelsey studied design at Columbia University and the New School for Social Research. She began the study of sculpture in 1934 at the Clay Club with Dorothea Denslow and learned the techniques of the various materials, showing her work there and in exhibitions in many other galleries and museums.

After the Kelseys moved to Sarasota, Florida, in 1951, Mrs. Kelsey began to exhibit with art associations there and receive awards. The Bradenton Art

Center gave her a one-man show in 1957. Animals are her preferred subjects, which she carves in stone with simplified forms. In the mild climate she can do her carving out of doors and use her studio for modeling in terra cotta or occasionally working in metal. Her works, in sizes appropriate for homes and gardens, are in many private collections.

Dancing Pickaninny

This statuette is an amusing and lively study of a small Negro girl. She stands on one foot, the other braced against the knee, one hand on her hip and one on the thigh, pigtails flying.

Dorothea Schwarcz Greenbaum

DOROTHEA R. SCHWARCZ was born in Brooklyn on June 17th, 1893. Her father, Maximilian Michael Schwarcz, a Hungarian, had musical and artistic ability. Her mother, Emma (Indig) Schwarcz, was American of German parentage. Dorothea Schwarcz studied painting at the New York School of Fine and Applied Art, where she won a scholarship, at the Art Students' League with Kenneth Hayes Miller, and also with Charles W. Hawthorne, Jonas Lie, and R. Sloan Bredin. One of her paintings, *Lighthouse*, has been acquired by the Whitney Museum of American Art. In 1920 she married Edward S. Greenbaum, a prominent lawyer. Although she had never studied sculpture, she began to model animals about 1927. A study of a rabbit is in the Lawrence Museum of Williams College. Since then she has made sculpture her main interest and has extended her talents to other than animal subjects. *Tired Shopper* shows her amused interest in everyday life. *Tiny*, a life-size bronze, was awarded the Widener Memorial Medal of the Pennsylvania Academy in 1941. *Big Business* is a caustic commentary on gross materialism in the form of a man's head.

As a special enthusiasm she mentions her admiration for Etruscan art, but a more obvious kinship is with Despiau, with whom she shares the ability to extract sculptural values from seemingly casual attitudes and endow her creations with a special evocative quality. In giving her a grant in 1947, The American Academy of Arts and Letters cited her work as "replete with a warm and sensitive appreciation of the human spirit." An unaffected, quiet

figure, *Young Woman*, cast in an edition of thirty, was acquired by many museums, including the Art Center at Fitchburg, Massachusetts, Oberlin College, San Juan in Puerto Rico, and the University of Nebraska, which also owns a *Torso*. *David*, a simple and natural study of one of her sons, won the IBM Purchase Prize for the District of Columbia. *Companions* is in the museum at Ogunquit, Maine, and *Susannah* in the New Jersey State Museum at Trenton. *The Rose* won the medal of honor of the National Association of Women Artists in 1952. In the same year Mrs. Greenbaum was the sculptor chosen as a member of the United States delegation to the Unesco International Art Conference at Venice. A marble, *Drowned Girl*, was bought by the Whitney Museum.

The sculptor's versatility in many media and her adventures into new themes illustrate her statement in the catalogue of her 1958 exhibition at the Sculpture Center:

"Sculpture is an elemental art—an art of feeling, of touching and molding . . .

"There is an urge, a rhythm in an artist—and everywhere he looks he finds the forms that set that urge in motion." In addition to carving in marble and stone, modeling in terra cotta and for casting in bronze, Mrs. Greenbaum has made reliefs of hammered lead, a method by which she produces an effect of veiled outlines and soft contours. When Saul Baizerman began to hammer out reliefs in copper, she took note of the possibilities in this technique. Further recognition of the excellence of her sculpture came in 1964 with the award of a Ford Foundation Grant. One of the works done through this incentive was a head of a girl called *Braided Hair*, an example of which became part of the collection of the Pennsylvania Academy. A purchase prize given by the New Jersey State Museum in 1967 added another of her works, *Woolen Cap*, in bronze, to that collection. An *Oriental Head* is in a museum at Moscow.

Later works are often characterized by a more impressionistic touch, by which each statuette keeps the fresh quality of a sketch. She has gradually left behind a predominant interest in character, and her quick imagination has found beauties of form in unexpected things such as heads based on the faces in a deck of cards or a boy in a Peruvian cap. She was one of the founders of the Sculptors Guild and is a member of the National Institute of Arts and Letters.

Rooting Hog

A hog stands with its nose to the ground, rooting. The characteristic position and the heavy masses of flesh are very true to life. The statuette was

modeled in 1931 at Gstaad, Switzerland, and about it the sculptor tells the following story: "I had intended taking a summer vacation but after finding two gigantic pink pigs in the rear of the hotel, I went to Lausanne for material and tools and set to work. Swiss pigs are much larger than ours and pink and hairless. They sunburn easily, so I had to do all my work before ten in the morning. The hotel built me an enclosure known as the studio and every morning I dragged the poor pig up a steep mountainside to it and set to work. . . . The real pigs were truculent and greedy and fought terribly . . . Finally about half way through I went to Italy for a few days and when I came back they were in the process of being made into hams and bacon! However my hotel had my interests at heart and had scoured the village for a pig that looked like the dear departed. They finally found one in a peasant's house and I moved my things there."

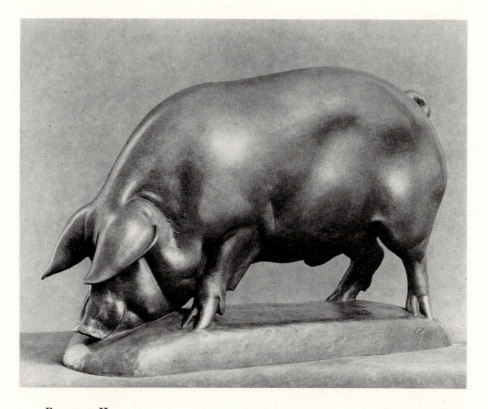

ROOTING HOG

Bronze statuette. Height 9 in. Base: Length 1 ft. 1¼ in.—Width 4½ in. Signed on base: *G* Founder's mark: CELLINI BRONZE WORKS-N-Y Placed in Brookgreen Gardens in 1936.

Gentle Tapir

A tapir is standing with nose to the ground, grazing. The back flows in a smooth curve from tip of nose to tail. The muscles swell beneath the firm skin. The work was modeled in 1943 from a Central American tapir in the Washington zoo. The placid, friendly nature of the animal is apparent.

Bronze statuette. Height 1 ft. 1½ in. Base: Length 1 ft. 4⅝ in.—Width 6 in. Signed on base at back: GREENBAUM SC Founder's mark: MODERN ART FNRY. N.Y. Placed in Brookgreen Gardens in 1948.

Anne Philbrick Hall

ELISABETH ANNE PHILBRICK was born at Belmont, Massachusetts, on April 17th, 1917, the daughter of Otis Philbrick. Her father was head of the Department of Painting and Drawing of the Massachusetts School of Art, where she studied from 1934 to 1938 with Raymond Porter and Cyrus Dallin. She has been an instructor at the School for Professional Artists, Boston. Her works include the Harriet Jenks Greenough Memorial Fountain for the Peabody Playhouse, Boston.

Miss Philbrick married Glenn Goodrich Hall, a professional dog handler, in 1944. A year later she won a national competition for the Gaines War Dog Memorial, and she also designed a bronze trophy for the New England Sled Dog Club. After her husband's death she supported the family by designing pins and charms of animal subjects, chiefly show dogs, cast in silver. In 1962 she collaborated with an architectural sculpture studio in Boston to make the Siberian husky cast in bronze for the Student Union Building at Northeastern University, Boston.

Lady

An English setter, Lady Cassia of Gwent, is sitting quietly erect. The sculptor, amused at the way the dog held herself so proudly after becoming the mother of six puppies, made this record. The statuette was modeled in 1938 and one example cast.

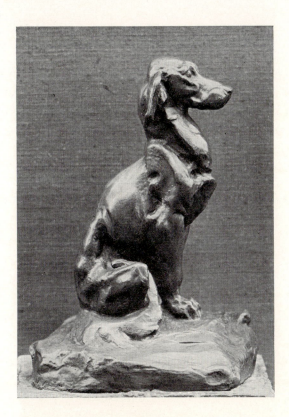

LADY

Bronze statuette. Height 10 in.
Base: Length 7 in.—Width 6 in.
Signed on base at back: PHIL-
BRICK Placed in Brookgreen
Gardens in 1940.

Ralph J. Menconi

RALPH JOSEPH MENCONI, born at Union City, New Jersey, on June
15th, 1915, is the son of an architectural sculptor, Raffaello E., and of
Josephine (Zampieri) Menconi. His father had come from Italy to the United
States at the age of seventeen and established in New York the firm of
Menconi Brothers, sculptors and carvers of architectural ornament. Later his
father reorganized the firm under his own name, doing extensive architectural
sculpture for clients the country over. The family lived at Hastings on
Hudson, and the son attended Scarborough School and later Hamilton Col-
lege. He began his professional training by working summers and vacations
in his father's studio. In 1933 he began a three-year apprenticeship with C.
Paul Jennewein and at the same time studied at the National Academy of
Design in the evenings. Subsequently he attended the Fine Arts School of
Yale University and received a Bachelor of Fine Arts degree in 1939. During

his three years at Yale he studied at the Tiffany Foundation, Oyster Bay, Long Island, every summer vacation.

Drafted as a private in the Second World War, Menconi was sent to the Engineer School at Fort Belvoir in 1942 and commissioned a second lieutenant. Serving in command and staff positions he was promoted to major. His unit saw three years of active service in the European theater and twice received citations for outstanding performance of duty. Menconi was awarded a number of medals: Bronze Star, European Theater of Operations, Victory, Pre Pearl Harbor, and Medal of Occupation.

After he was discharged from the army, he won a Tiffany Foundation grant that enabled him to resume his profession. Many of the men who have sat to him for portraits are distinguished engineers, inventors, and industri-

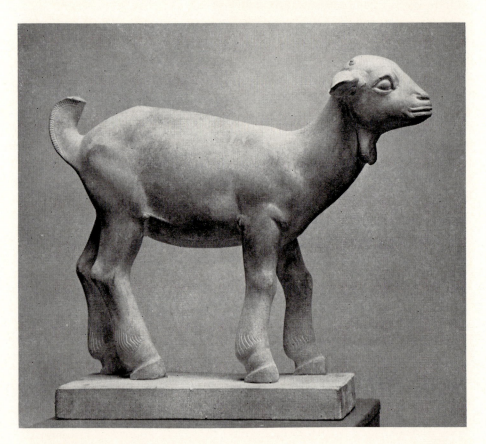

MOCHA

Bronze statuette. Height 1 ft. 2⅛ in. Base: Length 11¾ in.—Width 5 in. Signed on base at right: RALPH · J · MENCONI · SC · 19©41 ·　　Founder's mark: BEDI-RASSY N.Y.C. Placed in Brookgreen Gardens in 1950.

alists: Dr. Ernst Alexanderson of the General Electric Company, Albert
Sobey of the General Motors Institute, Dr. A. N. Goldsmith of the Radio
Corporation of America, and Lambert D. Johnson, president of Mead John-
son and Company. Portrait reliefs of William Green and Samuel Gompers
designed by Menconi were carved in wood and placed in the main lobby of the
Headquarters Building of the American Federation of Labor—Congress of
Industrial Organizations, Washington, D.C. A relief with portraits of the
seven astronauts involved in Project Mercury has been installed at Pad 14,
Cape Kennedy. He has also portrayed Dr. J. Horace McFarland, master
printer of Harrisburg, Dean Everett V. Meeks of the Yale School of Fine Arts,
and Charles Noyes, whose bust is in the student lounge at Pace College.

Since his father's profession had made him familiar with the demands of
sculpture in relation to architecture, much of his work has been designed for
buildings and carried out in terra cotta. Ecclesiastical buildings on which he
has worked are the Church of Saint Rose of Lima at Short Hills, New Jersey,
and Saint Joseph's Church at East Camden, New Jersey, for which he
modeled an overdoor depicting major events in the life of Saint Joseph. A
reredos for the Lutheran Church at Pleasantville, New York, combines brass,
wood, and stained glass, lighted from behind for varied effects. Sculpture on
the Herkimer County Office Building is based on the rich historical heritage
of Herkimer as well as the industries and dairy farming of the county. On the
façade of L. Bamberger's building at Morristown, New Jersey, eight por-
traits in polychrome terra cotta, of heroic size, represent personages of the
Revolutionary War who were connected with the history of the town. Terra
cottas for the Lester Patterson Houses in New York City develop the theme
that such housing projects give the American family a better place to live and
children a chance to grow. A memorial erected by Sigma Delta Chi, an honor
fraternity for journalism, on the campus of DePauw University, Greencastle,
Indiana, is a three-sided shaft of open shapes suggesting quills, with the seal
of the fraternity at the top of each side.

Another field in which Menconi has been active is low relief for medals and
plaques. He designed the National Book Award, the Ford Centennial, and the
Pittsburgh Bicentennial medals. Several, such as those for New York Univer-
sity Law Center, Kenyon College, and The New-York Historical Society,
called for views of buildings. Three presidents—Eisenhower, Kennedy, and
Johnson—have sat to him for medallic portraits, President Johnson having
given the sculptor a commission to design one for his personal use. The other
two are part of a series that he is doing to commemorate every president of the
United States. Two other extensive series being carried out by him are
dedicated, one to the signers of the Declaration of Independence, with scenes
of the American Revolution on the reverse, and the other to famous sons of

every state in the Union. In all, Menconi has designed about five hundred medals. He is a fellow of the National Sculpture Society and has been a director of the Municipal Art Society. He has served as police commissioner in Pleasantville, New York, where he lives.

Mocha

A young goat with horns just beginning to sprout stands awkwardly balanced on knobby legs. The head is held alertly with ears raised, and the stumpy tail is lifted. The body is simply and fluently modeled, while details such as the tufts of hair on the fetlocks and the narrow strips edging abdomen and tail are decoratively treated as rows of parallel wavy lines.

Mocha was modeled during the summer of 1937 while Menconi, still a student at Yale, held a Tiffany Foundation Scholarship.

Robert A. Weinman

THE SON OF Adolph Alexander and Margaret Lucille (Landman) Weinman, Robert Alexander Weinman, born on March 19th, 1915, was practically brought up in a sculptor's studio. As soon as he had graduated from Saint Francis Xavier High School, a semi-military academy in New York City, in 1931, he began studying at the National Academy of Design. During a period of some eight years there his instructors were, in drawing, Charles Louis Hinton, Ivan Olinsky, and C. P. Jennewein; in modeling, Edward McCartan, Gaetano Cecere, Chester Beach, Lee Lawrie, and Paul Manship. As an apprentice in the studios of James Earle Fraser, C. P. Jennewein, and Joseph Kiselewski, as well as of his father, he gained practical experience while continuing his studies in the evening. Later, another year was spent drawing at the Art Students' League under the instruction of Arthur Lee. In 1937, while he was still a student, his *Head of an English Setter* was exhibited at the National Academy of Design.

Weinman enlisted in the Army Air Corps in 1942. After completing the course in the school of photography at Denver, he was assigned there as instructor for a while before concluding his service as a photographer at several continental air bases. All this time he continued to work at sculpture

whenever possible, modeling, for instance, a portrait bust and several portrait reliefs. He commemorated the army fliers in *Morning Mission*, a statue of a man in a flying suit scanning the sky as he walks out to his plane. This statue was modeled while the sculptor was stationed in North Carolina. Cast in bronze, it has been placed as a memorial at the Tulsa Municipal Airport, Tulsa, Oklahoma.

After he was discharged from the army in 1945, Weinman shared his father's studio at Forest Hills for a time. There he enlarged the heroic *Elk* for the Elks' Lodge, Walla Walla, Washington. A *Caryatid* received honorable mention at the exhibition of the Allied Artists of America in 1946. He established his studio in New York City in 1948.

His work reflects his interest in all branches of the sculptor's art. It includes architectural sculpture, such as three tympana for Our Lady Queen of Martyrs Church in Forest Hills, a symbolic motif for the façade of the Brown Memorial Building at the University of Tennessee, Knoxville, and entrance doors for the Armstrong Browning Library at Waco, Texas. Illustrating quotations from Robert Browning's poems, the panels are imaginatively conceived and crisply designed with clean lines and uncluttered modeling. Weinman carved a granite eagle in heroic size for the Federal Bank at Buffalo, New York. Sculpture in limestone for the Church of Our Lady of Perpetual Help at Ozone Park, New York, conformed to the Gothic style of the architecture. Over the entrance is a crucifix between the mourning Virgin and Saint John, in front of a panel with the twelve Apostles in lower relief; at each end, under a canopy, is an archangel, Michael and Gabriel. For the interior of the same church Weinman made models of the four Evangelists to be carved in wood on the baldachin. Stations of the Cross for Manhattanville College of the Sacred Heart at Purchase, New York, with a few strong figures in low relief, depart from conventional iconography. The sculptor designed a bronze symbol of Saint Michael for Archangel College, Englewood Cliffs, New Jersey.

Weinman's skill in relief modeling has been called into play for a number of medals. A series to be awarded for twelve different sports, with reverses showing an athlete engaged in each sport, was designed for the National Collegiate Athletic Association and in 1952 awarded the Bennett Prize at the annual bas-relief exhibition sponsored by the National Sculpture Society. He also modeled a plaque dedicated to the army horse that was placed in the United States Military Academy at West Point. Both the Salvation Army and the Order of Elks commissioned medals from him to celebrate their centennials. He designed the President's Medal for the American Institute of Architects, the Emerson-Thoreau Award for the American Academy of Arts and

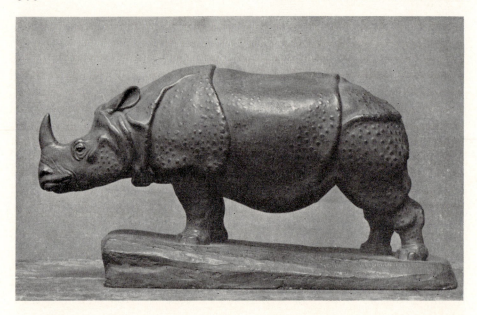

BESSIE THE BELLIGERENT

Bronze statuette. Height 10¾ in. Base: Length 1 ft. 1½ in.—Width 5¼ in. Signed
on base at right: ROBERT · A · WEINMAN · 1937 Placed in Brookgreen Gardens
in 1952.

Sciences, the Edwards Medal for the American Society for Quality Control,
the Duke Scholarship Medal for Duke University, and a medal for the
Research Institute of America. In the Hall of Fame series, his are the medals
dedicated to Daniel Webster, Roger Williams, and Emma Willard. Most
original is that for the Society of Medalists issued in 1964. On an unusual
rectangular shape he placed a mask of Socrates to stand for all philosophers
and on the reverse, a figure in relief banishing by the light of understanding
specters represented in contrasting hollow relief. The American Numismatic
Society awarded him the J. Sanford Saltus Medal for the excellence of his
medallic work in 1965.

A portrait bust of his father, upon which he worked for a long time, was
completed for exhibition at the National Academy of Design in 1953. Among
other portrait busts that he has modeled are those of two architects, Morris
Ketchum, Jr., and Charles M. Nes, Jr. A work done in 1967 is a group of
dolphins diving through the waves, made for a pool in the courtyard of Staten
Island Commercial College. Their sleek bodies curve in a graceful arch as
they rise over the water. Weinman is first vice-president of the National
Sculpture Society.

Bessie the Belligerent

An Indian rhinoceros stands firmly on all four feet, the back legs braced, the body thrust slightly forward. The head is a little lowered in a menacing attitude, eyes watching with a wary expression and ears laid back. The modeling is simplified to emphasize the main masses of the body. A decorative pattern is made by raised spots mottling the heavy skin that lies in deep folds over the forequarters, rump, and hips. The sculptor, in a simple pose, by the alertness of the head and the tenseness of the body poised for action, has given his subject vitality and a definite impress of personality. This statuette was modeled at the Bronx zoo in 1937 and entitled *Bessie the Belligerent* because of the pugnacious character of the subject.

Albert W. Wein

BORN IN NEW YORK CITY on July 27th, 1915, Albert Walter Wein began as a boy to be interested in sculpture and made rapid progress in the art. His parents were Frank and Elsa (Mehrer) Wein, his mother being a portrait painter. When the family moved to Baltimore for a period of eight years, he began his art studies at the Maryland Institute of Fine and Applied Arts, where his mother was teaching. In New York again he continued his professional studies at the Beaux-Arts Institute of Design and by 1934 was winning honorable mention in school competitions. He also studied at the National Academy of Design and the Grand Central Art School. In 1944 *Horizons*, carved in cherry wood, won the Henry O. Avery Prize of The Architectural League of New York.

In 1947 the winning of a fellowship at the American Academy in Rome, renewed the next year, gave him a chance to work at Rome and travel through Europe and in Greece. While he was in Italy he was able to have many pieces cast in bronze. Small sketches were often modeled in wax and cast directly from the model by the cire-perdue process, so that the fluency of the original modeling was left undisturbed. *Demeter*, an intricate linear composition of a girl stepping forward, tilting an urn to water a plant, the movement sweeping upward in slow spirals, won him the award of a Tiffany Foundation grant in the following year. Elected a fellow of the National Sculpture Society, in 1950 he was appointed corresponding secretary. By 1951 he had accumu-

lated enough work to show in a one-man exhibition at the Argent Galleries. In the exhibition of ecclesiastical sculpture arranged by the National Sculpture Society, second prize was given to his *Resurrection*, a strikingly original conception, with Christ's figure, raised on one knee, stretching diagonally upward, and an angel braced against a solid shaft of light leaning at right angles over his head. Also included was his *Sermon on the Mount*, a tall stylized figure in long, tubular folds.

Even Wein's early work had monumental qualities in the emphasis on volume and a classical tone in its studied proportions and simplification of detail. The impact of the art of Rome and Greece made itself felt in more powerful forms and stronger rhythms. Without following classical models or adopting archaic conventions, he developed a lyrical sense of movement fortified by the clear silhouettes and definite linear boundaries of which early Greek sculptors had been masters. For his own interpretation of these fundamental qualities he depends on ovoid volumes, strong profiles, and dramatic gestures. This tendency is apparent in a tribute to the Hungarian composer, *Homage to Béla Bartók*, two figures built up in a repetition of curving, swelling forms suggestive of musical harmonies. A statuette of Prometheus shows his favorite diagonal composition and, supported on clouds, gives the effect of a form freely floating in space. *La Jeunesse*, carved directly in alabaster, is a more compact arrangement of masses.

In relief modeling he works both in small scale and in large size for architectural purposes, a field which he particularly likes. *Memory*, a statuette of a woman kneeling with bowed head, fitted easily into a medallion because of its circular movement. In this form it was used on the Higgins mausoleum in Woodlawn Cemetery and later adopted by the American Institute of Commemorative Art for its seal. *Expulsion from Eden* received in 1942 the Mrs. Louis Bennett Prize, and Wein's design for the Herbert Adams Medal won in 1946 the Lindsey Morris Prize of the National Sculpture Society, both given for bas-reliefs. Commissioned to execute the forty-third issue of the Society of Medalists, Wein chose for his subject the Creation. On the obverse is a majestic figure of God creating the heavens and the earth; on the reverse, God, the Great Architect, seated, calipers in hand, is musing over what He has done. Like Wein's work in the round, his reliefs are firmly organized and handled with a telling use of strong profiles and swinging lines. For Steuben Glass he designed several vases in a series of Americana.

His work became more and more in demand for architectural settings, and occasionally he planned the settings themselves, such as natural habitats for the Bronx Zoo. A life-sized wood carving was placed in the post office at Frankfort, New York.

After Wein won a fellowship from the Huntington Hartford Foundation in

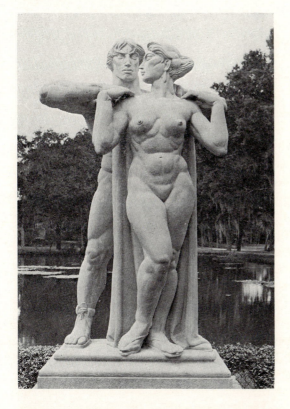

PHRYNE BEFORE THE JUDGES

Limestone group. Height 8 ft. 9
in. Base: Width 4 ft. 5 in.—
Depth 3 ft. 1 in. Placed in Brook-
green Gardens in 1952.

1955 he moved to the West Coast. He is equally skilled in painting, both in
oils and in encaustic, which attracts him by its possibilities for deep, rich
color. For a time he designed sets for television networks, since he had had
experience with scenic design for theaters in New York; he was also art
director for a television studio. Much of his sculpture was for synagogues.
Deborah, in bronze, is in Temple Israel at Hollywood, California. For Temple
Akiba at Culver City he not only made sculpture in bronze for the exterior and
planned a mosaic reflection pool but also designed the altar. He was again
employed as a designer for an altar and a stained-glass window in Temple
Beth El at Riverside, California. Bronze sculpture ornamented the walls of
Temple Beth David at Temple City and Temple Beth Shalom at Santa
Monica. He has been artist in residence at Brandeis Institute, Santa Susana,
California, and visiting professor of art at the University of Wyoming.

Wein has said of his own art, "I do not resort to abstraction in my work
because I am deeply interested in man, what he thinks, his emotions and his
works. Sculpture is an expression in three dimensions, of man's spirit." [1]

1 Wein, Albert Walter. *Art and man.* In *The Chelsea news*, New York. December
23rd, 1949. v. 1, no. 1 p. 3.

Phryne Before the Judges

Phryne stands insolently revealed, a cloak just stripped from her and held by the young man standing behind her. Her hands are raised to her shoulders as she releases it, and her head is turned sidewise. She holds her ripe form proudly erect, the firm muscles strongly modeled. The man is squarely braced on feet spread far apart; on his back the muscles have been conventionalized in a formal pattern after the manner of archaic sculpture. The features are sharply drawn, accented by strong lines and heavy ridges. The artist has given his work architectural solidity by the straight fall of the cloak and the man's arms raised at right angles in a horizontal line. The forms are reduced to definite planes set off by deep shadows.

During the sculptor's stay at the American Academy in Rome he was able to visit Greece, and there he heard the story of Phryne. It struck him as a good vehicle for presenting the nude form, and at Rome in 1948 he created a sketch model. Phryne was a Greek courtesan who is said to have posed for Apelles and Praxiteles. When she was being tried for profanation of the Eleusinian mysteries, her lawyer Hypereides, one of her lovers, obtained a verdict in her favor by pulling aside her robe and displaying to the judges her beautiful form. It is this moment that the sculptor has chosen to represent.

Allan Houser

ALLAN C. HOUSER, great-nephew of the famous Apache chief Geronimo, was born on June 30th, 1915, on the Apache reservation in Oklahoma. His father's name was Sam Haozous, an Apache word meaning "pulling roots." The son intended to be a professional athlete, but when he was in high school, an illness turned his attention to drawing. His art education began at the Indian Art School in Santa Fe, New Mexico, and later he continued his studies with the painter Olaf Nordmark at Fort Sill, Oklahoma. Creative work in painting and sculpture was encouraged by the award of a Guggenheim Fellowship in 1948. For his art Houser has chosen themes from the Indian life that he knows so intimately. He has painted murals for the Department of the Interior Building at Washington, D.C., the Fort Sill Indian School at Lawton, Oklahoma, and the Inter-Mountain School at Brigham City, Utah. A

bust of a Plains Indian girl, carved in sandstone, is in the Southern Plains Indians Museum at Anadarko, Oklahoma. As a tribute to students who died in World War II, his marble statue of an Indian brave, wrapped in a blanket with his war bonnet at his feet, was placed in the Memorial Auditorium, Haskell Institute, Lawrence, Kansas, in 1948. He has taught at the Inter-Mountain School and at the Institute of American Indian Arts, Santa Fe, New Mexico. In 1954 the French Government awarded him the *Palmes Académiques.*

Apache Medal

On the obverse an Indian horseman with drawn bow rides after a herd of buffalo. The artist describes a buffalo hunt in these words: "In the early days, Apache hunting parties made annual trips to the Plains states, an occasion that all young men looked forward to. . . .

"When a herd was located, the medicine man of the party would chant a song of prayer for a good kill and no casualties. The buffalo were forced to head in the direction of a steep hill, a narrow canyon, or in the direction of a steep cliff. This would allow the hunter to get a bigger kill.

"A good fast horse was important. One had to get close enough to almost touch the animal because of its heavy coat, which was hard to pierce. . . .

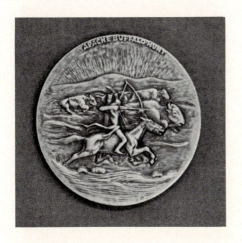 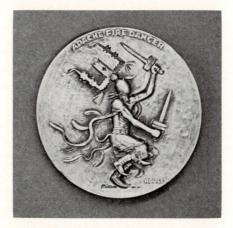

APACHE MEDAL

Bronze medal. Diameter 2⅞ in. On obverse, above, APACHE BUFFALO HUNT; below, ©. On reverse, above, APACHE FIRE DANCER. Signed below, at right, © HOUSER Around edge, SOCIETY OF MEDALISTS 59TH ISSUE MAY 1959 ALLAN HOUSER. SC. MEDALLIC ART CO. N.Y. BRONZE Placed in Brookgreen Gardens in 1959.

"The reverse side of my medal illustrates the Apache Fire Dance or 'Dance of the Mountain Gods,' which is still performed on the Mescalero Apache Reservation, New Mexico. As now celebrated, the dance commemorates the arrival at maidenhood of young Apache maidens and allegorically the super-natural beings are dancing to bring them good fortune in their adult life. The dance is the climax of four days of feasting and celebrating in the debut of these Apache girls." [1]

This medal was chosen by the Society of Medalists for their fifty-ninth issue.

1 *Society of Medalists' fifty-ninth issue.* In *The Numismatist.* July 1959. v. 72, p. [803].

References

Source material not indicated in the bibliography has been furnished by the photograph collections of The American Academy of Arts and Letters, The Frick Art Reference Library, The Metropolitan Museum of Art, and the National Sculpture Society and by the extensive clipping file at the New York Public Library. No attempt has been made to compile a complete bibliography for each sculptor; only such references as were found useful have been included.

GENERAL

ADAMS, Adeline Valentine (Pond). *The spirit of American sculpture*. [2. ed.] New York, 1929.

ADAMS, Herbert. *Aspects of present-day sculpture in America*. In *The American magazine of art*. October 1921. v. 12, p. 334–336.

AGARD, Walter Raymond. *The new architectural sculpture*. New York, 1935.

American art annual, 1898–1967. New York, 1898–[1967]. v. [1]–43.

APPLETON, Marion Brynner. *Who's who in northwest art*. Seattle, 1941.

BALL, Thomas. *My threescore years and ten*. Boston, 1891.

BARTLETT, Paul Wayland. *La sculpture américaine et la France*. In *Les États-Unis et la France*. Paris, 1914. p. 91–110. (*Bibliothèque France-Amérique*)

BARTLETT, Truman Howe. *The art life of William Rimmer*. Boston, 1882.

—— *Dr. William Rimmer*. (Extract from *American art review*. September 1880. v. 1, p. [461]–468, [509]–514)

BENJAMIN, Samuel Green Wheeler. *Art in America*. New York, 1880. p. 134–163.

BERRY, Rose V. S. *American sculpture at the Palace of the Legion of honor*. In California. University. *Chronicle*. October 1929. v. 31, p. [326]–372.

BING, Samuel. *La culture artistique en Amérique*. Paris, 1896.

The biographical cyclopaedia of American women. New York, 1924–1928. 3 v.

BISHOP, John Peale. *The American culture: studies in definition and prophecy. III. The arts*. In *The Kenyon review*. Spring 1941. v. 3, p. 179–190.

BITTER, Karl Theodore Francis. *Open-air sculpture; the work of American artists at the Louisiana purchase exposition*. In *Leslie's monthly magazine*. May 1904. v. 58, p. [3]–7.

—— *Sculpture for the St. Louis world's fair*. In *Brush and pencil*. December 1903. v. 13, p. 165–183.

BITTERMAN, Eleanor. *Art in modern architecture*. New York [c1952]. p. 77–149.

BORGLUM, Gutzon. *Aesthetic activities in America: an answer to his critics*. In *The Craftsman*. December 1908. v. 15, p. 301–307.

—— *Individuality, sincerity and reverence in American art*. In *The Craftsman*. October 1908. v. 15, p. [3]–6.

BRIMO, René. *L'évolution du goût aux États-Unis d'après l'histoire des collections*. Paris [c1938].

BRINTON, Selwyn. *American sculpture of to-day*. In *The International studio*. March 1907. v. 31, p. 34–42.

BRUMMÉ, C. Ludwig. *Contemporary American sculpture*. New York [c1948]

BULLARD, F. Lauriston. *Lincoln in marble and bronze*. New Brunswick, N.J. [c1952]

BURNET, Mary (Quick). *Art and artists of Indiana*. New York, 1921.

CAFFIN, Charles Henry. *American masters of sculpture*. New York, 1903.

—— *Some American sculptors*. In *The Critic*. April 1905. v. 46, p. 325–339.

CAHILL, Holger *and* BARR, Alfred H., Jr. *Art in America*. New York [c1935].

CALDER, Alexander Stirling. *Sculpture at the Exposition*. In *Sunset*. March 1914. v. 32, p. 610–615.

CASSON, Stanley. *Sculpture of to-day*. London [1939].

CHASE, George Henry *and* POST, Chandler Rathfon. *A history of sculpture*. New York and London [ᶜ1925].

CHENEY, Martha (Smathers) Candler. *Modern art in America*. New York, London [ᶜ1939].

CHENEY, Sheldon. *A primer of modern art*. New York [ᶜ1924].

CLARK, Edna Maria. *Ohio art and artists*. Richmond [ᶜ1932].

CLARK, Eliot. *History of the National academy of design, 1825–1953*. New York, 1954. p. 188–195.

CLARK, William J., Jr. *Great American sculptures*. Philadelphia, 1878.

CORTISSOZ, Royal. *Some imaginative types in American art*. In *Harper's magazine*. July 1895. v. 91, p. [165]–179.

CRAVEN, Thomas. *Contemporary American sculpture*. In *American mercury*. March 1928. v. 13, p. 365–368.

Dictionary of American biography. New York, 1928–1940. 22 v.

DODD, Loring Holmes. *The golden age of American sculpture*. Boston [ᶜ1936].

DODGE, Pickering. *Sculpture: and the plastic art*. Boston, 1850.

DOWNES, William Howe. *Monuments and statues in Boston*. In *The New England magazine*. November 1894. v. 11, p. [353]–372.

DUNLAP, William. *History of the rise and progress of the arts of design in the United States*. New York, 1834.

EDGERTON, Giles. *Bronze sculpture in America; its value to the art history of the nation*. In *The Craftsman*. March 1908. v. 13, p. 615–630.

FAIRMAN, Charles Edwin. *Art and artists of the capitol of the United States of America*. Washington, 1927.

—— *Works of art in the United States capitol building*. Washington, 1913.

FIELDING, Mantle. *Dictionary of American painters, sculptors and engravers*. New York, 1965.

FORBES, Harriette (Merrifield). *Gravestones of early New England and the men who made them, 1653–1850*. Boston, 1927.

FORTUNE, Jan *and* BURTON, Jean. *Elisabet Ney*. New York, 1943.

FRANK, Waldo. *The re-discovery of America*. New York, London, 1929.

FRENCH, Henry Willard. *The pioneers of art in America. Art and artists in Connecticut*. Boston, New York, 1879.

GALE, Robert L. *Thomas Crawford, American sculptor*. Pittsburgh [ᶜ1964].

GALERIE "LA RENAISSANCE," *Paris. Artistes américains modernes de Paris; préface 1932 par Chil Aronson*. Paris, 1932.

GARDNER, Albert TenEyck. *Sculpture survey, 1872–1951*. In The Metropolitan museum of art, New York. *Bulletin*. December 1951. v. 10, no. 4, p. 135–144.

—— *Yankee stonecutters*. New York, 1945.

GERDTS, William H., Jr. *American sculpture*. In *American artist*. September 1962. v. 26, no. 7, p. 40–47, 68–73.

—— *Painting and sculpture in New Jersey*. Princeton, N.J., 1964.

GLICKMAN, Maurice. *The sculptor and his market*. In *Magazine of art*. November 1940. v. 33, no. 11, p. 625, 648.

GOODRICH, LLOYD. *Three centuries of American art*. New York [ᶜ1966].

—— *and* BAUR, John I. H. *American art of our century*. New York [ᶜ1961].

GREEN, Samuel M. *American art; a historical survey*. New York [ᶜ1966].

GREENOUGH, Horatio. *Letters of Horatio Greenough to his brother, Henry Greenough*. Boston, 1887.

[——] *The travels, observations, and experiences of a Yankee stonecutter* [1852]. Gainesville, Fla., 1958.

GROCE, George C. *and* WALLACE, David H. *The New-York historical society's dictionary of artists in America 1564–1860*. New York, 1957.

HAMLIN, Talbot Faulkner. *Contemporary architectural sculpture in America*. In *Pencil points*. December 1938. v. 19, p. 767–774.

HANN, P. *Von amerikanischer Skulptur*. In *Die Kunst für Alle*. January 1903. v. 18, p. 179–183.

HARTMANN, Sadakichi. *Ecclesiastical sculpture in America*. In *The Catholic world*. September 1903. v. 77, p. [760]–767.

—— *A history of American art*. Boston, 1902. 2 v.

—— *Modern American sculpture*. New York, 1918.

HASKELL, Arnold L. *The sculptor speaks; Jacob Epstein to Arnold L. Haskell*. Garden City, New York, 1932.

HAWTHORNE, Nathaniel. *Passages from the French and Italian note-books*. Boston [ᶜ1871]. 2 v.

HENDERSON, Helen Weston. *The art treasures of Washington.* Boston, 1912.

—— *A loiterer in New York.* New York [ᶜ1917].

—— *The Pennsylvania academy of the fine arts and other collections of Philadelphia.* Boston, 1911.

HEYNEMAN, Julie Helen. *Desert cactus.* London [1934].

HICKS, Thomas. *Thomas Crawford; his career, character, and works.* New York, 1858.

HOBLITZELL, Clarence. *Collection of bronzes in the Metropolitan museum.* In *The Sketch book.* December 1906. v. 6, p. 183–188.

HOFFMAN, Malvina. *Sculpture inside and out.* New York [ᶜ1939].

HORN, Milton. *Concerning sculpture and its relation to architecture.* In *Parnassus.* October 1938. v. 10, p. 18–20.

HOSMER, Harriet Goodhue. *Letters and memories, edited by Cornelia Carr.* New York, 1912.

HUDNUT, Joseph. *Modern sculpture.* New York [ᶜ1929]. p. [88]–90.

HUNTER, H. Chadwick. *The American Indian in sculptural art.* In *Art and archaeology.* September–October 1918. v. 7, p. 323–336.

JACKMAN, Rilla Evelyn. *American arts.* Chicago [ᶜ1928]. p. 301–460.

JAMES, Henry. *William Wetmore Story and his friends.* Boston, 1903. 2 v.

KELLY, Florence Finch. *American bronzes at the Metropolitan museum.* In *The Craftsman.* February 1907. v. 11, p. 545–556.

KEPPEL, Frederick P. *and* DUFFUS, R. L. *The arts in American life.* New York and London, 1933.

KIMBALL, Fiske. *The beginnings of sculpture in Colonial America.* In *Art and archaeology.* May–June 1919. v. 8, p. 185–189.

KIRSTEIN, Lincoln. *William Rimmer: his life and art.* In *The Massachusetts review.* Summer 1961. v. 2, p. [685]–716].

KOHLMAN, Rena Tucker. *America's women sculptors.* In *The International studio.* December 1922. v. 76, p. 225–235.

LAFOLLETTE, Suzanne. *Art in America.* New York and London, 1929.

LATHROP, Gertrude Katherine. *Animals in sculpture.* In *National sculpture review.* Fall 1966. v. 15, no. 3, p. 8–14.

LEE, Hannah Farnham (Sawyer). *Familiar sketches of sculpture and sculptors.* Boston, 1854. 2 v.

LESTER, Charles Edwards. *The artists of America.* New-York, 1846.

LOCKE, Alain LeRoy. *Negro art: past and present.* Washington, D.C., 1936.

—— *The Negro in art.* Washington, D.C., 1940.

McINTYRE, R. G. *Small bronzes and their makers.* In *Arts and decoration.* January 1912. v. 2, p. [105]–107, 117.

MacNEIL, Hermon Atkins. *Sculpture—a report of progress.* In *The American magazine of art.* August 1917. v. 8, p. 411–414.

—— *Small bronzes.* In *Art and progress.* March 1913. v. 4, p. 908–912.

—— *Typical memorials.* In *The American magazine of art.* May 1919. v. 10, p. 252–257.

McSPADDEN, Joseph Walker. *Famous sculptors of America.* New York, 1927.

MALLETT, Daniel Trowbridge. *Mallett's index of artists.* New York, 1935.

—— —— *Supplement.* New York, 1940.

MANSHIP, Paul. *The sculptor at the American academy in Rome.* In *Art and archaeology.* February 1925. v. 19, p. 89–92.

MARCEAU, Henri. *William Rush, 1756–1833; the first native American sculptor.* Philadelphia, 1937.

MARYON, Herbert. *Modern sculpture; its methods and ideals.* London, 1933.

MATHER, Frank Jewett, Jr., MOREY, Charles Rufus, *and* HENDERSON, William James. *The American spirit in art.* New Haven, 1927. (*The pageant of America*)

MELLQUIST, Jerome. *The emergence of an American art.* New York, 1942.

MICHIGAN. State library. *Biographical sketches of American artists.* Lansing, 1924.

MORGAN, Theodora. *Sculpture in glass.* In *National sculpture review.* Summer 1959. v. 8, no. 2, p. 18–21.

The national cyclopædia of American biography. New York, 1893–1929. 13 v.

MURRAY, Freeman Henry Morris. *Emancipation and the freed in American sculpture.* Washington, D.C., 1916.

NATIONAL SCULPTURE SOCIETY. *Contemporary American sculpture.* [New York, ᶜ1929]

—— *Exhibition of American sculpture; catalogue.* New York, 1923.

NESS, Zenobia (Brumbaugh) *and* ORWIG, Louise. *Iowa artists of the first hundred years.* [Des Moines, ᶜ1939]

NEW YORK (City). Art commission. *Catalogue of the works of art belonging to the city of New York.* New York, 1909–1920. 2 v.

NEW YORK (City). Department of parks. *Construction and restoration of monuments, memorials and historic buildings.* [New York, 1941]

—— The Metropolitan museum of art. *American sculpture.* Greenwich, Conn. [ᶜ1965].

—— Museum of modern art. *American folk art; the art of the common man in America, 1750–1900.* New York [ᶜ1932].

—— The New-York historical society. *Catalogue of American portraits.* New York, 1941.

—— The Whitney museum of American art. *American art of our century.* New York [ᶜ1961].

NEWARK MUSEUM. *American folk sculpture.* Newark, 1931.

NORTH, Thomas. *In proud remembrance; American memorials and military cemeteries of World War II.* In *National sculpture review.* Spring 1965. v. 14, no. 1, p. 5–25.

O'BRIEN, Esse (Forrester). *Art and artists of Texas.* Dallas [ᶜ1935].

OSGOOD, Samuel. *Thomas Crawford and art in America.* New York, 1875.

PARKES, Kineton. *The art of carved sculpture.* London, 1931. v. 1, p. 136–174.

—— *Sculpture of to-day.* London, 1921. v. 1.

PARTRIDGE, William Ordway. *Art for America.* Boston, 1894.

PAYNE, Frank Owen. *Abraham Lincoln as a theme for sculptural art.* In *Art and archaeology.* June 1922. v. 13, p. 261–268.

—— *The American Indian in sculpture.* In *Munsey's magazine.* February 1917. v. 60, p. 41–50.

—— *The angel in American sculpture.* In *Art and archaeology.* April 1921. v. 11, p. 155–161.

—— *Famous statues by American sculptors.* In *The International studio.* April 1916. v. 58, p. XXXVII–XLIV.

—— *Motherhood in American sculpture.* In *Art and archaeology.* December 1921. v. 12, p. 253–263.

—— *Notable decorative sculptures of New York buildings.* In *The Architectural record.* February 1920. v. 47, p. 98–117.

—— *Noted American sculptors at work.* In *Art and archaeology.* March 1926. v. 21, p. 119–128.

—— *The present war and sculptural art.* In *Art and archaeology.* January–February 1919. v. 8, p. 17–35.

—— *The tribute of American sculpture to labor.* In *Art and archaeology.* August 1917. v. 6, p. 83–93.

PAYNE, Frank Owen. *The work of some American women in plastic art.* In *Art and archaeology.* December 1917. v. 6, p. 311–322.

PERRY, Stella G. S. *The sculpture & murals of the Panama-Pacific international exposition.* San Francisco, 1915.

PHILLIPS, Mary E. *Reminiscences of William Wetmore Story.* Chicago, New York, 1897.

PINCKNEY, Pauline A. *American figureheads and their carvers.* New York [ᶜ1940].

PLETCHER, Dorothy E. *American sculptors of wild life.* In *Nature magazine.* January 1931. v. 17, p. 21–25.

POST, Chandler Rathfon. *A history of European and American sculpture.* Cambridge, London, 1921. v. 2.

—— *Martin Milmore.* In *Art studies.* 1925. v. 3, p. 53–60.

PRICE, Frederick Newlin. *Sculpture in American gardens.* In *International studio.* May 1924. v. 79, p. 99–114.

PRIME, Alfred Coxe. *The arts & crafts in Philadelphia, Maryland, and South Carolina.* [Topsfield, Mass.] 1929–1932. 2 v.

PURDY, W. Frank. *Current American sculpture.* In *The Art world and Arts and decoration.* July 1918. v. 9, p. 143–145.

PUTNAM, Brenda. *The sculptor's way.* New York [ᶜ1939].

RAINEY, Ada. *American women in sculpture.* In *The Century magazine.* January 1917. v. 93, p. 434–435.

—— *A new note in art.* In *The Century magazine.* June 1915. v. 90, p. 193–199.

RÉAU, Louis. *L'art français aux États-Unis.* Paris, 1926.

—— *Histoire de l'expansion de l'art français; Pays Scandinaves, Angleterre-Amérique du Nord.* Paris, 1931.

RICH, Lorimer. *Sculpture—the scribe of history; the Civil war centennial.* In *National sculpture review.* Fall 1961. v. 10, no. 3, p. 6–19.

RICHARDSON, Edgar Preston. *The way of western art, 1776–1914.* Cambridge, 1939.

RIMMER, William. *Art anatomy.* Boston and New York [ᶜ1877, 1905].

—— *Elements of design.* Boston, 1891.

RINDGE, Agnes Millicent. *Sculpture.* New York, 1929.

RITCHIE, Andrew Carnduff. *Sculpture of the twentieth century.* New York [1952].

ROBERTS, Mary Fanton. *Modern sculpture in America.* In *The Touchstone.* July 1920. v. 7, p. 283–289.

RUGE, Klara. *Amerikanische Bildhauer.* In *Kunst und Kunsthandwerk.* 1903. 6. Jahrg., p. 229–252.

—— *Amerikanische Bildhauer und Maler der Gegenwart.* In *Westermanns illustrierte deutsche Monatshefte.* July 1904. v. 96, p. [484]–496.

RUSK, William Sener. *William Henry Rinehart, sculptor.* Baltimore, 1939.

RUTLEDGE, Anna Wells. *Cogdell and Mills, Charleston sculptors.* In *Antiques.* March 1942. v. 41, p. 192–193, 205–208.

SALTUS, J. Sanford *and* TISNÉ, Walter E. *Statues of New York.* New York and London, 1923.

SAYLER, Oliver Martin. *Revolt in the arts.* New York [1930].

SCHNIER, Jacques. *Sculpture in modern America.* Berkeley, Calif., 1948.

SCHWARZ, Karl. *Jewish sculptors.* Tel-Aviv [1954].

Sculptors of the Southwest. In *The Craftsman.* May 1915. v. 28, p. 150–155.

SESSIONS, Francis C. *Art and artists in Ohio.* In *Magazine of western history.* June 1886. v. 4, p. 152–166.

SHINN, Everett. *The first American art academy.* In *Lippincott's magazine.* February–March 1872. v. 9, p. 143–153, 309–321.

SMITH, Chetwood. *Rogers groups, thought and wrought by John Rogers.* Boston, 1934.

SMITH, Ralph Clifton. *A biographical index of American artists.* Baltimore, 1930.

SPENCER, Edwina. *America in contemporary sculpture.* In *The Chautauquan.* January 1904. v. 38, p. [460]–469.

—— *American sculptors and their art.* In *The Chautauquan.* November–December 1903. v. 38, p. [250]–256, [355]–365; February–May 1904. v. 38, p. [557]–567, v. 39, p. [41]–50, [139]–149, 242–250.

STORY, William Wetmore. *Conversations in a studio.* Boston and New York, 1890. 2 v.

STURGIS, Russell. *American bronzes.* In *Scribner's magazine.* June 1902. v. 31, p. [765]–768.

—— *Sculpture.* In *The Forum.* October–December 1902. v. 34, p. [248]–268.

SWAN, Mabel (Munson). *The Athenæum gallery, 1827–1873; the Boston athenæum as an early patron of art.* Boston, 1940.

TAFT, Lorado. *The history of American sculpture . . . new ed.* New York, 1930.

—— *Modern tendencies in sculpture.* Chicago [c1921].

—— *The monuments of Chicago.* In *Art and archaeology.* October 1921. v. 12, p. 120–127.

TAFT, Lorado. *Sculptors of the World's fair—a chapter of appreciations.* In *Brush and pencil.* December 1903. v. 13, p. 199–236.

—— *Women sculptors of America.* In *The Mentor.* February 1st, 1919. v. 6, no. 24.

TEALL, Gardner. *Women sculptors of America.* In *Good housekeeping magazine.* August 1911. v. 53, p. 175–187.

THIEME, Ulrich *and* BECKER, Felix. *Allgemeines Lexikon der bildenden Künstler.* Leipzig, 1908–1950. v. 1–37.

THORP, Margaret Farrand. *The literary sculptors.* Durham, N.C., 1965.

TUCKERMAN, Henry Theodore. *Book of the artists. American artist life.* New York, 1867. 2 v.

—— *A Memorial of Horatio Greenough.* New York, 1853.

U.S. Government. *Compilation of works of art and other objects in the United States capitol.* Washington, D.C., 1965.

VOLLMER, Hans. *Allgemeines Lexikon der bildenden Künstler des XX. Jahrhunderts.* Leipzig, 1953–1962. v. 1–6.

WALTON, William. *The art of the United States.* In Paris. Exposition universelle, 1900. *The chefs-d'oeuvre.* Philadelphia [c1900–1902]. v. 3, p. 29–39.

—— *Some contemporary young women sculptors.* In *Scribner's magazine.* May 1910. v. 47, p. 637–640.

WATERS, Clara Erskine (Clement) *and* HUTTON, Lawrence. *Artists of the nineteenth century and their works.* Boston and New York [c1884].

WHITNEY, Gertrude (Vanderbilt). *The end of America's apprenticeship; American influence on foreign sculpture.* In *Arts and decoration.* August 1920. v. 13, p. 150–151.

WHITTEMORE, Frances Dean (Davis). *George Washington in sculpture.* Boston, 1933.

Who's who in America, 1899/1900–1966/67. Chicago [c1899–1966] v. [1]–34.

Who's who in American art, 1936/37–1966. Washington, D.C., 1935–66. v. 1–8.

WRIGHT, Nathalia. *Horatio Greenough, the first American sculptor.* Philadelphia [c1963].

YOUNG, William. *A dictionary of American artists.* Cambridge, Mass. [c1968].

ZORACH, William. *American sculpture.* In *The Studio.* June 1944. v. 127, p. 185–187.

—— *Art is my life; the autobiography of William Zorach.* Cleveland and New York [c1967].

BY SCULPTOR

Adams, Herbert

BROOKGREEN GARDENS, *Brookgreen, S.C. Sculpture by Herbert Adams*. [New York] ᶜ1937.

Herbert Adams. In Pan American union. *Bulletin*. July 1917. v. 45, p. 93–104.

PAYNE, George Henry. *Herbert Adams*. In *The Criterion*. May 28th, 1898. v. 18, no. 436, p. 17.

PEIXOTTO, Ernest Clifford. *The sculpture of Herbert Adams*. In *The American magazine of art*. May 1921. v. 12, p. 151–159.

WEINMAN, Adolph Alexander. *Herbert Adams 1858–1945*. New York, 1951. (Commemorative tributes of The American Academy of Arts and Letters)

WILLIAMS, Wheeler. *Herbert Adams, fourth president of the National sculpture society*. In *National sculpture review*. Fall 1963. v. 12, no. 3, p. 17, 28.

Aitken, R. I.

AIKEN, Charles S. *A young sculptor and his "Victory."* In *Sunset*. March 1902. v. 8, p. [227].

COLUMBUS GALLERY OF FINE ARTS. *The Frederick W. Schumacher frieze "masters of art"; Robert Aitken, N.A., sculptor*. Columbus, O., [1937].

ETTL, Alex J. . . . *Robert I. Aitken, eighth president, National sculpture society*. In *National sculpture review*. Winter 1964–1965. v. 13, no. 4, p. 19, 26, 28.

HOEBER, Arthur. *Robert I. Aitken, A.N.A., an American sculptor*. In *The International studio*. July 1913. v. 50, p. III–VII.

—— *Sculpture of Robert Aitken, N.A*. In *The International studio*. November 1914. v. 54, p. XV–XVIII.

Robert I. Aitken. In Pan American union. *Bulletin*. October 1918. v. 47, p. 562–571.

Robert Ingersoll Aitken. In *Arts and decoration*. January 1920. v. 12, p. 184.

Robert Ingersoll Aitken. In *California art research*. San Francisco, 1937. v. 6, p. 60–94.

SEMPLE, Elizabeth Anna. *Art of Robert Aitken, sculptor*. In *Overland monthly*. March 1913. n.s., v. 61, p. [218]–225.

Amateis, Edmond

Amateis's sculpture for World's Fair. In *Pencil points*. July 1938. v. 19, p. 439.

BREUNING, Margaret. *A sculptor with plastic vision*. In *The International studio*. March 1926. v. 83, p. 44–46.

BROOKGREEN GARDENS, *Brookgreen, S.C. Sculpture by Edmond Amateis*. [New York] ᶜ1937.

DE LUE, Donald. . . . *Edmond Amateis, fifteenth president, National sculpture society*. In *National sculpture review*. Winter 1966. v. 15, no. 3, p. 22, 26–27.

Edmond Amateis and his sculpture for the Philadelphia post office. In *American artist*. December 1940. v. 4, no. 10, p. 5–8.

Edmond R. Amateis, sculptor. In *The American magazine of art*. October 1926. v. 17, p. 529–533.

Sculptures in metal by Edmond Amateis. In *The Metal arts*. May 1929. v. 2, p. 196–198, 225.

Baillie, R. A.

PROSKE, Beatrice (Gilman). *Robert A. Baillie, carver of stone*. Brookgreen, S.C., 1946.

Baker, Bryant

DE LUE, Donald. *Bryant Baker*. In *National sculpture review*. Fall 1964. v. 13, no. 3, p. 20–21, 27–28.

LACEY, Arda J. *Bryant Baker N.A*. In *Kent life*. January 1966. v. 5, no. 1, p. 42–44.

NELSON, W. H. de B. *P. Bryant Baker*. In *The International studio*. December 1917. v. 63, p. XXXVII–XLIV.

PARKES, Kineton. *An Anglo-American sculptor; Bryant Baker*. In *Apollo*. November 1932. v. 16, p. 221–230.

Barnard, G. G.

ARMSTRONG, Regina. *The sculptor of "Pan"; Mr. George Grey Barnard and his work*. In *The Critic*. November 1898. v. 33, p. 354–357.

Barnard's Lincoln, the gift of Mr. and Mrs. Charles P. Taft to the city of Cincinnati. Cincinnati, 1917.

Barnard's mighty sculptures for the Pennsylvania capitol. In *Current literature.* August 1910. v. 49, p. 207–209.

Barnard's plan for an art acropolis in memory of the war. In *Current opinion.* November 1920. v. 69, p. 695–698.

A calamity in bronze! Mr. Barnard's Lincoln once more. In *The Art world.* November 1917. v. 3, p. 99–[104].

CARPENTER, William H. *The great god Pan.* In *Columbia university quarterly.* September 1908. v. 10, p. 485–488.

CLEMEN, Paul. *George Grey Barnard.* In *Die Kunst für Alle.* June 1st, 1911. Jahrg. 26, p. 385–405.

COBURN, Frederick W. *The sculptures of George Grey Barnard.* In *The World today.* March 1909. v. 16, p. 273–280.

COFFIN, William A. *A new American sculptor. George Grey Barnard.* In *The Century magazine.* April 1897. v. 53, p. 877–882.

CRAVEN, Thomas. *Modern art.* New York, 1934. p. 290–301.

DICKSON, Harold E. *Barnard and Norway.* In *The Art bulletin.* March 1962. v. 44, p. 55–59.

—— *Barnard's sculptures for the Pennsylvania capitol.* In *The Art quarterly.* Summer 1959. v. 22, p. 126–147.

—— *Log of a masterpiece: Barnard's The Struggle of the Two Natures of Man.* In *Art journal.* Spring 1961. v. 20, p. 139–143.

—— *The origin of "The Cloisters."* In *The Art quarterly.* 1965. v. 28, p. 253–274.

EPSTEIN, Jacob. *Sculptors of today.* In *The Atlantic.* November 1940. v. 166, p. 596–597.

FRY, Roger. *The Lincoln statue.* In *The Burlington magazine.* June 1918. v. 32, p. 240–243.

George Grey Barnard, sculptor. In *Harper's weekly.* August 23rd, 1902. v. 46, p. 1155.

The Index of twentieth century artists. March–September 1936. v. 3, p. 253–256, sup., p. [lxxxi].

KNAUFFT, Ernest. *George Grey Barnard: a virile American sculptor.* In *The American review of reviews.* December 1908. v. 38, p. [689]–692.

LAURVIK, John Nilsen. *George Grey Barnard.* In *The International studio.* December 1908. v. 36, p. XXXIX–XLVI.

MACMONNIES, Frederick, HASTINGS, Thomas, and FLETCHER, Richard. *Barnard's Lincoln.* In *North American review.* December 1917. v. 206, p. 837–840.

MELTZER, Charles Henry. *Petrified emotion.* In *Cosmopolitan magazine.* November 1910. v. 49, p. 667–674.

A monument to art and labor is George Grey Barnard's idea of a war memorial. In *The Touchstone.* December 1920. v. 8, p. 201–209.

NYE, Fred. *George Grey Barnard's "Pan."* In *The Criterion.* September 3rd, 1898. v. 18, no. 450, p. 14.

THE PENNSYLVANIA STATE UNIVERSITY. *George Grey Barnard . . . Centenary exhibition* [n.p. ᶜ1964].

PICKERING, Ruth. *American sculptor, George Grey Barnard.* In *Arts and decoration.* November 1934. v. 42, p. 33–38.

ROOF, Katharine Metcalf. *George Gray Barnard: the spirit of the new world in sculpture.* In *The Craftsman.* December 1908. v. 15, p. 270–280.

STRAWN, Arthur. *Giant killer.* In *The Outlook.* September 10th, 1930. v. 156, p. 74–75.

TAFT, Lorado. *The casting of Pan.* In *Brush and pencil.* October 1898. v. 3, p. 50–52.

TARBELL, Ida. *"Those who love Lincoln": a word for Barnard's statue.* In *The Touchstone.* December 1917. v. 2, p. 224–228.

THAW, Alexander Blair. *George Grey Barnard, sculptor.* In *The World's work.* December 1902. v. 5, p. [2837]–2853.

TWOMBLY, Mary. *George Grey Barnard.* In *The World's work.* February 1909. v. 17, p. [11256]–11267.

VAN DER WEYDE, W. M. *Dramas in stone; the art of George Grey Barnard.* In *The Mentor.* March 1923. v. 11, p. 19–34.

WILLIAMS, Dan. *George Grey Barnard.* In *The North American review.* June 1937. v. 243, p. 276–286.

WILLIAMS, Talcott. *George Grey Barnard: the creator of stupendous marbles.* In *The Book news monthly.* September 1907. v. 26, p. [15]–21.

WISEHART, M. K. *The story of George Grey Barnard, a boy taxidermist who became a great sculptor.* In *The American magazine.* October 1929. v. 108, p. 52–53, 96, 98, 100, 102, 104, 106, 108, 110.

Bartlett, P. W.

AMERICAN ACADEMY OF ARTS AND LETTERS. *Catalogue of a memorial exhibition of the works of Paul Wayland Bartlett.* [New York] 1931.

BARTLETT, Ellen Strong. *Paul Bartlett: an American sculptor.* In *The New England magazine.* December 1905. v. 33, p. [369]–382.

BARTLETT, Paul Wayland. *Unveiling of the pediment group of the House wing of the national Capitol.* In *Art and archaeology.* September 1916. v. 4, p. 179–184.

BROWN, Glenn. *Bartlett's sculpture for the House wing of the federal Capitol.* In *The Art world.* October 1916. v. 1, p. 41–43.

CAFFIN, Charles Henry. *American masters of sculpture.* New York, 1903. p. 87–95.

CARROLL, Mitchell. *Paul Bartlett's pediment group for the House wing of the national Capitol.* In *Art and archaeology.* January 1915. v. 1, p. 163–[172].

—— *Paul Bartlett's decorative sculptures for the New York public library.* In *Art and archaeology.* January 1916. v. 3, p. 35–39.

CHAPMAN, Katharine Elise. *A sculptor who is also a craftsman.* In *The Craftsman.* July 1909. v. 16, p. 437–443.

FLAGG, Charles Noël. *The evolution of an equestrian statue.* In *Scribner's magazine.* March 1909. v. 45, p. 309–[316].

FRIEDLANDER, Leo. *. . . Paul Wayland Bartlett, sixth president of the National sculpture society.* In *National sculpture review.* Summer 1964. v. 13, no. 2, p. 22, 26.

KEYZER, Frances. *Some American artists in Paris.* In *The International studio.* June 1898. v. 4, p. 247–248.

KLABER, John J. *Paul W. Bartlett's latest sculpture.* In *The Architectural record.* March 1916. v. 39, p. [265]–278.

MAUS, OCTAVE. *The monument to La Fayette.* In *The Magazine of art.* January 1901. v. 25, p. 133–134.

PARIS. Musée de l'orangerie. *Paul Wayland Bartlett 1865–1925; sculptures.* [Paris] 1929.

Paul Wayland Bartlett. In Pan American union. *Bulletin.* September 1917. v. 45, p. 351–363.

PHILADELPHIA. Fairmount park art association. *Ceremonies attending the unveiling of the memorial bronze of Robert Morris on the steps of the Custom house at Philadelphia June 18, 1926.* Philadelphia, 1926.

STUART, Evelyn Marie. *Paul Bartlett: eminent sculptor.* In *Fine arts journal.* June 1914. v. 30, p. [315–320].

TAFT, Lorado. *The vigor of Bartlett.* In *The Mentor.* October 20th, 1913. v. 1, no. 36, p. 10–11.

WALTON, William. *Mr. Bartlett's pediment for the House of representatives, Washington, D.C.* In *Scribner's magazine.* July 1910. v. 48, p. 125–[128].

—— *Recent work by Paul W. Bartlett.* In *Scribner's magazine.* October 1913. v. 54, p. 527–530.

WHEELER, Charles V. *Bartlett (1865–1925).* In *The American magazine of art.* November 1925. v. 16, p. 573–584.

Z., Z. and STURGIS, Russell. *The statue of Michelangelo in the Washington congressional library.* In *Scribner's magazine.* March 1899. v. 25, p. [381]–384.

Beach, Chester

BROOKGREEN GARDENS, *Brookgreen, S.C. Sculpture by Chester Beach.* [New York] ᶜ1937.

DU BOIS, Guy Pène. *The art of Chester Beach.* New York [ᶜ1912].

—— *Sculpture by Chester Beach.* In *Arts and decoration.* January 1913. v. 3, p. 99.

MECHLIN, Leila. *A group of sculpture by Chester Beach.* In *The American magazine of art.* October 1916. v. 7, p. 502–[505].

PORTER, Beata Beach. *. . . Chester Beach, tenth president, National sculpture society.* In *National sculpture review.* Fall 1965. v. 14, no. 3, p. 20, 24.

REHN, Frank K. M., Jr. *Chester Beach; a sculptor who works with the stone.* In *Metropolitan.* December 1913. v. 39, no. 2, p. 34–35.

Subtle studies of human emotions shown in the sculpture of Chester Beach. In *The Craftsman.* July 1916. v. 30, p. 350–355.

Bitter, Karl

Art and progress. July 1915. v. 6, p. 295–312.

The Americanism of Karl Bitter. In *The Literary digest.* May 15th, 1915. v. 50, p. 1150–1151.

DENNIS, James. *Karl Bitter.* Madison, Wis., 1967.

GREER, H. H. *Work of Karl Bitter, sculptor.* In *Brush and pencil.* March 1904. v. 13, p. 466–478.

Karl Bitter. In *The Outlook.* April 21st, 1915. v. 109, p. 904–905.

LAURVIK, John Nilsen. *Karl Bitter—decorative sculptor.* In *Sketch book.* September 1906. v. 6, p. 1–10.

—— *Karl Bitter; a master of decorative sculpture.* In *The Booklovers magazine.* May 1904. v. 3, p. [599]–606.

RASTER-HERCZ, Anna. *Karl Bitter, ein deutschamerikanischer Bildhauer.* In *Die Glocke.* June 1907. 2. Jahrg., p. 148–149.

SCHEVILL, Ferdinand. *Karl Bitter; a biography.* Chicago [ᶜ1917].

VILLARD, Oswald Garrison. *Karl Bitter, American: an appreciation.* In *The Survey.* May 1st, 1915. v. 34, p. 112–113.

Blodgett, G. W.

REMINGTON, Preston. *A head of an Indian by George Winslow.* In New York. Metropolitan museum of art. *Bulletin.* February 1934. v. 29, p. 37–38.

SEABURY, David. *George Winslow's Indian sculpture.* In *Creative art.* May 1933. v. 12, p. 366–368.

Borglum, Gutzon

BORGLUM, Gutzon. *Aesthetic activities in America: an answer to his critics.* In *The Craftsman.* December 1908. v. 15, p. 301–307.

—— *The art tendencies of our time.* In *Arts and decoration.* January 1921. v. 14, p. 194.

—— *Art that is real and American.* In *The World's work.* June 1914. v. 28, p. 200–217.

—— *The betrayal of the people by a false democracy.* In *The Craftsman.* April 1912. v. 22, p. 3–9.

—— *The Confederate memorial.* In *The World's work.* August 1917. v. 34, p. [437]–446.

—— *Democracy and art; a program for an ideal American art.* In *Arts and decoration.* October 1919. v. 11, p. [267].

—— *Exhibition of sculpture.* New York, 1914.

—— —— Stamford, Conn., 1944.

—— *Individuality, sincerity and reverence in American art.* In *The Craftsman.* October 1908. v. 15, p. [3]–6.

—— *Moulding a mountain.* In *The Forum.* October 1923. v. 70, p. 2019–2026.

—— *Photogravures of work by Gutzon Borglum; sculpture* [n.p., 1913].

BORGLUM, Gutzon. *The political importance and the art character of the national memorial at Mount Rushmore.* In *The Black Hills engineer.* November 1930. v. 18, p. 285–299.

—— *What is beauty in sculpture?* In *The Black Hills engineer.* November 1930. v. 18, p. 304–308.

CASEY, Robert Joseph and BORGLUM, Mary Williams (Montgomery). *Give the man room; the story of Gutzon Borglum.* Indianapolis, New York [ᶜ1952].

DEAN, Robert J. *Living granite; the story of Borglum and the Mount Rushmore memorial.* New York, 1949.

DERIEUX, James C. *A sculptor who rode to fame on horseback.* In *The American magazine.* January 1924. v. 97, p. 12–14, 66, 68, 70, 72.

FITE, Gilbert C. *Mount Rushmore.* Norman, Okla. [ᶜ1952].

HUDSON, E. W. *Notes on American sculpture, chiefly in relation to Gothic work.* In Royal institute of British architects. *Journal.* September 26th, 1908. 3d. ser., v. 15, p. 605–616.

JOHNSON, Gerald White. *The undefeated.* New York, 1927.

[LUMMIS, Charles Fletcher] *Borglum and his work.* In *The Land of sunshine.* December 1895. v. 4, p. 34–37.

PRICE, Willadene. *Gutzon Borglum, artist and patriot.* Chicago [1961].

Borglum, Solon

ARMSTRONG, Selene Ayer. *Solon H. Borglum: sculptor of American life.* In *The Craftsman.* July 1907. v. 12, p. 382–389.

BORGLUM, John Gutzon de la Mothe. *Solon H. Borglum.* In *The American magazine of art.* November 1922. v. 13, p. 471–475.

BORGLUM, Solon Hannibal. *Sound construction.* New York [1923].

BOWDOIN, W. G. *S. Borglum and his work.* In *The Art interchange.* January 1901. v. 46, p. 2–4.

Bronzes by Solon H. Borglum, A.N.A. In Detroit. Museum of art. *Bulletin.* March 1916. v. 10, no. 7, p. 3–5.

CAFFIN, Charles Henry. *Solon H. Borglum, sculptor.* In *The International studio.* June 1903. v. 19, p. CXXVII–CXXX.

CARRINGTON, M. Marquette. *Solon H. Borglum, artist, soldier and patriot.* In *Art and archaeology.* March 1922. v. 13, p. 144.

Borglum, Solon, continued

EBERLE, Louise. *In recognition of an American sculptor.* In *Scribner's magazine.* September 1922. v. 72, p. 379–384.

GOODRICH, Arthur. *The frontier in sculpture.* In *The World's work.* March 1902. v. 3, p. [1857]–1874.

KEPPEL, Frederick, and company, *New York. Catalogue of an exhibition of bronzes, marbles and other sculpture by Solon H. Borglum; with an introduction by Charles H. Caffin.* New York [1904].

SEWALL, Frank. *Sculptor of the prairie, Solon H. Borglum.* In *The Century magazine.* June 1904. v. 68, p. 247–251.

Bracken, Clio Hinton

BRACKEN, Clio (Hinton). *Free hand modeling.* In *The Touchstone.* July 1919. v. 5, p. 346–347.

FANTON, Mary Annable. *Clio Hinton Bracken, woman sculptor and symbolist of the new art.* In *The Craftsman.* July 1905. v. 8, p. 472–481.

Persons of interest. In *Harper's bazaar.* May 1901. v. 35, p. 41, 42.

SCHWAB, Arnold T. *James Gibbons Huneker, critic of the seven arts.* Stanford, Calif., 1963.

Burroughs, Edith Woodman

BERLIN PHOTOGRAPHIC COMPANY, *New York. Sculptures by Edith Woodman Burroughs.* New York, 1915.

Four examples of the work of Edith Woodman Burroughs. In *Arts and decoration.* March 1915. v. 5, p. 190.

Calder, A. Stirling

ALLIOT, Hector. *Alexander Stirling Calder.* In *Out west.* September 1909. v. 31, p. [766]–784.

America, sculpture and war: from an interview with A. Stirling Calder. In *The Touchstone.* May 1917. v. 1, p. 22–29, 99.

BOWES, Julian. *The sculpture of Stirling Calder.* In *The American magazine of art.* May 1925. v. 16, p. 229–237.

BROOKGREEN GARDENS, *Brookgreen, S.C. Sculpture by A. Stirling Calder.* [New York] ᶜ1937.

CALDER, Alexander. *Calder; an autobiography with pictures.* New York [ᶜ1966].

CALDER, Alexander Stirling. *Thoughts of A. Stirling Calder on art and life.* New York, 1947.

Calder tells how he conceived Ericsson. In *The Art digest.* August 1st, 1931. v. 5, no. 19, p. 10.

The Depew memorial fountain for Indianapolis. In *The Art world.* March 1917. v. 1, p. 378.

GRAFLY, Dorothy. *The Ericsson memorial for Iceland.* In *The American magazine of art.* November 1931. v. 23, p. 392–394.

HOEBER, Arthur. *Calder—a "various" sculptor.* In *The World's work.* September 1910. v. 20, p. 13377–13388.

The Index of twentieth century artists. May–September 1935. v. 2, p. 123–127, sup., p. [xxi]; August–September 1936. v. 3, sup., p. [lx].

PARKES, Kineton. *Stirling Calder and the American sculptural scene.* In *Apollo.* March 1932. v. 15, p. 109–113.

PAULIN, L. R. E. *Alex. Stirling Calder; a young Philadelphia sculptor.* In *House and garden.* June 1903. v. 3, p. 317–325.

POORE, Henry Rankin. *Stirling Calder, sculptor.* In *The International studio.* April 1919. v. 67, p. XXXVII–[LI].

Recent sculpture by A. Stirling Calder. In *The American magazine of art.* June 1918. v. 9, p. 319–320.

Works of A. Stirling Calder. In *The Metal arts.* January 1929. v. 2, p. 41–43, 58.

Cecere, Gaetano

AGARD, Walter. *The sculptural portrait.* In *The International studio.* April 1925. v. 81, p. 27–28.

BERKELEY, Genevieve. *The sculpture of Gaetano Cecere.* In *The American magazine of art.* October 1927. v. 18, p. 540–543.

BROOKGREEN GARDENS, *Brookgreen, S.C. Sculpture by Gaetano Cecere.* [New York] ᶜ1937.

Choate, Nathaniel

DURAND-RUEL GALLERIES, *New York. Exhibition of sculptures by Nathaniel Choate.* New York, 1934.

Exotic sculpture. In *Pictures on exhibit.* May 1938. v. 1, no. 7, p. 1.

Clark, Allan

Allan Clark's small bronzes. In *The Metal arts.* November 1928. v. 1, p. 37–38.

BROOKGREEN GARDENS, *Brookgreen, S.C. Sculpture by Allan Clark.* [New York] ᶜ1937.

CHRISTENSEN, Erwin O. *An exhibition of sculpture by Allan Clark at the Fogg museum, Harvard university.* In *Art and archaeology.* December 1927. v. 24, p. 229–233.

PLARR, Amalie. *East and West meet in Allan Clark's vivid and graceful sculptures of Oriental figures.* In *The Mentor.* December 1928. v. 16, no. 11, p. 26–27.

STEELE, John. *The decorative sculpture of Allan Clark.* In *International studio.* February 1928. v. 89, p. 61–64.

Clark, J. L.

The bronzes and bas-reliefs of Dr. James L. Clark. New York, 1967.

BUMPUS, H. C. *The James L. Clark exhibit.* In Rhode Island school of design. *Bulletin.* January 1933. v. 21, p. 12–13.

CLARK, James Lippitt. *The bronzes of James L. Clark.* [New York, 1949].

—— *Good hunting.* Norman, Okla., 1966.

—— *The great arc of the wild sheep.* Norman, Okla., 1964.

—— *Trails of the hunted.* Boston, 1928.

HORNADAY, William T. *Masterpieces of American taxidermy.* In *Scribner's magazine.* July 1922. v. 72, p. 3–17.

MORDEN, William James. *Across Asia's snows and deserts.* New York–London, 1927.

Clews, Henry

BOREL, Pierre. *L'œuvre de Henry Clews.* In *Pro arte.* July–August 1942. année 1, nos. 3–4, p. 11–13.

CLEWS, Marie Elsie (Whelen). *Notes on the exhibition of sculpture by Henry Clews, Jr. held in the galleries of the Metropolitan museum of art, New York City.* Ms. lent by the author.

Gods, ogs, wogs; castle of weird images becomes a museum. In *Life.* October 15th, 1951. v. 31, no. 16, p. 119–120, 123–124.

Henry Clews sculptures. [n.p. 194–]

LANE, James W. *Notes from New York.* In *Apollo.* August 1939. v. 30, p. 72–73.

THE METROPOLITAN MUSEUM OF ART, New York. *Exhibition of sculpture by Henry Clews, Jr.* [New York, 1939]

PARIS. Musée Jacquemart-André. *Le monde étrange de Henry Clews.* [Paris] 1959.

PROSKE, Beatrice (Gilman). *Henry Clews, Jr., sculptor.* Brookgreen, S.C. 1953.

REMINGTON, Preston. *Sculpture by Henry Clews, Jr.* In The Metropolitan museum of art, New York. *Bulletin.* May 1939. v. 34, p. 107–109.

Coletti, J. A.

HURD, Harry Elmore. *Joseph Arthur Coletti, sculptor.* In *Art and archaeology.* February 1929. v. 27, p. 64–68.

The sculpture of Joseph Coletti. In *American artist.* February 1944. v. 8, no. 2, p. 8–11, 25.

The sculpture of Joseph Coletti; introduction by Alan Priest. New York, London [ᶜ1968].

Dallin, C. E.

DICKERSON, James Spencer. *Cyrus E. Dallin and his Indian sculpture.* In *The Monumental news.* September 1909. v. 21, p. 679–681.

DOWNES, William Howe. *Cyrus E. Dallin, sculptor.* In *Brush and pencil.* October 1899. v. 5, p. 1–18.

—— *Mr. Dallin's Indian sculptures.* In *Scribner's magazine.* June 1915. v. 57, p. 779–782.

HODGES, Katherine Thayer. *Dallin the sculptor; his Indian stories in marble.* In *The American magazine of art.* October 1924. v. 15, p. 521–527.

LONG, E. Waldo. *Dallin, sculptor of Indians.* In *The World's work.* September 1927. v. 54, p. [563]–568.

MAY, M. Stannard. *The work of Cyrus E. Dallin.* In *The New England magazine.* November 1912. n.s., v. 48, p. 408–415.

MECHLIN, Leila. *"The Spirit of life."* In *The American magazine of art.* November 1929. v. 20, p. [602]–603.

POMEROY, E. Wilbur. *Cyrus E. Dallin and the North American Indian.* In *Arts and decoration.* February 1914. v. 4, p. 152–153.

SEATON-SCHMIDT, Anna. *An American sculptor: Cyrus E. Dallin.* In *The International studio.* April 1916. v. 58, p. 109–114.

Davidson, Jo

AMERICAN ACADEMY OF ARTS AND LETTERS. *First retrospective exhibition of one hundred and seventy portrait busts and other works by Jo Davidson.* [New York, 1947]

ANDERSON, Eulalia. *Jo Davidson's portrait busts.* In *The American magazine of art.* November 1920. v. 11, p. 469–472.

The art of Jo Davidson. In *Aesthetics.* July 1913. v. 1, p. 59–60.

Davidson, Jo, continued

DAVIDSON, Jo. *Between sittings; an informal autobiography.* New York, 1951.

—— *Spanish portraits.* [New York, 1939?]

—— *Tendencies in sculpture.* In *Vanity fair.* October 1916. v. 7, no. 2, p. 73.

DU BOIS, Guy Pène. [*Jo Davidson*] In *The International studio.* November 1922. v. 76, p. 180–181.

FREUND, Karl. *Five busts by Davidson.* In *The International studio.* September 1924. v. 79, p. 425–432.

G., F. J. *The extremists: an interview with Jo Davidson.* In *Arts and decoration.* March 1913. v. 3, p. 170–171, 180.

GRIFFIN, Henry F. *Jo Davidson, sculptor.* In *The World's work.* August 1911. v. 22, p. 14746–14755.

HAPGOOD, Hutchins. *A Victorian in the modern world.* New York, 1940. p. 345–351.

The Index of twentieth century artists. August–September 1935. v. 2, p. [157]–159, sup., p. [xv]; August–September 1936. v. 3, sup., p. [lxv].

JACKSON, Holbrook. *All manner of folk.* New York, 1912. p. 189–192.

Jo Davidson, an American pupil of Rodin; American creator of the "new statuary." In *Current literature.* January 1912. v. 52, p. 99–101.

MELLETT, Lowell. *Yourself a thousand years from now.* In *Collier's.* January 15th, 1921. v. 67, no. 3, p. 12–13, 20.

New Jo Davidson studio is his own Hall of fame. In *Life.* March 17th, 1941. v. 10, no. 11, p. 108, 111.

PARKES, Kineton. *Jo Davidson at the Knoedler galleries.* In *Apollo.* July 1931. v. 14, p. 42–43.

PATTISON, James William. *Jo Davidson's "La Terre."* In *Fine arts journal.* August 1913. v. 29, p. 484–486.

A sculptor who records history. In *The Literary digest.* August 10th, 1918. v. 58, no. 6, p. 26.

SIEGRIST, Mary. *Jo Davidson—philosopher in stone.* In *Arts and decoration.* November 1922. v. 18, p. 18–19, 86.

STEFFENS, Lincoln. *The autobiography of Lincoln Steffens.* New York [1931]. v. 2, p. 835–837.

T., F. *Sculptors are different.* In *The New Yorker.* March 26th, 1927. v. 3, p. 27–29.

WINTER, Ella. [*Jo Davidson*] In *Creative art.* October 1927. v. 1, p. 302–303.

WYER, Raymond. *A new message in sculpture —the art of Jo Davidson.* In *Fine arts journal.* April 1912. v. 26, p. [262]–270.

de Coux, Janet

ELLIS, Joseph Bailey. *A Saturday sculptor's saga; the story of Janet de Coux.* In *The Carnegie magazine.* September 1940. v. 14, p. 109–112.

de Francisci, Anthony

Anthony de Francisci, 1887–1964. In *National sculpture review.* Winter 1964–1965. v. 13, no. 4, p. 6.

The medals of de Francisci. In *National sculpture review.* Winter 1959–1960. v. 8, no. 4, p. 14–15.

De Lue, Donald

CRESSON, Margaret (French). . . . *Donald De Lue, seventeenth president, National sculpture society.* In *National sculpture review.* Summer 1967. v. 16, no. 2, p. 22, 26–27.

Donald De Lue. [Athens, Ga., ᶜ1955] (American sculptors series, 15)

KENT, Norman. *Recent sculpture of Donald De Lue.* In *American artist.* October 1957. v. 21, p. 49–51.

Deming, E. W.

DEMING, Therese (Osterheld), *comp. Edwin Willard Deming.* [New York, ᶜ1925]

—— *Indian pictures . . . by Edwin Willard Deming.* New York, ᶜ1899.

The Deming bronzes. In *The Spur.* April 1940. v. 65, no. 4, p. 19.

Edwin W. Deming and the return of the Red man. In *The International studio.* 1905. v. 27, p. xv–xx.

Folk-lore of a vanishing race preserved in the paintings of Edwin Willard Deming—artist-historian of the American Indian. In *The Craftsman.* May 1906. v. 10, p. 150–167.

TSCHUDY, Herbert Bolivar. *The art of Edwin Willard Deming.* In *Brooklyn museum quarterly.* January 1923. v. 10, p. 32–36.

Denslow, Dorothea

SULLIVAN, Catherine. *Community of sculptors; a visit to the Clay Club sculpture center.* In *American artist.* April 1950. v. 14, no. 4, p. 48–50, 71–73.

Swarz, Sahl. *A community of sculptors; the story of the Clay Club of New York.* In *American artist.* March 1942. v. 6, no. 3, p. 18–19, 37.

—— *Profile of the director.* In New York (City). Sculpture center. *Twenty-fifth anniversary.* [New York] 1953. p. 11–18.

Derujinsky, Gleb

Comstock, Helen. *Sculptures of Derujinsky.* In *International studio.* September 1925. v. 81, p. 453–456.

Phillips, John Goldsmith, Jr. *A sculpture by Derujinsky.* In New York. Metropolitan museum of art. *Bulletin.* January 1935. v. 30, p. 19–20.

Diederich, Hunt

du Bois, Guy Pène. *Hunt Diederich, decorator, humorist and stylist.* In *Arts and decoration.* September 1917. v. 7, p. 515–517.

Freund, Frank E. W. *Amerikanische Künstlerprofile.* In *Jahrbuch der jungen Kunst.* 1921. [v. 2], p. 310–313.

Hunt Diedrich's art. In *Arts and decoration.* May 1920. v. 13, p. 22, 66.

Kingore galleries, New York. *Catalogue of the first American exhibition of sculpture by Hunt Diederich, with an introduction by Christian Brinton.* New York [19—?].

Price, Frederic Newlin. *Diederich's adventure in art.* In *International studio.* June 1925. v. 81, p. 170–173.

Eberle, Abastenia

Brookgreen gardens, Brookgreen, S.C. *Sculpture by Abastenia St. Leger Eberle.* [New York] ᶜ1937.

Chandler, Anna Curtis. *East side children in sculpture.* In *The Mentor.* December 1926. v. 14, no. 11, p. 28–31.

Merriman, Christina. *New bottles for new wine, the work of Abastenia St. Leger Eberle.* In *The Survey.* May 3rd, 1913. v. 30, p. 196–199.

People who interest us: Abastenia Eberle, sculptor of national tendency. In *The Craftsman.* July 1910. v. 18, p. 475.

A sculptress who has caught the American rhythm. In *Current opinion.* August 1913. v. 55, p. 124–125.

Smith, Bertha H. *Two women who collaborate in sculpture.* In *The Craftsman.* August 1905. v. 8, p. 623–633.

Wilhelm, Donald. *Babies in bronze; the life-work of Miss Abastenia Eberle.* In *Illustrated world.* November 1915. v. 24, p. 328–331.

Evans, Rudulph

Caffin, Charles Henry. *"The Golden Hour," by Rudolph Evans.* In *The Century.* June 1915. v. 90, p. [208].

Candee, Helen Churchill. *Sculpture of Rudulph Evans.* In *The International studio.* May 1915. v. 55, p. lxxxiv–lxxxvi.

Evans, Rudulph. *A collection from works by Rudulph Evans, sculptor.* [New York, n.d.]

Fairbanks, Avard

Avard Fairbanks, sculptor and teacher. In *Town and country review.* July 1934. v. 5, p. 26–29.

A boy sculptor. In *The International studio.* October 1912. v. 47, p. lxxi.

Brookgreen gardens, Brookgreen, S.C. *Sculpture by Avard Fairbanks.* [New York] ᶜ1937.

A notable war memorial. In *The American magazine of art.* September 1930. v. 21, p. 527–528.

Seaman, Augusta Huiell. *What one boy is doing.* In *St. Nicholas.* November 1911. v. 39, p. 14–16.

Zeh, Lillian E. *Remarkable boy sculptor.* In *Technical world magazine.* May 1912. v. 17, p. 294–296.

Farnham, Sally James

Farrar, John. *The jinx statue in Central Park.* In *The World magazine.* December 14th, 1919.

Hewett, Edgar L. *Ancient America at the Panama-California exposition.* In *Art and archaeology.* November 1915. v. 2, p. 77, [80–81].

McMein, Neysa. *We do the President.* In *The Ladies' home journal.* August 1921. v. 38, no. 8, p. 13, 65–66.

Newton, Frances. *To fame on a galloping paper horse.* In *New York herald tribune; this week.* June 25th, 1939.

Sally James Farnham, sculptor. In *The Musical monitor.* August 1923. v. 13, no. 11, p. 12.

Savoy art and auction galleries, New York. *Artistic property; the estate of Sally James Farnham.* New York, 1943.

Farnham, Sally James, continued

Statue of Bolivar for Central Park, New York City. In Pan American union. *Bulletin.* August 1916. v. 43, p. 141–145.

WOOLLCOTT, Alexander. *Sally Farnham's art.* In *The Delineator.* May 1921. v. 98, no. 4, p. 16.

Fenton, Beatrice

Brookgreen gardens, *Brookgreen, S.C. Sculpture by Beatrice Fenton.* [New York] ᶜ1937.

Fjelde, Paul

JAEGER, Luth. *Two American sculptors: Fjelde—father and son.* In *The American-Scandinavian review.* August 1922. v. 10, p. [467]–472.

Fraser, J. E.

BENNETT, Helen Christine. *James Earle Fraser, sculptor.* In *Arts and decoration.* July 1911. v. 1, p. 375–376.

EBERLE, Louise. *The Fraser bust of Roosevelt.* In *Scribner's magazine.* October 1920. v. 68, p. 427–433.

Farewell to adventure. In *Kennedy quarterly.* May 1965. v. 5, no. 3, p. 233.

FRASER, Laura Gardin. . . . *James Earle Fraser, ninth president, National sculpture society.* In *National sculpture review.* Summer 1965. v. 14, no. 2, p. 22, 26–27.

James Earle Fraser. [Athens, Ga. ᶜ1955] (The American sculptors series, 13)

James Earle Fraser. In Pan American union. *Bulletin.* May 1918. v. 46, p. 648–655.

James E. Fraser: American sculptor. In *The Craftsman.* June 1910. v. 18, p. 364.

James E. Fraser's sculptures in bronze. In *The Metal arts.* August 1929. v. 2, p. 365–368, 382.

LOUCHHEIM, Aline B. *Most famous unknown sculptor.* In *The New York times.* May 13th, 1951. v. 100, p. 24–25, 65–67.

PAYNE, Frank Owen. *Theodore Roosevelt in sculpture.* In *Art and archaeology.* March–April 1919. v. 8, p. 109–113.

SAINT-GAUDENS, Homer. *James Earle Fraser.* In *The Critic.* November 1905. v. 47, p. 425.

The sculptor of American victory. In *Current opinion.* April 1921. v. 70, p. 531–534.

A sculptor of people and ideals: illustrated with the work of James Earle Fraser. In *The Touchstone.* May 1920. v. 7, p. 87–93, 161.

SEACHREST, Effie. *James Earle Fraser.* In *The American magazine of art.* May 1917. v. 8, p. 276–278.

SEMPLE, Elizabeth Anna. *James Earle Fraser, sculptor.* In *The Century magazine.* April 1910. v. 79, p. 929–932.

Fraser, Laura Gardin

M., F. P. *Laura Gardin Fraser, artist, sculptor.* In *The Numismatist.* July 1920. v. 33, p. 315.

HOBSON, Katherine T. *Laura Gardin Fraser . . . seen through stars.* In *National sculpture review.* Spring 1967. v. 16, no. 1, p. 18–19, 29.

French, D. C.

ABBOTT, Nelson R. *Recent work by Daniel Chester French.* In *Brush and pencil.* April 1901. v. 8, p. 43–48.

ADAMS, Adeline Valentine (Pond). *Daniel Chester French: sculptor.* Boston and New York, 1932.

BARR, Ferree. *"Chesterwood," the country home of Daniel Chester French, N.A., Glendale, Massachusetts.* In *American homes and gardens.* January 1909. v. 6, p. [5]–10.

BRINTON, Selwyn. *An American sculptor: Daniel Chester French.* In *The International studio.* May 1912. v. 46, p. 211–214.

—— *The recent sculpture of Daniel Chester French.* In *The International studio,* July 1916. v. 59, p. 17–24.

CAFFIN, Charles Henry. *Daniel Chester French, sculptor.* In *The International studio.* July 1903. v. 20, p. CXXXIII–CXXXVI.

—— *French's bronze doors for the Boston public library.* In *The International studio.* December 1904. v. 24, p. XXXII–XXXVI.

COFFIN, William A. *The sculptor French.* In *The Century magazine.* April 1900. v. 59, p. 871–879.

CORTISSOZ, Royal. *New figures in literature and art. 1. Daniel Chester French.* In *The Atlantic monthly.* February 1895. v. 75, p. 223–229.

COUGHLAN, J. P. *Daniel Chester French, American sculptor.* In *The Magazine of art.* May 1901. v. 25, p. 311–315.

CRESSON, Margaret (French). *Journey into fame; the life of Daniel Chester French.* Cambridge, Mass., 1947.

Daniel Chester French, sculptor. In *Munsey's magazine.* May 1898. v. 19, p. [234]–241.

Daniel Chester French's four symbolic groups for the New York custom house. In *The Craftsman*. April 1906. v. 10, p. 75–83.

DE KAY, Charles. *French's groups of the continents*. In *The Century magazine*. January 1906. v. 71, p. 427–431.

DEWING, Maria Oakey. *French's statue—"Memory."* In *The American magazine of art*. April 1919. v. 10, p. 195–196.

EMERSON, Helen B. *Daniel Chester French*. In *The New England magazine*. May 1897. n.s., v. 16, p. [259]–274.

Daniel Chester French. New York [ᶜ1947] (American sculptors series. 4)

FRENCH, Daniel Chester. *Daniel Chester French, sculptor of the great Lincoln memorial statue in Washington, pays tribute to Amy, the artist in* Little women, *who gave him his first modeling tools*. In *Delineator*. February 1927. v. 110, p. 29.

FRENCH, Mary Adams (French). *Memories of a sculptor's wife*. Boston and New York, 1928.

A history of the erection and dedication of the monument to Gen'l James Edward Oglethorpe unveiled in Savannah, Ga., November 23, 1910. In Georgia historical society. *Collections*. Savannah, 1911. v. 7, pt. 2.

The Index of twentieth century artists. May–September 1935. v. 2, p. [113]–121, sup., p. [xxi]; August–September 1936. v. 3, sup., p. [lix].

MOORE, N. Hudson. *Daniel Chester French*. In *The Chautauquan*. October 1903. v. 38, p. [141]–148.

ROCKWELL, Edwin A. *Daniel Chester French*. In *The International studio*. September 1910. v. 41, p. LV–LX.

SAMPLE, Omar H. *A new development in monumental sculpture*. In *Art and progress*. February 1911. v. 2, p. 95–100.

Sculptors of the Americas. In Pan American union. *Bulletin*. January 1917. v. 44, p. 66–76.

SEATON-SCHMIDT, Anna. *Daniel Chester French, sculptor*. In *The American magazine of art*. January 1922. v. 13, p. 3–10.

STURGIS, Russell. *Bronze doors for the Boston public library*. In *Scribner's magazine*. December 1904. v. 36, p. 765–768.

TAFT, Lorado. *Daniel Chester French, sculptor*. In *Brush and pencil*. January 1900. v. 5, p. [145]–163.

TITTLE, Walter. *A sculptor of the spirit of America*. In *The World's work*. July 1928. v. 56, p. [298]–305.

WALTON, William. *Some of Daniel C. French's later work*. In *Scribner's magazine*. November 1912. v. 52, p. 637–640.

WILSON, Rufus R. *Daniel Chester French*. In *The Monthly illustrator and Home and country*. May 1896. v. 12, p. [283]–290.

Frisch, Victor

FRISCH, Margaret S. *Victor Frisch*. [n.p., n.d.]

FRISCH, Victor *and* SHIPLEY, Joseph T. *Auguste Rodin*. New York, 1939.

Frishmuth, Harriet

BROOKGREEN GARDENS, Brookgreen, S.C. *Sculpture by Harriet Whitney Frishmuth*. [New York] ᶜ1937.

Dancing garden sculpture. In *Arts and decoration*. July 1928. v. 29, no. 3, p. 41.

Harriet Frishmuth's bronzes in evolution. In *The Metal arts*. December 1928. v. 1, p. 101–104.

ROBERTS, Mary Fanton. *Harriet Frishmuth, sculptress*. In *The Arts*. October 1921. v. 2, p. 31–32.

SMITH, Marion Couthouy. *The art of Harriet Frishmuth*. In *The American magazine of art*. September 1925. v. 16, p. [474]–479.

Fry, Sherry

BRUSH, Edward Hale. *Fountain and garden sculpture*. In *Fine arts journal*. September 1913. v. 29, p. [557]–559.

Glinsky, Vincent

GALERIE "LA RENAISSANCE," Paris. *Artistes américains modernes de Paris; préface 1932 par Chil Aronson*. Paris, 1932.

RAMBOSSON, Yvanhoé. *Plastik von Glinsky*. In *Deutsche Kunst und Dekoration*. May 1929. v. 64, p. 105.

Godwin, Frances Bryant

SMITH, Harry Worcester. *Life and sport in Aiken and those who made it*. New York [ᶜ1935]. p. 110, 171, 172, 195.

Grafly, Charles

DALLIN, Vittoria Colonna (Murray). *Charles Grafly's work*. In *The New England magazine*. October 1901. n.s., v. 25, p. 228–235.

HENDERSON, Helen Weston. *Charles Grafly, sculptor*. In *The Booklovers magazine*. November 1903. v. 2, p. 499–507.

Grafly, Charles, continued

HENDERSON, Helen Weston. *The Pennsylvania Academy of the fine arts.* Boston, 1911. p. 203–206.

THE PENNSYLVANIA ACADEMY OF THE FINE ARTS. *Memorial exhibition of work by Charles Grafly.* Philadelphia [1930].

SEATON-SCHMIDT, Anna. *Charles Grafly in his summer home.* In *The American magazine of art.* December 1918. v. 10, p. 52–58.

TAFT, Lorado. *Charles Grafly, sculptor.* In *Brush and pencil.* March 1899. v. 3, p. 343–353.

TRASK, John E. D. *Charles Grafly, sculptor.* In *Art and progress.* February 1910. v. 1, p. 83–89.

WILCOX, Uthai Vincent. *A tribute to peace— the Meade memorial.* In *The American magazine of art.* April 1927. v. 18, p. 194– 198.

Greenbaum, Dorothea

HIRSCHL & ADLER GALLERIES, *New York. Dorothea Greenbaum.* [New York, 1967].

Gregory, John

HARD, Charles Frederick. *The sculptured scenes from Shakespeare; a description of John Gregory's marble reliefs in the Folger library building.* Washington, D.C., 1959.

John Gregory, sculptor. In *Arts and decoration.* November 1919. v. 12, p. 8.

John Gregory's sculptures in bronze. In *The Metal arts.* July 1929. v. 2, p. 315–319, 322.

MECHLIN, Leila. *Sir Launcelot; the Eustis memorial by John Gregory.* In *The American magazine of art.* June 1925. v. 16, p. 300–301.

PARKES, Kineton. *A classical sculptor in America: John Gregory.* In *Apollo.* February 1933. v. 17, p. 28–31.

SOLON, Léon Victor. *The garden sculpture of John Gregory.* In *The Architectural record.* April 1924. v. 55, p. 401–404.

Grimes, Frances

ADAMS, Adeline Valentine (Pond). *A relief by Frances Grimes.* In *Art and progress.* May 1915. v. 6, p. 215–217.

FULLER, Lucia Fairchild. *Frances Grimes.* In *Arts and decoration.* November 1920. v. 14, p. 34, 74.

Hammer, Trygve

CAHILL, Edgar Holger. *Trygve Hammer.* In *The American-Scandinavian review.* October 1922. v. 10, p. [604]–608.

CAHILL, Edgar Holger. *Trygve Hammer's sculpture.* In *International studio.* November 1922. v. 76, p. 104–107.

EATON, Allen H. *Immigrant gifts to American life.* New York, 1932. p. 125–126.

Hancock, Walker

HANCOCK, Walker. *The Pennsylvania railroad memorial.* In *American artist.* October 1952. v. 16, no. 8, p. 28–31, 69–70.

P., M. *Toivo by Walker Hancock.* In Saint Louis. City art museum. *Bulletin.* October 1926. v. 11, p. 62.

Harvey, Eli

BROOKGREEN GARDENS, *Brookgreen, S.C. Sculpture by Eli Harvey.* [New York] ᶜ1937.

LAMONT, Jessie. *Impressions in the studio of an animal sculptor.* In *The International studio.* November 1913. v. 51, p. CVI– CVIII.

McINTYRE, R. G. *Eli Harvey—sculptor.* In *Arts and decoration.* December 1912. v. 3, p. 58–59, 74.

Haswell, E. B.

From Haswell's diary. In *The Art digest.* November 15th, 1940. v. 15, no. 4, p. 26.

Hering, Elsie Ward

Leslie's weekly. July 9th, 1903. v. 97, p. 27.

Hering, Henry

BROOKGREEN GARDENS, *Brookgreen, S.C. Sculpture by Henry Hering.* [New York] ᶜ1937.

CORNELIUS, Charles Over. *Henry Hering's sculpture for the Field museum of natural history in Chicago.* In *The Architectural record.* November 1918. v. 44, p. [430– 449].

DU BOIS, Guy Pène. *The work of Henry Hering.* In *The Architectural record.* December 1912. v. 32, p. [510–530].

Herzel, Paul

HERZEL, Paul. *Modeling book ends and statuettes from life.* In *The Jewelers' circular.* February 2nd, 1927. v. 94, no. 1, p. 277– 279.

Hoffman, Malvina

ADAMS, Mildred. *Malvina Hoffman, sculptor.* In *The Woman citizen.* April 18th, 1925. v. 9, no. 22, p. 9–10, 24.

ALEXANDRE, Arsène. *Malvina Hoffman.* Paris, 1930.

—— *Malvina Hoffman.* In *La Renaissance.* November 1928. v. 11, p. 471–476.

BALKEN, Edward Duff. *Malvina Hoffman— American sculptor.* In *The Carnegie magazine.* February 1929. v. 2, p. 270–272.

BLASHFIELD, Edwin Howland. *Malvina Hoffman's war memorial.* In *Art and archaeology.* April 1924. v. 17, p. 196.

BOUVÉ, Pauline Carrington. *The two foremost women sculptors in America: Anna Vaughn Hyatt and Malvina Hoffman.* In *Art and archaeology.* September 1928. v. 26, p. 77–82.

CRESSON, Margaret (French). *Malvina Hoffman, a great lady of sculpture.* In *National sculpture review.* Summer 1962. v. 11, no. 2, p. 16–17, 24.

DÉZARROIS, André. *Un statuaire américain; Malvina Hoffman.* In *La Revue de l'art ancien et moderne.* November 10th, 1919. v. 36, p. [211]–212.

HOFFMAN, Malvina. *Heads and tales.* New York, 1936.

—— *A sculptor goes head-hunting.* In *Asia.* July–August 1933. v. 33, p. 423–[433], 450–[452].

—— *Sculpture inside and out.* New York, 1939.

—— *Through Jugoslavia with pen and pencil.* In *The Survey.* March 6th, 1920. v. 43, p. 681–683.

—— *Yesterday is tomorrow.* New York [c1965].

The Index of twentieth century artists. October 1934–September 1935. v. 2, p. 8–12, sup., p. [iv]; August–September 1936. v. 3, sup., p. [xxxviii].

Malvina Hoffman. [New York] 1948. (American sculptors series, 5)

Malvina Hoffman's races of man. In *The Carnegie magazine.* April 1934. v. 8, no. 1, p. 12–13.

MOORE, Marianne. *Malvina Hoffman: 1887– 1966.* In *National sculpture review.* Fall 1966. v. 15, no. 3, p. 7, 30.

Racial types in sculpture by Malvina Hoffman. In *The London studio.* May 1934. v. 7, p. 251–254.

RICHMOND. Virginia museum of fine arts. *A comprehensive exhibition of sculpture by Malvina Hoffman.* [Richmond? c1937]

SMITH, Marion Couthouy. *The art of Malvina Hoffman.* In *The Outlook.* August 6th, 1924. v. 137, p. 535–537.

TEMPERLEY, Harold. *Malvina Hoffman in the east.* In *The American magazine of art.* March 1929. v. 20, p. 132–135.

Horn, Milton

HORN, Milton. *Architecture . . . sculpture . . . cybernetics.* In *Inland architect.* June 1965. v. 8, no. 10, p. 9–11.

—— *Concerning sculpture and its relation to architecture.* In *Parnassus.* October 1938. v. 10, p. 18–20.

—— *Sculpture by Horn.* [Lansing, Mich., 1948]

Houser, Allan

GRIDLEY, Marion E. *America's Indian statues.* Chicago, c1966. p. 33.

—— *Indians of today.* Chicago, 1960. p. 215–216.

SNODGRASS, Jeanne Owens. *American Indian painters: a biographical dictionary.* New York, 1968 (in press).

Society of Medalists' fifty-ninth issue. In *The Numismatist.* July 1959. v. 72, p. [802–803]

Howard, Cecil

Cecil Howard. [Athens, Georgia, c1950] (The American sculptors series, 10)

FRIEDLANDER, Leo. *Cecil Howard.* In *National sculpture review.* Fall 1956. v. 5, no. 3, p. 6.

The society of medalists . . . Forty-second issue. In *The Numismatist.* January 1951. v. 64, p. 30–31.

VALOTAIRE, M. *Paris.—Mr. Cecil de Blaquière Howard.* In *Studio.* January 15th, 1927. v. 93, p. 53–56.

WATSON, Forbes. *The sculpture of Cecil Howard.* In *The Arts.* February 1925. v. 7, no. 2, p. 99–[101].

Humes, Ralph

BROOKGREEN GARDENS, *Brookgreen, S.C. Sculpture by Ralph Hamilton Humes.* [New York] c1937.

Huntington, Anna Hyatt

AMERICAN ACADEMY OF ARTS AND LETTERS. *Catalogue; exhibition of sculpture by Anna Hyatt Huntington.* New York, 1936.

Anna Hyatt Huntington. [New York, 1936]

Anna Hyatt Huntington. New York [1947]. (American sculptors series, 3)

BOUVÉ, Pauline Carrington. *The two foremost women sculptors in America: Anna Vaughn Hyatt and Malvina Hoffman.* In *Art and archaeology.* September 1928. v. 26, p. 74–77.

BROOKGREEN GARDENS, *Brookgreen, S.C. Sculpture by Anna Hyatt Huntington.* [New York] °1937.

CAFFIN, Charles Henry. *Miss Hyatt's statue of Joan of Arc.* In *The Century magazine.* June 1916. v. 92, p. 308–311.

DEVAUX, André. *Anna Hyatt-Huntington.* In *L'Esprit français.* May 10th, 1933. n.s., v. 9, no. 82, p. [23]–27.

ESPINA DE SERNA, Concha. *Anna Hyatt de Huntington.* In *La Esfera.* April 5th, 1930. v. 17, no. 848, p. 26–27.

HUMPHREY, Grace. *Anna Vaughn Hyatt's statue.* In *The International studio.* December 1915. v. 57, p. XLVII–L.

LADD, Anna Coleman. *Anna V. Hyatt—animal sculptor.* In *Art and progress.* November 1912. v. 4, p. 773–776.

Le Manuscrit autographe. January–March 1933. 8. année, no. 41.

MECHLIN, Leila. *Anna Hyatt Huntington, sculptor.* In *The Carnegie magazine.* June 1937. v. 11, p. 67–71.

MORROW, Cecilia. *An artist-patriot: a sketch of Anna Vaughn Hyatt.* In *The Touchstone.* July 1919. v. 5, p. 286–293.

PARKES, Kineton. *An American sculptress of animals; Anna Hyatt Huntington.* In *Apollo.* August 1932. v. 16, p. 61–66.

PRICE, Frederick Newlin. *Anna Hyatt Huntington.* In *The International studio.* August 1924. v. 79, p. 319–323.

ROYÈRE, Jean. *Le musicisme sculptural: Madame Archer Milton Huntington.* Paris, 1933.

SCHAUB-KOCH, Émile. *L'évolution de l'art animalier; Madame Anna Hyatt-Huntington.* In *La Nouvelle revue.* June 15th, 1938. v. 155, p. [241]–252.

SCHAUB-KOCH, Émile. *Madame Anna Hyatt Huntington et la statuaire moderne.* New York, 1936.

—— *Madame Huntington et la statuaire française contemporaine.* In *Sud.* September 1936. 9. année, no. 140, p. [16]–19.

—— *A obra animalista e monumental de Anna Hyatt-Huntington.* Braga, 1955.

—— *Las obras recientes de Anna Hyatt-Huntington.* Barcelona, 1954.

—— *Sculpture d'Ana Hyatt-Huntington (1949 à 1960).* Lisbon, 1961.

—— *Vie et modelage; contribution à l'étude de l'oeuvre d'Anna Hyatt-Huntington.* Lisbon, 1957.

[SECKLER, DOROTHY GEES] *Epic sculptor.* In *MD, medical news magazine.* March 1965. v. 9, no. 3, p. 192–198.

SMITH, Bertha H. *Two women who collaborate in sculpture.* In *The Craftsman.* June–September 1905. v. 8, p. 623–633.

Jennewein, C. Paul

BROOKGREEN GARDENS, *Brookgreen, S.C. Sculpture by Carl Paul Jennewein.* [New York] °1937.

C. Paul Jennewein. [Athens, Ga., °1950] (The American sculptors series. 11)

HANOFEE, James S. *Creating colossi in terracotta.* In *Art and archaeology.* November–December 1933. v. 34, p. [298]–311, 324.

LEE, Anne. *Color sculpture and architecture; Philadelphia revives the ancient art of Greek polychrome.* In *The Mentor.* May 1928. v. 16, no. 4, p. 41–44.

PARKES, Kineton. *Plastic form and colour: the work of Paul Jennewein.* In *Apollo.* April 1933. v. 17, p. 130–134.

Jester, Ralph

JESTER, Ralph. *Things about architecture that irritate me.* In *The American architect.* April 1930. v. 137, p. 47.

Johnson, Grace Mott

MOORE, Isabel. *A sculptor of animals.* In *The American magazine of art.* February 1923. v. 14, p. 59–[61].

WOOD, Ruth Kedzie. *Portraying animals is her life work.* In *The Mentor.* May 1929. v. 17, no. 4, p. 26–28.

Jonas, Louis P.

An abandoned railroad station is Jonas' Ark. In *Life.* March 23rd, 1942. v. 12, no. 12, p. 86, 89–90.

JONES, H. D. *Louis Jonas—sculptor and taxidermist.* In *The Mentor.* May 1929. v. 17, no. 4, p. 29–32.

MERRITT, Zella (Jonas). *The world of Louis Paul Jonas.* In *American artist.* January 1967. v. 31, no. 1, p. 54–60.

Judson, Sylvia Shaw

For gardens and other places; the sculpture of Sylvia Shaw Judson. Chicago [1967].

Sylvia Shaw Judson. In Chicago. Art Institute. *Bulletin.* April–May 1938. v. 32, p. 59.

Keck, Charles

AGOPOFF, Agop. . . . *Charles Keck, twelfth president, National sculpture society.* In *National sculpture review.* Spring 1966. v. 15, no. 1, p. 22, 26–28.

"Amicitia" by Charles Keck. In *The American magazine of art.* September 1922. v. 13, p. 287.

BYNE, Arthur. *Salient characteristics of Keck's work.* In *The Architectural record.* August 1912. v. 32, p. 120–128.

KIMBALL, Fiske. *Monument to Lewis and Clarke, Charlottesville, Virginia; Charles Keck, sculptor.* In *Art and archaeology.* November–December 1919. v. 8, p. [362]–363.

Keyser, E. W.

BROOKGREEN GARDENS, *Brookgreen, S.C. Sculpture by Ernest Wise Keyser.* [New York] ᶜ1937.

Kiselewski, Joseph

KISELEWSKI, Joseph. *My four years with Lee Lawrie.* In *National sculpture review.* Summer 1963. v. 12, no. 2, p. 7, 26.

Konti, Isidore

BRUSH, Edward Hale. *The art of Isidore Konti —sculptor.* In *Fine arts journal.* May 1912. v. 26, p. [330]–335.

—— *Carson and Beale in bronze.* In *Sunset.* March 1911. v. 26, p. 348–349.

LEVETUS, A. S. *Isidore Konti; a Hungarian sculptor in America.* In *The International studio.* January 1912. v. 45, p. 197–203.

Recent sculpture by Isidore Konti. In *The Monumental news.* December 1909. v. 20, p. 890–891.

Korbel, Mario

GENTHE, Arnold. *The work of Mario Korbel and Walter D. Goldbeck.* In *The International studio.* November 1915. v. 57, p. XIX–XXIII.

PATTERSON, Augusta Owen. *Mario Korbel and his sculpture.* In *International studio.* July 1926. v. 84, p. 51–55.

Kurtz, Benjamin T.

DE HAAS, Arline. *Egypt's people in modern sculpture.* In *International studio.* November 1926. v. 85, p. 49–54.

—— *Kurtz: an interpreter in sculpture of modern Egypt.* In *Art and archaeology.* October 1927. v. 24, p. 125–131, 143.

MORRO, Clément. *Benjamin Turner Kurtz.* In *La Revue moderne.* August 30th, 1932. 32. année, no. 16, p. 11.

Lachaise, Gaston

AMES, Winslow. *Gaston Lachaise 1882–1935.* In *Parnassus.* March 1936. v. 8, p. 5–7.

CUMMINGS, Edward Estlin. *Gaston Lachaise.* In *Creative art.* August 1928. v. 3, no. 2, p. XXVII–XXVIII.

GALLATIN, Albert Eugene. *Gaston Lachaise.* New York, 1924.

—— *Gaston Lachaise.* In *The Arts.* June 1923. v. 3, p. 397–402.

GOODALL, Donald B. *Gaston Lachaise, 1882–1935.* In *The Massachusetts review.* August 1960. v. 1, p. 674–684.

KNOEDLER, M. and Company. *Gaston Lachaise, 1882–1935.* New York, 1947.

LACHAISE, Gaston. *A comment on my sculpture.* In *Creative art.* August 1928. v. 3, no. 2, p. XXIII–XXVI.

The last work of Gaston Lachaise. In *The American magazine of art.* August 1936. v. 29, p. 518–519.

LOS ANGELES, Calif. County Museum. *Gaston Lachaise, 1882–1935; Sculpture and drawings.* Los Angeles, 1963.

MAYOR, Alpheus Hyatt. *Gaston Lachaise.* In *Hound and horn.* July–September 1932. v. 5, p. [563–579].

MILLIKEN, William Mathewson. *Head of a woman by Gaston Lachaise.* In The Cleveland museum of art. *Bulletin.* October 1924. 11th year, p. 160–161.

Lachaise, Gaston, continued

NEW YORK. Museum of modern art. *Gaston Lachaise; retrospective exhibition.* New York, 1935.

The sculpture of Gaston Lachaise, with an essay by Hilton Kramer. New York, 1967.

SELDES, Gilbert. *Lachaise: sculptor of repose.* In *The New republic.* April 4th, 1928. v. 54, p. 219–220.

—— *Hewer of stone.* In *The New Yorker.* April 4th, 1931. v. 7, p. 28–31.

Ladd, Anna Coleman

ROSS, Mary. *New faces for old; how a Boston sculptor is putting life into copper features for soldiers.* In *The Survey.* March 30th, 1918. v. 39, p. 707–708.

SEATON-SCHMIDT, Anna. *Anna Coleman Ladd: sculptor.* In *Art and progress.* July 1911. v. 2, p. 251–255.

TUTWILER, Julia R. *Women who achieve; Anna Coleman Ladd.* In *Harper's bazar.* March 1915. v. 50, no. 3, p. 39.

Two fountains by Anna Coleman Ladd. In *Art and progress.* October 1912. v. 3, p. 740–742.

The work of Anna Coleman Ladd. Boston, 1920.

Laessle, Albert

BROOKGREEN GARDENS, *Brookgreen, S.C. Sculpture by Albert Laessle.* [New York] ᶜ1937.

HENDERSON, Helen Weston. *Albert Laessle.* [Typescript]

—— *The Pennsylvania academy of the fine arts.* Boston, 1911. p. 208–209.

MILLER, D. Roy. *A sculptor of animal life.* In *International studio.* October 1924. v. 80, p. 23–27.

Lathrop, Gertrude Katherine

BROOKGREEN GARDENS, *Brookgreen, S.C. Sculpture by Gertrude Katherine Lathrop.* [New York] ᶜ1937.

Sculpture by Gertrude K. Lathrop. In *American artist.* October 1942. v. 6, no. 8, p. 16–17.

Laurent, Robert

Art takes Laurent from Brittany to Brooklyn. In *Life.* June 2nd, 1941. v. 10, no. 22, p. 64, 67–68.

BOURGEOIS GALLERIES, *New York. Exhibition of sculptures by Robert Laurent.* [New York] 1922.

BRODSKY, Horace. *Concerning sculpture and Robert Laurent.* In *The Arts.* May 1921. v. 1, p. [13–15].

EGLINGTON, Guy. *Modern sculpture and Laurent.* In *International studio.* March 1925. v. 80, p. 439–444.

FROST, Rosamund. *Laurent: frames to figures, Brittany to Brooklyn.* In *The Art news.* April 1st–14th, 1941. v. 40, no. 4, p. 10–11, 37.

GOODRICH, Lloyd. *Robert Laurent.* In *The Arts.* April 1931. v. 17, p. 517, 518.

HERDLE, Gertrude R. *Sculpture by Robert Laurent.* In Rochester N.Y. Memorial art gallery. *Bulletin.* April 1931. v. 3, no. 5, p. 4, 11.

The Index of twentieth century artists. August 1935. v. 2, p. 161–163, sup., p. [xv]; August–September 1936. v. 3, sup., p. [lxv].

INDIANA UNIVERSITY. *Laurent: fifty years of sculpture.* [Bloomington, Ind., 1961]

KENT, Norman. *Robert Laurent, master carver.* In *American artist.* May 1965. v. 29, no. 5, p. 42–47, 73–76.

READ, Helen Appleton. *Robert Laurent.* In *The Arts.* May 1926. v. 9, p. 251–259.

Robert Laurent. New York [1930?] (The arts portfolio series)

ROBERTS, Mary Fanton. [*Robert Laurent*] In *The Arts.* February 1922. v. 2, p. 298.

VANAMEE, Esther Ryker. *Robert Laurent.* In *Vassar journal of undergraduate studies.* May 1935. v. 9, p. 25–39.

Lentelli, Leo

BROOKGREEN GARDENS, *Brookgreen, S.C. Sculpture by Leo Lentelli.* [New York] ᶜ1937.

HARTMANN, Sadakichi. *An expression of decorative sculpture.—Leo Lentelli.* In *The Architect and engineer of California.* March 1918. v. 52, no. 3, p. 59–68.

Leo Lentelli's masterpieces in bronze. In *The Metal arts.* February 1929. v. 2, p. 99–102.

Lober, G. J.

Georg J. Lober's sculptures in metal. In *The Metal arts.* October 1929. v. 2, p. 473–476, 486.

Portrait bas-relief by Georg Lober. In *International studio.* September 1925. v. 81, p. 466.

Lone Wolf

BABCOCK GALLERIES, *New York. Exhibition of paintings by Lone Wolf, Blackfoot Indian.* New York, 1922.

GRIDLEY, Marion E. *Indians of today.* Chicago, 1947, p. 49.

NEBRASKA. University. *Art collections of the University of Nebraska.* Lincoln [c1933]. p. 28.

SCHULTZ, James Willard. *Blackfeet and buffalo; memories of life among the Indians.* Norman, Okla. [c1962]. p. vii, pl. fac. p. 144, 145.

Longman, Evelyn Beatrice

ADAMS, Adeline Valentine (Pond). *Evelyn Beatrice Longman.* In *The American magazine of art.* May 1928. v. 19, p. 237–250.

BROOKGREEN GARDENS, *Brookgreen, S.C. Sculpture by Evelyn Beatrice Longman.* [New York] c1937.

DICKERSON, James Spencer. *Evelyn B. Longman; a western girl who has become a national figure in sculpture.* In *The World to-day.* May 1908. v. 14, p. 526–530.

FRENCH, Mary Adams (French). *Memories of a sculptor's wife.* Boston and New York, 1928. p. 187–188, 259.

RAWSON, Jonathan A., Jr. *Evelyn Beatrice Longman: feminine sculptor.* In *The International studio.* February 1912. v. 45, p. XCIX–CIII.

McCartan, Edward

BROOKGREEN GARDENS, *Brookgreen, S.C. Sculpture by Edward McCartan.* [New York] c1937.

CORTISSOZ, Royal. *The sculpture of Edward McCartan.* In *Scribner's magazine.* February 1928. v. 83, p. 236–244.

PATTERSON, Augusta Owen. *Edward McCartan, sculptor.* In *International studio.* January 1926. v. 83, p. 27–31.

SHERWOOD, Blythe. *"The Rock-a-by Lady"* becomes a monument. In *Arts and decoration.* December 1922. v. 18, p. 17, 101.

McKenzie, R. Tait

ADLER, Waldo. *McKenzie, a molder of clay—and of men.* In *Outing.* February 1915. v. 65, p. 586–596.

BARR, Robert. *An American sculptor.* In *The Outlook.* March 4th, 1905. v. 79, p. [556]–562.

BROOKGREEN GARDENS, *Brookgreen, S.C. Sculpture by R. Tait McKenzie.* [New York] c1937.

EBERLEIN, Harold Donaldson. *R. Tait McKenzie,—physician and sculptor.* In *The Century magazine.* December 1918. v. 97, p. 249–257.

GARDINER, E. Norman. *The revival of athletic sculpture: Dr. R. Tait McKenzie's work.* In *The International studio.* December 1920. v. 72, p. 133–138.

HUSSEY, Christopher. *Tait McKenzie; a sculptor of youth.* London [1929].

MCKENZIE, Robert Tait. *The athlete in sculpture.* In *Art and archaeology.* May–June 1932. v. 33, p. 115–125.

MORRIS, Harrison Smith. *R. Tait McKenzie, sculptor and anatomist.* In *The International studio.* July 1910. v. 41, p. XI–XIV.

MacMonnies, Frederick

CORTISSOZ, Royal. *An American sculptor: Frederick MacMonnies.* In *The Studio.* October 1895. v. 6, p. 17–26.

DREISER, Theodore. *The art of MacMonnies and Morgan.* In *Metropolitan magazine.* February 1898. v. 7, p. [143]–151.

GREER, H. H. *Frederick MacMonnies, sculptor.* In *Brush and pencil.* April 1902. v. 10, p. [1]–15.

HENDERSON, Helen Weston. *A loiterer in New York.* New York [c1917]. p. 405–424.

LOW, Will Hicok. *Frederick MacMonnies.* In *Scribner's magazine.* November 1895. v. 18, p. [617]–628.

MELTZER, Charles Henry. *Frederick MacMonnies—sculptor.* In *Cosmopolitan magazine.* July 1912. v. 53, p. 207–211.

PETTIT, Edith. *Frederick MacMonnies, portrait painter.* In *The International studio.* October 1906. v. 29, p. 319–324.

POLK, R. A. *The Princeton battle monument.* In *The American magazine of art.* January 1923. v. 14, p. 6–8.

QUÉLIN, René de. *Early days with MacMonnies in St. Gaudens' studio.* In *Arts and decoration.* April 1922. v. 16, p. 424–425, 479.

STROTHER, French. *Frederick MacMonnies, sculptor.* In *The World's work.* December 1905. v. 11, p. 6965–6981.

TAFT, Lorado. *Frederick MacMonnies.* In *The Mentor.* October 20th, 1913. v. 1, no. 36, p. 7–9.

MacNeil, H. A.

BLOCK, Adolph. . . . *Hermon A. MacNeil*. In *National sculpture review*. Winter–Spring 1963–1964. v. 12, no. 4, v. 13, no. 1, p. 17–18, 28.

BROOKGREEN GARDENS, *Brookgreen, S.C. Sculpture by Hermon Atkins MacNeil*. [New York] ᶜ1937.

HOLDEN, Jean Stansbury. *The sculptors MacNeil*. In *The World's work*. October 1907. v. 14, p. 9403–9419.

"Lincoln the Lawyer"; proposed statue by Hermon A. McNeil. In *The Art world*. February 1918. v. 3, p. 366–368.

MORRO, Clément. *Hermon A. MacNeil*. In *La Revue moderne*. July 15th, 1932. 32. année, no. 13, p. 18–19.

Some recent work by H. A. MacNeil. In *Brush and pencil*. November 1899. v. 5, p. 68.

Maldarelli, Oronzio

The Index of twentieth century artists. June–September 1936. v. 3, p. 303, sup., p. [xcii].

MIDTOWN GALLERIES, *New York. Maldarelli*. New York [1934].

Modern classicist. In *Life*. March 24th, 1947. v. 22, p. 137–140.

MOE, Henry Allen. *A letter to Oronzio Maldarelli*. In *National sculpture review*. Spring 1963. v. 12, no. 1, p. 14–15.

WATSON, Ernest W. *Oronzio Maldarelli*. In *American artist*. March 1948. v. 12, no. 3, p. 35–39, 54.

U.S. TREASURY DEPARTMENT. Procurement division. Public works branch. Section of painting and sculpture. *Bulletin*. October–November 1935. no. 6, p. 10.

Manca, Albino

The contemporary medals of Albino Manca. In *Coin age*. March 1967. v. 3, no. 3, p. 27–29.

RYPINS, Evelyn. *Art finds a way; from Rome to Village*. In *The Villager*. January 24th, 1946.

Manship, Paul

ADAMS, Herbert. *Paul H. Manship*. In *Art and progress*. November 1914. v. 6, p. 20–[24].

BIRNBAUM, Martin. *Introductions*. New York, 1919. p. 51–58.

BOUTET DE MONVEL, Roger. *La sculpture décorative de Paul Manship*. In *Art et industrie*. December 10th, 1927. v. 3, no. 12, p. 33–37.

BROOKGREEN GARDENS, *Brookgreen, S.C. Sculpture by Paul Manship*. [New York] ᶜ1938.

CASSON, Stanley. *XXth-century sculptors*. London, 1930. p. 41–54.

CORTISSOZ, Royal. *American artists*. New York, London, 1923. p. 285–292.

COX, Kenyon. *A new sculptor*. In *The Nation*. February 13th, 1913. v. 96, p. 162–163.

DE CUEVAS, George. *Paul Manship*. In *La Renaissance*. July–September 1932. v. 15, p. 131–135.

DÉZARROIS, André. *Une exposition d'art américain*. In *La Revue de l'art ancien et moderne*. June–December 1923. v. 44, p. [142]–155.

ELLIS, Joseph Bailey. *Paul Manship in the Carnegie institute*. In *The Carnegie magazine*. September 1937. v. 11, p. 110–113.

An English estimate of Manship. In *Arts and decoration*. October 1921. v. 15, p. 384.

Exhibitions at the Art institute; sculpture by Paul Manship. In *Fine arts journal*. October 1915. v. 33, p. 429–434.

GALLATIN, Albert Eugene. *An American sculptor: Paul Manship*. In *The Studio*. October 1921. v. 82, p. 137–144.

—— *Paul Manship; a critical essay on his sculpture and an iconography*. New York, 1917.

—— *The sculpture of Paul Manship*. In New York. Metropolitan museum of art. *Bulletin*. October 1916. v. 11, p. 218–222.

The greatness of Paul Manship? In *Arts and decoration*. April 1916. v. 6, p. 291.

HANCOCK, Walker. *Paul Manship*. In *Fenway court*. October 1966. v. 1, no. 1, p. [1]–7.

HUMBER, George. *Paul Manship*. In *The New republic*. March 25th, 1916. v. 6, p. 207–209.

The Index of twentieth century artists. November–December 1933. v. 1, p. 30–36; September 1935. v. 2, sup., p. [xli]; August–September 1936. v. 3, sup., p. [xl].

KAMMERER, Herbert L. *In memoriam—Paul Manship*. In *National sculpture review*. Winter 1965–1966. v. 14, no. 4, p. 7.

KAMMERER, Herbert L. . . . *Paul Manship, fourteenth president, National sculpture society*. In *National sculpture review*. Fall 1966. v. 15, no. 3, p. 22, 27–28.

MARAINI, Antonio. *Lo scultore Paul Manship*. In *Dedalo*. August 1923. anno 4, p. 181–195.

A modern primitive in art. In *The Literary digest*. May 6th, 1916. v. 52, p. 1278–1279.

MURTHA, Edwin. *Paul Manship*. New York, 1957.

A new sculptor. In *The Outlook*. February 14th, 1914. v. 106, p. 335–336.

The newest sculpture of Paul Manship. In *Vanity fair*. January 1923. v. 19, no. 5, p. 43.

Paul Manship's dramatic vision of John D. Rockefeller. In *Current opinion*. July 1920. v. 69, p. 96–98.

Paul Manship's work in sculpture. In *The Outlook*. March 8th, 1916. v. 112, p. 542–543.

PAYNE, Frank Owen. *Two amazing portraits by Paul Manship*. In *The International studio*. October 1920. v. 71, p. LXXV–LXXVII.

ROGERS, Cameron. *The compleat sculptor*. In *The New Yorker*. September 1st, 1928. v. 4, p. 21–23.

VAN RENSSELAER, Mariana (Griswold). *"Pauline" (Mr. Manship's portrait of his daughter at the age of three weeks)*. In *Scribner's magazine*. December 1916. v. 60, p. 772–776.

VITRY, Paul. *Paul Manship*. Paris, 1927.

Mellon, Eleanor M.

MELLON, Eleanor Mary. *Sculpture for the church*. In *National sculpture review*. Winter 1962–1963. v. 11, no. 4, p. 6–12, 22.

—— *Sculpture in the service of the church*. In *The Cathedral age*. Spring 1952. v. 27, no. 1, p. 9–10.

Sculptor Mellon seeks serenity and beauty in ecclesiastical art. In *Art voices from around the world*. January 1963.

Menconi, R. J.

WINCHESTER, James A. *Police commissioner is one of nation's leading artists*. In *The Christian science monitor*. July 6th, 1962. p. 15.

Moore, Bruce

Bruce Moore, his sculpture and drawings. In *American artist*. June 1942. v. 6, no. 6, p. 21–23.

GETLEN, Frank. *The look of nature; sculptor Bruce Moore draws animals from life*. In *The Star magazine*, Washington, D.C. August 5th, 1962.

Nadelman, Elie

BEAUNOM, André. *Ein Hellenist: Elie Nadelman*. In *Das Zelt*. March 1924. 1. Jahrg., p. 94, 95.

BIRNBAUM, Martin. *Éli Nadelman*. In *The International studio*. December 1915. v. 57, p. LIII–LV.

—— *Elie Nadelman: sculptor*. In *The Menorah journal*. October 1925. v. 11, p. 484–488.

—— *Introductions*. New York, 1919. p. 59–68.

Breaking loose from the Rodin spell. In *Current opinion*. March 1917. v. 62, p. 206–208.

BURROUGHS, Clyde H. *The sculpture of Elie Nadelman*. In Detroit institute of arts. *Bulletin*. February 1920. v. 1, p. 73–75.

DAVIS, Virginia H. *Heads by Eli Nadelmann*. In *International studio*. March 1925. v. 80, p. 482–483.

A "Hellenist" sculptor driven here by the war. In *The Literary digest*. March 3rd, 1917. v. 54, p. [550]–551.

The Index of twentieth century artists. March–September 1936. v. 3, p. 259–261, sup., p. [lxxxii].

KIRSTEIN, Lincoln. *The sculpture of Elie Nadelman*. New York [c1948].

McBRIDE, Henry. *Elie Nadelman*. In *Creative art*. May 1932. v. 10, p. 393–394.

—— *Elie Nadelman's sculpture*. In *Fine arts journal*. March 1917. v. 35, p. 227–228.

MURRELL, William, ed. *Elie Nadelman*. Woodstock, New York, 1923. (*Younger artists series*. no. 6)

NADELMAN, Elie. *Elie Nadelman drawings*. New York, 1949.

—— *Vers la beauté plastique; thirty-two reproductions of drawings*. New York, 1921.

Nadelman, Elie, continued

READ, Helen Appleton. *Eli Nadelman.* In *The Arts.* April 1925. v. 7, p. 228–229.

SALMON, André. *Éli Nadelman.* In *L'Art décoratif.* March 1914. v. 31, p. 107–114.

—— *La jeune sculpture française.* Paris, 1919. p. 77–82.

Sculpture of mystery, by Eli Nadelman. In *Vanity fair.* September 1917. v. 9, no. 1, p. 58.

WHITE, Charles S. *The dry points of Elie Nadelman.* New York, 1953.

Nicolosi, Joseph

BROOKGREEN GARDENS, *Brookgreen, S.C. Sculpture by Joseph Nicolosi.* [New York] ᶜ1937.

Niehaus, C. H.

ARMSTRONG, Regina. *The sculpture of Charles Henry Niehaus.* New York, 1901.

BRUSH, Edward Hale. *The Francis Scott Key monument at Baltimore.* In *The International studio.* April 1917. v. 61, p. XLV–XLVI.

Charles Henry Niehaus A.N.A., American sculptor. In *The International studio.* August 1906. v. 29, p. 104–111.

INGERSOLL, W. H. *Charles Henry Niehaus, sculptor.* In *The Art interchange.* September 1904. v. 53, p. 58–60.

PAYNE, Frank Owen. *The national memorial to the author of The Star spangled banner.* In *Art and archaeology.* July 1917. v. 6, p. 5–6.

Sculptors of the Americas. In Pan American union. *Bulletin.* December 1916. v. 43, p. 763–771.

WILSON, Rufus R. *Charles Henry Niehaus.* In *The Monthly illustrator and Home and country.* June 1896. v. 12, p. [391–400].

Paddock, W. D.

PADDOCK, Willard Dryden. *Some reproductions of works by Willard Paddock, sculptor.* New York, 1928.

Some bronzes by Willard Dryden Paddock. In *The International studio.* December 1911. v. 46, p. 13–16.

WANGEMAN, Anna Louise. *Willard Dryden Paddock: idealist.* In *American magazine of art.* June 1916. v. 7, p. 328–331.

Park, Madeleine

Madeleine Park, circus sculptress. In *Ringling circus magazine.* 1940.

Patigian, Haig

PARKES, Kineton. *Haig Patigian: an architectural sculptor of San Francisco.* In *The Builder.* October 12th, 1923. v. 125, p. 561–562.

PRATT, Harry Noyes. *Haig Patigian, California's noted sculptor.* In *Overland monthly.* August 1923. v. 32, no. 4, p. 11.

Perry, R. Hinton

HUGHES, Rupert. *A dual talent.* In *The Art interchange.* August 1900. v. 45, p. 28–30.

LEE, Cuthbert. *Contemporary American portrait painters.* New York, 1929. p. 50.

Roland Hinton Perry, sculptor-painter. In *The Musical monitor.* June 1923. v. 13, no. 9, p. 18.

A sculptor of the month. In *Metropolitan magazine.* November 1895. v. 2, p. 316–318.

Shakespearean scenes in bas-relief. In *Current literature.* March 1906. v. 40, p. 265–269.

The work of R. Hinton Perry. In *The Commercial advertiser.* October 21st, 1899.

Piccirilli family

ADAMS, Adeline Valentine (Pond). *A family of sculptors.* In *The American magazine of art.* July 1921. v. 12, p. 223–230.

BERGER, W. M. *Making a great statue; how French's Lincoln was put into marble.* In *Scribner's magazine.* October 1919. v. 66, p. 424–431.

EATON, Allen H. *Immigrant gifts to American life.* New York, 1932. p. 128–129.

LOMBARDO, Josef Vincent. *Attilio Piccirilli; life of an American sculptor.* New York, Chicago [ᶜ1944].

WILLSON, Dixie. *Six brothers with but a single goal.* In *The American magazine.* February 1930. v. 109, no. 2, p. 70–73.

Polášek, Albin

ADLER, William F. *Peril on Parnassus.* New York [1954]. p. 169–172.

Albin Polášek, noted sculptor of the unusual. In *Town and country review.* July 1934. 2d. ser. v. 5, no. 1, p. 30.

BROOKGREEN GARDENS, *Brookgreen, S.C. Sculpture by Albin Polášek.* [New York] ᶜ1937.

EATON, Allen H. *Immigrant gifts to American life.* New York, 1932. p. 128.

HOUGH, Dorothy Whitehead. *Man chiseling his own destiny.* In *Art and archaeology.* September 1929. v. 28, p. 85–88.

RICHARDS, Agnes Gertrude. *The Polášek exhibition.* In *Fine arts journal.* February 1917. v. 35, p. 122–126.

SHERWOOD, Ruth. *Carving his own destiny.* Chicago [1954].

Proctor, A. Phimister

BRUSH, Edward Hale. *An animal sculptor.* In *Arts and decoration.* August 1911. v. 1, p. 392–394.

CORTISSOZ, Royal. *Some wild beasts sculptured by A. Phimister Proctor.* In *Scribner's magazine.* November 1910. v. 48, p. 637–640.

NELSON, W. H. de B. *Phimister Proctor: Canadian sculptor.* In *The Canadian magazine.* April 1915. v. 44, p. 495–501.

PEIXOTTO, Ernest Clifford. *A sculptor of the west.* In *Scribner's magazine.* September 1920. v. 68, p. 266–277.

Remarkable animal sculpture at New York zoo. In *The Monumental news.* May 1909. v. 21, p. [371]–372.

TAFT, Lorado. *A. Phimister Proctor.* In *Brush and pencil.* September 1898. v. 2, p. 241–248.

WHITTEMORE, Margaret. *Phimister Proctor's statue of a pioneer mother.* In *The American magazine of art.* July 1928. v. 19, p. 376–378.

Putnam, Brenda

ADAMS, Mildred. *Brenda Putnam, sculptor.* In *The Woman citizen.* November 1925. n.s., v. 10, no. 8, p. 14–15.

BROOKGREEN GARDENS, *Brookgreen, S.C. Sculpture by Brenda Putnam.* [New York] ᶜ1937.

Recchia, R. H.

HURD, Harry Elmore. *Richard Henry Recchia; Cape Ann's only permanent resident sculptor.* In *The Breeze.* June 26th, 1931. p. 54–56.

Remington, Frederic

AMON CARTER MUSEUM OF WESTERN ART, *Fort Worth, Texas. Inaugural exhibition.* Fort Worth, 1961.

BARNES, James. *Frederic Remington—sculptor.* In *Collier's.* March 18th, 1905. v. 34, p. 21.

BIGELOW, Poultney. *Frederic Remington; with extracts from unpublished letters.* In New York state historical association. *The Quarterly journal.* January 1929. v. 10, p. 45–52.

—— *Seventy summers.* London, 1925. v. 1, p. 301–332; v. 2, p. [1]–5.

CARD, Helen Luise. *The collector's Remington . . . II. The story of his bronzes.* Woonsocket, R.I. [ᶜ1946].

CORTISSOZ, Royal. *American artists.* New York, London, 1923. p. 227–243.

DAVIS, Charles Belmont. *Remington—the man and his work.* In *Collier's.* March 18th, 1905. v. 34, p. 15.

DE KAY, Charles. *A painter of the West; Frederic Remington and his work.* In *Harper's weekly.* January 8th, 1910. v. 54, no. 2768, p. 14, 38.

EDGERTON, Giles. *Frederic Remington, painter and sculptor: a pioneer in distinctive American art.* In *The Craftsman.* March 1909. v. 15, p. 658–670.

GREGG, Richard N. *The art of Frederic Remington.* In *The Connoisseur.* August 1967. v. 165, p. 269–273.

HOUGH, Nellie. *Remington at twenty-three.* In *International studio.* February 1923. v. 76, p. 413–415.

McCRACKEN, Harold. *Frederic Remington, artist of the Old West.* Philadelphia and New York [ᶜ1947].

MAXWELL, Perriton. *An appreciation of the art of Frederic Remington.* In *Pearson's magazine.* October 1907. v. 18, p. [395]–407.

REMINGTON ART MEMORIAL, *Ogdensburg, N.Y. A catalogue of the Frederic Remington memorial collection.* New York, 1954.

SMITH, Frank Hopkinson. *American illustrators.* New York, 1893. p. 22–25.

SYDENHAM, Alvin H. *Frederic Remington.* In New York public library. *Bulletin.* August 1940. v. 44, p. 609–613.

THOMAS, Augustus. *Recollections of Frederic Remington.* In *The Century magazine.* July 1913. v. 86, p. 354–361.

Remington, Frederic, continued

VAIL, Robert William Glenroie. *Frederic Remington, chronicler of the vanished west.* New York, 1929. (Reprinted from New York public library. *Bulletin.* February 1929. v. 33, p. 71–75)

Renier, Joseph

MORRO, Clément. *Joseph Renier.* In *La Revue moderne illustrée des arts et de la vie.* August 30th, 1932. 32. année, no. 16, p. 13–16.

Rockwell, R. H.

ROCKWELL, Robert Henry. *Adventures in sculpture-taxidermy.* In *Asia.* January 1929. v. 29, p. 22–[29], 72–74.

—— *Hunting the big brown bear.* In *Brooklyn museum quarterly.* January 1922. v. 9, p. 1–23.

—— *Sheep hunting in Alaska.* In *Brooklyn museum quarterly.* April 1923. v. 10, p. 71–82.

—— *Too close to bears.* In *Natural history.* March 1941. v. 47, p. 136–138.

—— *and* ROCKWELL, Jeanne. *My way of becoming a hunter.* New York [1955].

Roth, F. G. R.

Animal and other sculpture of Frederick G. R. Roth. In *The Art world and Arts and decoration.* October 1918. v. 9, p. 346–347.

CAFFIN, Charles Henry. *American masters of sculpture.* New York, 1903. p. 199–202.

HOEBER, Arthur. *Mr. Roth's ceramics.* In *The International studio.* January 1909. v. 36, p. LXXXV–LXXXVI.

OSTERKAMP, F. E. *F. G. R. Roth, N.A., sculptor.* In *The Studio.* May 1927. v. 93, p. 322–329.

ROTH, Roger F. von. . . . *Frederick G. R. Roth, seventh president, National sculpture society.* In *National sculpture review.* Fall 1964. v. 13, no. 3, p. 17, 28–29.

WELLS, Griffith T. *Frederick G. R. Roth, N.A., interpreter of animals.* In *Arts and decoration.* April 1912. v. 2, p. 222–224.

Rudy, Charles

GRAFLY, Dorothy. *Charles Rudy.* In *American artist.* April 1948. v. 2, no. 4, p. 38–40, 62.

Painters and sculptors of modern America; introduction by Monroe Wheeler. New York, 1942. p. 102–106.

Rumsey, C. C.

ALEXANDRE, Arsène. *Charles Cary Rumsey.* In *La Renaissance de l'art français et des industries de luxe.* June 1927. 10. année, p. [257]–262.

FOX, William Henry. *Two important works by American sculptors.* In *The Brooklyn museum quarterly.* July 1930. v. 17, p. 79–80.

PARIS. Société nationale des beaux-arts. *Exposition rétrospective de l'œuvre de Charles Cary Rumsey (1879–1922).* Paris, 1927.

Saint-Gaudens, Augustus

ADAMS, Adeline Valentine (Pond). *Aspet; the home of Saint-Gaudens.* In *Art and progress.* March–April 1915. v. 6, p. 139–144, 189–194.

ARMSTRONG, David Maitland. *Day before yesterday.* New York, 1920. p. 258–287.

ARMSTRONG, Hamilton Fish. *Saint-Gaudens: recollections of his friend Maitland Armstrong.* In *Scribner's magazine.* January 1917. v. 62, p. 22–33.

ATKINSON, Edward, COFFIN, William A., and HIGGINSON, Thomas Wentworth. *The Shaw memorial and the sculptor St. Gaudens.* In *The Century magazine.* June 1897. v. 54, p. 176–200.

Augustus Saint-Gaudens. In *The Craftsman.* October 1907. v. 13, p. 59–67.

BELL, Hamilton. *Un sculpteur américain de descendance française. Auguste Saint-Gaudens.* In *Gazette des beaux-arts.* May 1920. 62. année, 5. série, v. 1, p. [367]–382.

BERKELMAN, Robert G. *America in bronze; Augustus Saint-Gaudens.* In *Sewanee review.* 1940. v. 48, p. 494–509.

CAFFIN, Charles Henry. *Augustus Saint-Gaudens; an appreciation.* In *Putnam's monthly.* November 1907. v. 3, p. 205–210.

—— *Saint-Gaudens: an American genius.* In *Harper's weekly.* August 24th, 1907. v. 51, p. 1234–1236, 1247.

—— *The work of the sculptor Augustus Saint-Gaudens.* In *The World's work.* February 1904. v. 7, p. 4403–4419.

CHAMBRUN, A. de. *Un sculpteur américain né français; Saint-Gaudens.* In *Revue des deux mondes.* February 1st, 1932. 102. année, 8. série, v. 7, p. [664]–674.

CLEMEN, Paul. *Augustus Saint-Gaudens.* In *Die Kunst für Alle.* February–March 1910. v. 25, p. 252–260, 281–286.

CORTISSOZ, Royal. *Augustus Saint-Gaudens.* Boston and New York, 1907.

—— *Augustus St. Gaudens.* In *The North American review.* November 1903. v. 177, p. [725]–738.

—— *Augustus Saint-Gaudens.* In *The Outlook.* September 22nd, 1906. v. 84, p 199–208.

—— *The painter's craft.* New York, London, 1930. p. 403–412.

COX, Kenyon. *Artist and public.* New York, 1914. p. 169–228.

—— *Augustus Saint-Gaudens.* In *The Atlantic monthly.* March 1908. v. 101, p. 298–310.

—— *Augustus Saint-Gaudens.* In *The Century magazine.* November 1887. v. 35, p. [28]–37.

—— *In memory of Saint-Gaudens.* In *The Architectural record.* October 1907. v. 22, p. [249]–251.

—— *Old masters and new.* New York, 1905. p. 266–285.

GILDER, Richard Watson. *The Farragut monument.* In *Scribner's monthly.* June 1881. v. 22, p. [161]–167.

HIND, Charles Lewis. *Augustus Saint-Gaudens.* [New York] 1908.

The Index of twentieth century artists. May–September 1934. v. 1, p. [113]–123, sup., p. [xxv]; September 1935. v. 2, sup., p. [xliii]; August–September 1936. v. 3, sup., p. [xxv–xxvi].

KNAUFFT, Ernest. *Saint Gaudens and American sculpture.* In *The American review of reviews.* September 1907. v. 36, p. [290]–300.

LOW, Will Hicok. *A chronicle of friendships, 1873–1900.* New York, 1908.

MIGEON, Gaston. *Augustin Saint-Gaudens.* In *Art et décoration.* January–June 1899. v. 5, p. [43]–49.

The monument to Robert Gould Shaw. Boston and New York, 1897.

NEW YORK. Metropolitan museum of art. *Catalogue of a memorial exhibition of the works of Augustus Saint-Gaudens.* New York, 1908.

PEIXOTTO, Ernest. *A Saint-Gaudens pilgrimage.* In *Scribner's magazine.* April 1918. v. 63, p. 424–431.

Roosevelt and our coin designs; letters between Theodore Roosevelt and Augustus Saint Gaudens. In *The Century magazine.* April 1920. v. 99, p. 721–736.

SAINT-GAUDENS, Augustus. *Familiar letters . . . ed. by Rose Standish Nichols.* In *McClure's magazine.* October 1908. v. 31, p. 603–616; November 1908. v. 32, p. 1–16.

—— *The reminiscences of Augustus Saint-Gaudens.* New York, 1913. 2 v.

SAINT-GAUDENS, Homer. *The later works of Augustus Saint-Gaudens.* In *The Century magazine.* March 1908. v. 75, p. 695–713.

SULLIVAN, T. R. *Augustus Saint Gaudens.* In *The Reader.* December 1905. v. 7, p. [1]–10.

TAFT, Lorado. *Saint-Gaudens, the master.* In *The Mentor.* October 20th, 1913. v. 1, no. 36, p. 4–5.

VAN RENSSELAER, Mariana (Griswold). *Saint Gauden's Lincoln.* In *The Century magazine.* November 1887. v. 35, p. 37–39.

WALTON, William, comp. *A list of the works of Augustus Saint Gaudens.* In *The Burlington magazine.* December 1907. v. 12, p. 189–190.

WILLIAMS, Talcott. *Augustus Saint-Gaudens.* In *The International studio.* February 1908. v. 33, p. CXXIII–CXXXVIII.

St.-Gaudens, Louis

ARMSTRONG, David Maitland. *Day before yesterday.* New York, 1920. p. 263, 266, 308.

CORTISSOZ, Royal. *American artists.* New York, London, 1923. p. 276–279.

[JACKSON, Robert M.] *Examples of modern sculpture.* In New York. Metropolitan museum of art. *Bulletin.* November 1914. v. 9, p. 244.

MOORE, Charles. *Daniel H. Burnham.* Boston, New York, 1921. v. 1, p. 56; v. 2, p. 5–10.

SAINT-GAUDENS, Augustus. *The reminiscences of Augustus Saint-Gaudens.* New York, 1913. 2 v.

Sanford, E. F., Jr.

The animal frieze of the New York state Theodore Roosevelt memorial. In *Architecture.* July 1934. v. 70, p. 31–33.

Architectural sculpture by Edward Field Sanford, jr. [New York] 1926.

Architectural sculptures by Edward Field Sanford, jr. In *The Metal arts.* June 1929. v. 2, p. 265–268, 277.

BROOKGREEN GARDENS, Brookgreen, S.C. *Sculpture by Edward Field Sanford, junior.* [New York] ᶜ1937.

EDMISTON, Eustace. *Modern-archaic sculpture in America.* In *The International studio.* December 1915. v. 57, p. LI–LII.

Sanford, E. F., Jr., continued

P., C. M. *Some recent studies by a new sculptor.* In *The International studio.* January 1912. v. 15, p. 8–11.

SANFORD, Edward Field, Jr. *A portfolio of sculpture.* New York [19—?].

WELLS, Griffith T. *Expression in sculpture; some interesting work in varied moods, by E. F. Sanford, jr.* In *Arts and decoration.* July 1912. v. 2, p. 329–332.

Scudder, Janet

FERARGIL GALLERIES, *New York. An exhibition of the sculpture of Janet Scudder.* [New York] 1926.

HALL, Alice. *Fountains designed by Janet Scudder.* In *The House beautiful.* June 1914. v. 36, p. 10–12.

MECHLIN, Leila. *Janet Scudder—sculptor.* In *The International studio.* February 1910. v. 39, p. LXXXI–LXXXVIII.

SCUDDER, Janet. *Modeling my life.* New York [ᶜ1925].

Shonnard, Eugenie F.

BROOKGREEN GARDENS, *Brookgreen, S.C. Sculpture by Eugenie F. Shonnard.* [New York] ᶜ1937.

CHASSÉ, Charles. *Une femme sculpteur; Miss Eugénie Shonnard.* In *L'Art et les artistes.* December 1924. n.s., v. 10, p. 91–96.

Indian sculpture exhibit by Shonnard. In *El Palacio.* January–February 1937. v. 42, p. 19–20.

SANTA FE, New Mexico. Museum of New Mexico. *Catalogue of an exhibition of sculpture by Eugenie F. Shonnard.* [Santa Fe, 1927]

—— *An exhibition of sculpture by Eugenie Shonnard.* Santa Fe, 1954.

How Miss Shonnard discovered Miss Shonnard. In *The Literary digest.* June 7th, 1924. v. 81, no. 10, p. 36.

WALTER, Paul A. L. *Eugénie F. Shonnard.* In *The American magazine of art.* October 1928. v. 19, p. 549–556.

Snowden, G. H.

FAIRBANKS, Frank P. *George H. Snowden, fellow in sculpture, American Academy in Rome.* In *Art and archaeology.* March 1931. v. 31, p. 146–151.

Stevens, L. T.

The beginning of a career. In *Stone & Webster journal.* August 1922. v. 31, p. [143]–153.

OWEN, Mary Jane. *Lawrence Tenney Stevens, sculptor.* In *Arizona highways.* January 1962. v. 38, no. 1, p. 2–9.

Sixty foot wood sculpture. In *Design.* December 1938. v. 40, no. 5, sup., p. [3].

Stewart, Albert

Albert Stewart. Claremont, Calif. [ᶜ1966].

McFEE, Henry Lee. *Animal drawings by Albert Stewart.* In *American artist.* April 1950. v. 14, no. 4, p. 31–33.

STEWART, Albert. *Ecclesiastical sculpture.* In *American artist.* December 1954. v. 18, no. 10, p. 24–25, 55, 56.

Swarz, Sahl

Sculpture by Swarz on view this month. In *Philadelphia art alliance. Bulletin.* January 1959. v. 37, no. 4, p. 13.

SWARZ, Sahl. *Sahl Swarz makes a new approach to an ancient art.* In *American artist.* January 1955. v. 19, no. 1, p. 19–23.

Taft, Lorado

BROWNE, Charles Francis. *Lorado Taft: sculptor.* In *The World to-day.* February 1908. v. 14, p. 191–198.

CLARK, Neil M. *A wonderful thing happened to this boy!* In *The American magazine.* April 1922. v. 93, p. 20–21, 143–146.

FULLER, Henry Blake. *Notes on Lorado Taft.* In *The Century magazine.* August 1908. v. 76, p. 618–621.

GARLAND, Hamlin. *The art of Lorado Taft.* In *The Mentor.* October 1923. v. 11, no. 9, p. 19–34.

HAZELTINE, Elizabeth. *Lorado Taft—master sculptor.* In *The School arts magazine.* January 1926. v. 25, p. 260–268.

The Index of twentieth century artists. March 1937. v. 4, p. 409–415.

Lorado Taft. In Pan American union. *Bulletin.* January 1919. v. 48, p. 50–58.

MOSE, Ruth Helming. *Midway studio.* In *The American magazine of art.* August 1928. v. 19, p. 413–422.

MOULTON, Robert H. *Lorado Taft and his work as a sculptor.* In *The American review of reviews.* June 1912. v. 45, p. 721–725.

—— *Lorado Taft, dean of Chicago sculptors.* In *Art and archaeology.* December 1921. v. 12, p. 243–252.

—— *Lorado Taft, interpreter of the middle west.* In *The Architectural record.* July 1914. v. 36, p. [13]–24.

NASH, J. V. *The art of Lorado Taft.* In *Haldeman-Julius quarterly.* April 1927. v. 1, no. 3, p. [194]–203.

ROLFE, M. A. *Our western sculptor—Lorado Taft.* In *The Western architect.* April 1924. v. 33, p. 42–46.

ROVELSTAD, Trygve A. *Impressions of Lorado Taft.* In The Illinois state historical society. *Papers in Illinois history and transactions for the year 1937.* Springfield, Ill., 1938. p. [18]–33.

Sermons in sculpture. In *Illinois journal of commerce.* April 1936. v. 18, no. 4, p. 8–9, 24, 29, 31.

TAFT, Ada (Bartlett). *Lorado Taft, sculptor and citizen.* Greensboro, N.C., 1946.

TSCHAEGLE, Robert. *A mid-American prophet of beauty.* In *Kessinger's midwest review.* February 1925. v. 4, no. 2, p. 22–25.

UNGER, Giselle d'. *A sculptor's dream of the Chicago beautiful.* In *Fine arts journal.* March 1912. v. 26, p. [158]–166.

WIGHT, Peter B. *Apotheosis of the Midway plaisance; Lorado Taft's symposium of adornment with sculpture.* In *The Architectural record.* November 1910. v. 28, p. [335]–349.

Talbot, Grace H.

Plastic forms that sing. In *The Mentor.* December 1928. v. 16, no. 11, p. 28–29.

Troubetzkoy, Paul

AMERICAN NUMISMATIC SOCIETY. *Catalogue of sculpture by Prince Paul Troubetzkoy.* New York, 1911.

BRÉMONTIER, Jeanne. *Paul Troubletzkoy.* In *La Revue de l'art.* January 1921. v. 39, p. [63]–74.

FRIEDENTHAL, Joachim. *Paul Troubetzkoy.* In *Über Land und Meer.* 1911. v. 105, p. 628–630.

GALERIE "LA RENAISSANCE", Paris. *Catalogue; exposition d'art russe.* Paris, 1932.

GIOLLI, Raffaello. *P. Troubetzkoy.* Milano [19–?].

GUILLEMOT, Maurice. *Troubetzkoy, sculpteur.* In *L'Art décoratif.* September 1908. v. 19, p. [103]–109.

JARVIS, William. *Paul Troubetzkoy, sculptor.* In *Scribner's magazine.* February 1902. v. 31, p. 181–188.

JEFFERIS, Jessie Willis. *Paul and Pierre Troubetzkoy.* In *The International studio.* July 1919. v. 68, p. x–xv.

JOERISSEN, Gertrude Laughlin. *Troubetzkoy —an interpreter of life.* In *The American magazine of art.* October 1923. v. 14, p. 560–569.

MÉRIEM, Jean. *Paul Troubletzkoy.* In *L'Art et les artistes.* April 1906. v. 3, p. 8–12.

MOWBRAY-CLARKE, M. H. *Sculptures by Prince Troubetzkoy.* In *The Independent.* March 9th, 1911. v. 70, p. 495–496.

PICA, Vittorio. *Artisti contemporanei: Paolo Troubetzkoy.* In *Emporium.* July 1900. v. 12, p. [3]–19.

SEGARD, Achille. *The sculpture of Prince Paul Troubetzkoi.* In *The Studio.* January 1910. v. 48, p. 266–274.

SNABILIÉ, Charles. *Paul Troubletzkoy.* In *Elsevier's geïllustreerd maandschrift.* January–June 1911. v. 41, p. [241]–252.

Vonnoh, Bessie Potter

BROOKGREEN GARDENS, *Brookgreen, S.C. Sculpture by Bessie Potter Vonnoh.* [New York] ᶜ1937.

Miss Bessie Potter's figurines. In *Scribner's magazine.* January 1896. v. 19, p. 126–127.

MONROE, Lucy. *Bessie Potter.* In *Brush and pencil.* April 1898. v. 2, p. 29–36.

A sculptor of statuettes. In *Current literature.* June 1903. v. 34, p. 699–702.

Some sculpture by Mrs. Vonnoh. In *The International studio.* August 1909. v. 38, p. 121–[124].

VONNOH, Bessie Onahotema (Porter). *Tears and laughter caught in bronze.* In *The Delineator.* October 1925. v. 107, no. 4, p. 8–9, 78, 80, 82.

The Vonnohs. In *The International studio.* December 1914. v. 54, p. XLVIII–[LII].

ZIMMERN, Helen. *The work of Miss Bessie Potter.* In *The Magazine of art.* 1900. v. 24, p. 522–524.

Ward, J. Q. A.

ADAMS, Adeline Valentine (Pond). *John Quincy Adams Ward; an appreciation.* New York. 1912.

CENTURY ASSOCIATION, *New York. John Quincy Adams Ward; memorial addresses delivered before the Century association November 5, 1910.* New York, 1911.

CORTISSOZ, Royal. *American artists.* New York, London, 1923. p. 269–272.

"The first of American sculptors." In *Current literature.* June 1910. v. 48, p. 667–670.

Ward, J. Q. A., continued

John Quincy Adams Ward 1830–1910, first president of the National sculpture society. In *National sculpture review.* Winter 1963–1964. v. 11, no. 4, p. 18, 24.

KNAUFFT, Ernest. *Ward, the American sculptor.* In *The American review of reviews.* June 1910. v. 41, p. [694]–696.

NEW YORK (STATE). CHAMBER OF COMMERCE. *Proceedings at the unveiling of the statue of W. E. Dodge . . . Oct. 22, 1885.* [New York] 1886.

SCHUYLER, Montgomery. *John Quincy Adams Ward; the work of a veteran sculptor.* In *Putnam's magazine.* September 1909. v. 6, p. 643–656.

SESSIONS, Francis C. *Art and artists of Ohio.* In *Magazine of western history.* June 1886. v. 4, p. 161–163.

Shakespeare. Ward's statue in the Central Park, New York. New York, 1873.

SHELDON, G. W. *An American sculptor.* In *Harper's new monthly magazine.* June 1878. v. 57, p. 62–68.

SLOANE, William Milligan. *Commemorative tributes to Charles Follen McKim, Charles Eliot Norton, John Quincy Adams Ward, Thomas Bailey Aldrich, Joseph Jefferson.* New York, 1922. (Reprinted from The American academy of arts and letters. *Proceedings.* v. 4)

STURGIS, Russell. *The pediment of the New York stock exchange.* In *Scribner's magazine.* September 1904. v. 36, p. [381]–384.

—— *The work of J. Q. A. Ward.* In *Scribner's magazine.* October 1902. v. 32, p. [385]–399.

TAFT, Lorado. *Famous American sculptors.* In *The Mentor.* October 20th, 1913. v. 1, no. 36, p. 2–4.

TOWNLEY, D. O'C. *Living American artists: J. Q. Adams Ward.* In *Scribner's monthly.* August 1871. v. 2, p. 403–407.

WALTON, William. *The work of John Quincy Adams Ward, 1830–1910.* In *The International studio.* June 1910. v. 40, p. LXXXI–LXXXVIII.

Warneke, Heinz

A guide to the painting and sculpture in the Post office department building. Washington, D.C., 1938. p. 16.

HUTCHINGS, Emily Grant. *The simple genius of Heinz Warneke.* In *International studio.* February 1926. v. 83, p. 35–38.

HYSLOP, Francis E., Jr. *Heinz Warneke—his art.* In *Penn state alumni news.* October 12th, 1965. v. 52, no. 5, p. 4–9.

The Index of twentieth century artists. March–September 1936. v. 3, p. 263–264; sup., p. [lxxxii].

NATHAN, Walter L. *Living forms: the sculptor Heinz Warneke.* In *Parnassus.* February 1941. v. 13, p. 55–57.

TSCHAEGLE, Robert. *Brick and brass, wood and stone.* In *The Mentor.* May 1928. v. 16, no. 4, p. 33–36.

WARNEKE, Heinz. *"First and last a sculptor."* In *Magazine of art.* February 1939. v. 32, p. 74–80.

ZIGROSSER, Carl. *Heinz Warneke: sculptor.* In *Creative art.* April 1928. v. 2, p. XXXV–XXXVIII.

Waugh, Sidney

GRAFLY, Dorothy. *Waugh's designs for engraved glass.* In *American artist.* June 1947. v. 11, p. 22–27, 51–52.

A guide to the painting and sculpture in the Post office department building. Washington, D.C., 1938. p. 22.

KNOEDLER AND COMPANY, *New York. The exhibit of Steuben glass designed by Sidney Waugh.* New York, 1935.

LAWTON, Isobel Smith. *Sidney Waugh: master sculptor of glass.* In *The News and courier,* Charleston, S.C. January 19th, 1964.

MORGAN, Charles H. . . . *Sidney Waugh, eighteenth president, National sculpture society.* In *National sculpture review.* Fall 1967. v. 16, no. 3, p. 22, 28–29.

Sidney Waugh. New York [ᶜ1948]. (American sculptors series, 6)

SMITH, J. Kellum, Jr. *Sidney Waugh, 1904–1963.* In *National sculpture review.* Fall 1963. v. 12, no. 3, p. 18–19, 30.

STEUBEN GLASS, *firm. The collection of designs in glass by twenty-seven contemporary artists.* [New York, 1940] no. 26.

U.S. TREASURY DEPARTMENT. Procurement division. Public works branch. Section of painting and sculpture. *Bulletin.* October–November 1935. no. 6, p. 10.

Weems, Katharine Lane

BROOKGREEN GARDENS, *Brookgreen, S.C. Sculpture by Katharine Ward Lane.* [New York] ᶜ1937.

Wein, Albert

The Chelsea news, New York. December 23rd, 1949. v. 1, no. 1, p. 3.

Lovoos, Janice. *The art of Albert Wein*. In *American artist*. January 1963. v. 27, no. 1, p. 32–37, 82–84.

Schaller, Harold. *The need for sculpture*. In *American art in stone*. May 1951. v. 51, no. 5, p. 14–15.

The society of medalists . . . forty-third issue. In *The Numismatist*. June 1951. v. 64, p. 610–611.

Weinman, A. A.

Adolph A. Weinman's sculptures in bronze. In *The Metal arts*. September 1929. v. 2, p. 423–427, 436.

Adolph Alexander Weinman. In Pan American union. *Bulletin*. December 1917. v. 45, p. 775–787.

Brookgreen gardens, *Brookgreen, S.C. Sculpture by Adolph Alexander Weinman.* [New York] ᶜ1937.

Dorr, Charles H. *A sculptor of monumental architecture*. In *Architectural record*. June 1913. v. 33, p. [518]–532.

Dyar, Clara E. *Adolph A. Weinman's monument to Major-General Alexander Macomb*. In *The International studio*. December 1909. v. 39, p. xliv–xlv.

Noe, Sydney Philip. *The medallic work of A. A. Weinman*. New York, 1921.

The sculptor Weinman and a few examples of his work. In *The Century magazine*. March 1911. v. 81, p. 705–[707].

Weinman, Robert Alexander. *Adolph A. Weinman, 1870–1952, eleventh president, National sculpture society*. In *National sculpture review*. Winter 1965–1966. v. 14, no. 4, p. 22, 28.

Whitney, Gertrude Vanderbilt

du Bois, Guy Pène. *Mrs. Whitney's journey in art*. In *International studio*. January 1923. v. 76, p. 351–354.

Gertrude V. Whitney. In *The Art digest*. May 1st, 1942. v. 16, no. 15, p. 6.

Knoedler, M., and company, *New York. Sculpture by Gertrude V. Whitney*. New York, 1936.

Mrs. Whitney's sculptures winning Europe. In *The Literary digest*. July 2nd, 1921. v. 70, p. 28–29.

Petit, Georges, *galeries, Paris. Exposition de sculptures par Gertrude Whitney*. Paris, 1921.

Sculpture of war, the work of Gertrude V. Whitney. In *Touchstone*. January 1920. v. 6, p. 188–194.

Watson, Forbes. *An American tribute to Spain*. In *The Arts*. 1929. v. 16, p. 43–44.

Williams, Wheeler

Brookgreen gardens, *Brookgreen, S.C. Sculpture by Wheeler Williams*. [New York] ᶜ1937.

Garden of the gods. In *The Spur*. May 1940. v. 65, no. 5, p. 29.

Wheeler Williams. New York [ᶜ1947]. (American sculptors series, 1)

Wright, Alice Morgan

Sterner, Marie, *firm, New York. Alice Morgan Wright; exhibition*. New York, 1937.

—— *Sculpture; Alice Morgan Wright*. New York, 1937.

Yates, Julie

Gorham company, *New York. Famous small bronzes*. New York [ᶜ1928]. p. 109.

Young, Mahonri

American artists group. *Handbook*. [New York, 1935] [no. 1], p. 75–76.

Andover, Mass. Phillips academy. Addison gallery of American art. *Mahonri M. Young; retrospective exhibition*. Andover, Mass., 1940.

An art born in the west and epitomizing the west: illustrated from the work of Mahonri Young. In *The Touchstone*. October 1918. v. 4, p. 8–18.

Dougherty, Paul. *"Rolling his own"—a new bronze by Mahonri Young*. In *Vanity fair*. May 1925. v. 24, p. 59.

The drawings of Mahonri Young. In *Art instruction*. June 1939. v. 3, no. 6, p. 15–[19].

du Bois, Guy Pène. *Mahonri Young—sculptor*. In *Arts and decoration*. February 1918. v. 8, p. 169, 188.

Faulkner, Barry. Mahonri M. Young, 1877–1957. In The American academy of arts and letters. *Proceedings*. New York, 1959. 2. ser., no. 9, p. 300–304.

Young, Mahonri, continued

HIND, Charles Lewis. *Mahonri Young's drawings.* In *The International studio.* April 1918. v. 64, p. LIII–LX.

The Index of twentieth century artists. December 1934–September 1935. v. 2, p. 45–48, sup., p. [xlv]; August–September 1936. v. 3, sup., p. [xlvi].

LEWINE, J. Lester. *The bronzes of Mahonri Young.* In *The International studio.* October 1912. v. 47, p. LV–LVIII.

Life as Mahonri Young sees it. In *The Touchstone.* October 1918. v. 4, p. 8–16.

Mahonri Young's artistic search for the rhythm of labor. In *Current opinion.* September 1914. v. 57, p. 200–201.

Mahonri Young's sculpture preserves his Mormon past. In *Life.* February 17th, 1941. v. 10, no. 7, p. 76, 79.

Plastic interpretations of labors. In *Dress and Vanity fair.* October 1913. n.s., v. 1, p. 46.

Prize ring sculptures by Mahonri Young. In *Vanity fair.* September 1928. v. 31, no. 1, p. 41.

WATSON, Ernest W. *Wayman Adams paints a portrait.* In *Art instruction.* June 1939. v. 3, no. 6, p. 6–13.

WEITENKAMPF, Frank. *An etching sculptor: Mahonri Young.* In *The American magazine of art.* April 1922. v. 13, p. 109–113.

WILSON, James Patterson. *Art and artists of the golden west; a sculptor and a painter of Utah.* In *Fine arts journal.* February 1911. v. 24, p. 96–99.

Index

Index 573

Location of Sculpture on Plan

1, 2 Baillie. Vases
3 Huntington. The Visionaries
4, 5 Huntington. Lions
6 Huntington. Diana of the Chase
7, 8 Williams. Black Panthers
9 Huntington.
 Spout for a Drinking Fountain
10 Piccirilli, F. and H.
 Barberini Candelabrum
11 Wein. Phryne before the Judges
12 Bracken. Chloe
13 Jennewein. Indian and Eagle
14 Lachaise. Swans
15 Jonas. Crane Fountain
16 Clews. The Thinker
17 Manship. King Penguin
18 Manship. Owl
19 Huntington. Reaching Jaguar
20 Weinman, A. A. Narcissus
21 Hering, E. Boy and Frog
22 Huntington. Jaguar
23 Saint-Gaudens, A. The Puritan
24 French. Benediction
25 Aitken. Zeus
26 Mckenzie.
 The Youthful Franklin
27 Cecere. Boy and Fawn
28 Journey. Dawn
29 Humes. The Eagle's Egg
30 Hoffman, E. Susan
31 MacNeil. The Sun Vow
32 Diederich. Goats Fighting
33 Laessle. Penguins
34 Lathrop. Great White Heron
35 Grimes. Girl by a Pool
36 Belskie. Christ Child
37 Korbel. Night
38 Amateis. Pastoral
39 Jennewein. Nymph and Fawn
40 Evans. Boy and Panther
41 Hancock. Boy and Squirrel

42 Barnard. Maidenhood
43 Renier. Boy with Snails
44 Cecere. Eros and Stag
45 Humes. Performing Goat
46 Jester.
 Sea Horse and Companion
47 Sanford, E. Inspiration
48 Piccirilli, F. Seal
49 Niehaus. The Scraper
50 Manship. Evening
51 Maldarelli. Two Kids
52 Holschuh. The Whip
53 Baker. L'Après-midi d'un Faune
54 Davidson. My Niece
55 Waugh. Lion
56 Lascari. Autumn Leaves
57 Korbel. Sonata
58 Beach. Sylvan
59 Piccirilli, B. Leda and the Swan
60 Tennant.
61 Archer—Tejas Warrior
62 Swarz. The Guardian
63 Harvey. Adonis
64 Shonnard. Marabou
65 Piccirilli, A.
 Laughing Boy and Goat
66 Eliscu. Shark Diver
67 Keyser. Meditation
68 Polášek.
 Man Carving His Own Destiny
69, 70 Baillie. Vases
71 Gruppe. Joy
72 Frishmuth. Call of the Sea
73 Fraser, L. Pegasus
74 Derujinsky. Diana
75 Fraser, J. The End of the Trail
76 Keck. Fauns at Play
77 Manship. Actaeon
78 Hawkins. Triton on Dolphin
79 Borglum, G. Mares of Diomedes

80 Manship. Adjutant Stork
81 Manship. Shoebill Stork
82, 83 de Coux. Eve and Adam
84 Polášek. Forest Idyl
85, 86 Hartley. Furies
87 Manship. Pelican
88 Manship.
 Concave-Casqued Hornbill
89 Huntington. Winged Bull
90 Huntington. Winged Horse
91 Kiselewski. Sea Horse
92 Manship. Diana
93 Lentelli. Faun
94 Fjelde. Nymph
95 Branning. Doe
96 Scudder. Seated Faun
97 Moore. Pelican and Fish
98, 99 Baillie. Vases
100 de Francisci.
 Children and Gazelle
101 MacNeil. Into the Unknown
102 Scudder. Tortoise Fountain
103, 104 Hering. Wood Nymphs
105 Fenton. Seaweed Fountain
106 Laessle. Duck and Turtle
107 Manship. Flamingo
108 Manship. Black-Necked Stork
109, 110 Rumsey. Hounds
111 Manship. Crowned Crane
112 Manship. Goliath Heron
113 Denslow. Playmates
114 Denslow. Pelican Rider
115 Putnam. Sundial
116 Stewart. Baby and Rabbits
117 Stewart. Young Centaur
118 Huntington. The Young Diana
119 Laessle. Dancing Goat
120 Mellon. Saint Christopher
121 Haswell. Little Lady of the Sea
122 Horn. Boy with Dolphin
123 Choate. Alligator Bender

124 Huntington. Alligator Fountain
125 Horn. Girl with Dolphin
126 Adams. Sea Scape
127 Belskie. The Moonbeam
128 Fry. Maidenhood
129 Snowden. Play
130 Snowden. Play
131 McCartan. Dionysus
132 Calder. Nature's Dance
133 Gregory. Orpheus
134 Howland. Between Yesterday
 and Tomorrow
135 Williams. Sea Lion
136 Rotan. Reclining Woman with
 Gazelle
137 Renier. Pomona
138 Weinman, A. A. Riders of the
 Dawn
139 Nebel. Nereid
140 Nicolosi. Dream
141 Mayor. Girl with Fish
142 Putnam. Communion
143 Huntington. A Female Centaur
144 Huntington.
 The Centaur Cheiron
145 Perry.
 Primitive Man and Serpent
146 French. Disarmament
147 Evans. Athlete
148 Pippenger. Paul Bunyan
149 Manca. Gazelle and Cactus
150 De Lue. Icarus
151 Laurent. Goose
152 Derujinsky.
 Samson and the Lion
153 Bohland. Group of Anhingas
154 Grafly. Vulture of War
155 Manship. Cycle of Life
156 Ellis. Water Buckaroo
157 Derujinsky. Ecstasy
158 Glinsky. Awakening
159 Huntington. Don Quixote